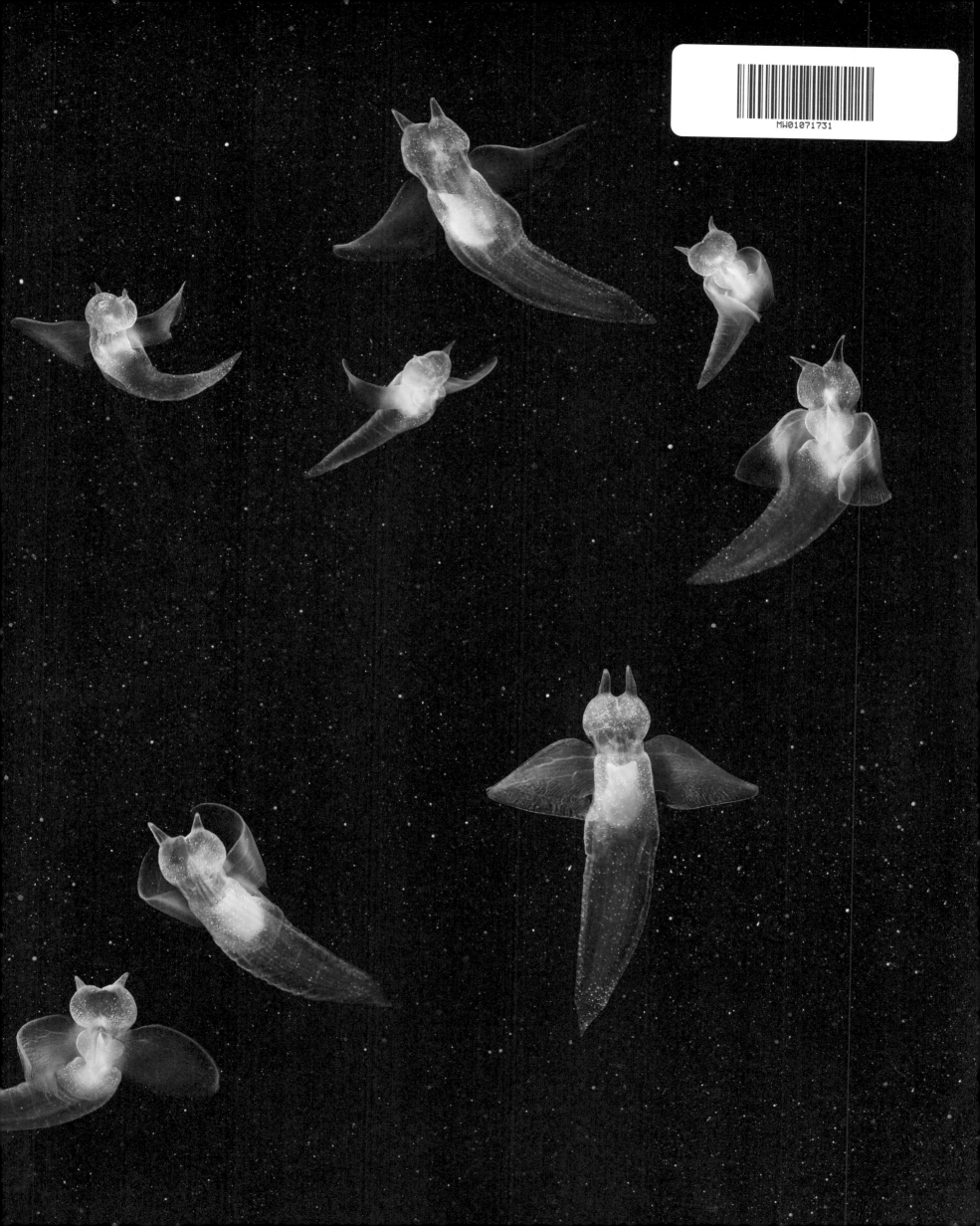

ENDANGERED

TIM FLACH

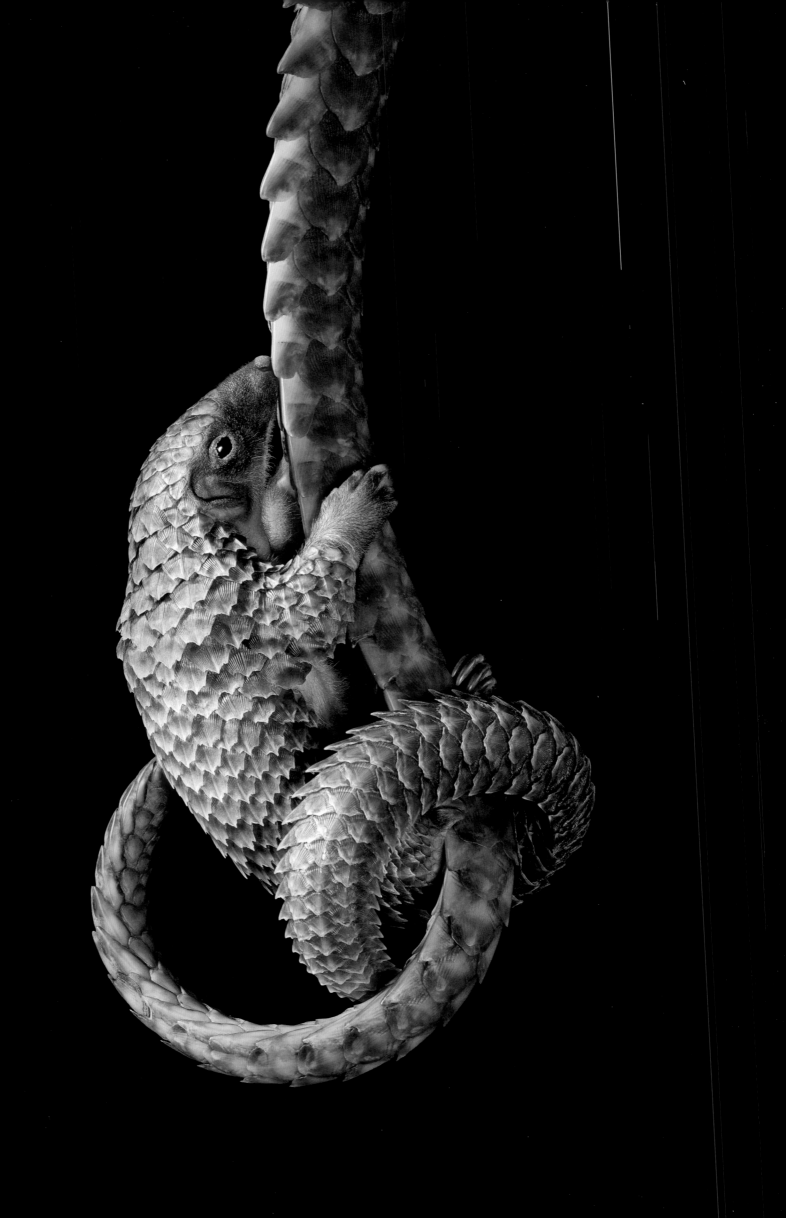

ENDANGERED

TIM FLACH

Text by
Professor Jonathan Baillie
Sam Wells

Abrams, New York

in association with

Blackwell&Ruth.

To my wife, Yuyu, and son, James, for their great understanding, support, and encouragement.

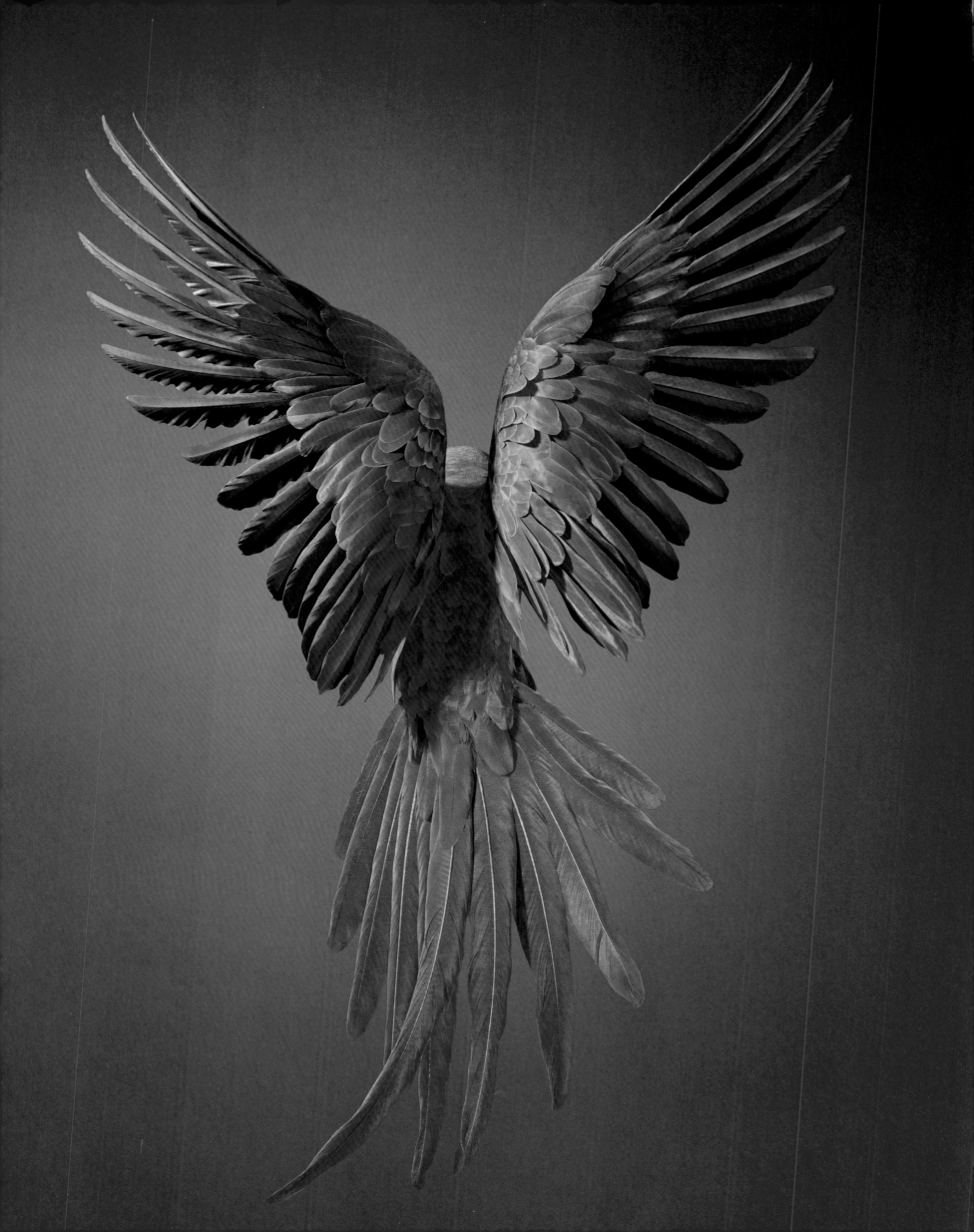

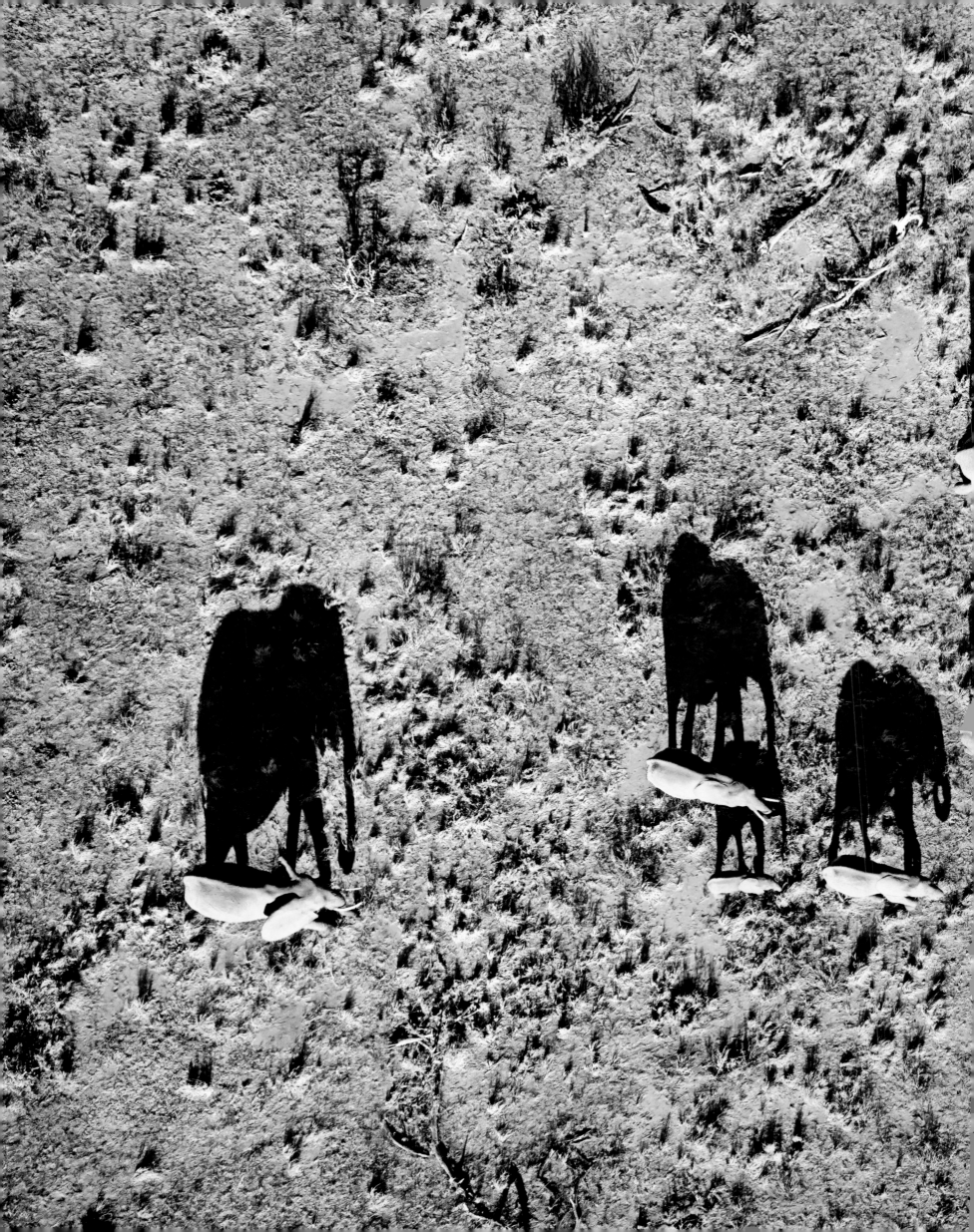

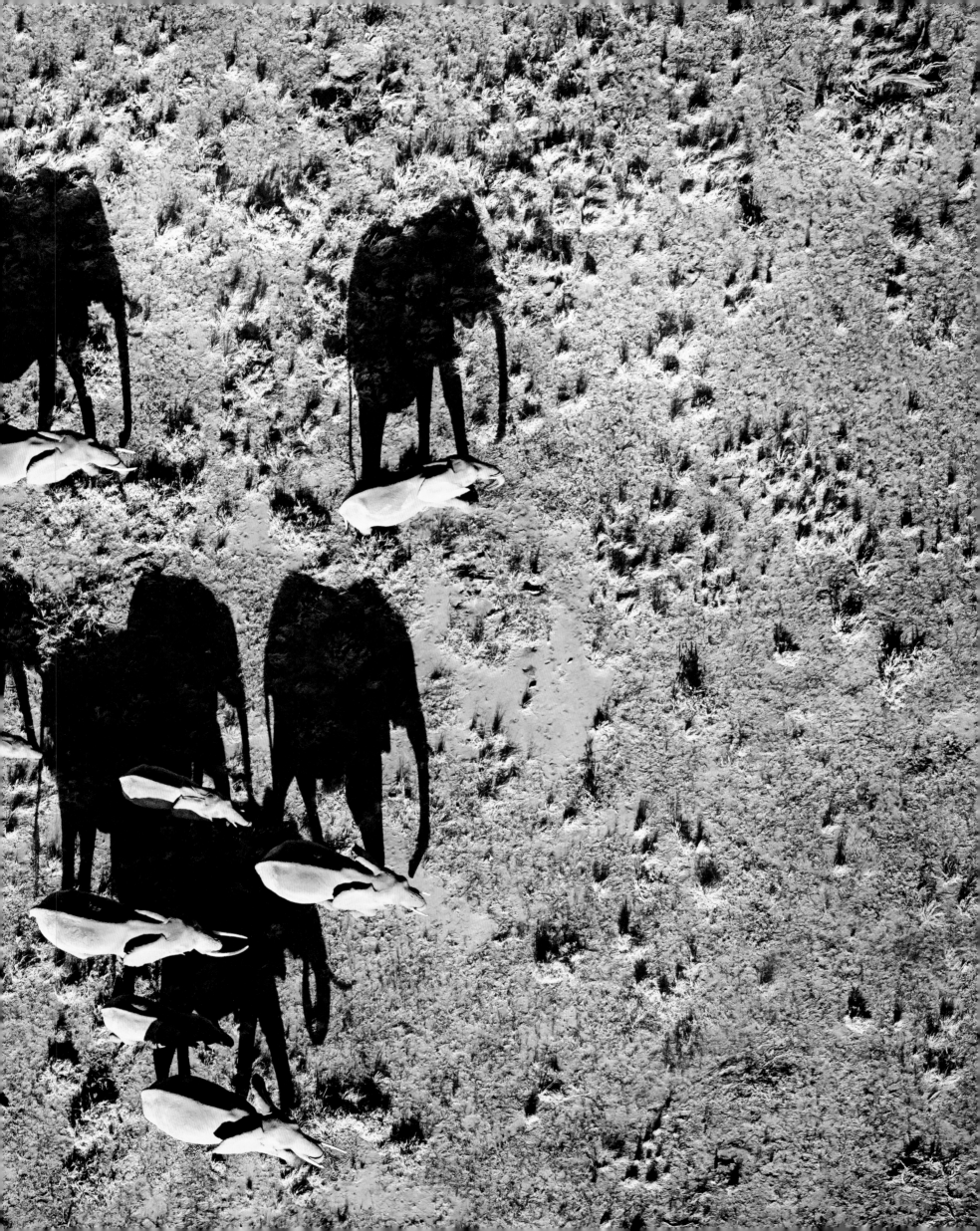

The title of this book is *Endangered*,

but the question is: to whom does that apply?

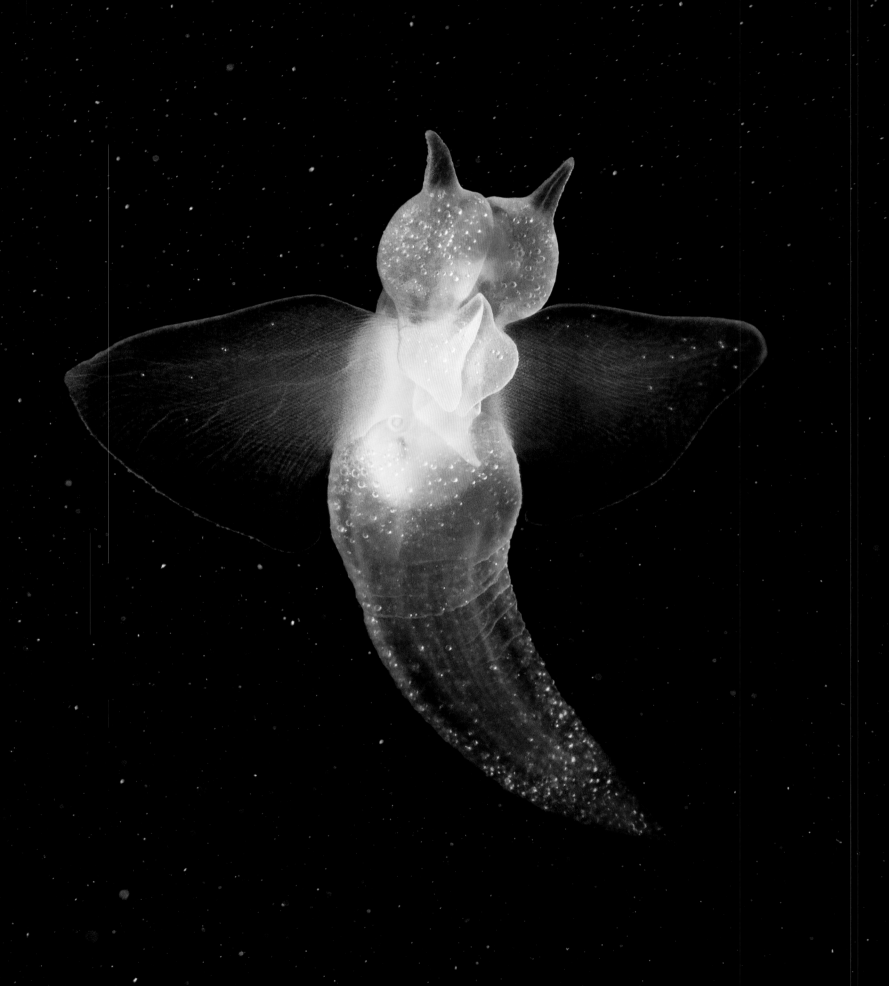

Introduction
Tim Flach

I photographed some of the most threatened species on Earth for this project. Some iconic, some lesser-known. Several are recognized the world over and it is surprising to find these iconic animals on the brink of extinction, animals still proudly represented in films and books, as cuddly toys in the menagerie of a child's bedroom. I have always felt a sense of wonderment toward the natural world. As a child, I would go on walks, and spend time outside drawing and painting landscapes; I suppose I was what you might call reflective. I remember one occasion very vividly. I had been sitting in a cornfield drawing my surroundings for days and had become so focused on my environment that, as a bee passed in front of me, I could feel its energy streaking through the sky as my own pencil scratched across my paper. That feeling of heightened awareness—of our own immersion in nature—has become something I am always seeking to rediscover, and to communicate, in my work as a photographer.

Such a strong connection with our natural world is not some strange or arcane feeling; theories like the Gaia hypothesis have attempted to explain the incredible complexity of our planet, with its remarkable homeostatic capabilities—that perfect equilibrium that permits, sustains, and fuels life on our planet. Of course, if we cannot understand how Earth is able to maintain this environment for flourishing life, we will be unaware of the tipping point at which we may damage it irreversibly.

As I have been working on this book, I have become much more mindful of what modern conservationists call the Great Acceleration: the continuing exponential growth of humanity's population, of our consumption, and of our emissions, and the resultant exponential decline of natural resources and animal populations. Many of the animal stories I cover in *Endangered* illustrate changes to

the state of the natural world and I now have a visceral understanding of Sir David Attenborough's observation that "If we damage the natural world, we damage ourselves."

In this work, I feel incredibly privileged to have had the guidance of many prominent conservationists, who have stressed the importance of ecosystems. As an artist, I'm very honored to be collaborating on this book with scientist Jonathan Baillie, who shares my interest in conservation communication. The *IUCN Red List of Threatened Species* has also been an invaluable resource, illustrating in phenomenal detail how quickly and how broadly animal species are undergoing dangerous and fatal declines.

Throughout this project, I felt fortunate to have witnessed and photographed some of the world's most extraordinary animals. In Kenya, I have stood and looked the very last male northern white rhino in the eye. In the waters off the coast of the Galapagos Islands, I have watched hammerhead sharks circling serenely above me. In Mexico, I have turned my gaze upward to see thousands of monarch butterflies filling the sky like golden confetti.

This journey has made it clear to me that we cannot just pluck animals from their native environment and put them on an ark to protect their future, without considering the significance of the habitat they have been taken from. Community-based conservation, therefore, has a more important role to play now than ever before; with increasing economic inequality in the world, it can enable people to maintain their livelihoods while protecting their natural heritage.

In all of this, I have been informed by studies regarding animal imagery and how powerful their impact is upon our hearts, minds, and souls. In traditional wildlife photography, animals are seen in their environment—wild and free—and thus the

sense of "otherness" (and of their separation from humans) is enhanced. However, Kalof, Zammit-Lucia, and Kelly's thought-provoking 2011 study on the meaning of animal portraiture in a museum setting has shown that "placing animal representations in a visual context that is usually associated with human representation had the effect of enhancing feelings of kinship."

Dr. George Schaller, one of the world's most respected biologists, has said: "You can do the best science in the world but unless emotion is involved it's not really very relevant. Conservation is based on emotion. It comes from the heart and one should never forget that." I think this is particularly true when communicating visually; we must be emotionally touched to spur us into action.

With that in mind, this book is something of an experiment: I have tried to bridge that *otherness* and instead invite *sameness* by creating portraits of animals that emphasize their personality, while incorporating abstracts and landscapes that show the material aspects of their ecosystems.

People now talk about the Anthropocene epoch. They say that we have moved away from a world shaped by the flux of natural forces to one that is being shaped predominantly by humankind. This is a theory backed by powerful scientific evidence, and one that is guiding many creative and academic disciplines today.

The idea that the natural world is vulnerable has only entered the modern general consciousness in the last few decades. Throughout history, nature has been considered an immeasurably vast and infinitely bountiful resource; but today the power structures have changed, and the natural world depends on us as much as we depend on it.

The title of this book is *Endangered*, but the question is: to whom does that apply?

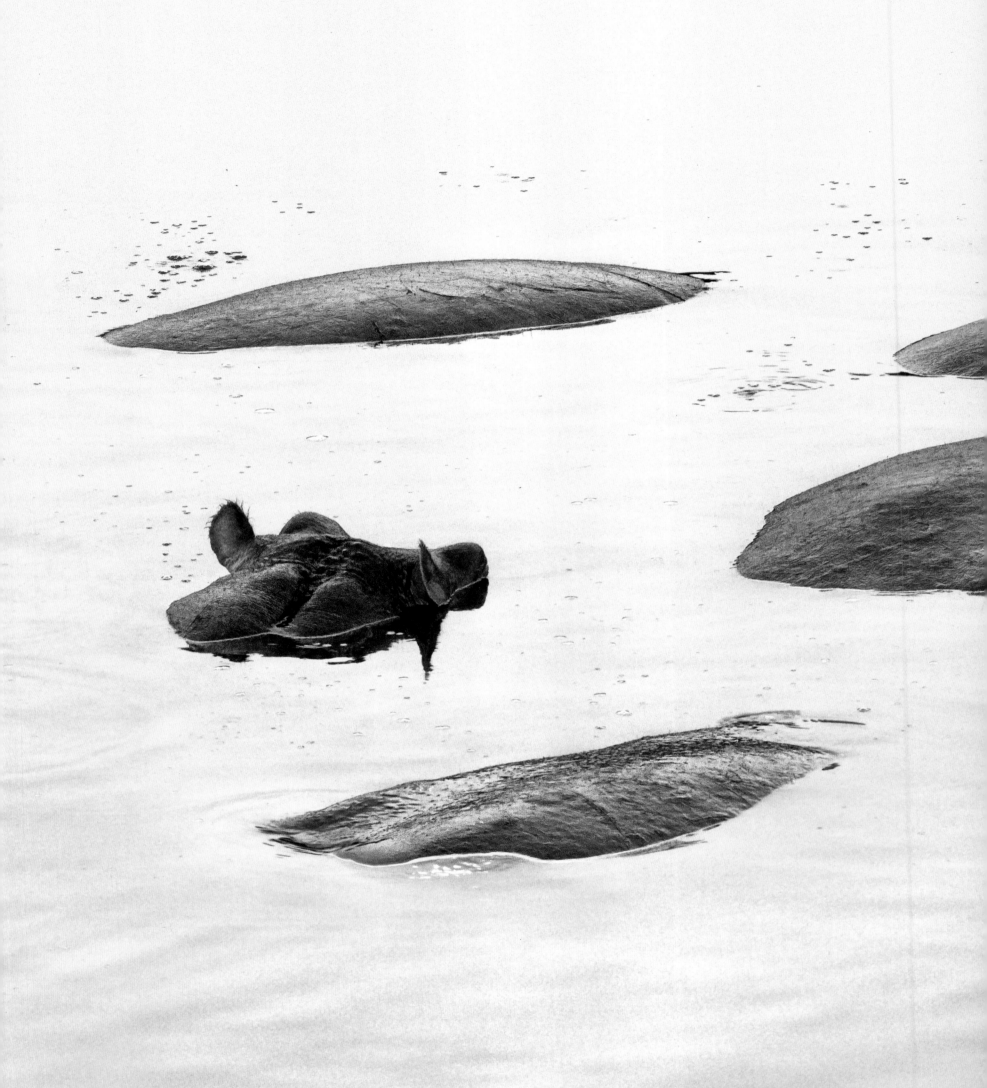

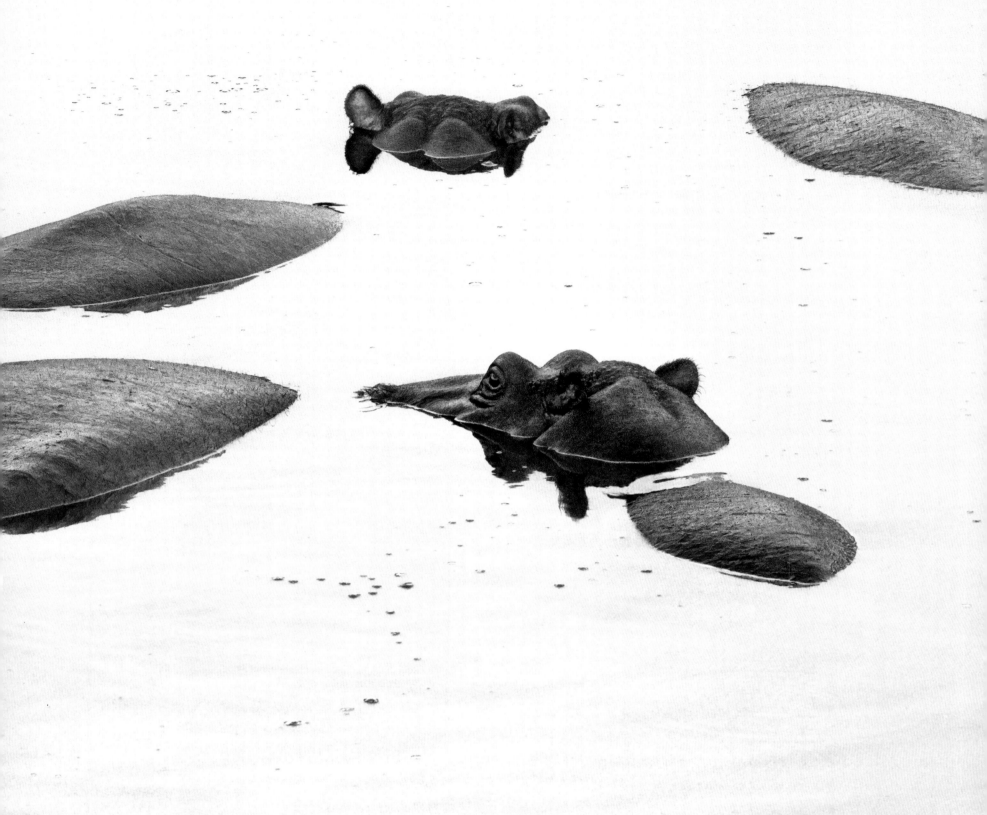

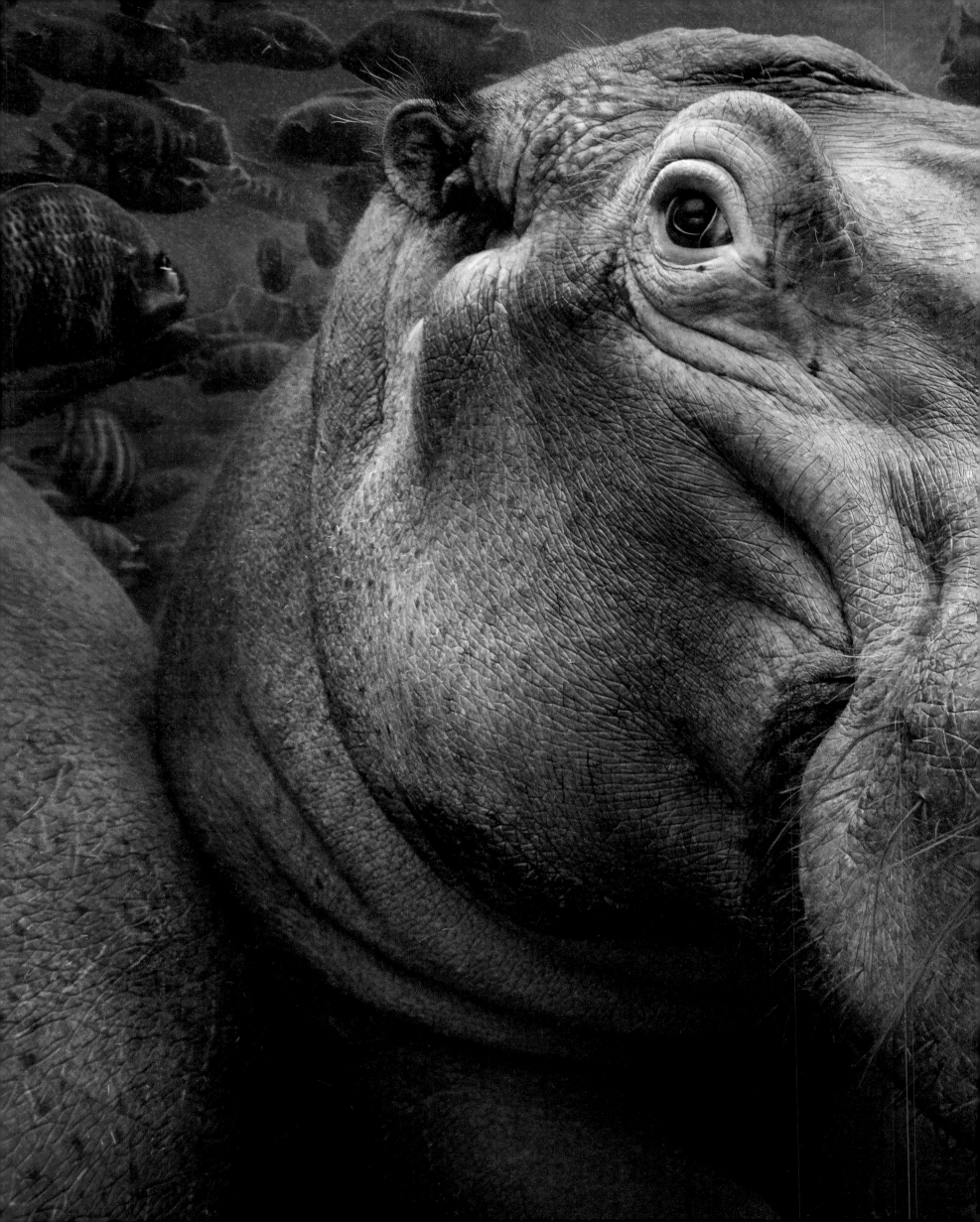

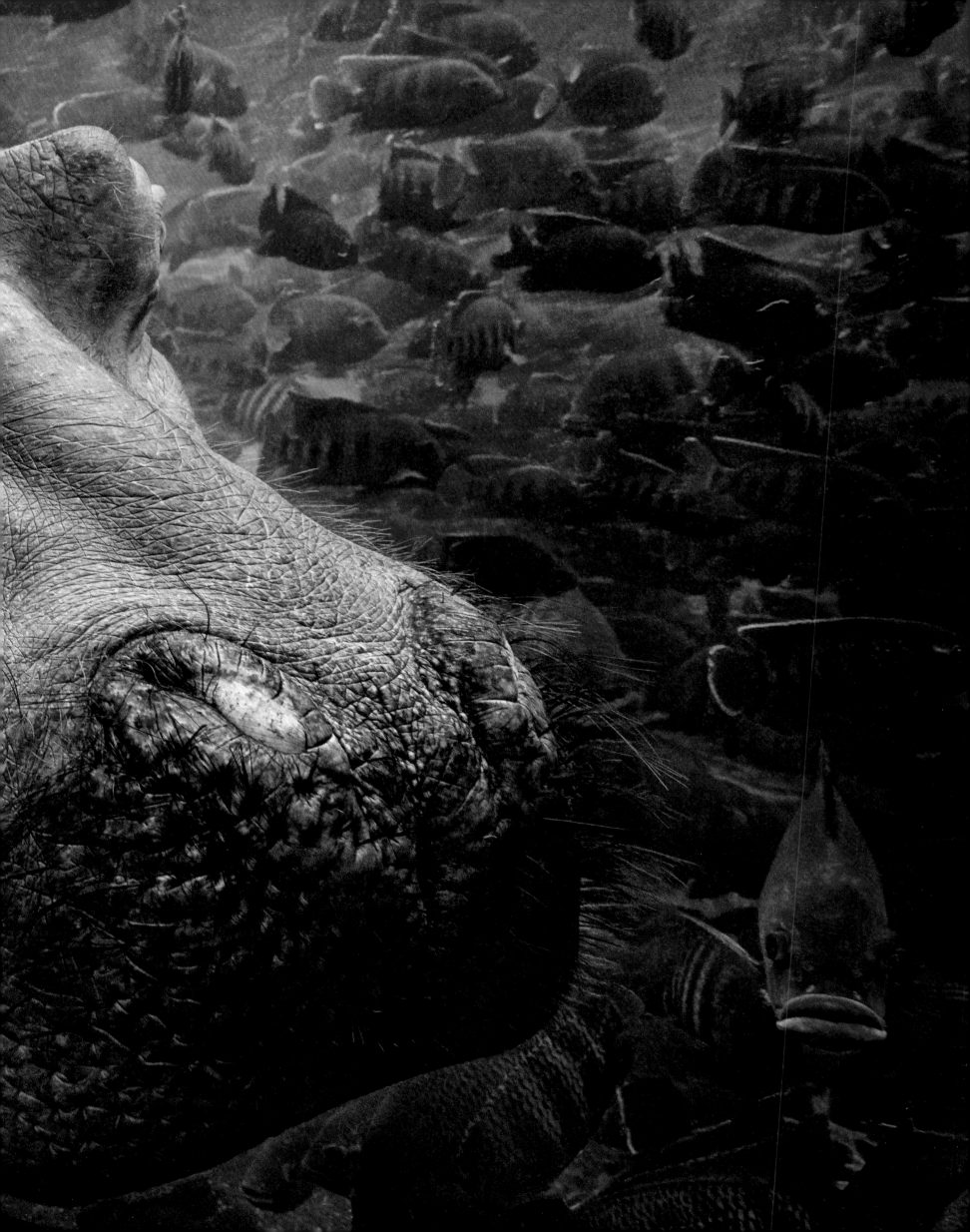

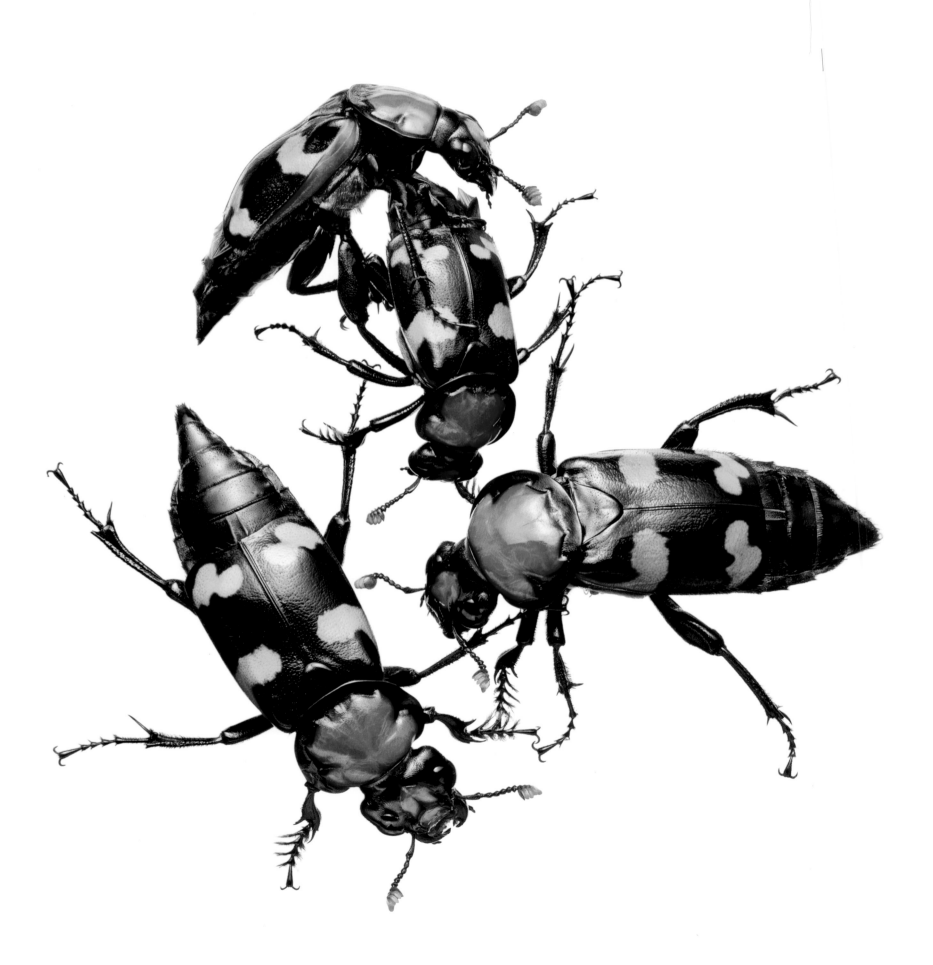

Prologue
Professor Jonathan Baillie

This book introduces an amazing diversity of endangered species, from corals to polar bears, and depicts the specific environments they need to survive. It also highlights the unique combination of human-caused threats each species faces, including disease, introduced species, habitat loss, illegal wildlife trade, pollution, and climate change. *Endangered* is extremely informative, but it is much more than a book on the status of threatened species—it is a unique experiment exploring the role of imagery in fostering an emotional connection with species and their habitats.

Today over half the world's population lives in cities, and people are spending far less time outdoors or in wild places. There are more mobile devices than there are people on the planet, and children in the developed world spend a good part of every day looking at a screen. Modern society is losing touch with nature and with the basic rhythms of life. Few people have any sense of the position of the stars, of the lunar cycle, and the timing of the tides, or even when the sun rises or sets. Fewer still know when the large bird or insect migrations occur or when the frogs start and stop calling every year. We continue to remove ourselves from the environment that nurtured our ancestors for millions of years and shaped us as humans.

This disconnection from nature comes at a time when society is having an unprecedented impact on the world's species and ecosystems. The world's vertebrate populations (mammals, birds, reptiles, amphibians, and fish) have declined by more than 50 percent since 1970, and currently around 20 percent of the world's species are threatened with extinction. In the history of this planet, there have been five major extinction events, the last of which occurred about sixty-five million years ago. We are currently entering the sixth major extinction, but this differs from all previous extinctions in that it is driven by us.

If we are to reverse this destructive trend, we need to redefine our cultural relationship with nature. Simply put: we need to place greater value on forms of life other than our own. This change will only be achieved if we begin to feel a deep connection with other species and better understand the role they play in our mental, physical, and emotional health as well as in our very survival.

Tim Flach's photographs have the unique ability of capturing the essence of a species while fostering a deep emotional connection with the audience. I first came across Tim's work when I was the director of conservation programs at the Zoological Society of London. He had been photographing Przewalski's horses in Mongolia and was kind enough to let the society use his captivating images to promote its conservation work. Tim's photographs of wild horses were stunning, but also engaged on a visceral level—there was something human about them or at least something to which a human could relate. His images do not overly anthropomorphize animals; rather, they foster a relationship by capturing instincts or emotions we share with them: fear, excitement, vulnerability, or the need to be a part of a group or protect young. He also connects us with his subjects by capturing shapes or forms that we are predisposed to engage with, such as baby-like traits.

In *Endangered*, Tim takes his work one step further by creating an emotional response to an individual animal in viewers, and then building on that experience by introducing us to the habitat in which the animal needs to survive. He also tells the story of why each species is important and the unique challenges it faces.

A number of culturally iconic species, such as lions, tigers, pandas, elephants, and rhinos, are portrayed, but Tim also helps bring a number of poorly known species to our attention. Few people have ever heard of the pangolin, a scaly anteater that looks like an artichoke with eyes, yet it is the most illegally traded mammal on the planet; over a million pangolins have been illegally traded in the past ten years. Even less well known are bioluminescent fungi, lichen, the Lord Howe stick insect, or nudibranchs. Yet each creature has an amazing story to tell.

As we delve into *Endangered*, we learn about the many benefits that threatened species or ecosystems provide humanity: coral reefs that support major fisheries, bats assisting with pest control, or vultures that reduce disease by eating carcasses. Tim also highlights the multiple threats faced by species in this book. The most common threat to species around the world is habitat loss and degradation, and the greatest future threat will be climate change. This is already having a negative impact on polar bears, snow leopards, and coral reefs—if current trends continue it will cause the extinction of many of the species in this book. Even successful initiatives such as panda conservation in China could be reversed as increasing temperatures kill off their primary food source, bamboo. Threats are also interrelated: those species stressed by habitat destruction or climate change will likely be more susceptible to disease.

Another rapidly growing threat affecting many species in this book is the illegal trade in wildlife. This affects species that are prized in the pet trade such as the ploughshare tortoise, but also elephants, rhinoceroses, and sharks, which are killed for their body parts.

Despite the many threats and challenges Tim brings to our attention, there are also very encouraging stories of successful conservation. The Lord Howe stick insect, partula snail, scimitar oryx, and Przewalski's horse have all recovered from very small populations. They provide a lesson that we should never give up on a species, that focused conservation attention does work.

If Tim is successful and we can emotionally connect with the species in this book and truly value them, they can all be brought back from the edge of extinction. Perhaps the one exception is the northern white rhinoceros that has now been reduced to three related individuals, Sudan, Najin, and Fatu. The northern white rhino will likely disappear forever—a reminder of how important it is to connect people with these amazing creatures . . . before it is too late.

Slipping away

Polar bears depend on sea ice to catch their prey. They pounce on seals when they emerge through their breathing holes and stalk them as they bask in the open, but the ice is melting away as our climate warms. The thirteen winters following the year 2003 yielded the thirteen smallest ice extents on satellite record. Hunting seasons are becoming shorter, and for each week of ice that is lost from Arctic winters, polar bears lose around 15 pounds (7 kg) of fat. Before 2020, we could see an ice-free summer at the North Pole.

Ice reflects solar radiation, and if it disappears, new seawaters will absorb the heat and global warming will accelerate across our planet. In 2015, the Paris Agreement was signed to limit anthropogenic warming to a maximum of 35.6 degrees Fahrenheit (2 °C). If ratified and respected by its 194 signatories, it could go a long way to protecting both polar bears and humans from melting ice and rising seas.

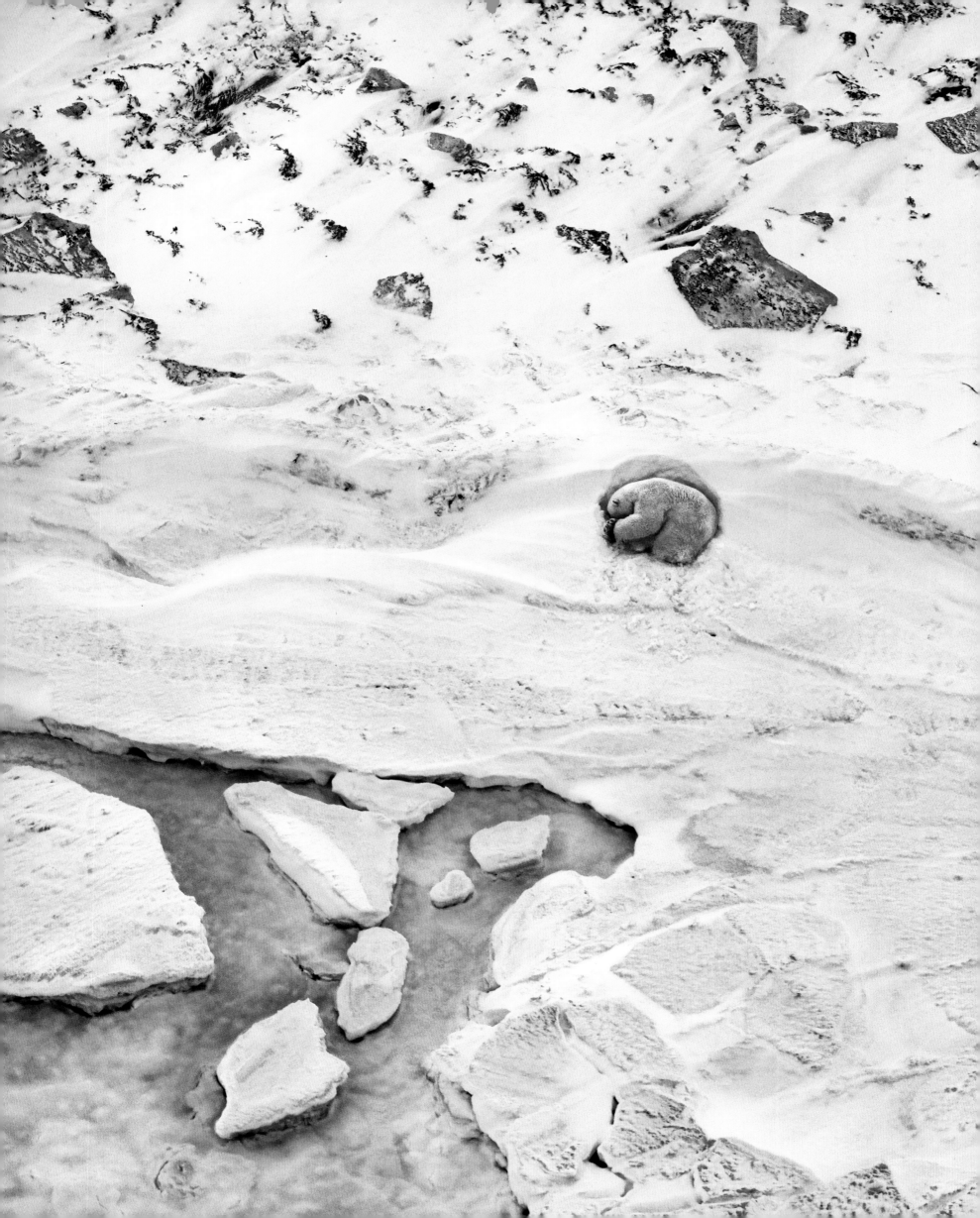

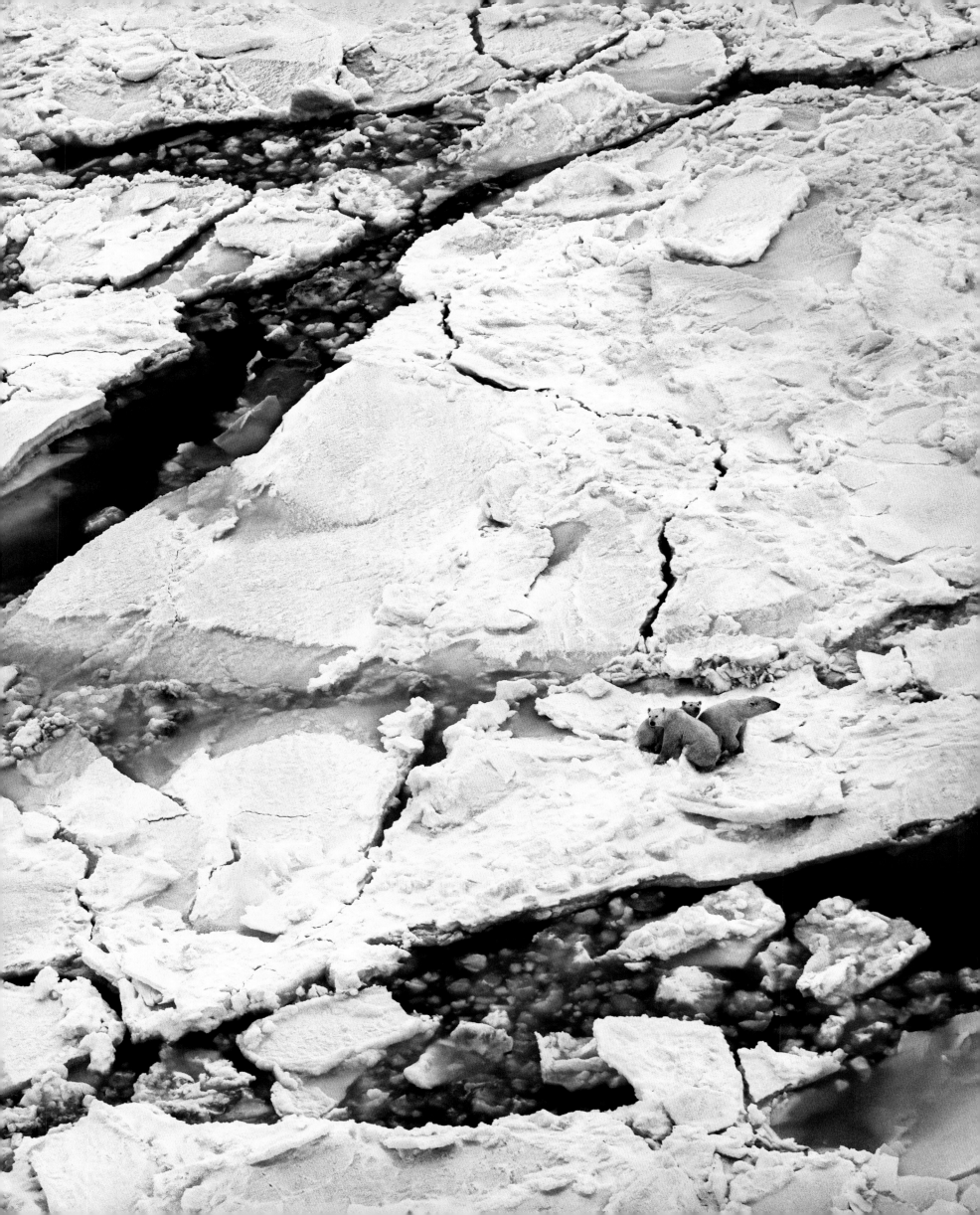

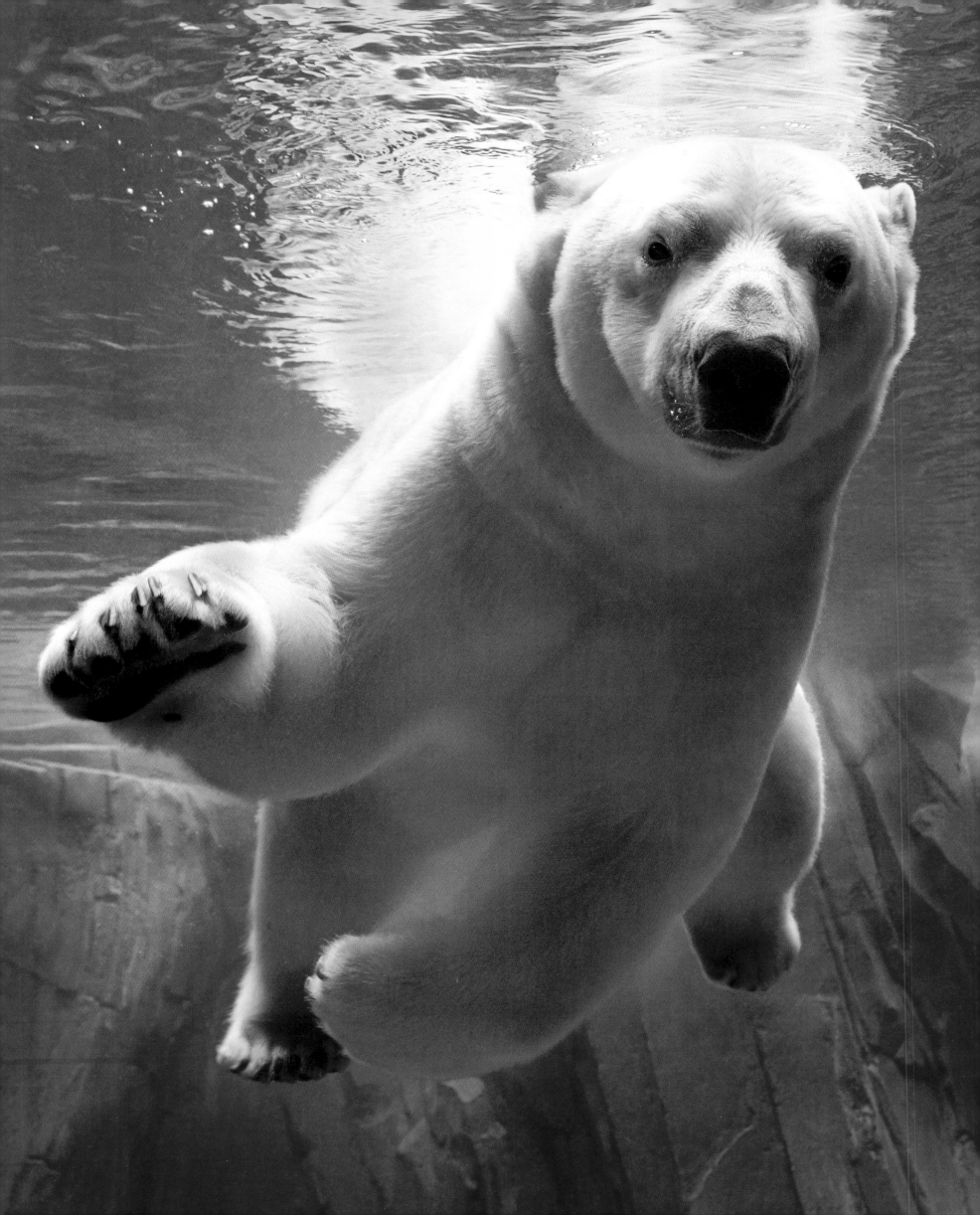

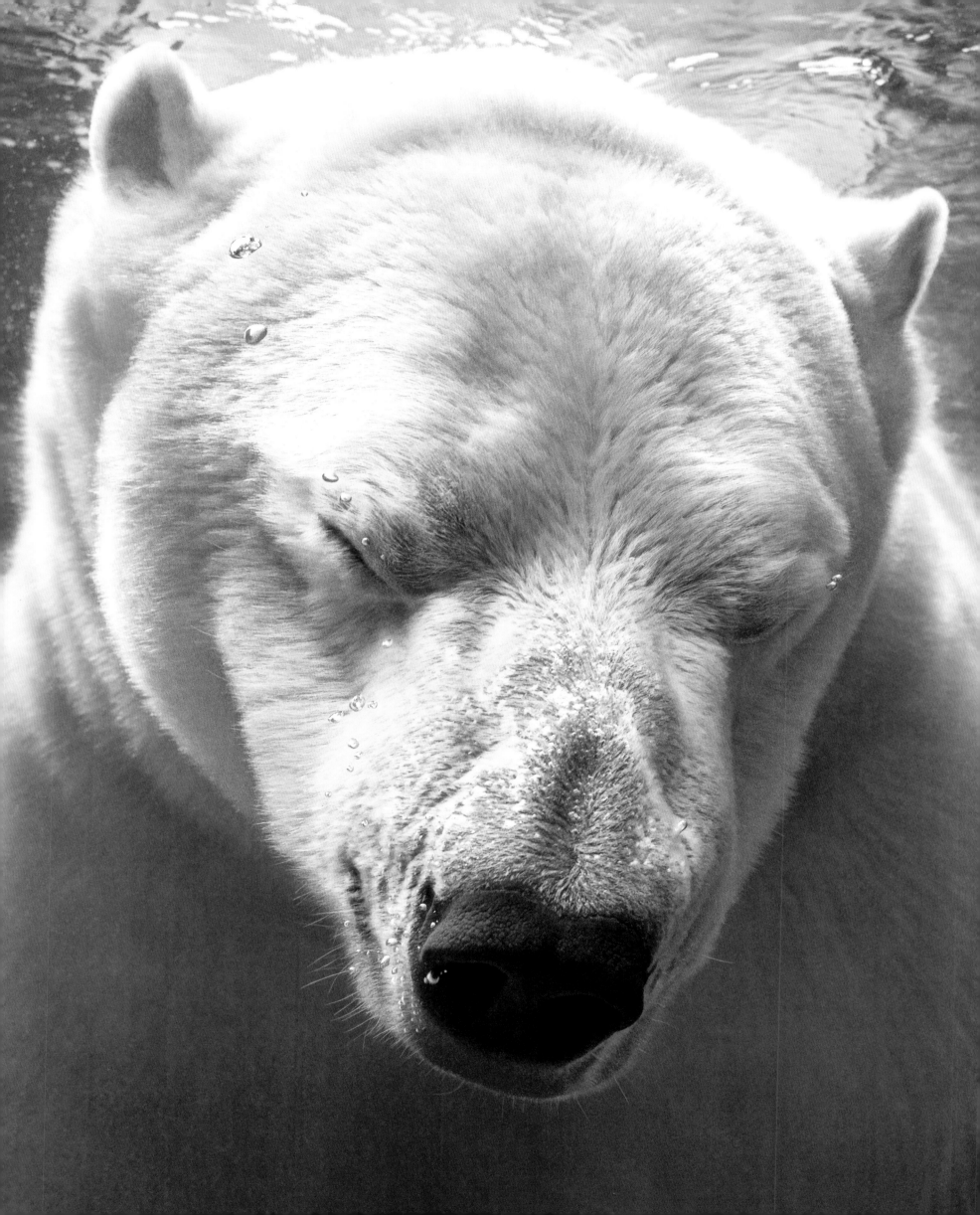

Pushed back

As Arctic ice melts away, we are moving further north with new towns, oil and gas rigs, military bases, and tourist expeditions. Polar bears have evolved in an environment that is inhospitable to most life-forms, and they are unfamiliar with most bacteria and disease. As apex predators, they suffer most from the new toxins introduced by human activity, as these accumulate in the animals beneath them in the food chain. Furthermore, the receding ice depletes their territories, squeezing them in with human communities and heightening the mutual dangers of lethal conflict. Broadly, however, hunting is thought to be at a sustainable balance, and poaching is rare outside of central Russia. Inuit communities, which depend on polar bears for food and clothing, follow strict quotas so as not to damage their population. The four million people of the Arctic generally work closely with governments, as they, too, want to conserve this historic icon of their culture.

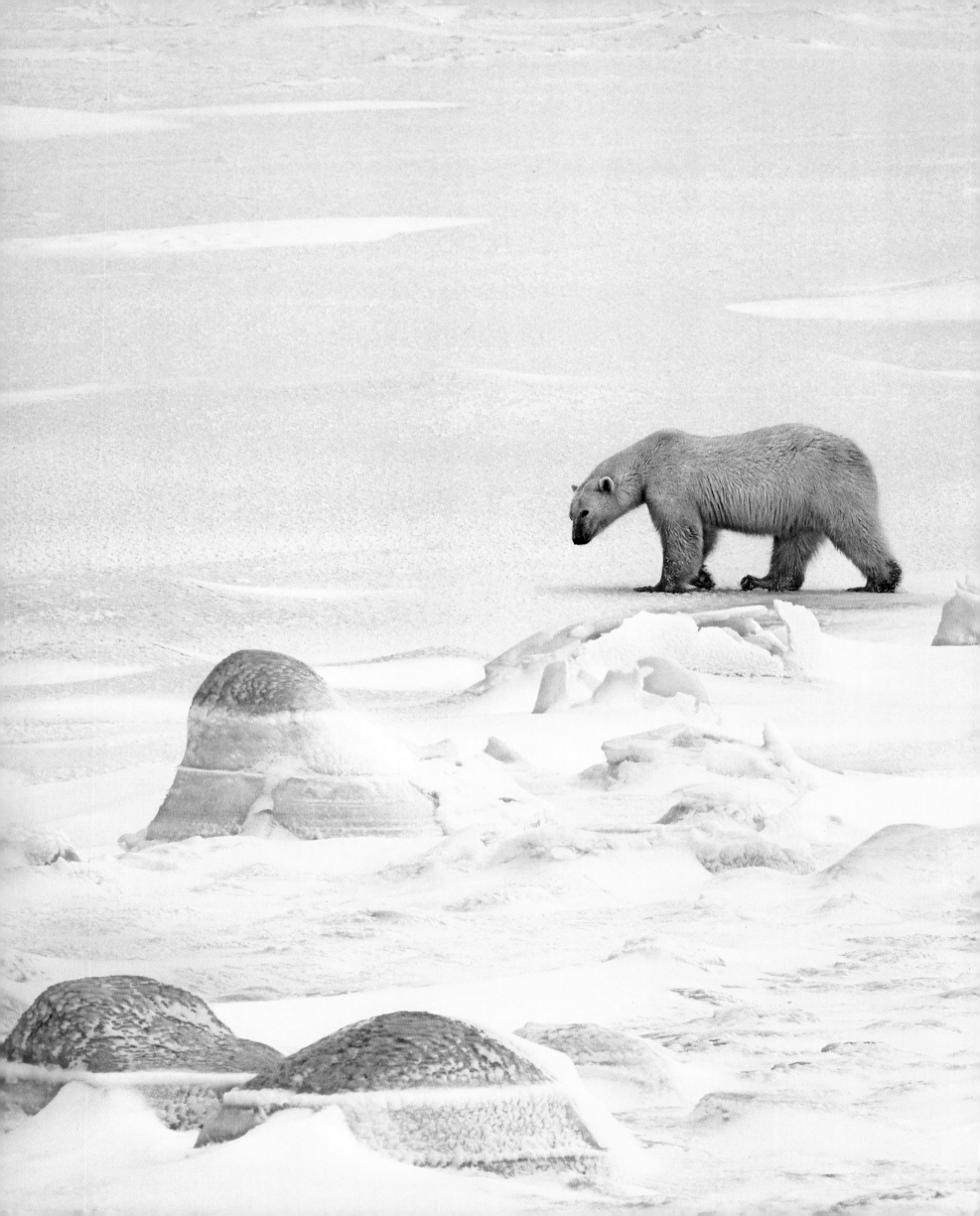

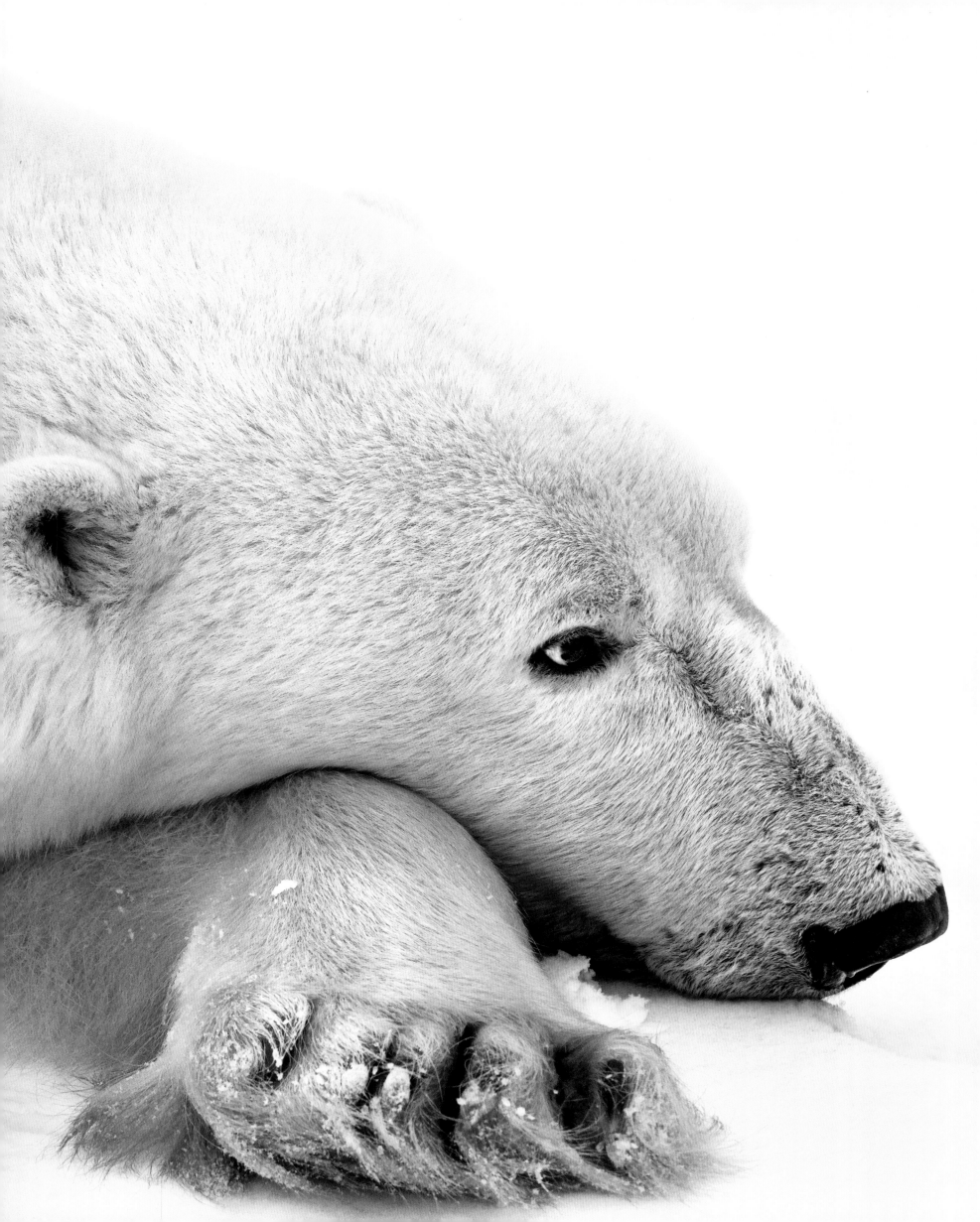

The big picture

Coral reefs are lifelines for our oceans. Lining the coasts of a few tropical countries, they cover less than 0.1 percent of Earth's surface, but are home to a quarter of all marine life. They have become adept at drawing nutrients from the barren seas and, today, these amazingly diverse ecosystems support humankind, too. In corals, we have found biological materials that are widely used to treat arthritis, asthma, and various cancers, and they likely still hold undiscovered medicinal properties. Coral reefs also yield our most abundant fisheries, they protect communities against storms and flooding, they provide local income from tourism, and they are universally renowned for their beauty. They are worth as much as US$375 billion to the world economy, but we are allowing them to die. Around a quarter have been lost due to mining, blast fishing, pollution, sedimentation, overfishing, rising sea levels, and ocean acidification. Two-thirds of what remains are under serious threat.

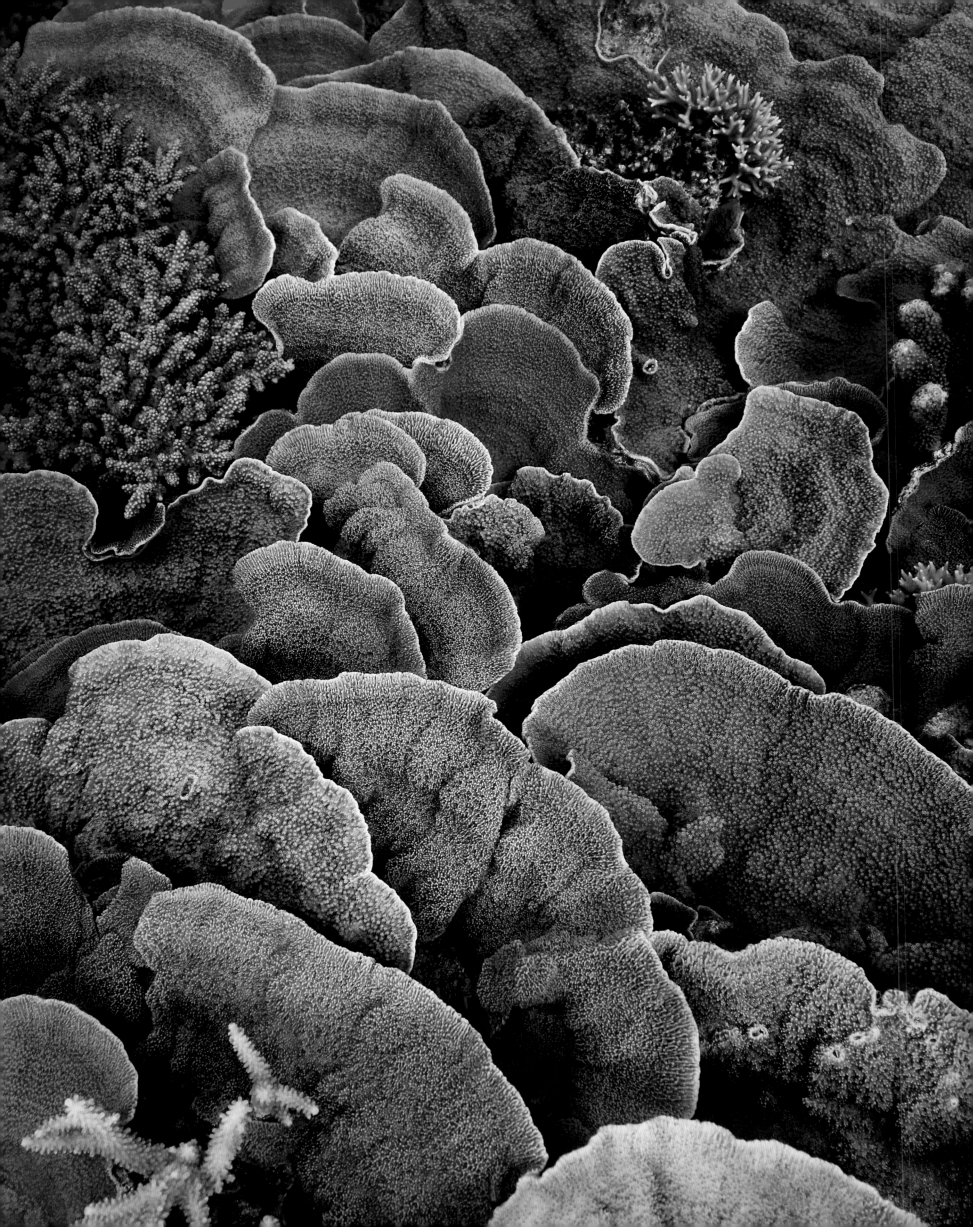

A delicate balance

The structure of coral is comprised largely of zooxanthellae, single-celled photosynthetic organisms that, in return for their security, provide the coral with sugars and amino acids. As sea temperatures rise, zooxanthellae are abandoning their corals and leaving them white in a process known as "bleaching." Without their primary source of food, bleached corals become susceptible to disease and struggle to survive. In 2016 alone, over 90 percent of the Great Barrier Reef's coral suffered bleaching, and 20 percent perished.

In its entire history, Earth has seen five mass extinctions. After each, coral reefs took millions of years to recover, leaving "reef gaps" in our geological timeline. The primary causes of these prehistoric destructions—the last of which wiped out the dinosaurs—were changes in sea level, acidity, and temperature, and all are occurring again today. We must carefully watch the "rainforests of the sea" if we are to curb Earth's sixth mass extinction event.

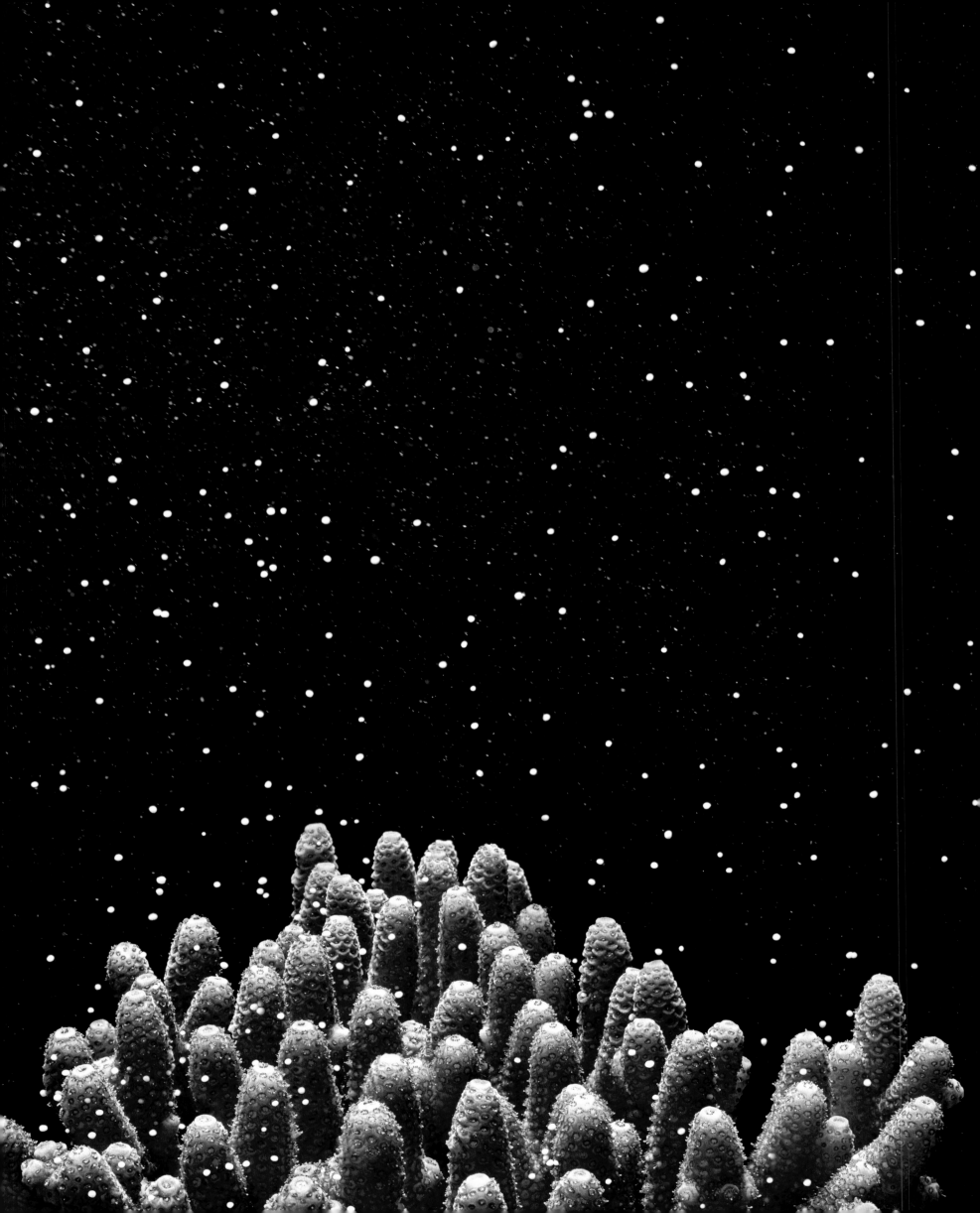

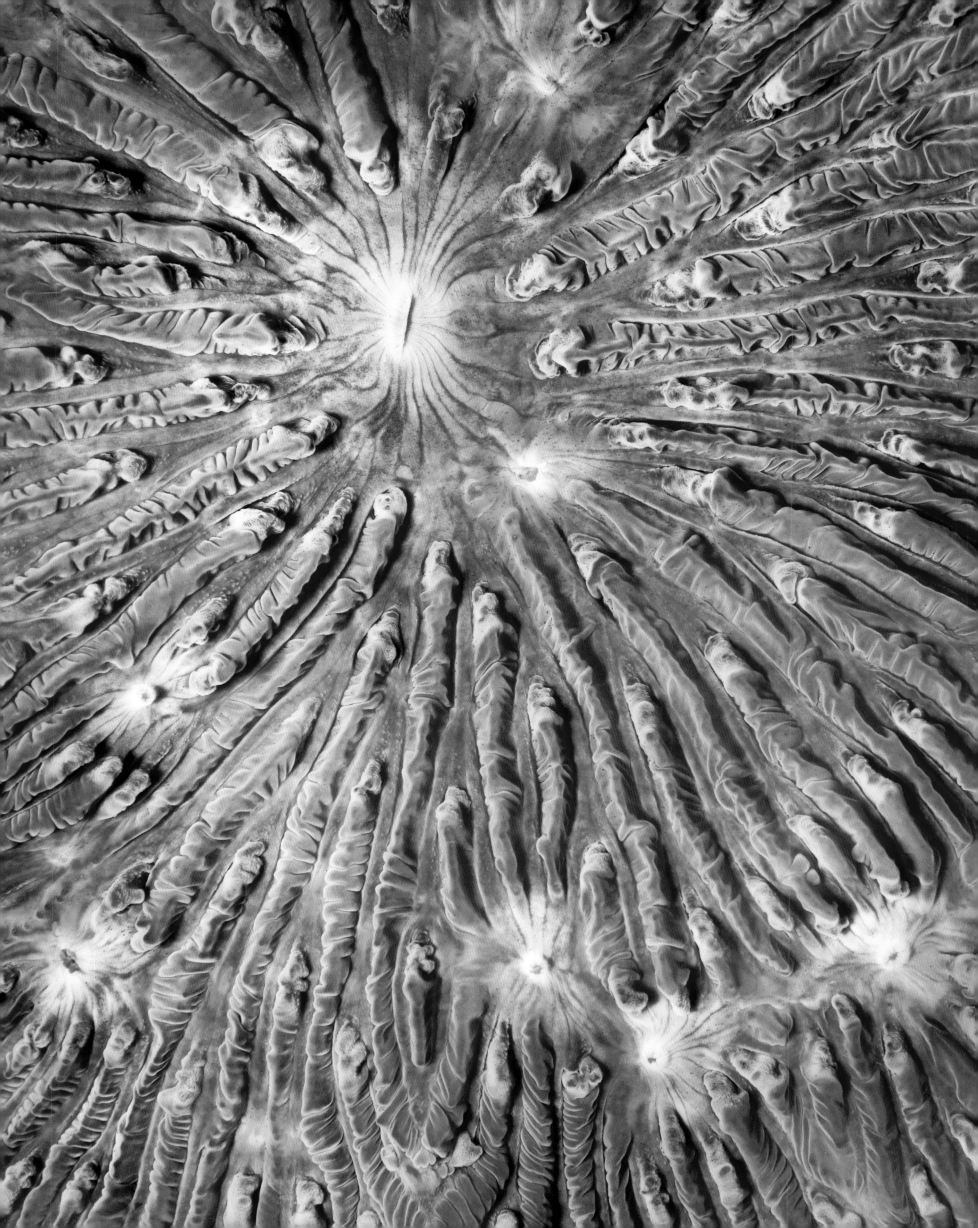

Born into hardship

The eggs of the yellow-eyed tree frog each measure around ⅛ inch (3 mm) across. Yesterday, the embryos had no eyes and, tomorrow, they will become dark, like tadpoles. While the rate of gestation is precise, it is responsive to temperature, and climate change is making frogs hatch early or late, confusing predators and disturbing the entire food chain.

The changing climate is also encouraging the spread of a deadly fungus known as chytrid. Lowland forests are becoming warmer, but as more moisture rises, thicker clouds form in the mountains and the habitat for these frogs becomes substantially cooler. As frogs are ectothermic—they depend on external sources for body heat—their immune systems weaken, and the chytrid fungus thrives. The resultant disease, chytridiomycosis, has afflicted amphibians worldwide, infecting and destroying more vertebrate species than any disease in recorded history. One-third of amphibian species are now threatened with extinction; around 120 have already been lost.

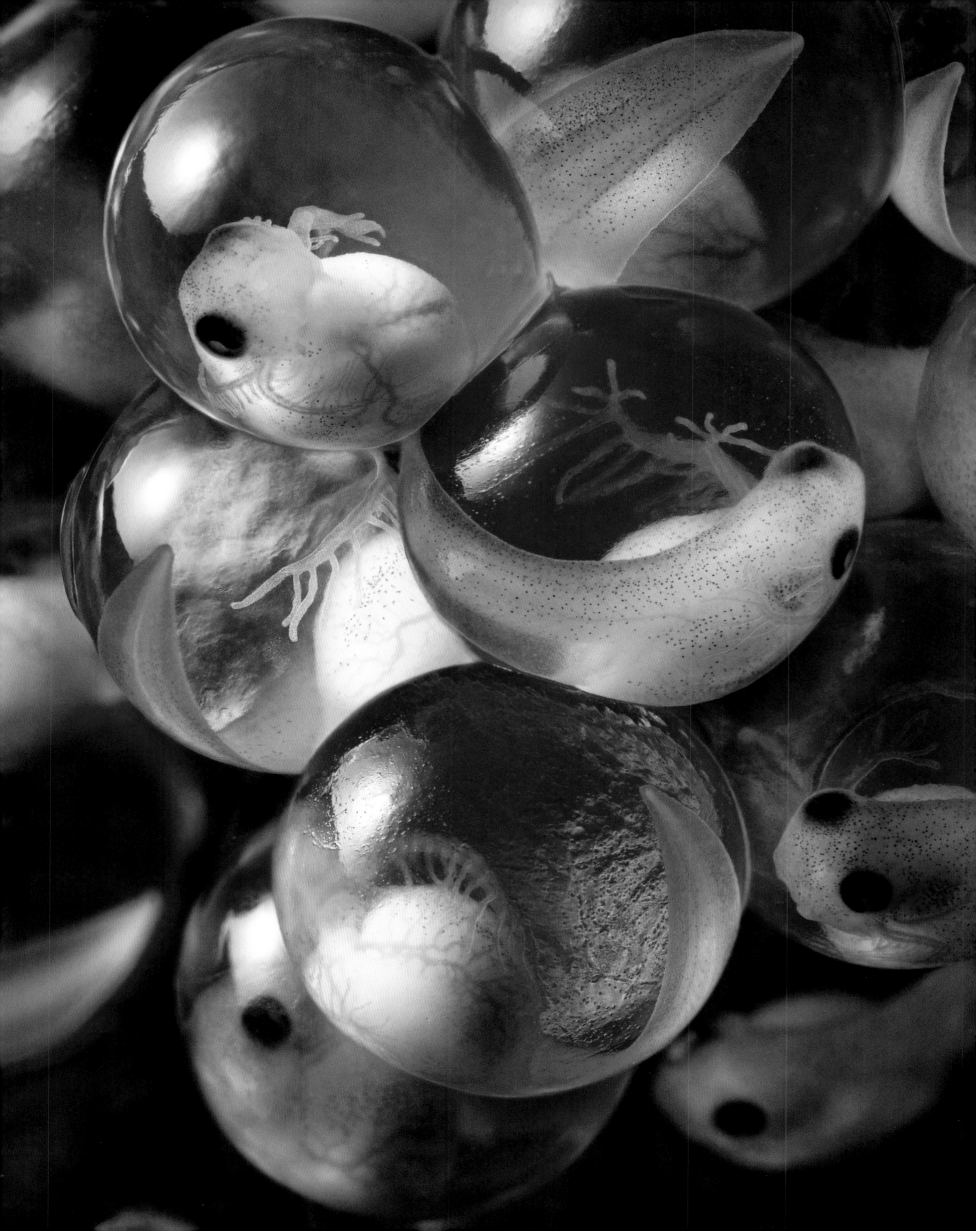

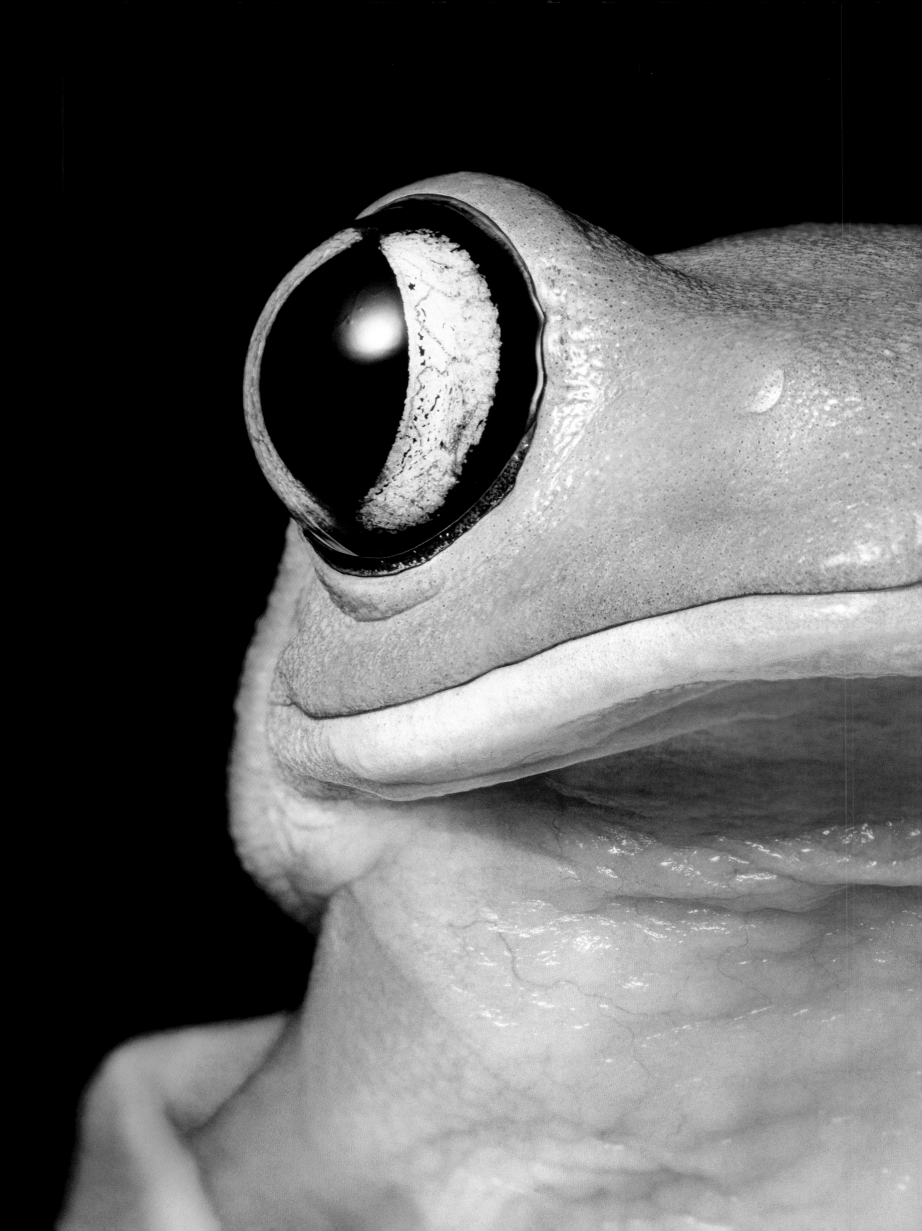

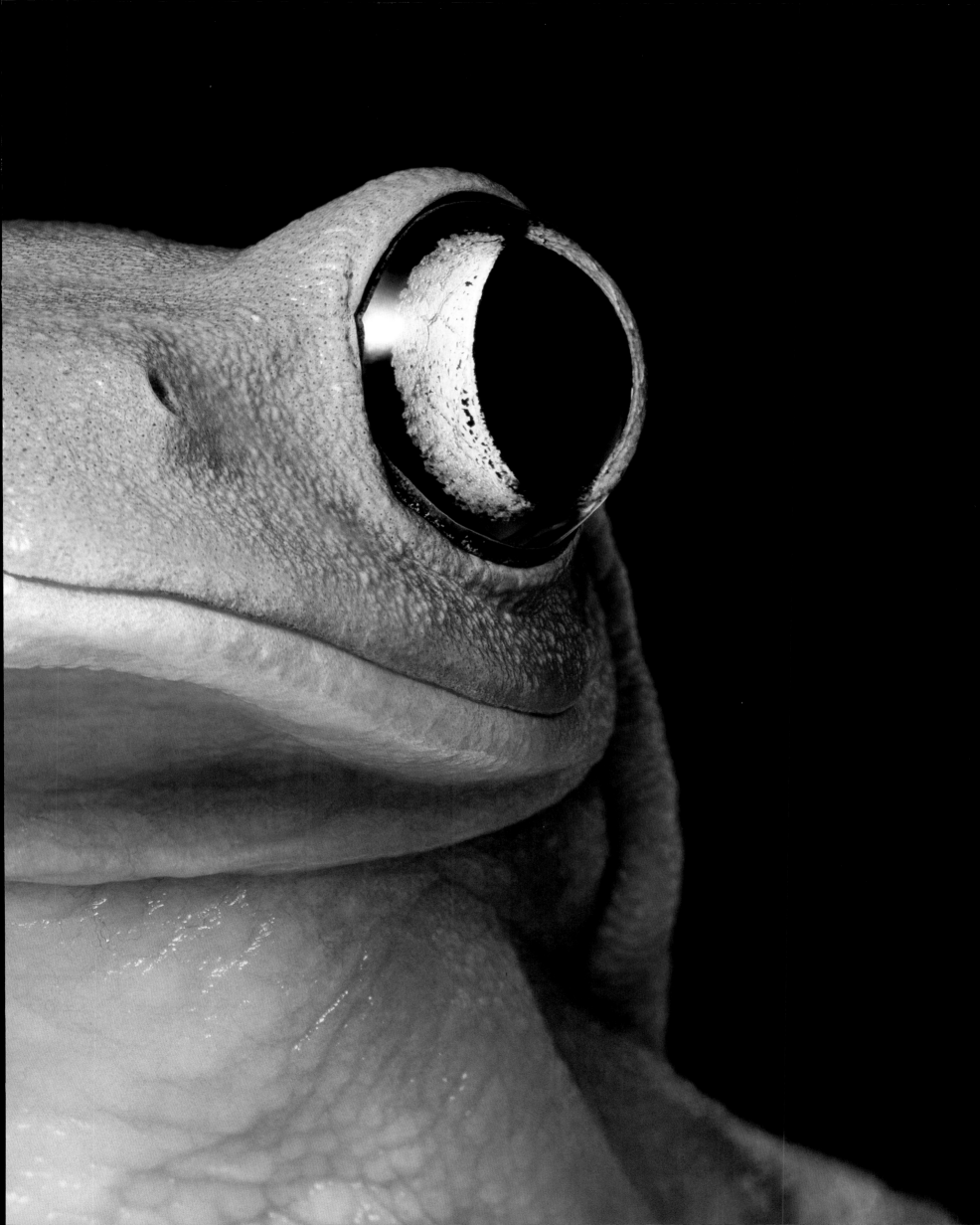

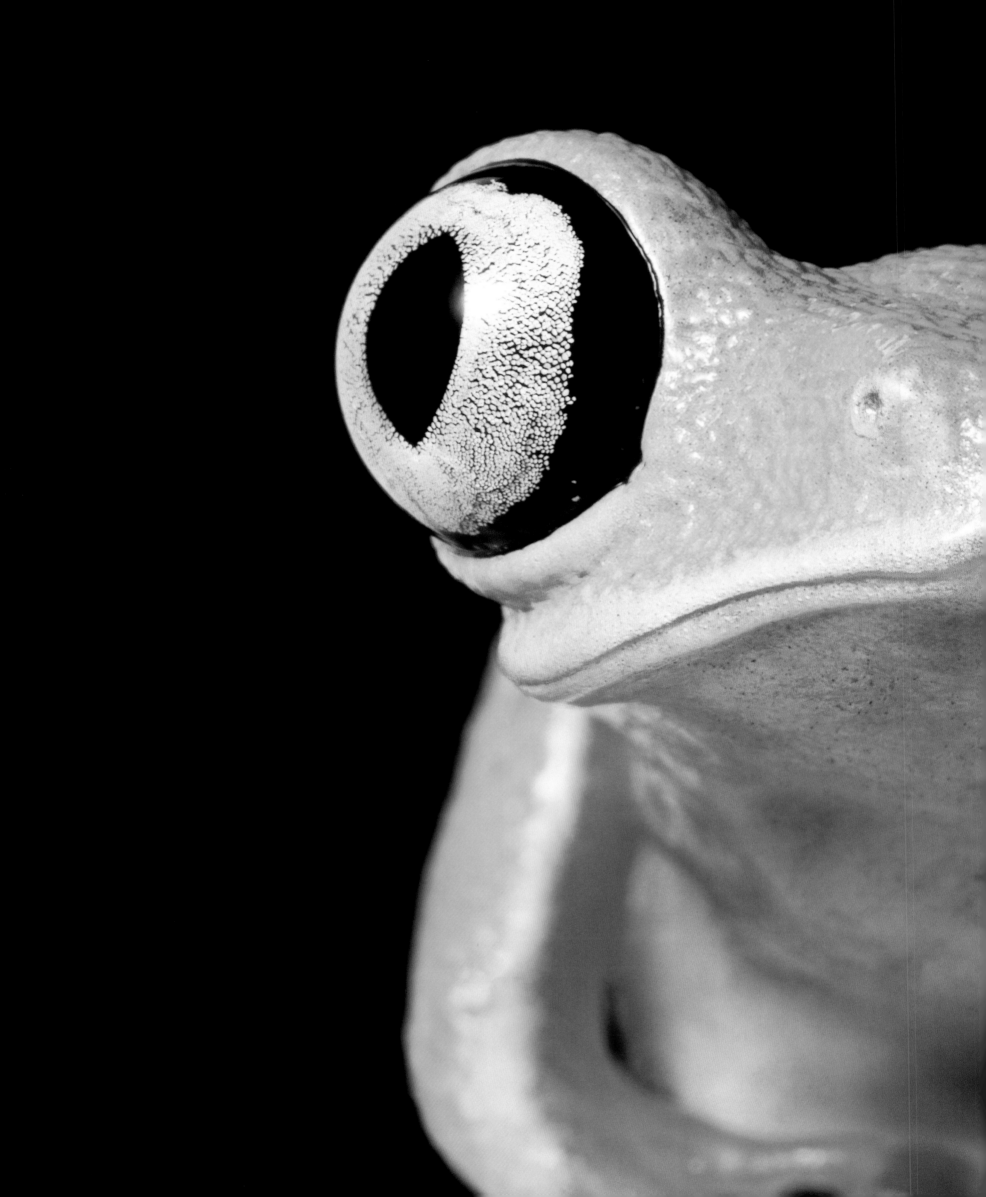

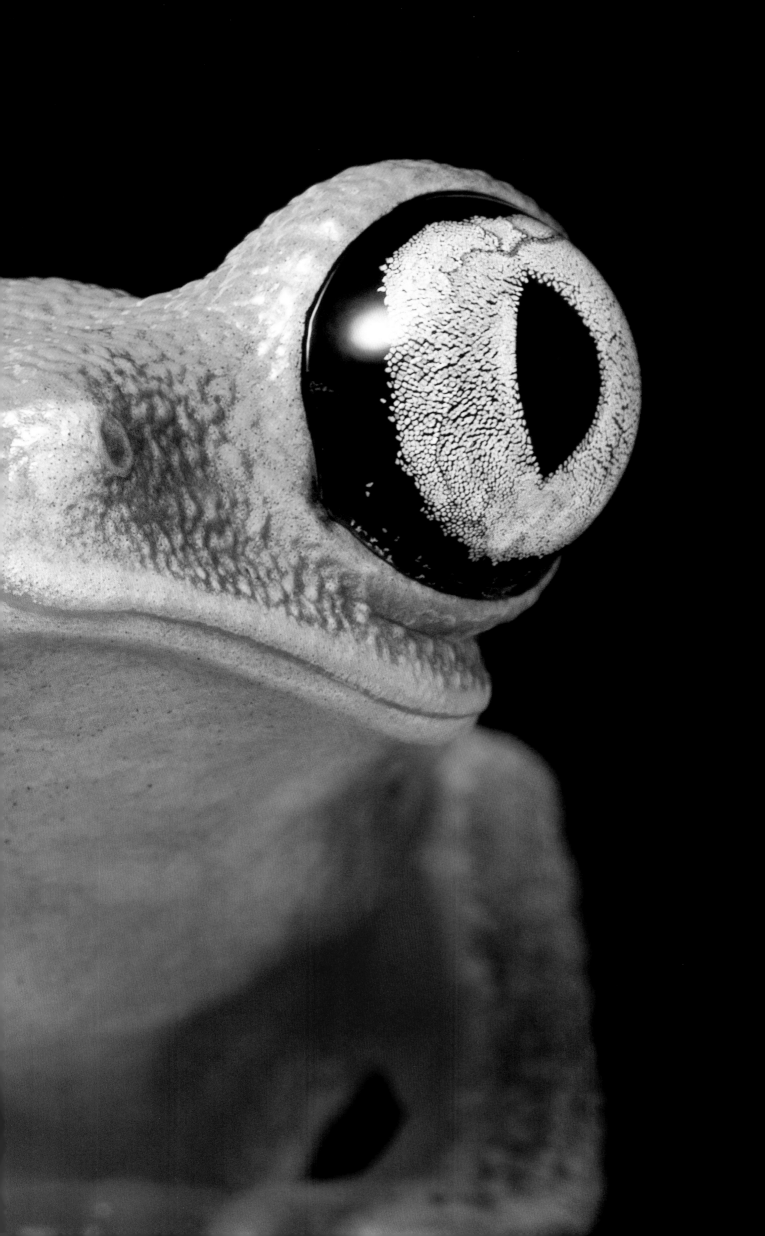

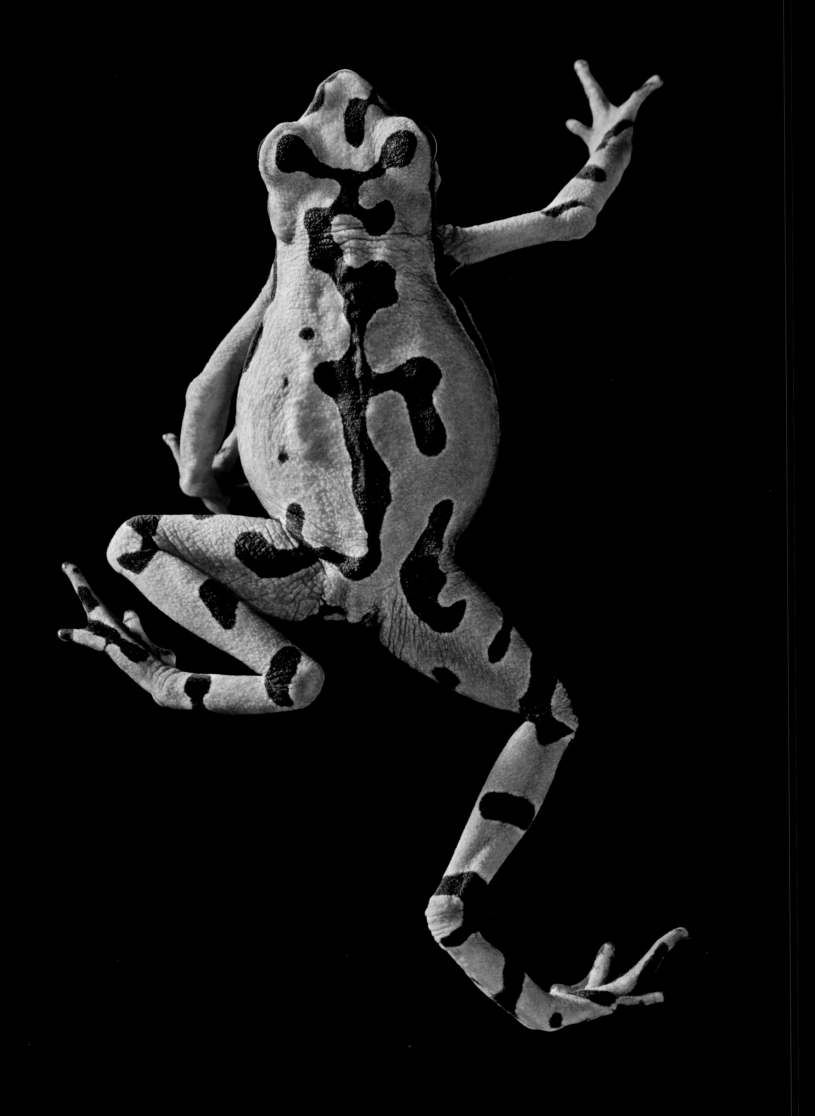

Ancient backbones

Amphibians were the first class of vertebrates to appear on Earth, but at the hands of a far younger species, they may become the first to disappear. They owe the first 370 million years of their existence to a remarkable adaptiveness across their seven thousand species. For instance, the harlequin toad, which inhabits noisy environments around rivers and waterfalls, has learned to communicate visually, waving its forearms when its croaks are drowned out by the noise of rushing water. Each individual bears a unique, dazzling pattern of colors that attracts mates and deters predators, but it does not defend them from human beings. Although harlequin toads are under serious threat from chytridiomycosis, one of the deadliest diseases of all time, deforestation of their habitat is four times as dangerous.

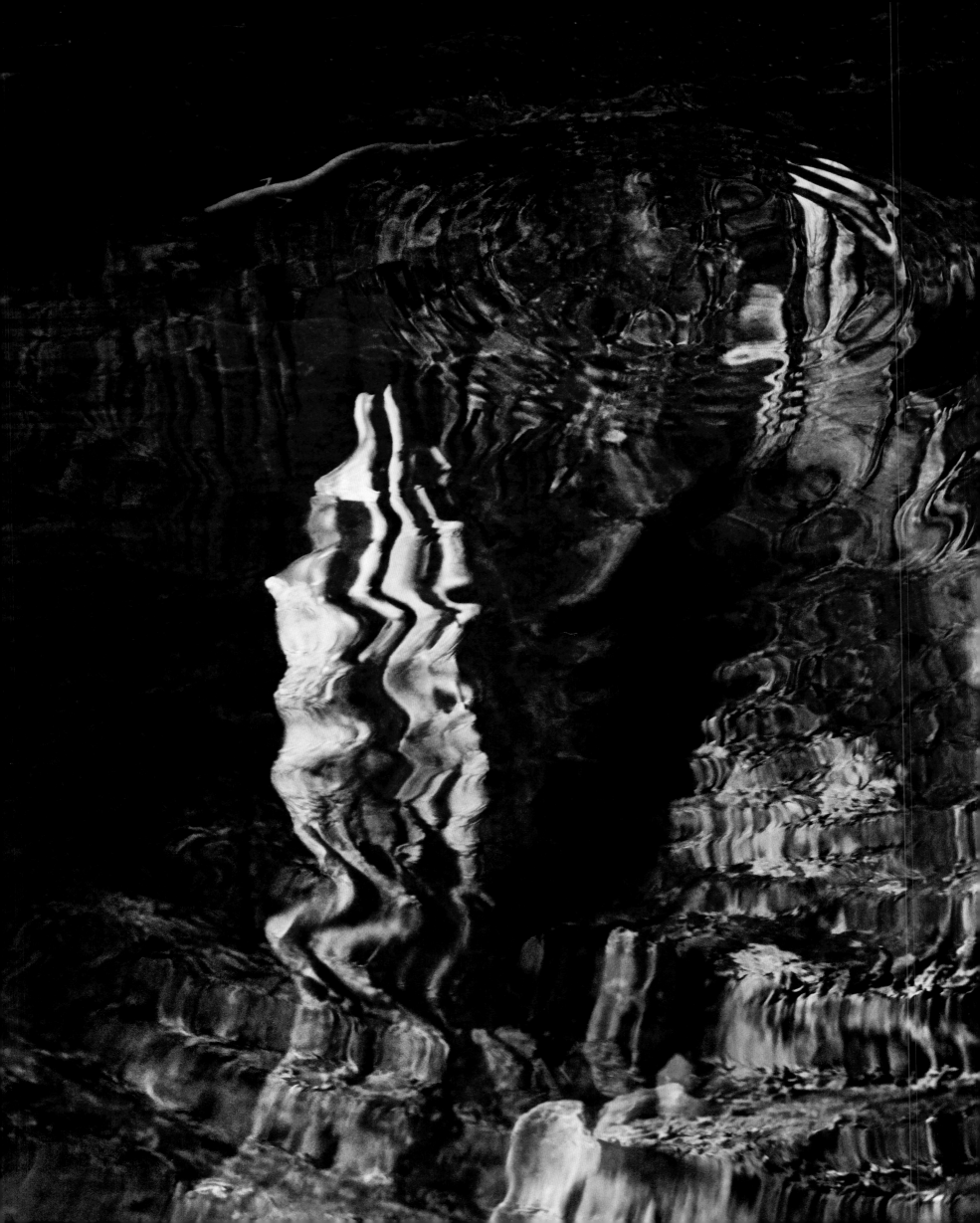

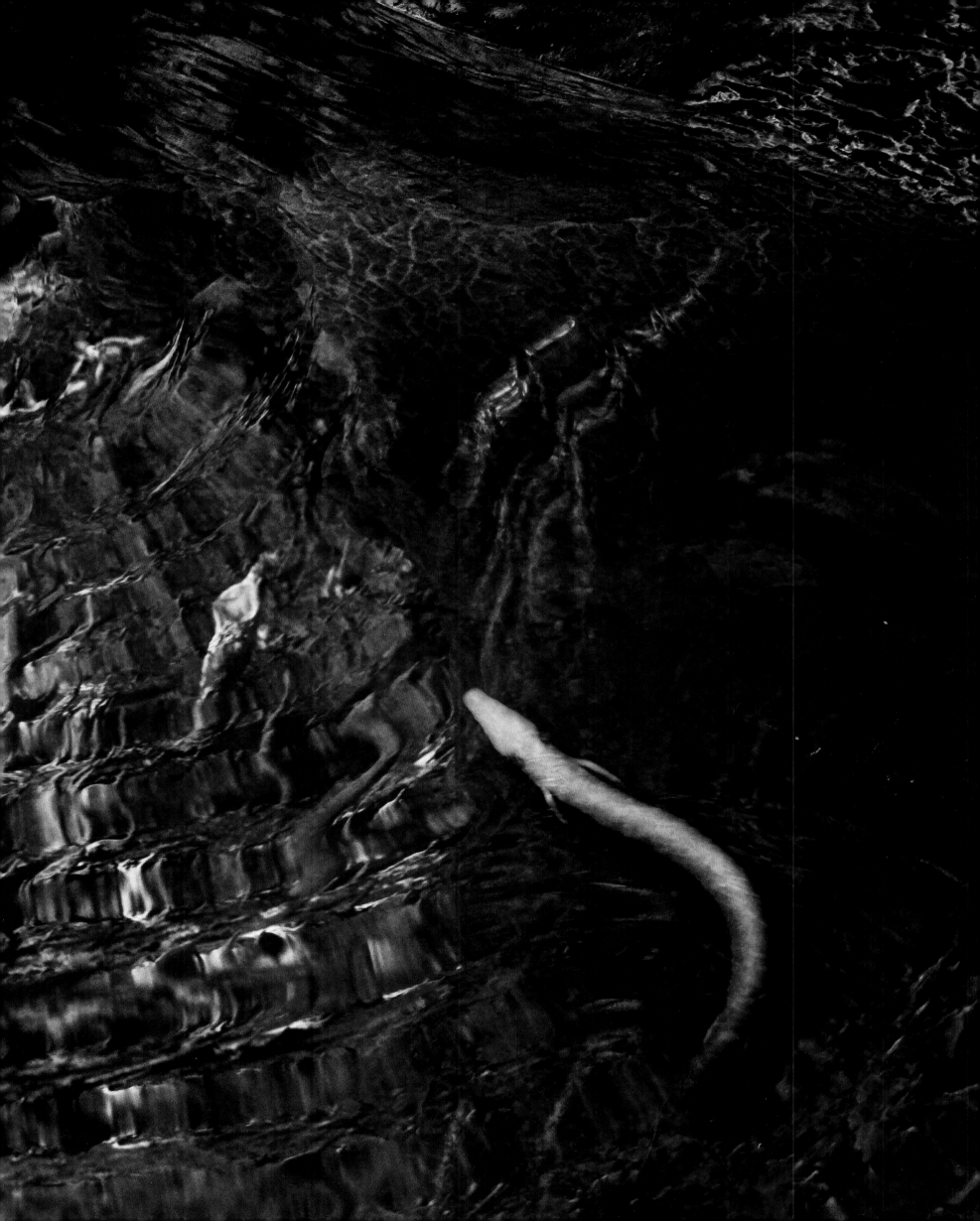

Olm

Sixty-six million years ago, when the impact
of a meteorite destroyed most of Earth's
life-forms, the olm kept swimming. It had
emerged around eighty million years prior, in
the blackest caves beneath what is now eastern
Europe, and with no dependence on sunlight,
hardly noticed Earth's fifth mass extinction at
all. As the olm is never seen by its mate, it has
not developed the colorful patterning of its
tropical amphibian cousins, and has almost no
pigmentation whatsoever. Sightless, it orients
itself with smell, hearing, electrosensitivity
and, it is thought, even by detecting Earth's
magnetic fields. It may live for up to one
hundred years and can survive for ten years
without food, but it needs clean water. The
forests above its habitat act as purifiers, but as
they are converted into farmland, pollutants
permeate its subterranean home. For the first
time in the olm's long, long history, it has
become vulnerable.

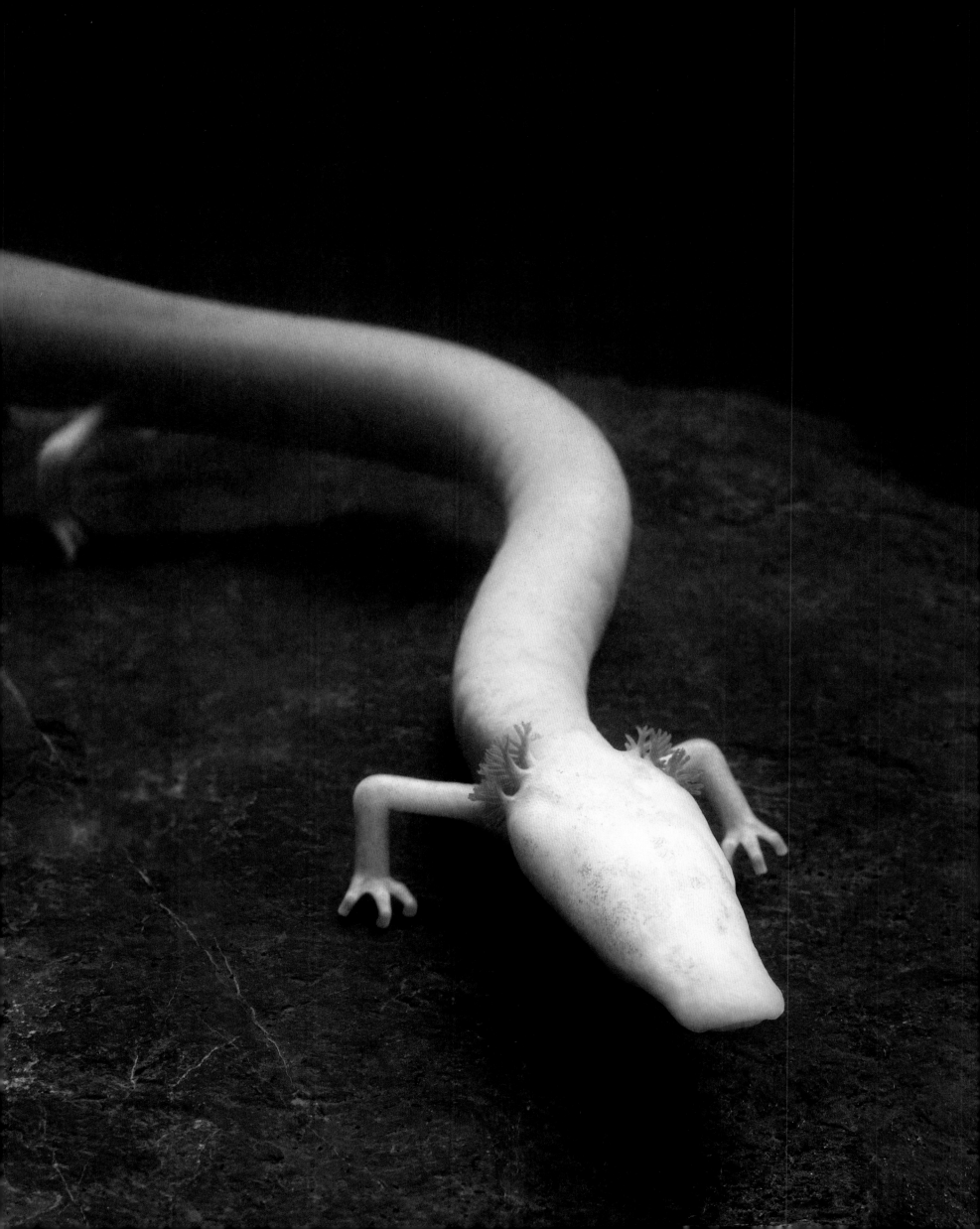

Child at heart

In the axolotl, Aztec people saw a manifestation of the god Xolotl, who led souls into the underworld alongside the setting sun. The Aztecs revered the axolotl's meat, and caught the creatures from the huge network of canals and lakes that supported their central Mexican communities. Today, only a fraction of this aquatic system remains, and it is being polluted by fertilizers, pesticides, feces, and garbage from Mexico City.

Axolotls, like their European cousins, olms (pp. 50–55), are neotenic, meaning they reach sexual maturity still looking like larvae, retaining their gills and tail fins. They do not develop physically between infancy and adulthood, but they do regenerate; they can regrow limbs, bones, and organs that have been damaged or severed. They are one thousand times more resistant to cancer than mammals. If they survive modern threats long enough for us to gain an understanding of their immune cells, we could make tremendous advancements in numerous medical therapies.

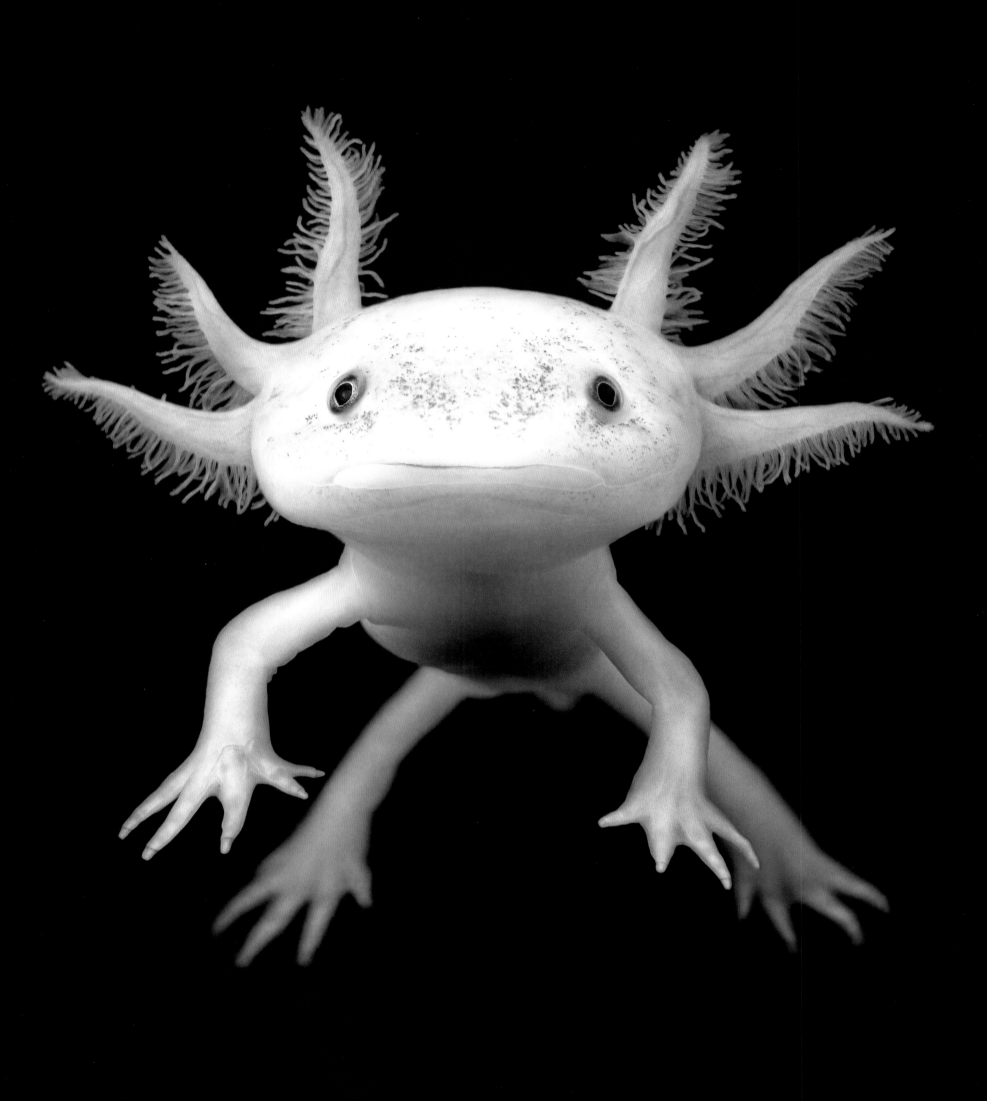

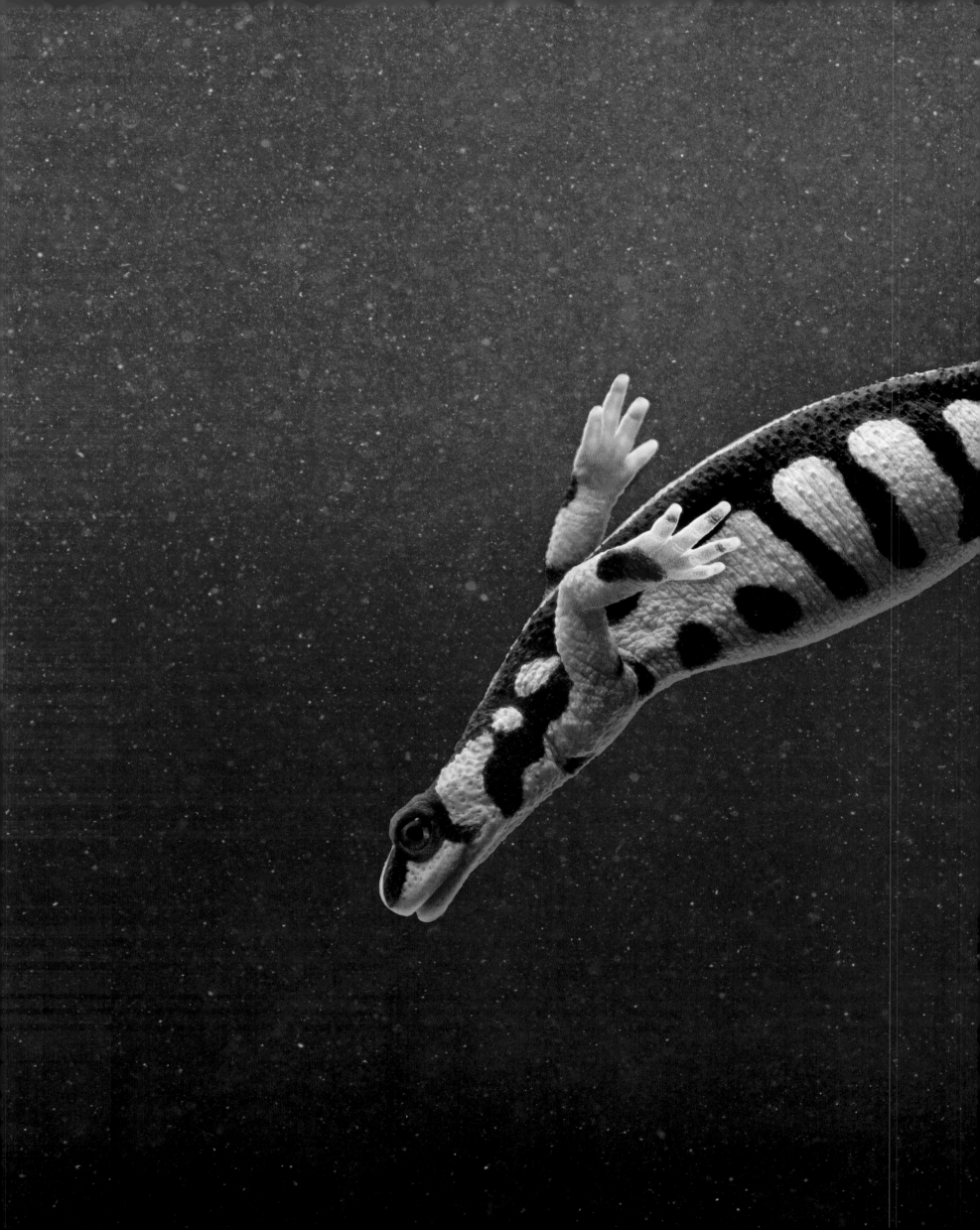

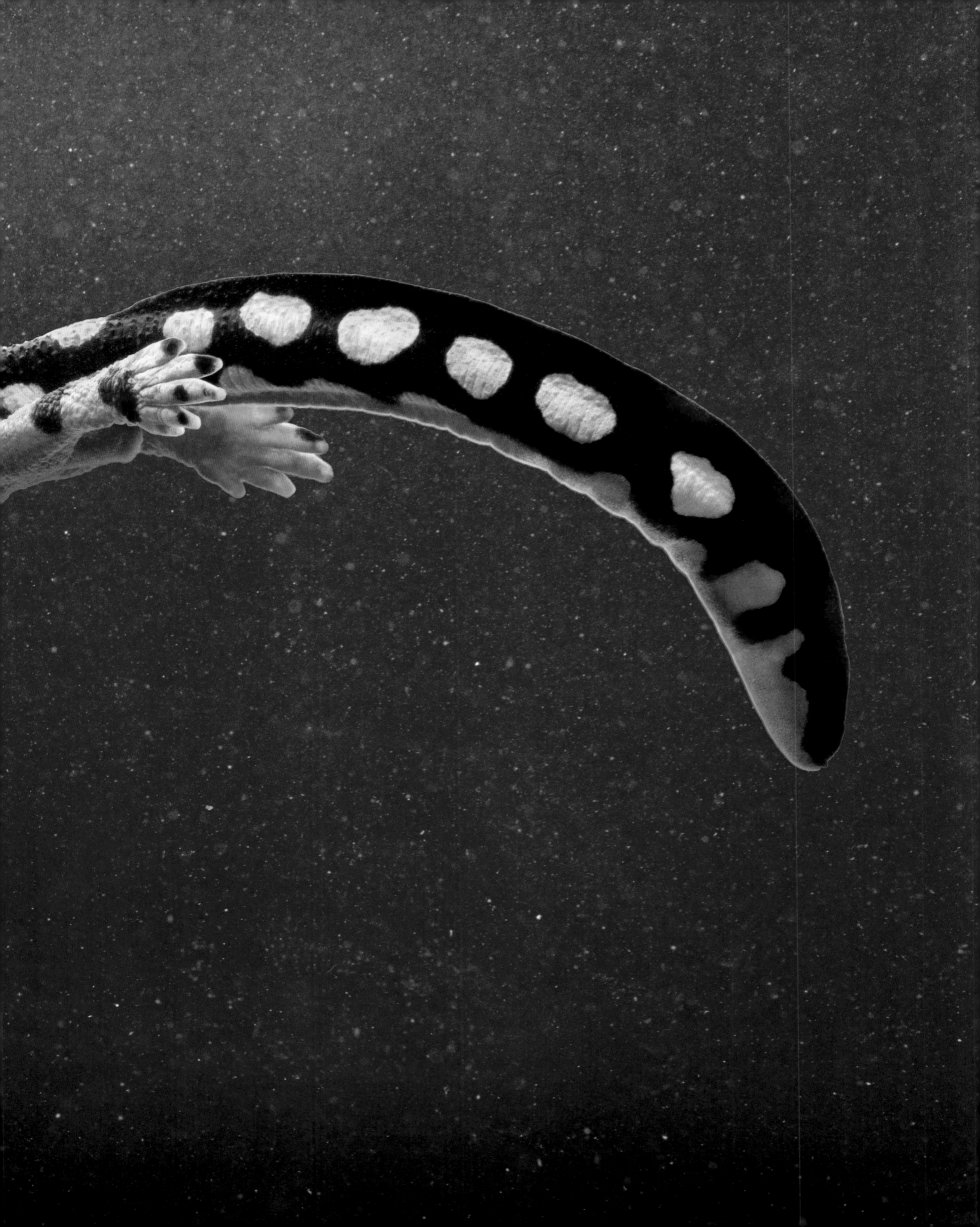

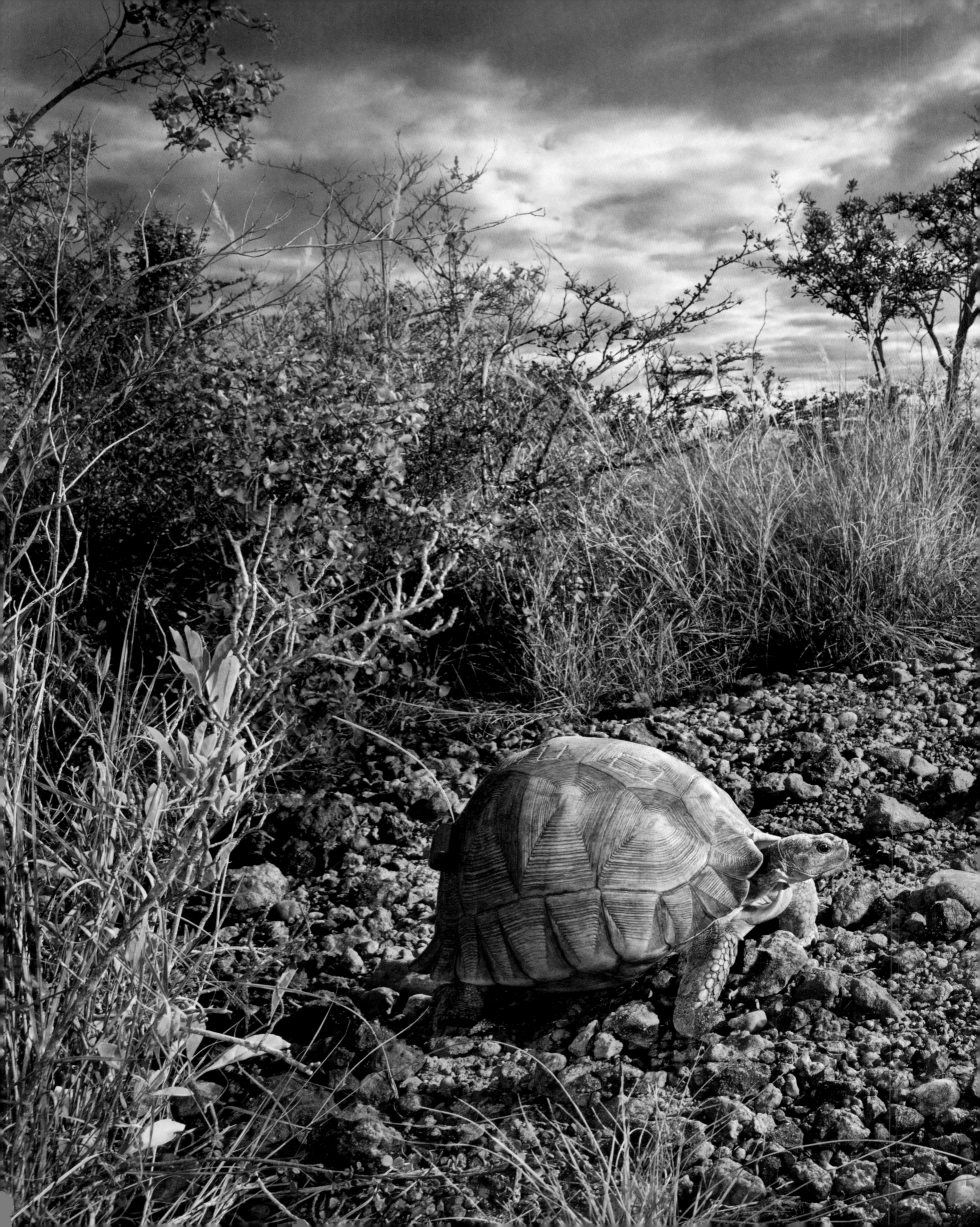

Slow progress

The rarest tortoise in the world takes fifteen years to reach breeding age. This makes every bush fire, every theft, and every felled tree a crushing setback for this species on the brink of extinction.

The ploughshare tortoise was once believed to have died out already, but in 1984 it was rediscovered in northwest Madagascar, and Durrell Wildlife Conservation Trust swiftly launched a captive-breeding program. In 1998, the ploughshares' only habitat was officially made a national park—the first created to protect a single species— and the Durrell Trust succeeded in releasing one hundred individuals into the wild.

The ploughshare's rediscovery also made it one of the world's most desirable animals for illicit dealers in rare species and ornamental shells; every conservational success has been achieved under a constant struggle with this powerful international trade. Recently, poaching has intensified, and all releases into the wild have been suspended while guards battle to secure the area, which now holds just a few hundred individuals.

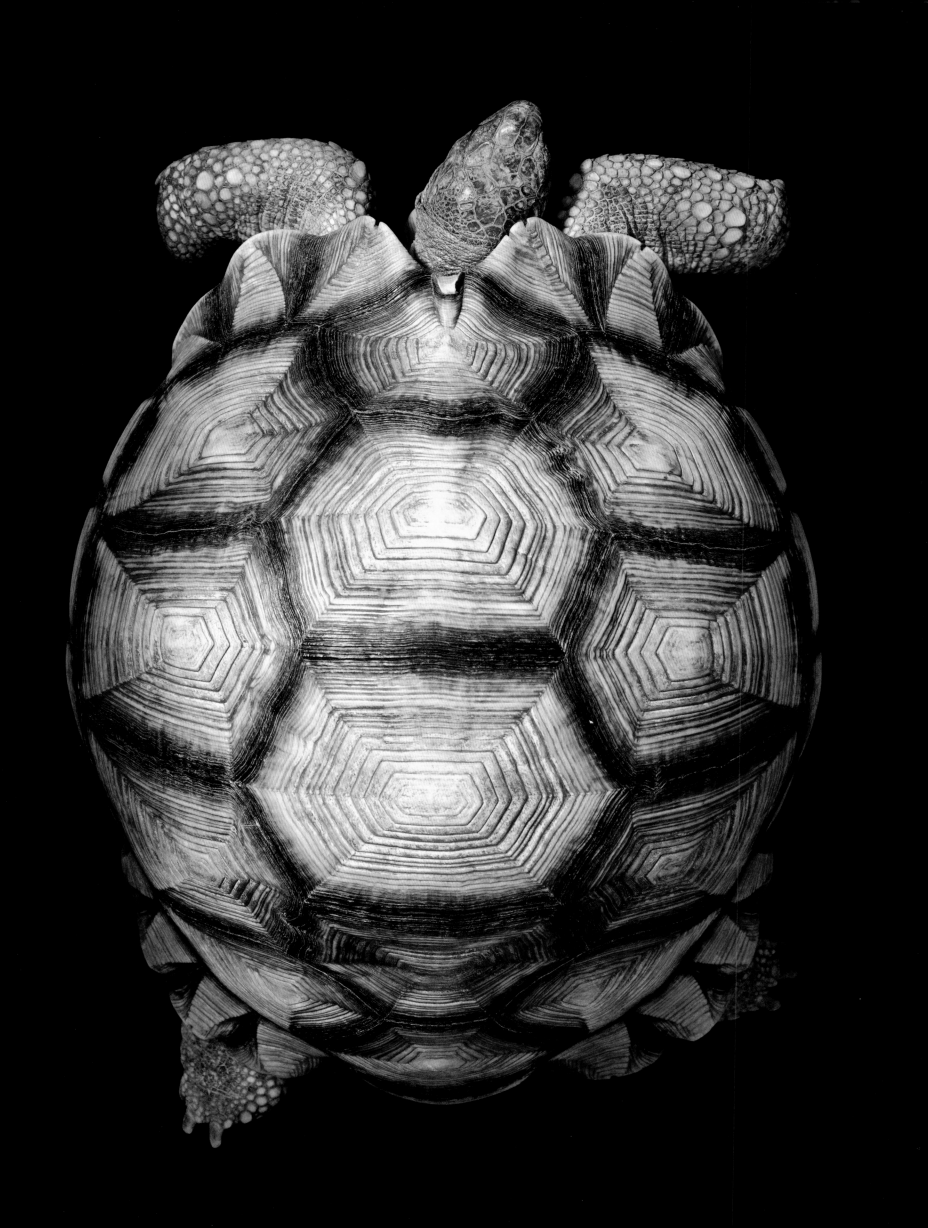

Tough love

The beauty of the ploughshare tortoise's
domed, golden shell, and the rarity of
the creature itself, make it incredibly
valuable on the black market. Armed
security was employed at the ploughshares'
breeding center, but thieves persisted, and
conservationists have been forced to deface
the tortoises' shells. Engraving is painless
for the animals, but it renders them almost
worthless to dealers, and easier to identify for
scientists. The marks can be discomforting to
look at, but they actually represent a healthy
and progressive relationship between our
species and those with which we share the
world. Often, conservation demands creative
intervention, not segregation.

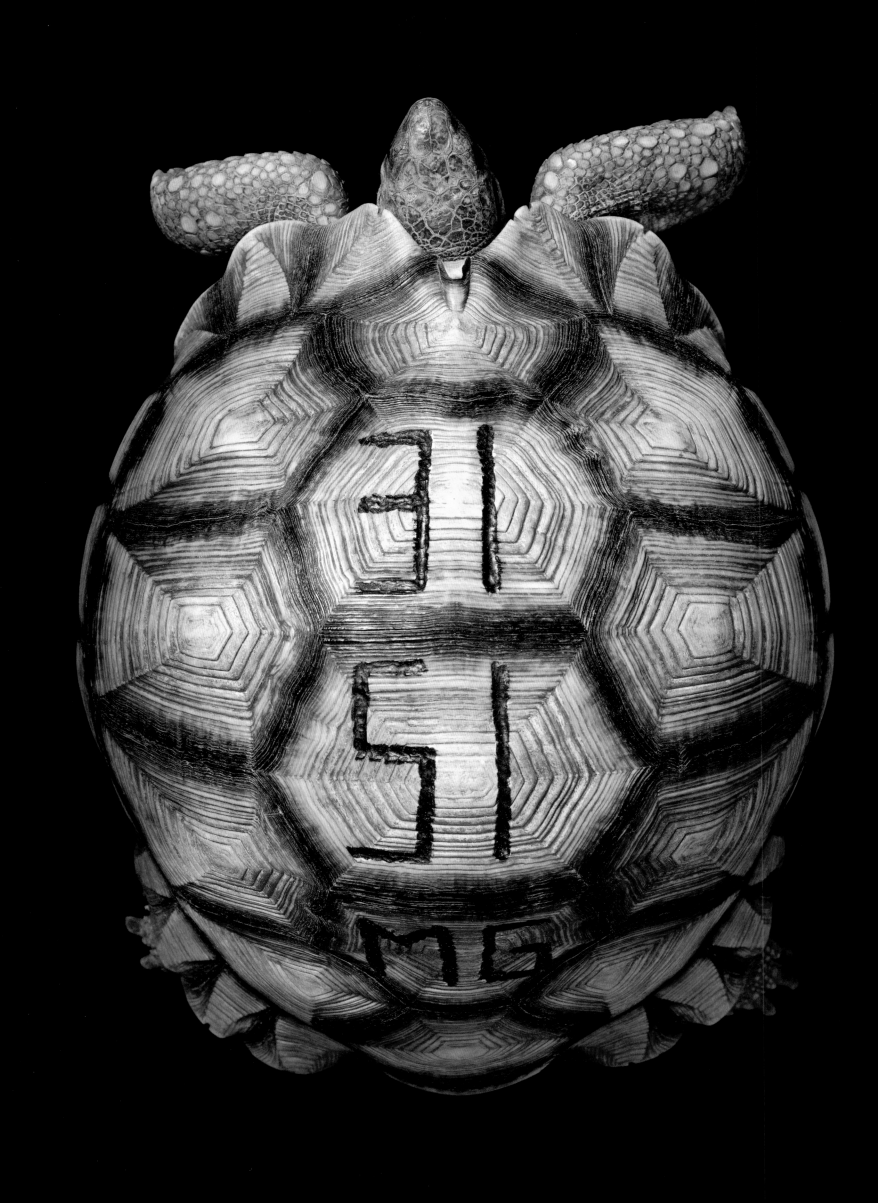

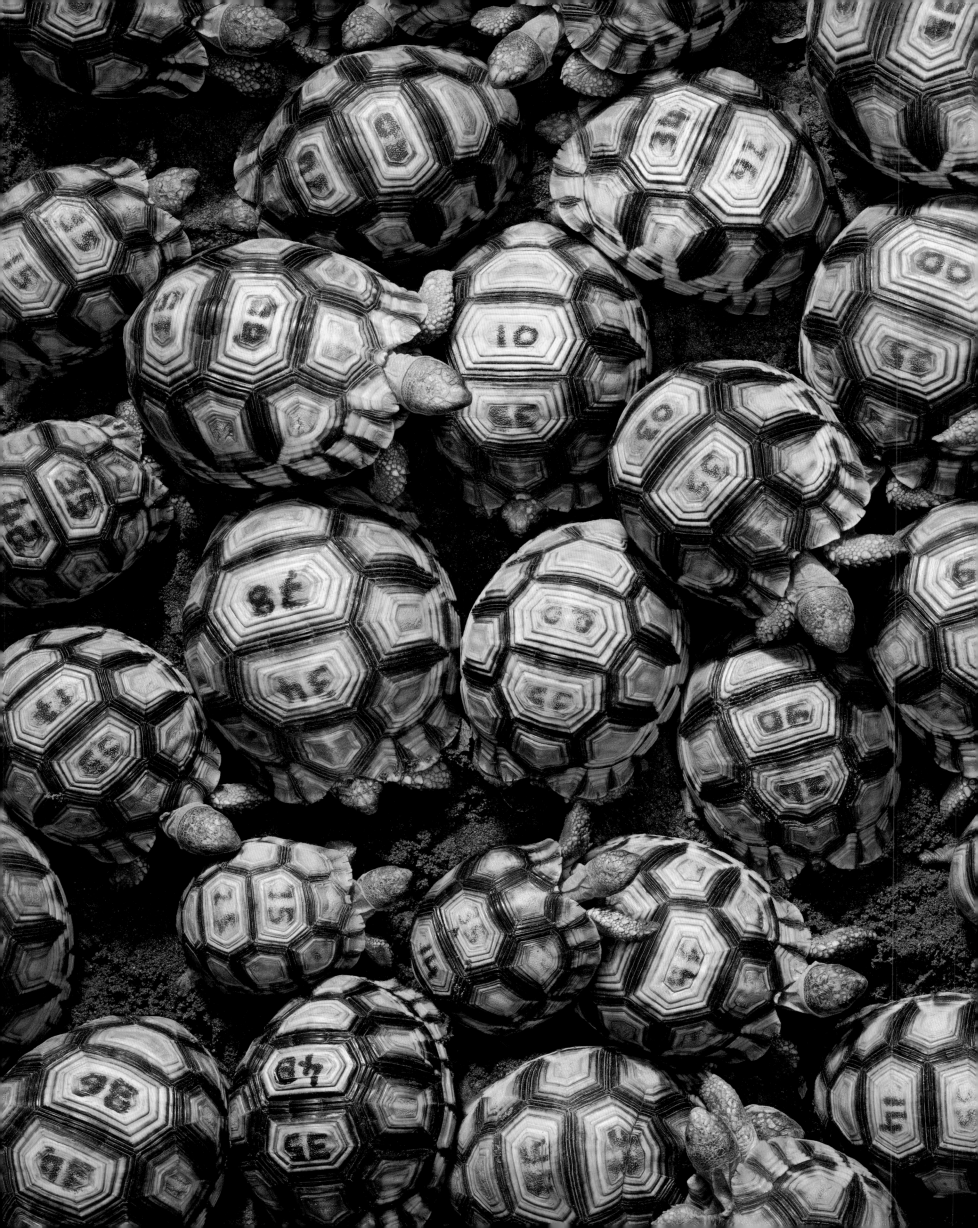

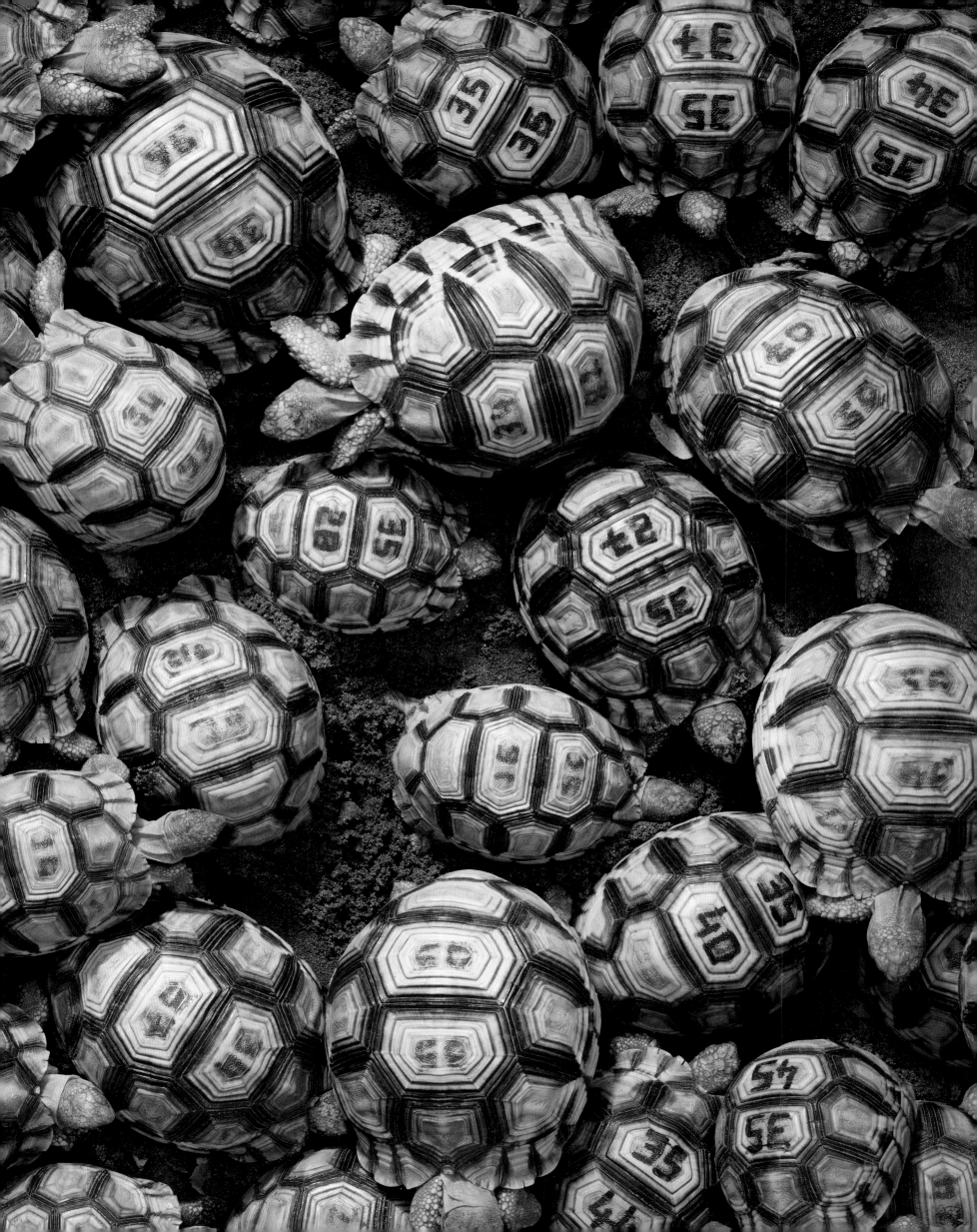

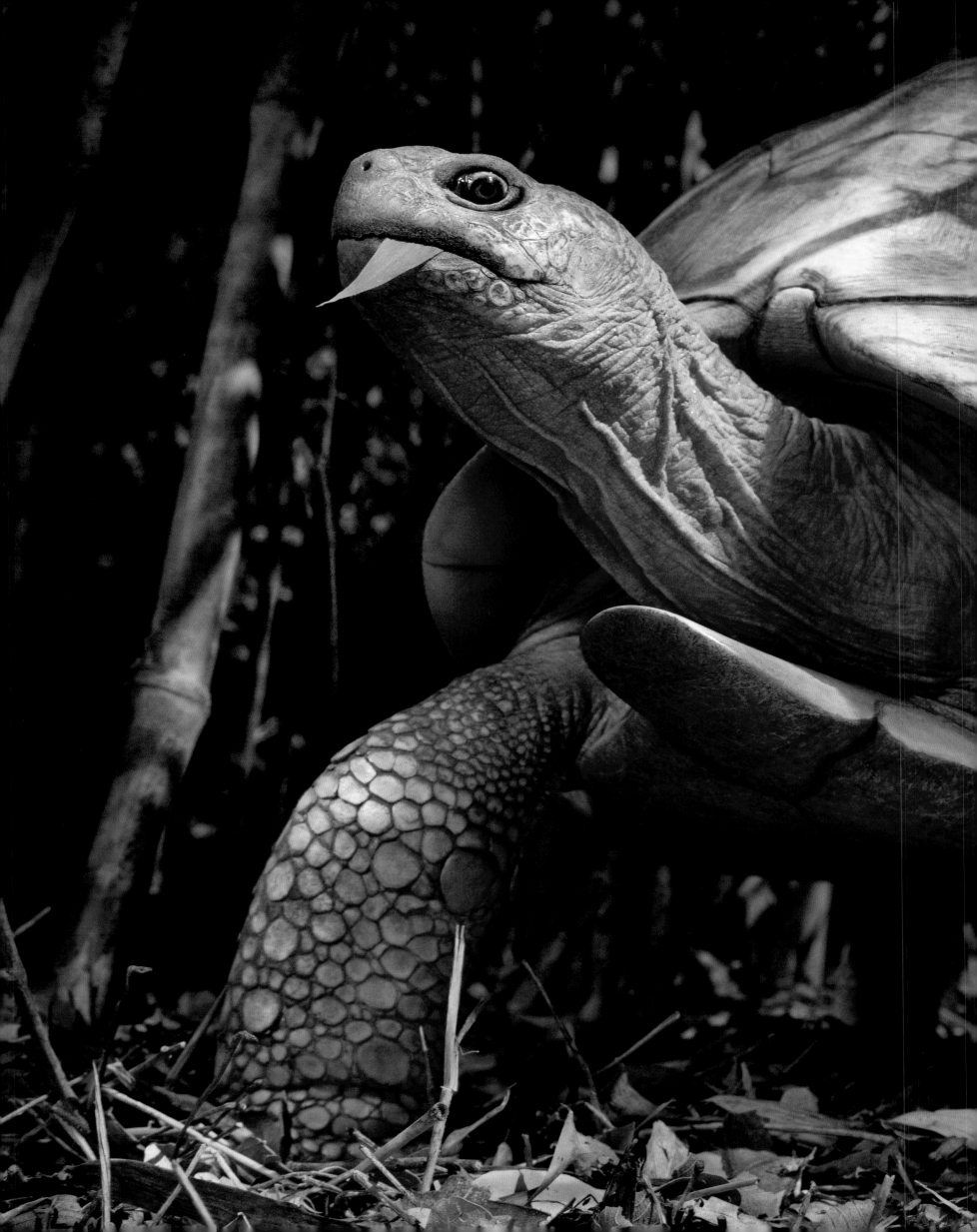

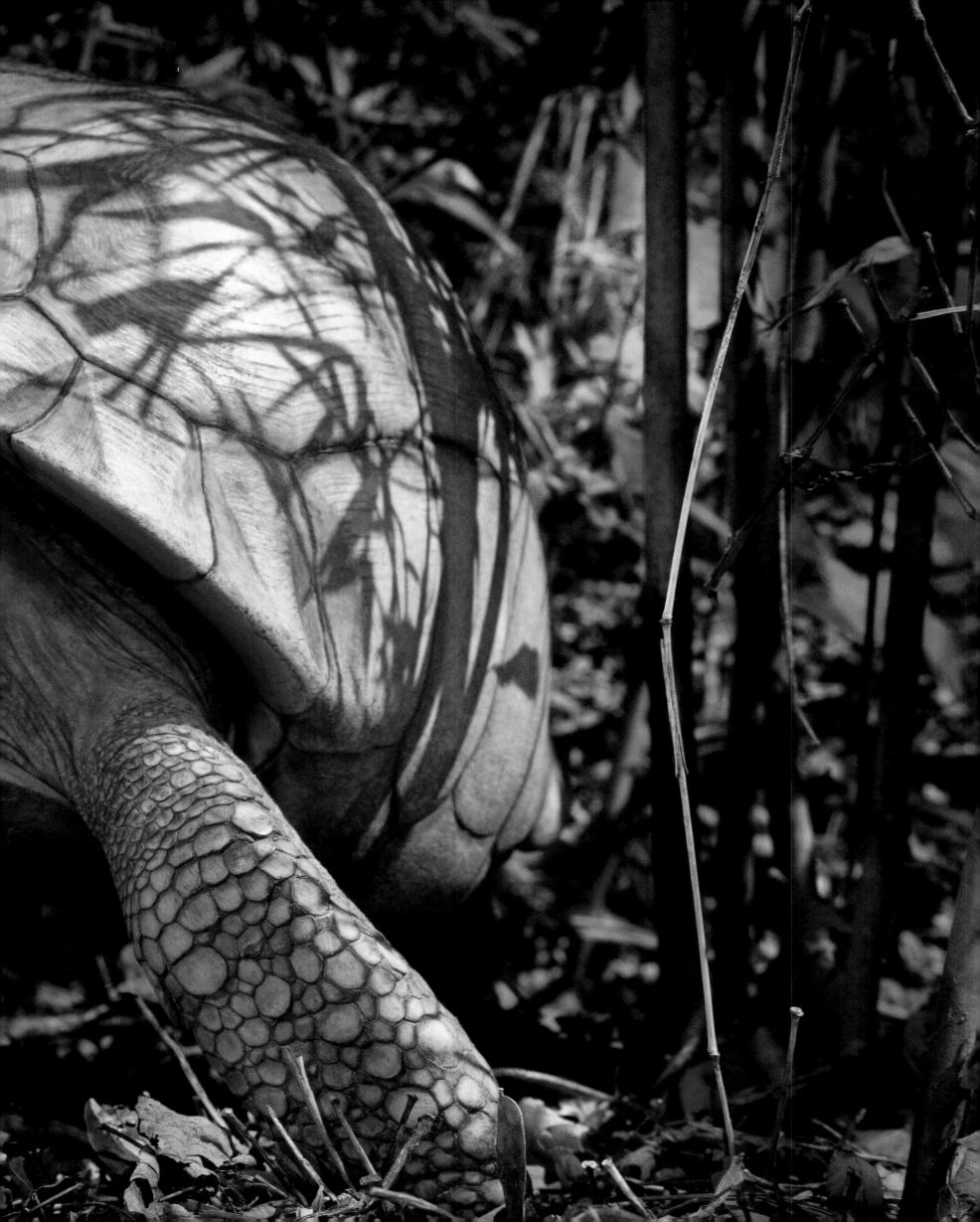

A cry for help

The black-and-white ruffed lemur of eastern Madagascar has one of the loudest voices of all the world's primates. These ringing calls of alarm have become a dangerous liability, however, as the lemurs are hunted for meat by poachers who can locate them with ease. Only 10 percent of Madagascar's historic forests remains, and they are sustained by these critically endangered lemurs; with a taste for nectar, they are thought to be the world's largest pollinators. Unlike most primates, they give birth to large litters, and so they thrive in captivity where survival rates are high, but because they have been bred from such a small gene pool, reintroductions come with many complications. Conservation will be achieved when we simply leave them at peace in an undisturbed rainforest canopy.

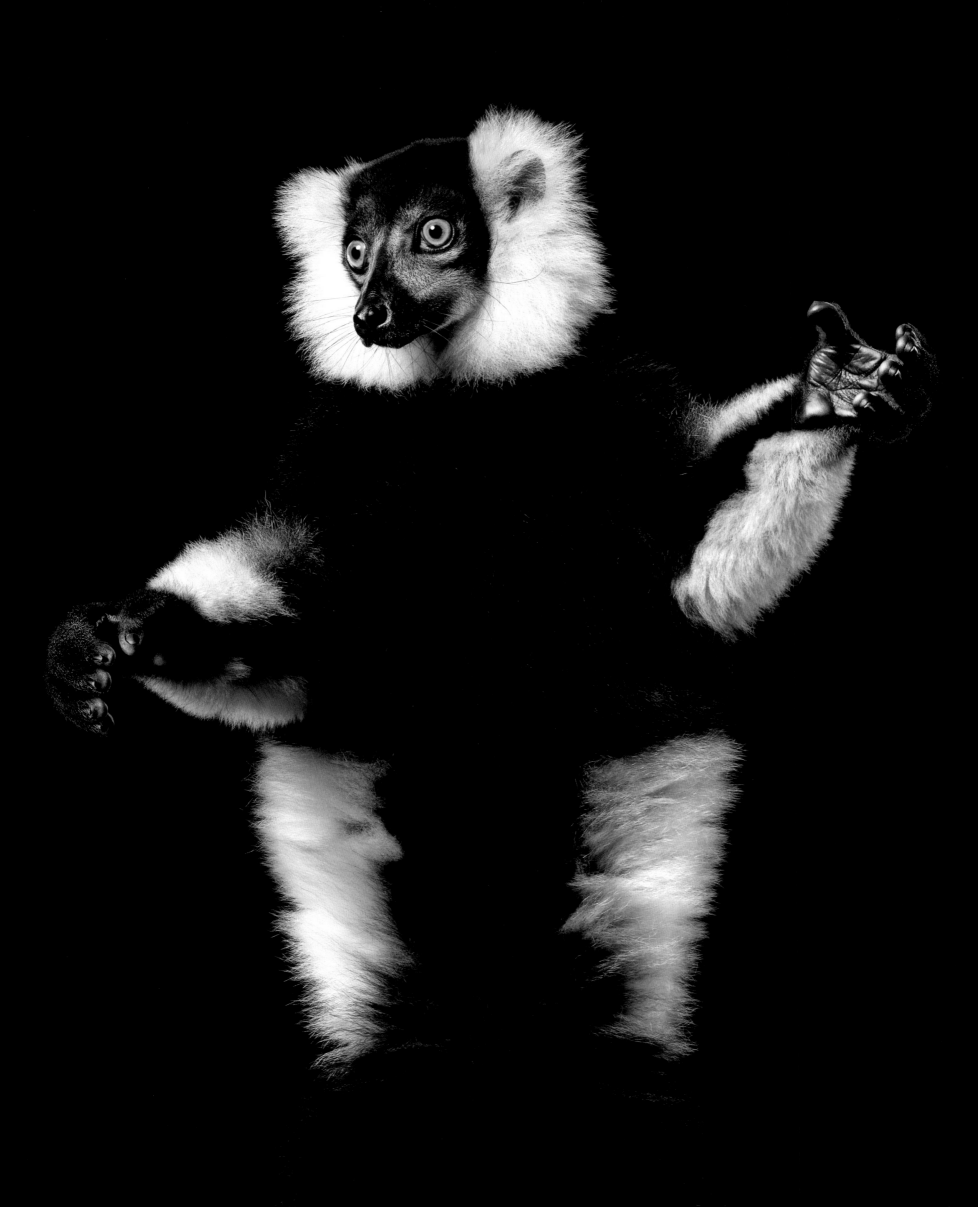

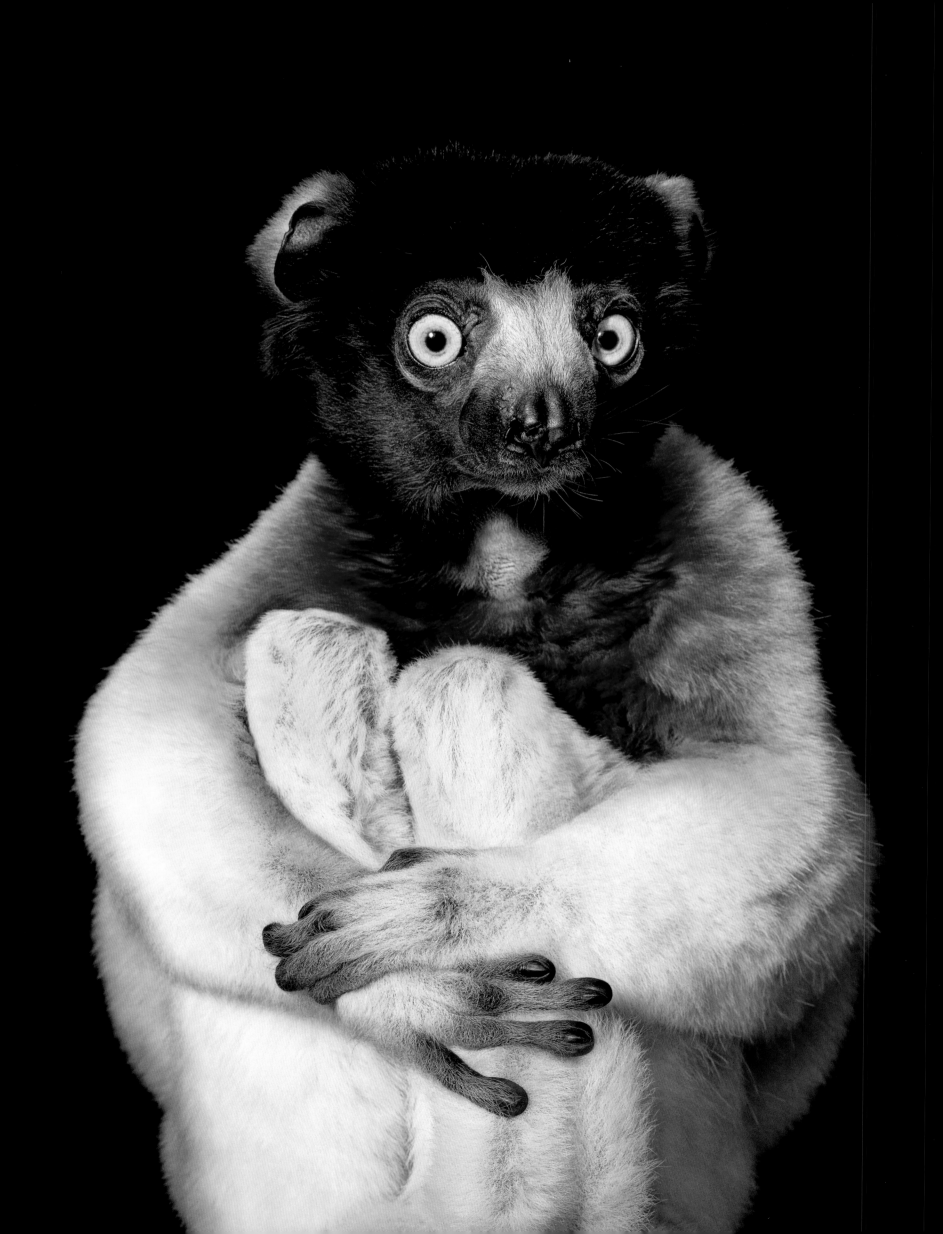

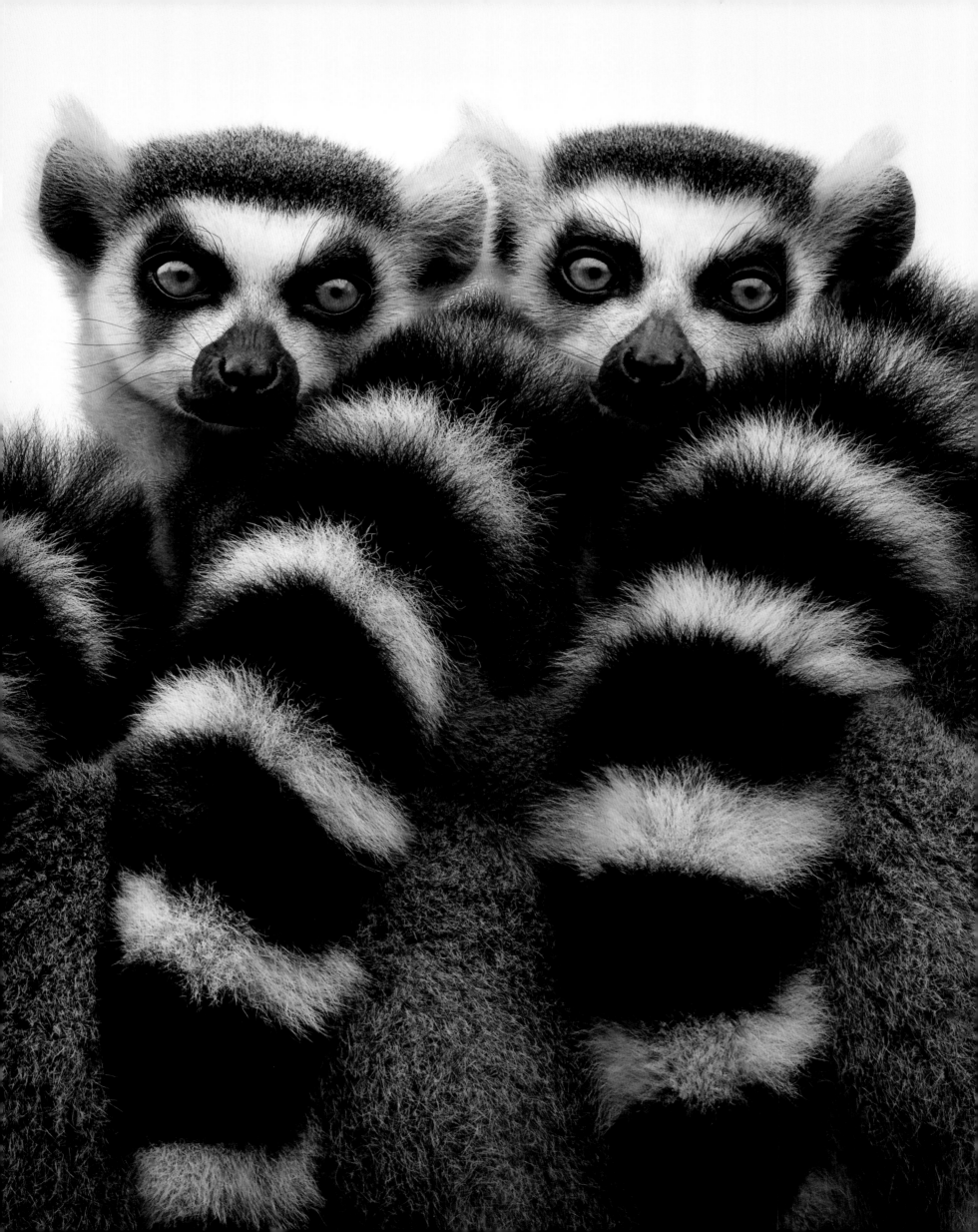

Silent decline

It is estimated that more than one million pangolins were illegally traded between 2007 and 2017, making them officially the most trafficked mammals in the world. They are shy, toothless, and mostly nocturnal, and they roll into a ball when afraid, cocooned by an armor of keratin scales. This defense protects them from their historic predators, but humans can simply pick them up and carry them away.

Pangolins bear a unique evolutionary heritage, having diverged from other mammals while dinosaurs still walked the earth. There are four species in Africa and four in Asia; all are now vulnerable to extinction and two are critically endangered. They are traded by the ton, but are largely hidden from the public eye, and their stories remain, for now, underground.

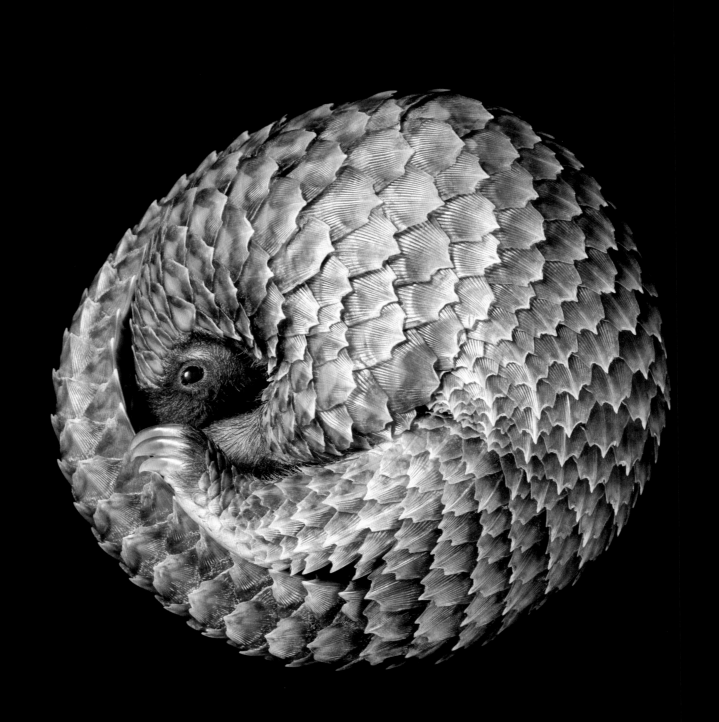

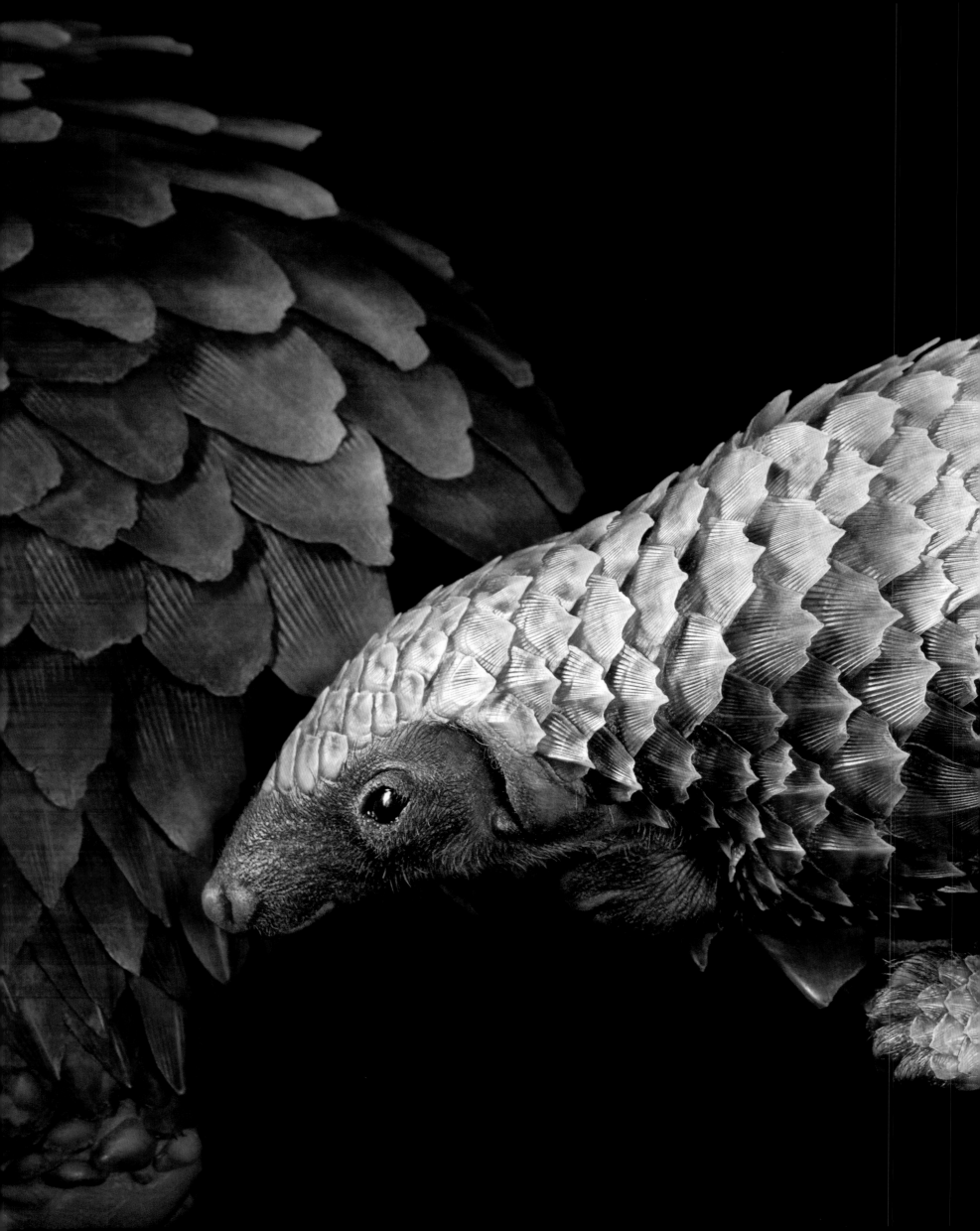

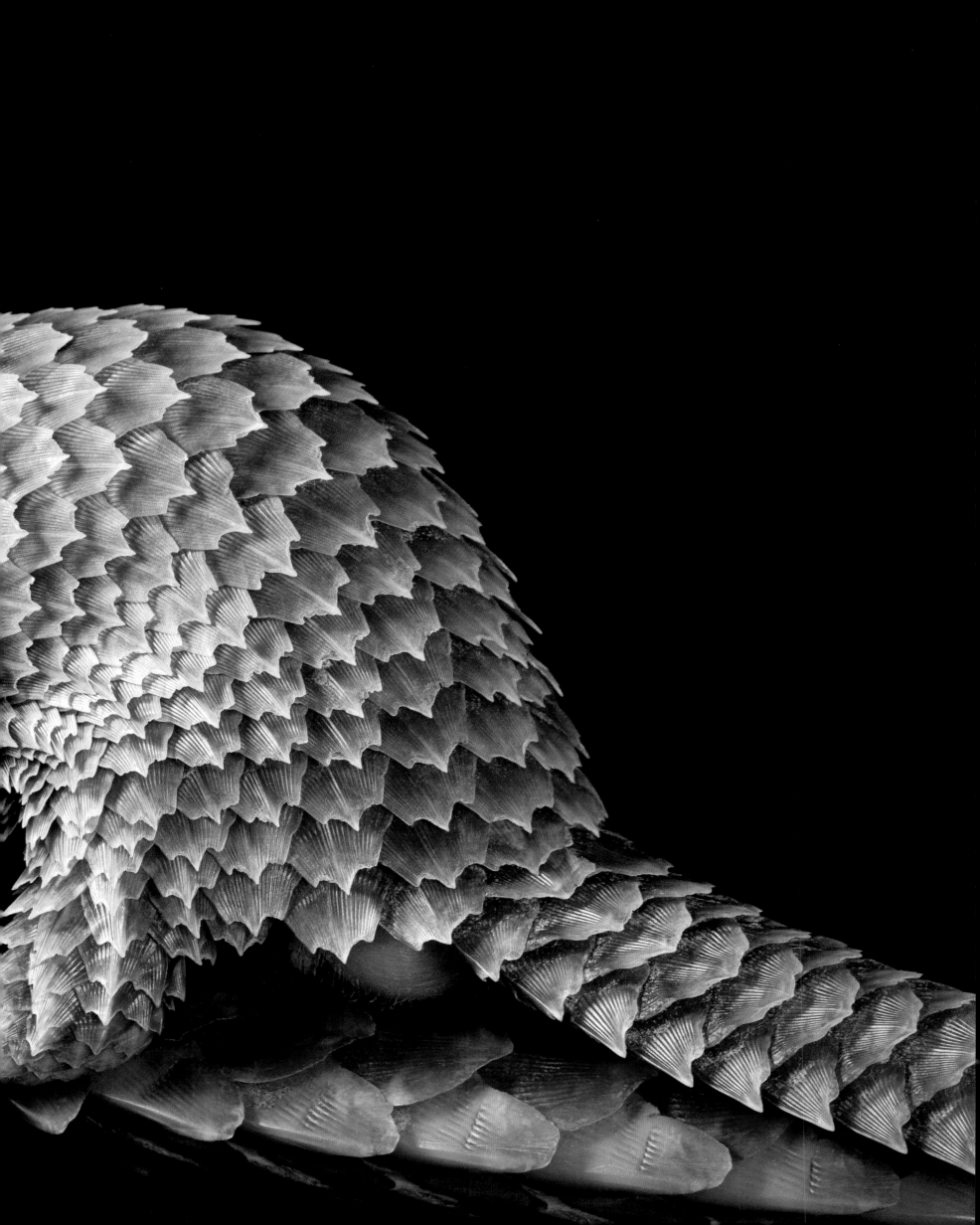

Pushing boundaries

In Africa, pangolins are traditionally hunted as bushmeat. In Asia, they are mostly traded for their scales, which are harvested, dried, and then ground into unproven traditional medicines. In much of East Asia, pangolin meat has now become a popular statement of wealth, but local species have already been hunted to the brink of extinction. In recent years, Chinese companies and Chinese laborers have been building Africa's newest roads and railways. This developing infrastructure cuts through pangolin habitat, giving the Asian market access to the more numerous pangolins of rural Africa, where their local value has accordingly soared and their populations have plummeted. Each pangolin eats about two hundred thousand insects per day, and farms and forests alike will be hurt by their decline.

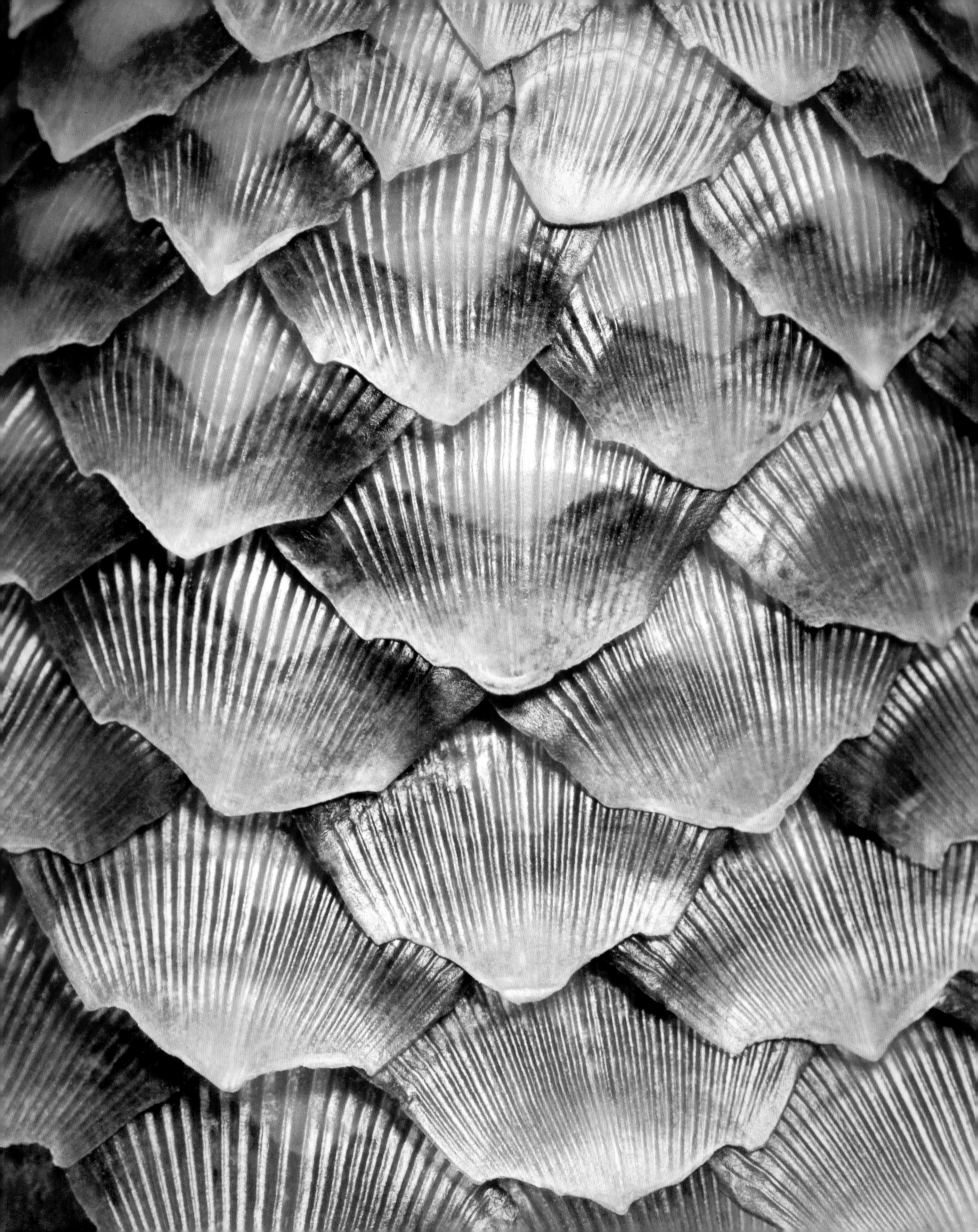

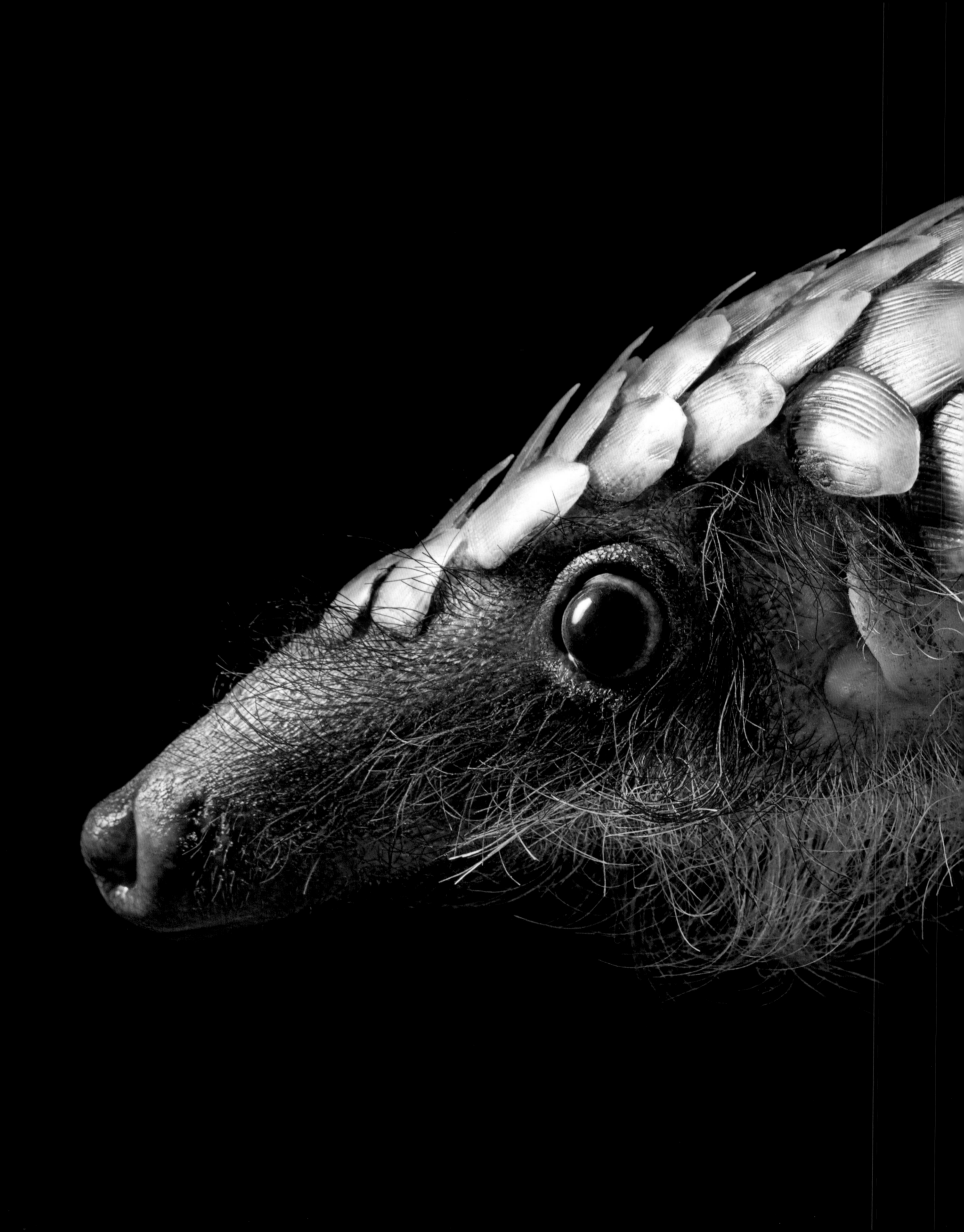

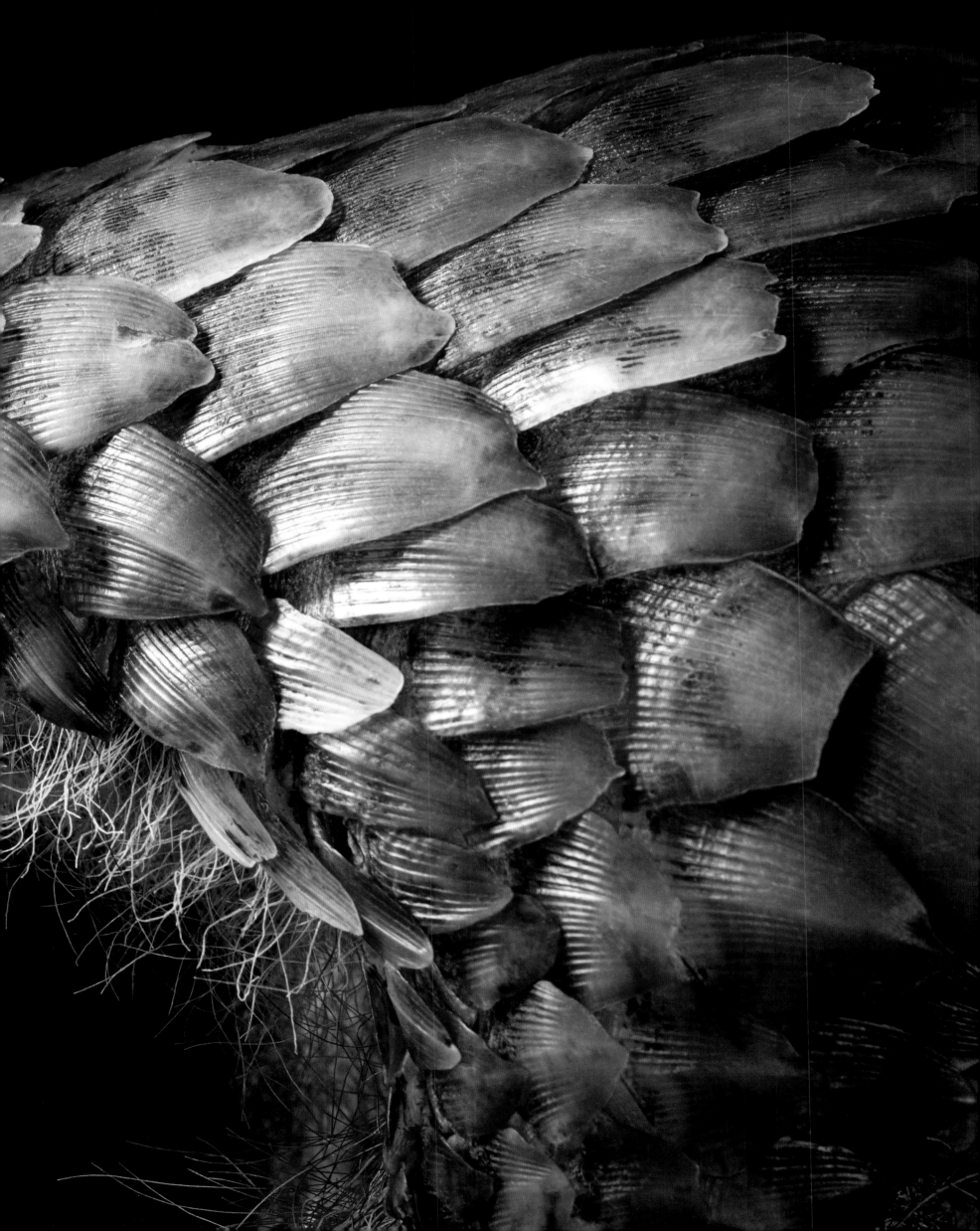

Labor of love

This is Djala, a western lowland gorilla, photographed at an English sanctuary run by the Aspinall Foundation. He was rescued from Gabon in the 1980s as an infant, having seen his entire family murdered by poachers. At the rescue center, he gradually overcame the profound traumas of his childhood, and after thirty years was taken home to the Gabonese forests with his new family (pp. 86–91). In the wild, his health has improved: the lumps above his left eye receded, he lost excess bodyweight, and he continues to flourish despite his old age.

The rescue and reintroduction of gorillas is expensive, and some conservationists criticize the approach, arguing that funds could be used more efficiently to defend critically endangered gorillas in the wild. However, by securing release sites for these reintroductions, they provide the incentives to legally protect land in poorly governed jungles. Besides, the practice embodies the noblest impulses of our race: rescuers see no alternatives to saving an orphan from starvation.

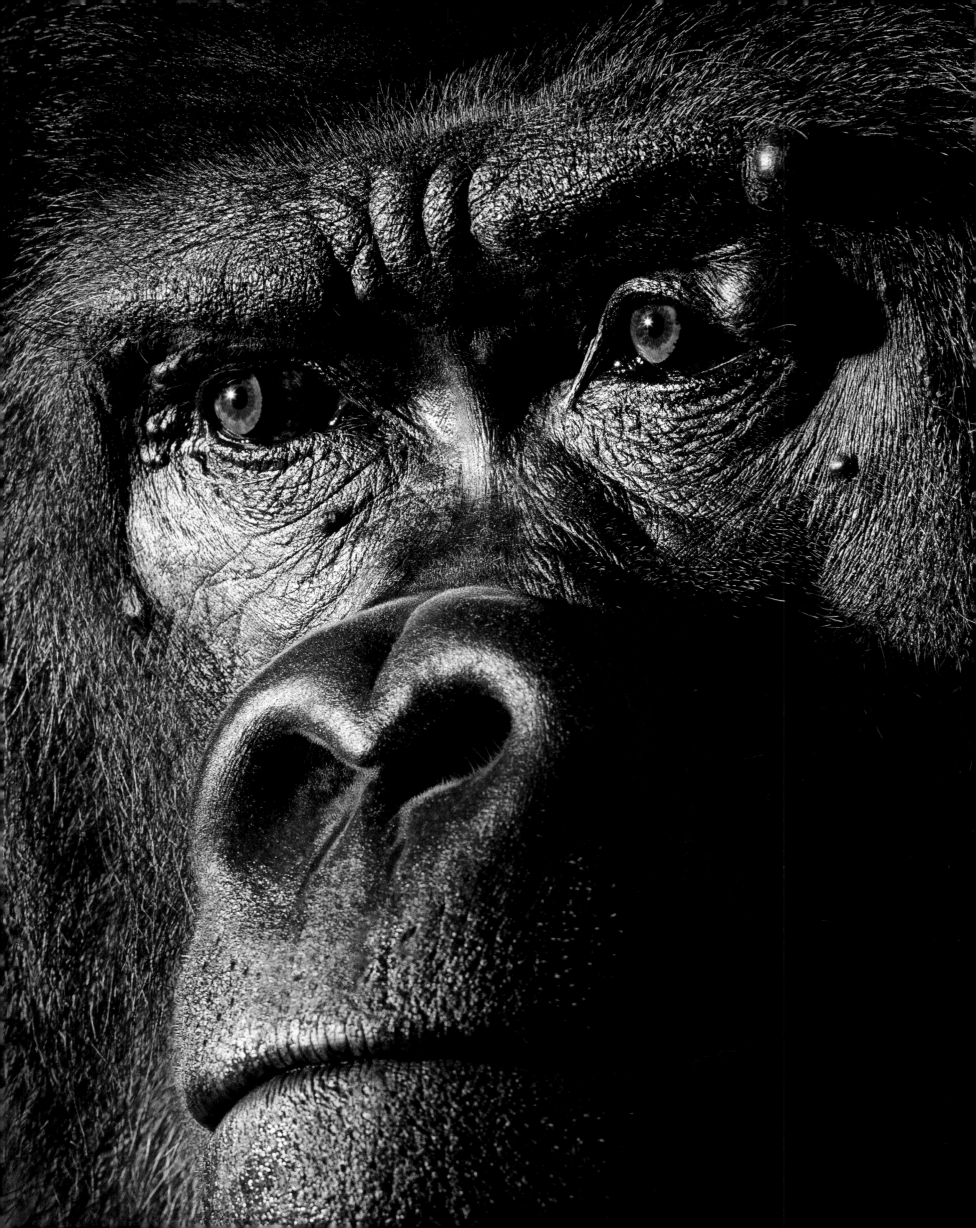

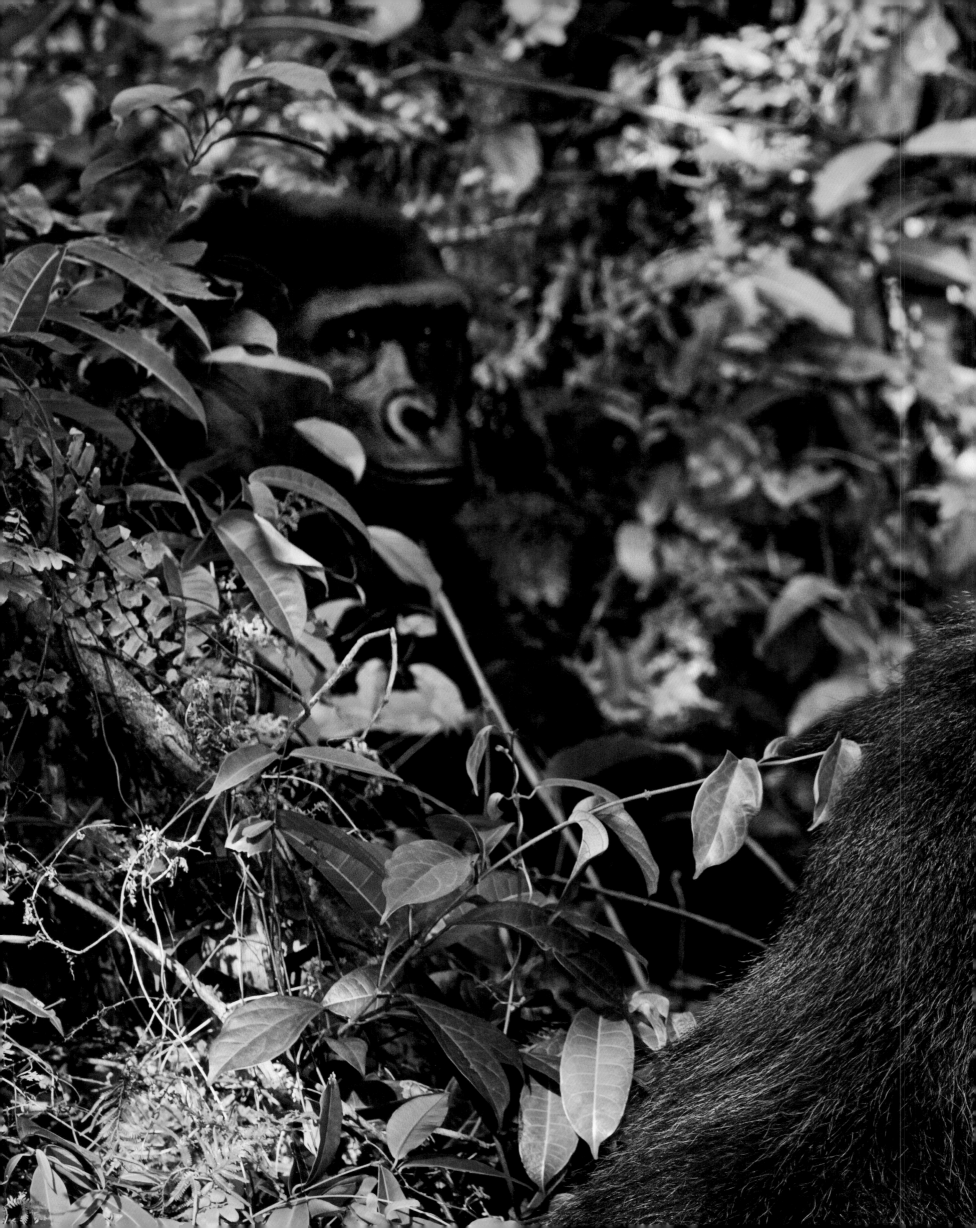

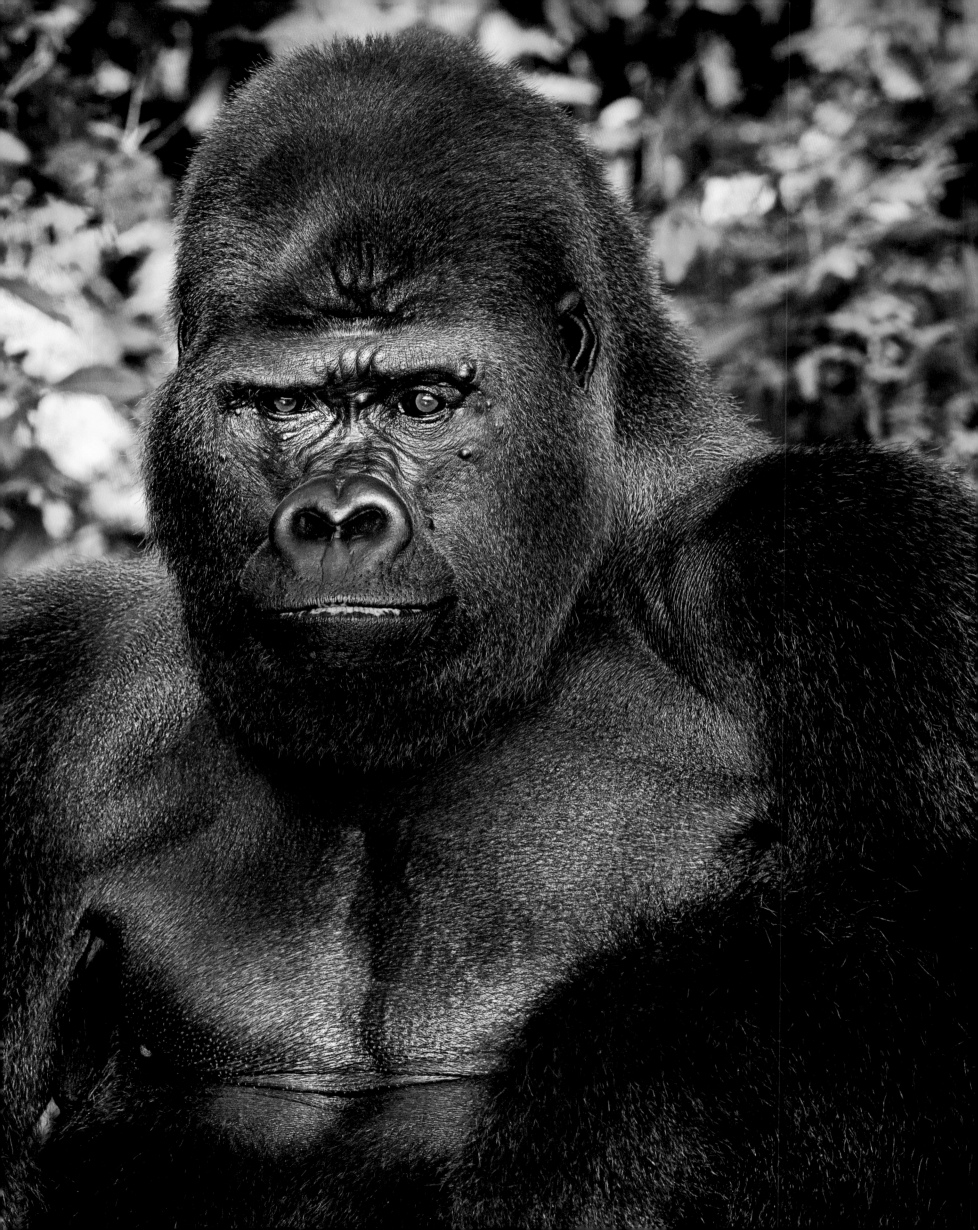

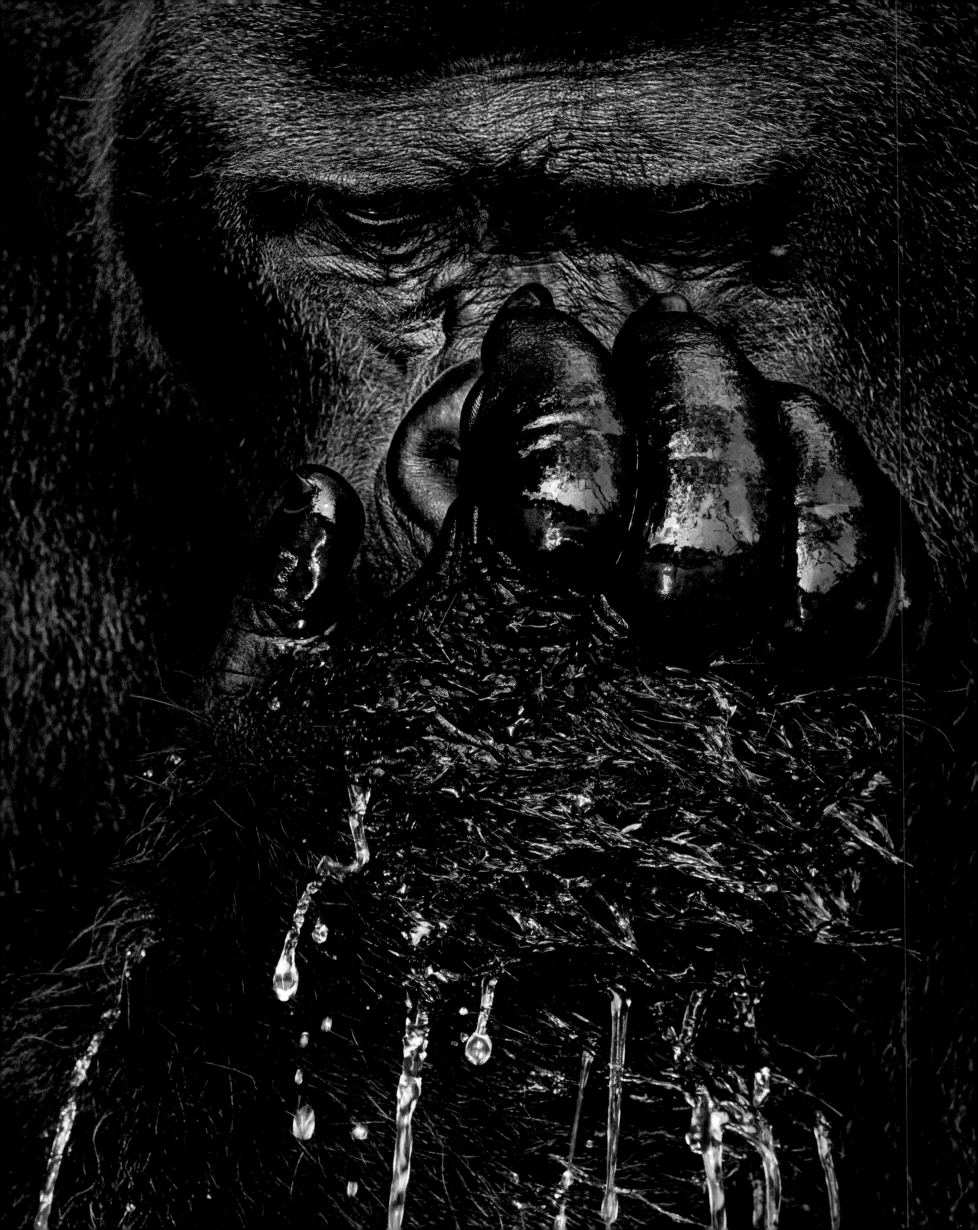

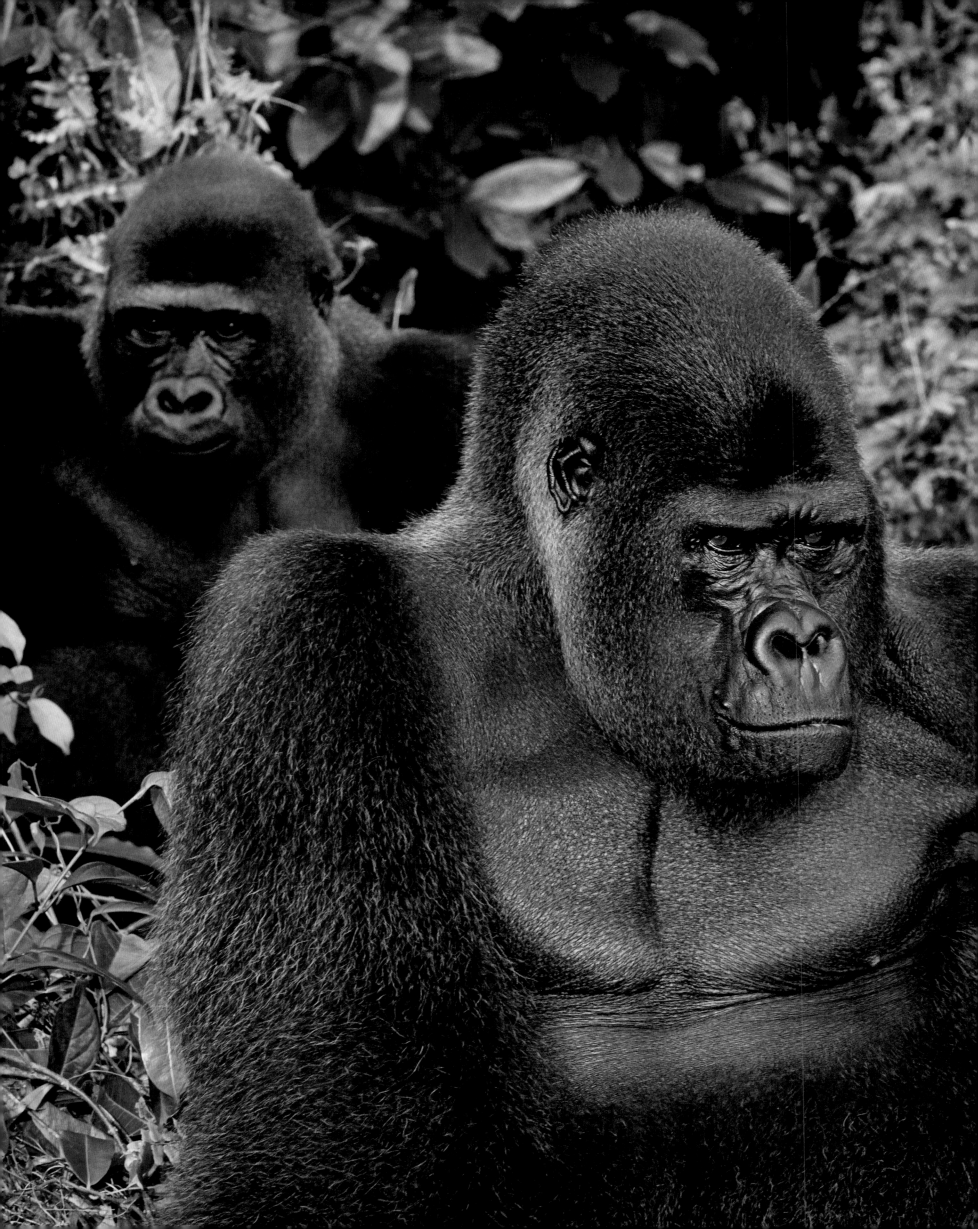

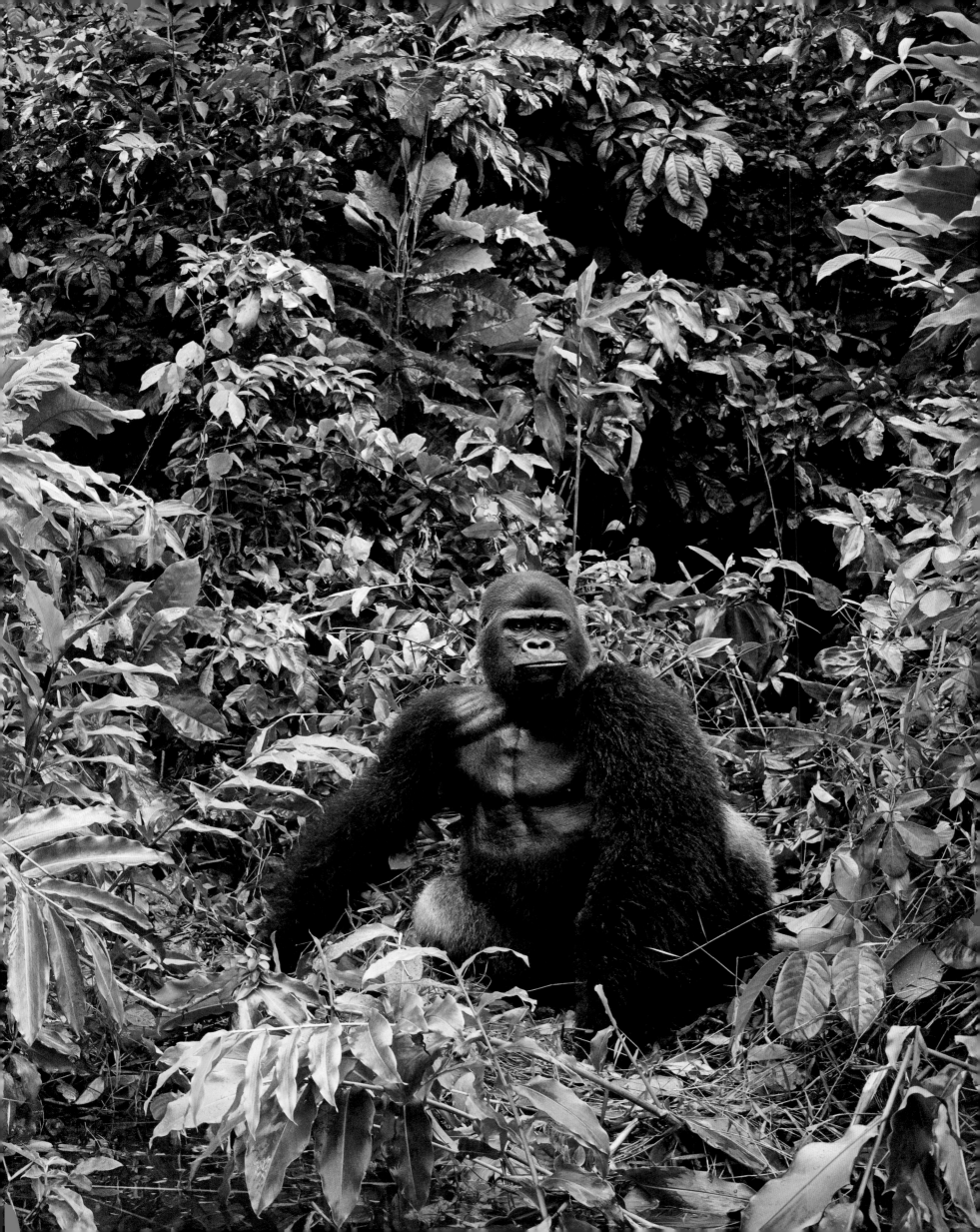

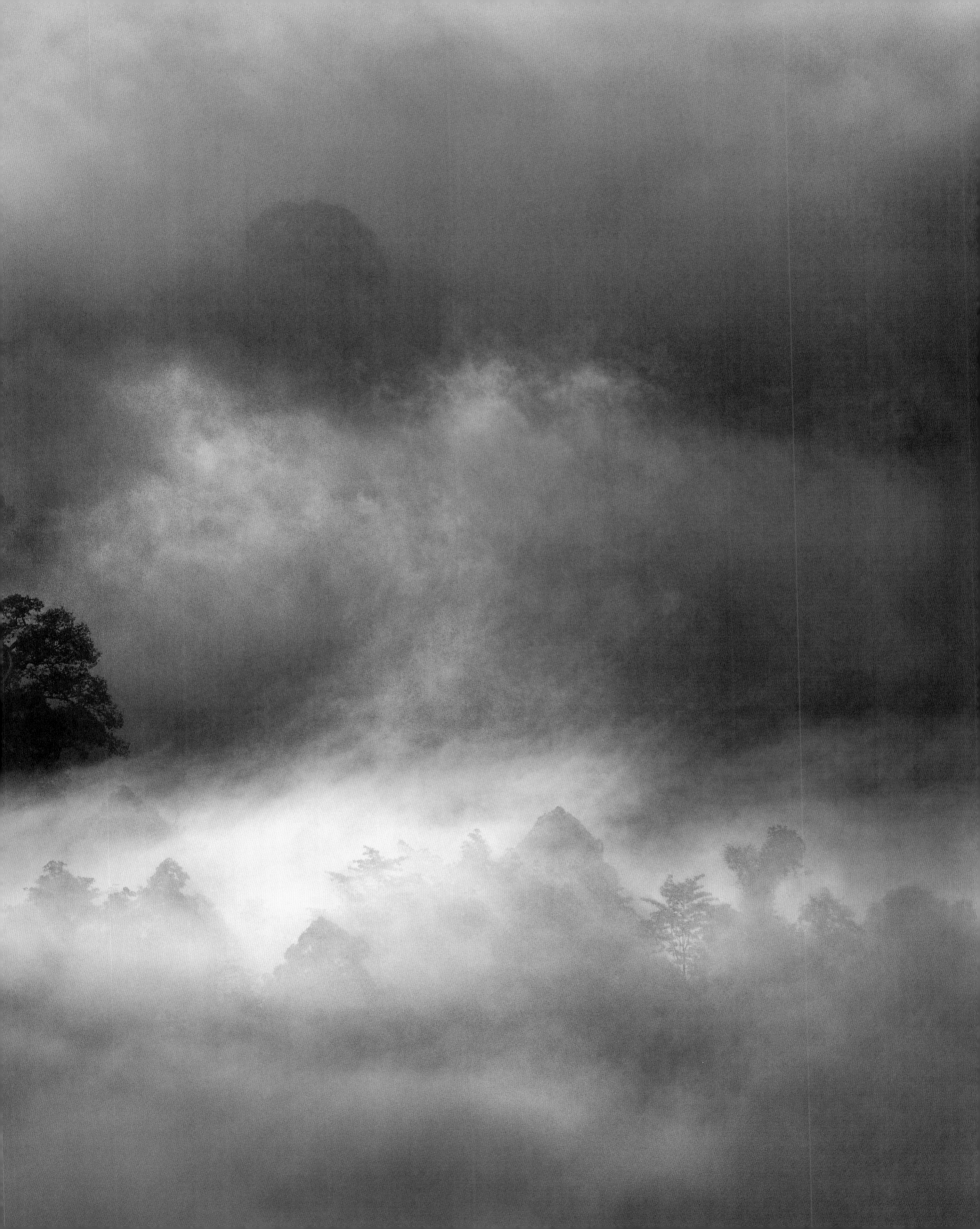

True colors

Flair is everything when you live in a group as large as a mandrill's. Mandrills form the largest social groups of any non-human primate, with a troop of 1,300 once recorded in the forests of Gabon. With their striking faces and eyes, they have evolved some of the most spectacular coloration of any mammalian species, the intensity of which signifies their social and sexual status. Sadly, it is not just their appearance that is appealing; mandrill meat is considered a delicacy in West Africa, and it is part of a growing trade, with tons of bushmeat being smuggled into western Europe every week. Because mandrills live in such huge groups, large swathes of their population can fall to the booming trade in just one hunt. Logging and farming are limiting their places of refuge, and these remarkable animals are in urgent need of stronger protections.

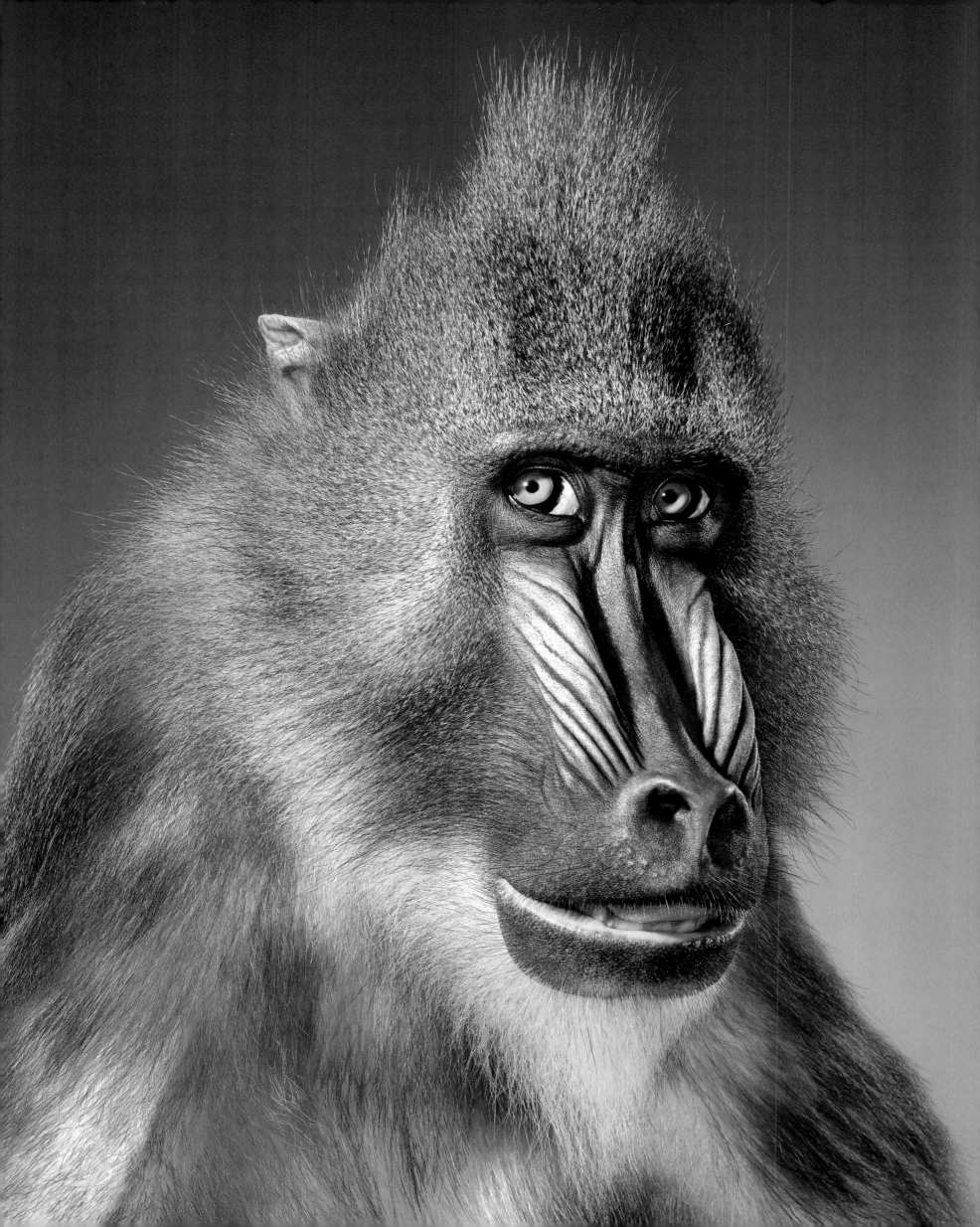

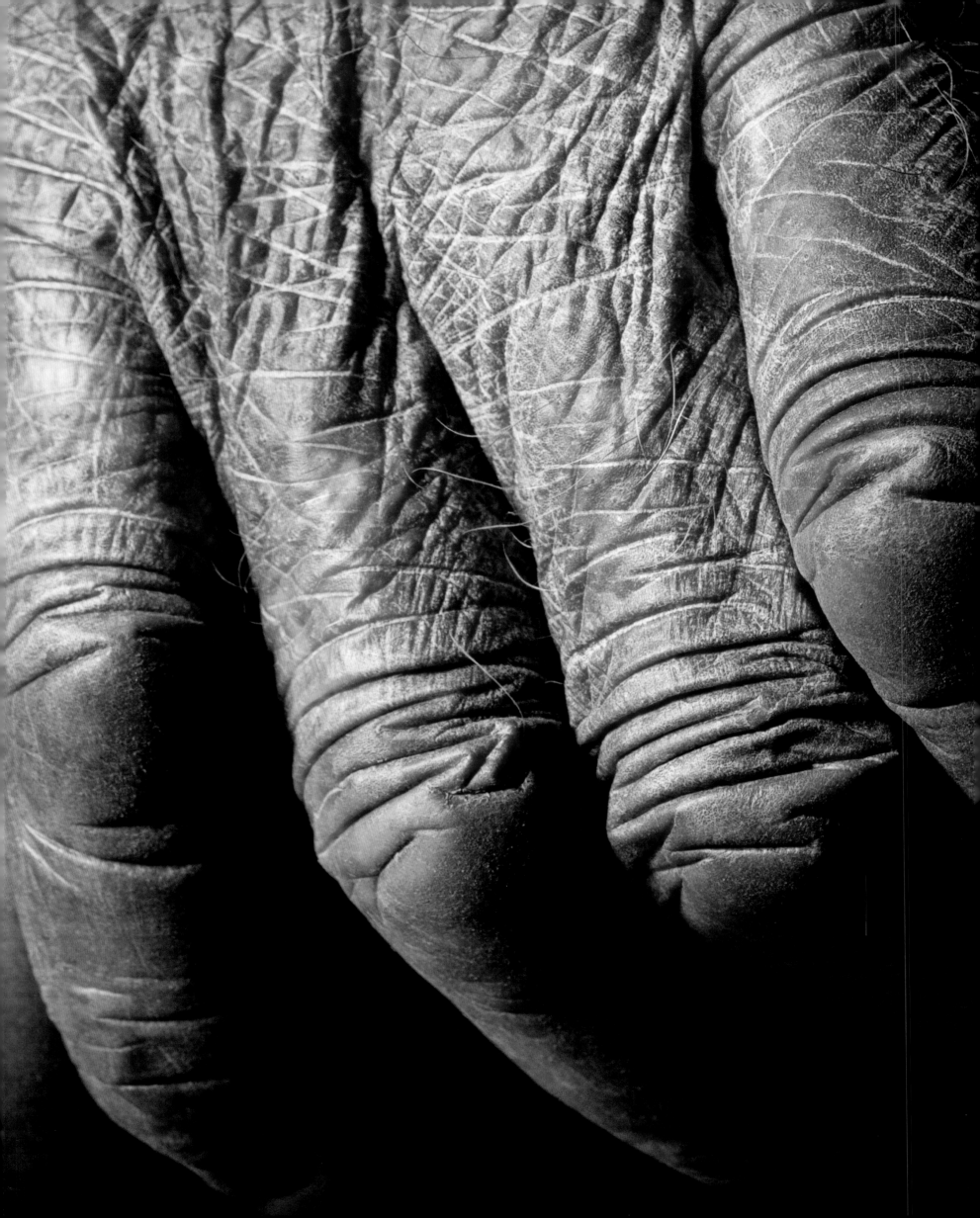

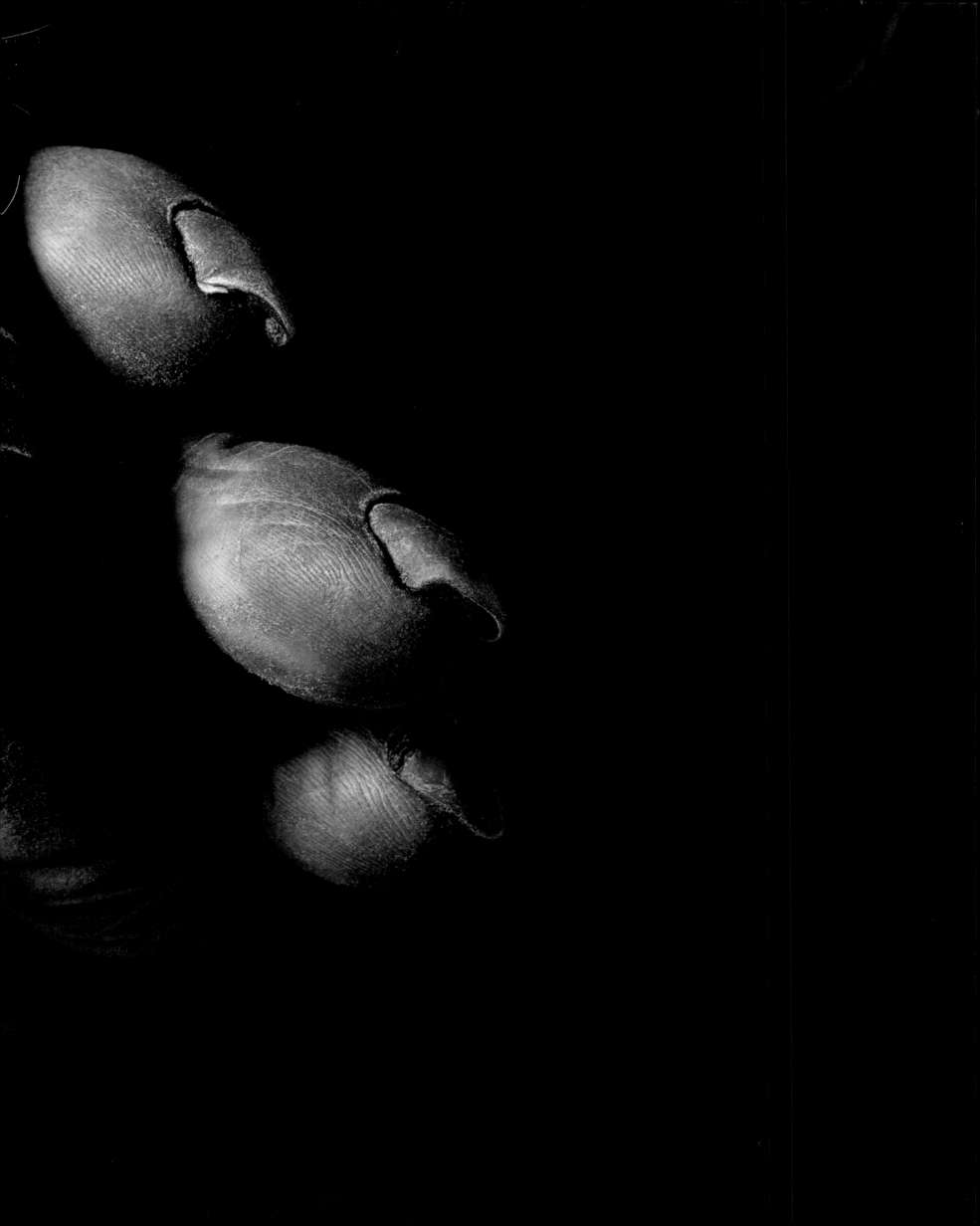

More than human

Deforestation has occurred slowly in western Central Africa, at least compared with other tropical regions overseas. The common chimpanzee's habitat has remained relatively intact, and yet they have lost around three-quarters of their population in the last century. They are widely hunted for bushmeat, which is eaten locally and also smuggled abroad, while human infrastructure is developing throughout their range. Agriculture, logging, oil extraction, mining, and road construction are cutting through the forests and fragmenting their tight-knit communities.

In traditional African culture, chimpanzees are usually represented as untrustworthy—their similarity to our own species makes them seem wickedly subversive. Their extraordinary likeness is fascinating to us, but for them it can be devastating; they, too, are susceptible to outbreaks of anthrax, Ebola, and respiratory disease. As we push deeper into their homelands, the threats will only become more severe.

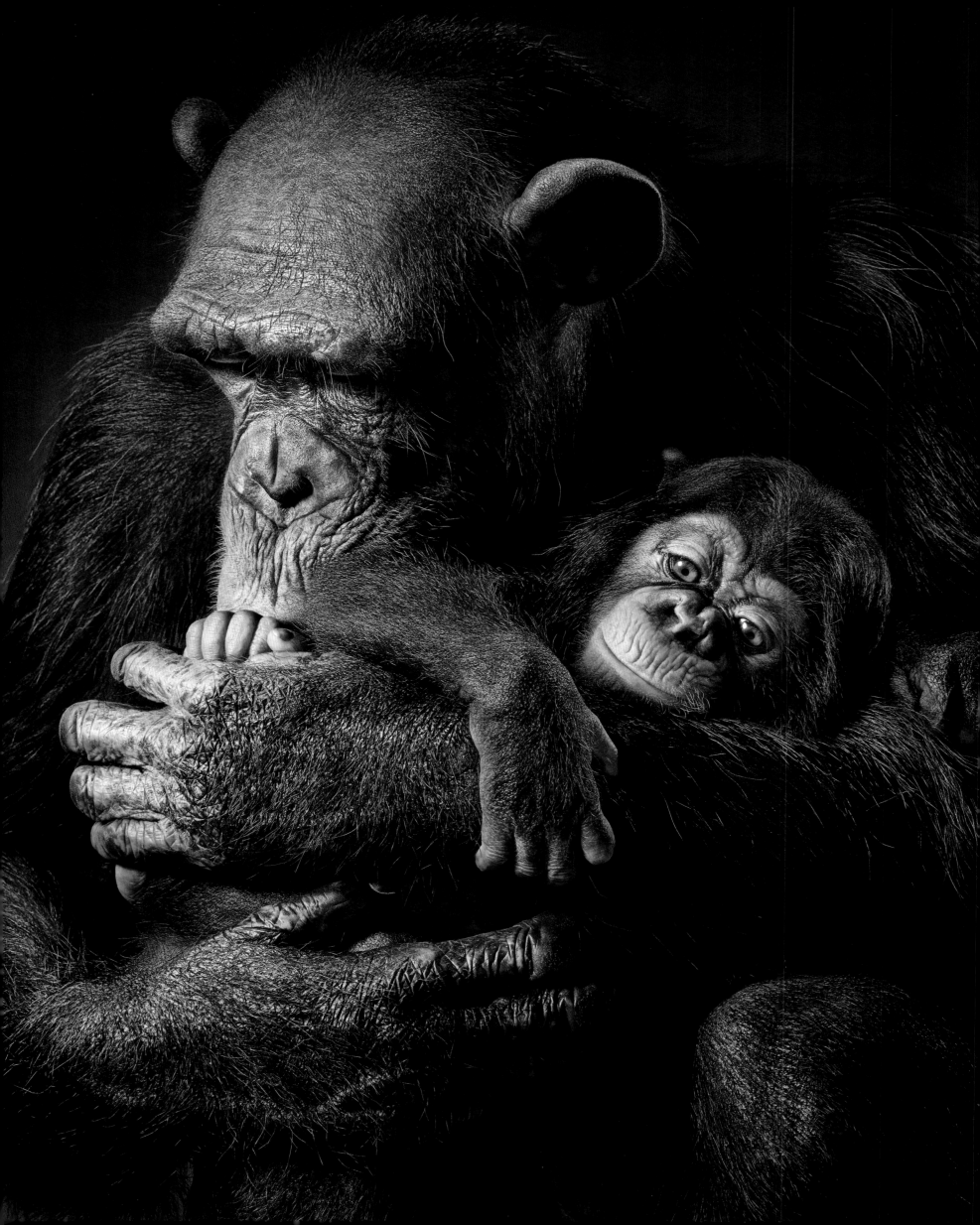

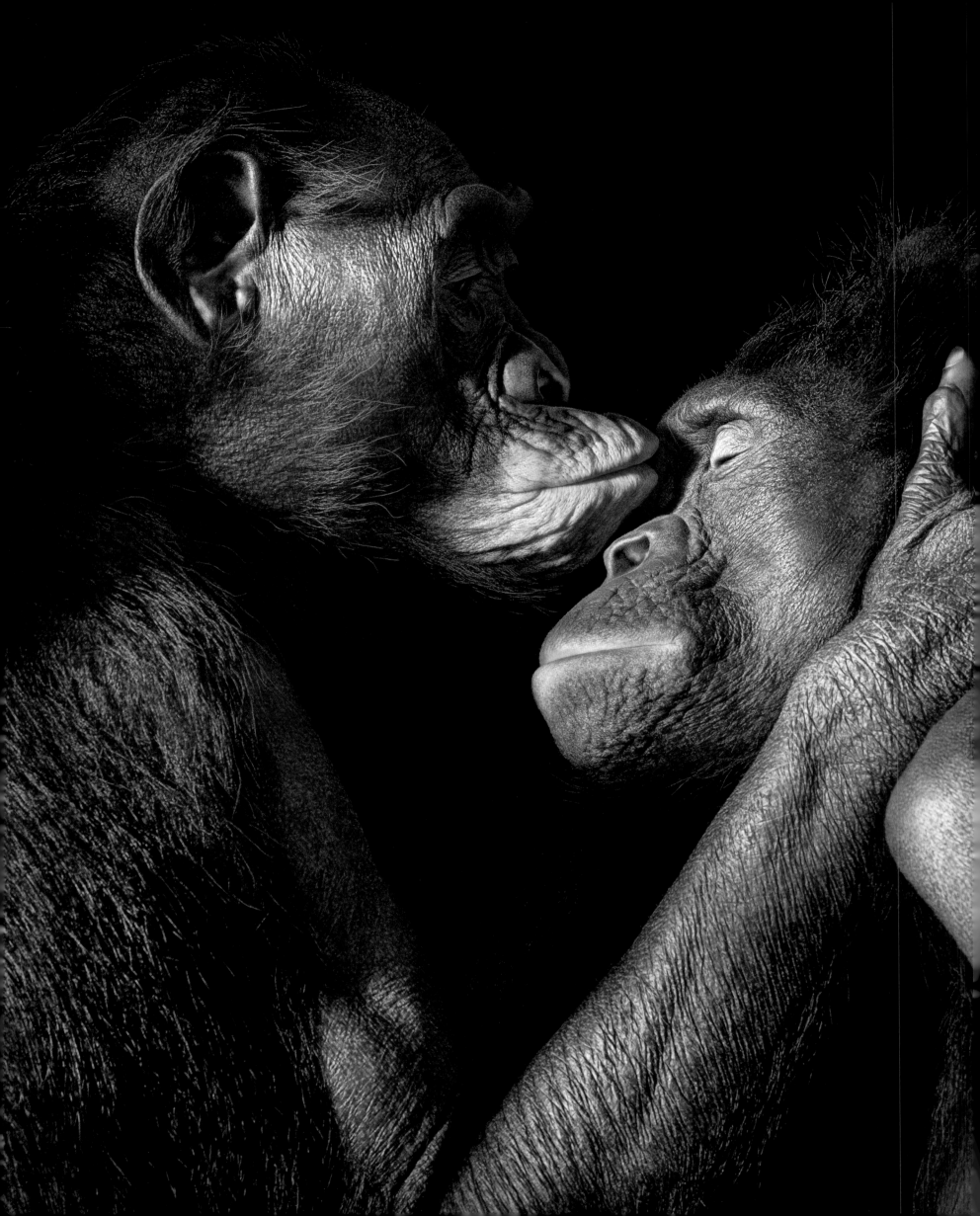

War and peace

The bonobo, found exclusively in the Democratic Republic of the Congo, has suffered hugely alongside its human compatriots as a result of civil wars. War has impeded international conservation efforts and the influx of guns has intensified poaching. Bonobos are shy creatures and can be hostile to outsiders, but within their troops they are largely pacifistic. Their matriarchal communities are built around highly sexual interactions, which reduce conflict and establish strong social bonds.

Their populations are strongest in remote regions, where indigenous communities have ancient taboos against killing them. But wars are opening these areas up to poachers. Bonobos reside deep in the jungle, but they are unlikely to elude us for much longer: as the palm-oil industry continues to devour Southeast Asia's landscape, it is looking toward Central Africa for new space, and a terrifying 99.2 percent of the bonobo's habitat will be suitable.

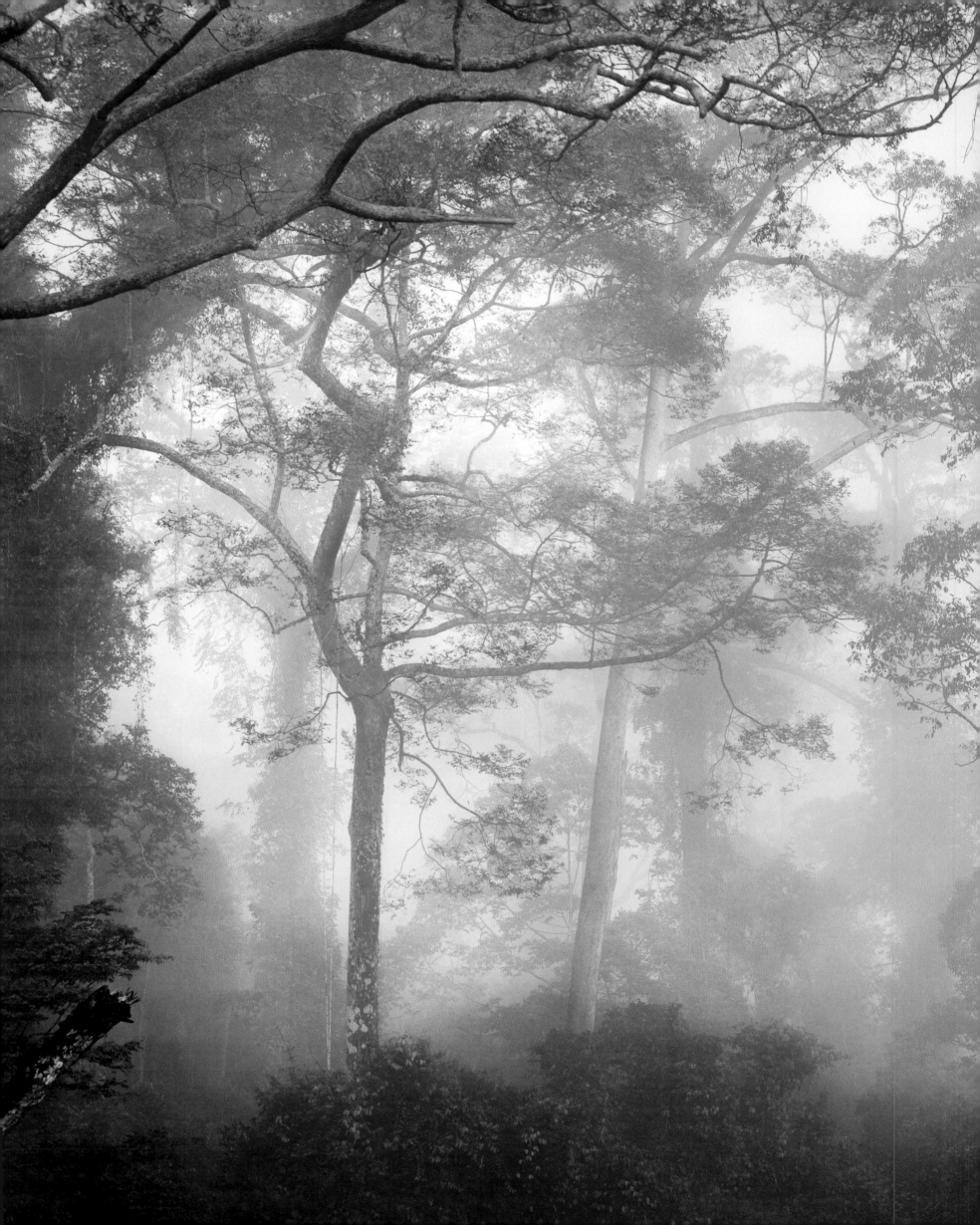

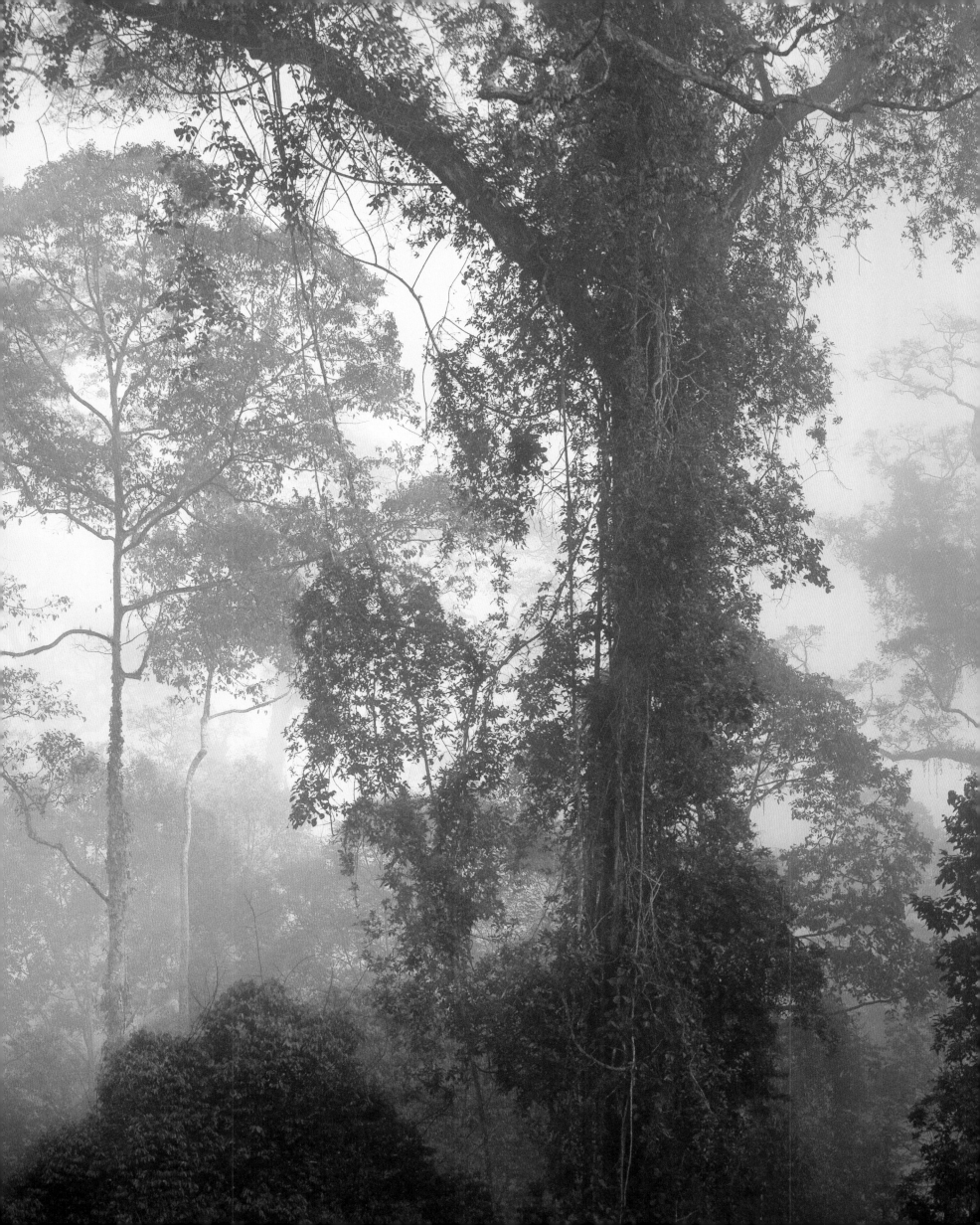

Forbidden fruit

As Celebes crested macaques forage in the canopies of Sulawesi's rainforests, they are often followed by flocks of birds, preying on the insects disturbed from the trees. Meanwhile, as the macaques eat their favorite fruits, they do the trees the favor of dispersing their seeds.

Increasingly, they are wandering into farms that were once their homelands, and are killed by farmers for eating crops. They are also hunted to be served as a delicacy on special occasions such as weddings. Breeding centers around the world are establishing captive populations for this critically endangered species, but reintroductions are a last resort. To protect Sulawesi's most threatened macaques, their habitat must be secured and their importance and vulnerability must be brought to local awareness.

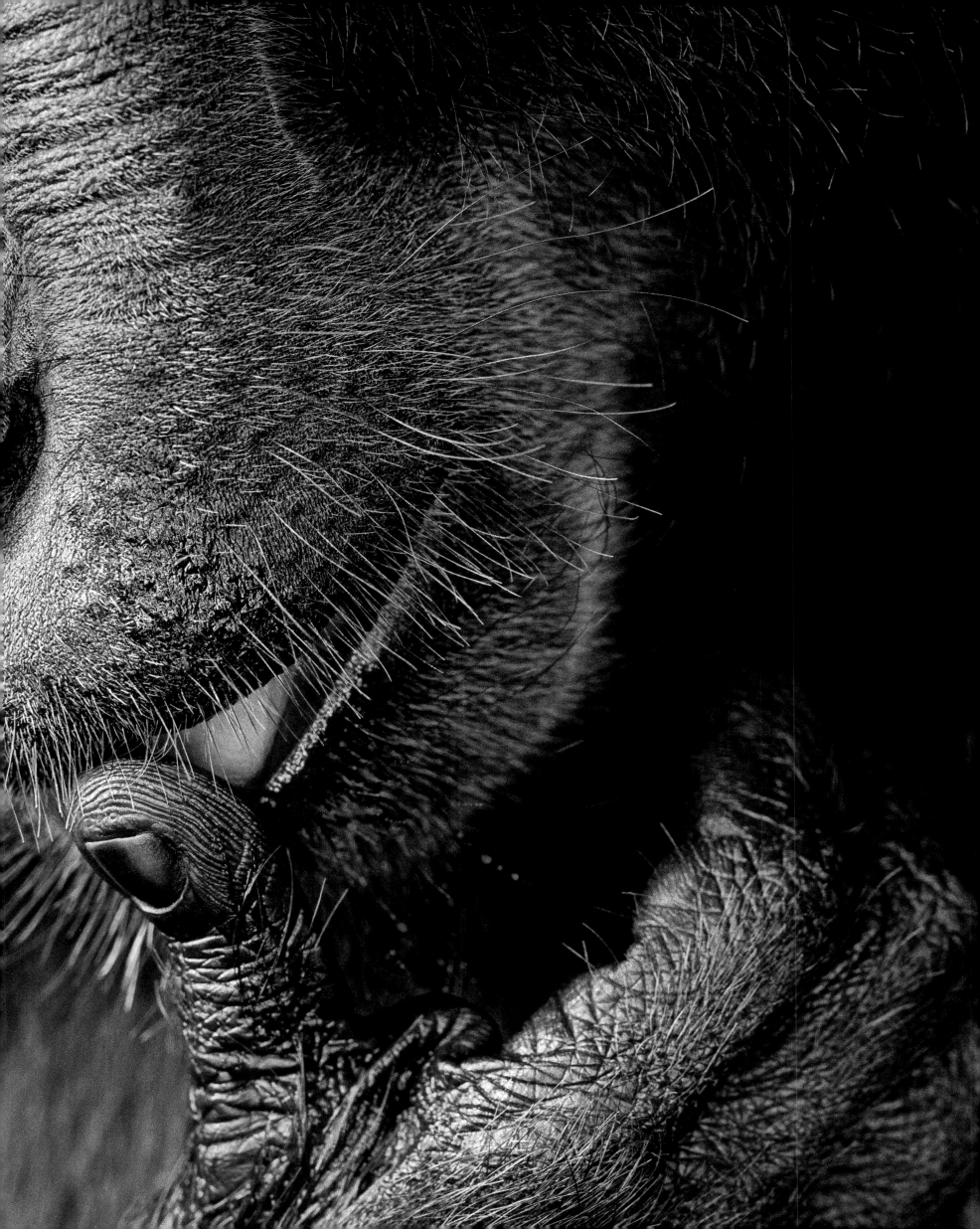

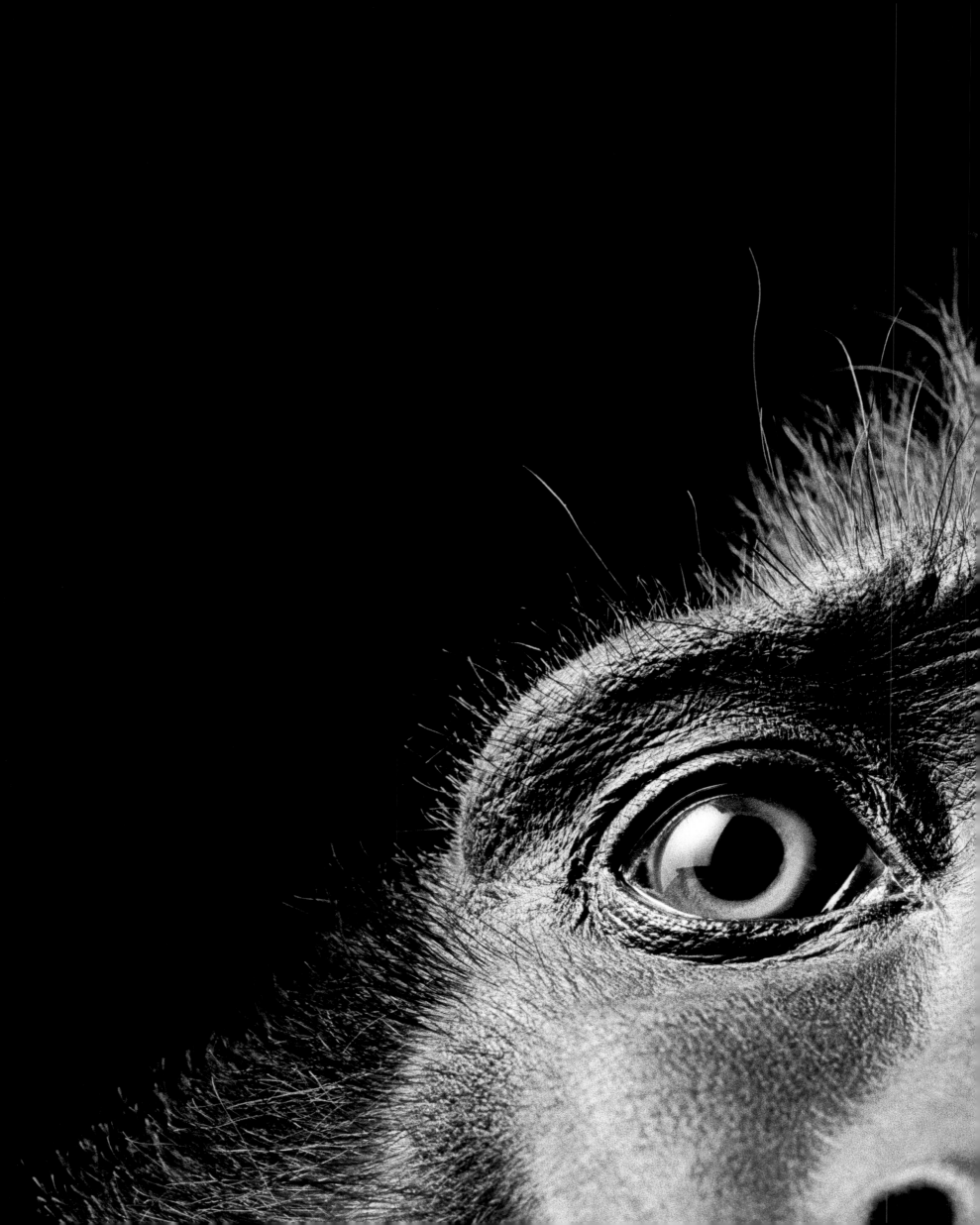

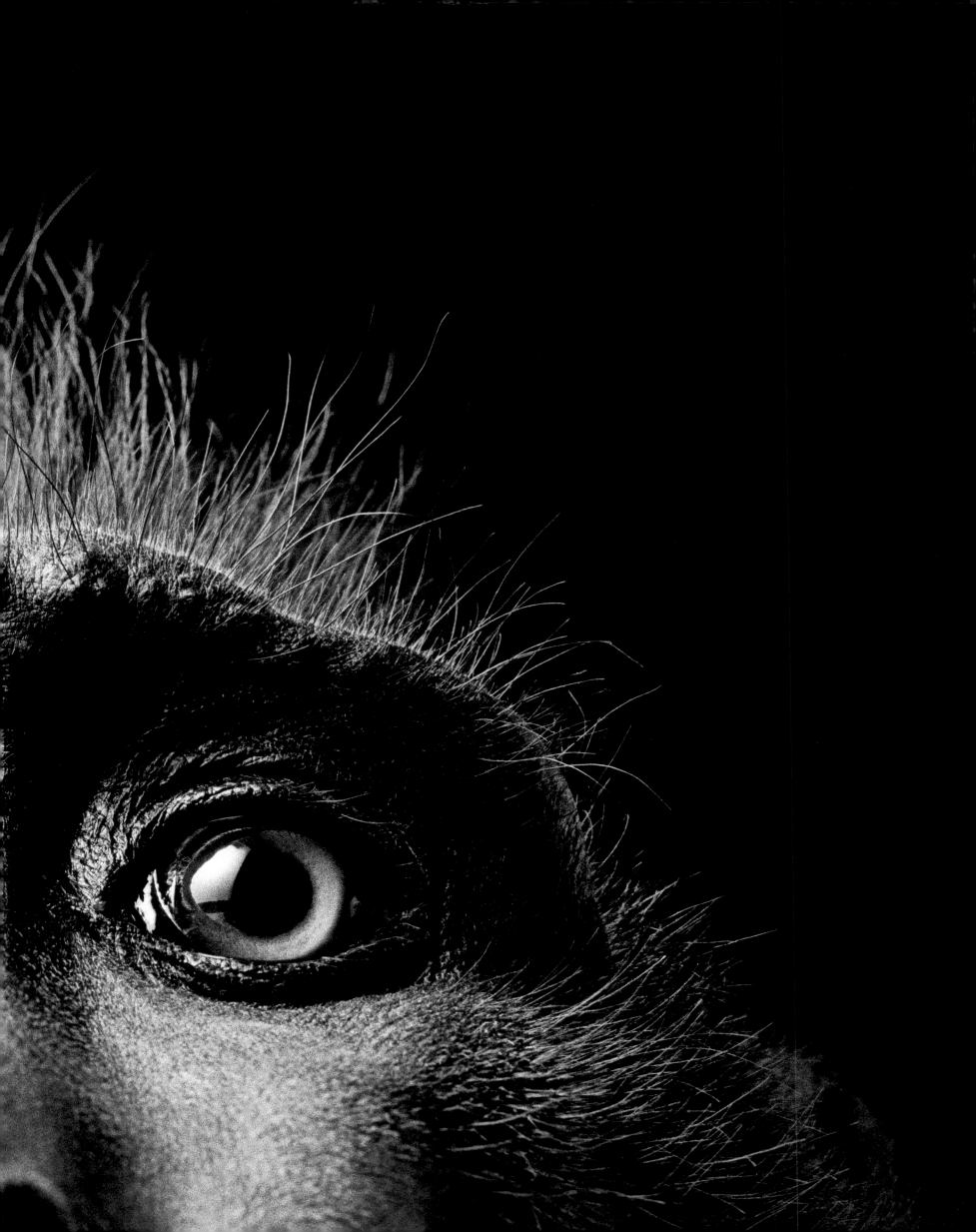

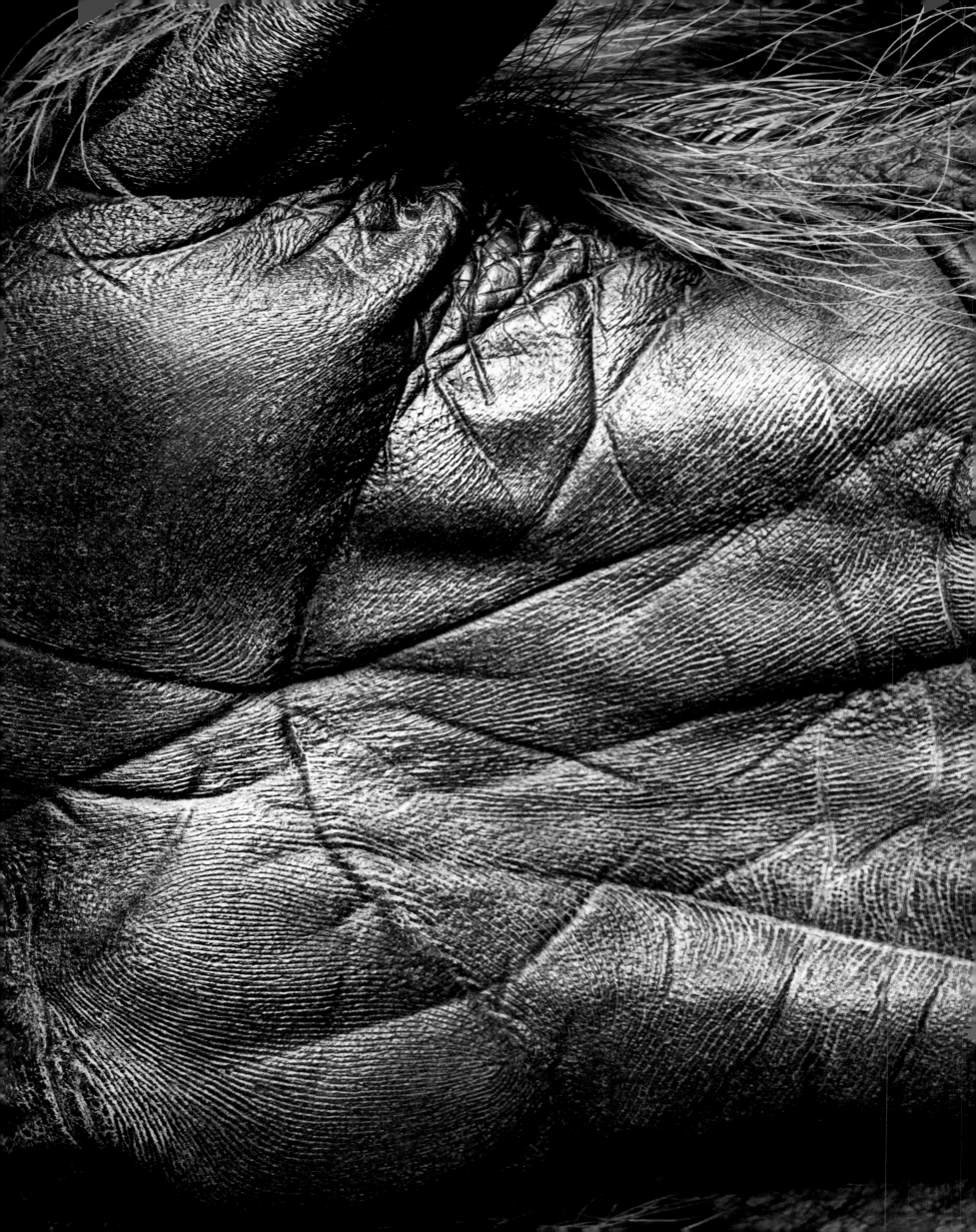

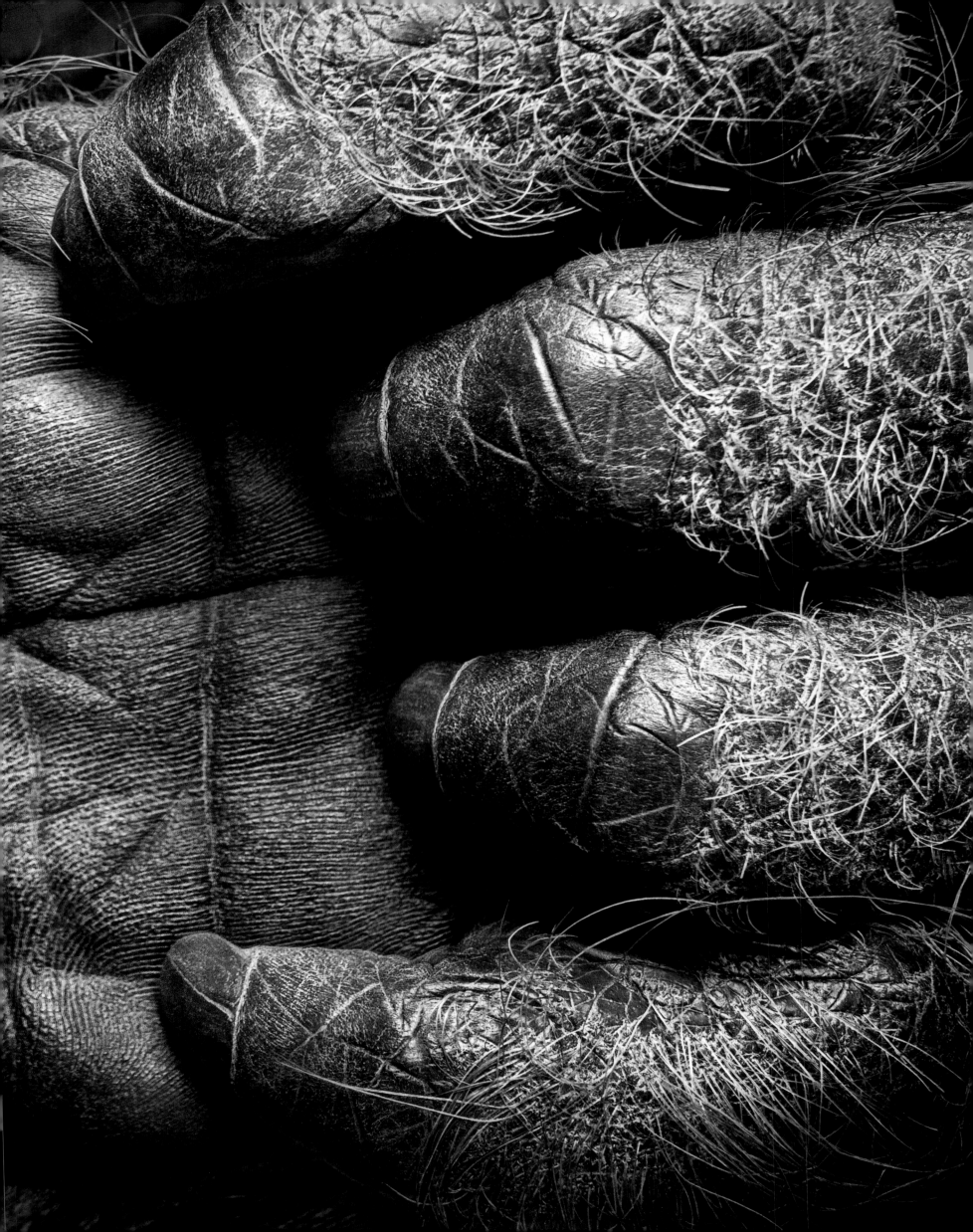

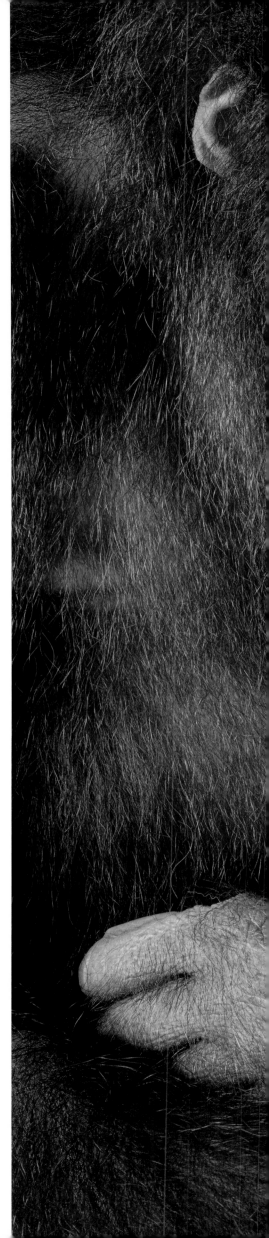

Broken home

In many Bornean cultures, it was traditionally considered bad luck to look an orangutan in the eyes; they were vilified in tales of murder, seduction, and deceit. Today, though, they are recognized worldwide as emblems of nature's innocence and exploitation, and their downfall has indeed been staggering. In the last century, Indonesia's human population has grown by 2,500 percent, and orangutans have been largely displaced by rampant expansionism. They are being captured and sold as pets around the world, while their forests are being swallowed by the demand for palm oil. Massive-scale slash-and-burn farming has exacerbated habitat loss, and even started the forest fires that killed one-third of the world's orangutans in 1997. These great apes are Borneo's largest seed distributors; their survival is entwined with the survival of the jungles, but they are now critically endangered.

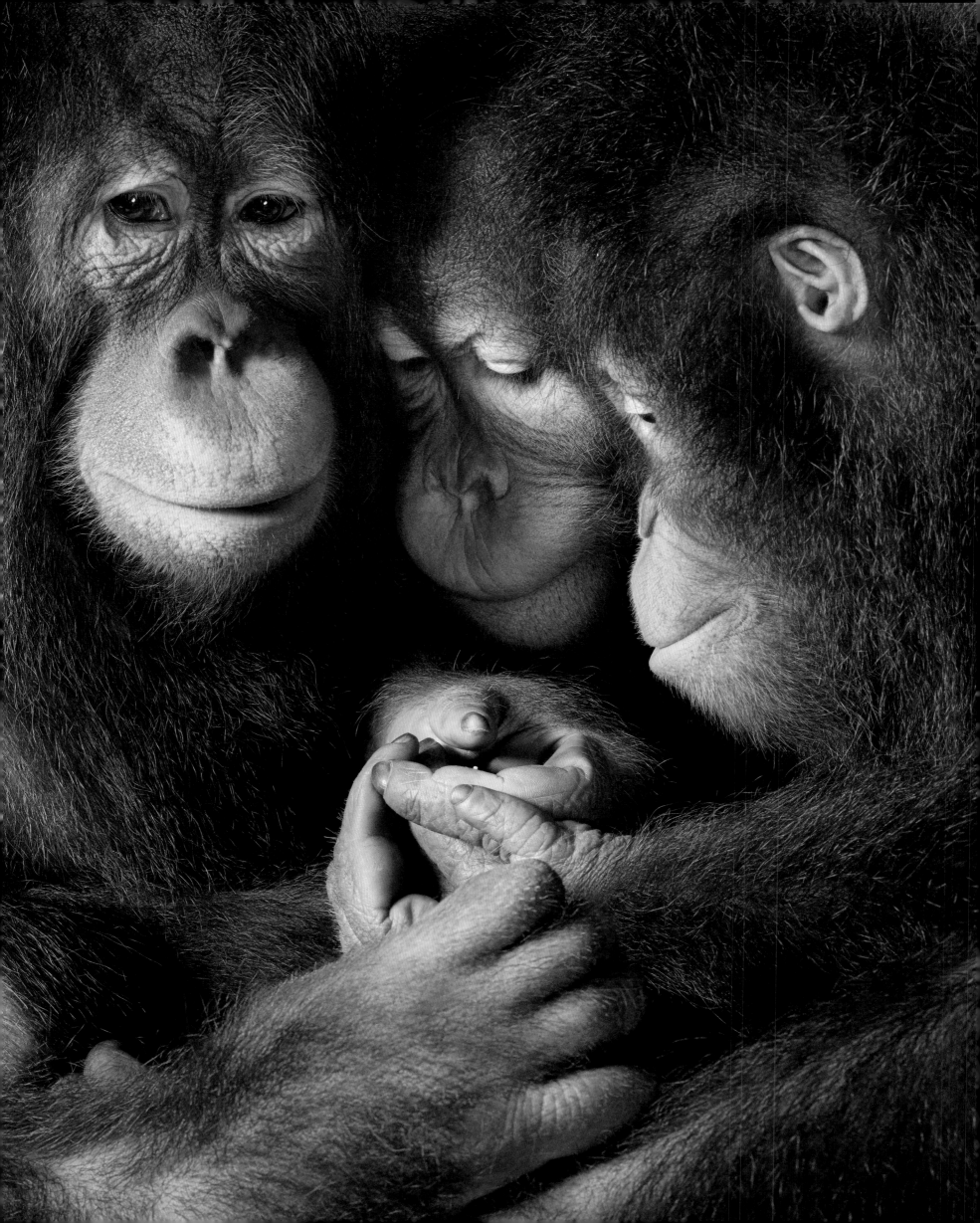

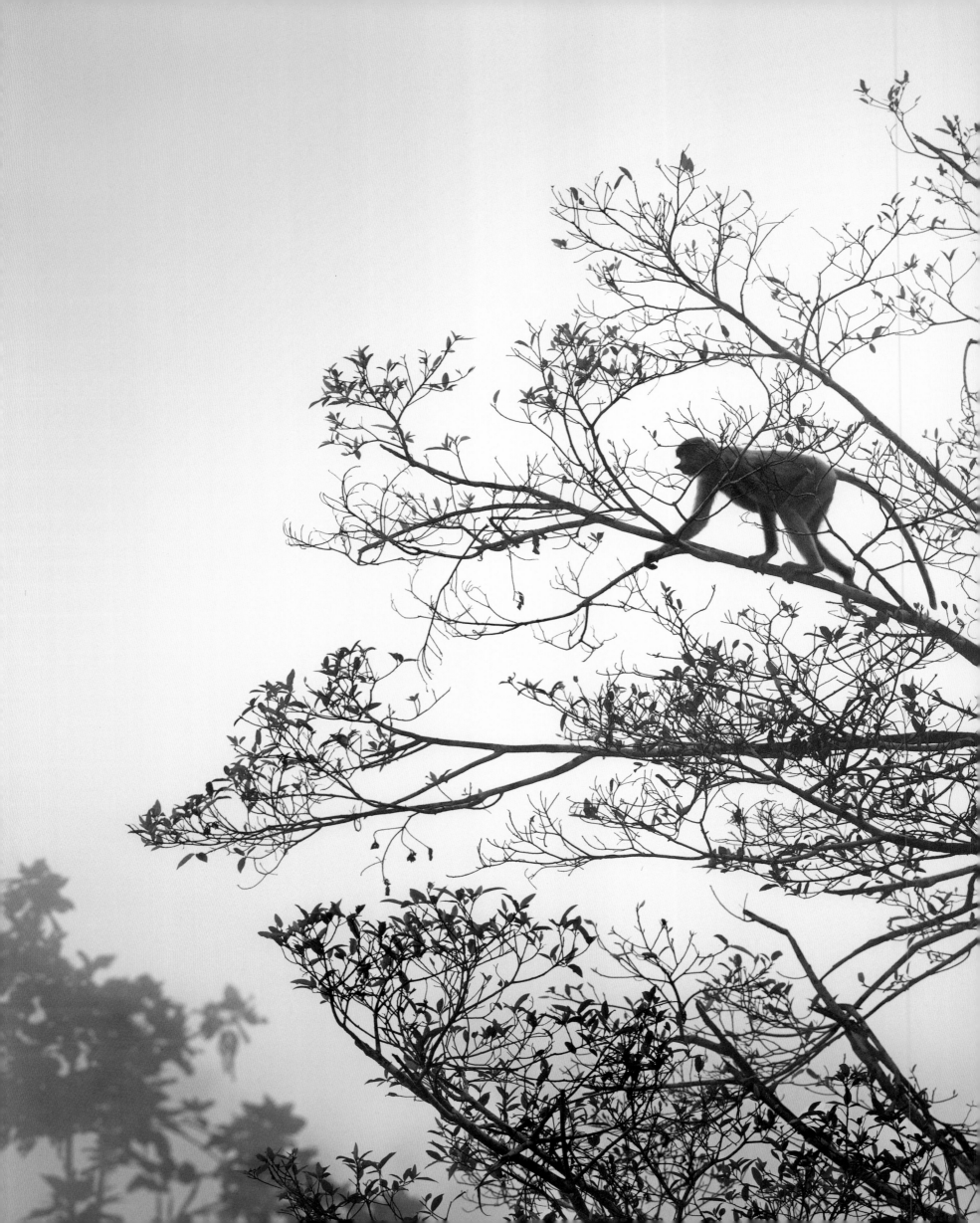

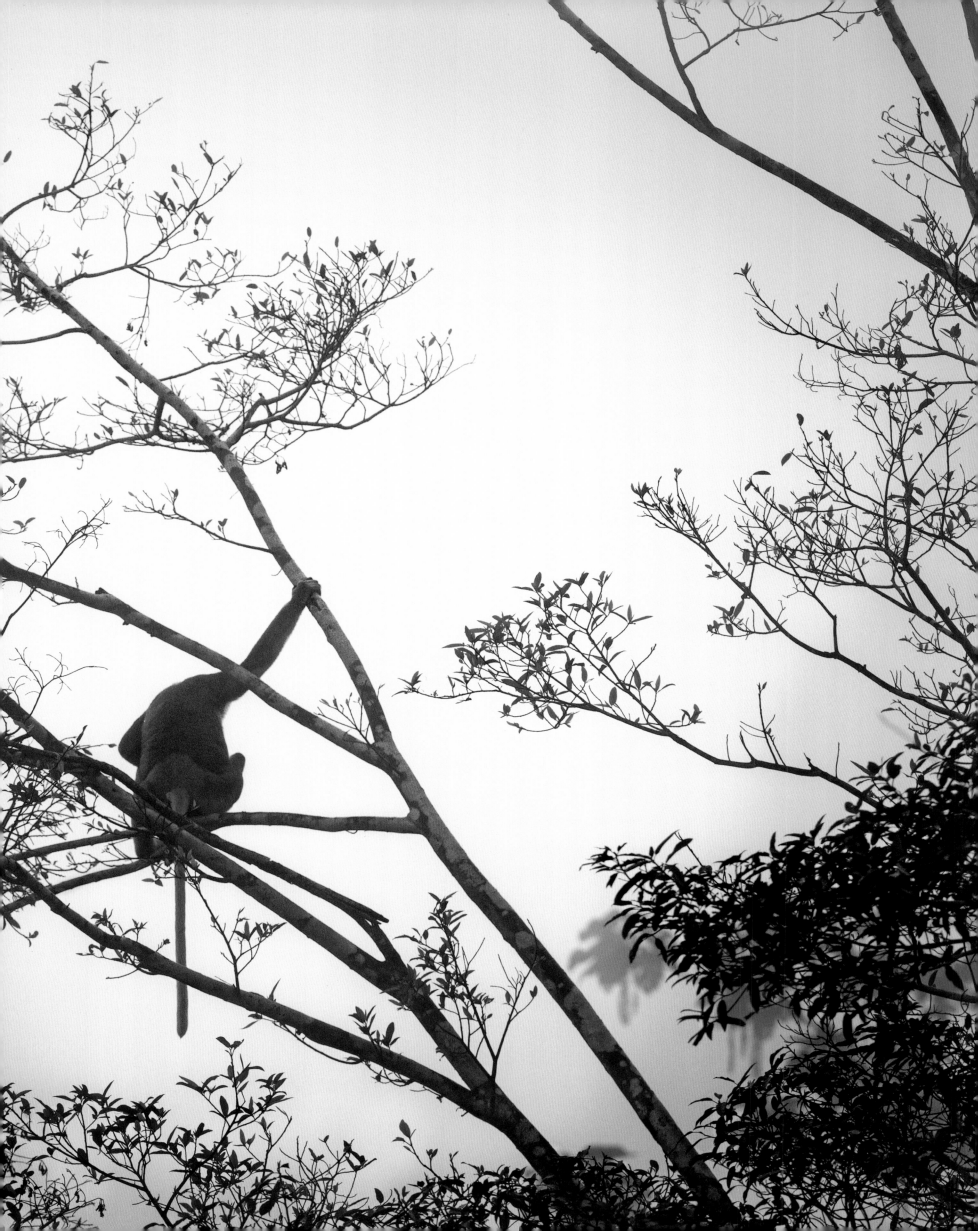

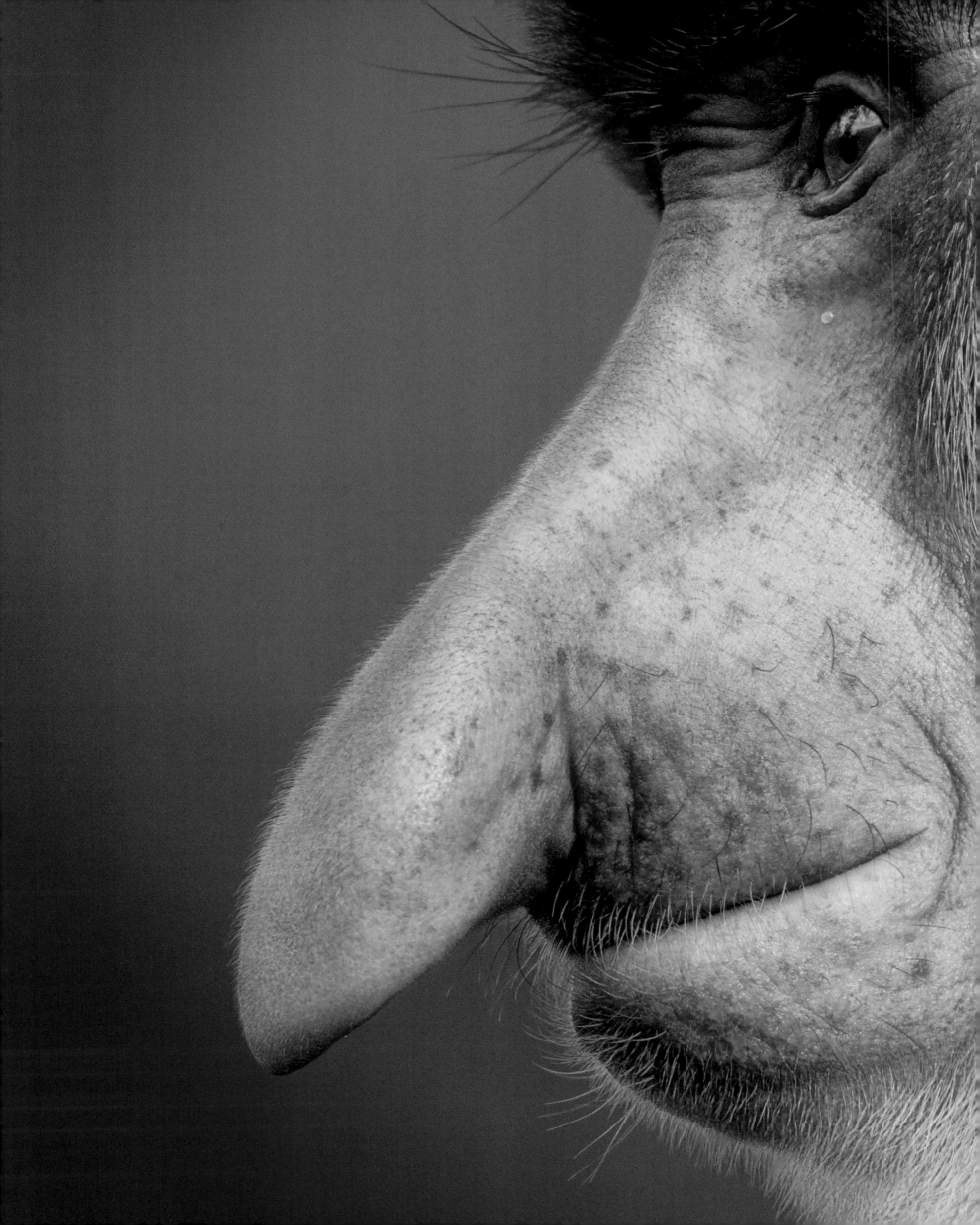

Battlegrounds

Lichens often grow at less than ⅟25 inch (1 mm) per year, about fifty times slower than the movement of tectonic plates. Some lichens are so old that we cannot measure their age, but many have certainly been alive since before the birth of Christ. A permanent feature of many walls, tree trunks, pavements, and gravestones, it can be easy to forget that they are really living at all, and yet they are one of Earth's great expressions of life. They are hypersensitive to pollution, and thrive only where the air, earth, and water are clean; scientists have used them since the nineteenth century to judge the health of the environment. In the glorious abundance of Borneo's rainforests, lichens cover every surface, but they will quietly fade away as human infrastructure expands—as towns, farms, and quarries push into Borneo's natural land, and poisons and pesticides leak into the jungles.

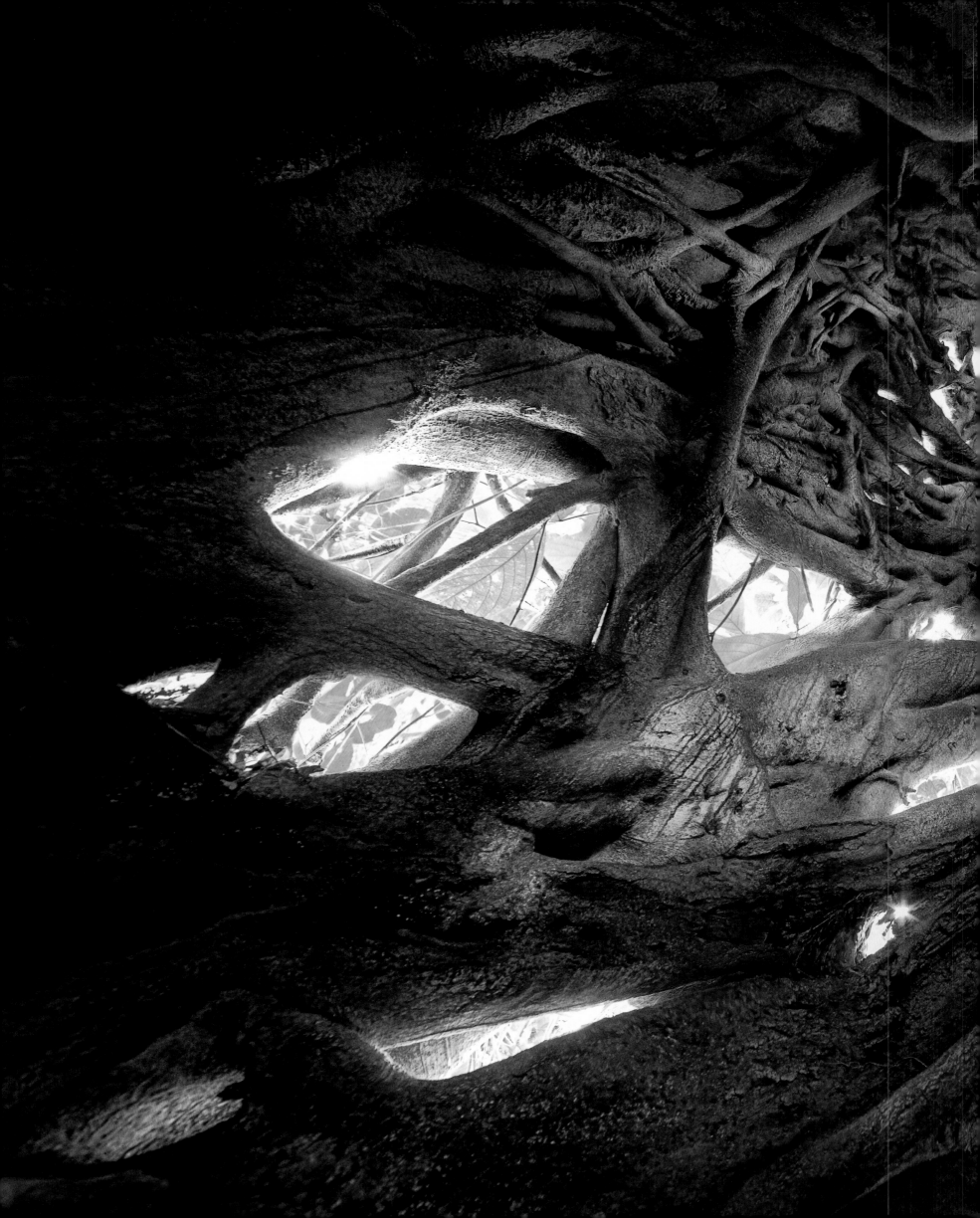

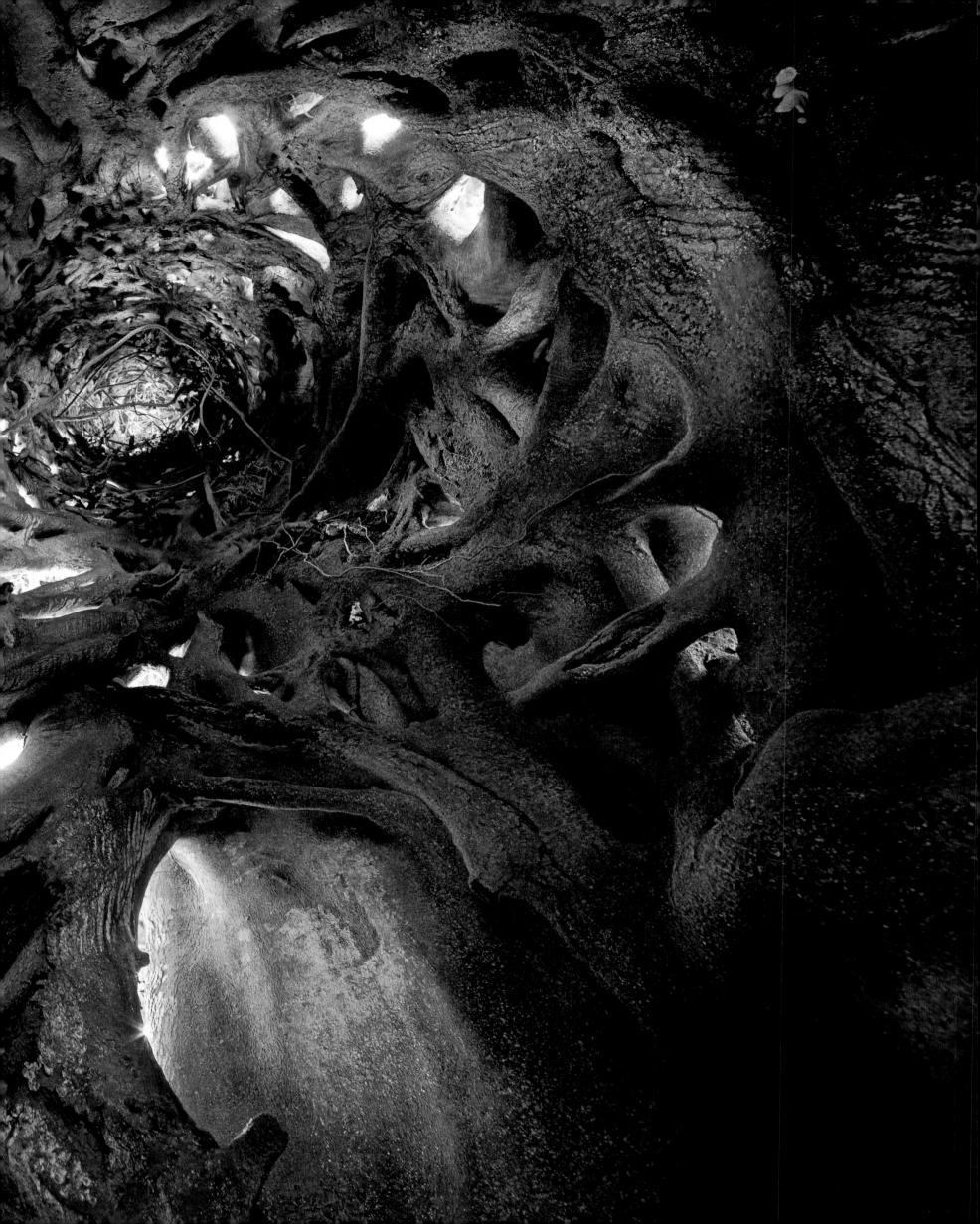

The night shift

While we sleep, bats do vital work across the globe. As pest control, they are invaluable to our agricultural industries, and over five hundred flowering plants—including bananas, mangoes, and cocoa—depend on them for pollination. In fact, bats are as important as bees for maintaining healthy crops, particularly because they migrate so far and can diversify flora across huge regions. The Mexican free-tailed bat (pp. 122–23) migrates a thousand miles (1,600 km) between its seasonal habitats, and can reach speeds of up to 100 miles per hour (160 km/h). Living in colonies of up to twenty million—forming some of the world's largest animal congregations—it is one of North America's most abundant mammals. In recent decades, a mysterious fungal disease known as white-nose syndrome has swept across the continent and killed tens of millions of bats. If the disease is not curbed, the Mexican free-tailed bat could become infected and carry it into South America, and from there it may spread around the world.

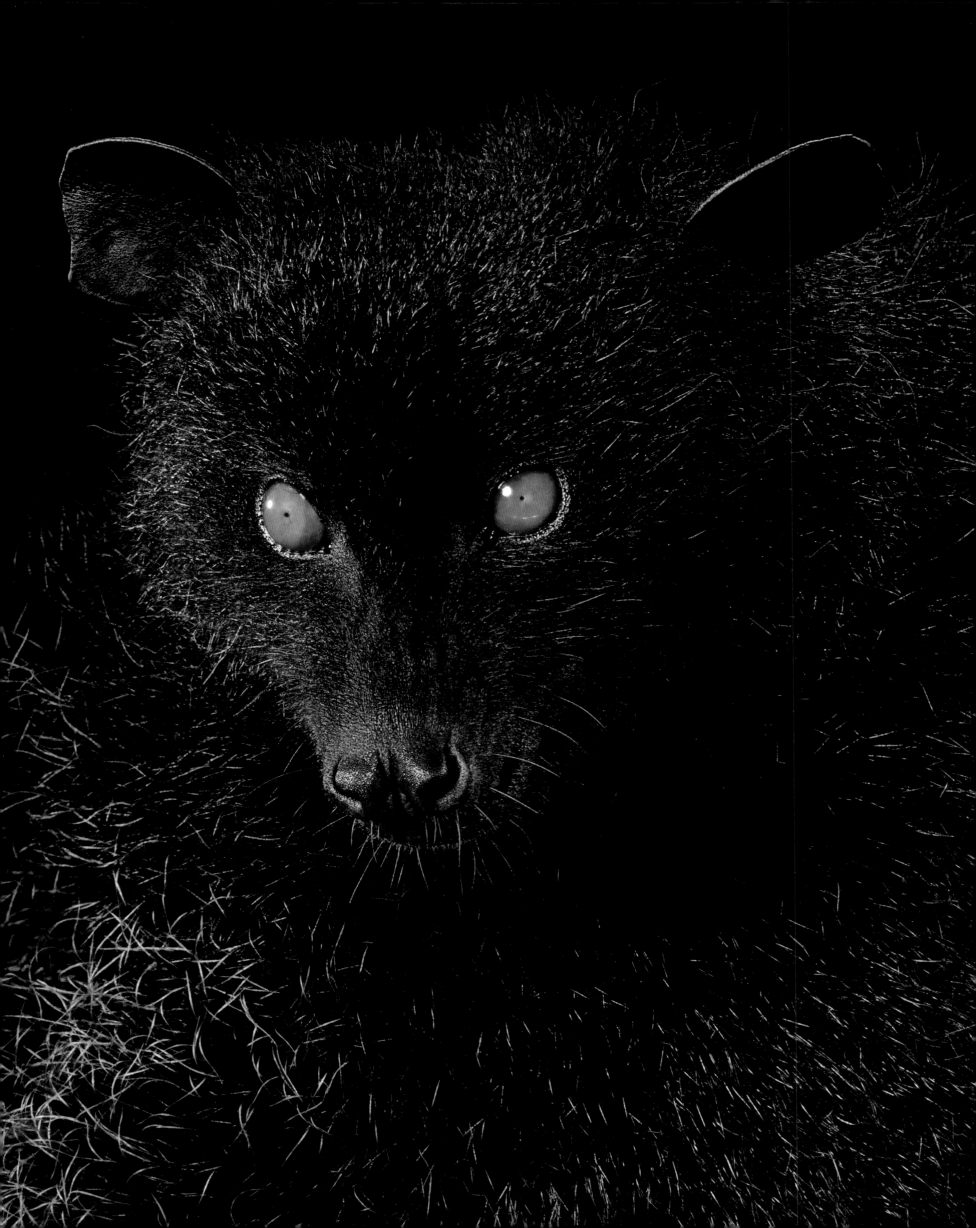

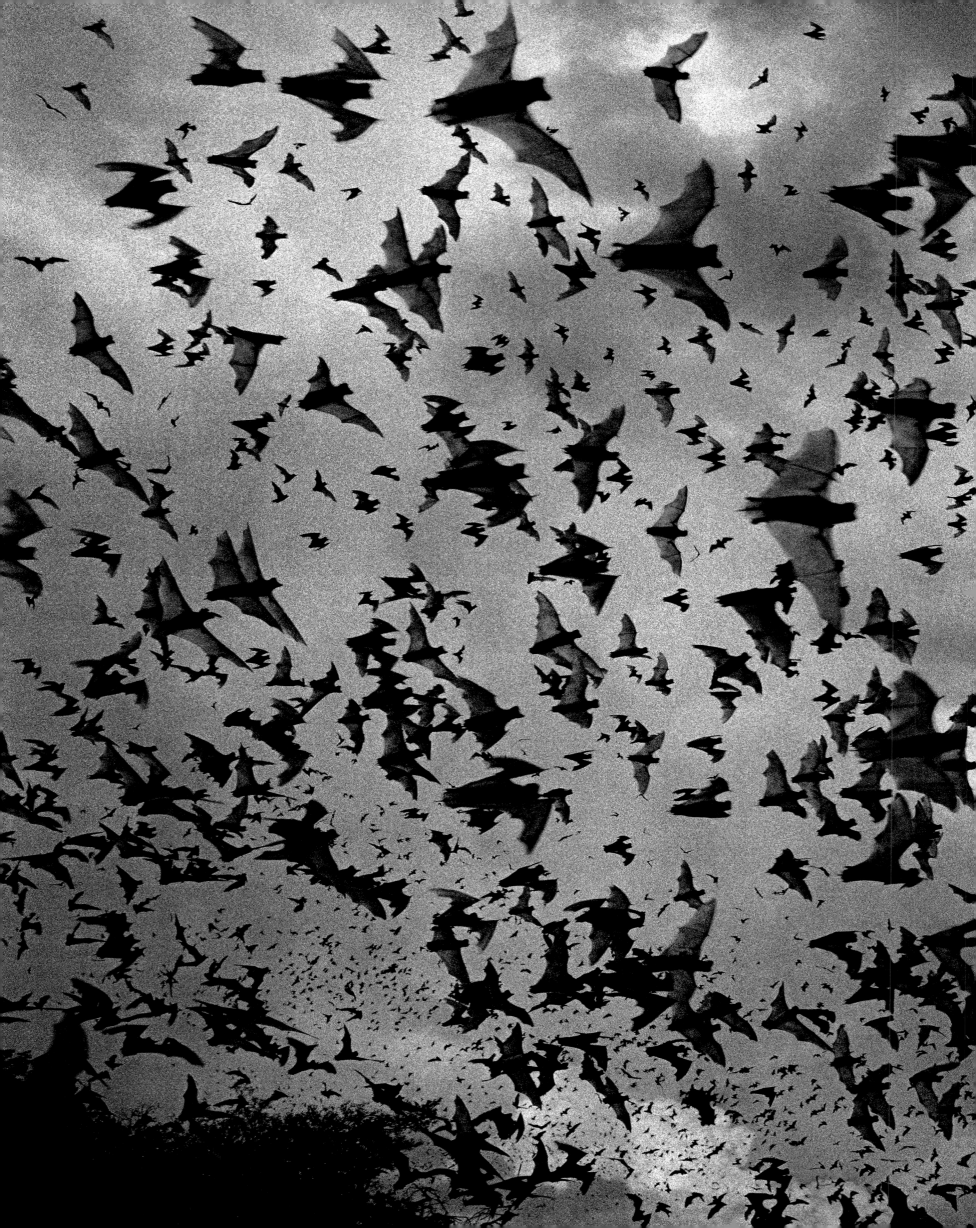

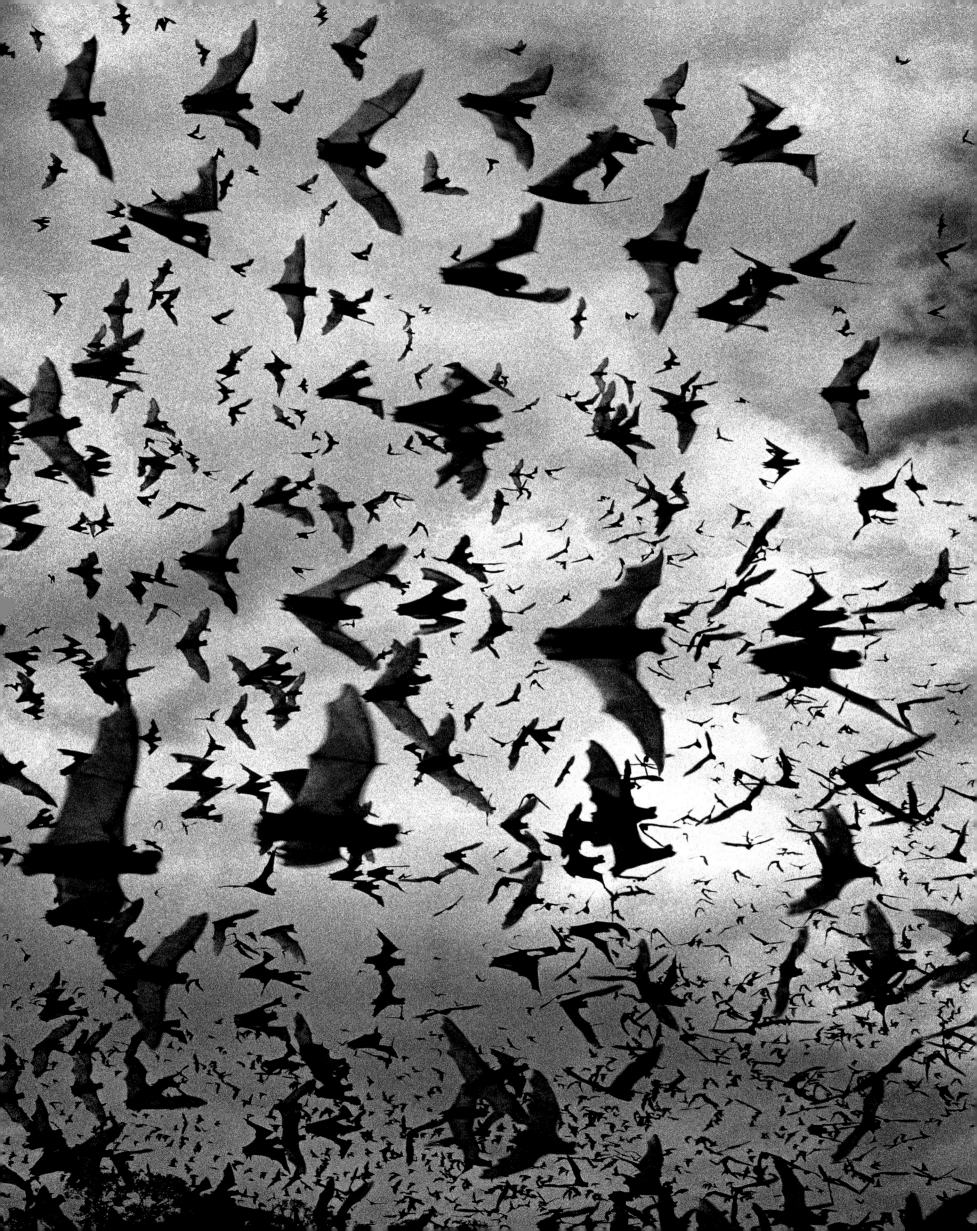

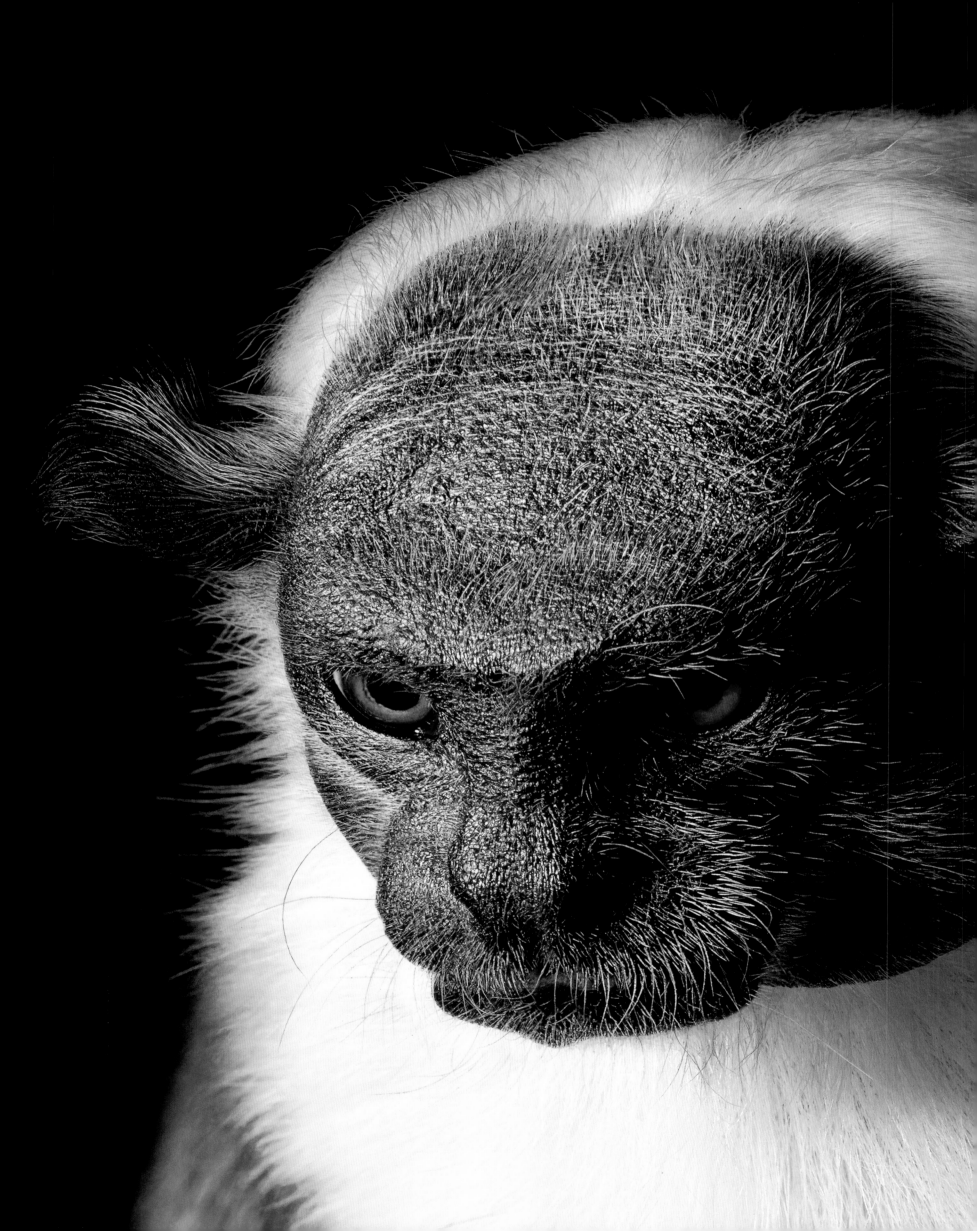

Concrete jungle

The pied tamarin has evolved with one of the smallest ranges of any primate species—a tiny area in the northeastern Amazon Rainforest. Their riverside habitat provided all the prey and vegetation they needed, but in the late seventeenth century, a human settlement arrived. This settlement has now grown into the port of Manaus, a regional capital with over two million residents. Much of the pied tamarin's home has been paved over, and although it can be found in some protected areas, the invading red-handed tamarin is winning most of the remaining food and habitat. Unlike some species of monkey, the pied tamarin has been unable to adapt to urban life either, and is frequently killed by dogs, cars, and power lines when it crosses the city between isolated forest fragments. Economic pressure continues to push Manaus to grow, making the extinction of this most intriguing primate an increasingly real possibility.

Unshrouding mystery

Yunnan snub-nosed monkeys were discovered by scientists in the 1890s, but they then faded into obscurity, and were believed to be extinct until another was spotted in 1962. They are one of Earth's most elusive primates. They are semi-nomadic, and live at higher altitudes than any other monkey, in the dense bamboo thickets of the Hengduan Mountains in southwestern China. Like their golden-coated cousins (pp. 130–33), they face winter temperatures of minus 40 degrees Fahrenheit (–40 °C), and are traditionally revered for their resilience by local people, who see them as ancestors and call them "wild men of the mountains." If China effectively enforces its protection of old-growth forests, the future of Yunnan snub-nosed monkeys will be significantly improved, but high levels of inbreeding will remain a serious threat. Surviving populations are so small and so isolated, they may not have enough genetic diversity to see them through the coming centuries.

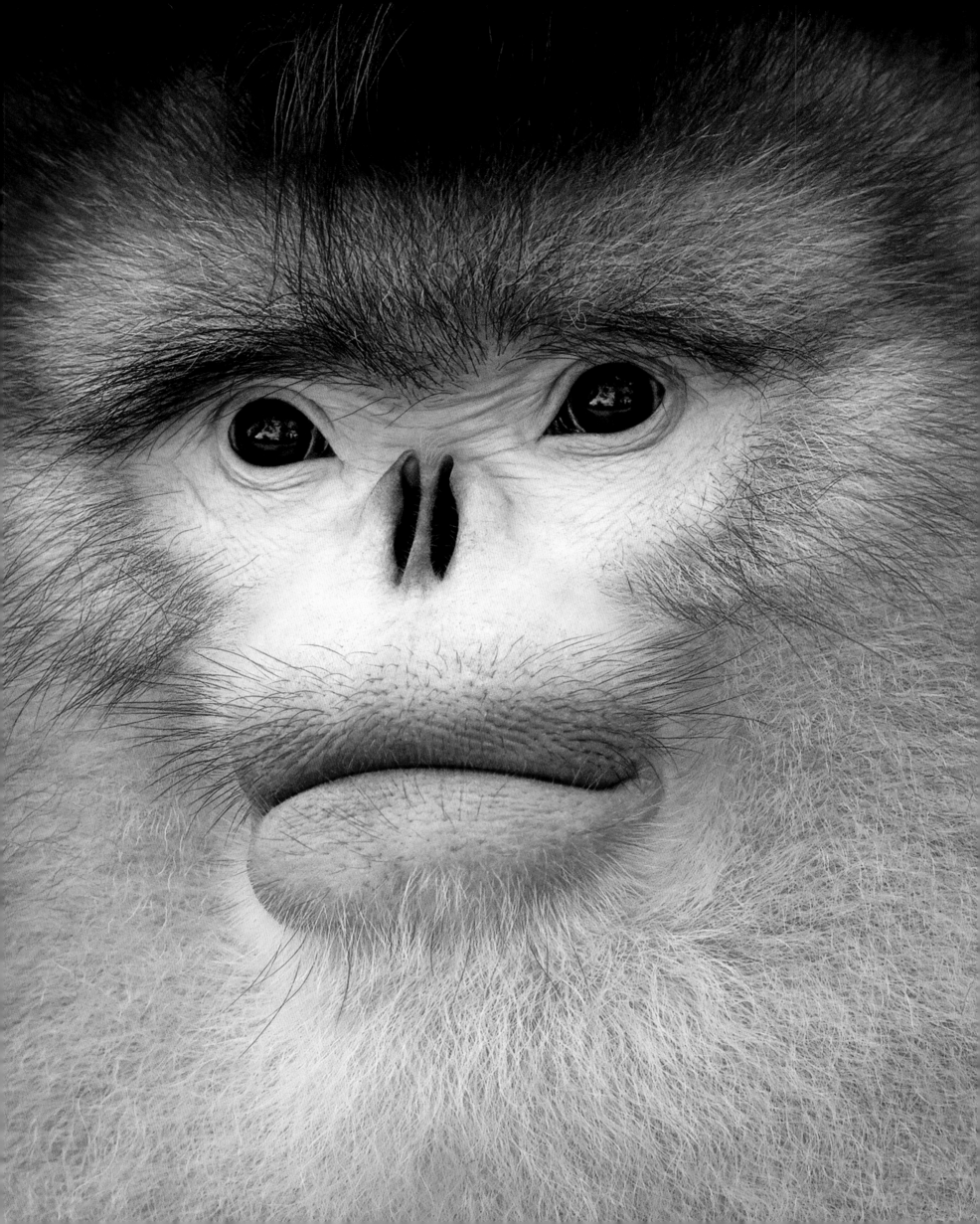

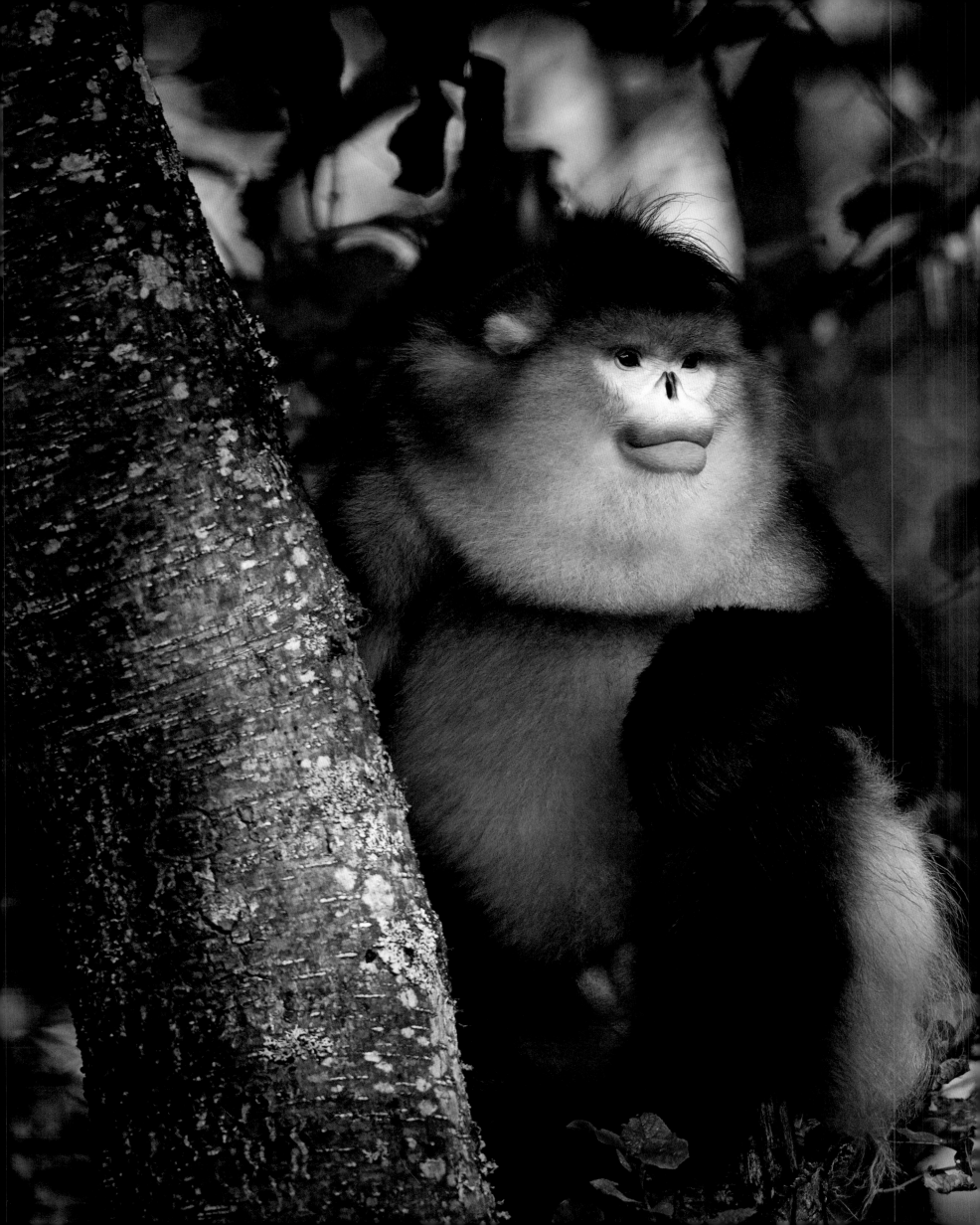

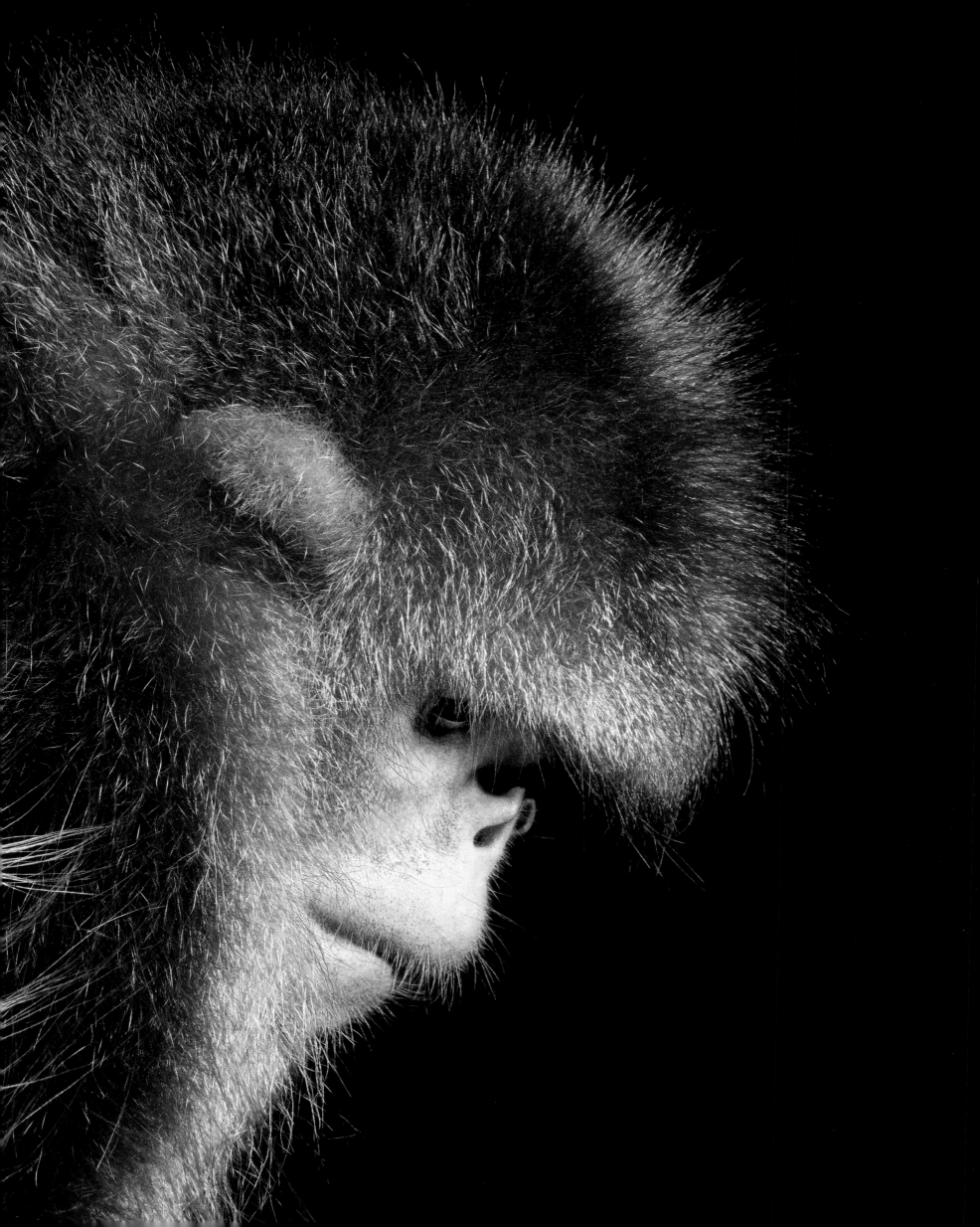

Golden fleece

Found throughout the mountains of central China, the golden snub-nosed monkey endures some of the harshest winters of any non-human primate. Its long, fiery cloak shields it from icy winds while its flat, bare face bears the brunt of the cold. It has long been hunted for its beautiful coat, but since the early 1990s, poaching has been reduced thanks to increased government protection. Nonetheless, its numbers have continued to fall as its forests have been cleared for timber and farmland. Furthermore, tourism has surged under China's economic growth, and monkey troops have been harassed and herded for viewing. Around 150 troops now remain in the wild.

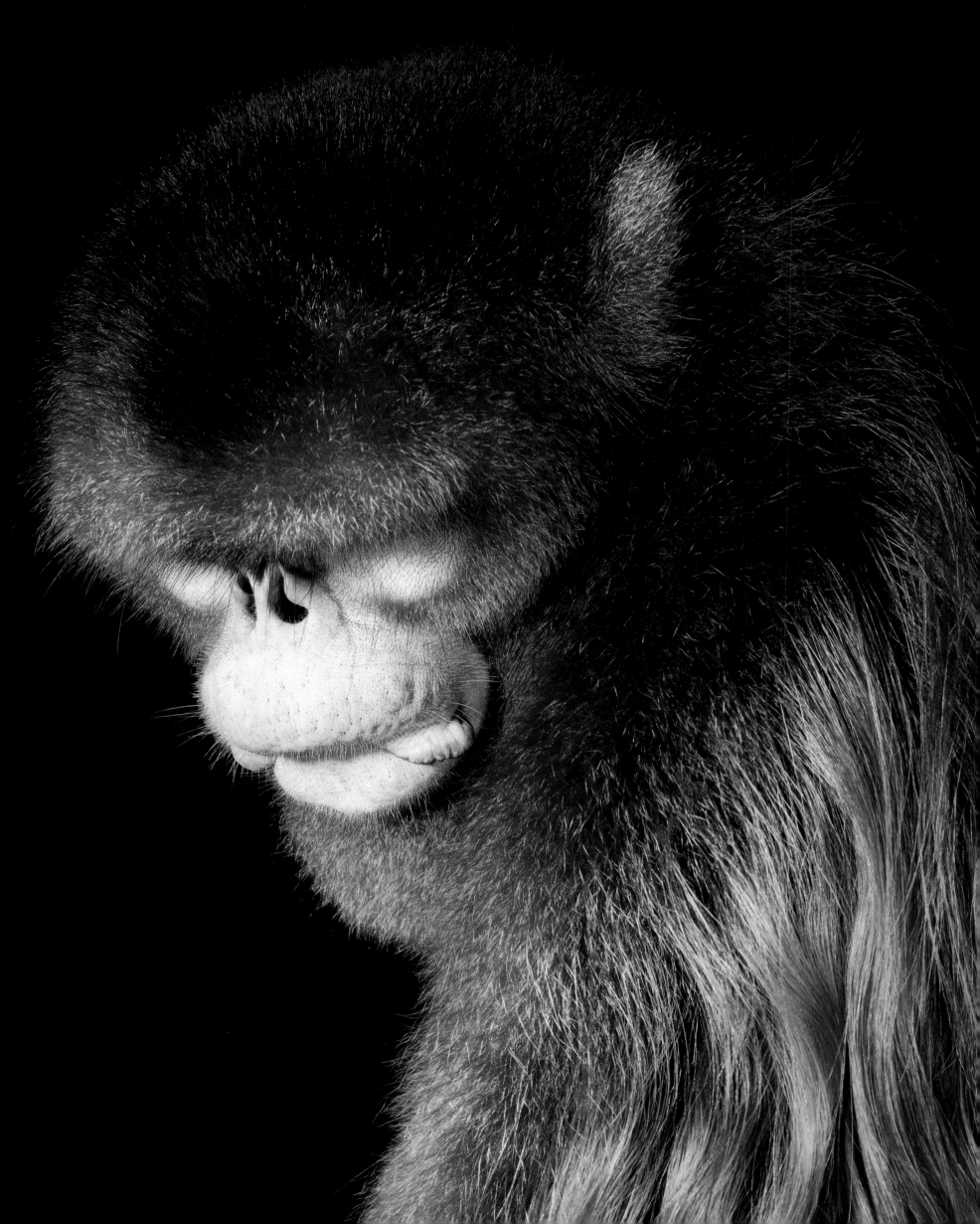

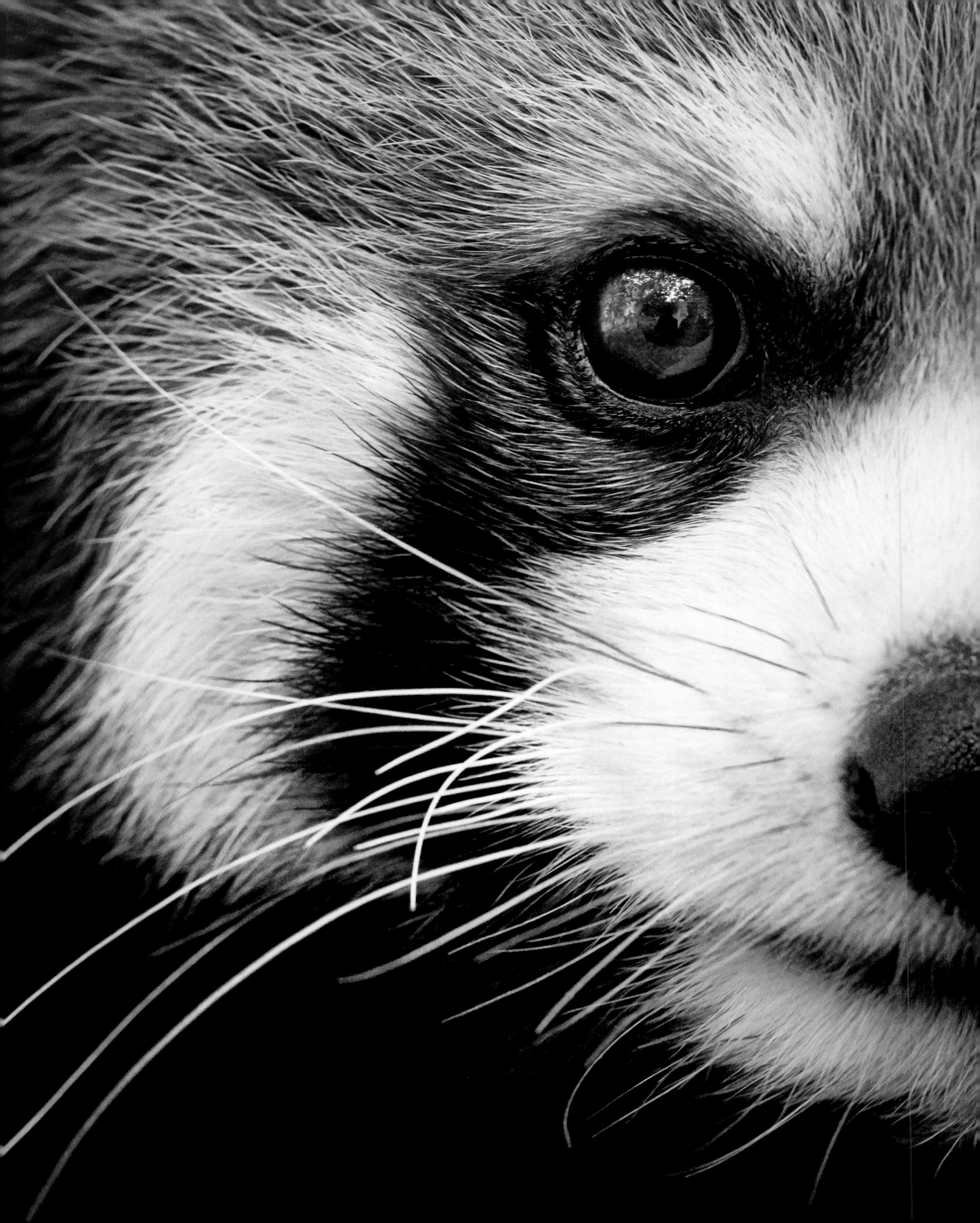

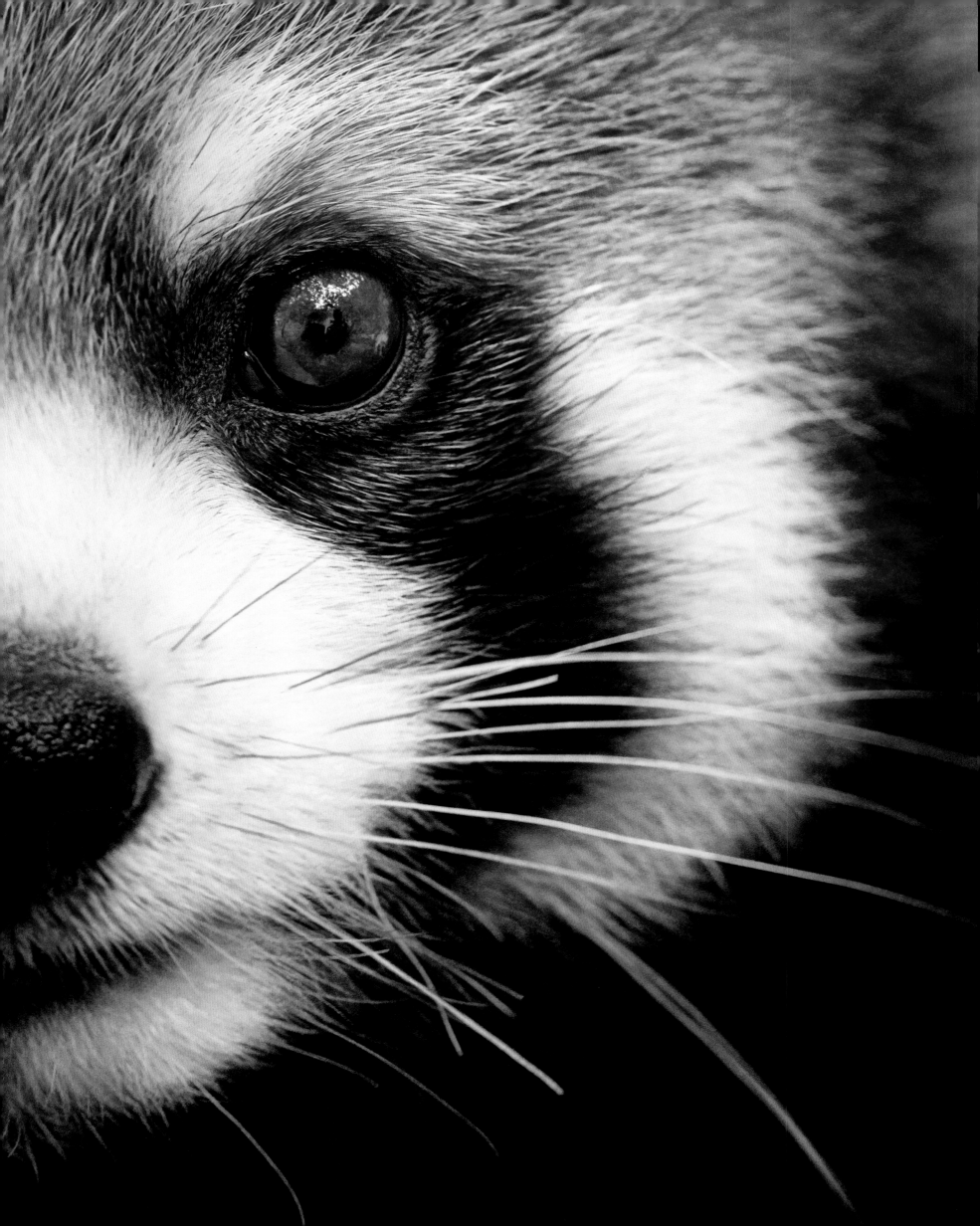

Time for change

Red pandas are small animals found in the highlands of Nepal, India, Bhutan, Myanmar, and China. Today, they are endangered, as farmland is pushing into their once-remote range and eliminating their forest habitats, while their beautiful pelts are widely traded as decorations. Worldwide, red pandas are finding fame with pictures shared on social media, but this seems only to have heightened pressure from the international pet trade.

We have evolved with a dependence on animals, eating them to sustain ourselves, using their fur to keep warm, and taming them for work or companionship. Now, we are simply too numerous and too powerful; red pandas and many other species are declining at completely unsustainable rates. To maintain stable ecosystems, we must innovate new relationships with the natural world that are peaceful, respectful, and restrained.

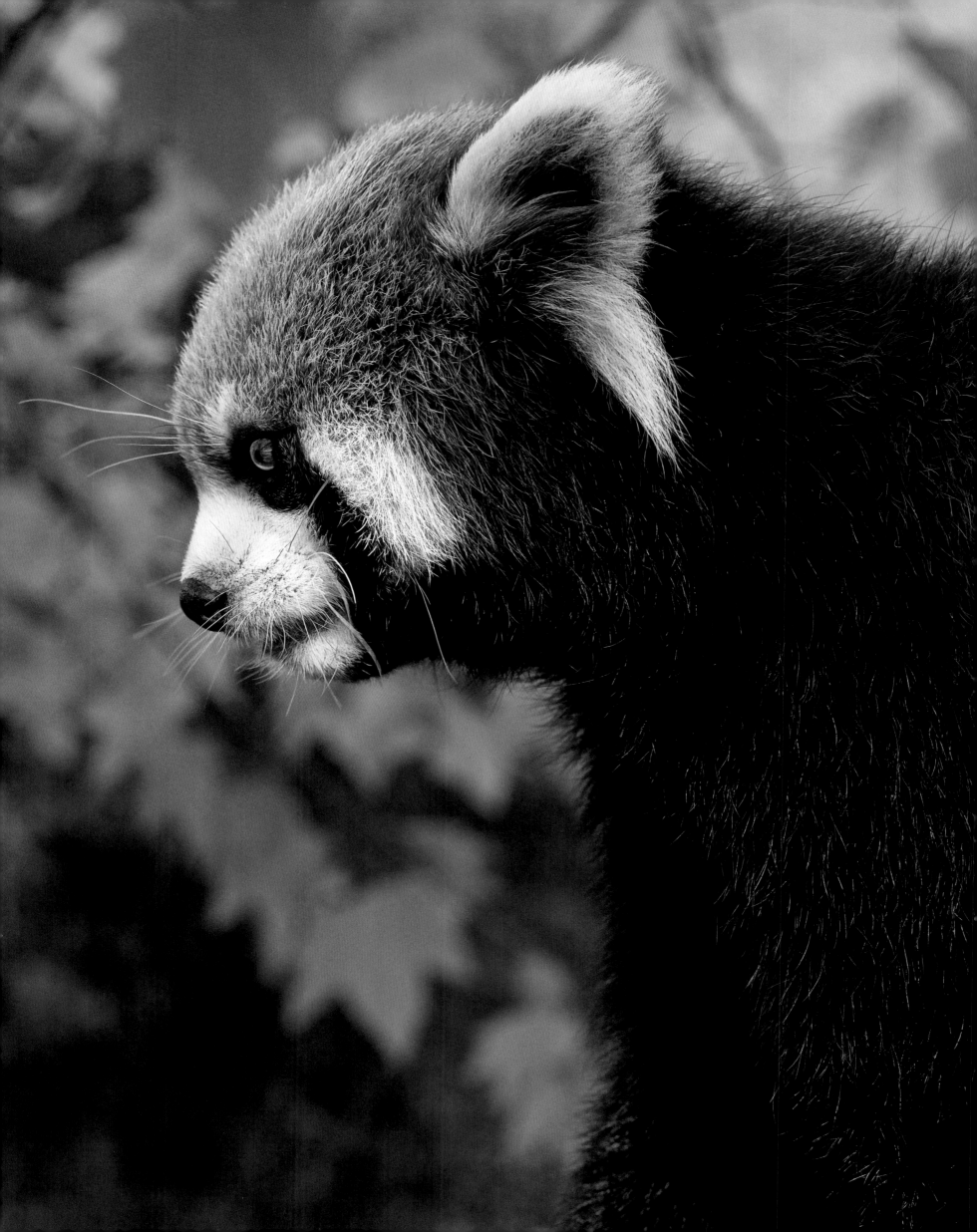

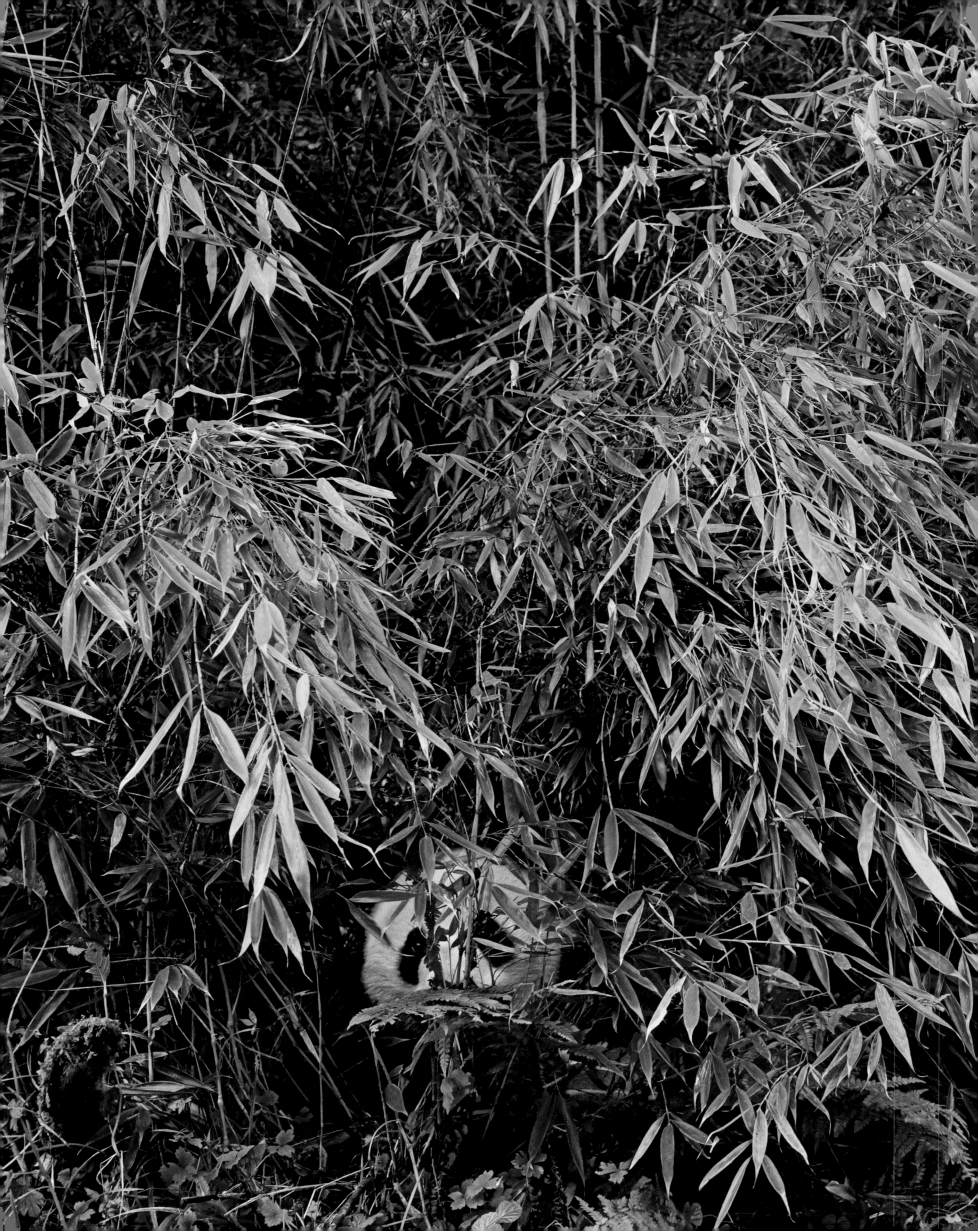

Success

In the 1980s, the Chinese government launched one of history's largest and most expensive conservation campaigns, to save the giant panda. Poaching was banned, forests were protected, and the plight of the panda was brought to international recognition. The effort eventually led to an increase in the giant panda's wild population, and in 2016, the species was finally downgraded from Endangered to Vulnerable. Many groups were jubilant, and saw the reclassification as a triumph of hard work and government action, but others were concerned that the downgrade was misleading, and could encourage funding and research to slacken. Indeed, the giant panda's future remains precarious: there are still only two thousand individuals living in the wild, scattered across several isolated populations. Furthermore, their food source, bamboo, is highly sensitive to temperature, and China's bamboo forests will soon be widely and severely damaged by climate change.

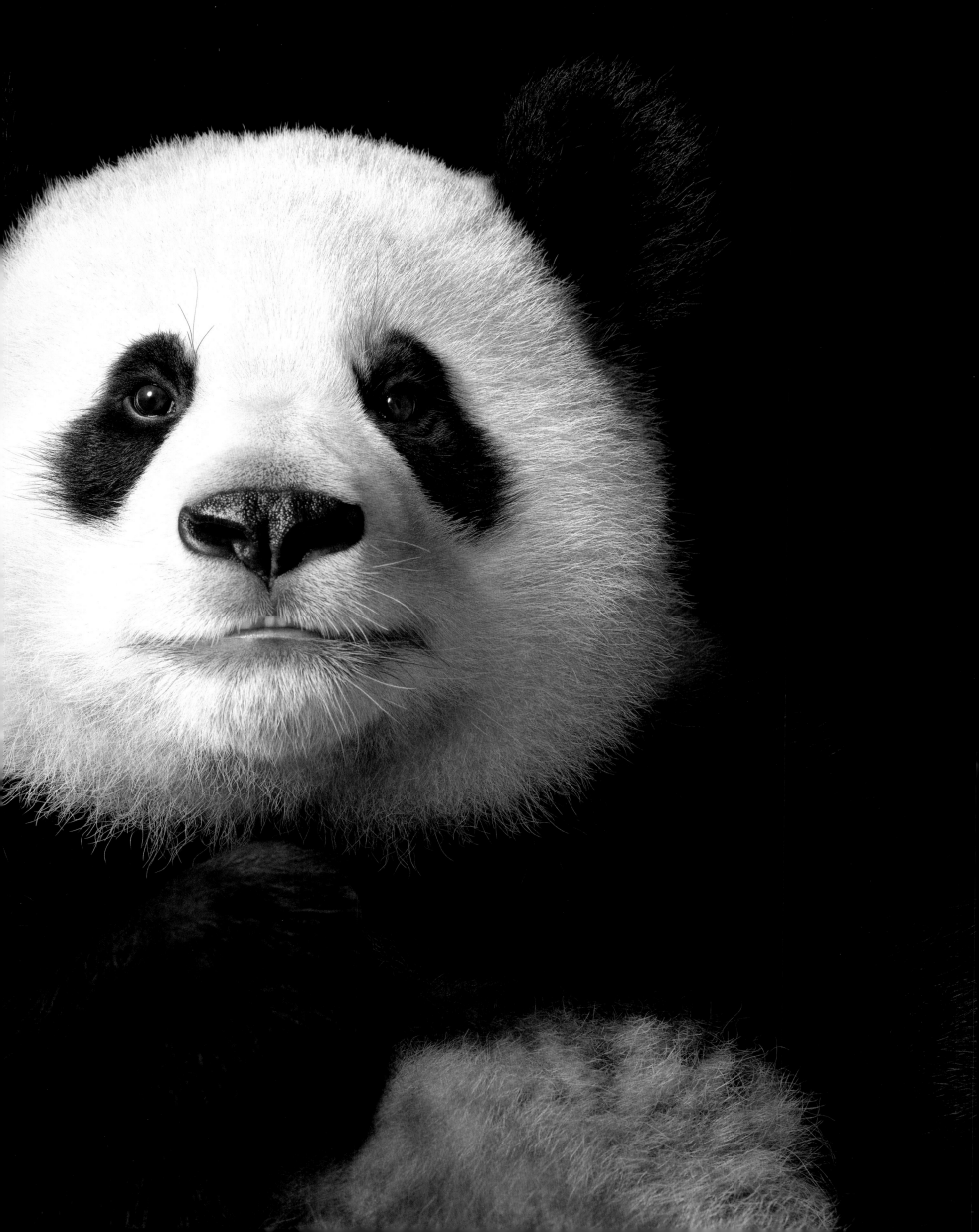

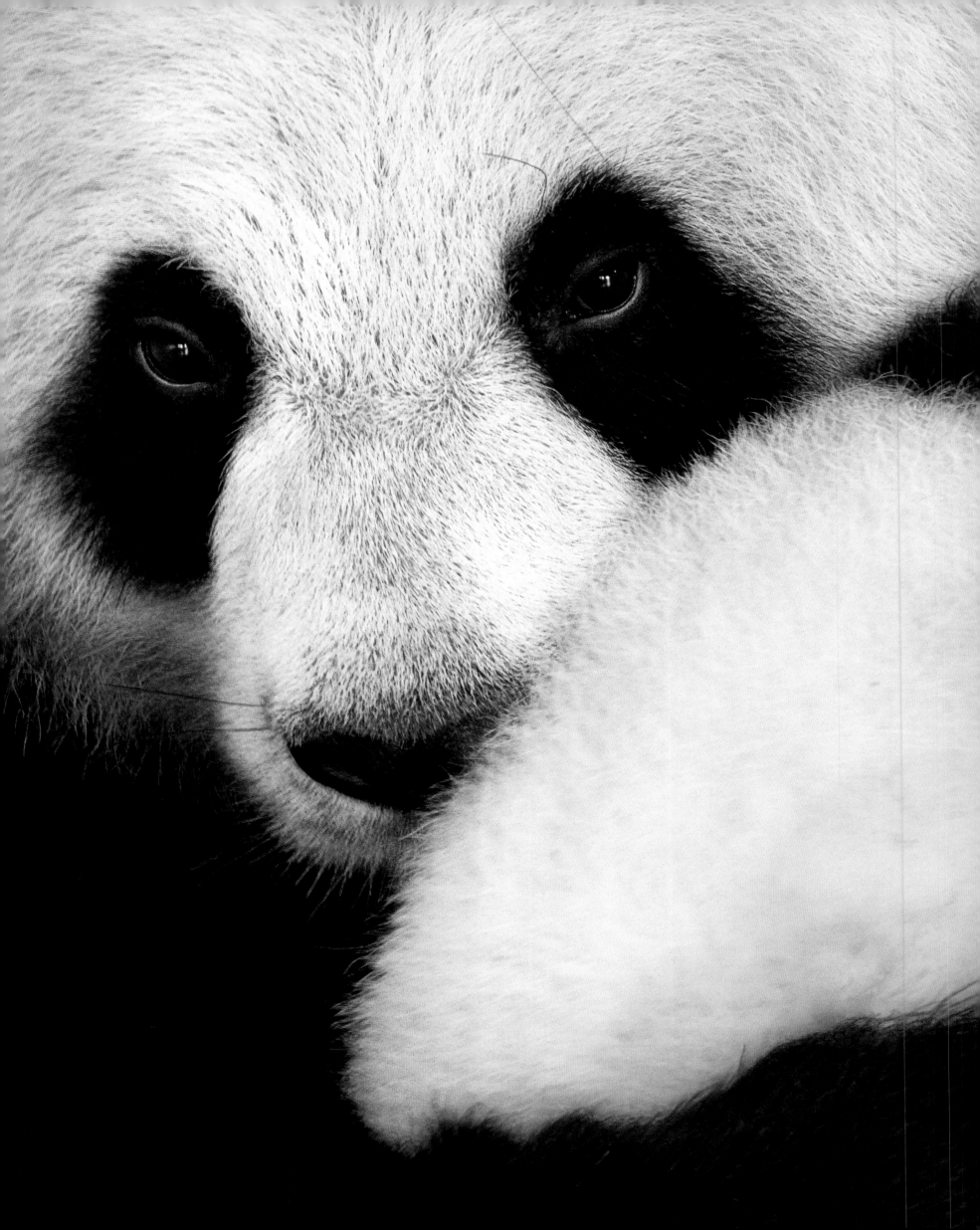

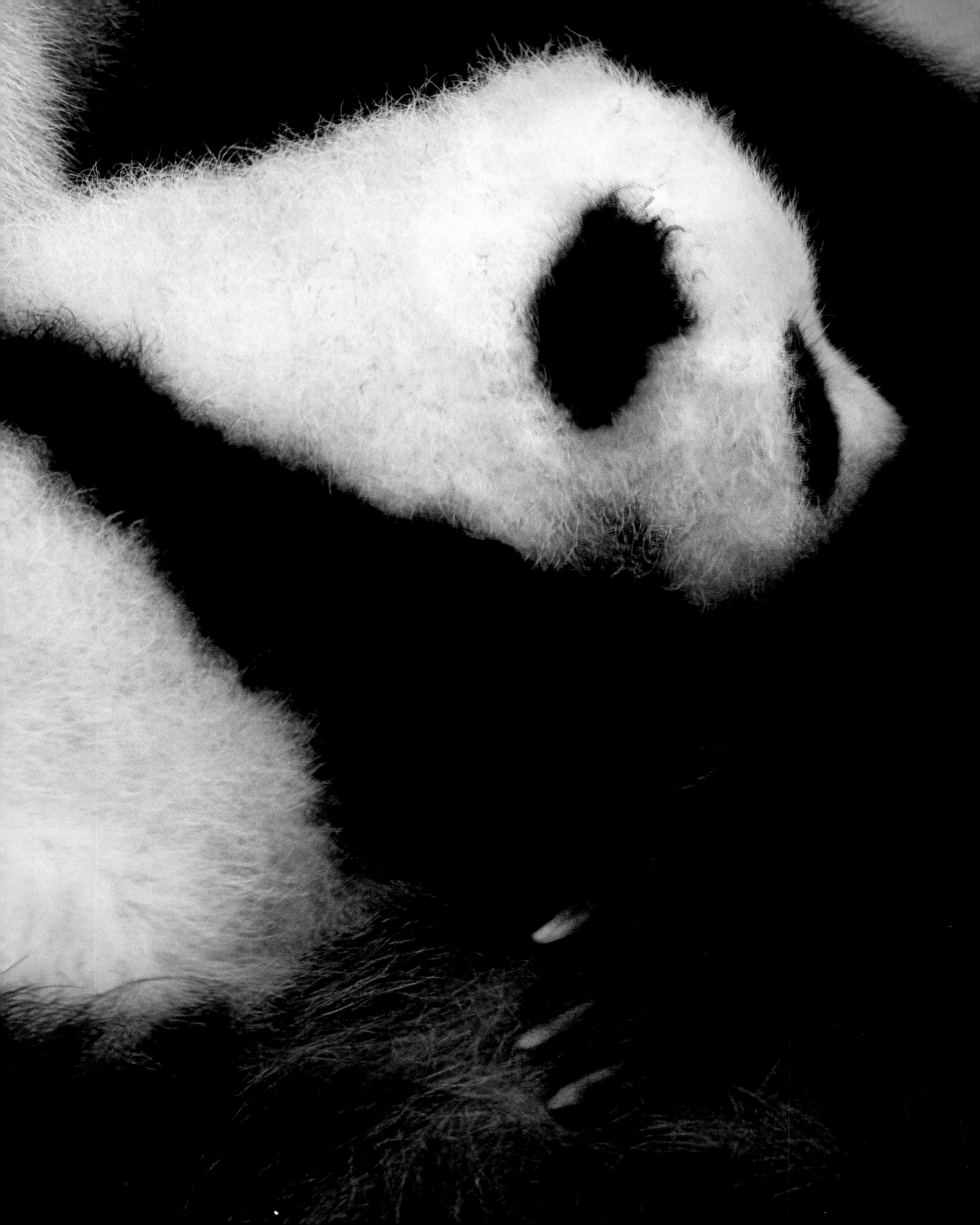

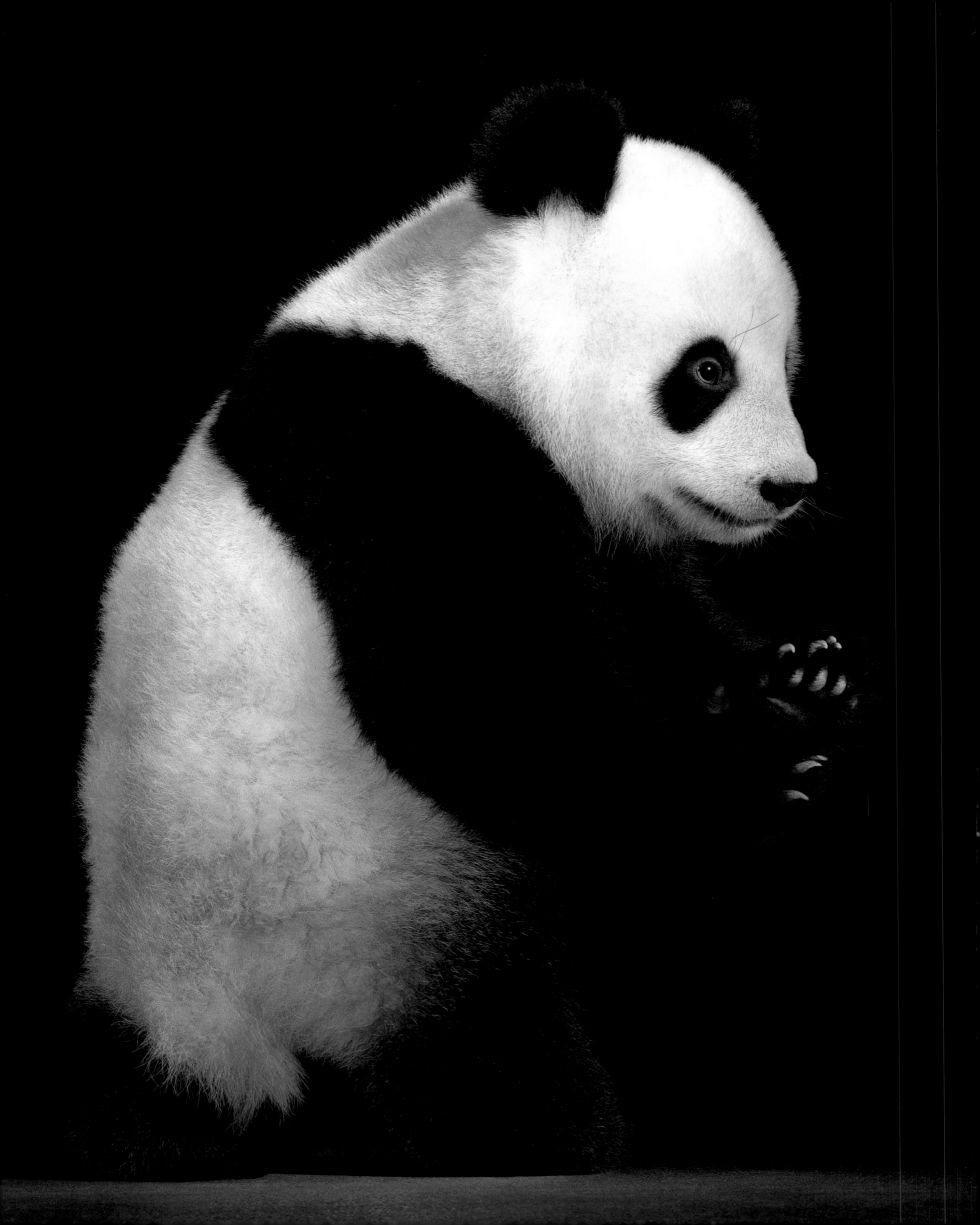

Pandemonium

Giant pandas have inspired films, cuddly toys, and a surge in nature tourism. A national treasure, and an international emblem for wildlife, they have charmed people in China and across the globe. However, each year, while fortunes are spent protecting them, thousands of other, less "charismatic" species slip silently toward extinction. As the world's biodiversity becomes increasingly threatened, many argue that there are more useful ways to apply limited conservation resources. Critics also point out that, because giant pandas are herbivores, their disappearance would have little impact on the food chain. But by defending pandas and their habitat, we have preserved 5,400 square miles (14,000 sq. km) of highly diverse forest. The world's love of giant pandas has incidentally helped to protect the Yunnan (pp. 126–29) and golden snub-nosed monkeys (pp. 130–33), the red panda (pp. 134–39), and many other threatened species in central China. Perhaps any animal that opens human hearts to nature is worth trying to save.

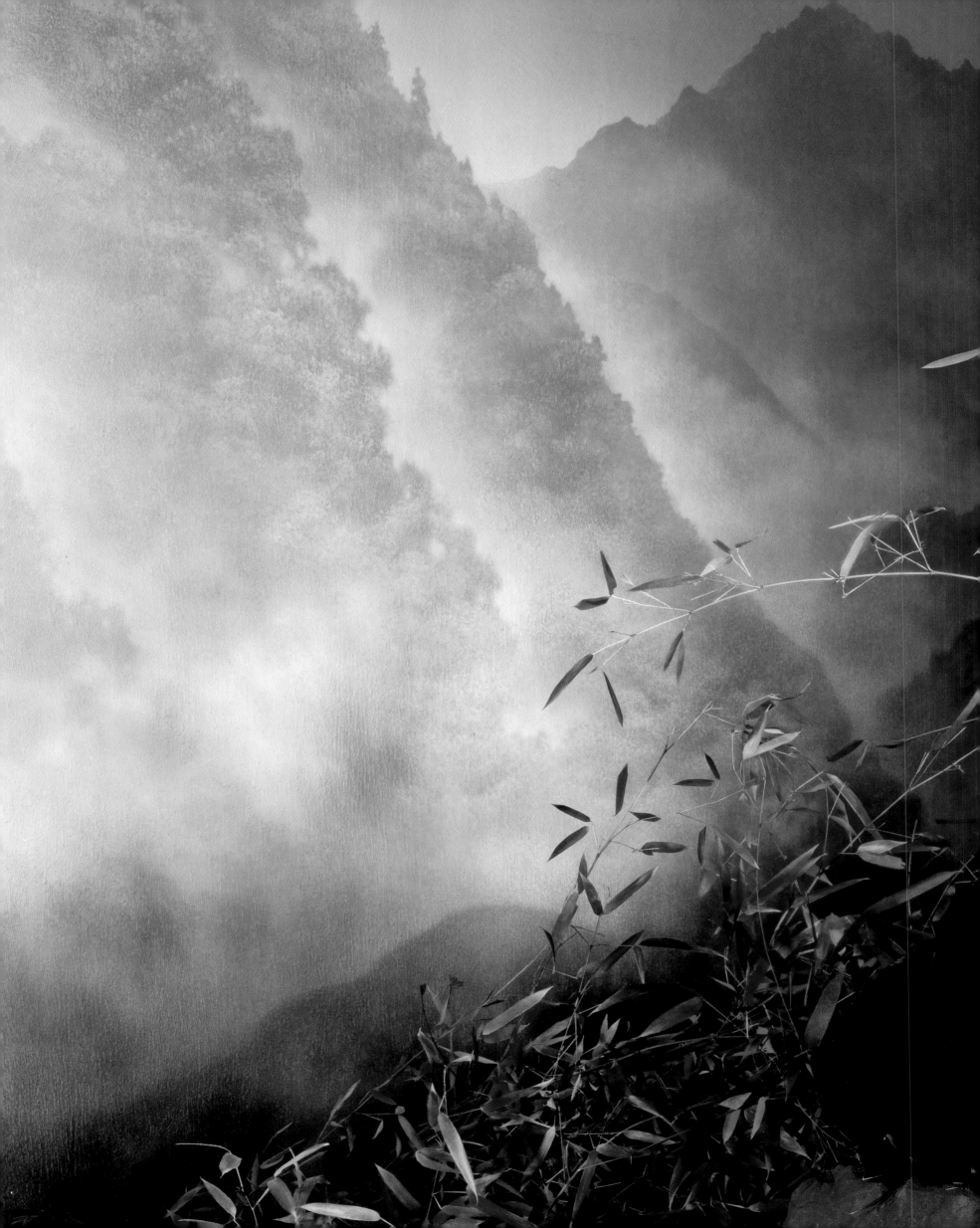

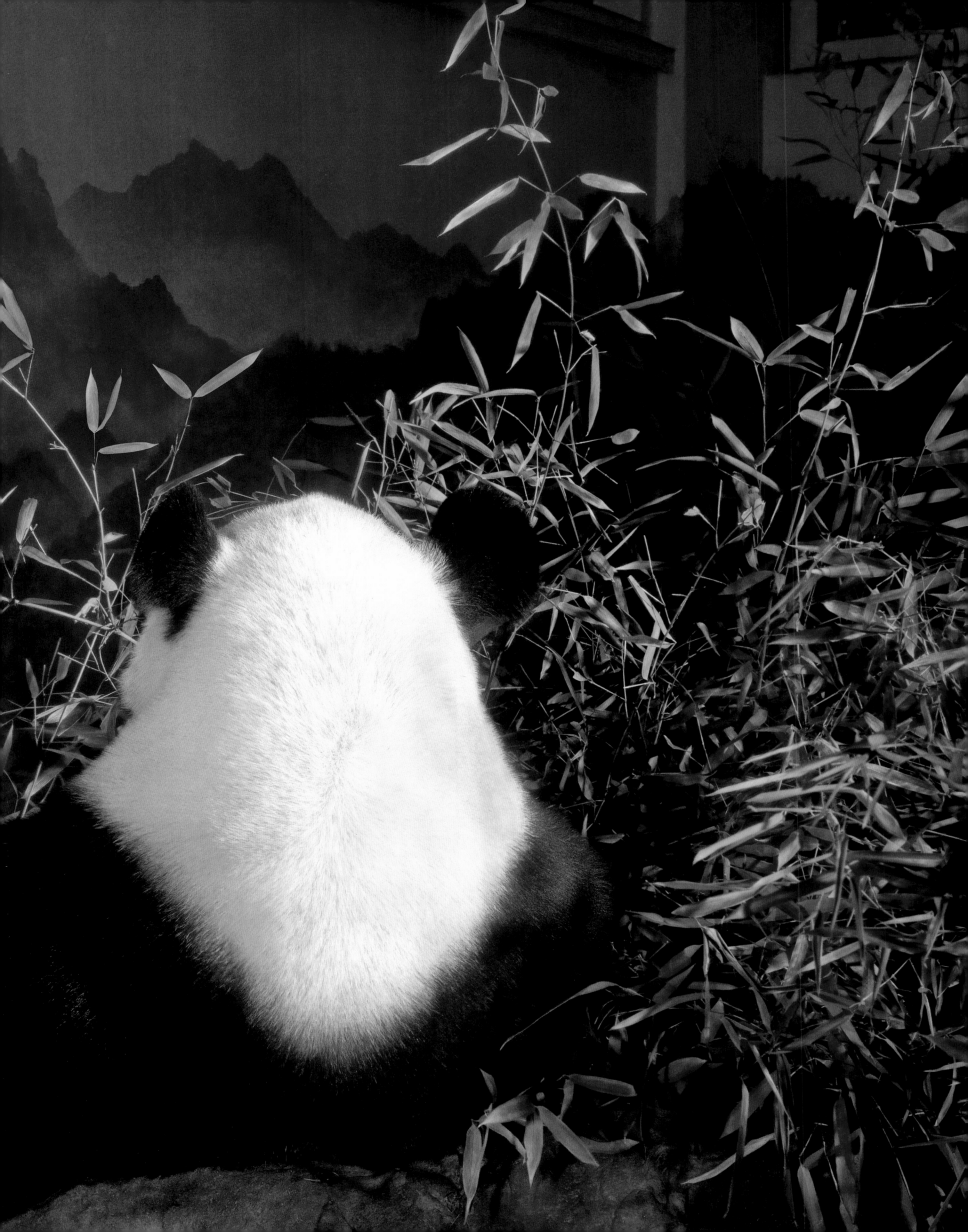

The face of the earth

In Christian theology, human beings are
"Earth's stewards," the guardians and rulers
of this planet. But in many cultures, every
feature of Earth is seen as interdependent
and counterbalanced, forming one complete
being. This philosophy of equity and
symbiosis appeared in modern biological
science in 1979, with James Lovelock's
Gaia hypothesis. The theory argues that
life naturally interacts with its inorganic
surroundings to promote for itself a healthy,
temperate world. Four billion years ago, the
first life-forms to emerge on Earth's noxious
wastelands were photosynthetic bacteria, and
they gradually released enough oxygen to
support more complex life. Today, breathing
forests regulate the climate and animals
disperse their flora, but for the first time in
Earth's history, a species is disturbing this
equilibrium. We are laying waste to forests,
filling oceans with plastic, and pumping
poison into the air, altering our world so
profoundly that many scientists argue we
have entered a new geological age. It is
self-destruction to destabilize the home that
we have evolved in, that has begotten and
accommodates us, but we have the capacity
to bend our course back toward our natural
destiny, and unify with our planet in this new
Anthropocene Epoch.

Lights out

In a reverse of the falling, feathery spores of a dying dandelion, these forest light mushrooms are climbing and glowing to attract insects that might spread their spores elsewhere. Despite humanity's growing separation from the natural world, our collective consciousness is still receptive to the spiritual potency of bioluminescence. In the film *The BFG*, dreams are represented as floating forms of light, and in *Avatar* and *Life of Pi,* clusters of stars and swarms of fireflies offer guidance and tranquility. Indeed, just as stars hold their place in the sky, fireflies (pp. 154–55) hold theirs in the woods, growing, reproducing, and dying in the same place they are born.

These forest light mushrooms have only been known to exist since 2008 and, in many ways, the phenomenon of bioluminescence remains one of nature's greatest mysteries. However, in the glimmer of the firefly, we are beginning to decipher languages—flash patterns working like Morse code. The rhythms of these dialogues are astonishingly precise, but also highly sensitive; they are disturbed by light pollution, which makes hunting and mating difficult. Meanwhile, we pave over the fireflies' homes, and their populations fall.

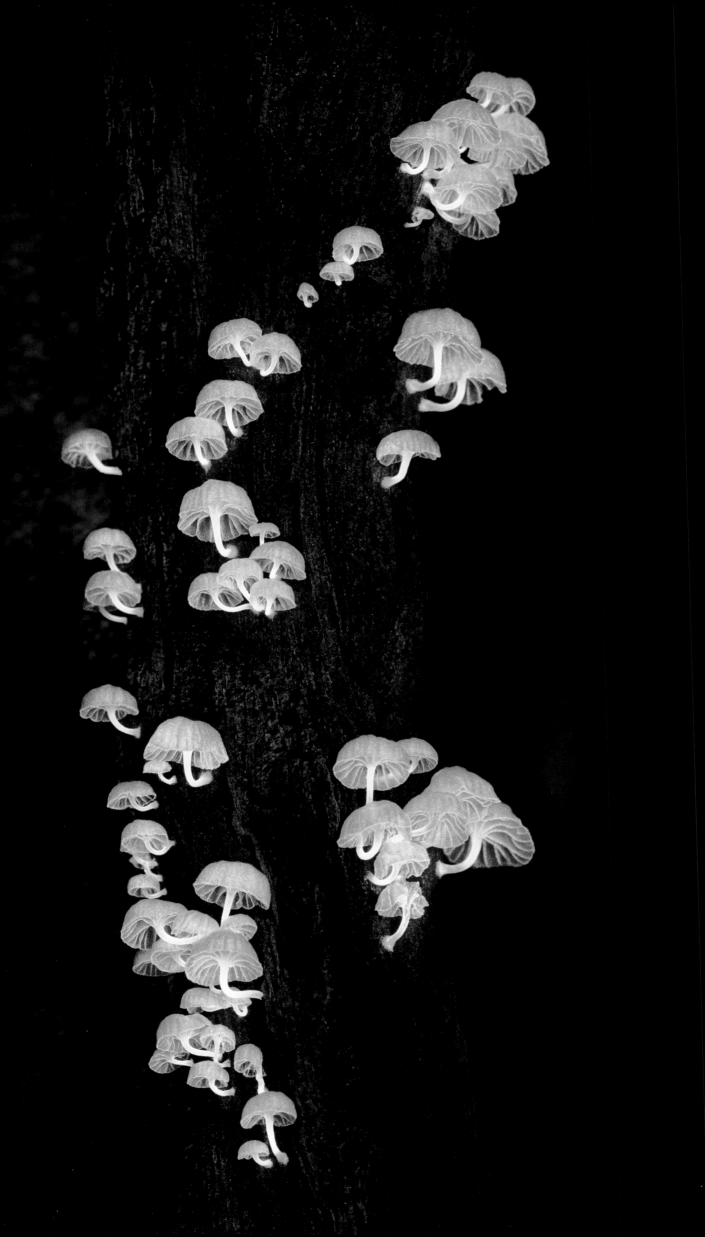

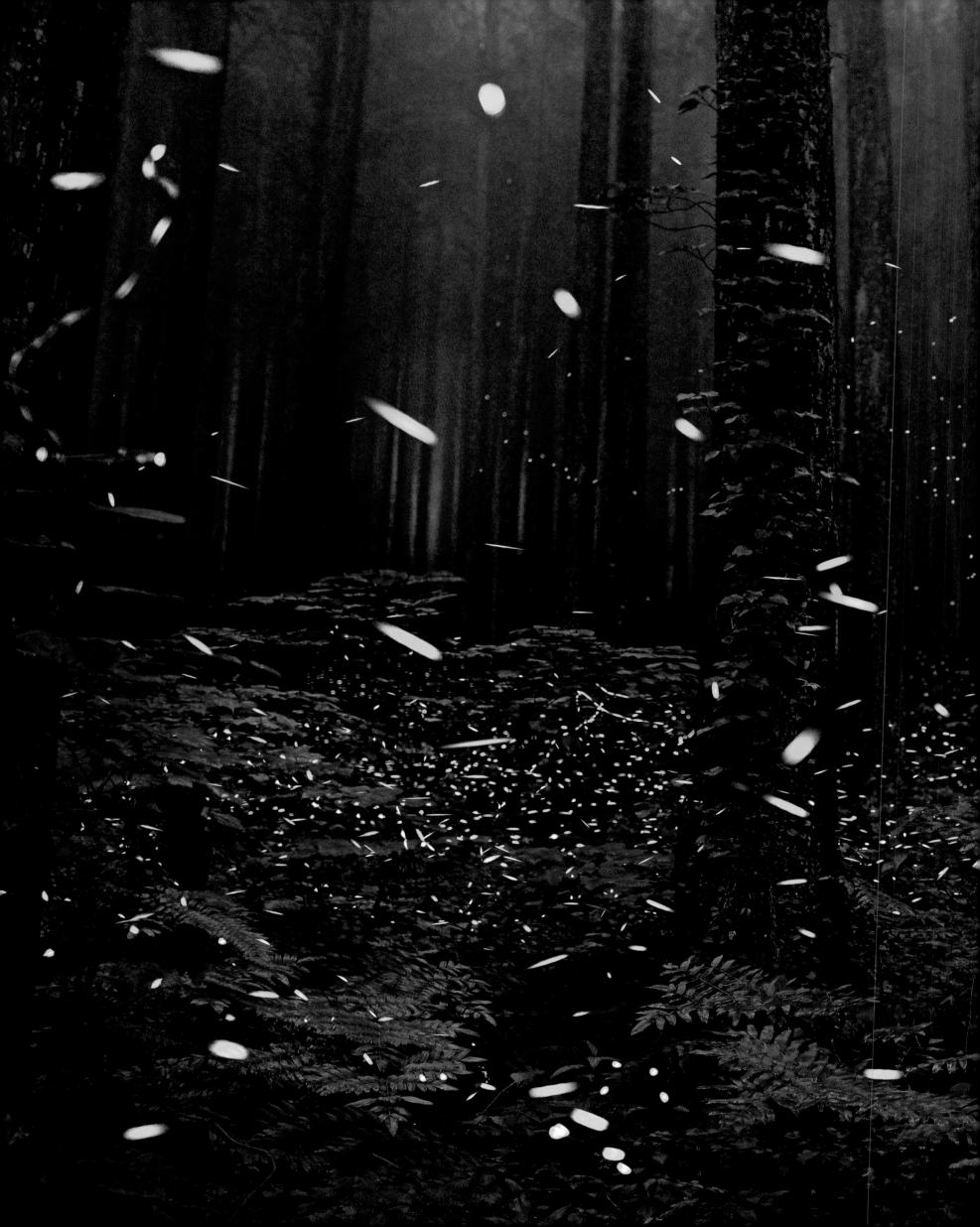

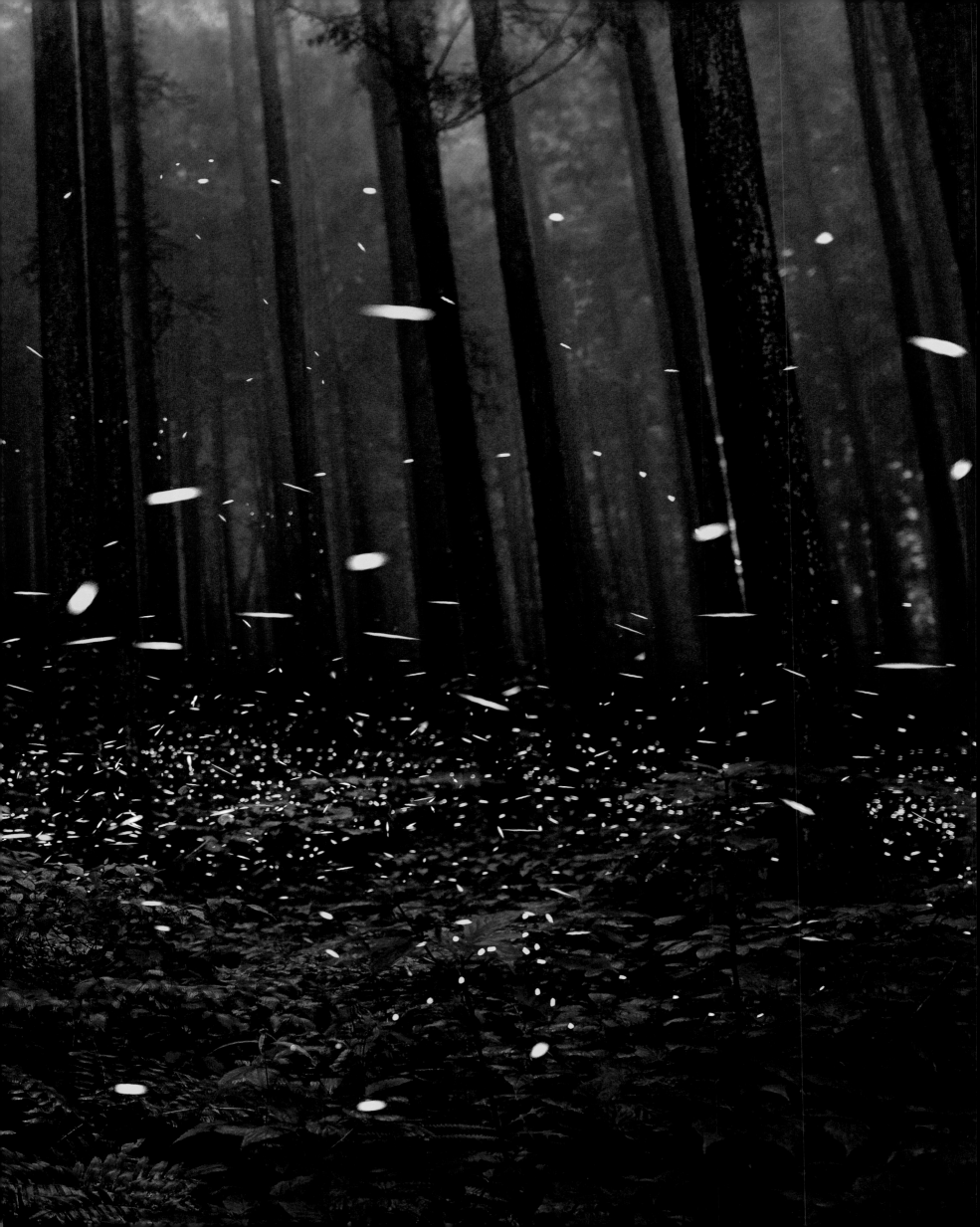

The value of nature

Conservation of the natural world is often taken to be at odds with the industrial advancement of human society, but increasingly, each is becoming reliant on the other. Our prosperity depends on ecological stability, but the natural world needs our conscious investment.

Many bee species, which pollinate fruits, vegetables, and fodder for our livestock, are in decline. Their wildflower habitats are being continually degraded, while the bees themselves are being poisoned by the insecticides that we spread on our crops. Many have been unable to adapt to our warming climate: disrupted flowering seasons have left bees with less food, and plants with fewer pollinators.

Replacing bees' unique services would, in all likelihood, prove impossible. They are worth about US$300 billion to the global economy, but funding for conservation research remains dismally weak. To protect them, we must move away from chemical-intensive farming, defend their natural habitats, and encourage floral diversity. It is not only a moral obligation; it is an economic imperative.

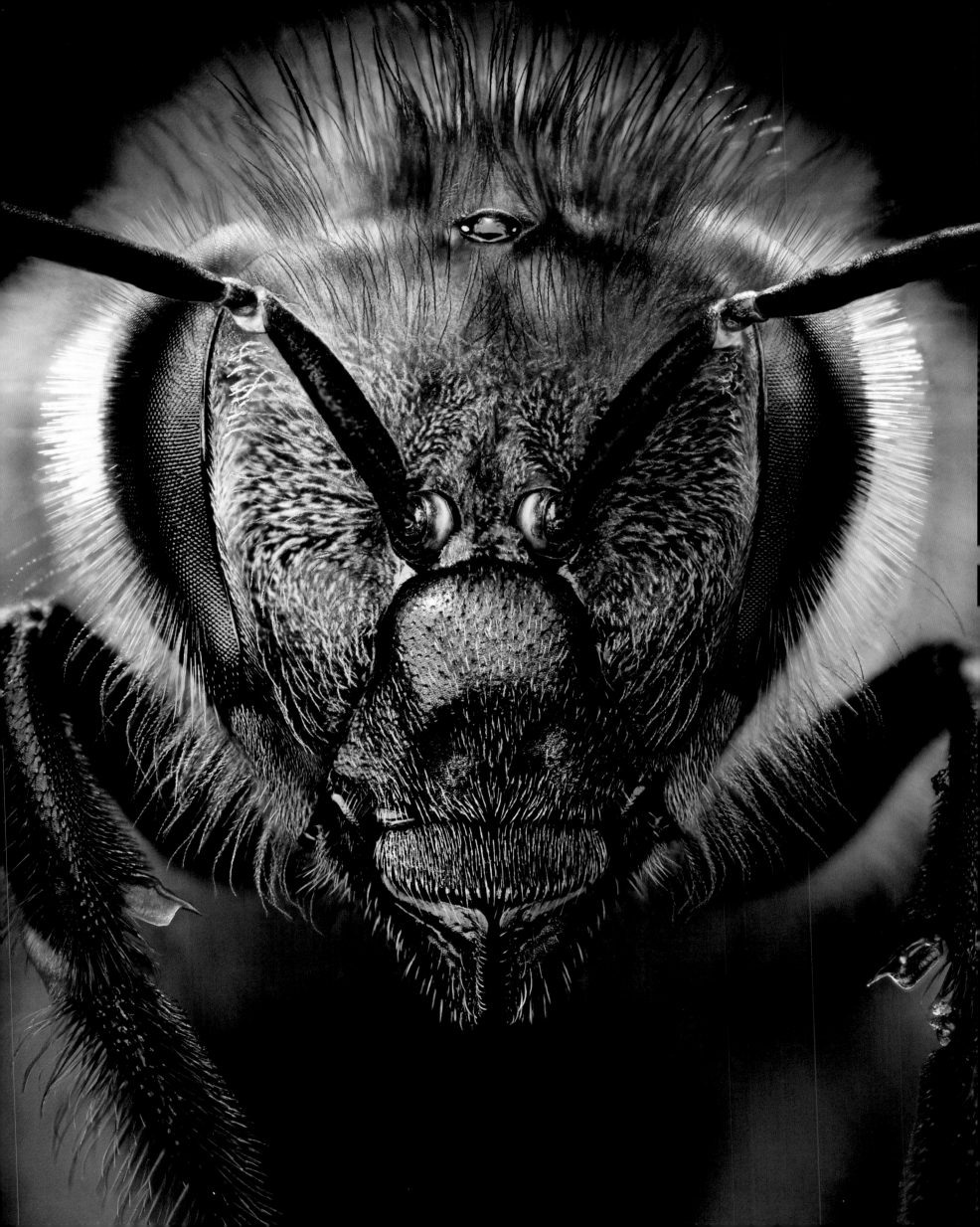

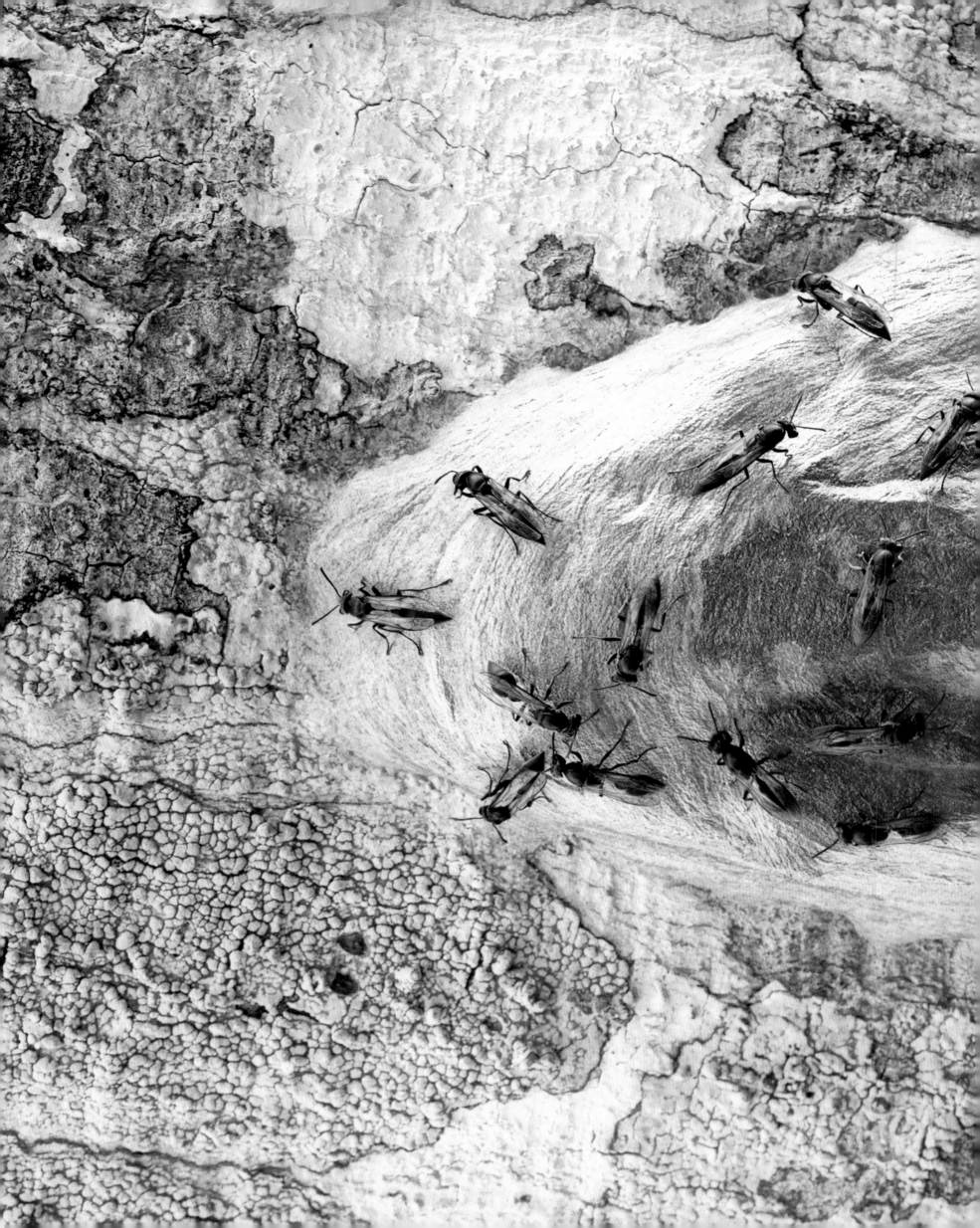

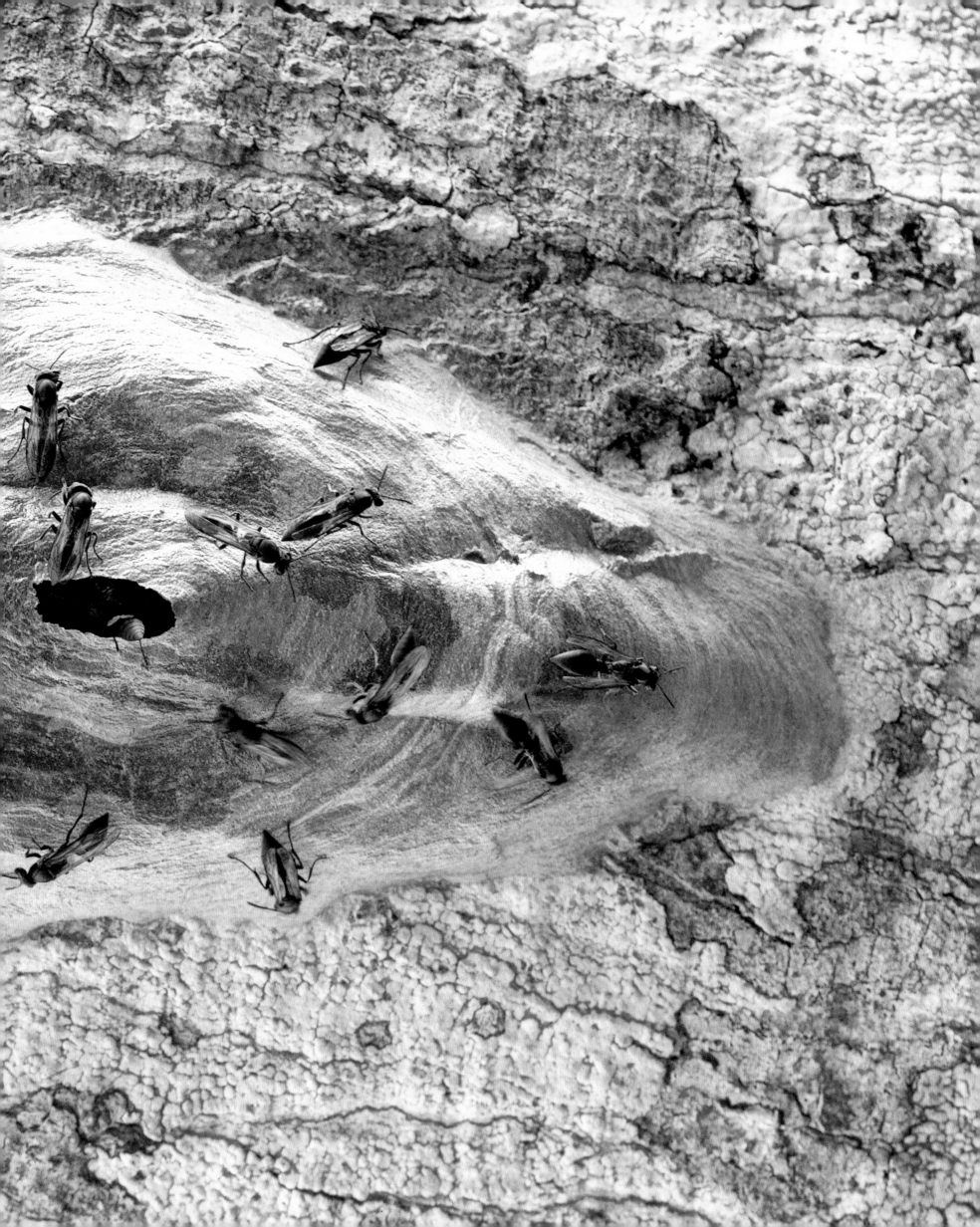

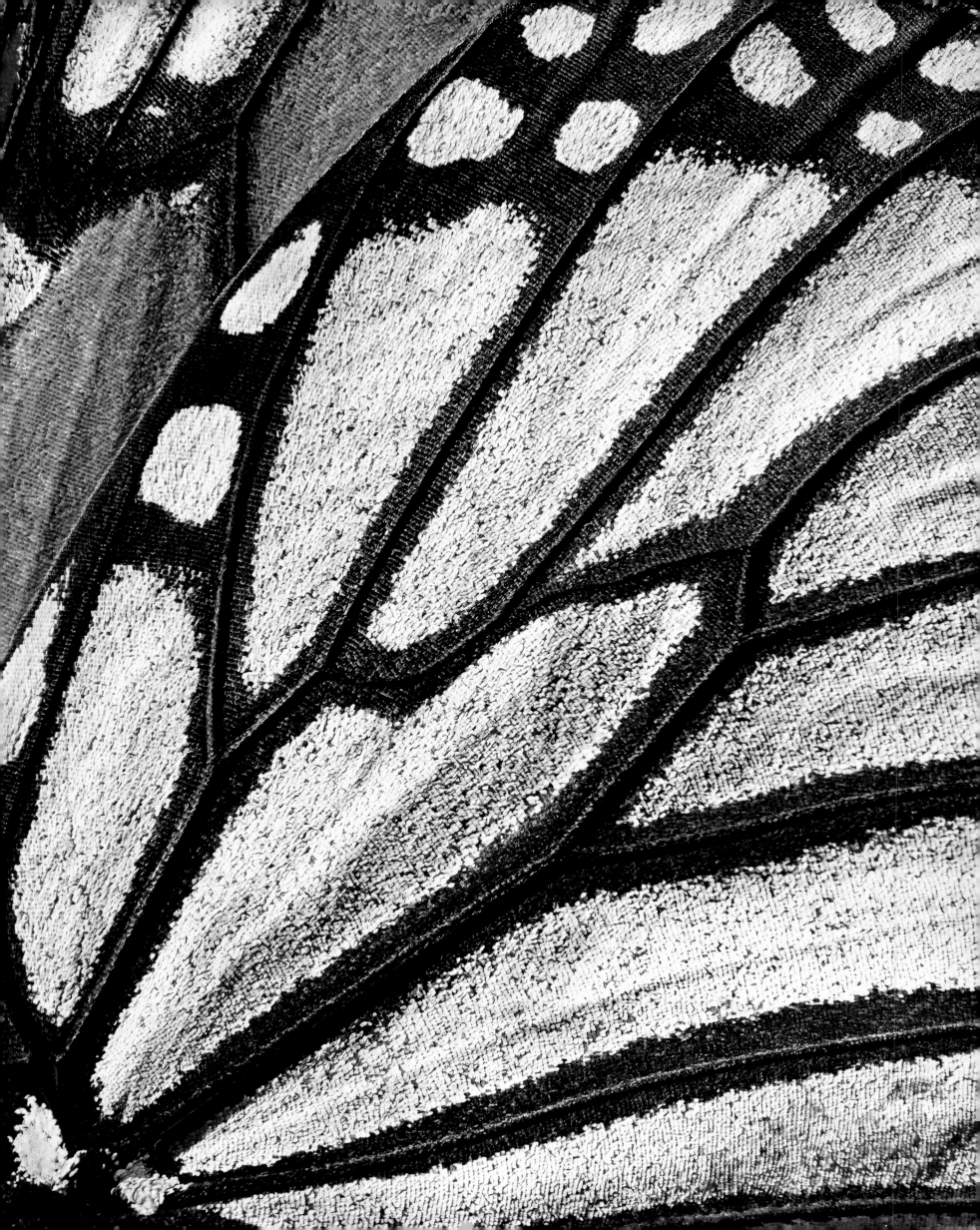

Lost in the crowd

Every winter, a journey of several thousand miles is made by hundreds of millions of insects, despite each weighing less than a dollar bill. In one of the natural world's most spectacular phenomena, monarch butterflies migrate from Canada and northern USA to Mexico and California, where they blanket the pine forests in orange, white, and black. The next three generations have much shorter life expectancies, and make their way back north in increments, so that the southerly migrators' long-lived great-great-grandchildren retrace their path the following winter.

Monarch caterpillars feed on milkweed, a toxic plant that makes them poisonous to potential predators, but herbicides are destroying millions of acres of this essential food source each year. Meanwhile, flowering seasons are being disrupted by climate change, leaving butterflies with less food to sustain them on their immense winter flights. These vast, majestic swarms are comprised of fragile individuals, facing a changing environment and a profoundly uncertain future.

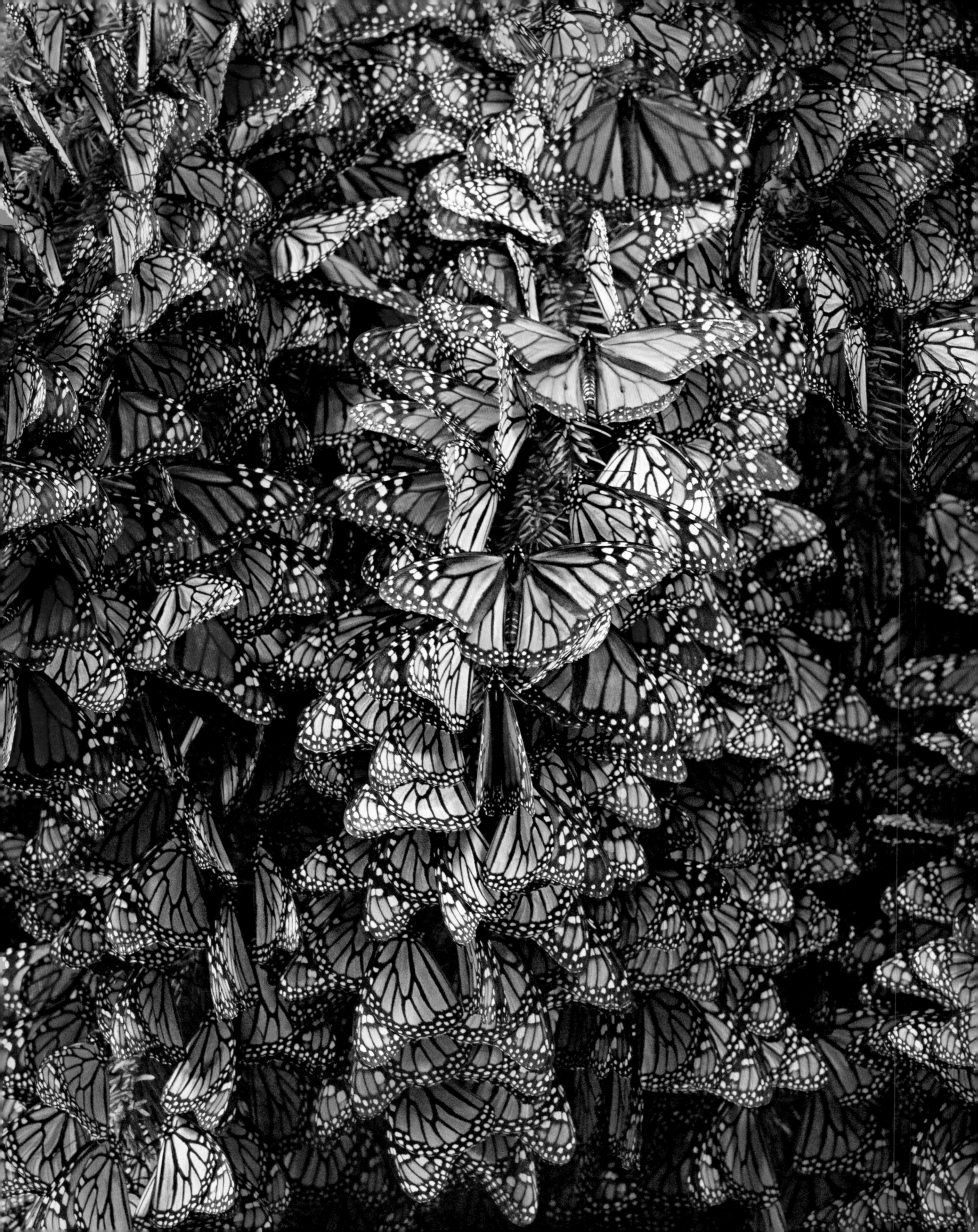

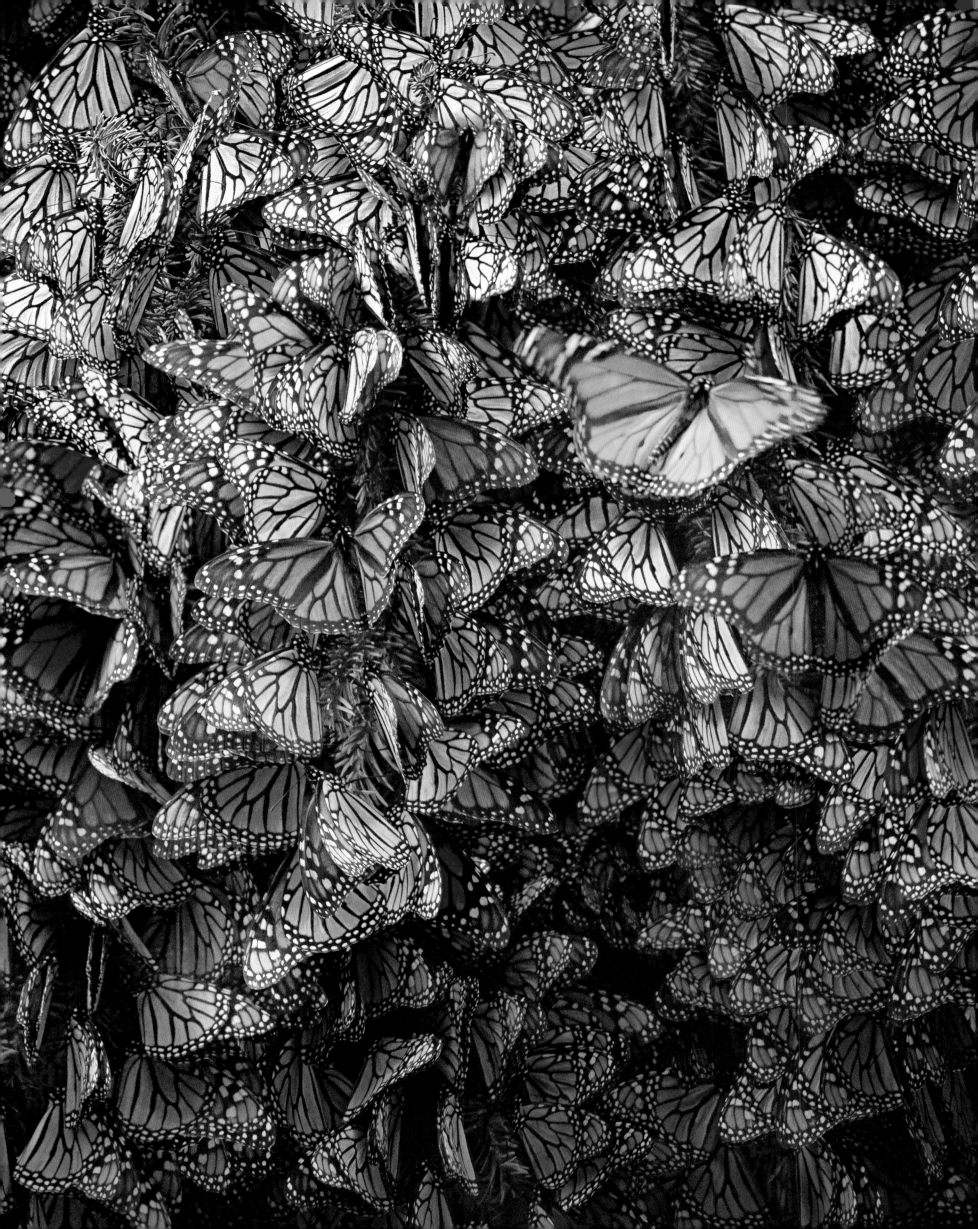

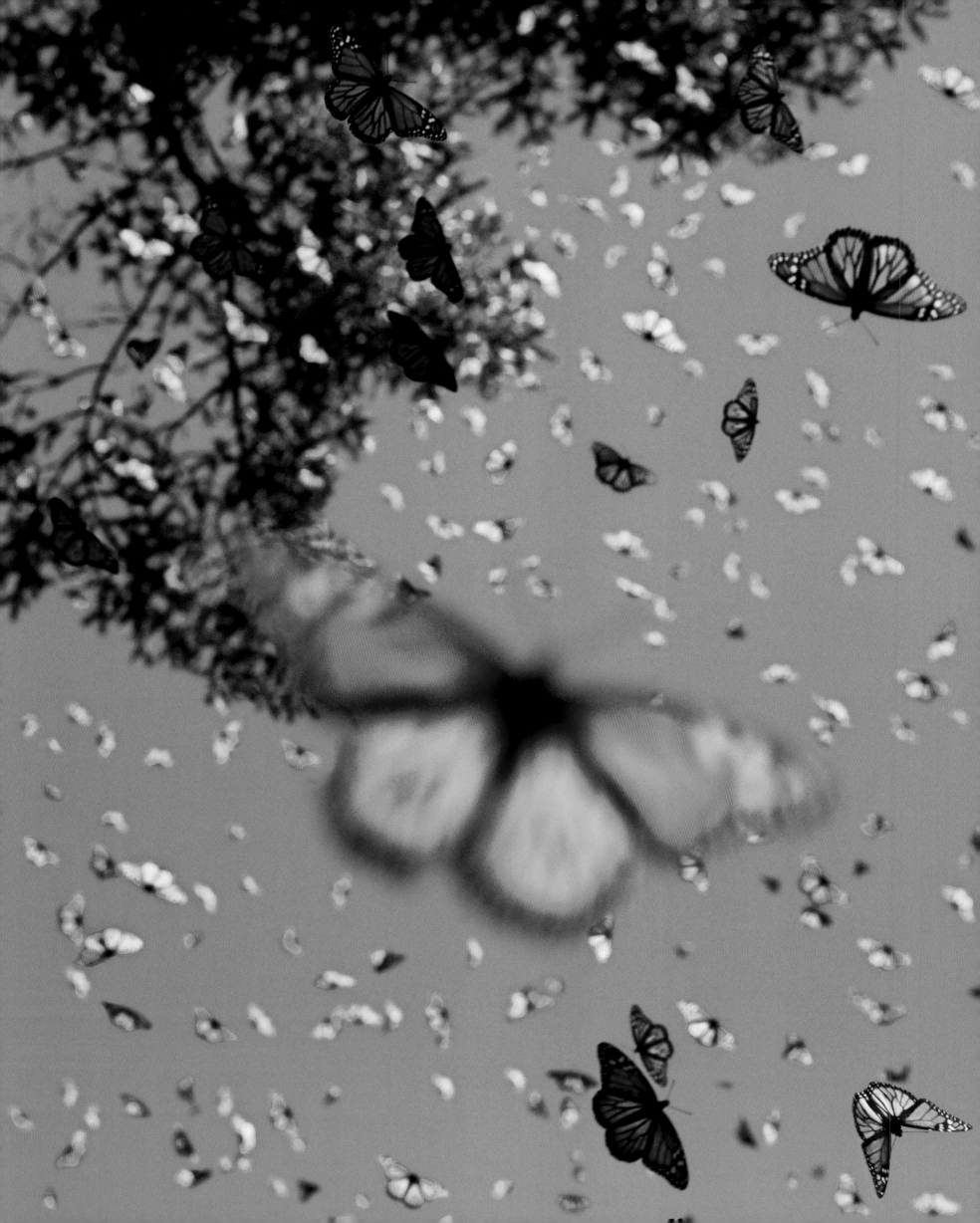

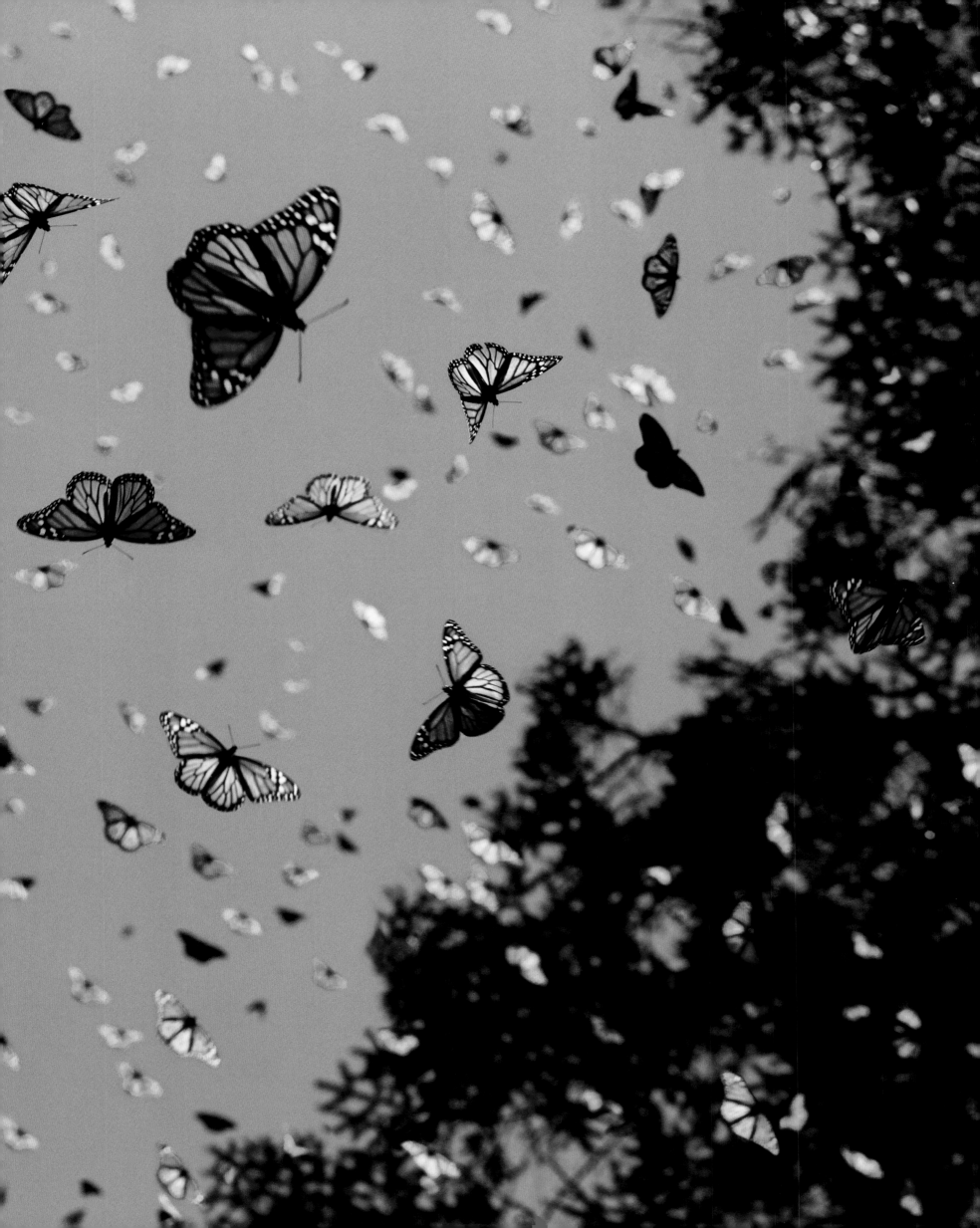

Into the shadows

Known only to the lowlands of Jamaica, the brilliant *Urania sloanus* is only 3 inches (7.5 cm) across, but bursts with color. Like the monarch butterfly (pp. 160–65), this adaptation warns predators that they feed on toxic plants, and will themselves be poisonous to eat. These day-flying moths have long been renowned as one of Earth's most beautiful insects, but there is no one alive today who has seen a living specimen. They went extinct around 1895, and exist now only in glass cases. The precise cause of their extinction remains a mystery. Forests were being cleared for farmland during Jamaica's colonial era, but a significant amount of habitat was still present by the end of the nineteenth century. Possibly, one of their larvae's primary food plants was destroyed, preventing one year's population from assembling into viable swarms. Today, the preserved specimens represent the fragility and unpredictability of the natural world, and of our neglected insects in particular.

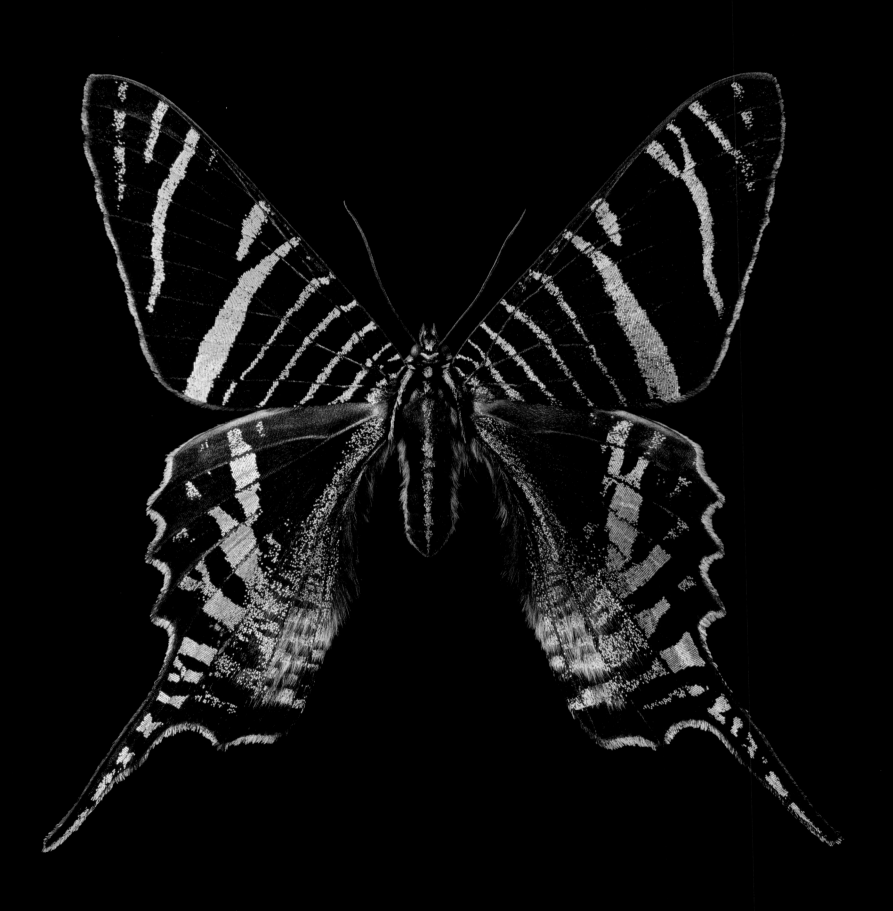

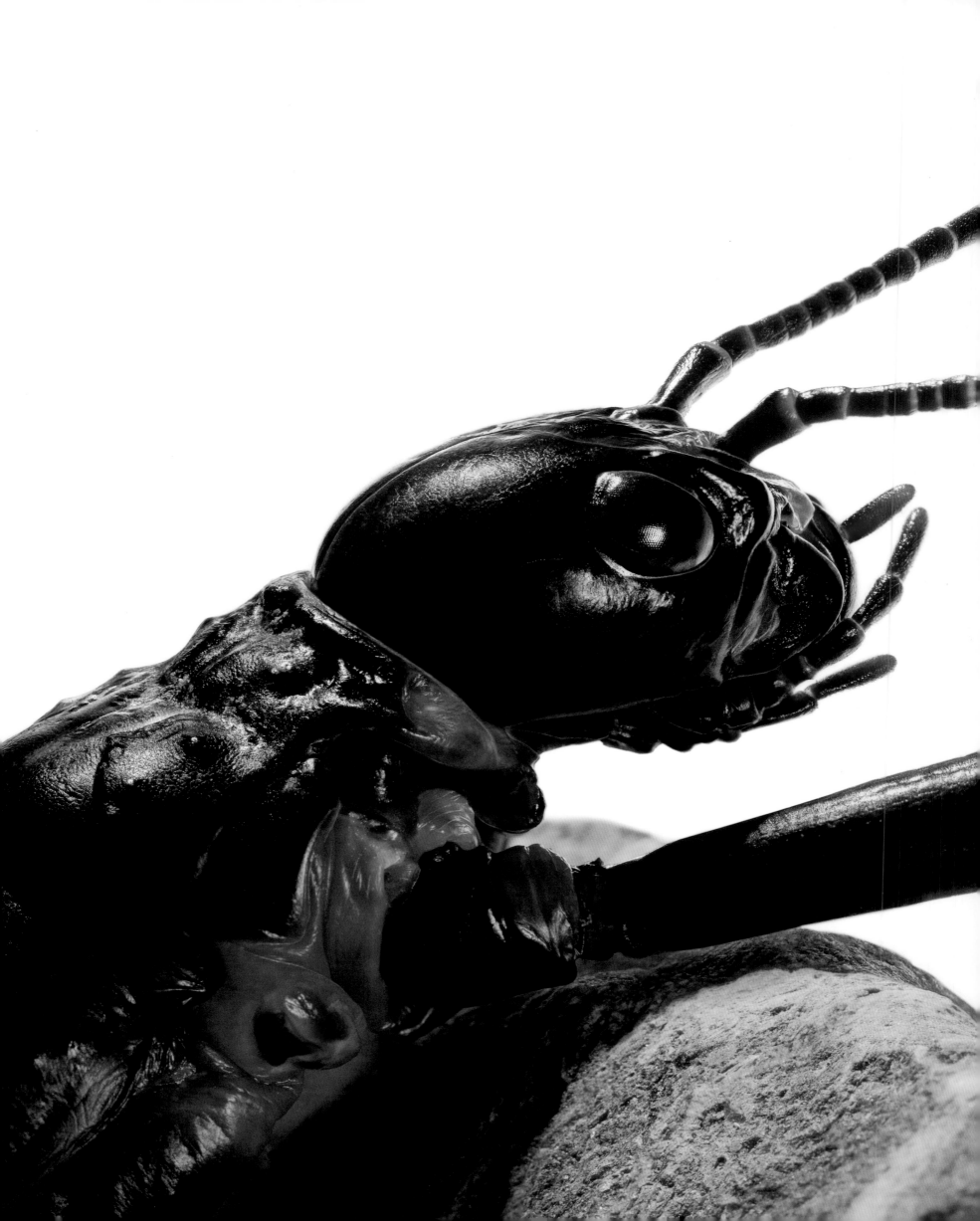

Cheating death

In 1918, a Glaswegian cargo ship ran aground on the northern coast of Australia's Lord Howe Island. Black rats made it to shore and caused chaos, eating crops, destroying native plants, and wiping out the endemic population of Lord Howe Island stick insects. By 1920, the insects were thought to be extinct, but in 2001, on a tiny rocky islet some 12 miles (19 km) into the Pacific Ocean, a group of scientists discovered twenty-four living specimens. They have been dubbed the rarest insects in the world, but are now being bred with great success at zoos in Melbourne, Bristol, Toronto, and San Diego. Once these captive populations are large enough and Lord Howe Island is cleared of its rats, they will return home after almost one hundred years.

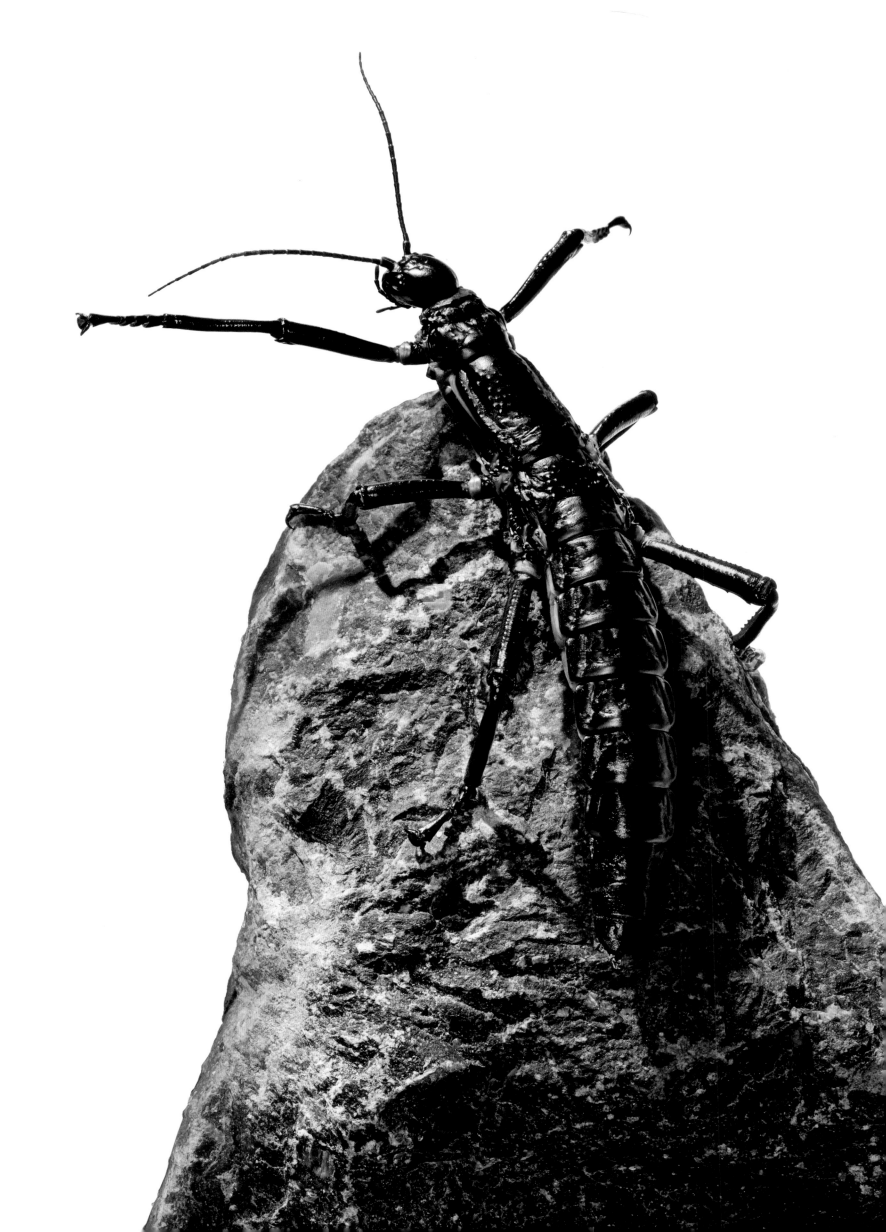

Invulnerable

Until the start of the nineteenth century, forests covered about half of North America, and passenger pigeons comprised 40 percent of all its birds. Each flock contained billions, outnumbering all of humanity and blackening the skies for several days. Early European settlers could kill dozens by aiming upward and firing a single gunshot.

In the 1850s, some naturalists warned that passenger pigeons would not cope with unrestrained hunting, but to politicians, and to the general public, the notion of extinguishing such a powerful force of nature seemed absurd. Hunting methods were expanded to include netting and starting fires under nest sites, while trees continued to be felled for timber and to make way for new towns. For several decades, 13 square miles (34 sq. km) of forest were cleared daily for farmland alone. By the end of the nineteenth century, passenger pigeons had disappeared from the wild, and the very last one died in Cincinnati Zoo on September 1, 1914.

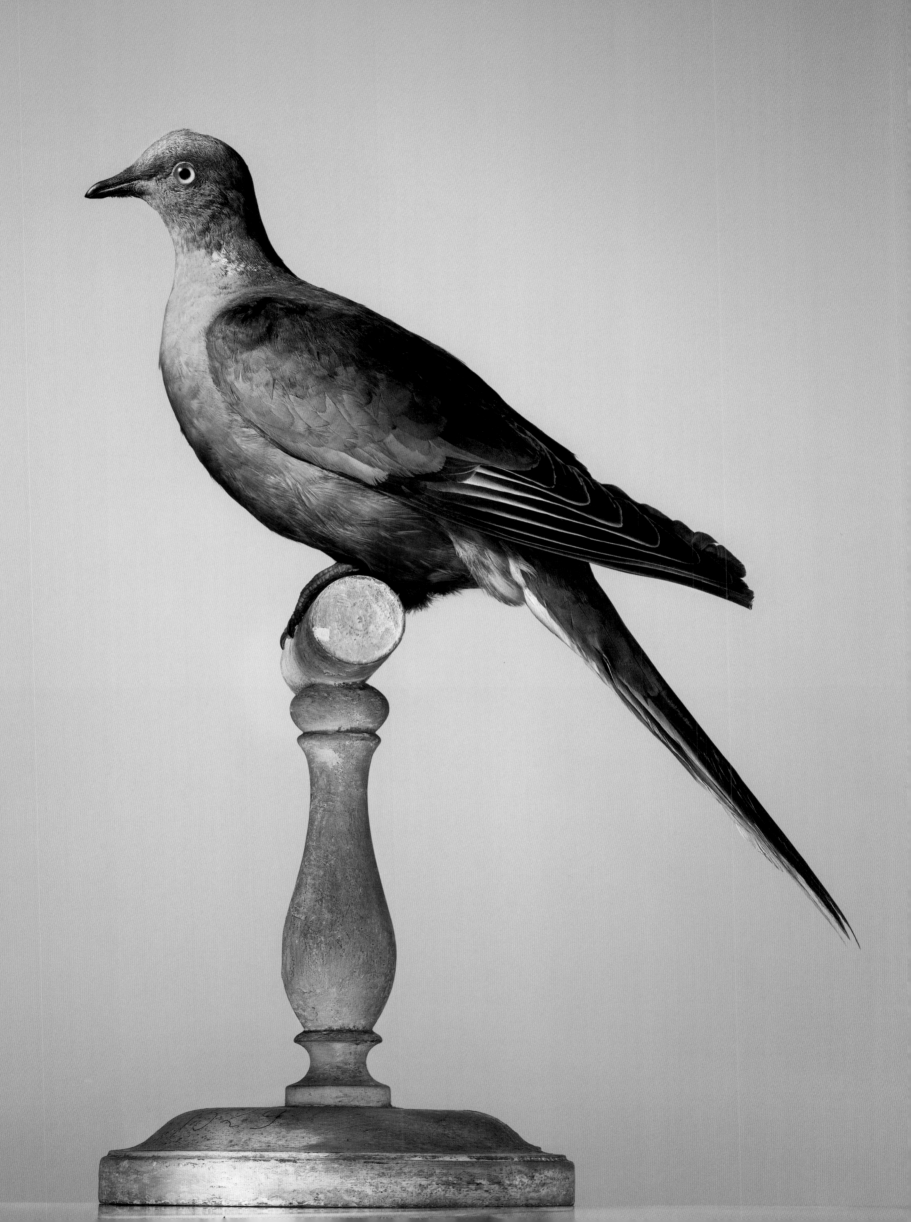

Digging a grave

American burying beetles are scavengers. When a couple finds a chipmunk's carcass or the body of a small bird, they dig a hole in the soil and bury it. Once they have secured the carcass, they mate and then, unusually for insects, raise their young together. They help their larvae to devour the carcass underground, allowing decaying materials to be recycled into the earth, rather than rot and spread disease.

Around the start of the twentieth century, they lost one of their major food sources as passenger pigeons went extinct. Since then, the American woodland and most of its terrestrial species have been in constant decline, so American burying beetles have become critically endangered. There are four hundred thousand known species of beetle that help maintain the world's ecosystems; in fact, they account for one-quarter of all known animal species. They are barely noticed, and yet, without them, the structures of the natural world would collapse.

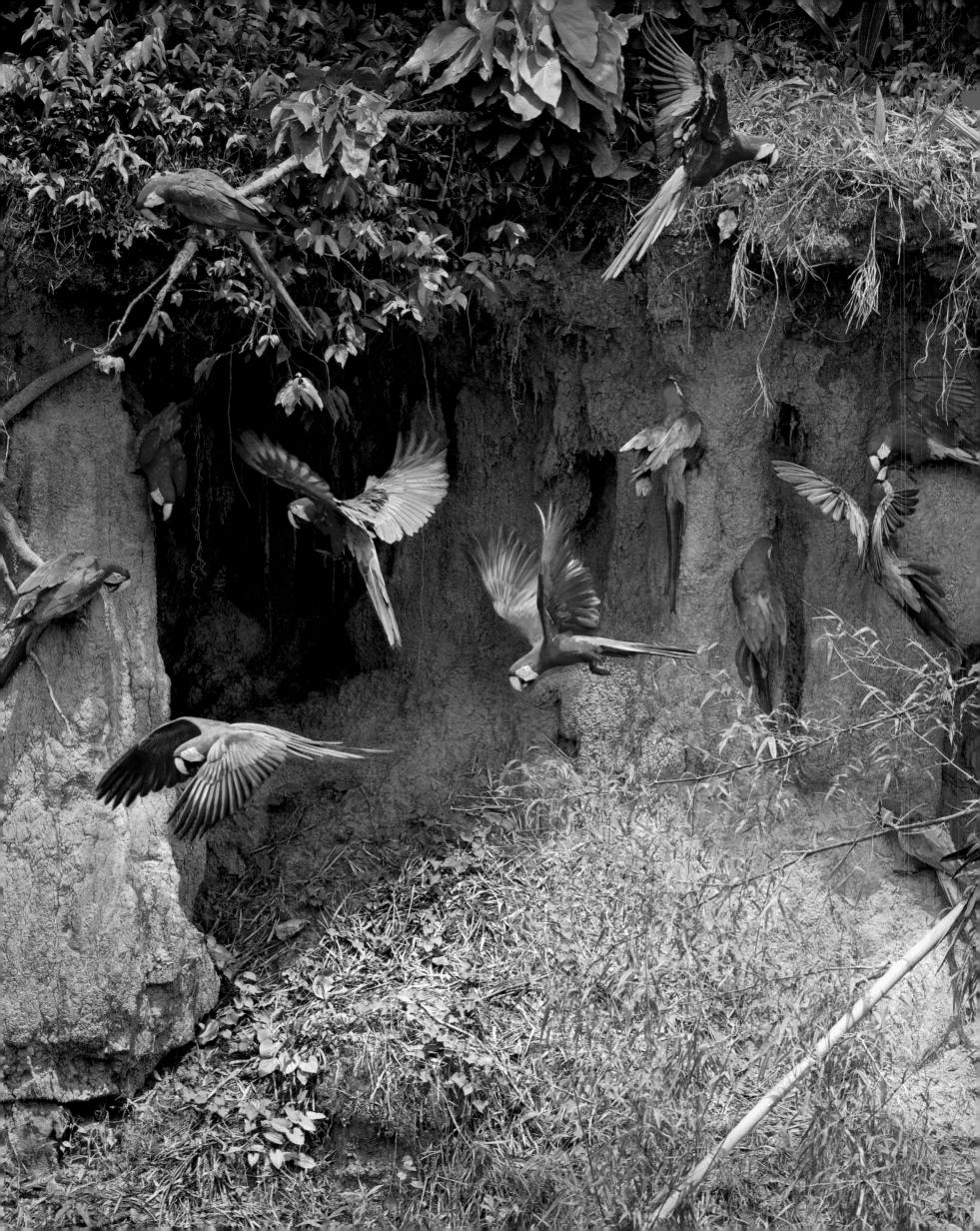

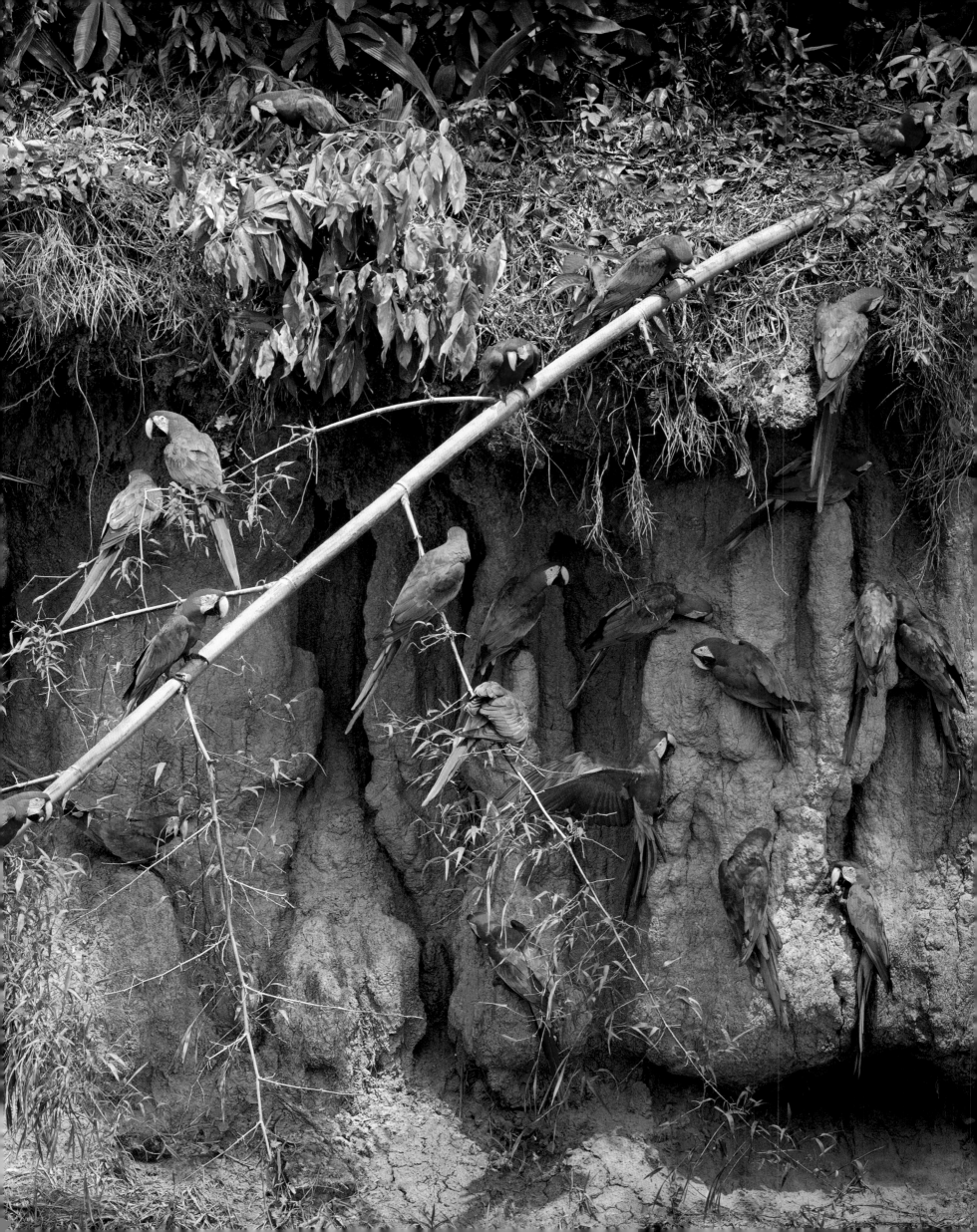

Lost in translation

Military macaws have some of the loudest voices in South America's forests. They do not know their calls innately, but learn them from their parents and peers, which gives rise to local dialects that distinguish one flock from another. In the wild, military macaws remains monogamous for life, and as pets they are exceptionally loyal birds. Their beauty and good companionship puts them in high demand from the pet industry, but many dealers take them from the wild, rather than breed them in captivity.

The connection you might feel to a parrot that returns your greetings is not misguided, as it means you are a part of their flock. Macaws imitate our words, but cannot understand them. If they could, they might persuade us to leave them in their trees, and to leave those trees in the ground.

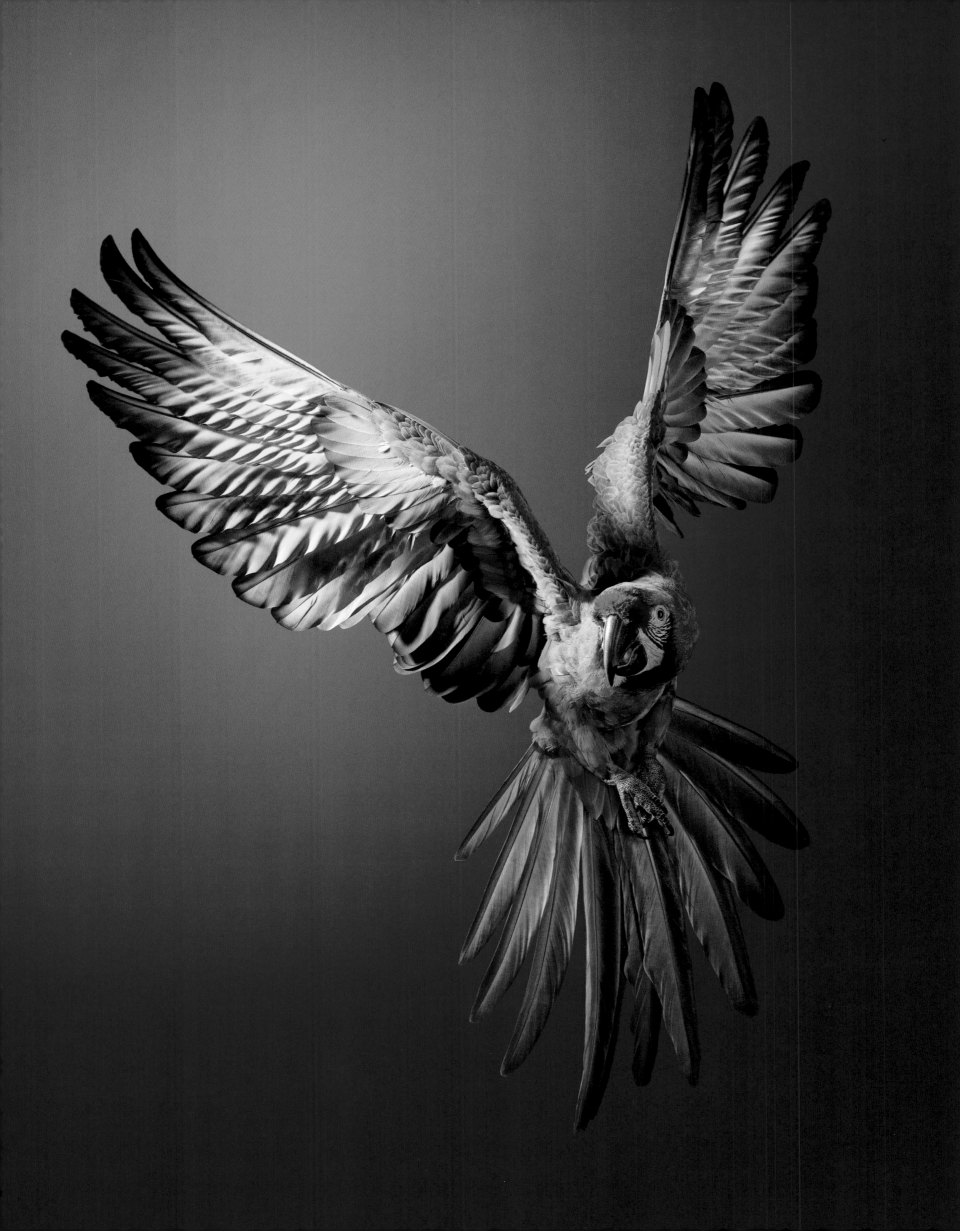

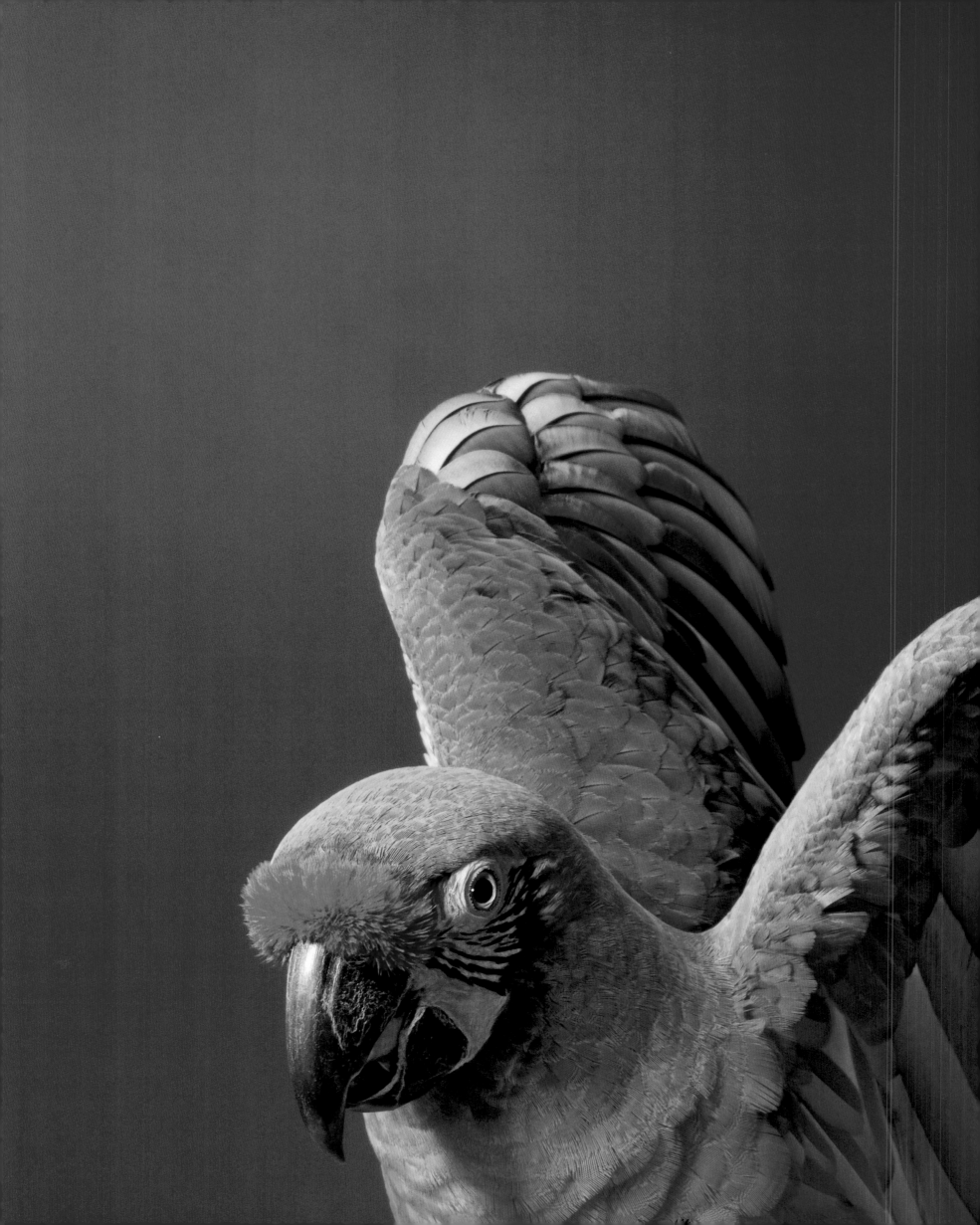

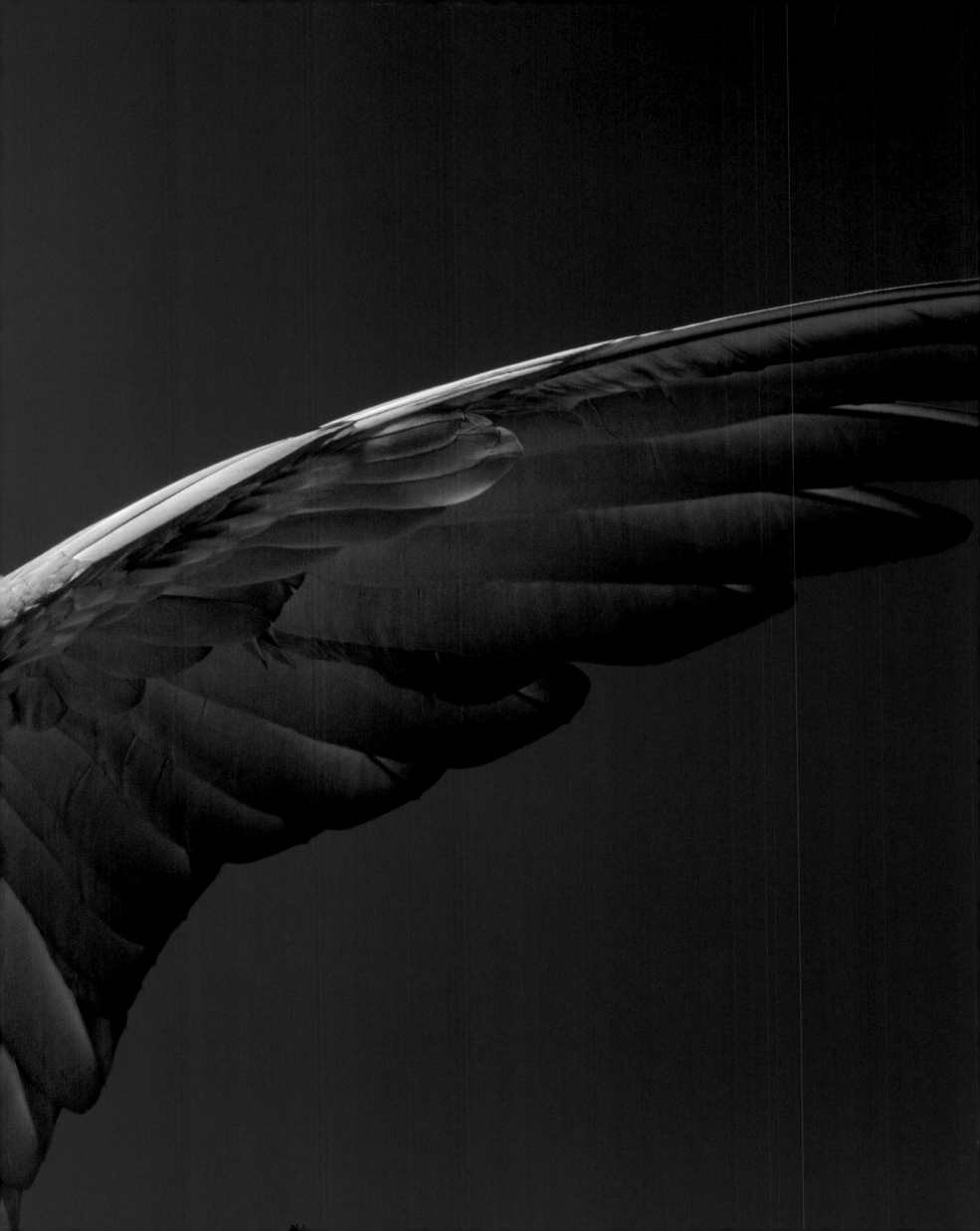

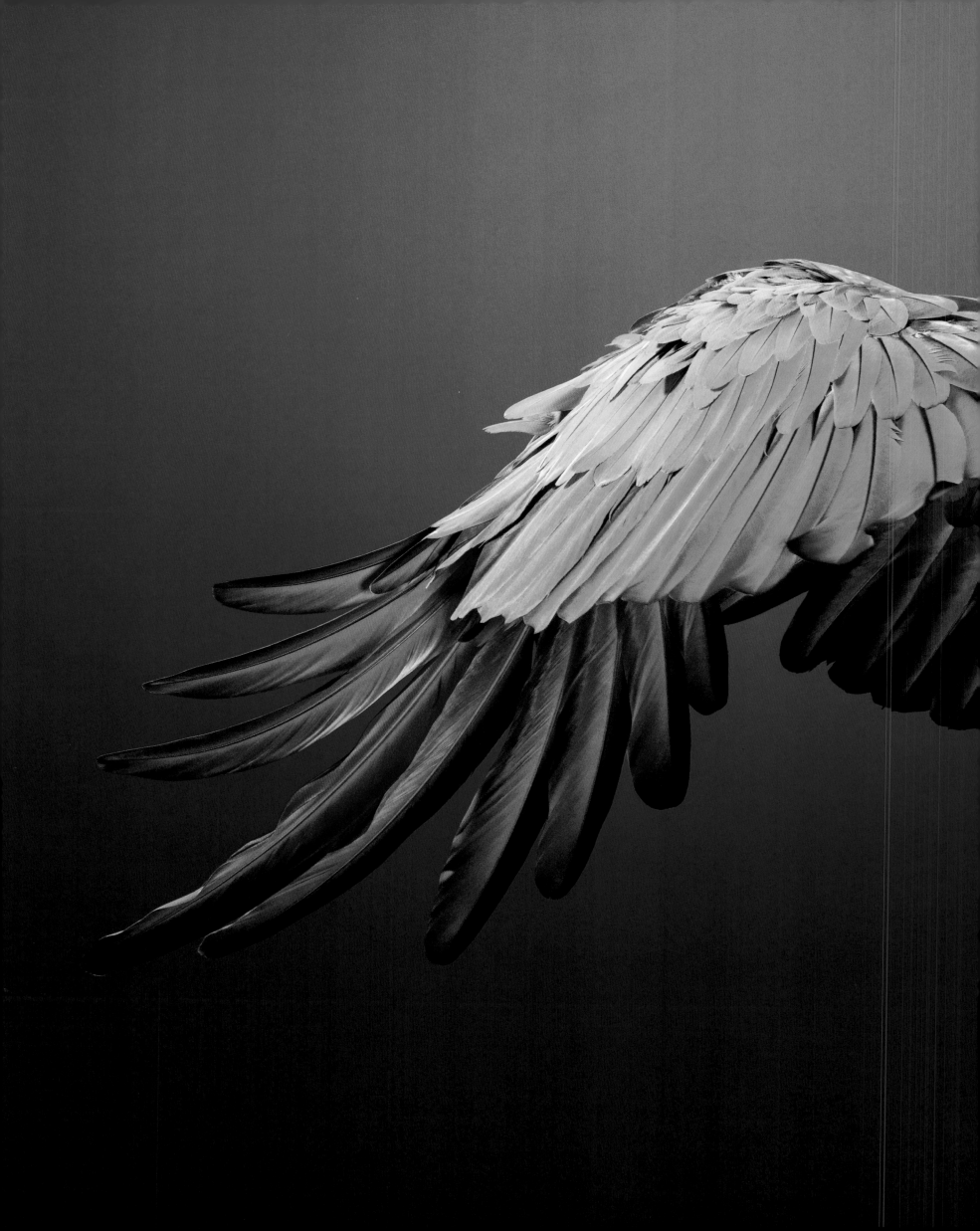

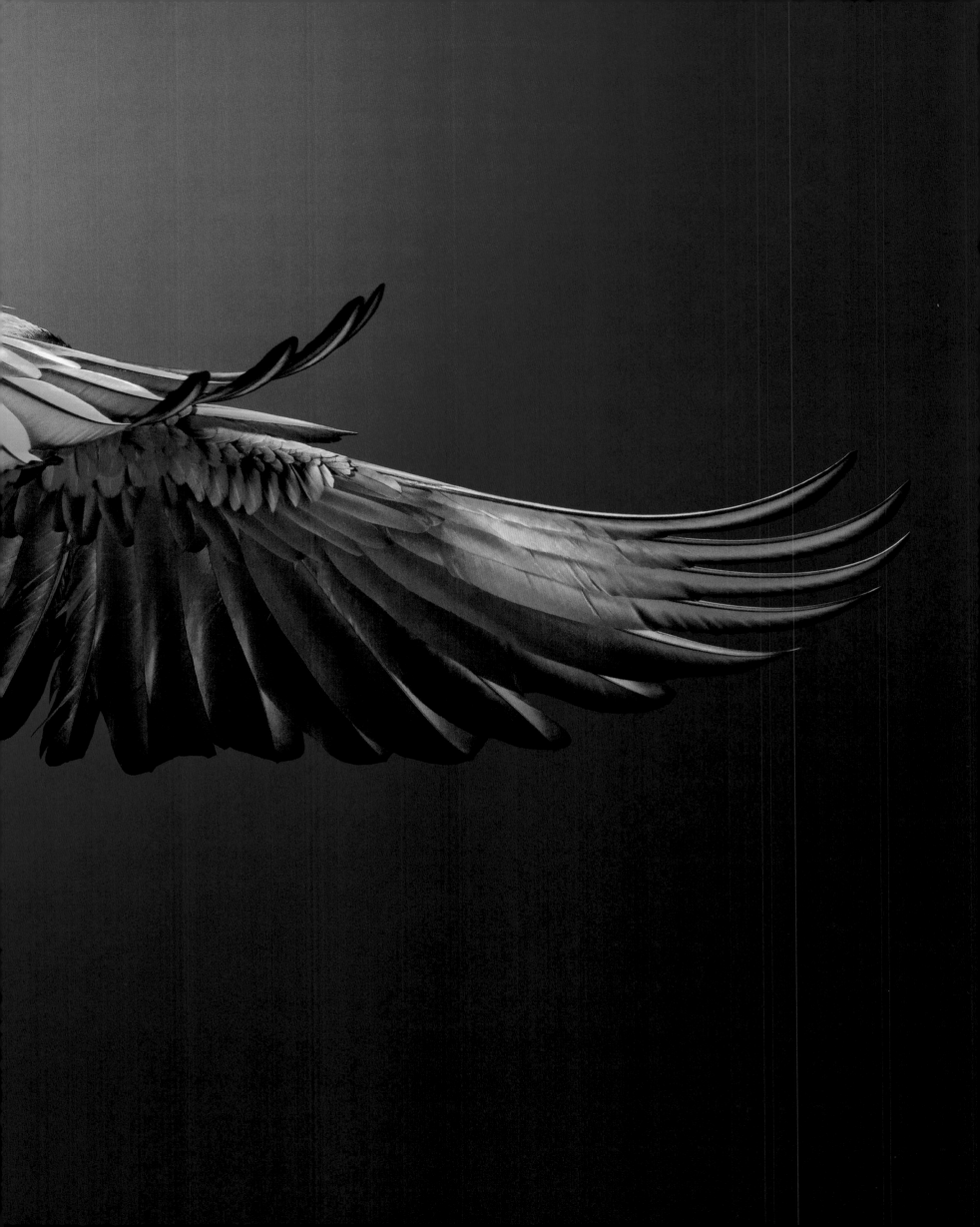

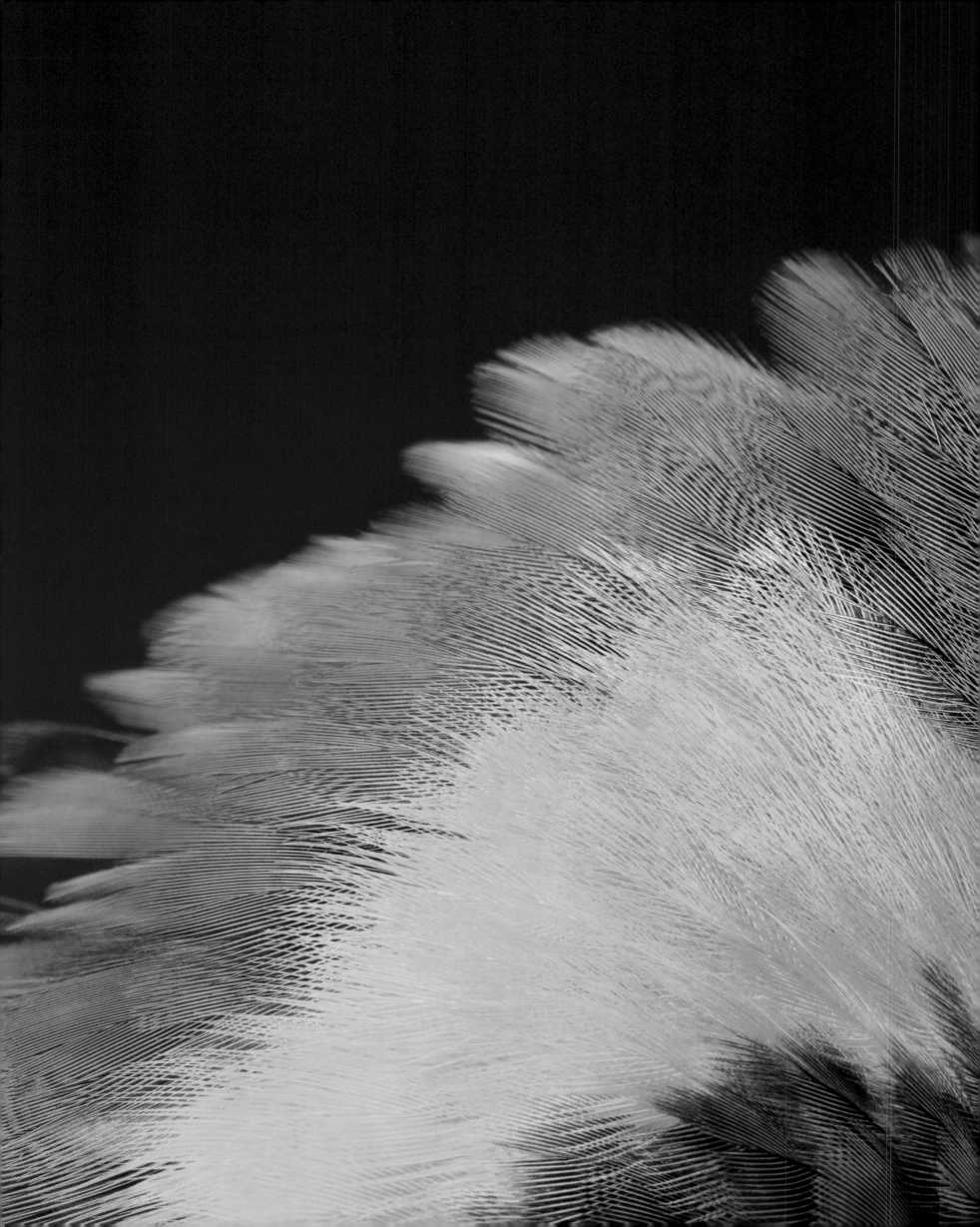

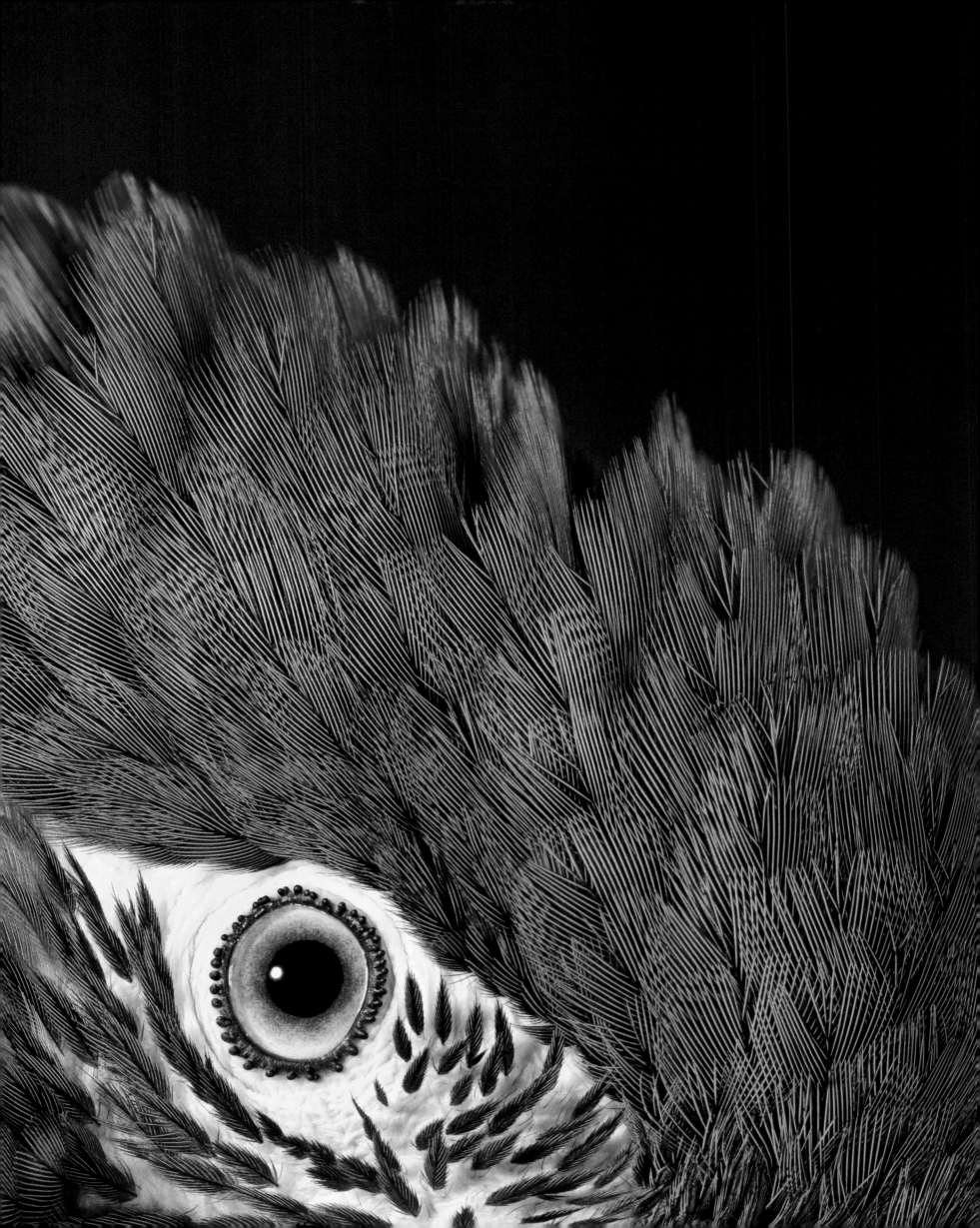

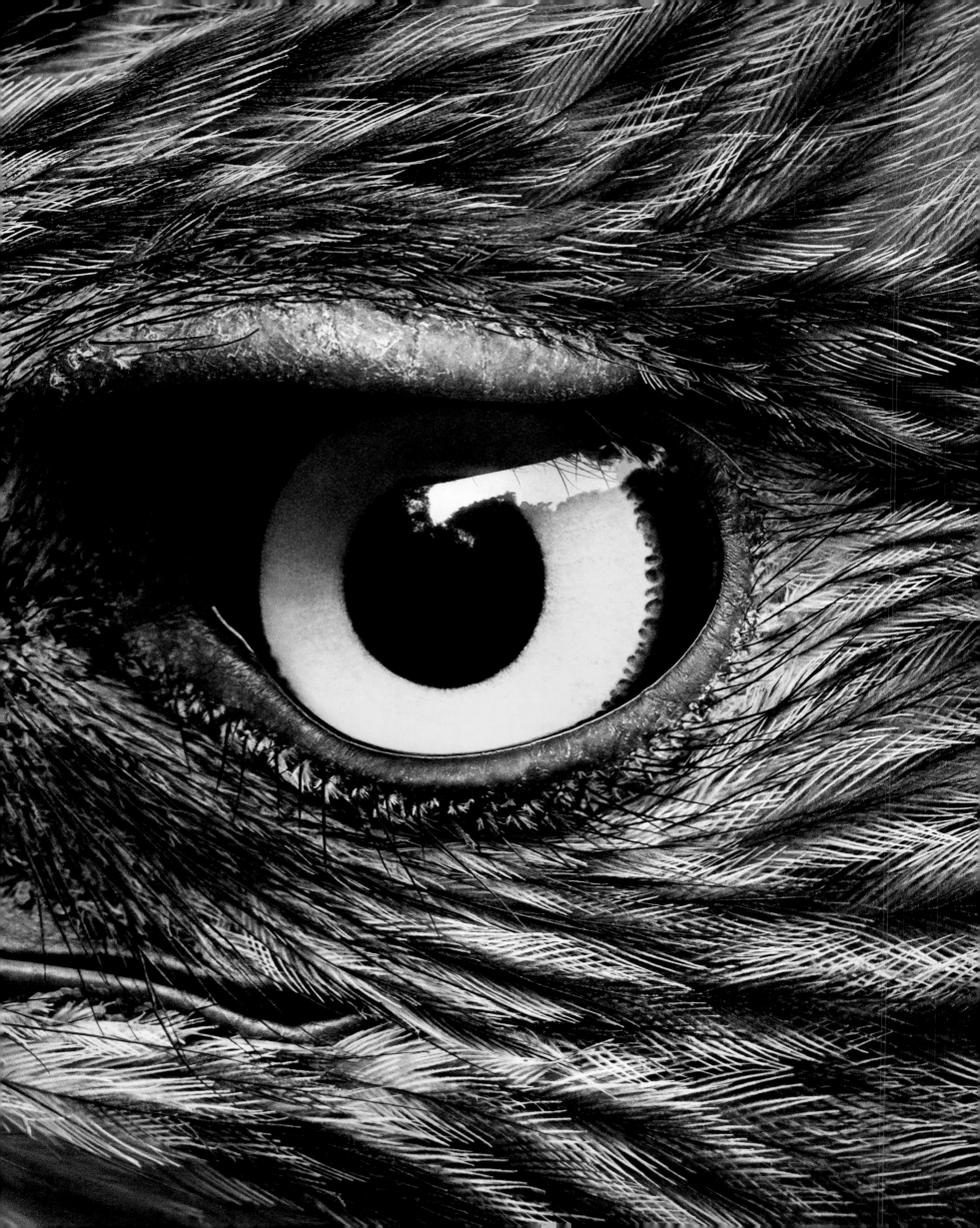

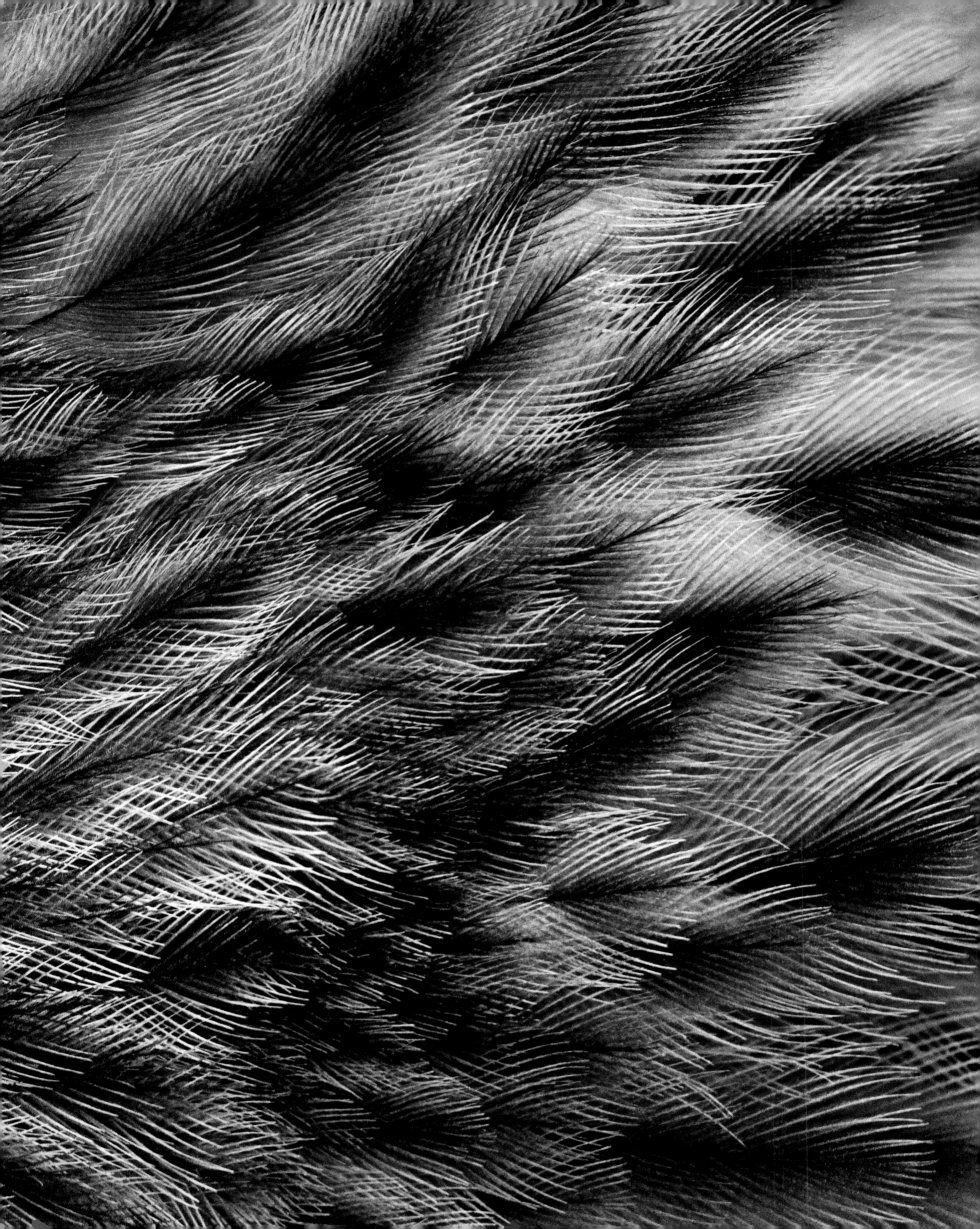

Bird's-eye view

The South Philippine hawk-eagle has only
recently been granted full species status. It
was previously recognized as a subspecies
of the North Philippine hawk-eagle, but
genetic tests have proven its uniqueness,
manifested outwardly in its feathered
legs, the fine black streaks in its feathered
crown, and the distinctive barred coloring
of its chest. It was immediately listed as an
endangered species, as it had lost over half
of its population within three generations,
and up to 90 percent of its historic forest
habitat. Research into this new species must
be upscaled quickly to fully understand
the dangers it faces and the help it needs.
The reclassification suddenly showed how
little we know about this raptor, which now
numbers less than one thousand in the wild.

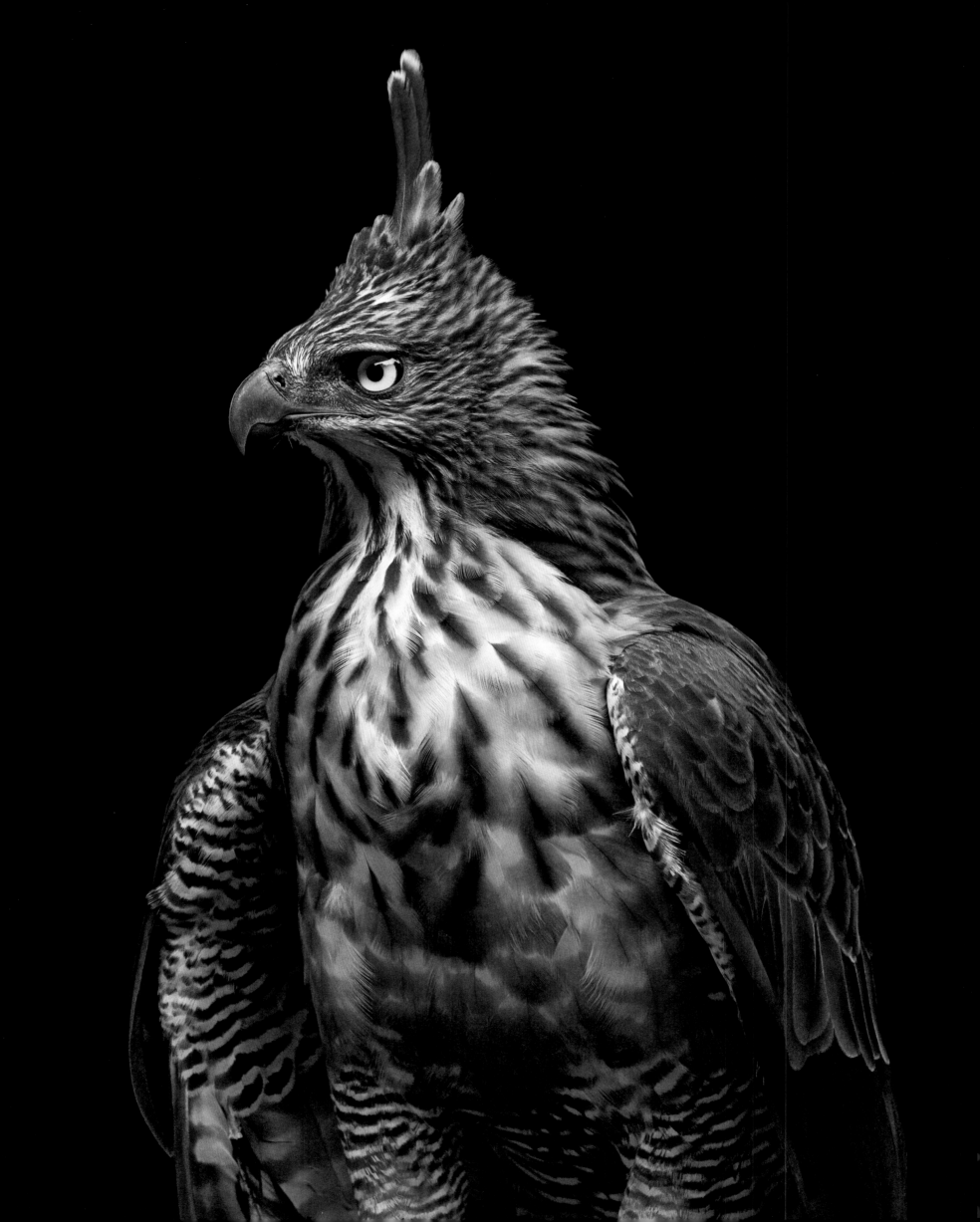

Dizzying heights

The majestic Philippine eagle is one of the world's very largest birds of prey. With short, strong wings it threads its way through the canopy with speed and precision, on the hunt for snakes, lizards, monkeys, civets, squirrels, and birds. The top predator in its range, it also resides highest in the forest, building nests in the tallest trees that stay in a family for generations.

As apex predators, Philippine eagles are particularly vulnerable to toxins from farms and quarries, as these build up in the species ascending the food chain. They are also sensitive to the deforestation of their home nation, as one breeding pair needs 40 square miles (103 sq. km) to survive, and most of their nests remain in unprotected land. These monogamous couples raise just one chick every two years, so their falling population will struggle to rebound. Now numbering less than one thousand in the wild, and sparsely populated in deteriorating forests, they are perhaps the most critically endangered eagles in the world.

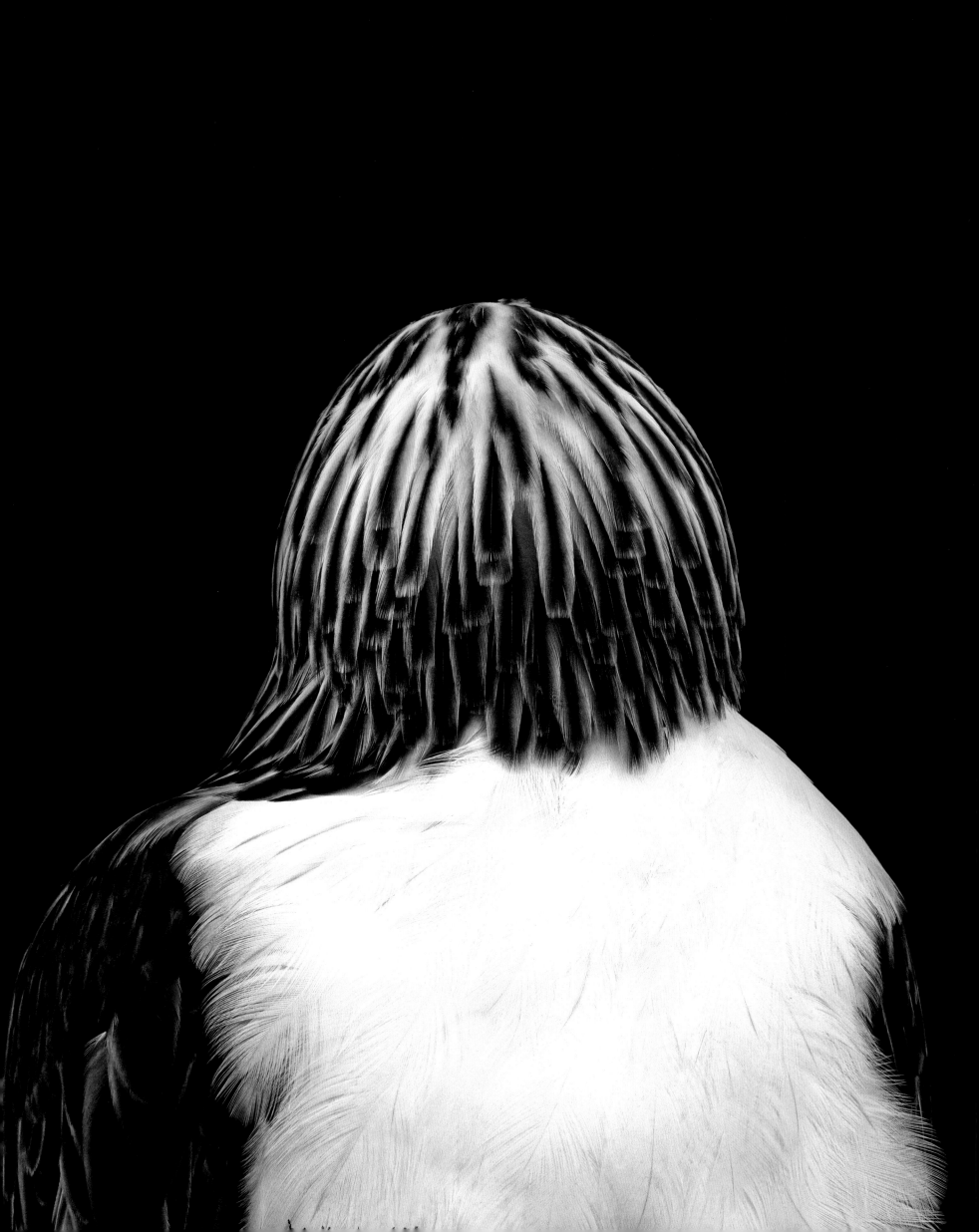

National pride

Preventing the extinction of Philippine eagles will require cooperation at a local level and on a national scale. They became the Philippines' national bird in 1995, but people continued searching the forests to hunt them. Now, on Mindanao Island, 350 Indigenous people have been employed by a local non-governmental organization to prevent poaching and replant the forest. Like the eagle, these people's ancient homes are being destroyed by outsiders, so they see their fortunes as linked to the eagle's fate, especially as it is beginning to bring revenue through eco-tourism. In 2016, the government suspended half of the country's large-scale metal mines over fears of environmental damage, and if forests are protected and replenished, the Philippine eagle, and all its neighbors, may begin to recover.

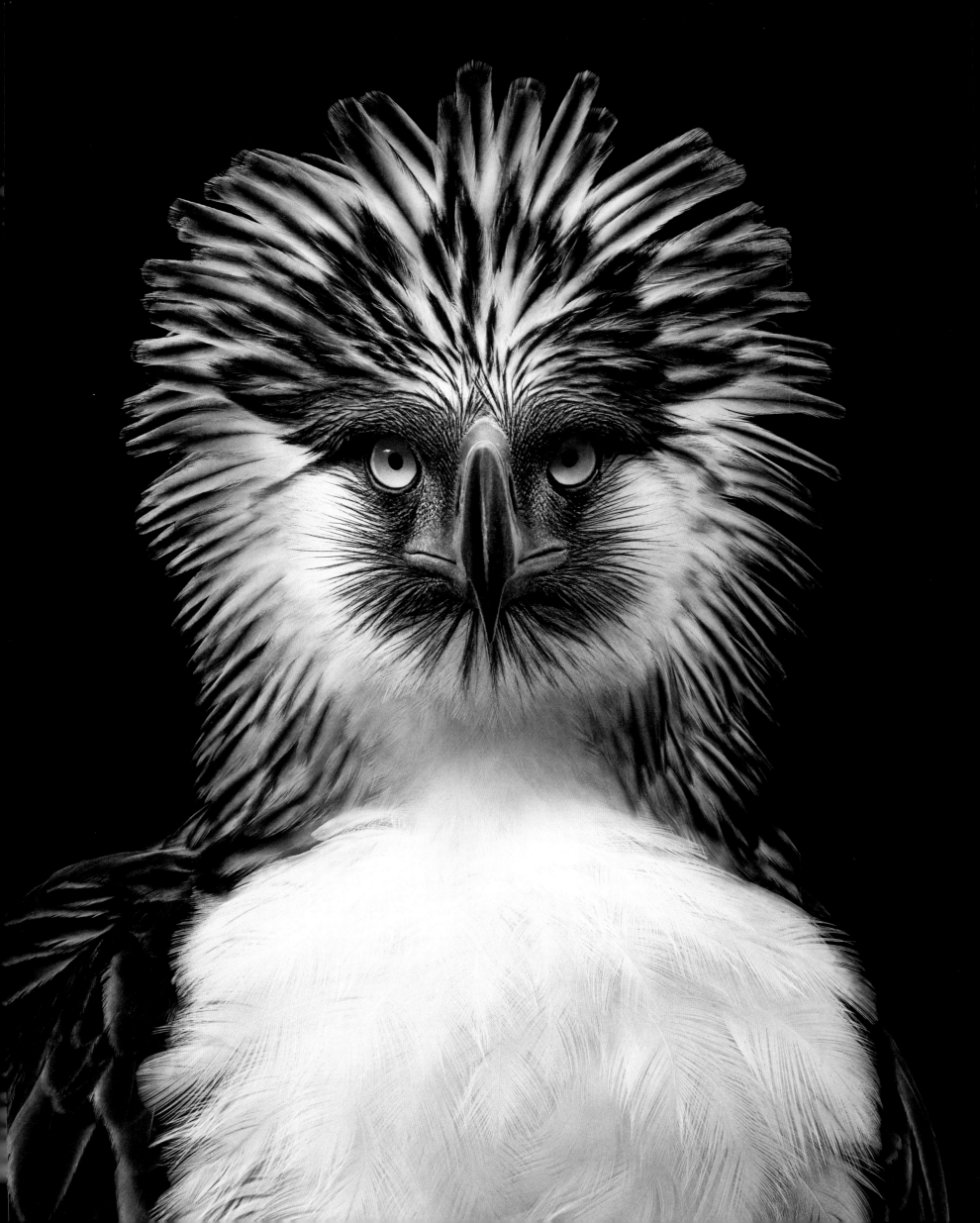

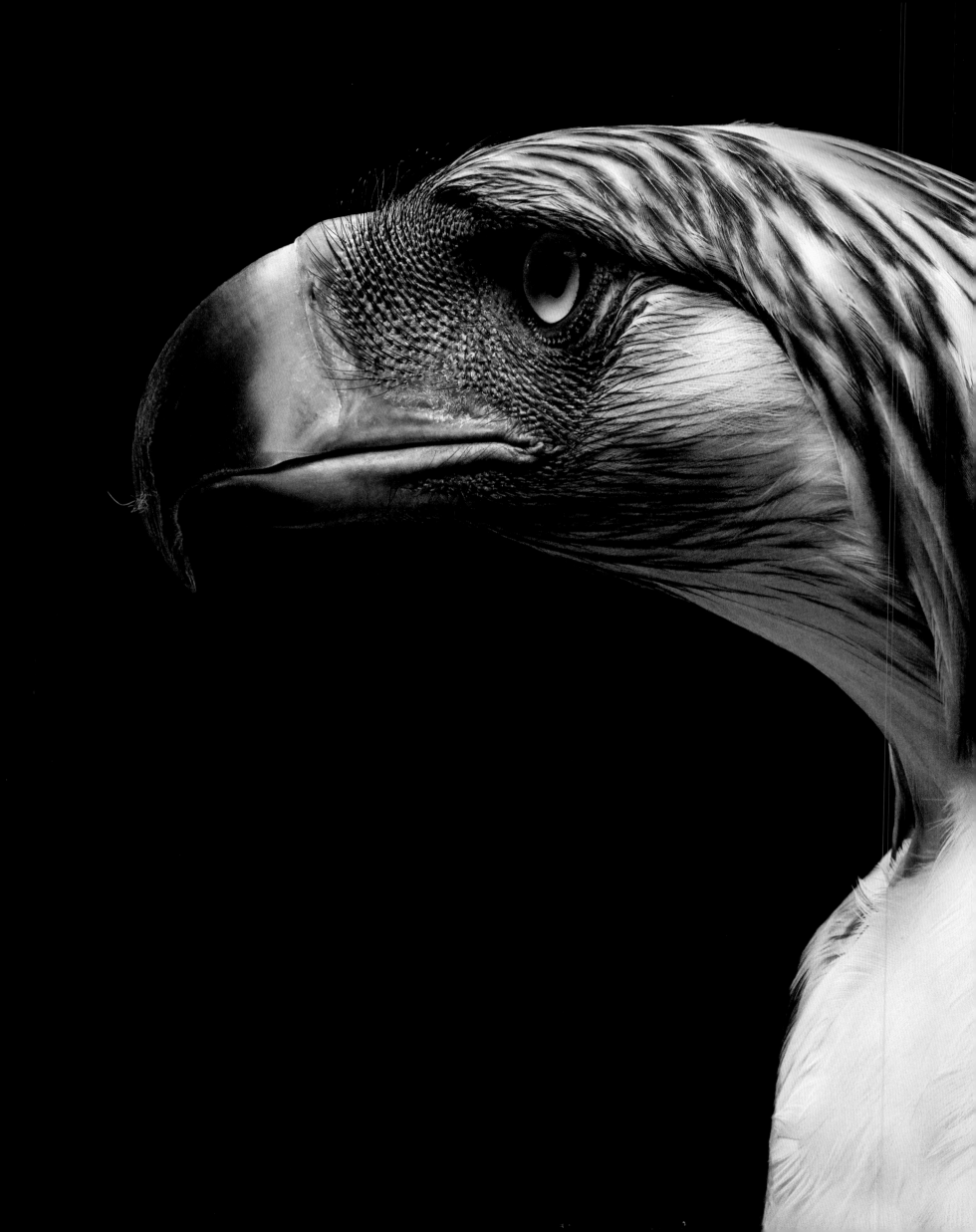

A different perspective

Shoebills are quiet, solitary birds that live and hunt fish in the swamps of East Africa. Local human conflict has proliferated the ownership of guns and intensified the pressure of poaching, but it is predominantly habitat loss that has made shoebills vulnerable to extinction. Wetlands—even those in national parks—have generally been disregarded as wastelands, and marshes are often drained for conversion into pasture or even used as waste-disposal sites. This not only endangers a multitude of species, but threatens the human settlements that ultimately depend on the source of water.

To preserve their environment, local farmers are increasingly rearing goats rather than cows, as goats can coexist with swamplands. They also keep more honey bees and cultivate more fruits, generating income while simultaneously strengthening their natural environment, which, in turn, provides further economic opportunities. This practice allows nature and farmland to become mutually beneficial, and equally prosperous.

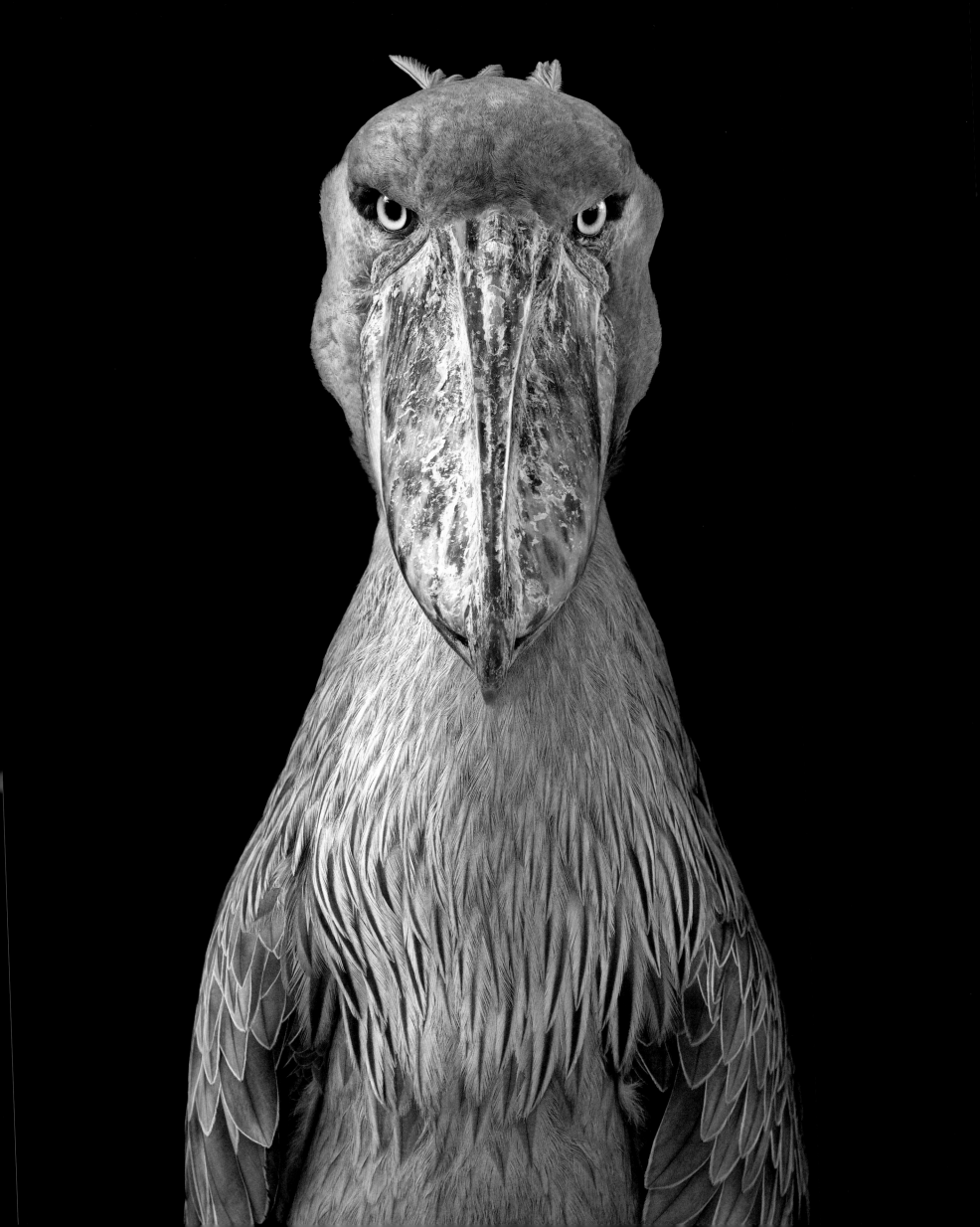

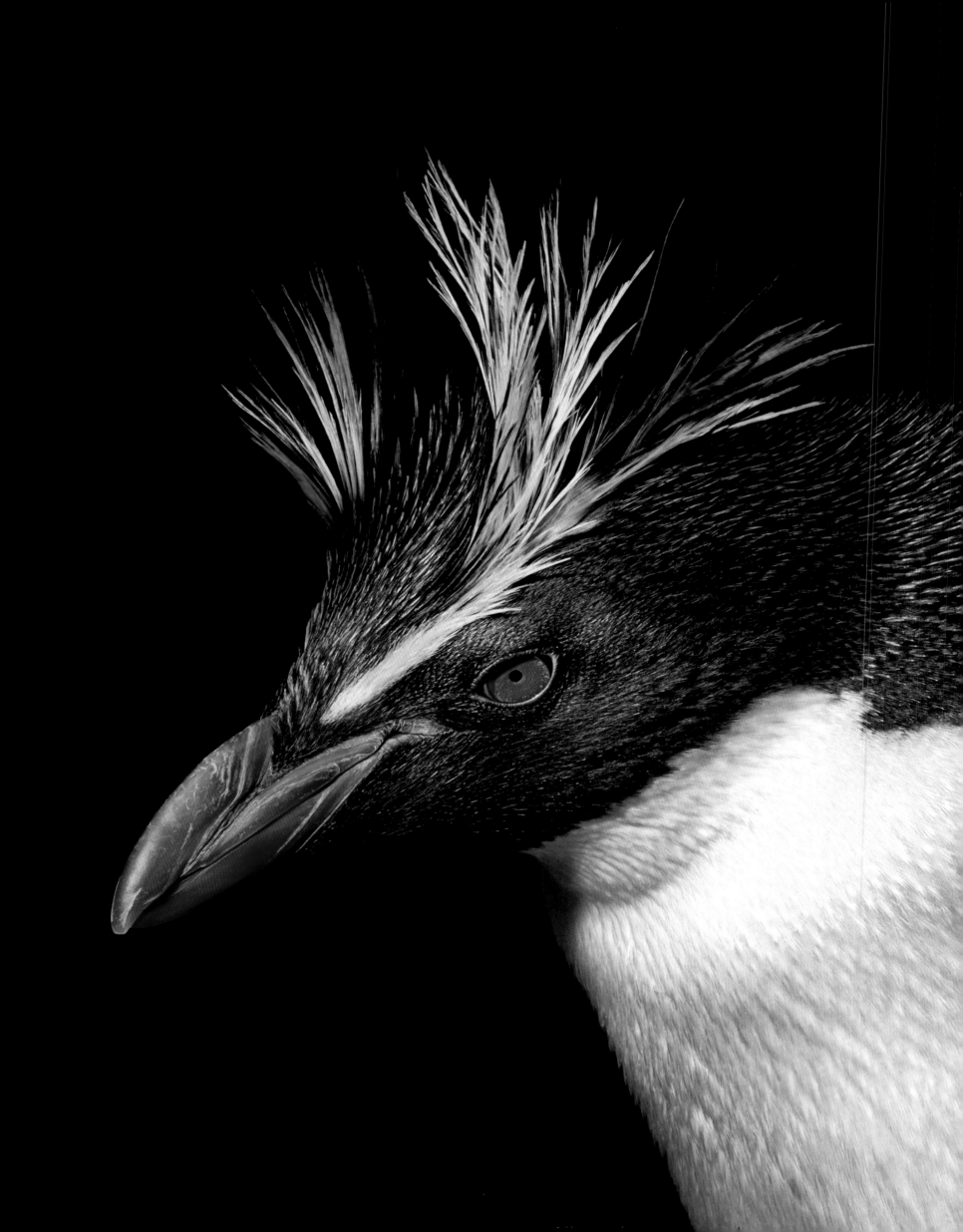

Out of reach

Northern rockhopper penguins are recognized around the world for their hairstyles, but as they live just north of the Antarctic Circle, on remote islands in the Atlantic and Indian Oceans, we are still gathering precise data about their ecology. Certainly, however, their population has declined by over half since 1980. We have overfished many of their prey species, and the growing population of subantarctic fur seals competes for the same diet. Meanwhile, the penguins' nests are robbed by mice and rats that have reached the islands from cargo ships.

In March 2011, the MS *Oliva* ran aground at the archipelago that supports most northern rockhopper penguins, spilling more than 800 tons (726 tonnes) of fuel oil and coating some twenty thousand individuals. The practice of collecting eggs for human consumption has been banned while the penguins recover, but with more and more ships coming through the area, chronic oiling and potentially catastrophic spills are a growing threat.

National treasure

The red-crowned cranes of northeast Asia are best known for their graceful courtship dances: they arch their necks and then leap into the air, floating back to the ground with a flap of their wings and then tiptoeing around their partner. Hunted for their splendid plumage, the resident population of Japan's Hokkaido Island fell as low as thirty during the 1920s, but local farmers stepped in to save them, and they still feed them every morning to this day. Having passed through a population bottleneck, these endangered cranes have been left with little genetic diversity, making them vulnerable to outbreaks of disease. Meanwhile, the loss and conversion of their wetland habitat remains a universal threat. On the continent, red-crowned cranes are still in decline. Ninety-two percent of Chinese habitat has been lost in the last thirty years, and what is left is surrounded by towns, farms, and poisonous oilfields. Their best chances of survival may be in Japan, where they are most valued by the national community.

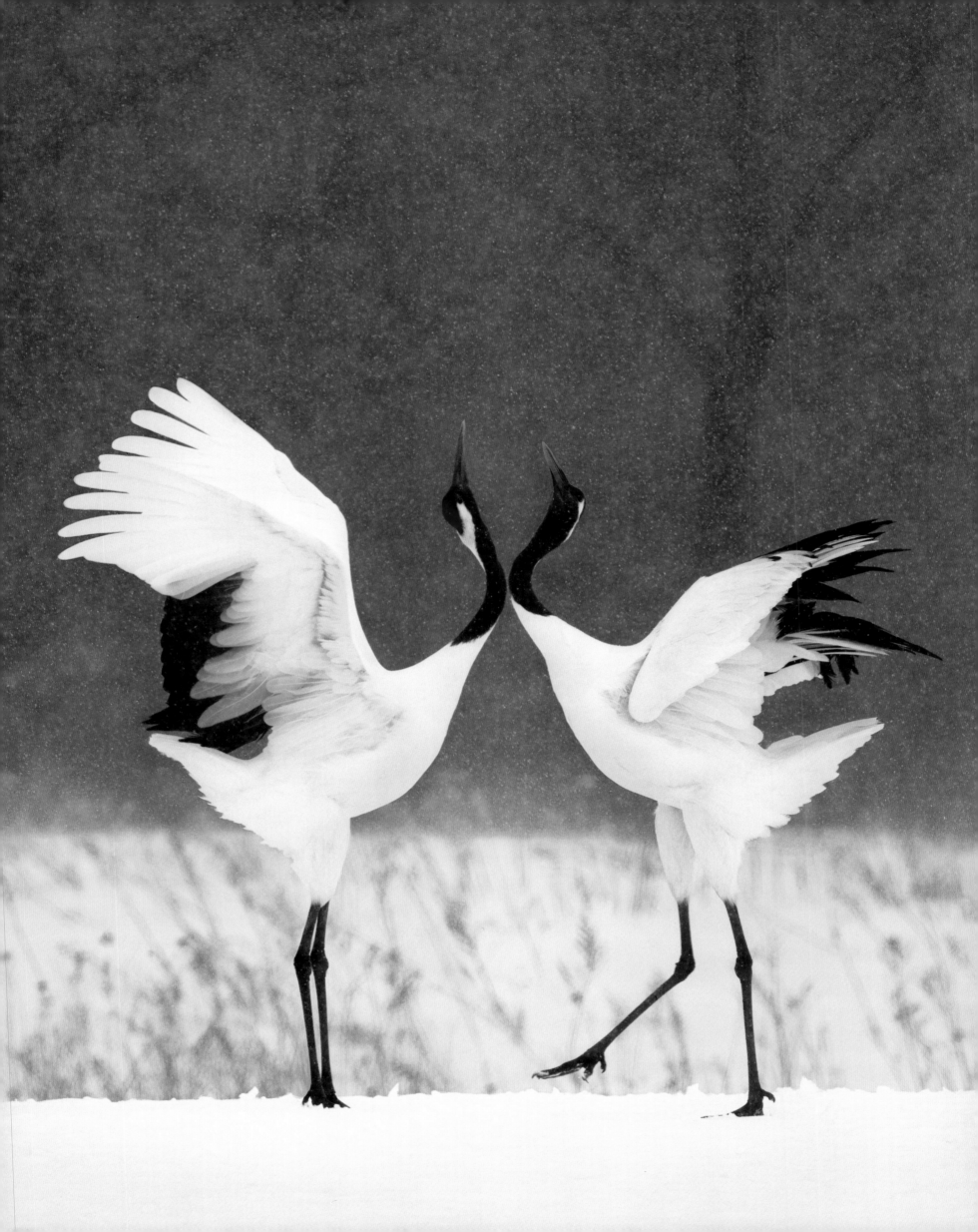

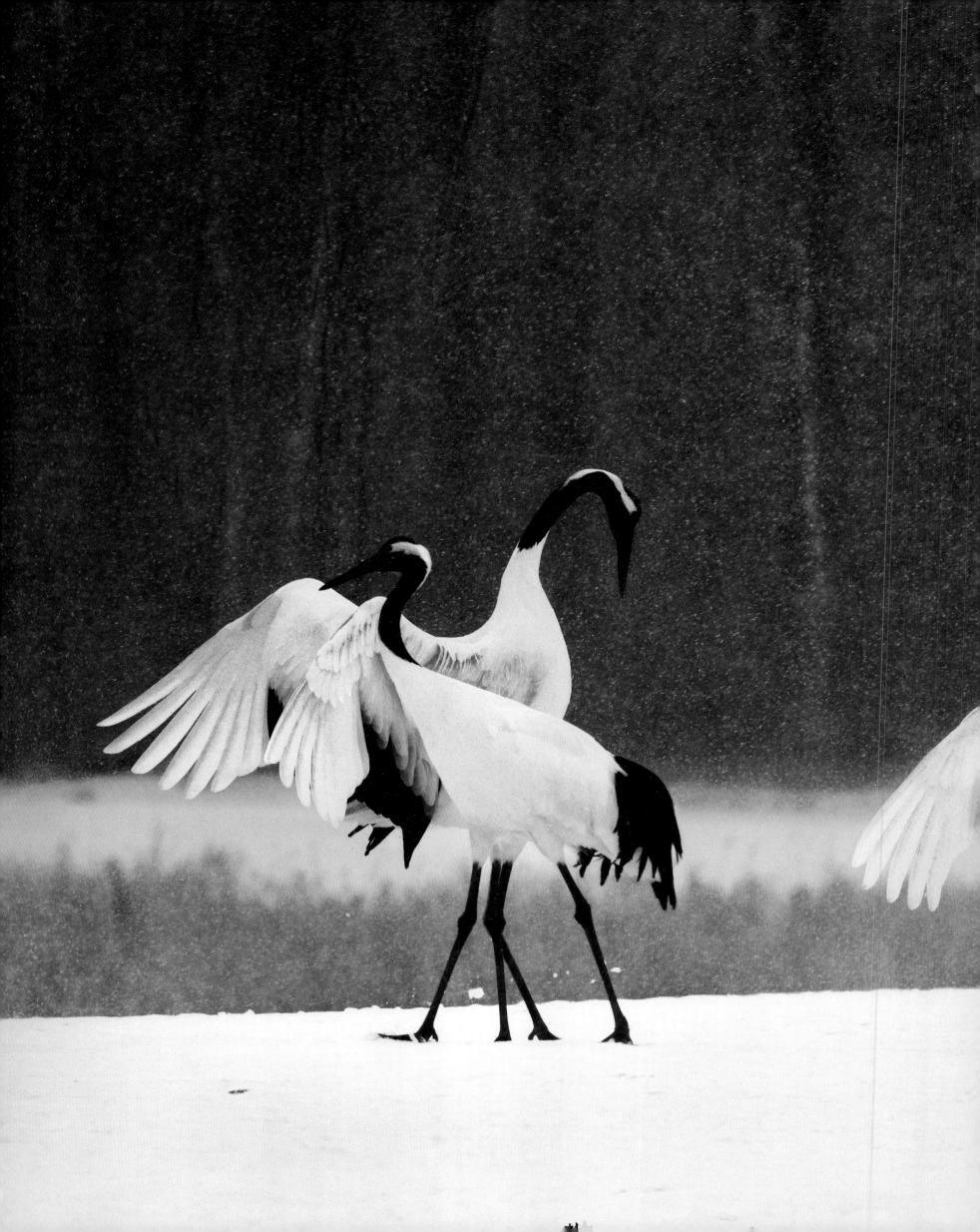

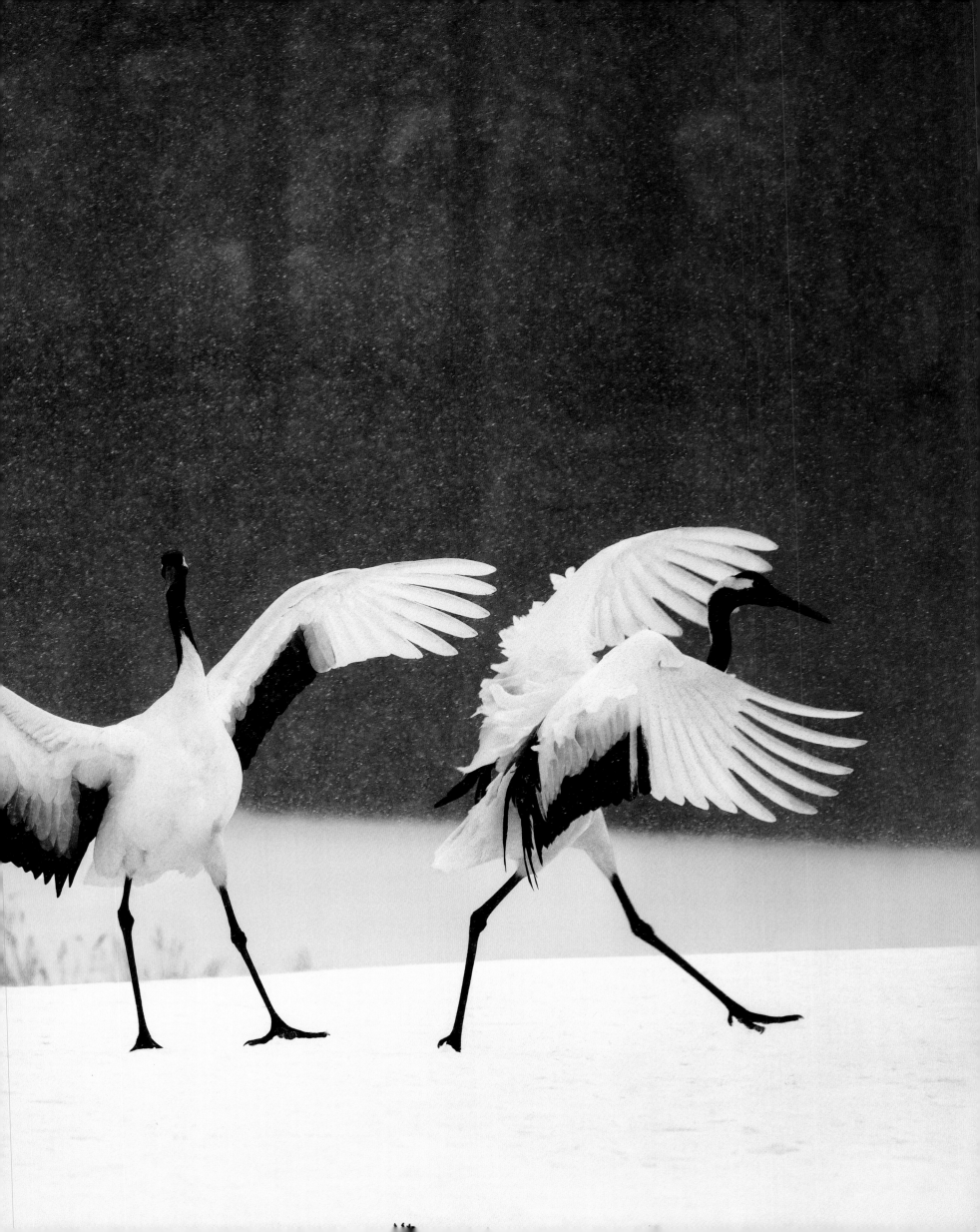

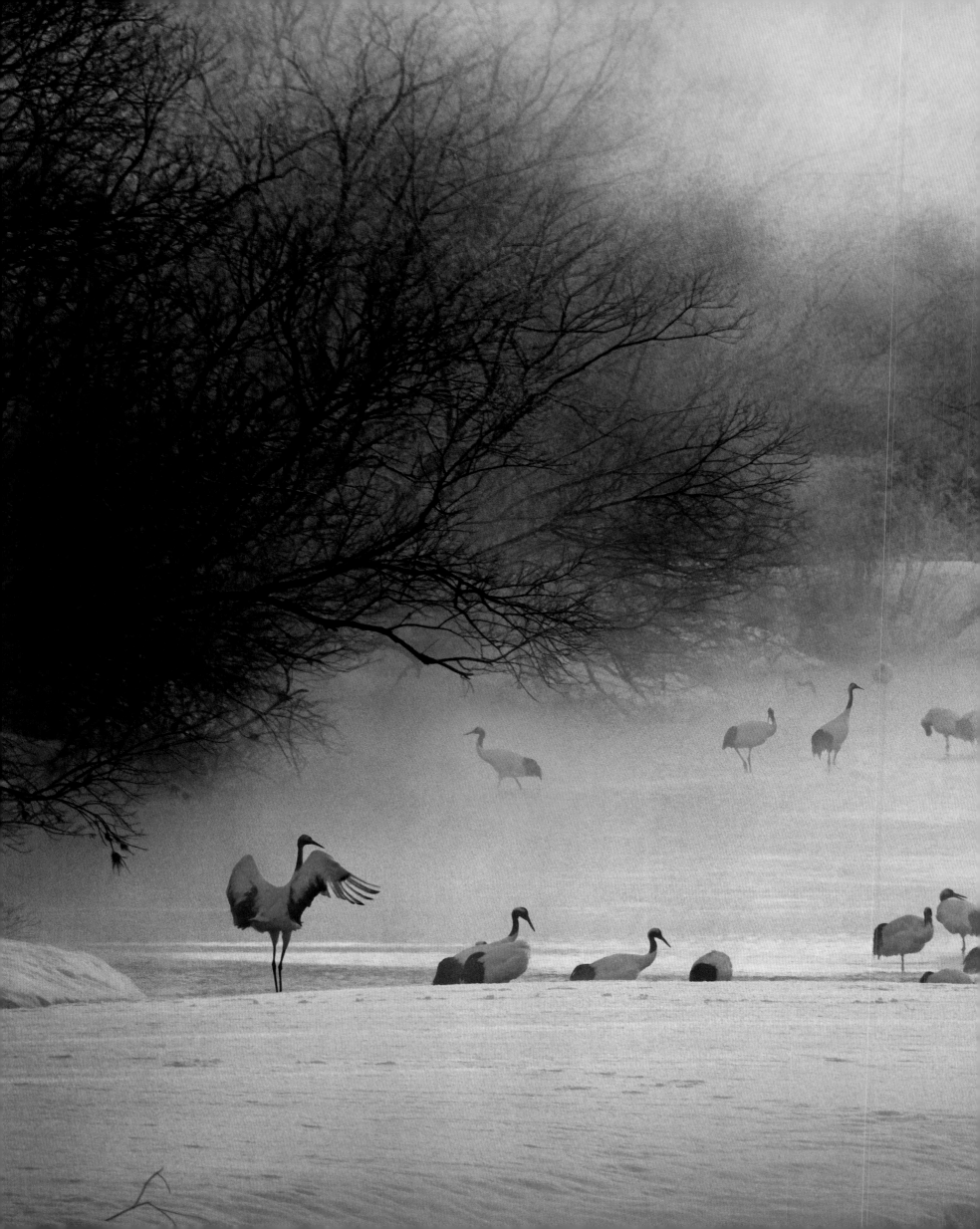

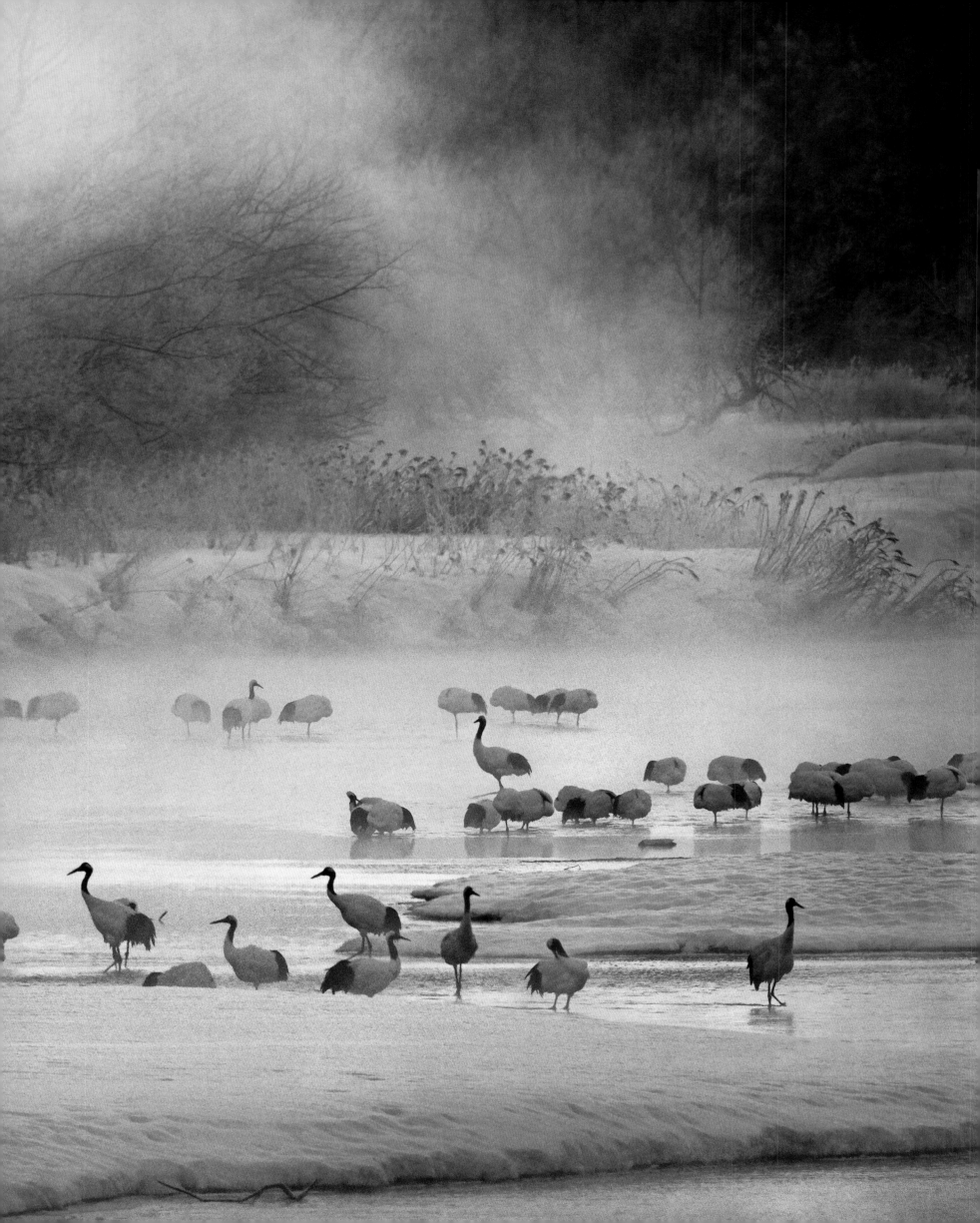

Paradox

In May 2015, at the port of Surabaya, Indonesia, customs officials found twenty-four yellow-crested cockatoos stuffed inside plastic water bottles, being smuggled abroad to be sold as pets. While those cockatoos were lucky to be returned to the wild, it is a very rare success story. These cockatoos are protected by law, but each one sells for almost half of the average Indonesian annual salary, so thousands are stolen from the wild every year. Now, they are critically endangered and their numbers are still falling. This tremendous loss can be attributed almost entirely to the pet industry and our interest in these wonderful birds. We adore parrots and, in fact, they in turn can develop a particular affection for us, but we must recognize them as living beings, and not as living ornaments.

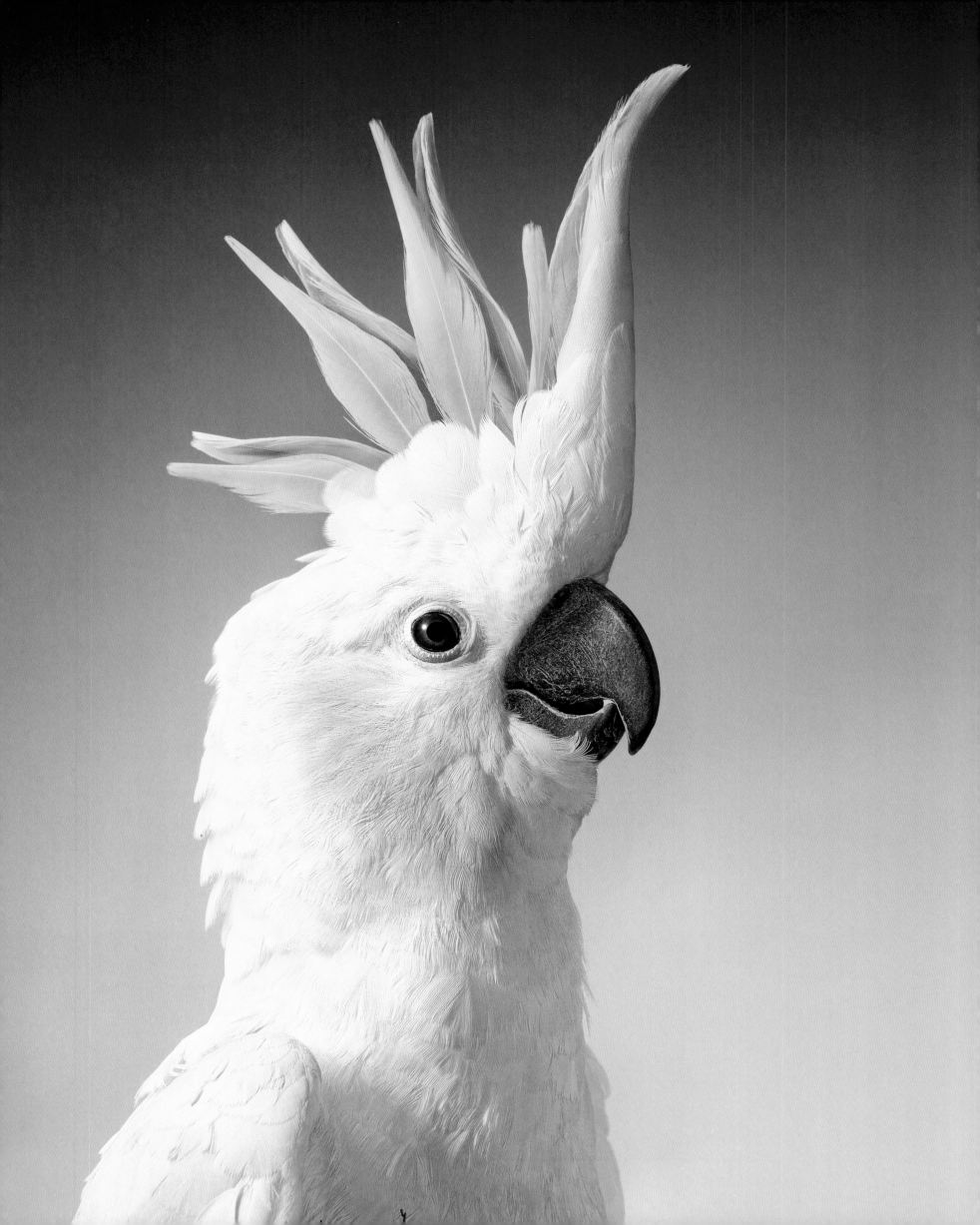

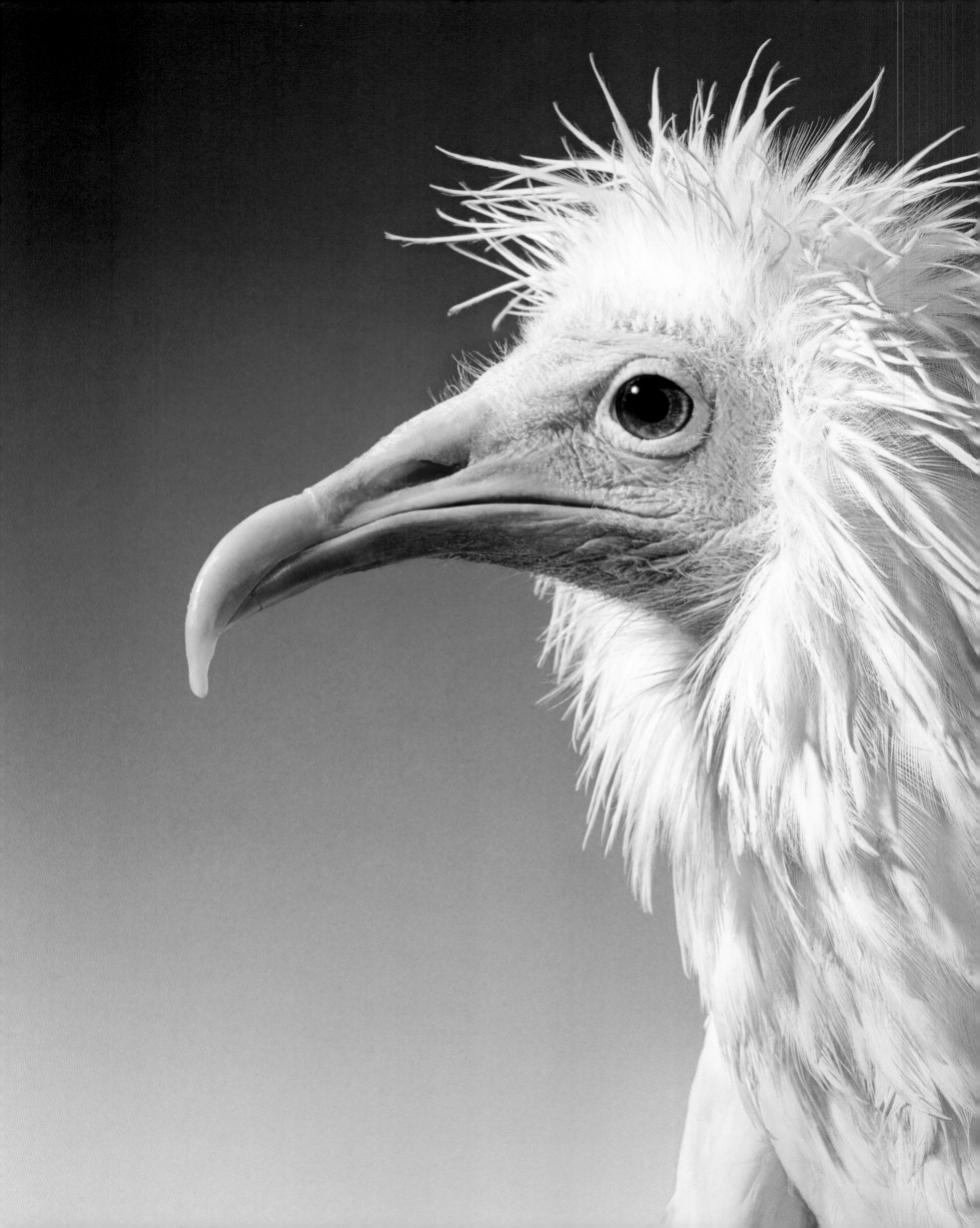

Nature's cleaners

The distinctive yellow face of the Egyptian
vulture is a result of ingesting the carotenoid
pigments in animal dung. Feeding on feces and
carrion, these birds are an essential resource in
waste management from southwestern Europe
through to India. Vultures' digestive systems
can destroy dangerous pathogens, but they
cannot cope with poisons. Today, vultures are
scavenging on dead farm animals filled with
drugs and others shot with lead bullets. As a
result, their populations are a fraction of what
they were thirty years ago. Other scavengers
such as dogs and rats are filling the gaps left
by their decline, but rather than eliminate
pathogens, they carry them and spread disease.
Covering for vultures' lost services in disease
prevention costs our governments tens of
billions of dollars per year. In ancient Egypt,
they were worshipped, and modern society
would do well to hold them in higher esteem.

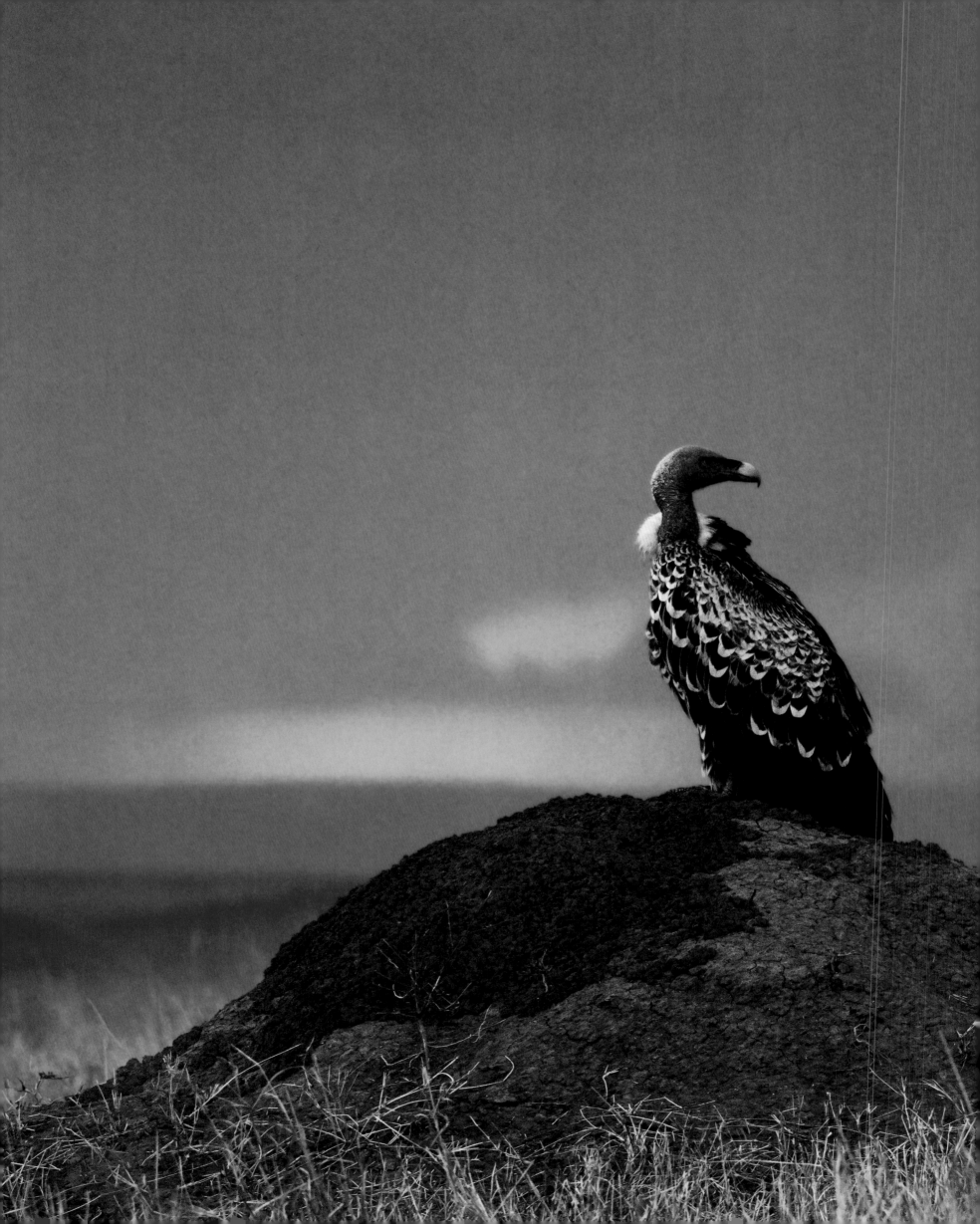

Funeral rites

Throughout most of the world, the death of a large animal is quickly marked by a circling kettle of vultures. They alert each other to a new carcass and then gather in their hundreds before descending to feed. They are icons of death in popular culture, but are in fact great symbols of life. Not only do they suppress the spread of disease in innumerable communities and ecosystems, they also protect endangered mammals by alerting wardens to the location of a poacher's kill. Unfortunately, the poachers are retaliating by lacing their kills with cyanide, so that one dead elephant may directly kill hundreds of adult vultures. Of all the world's vulture species, almost half are now critically endangered.

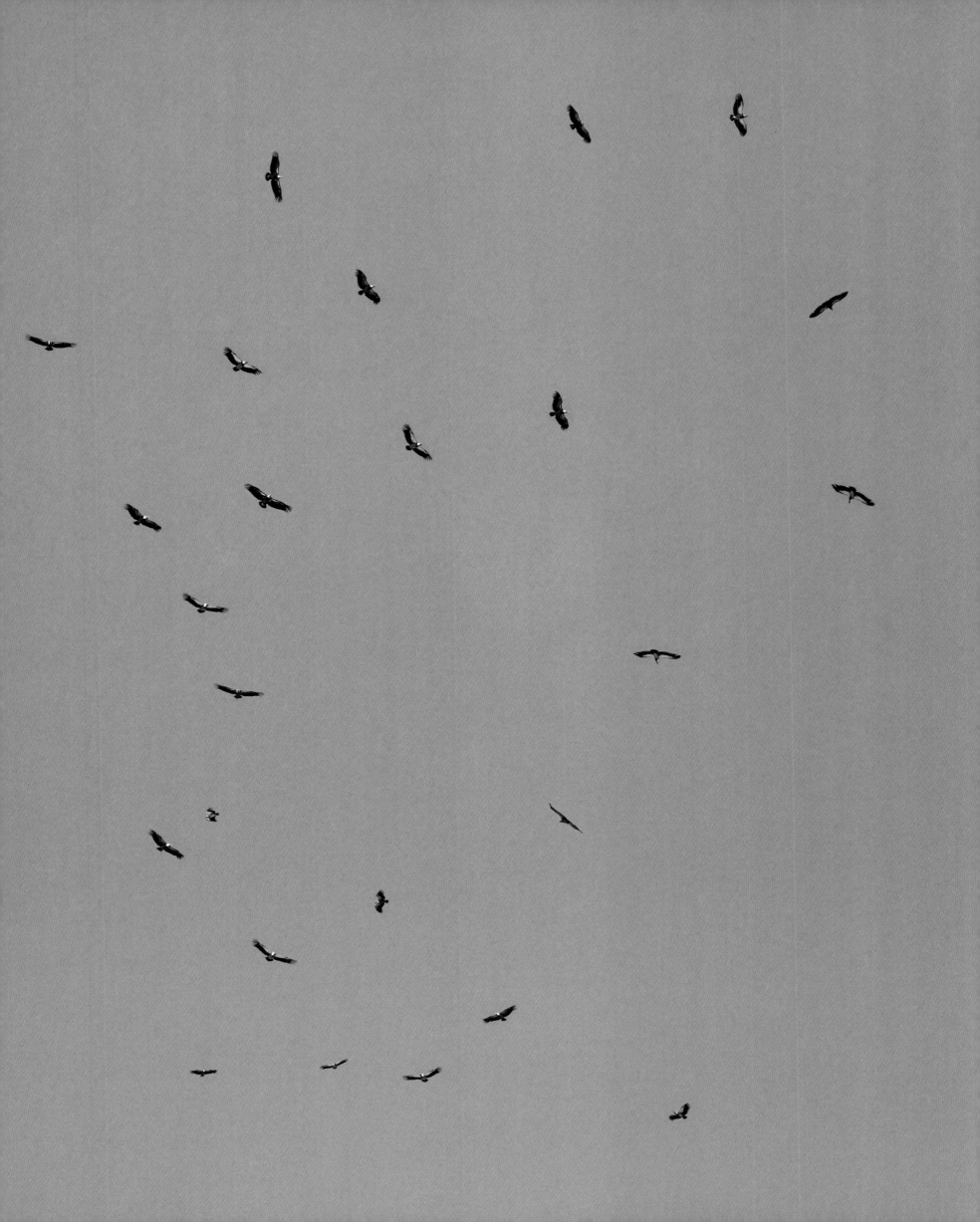

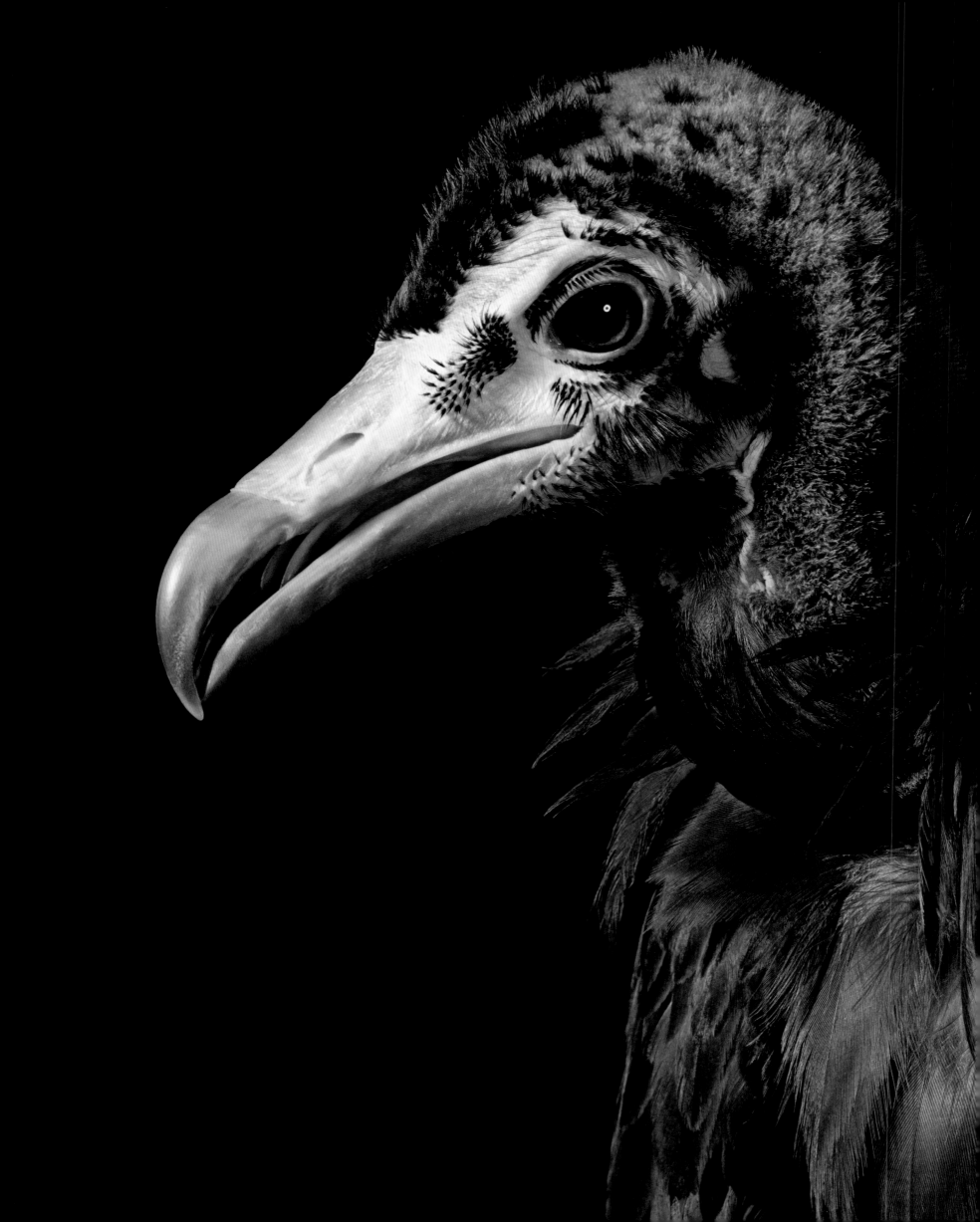

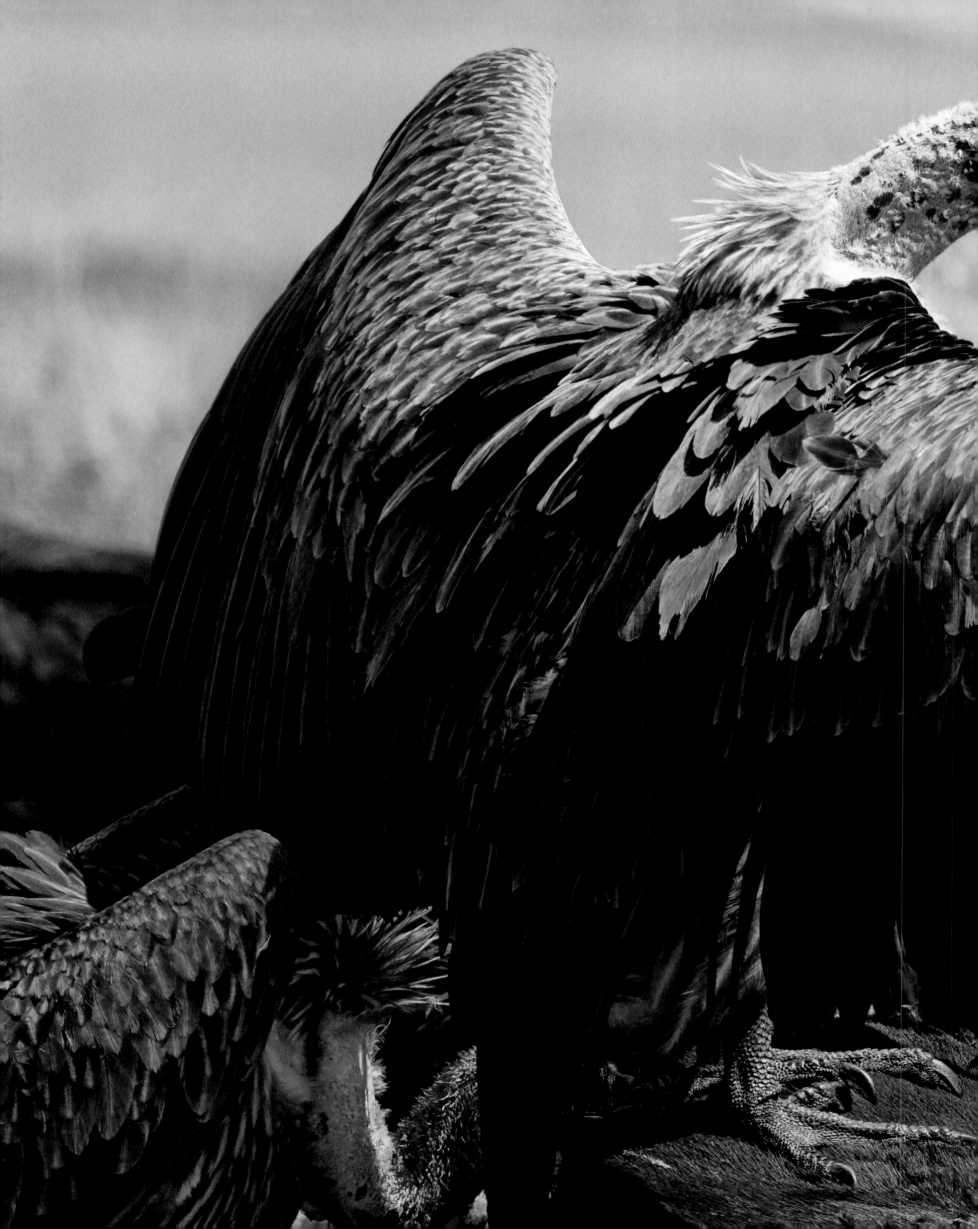

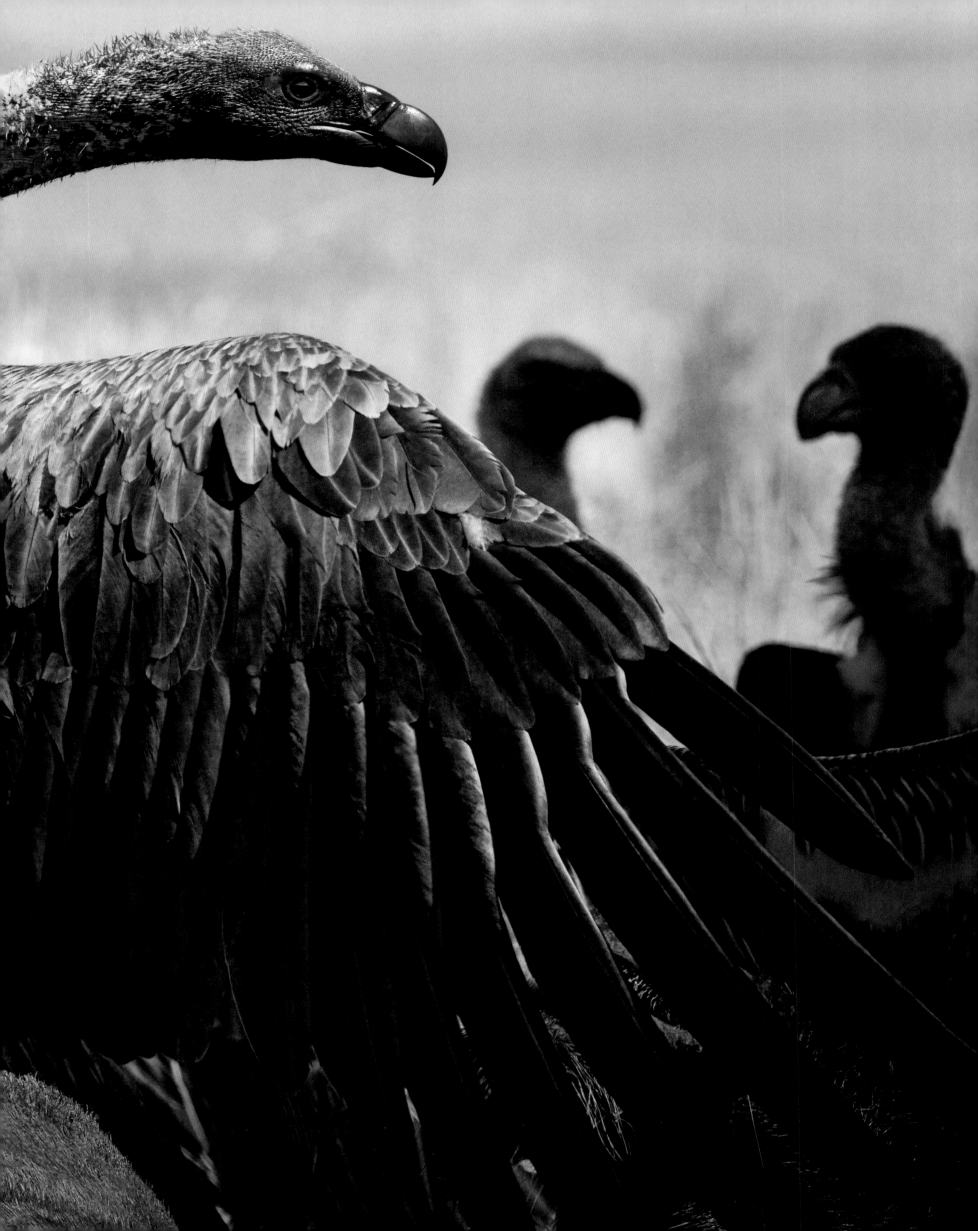

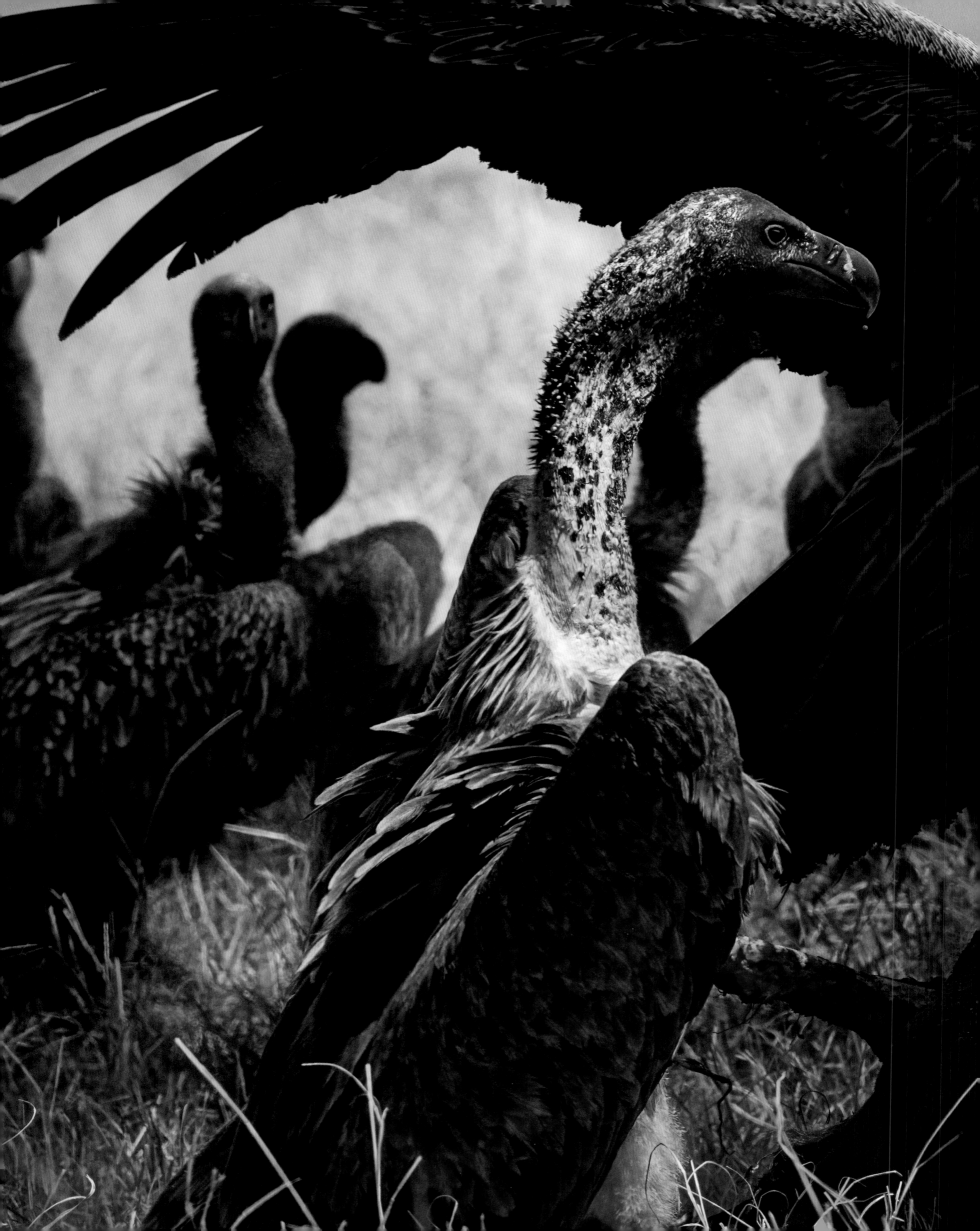

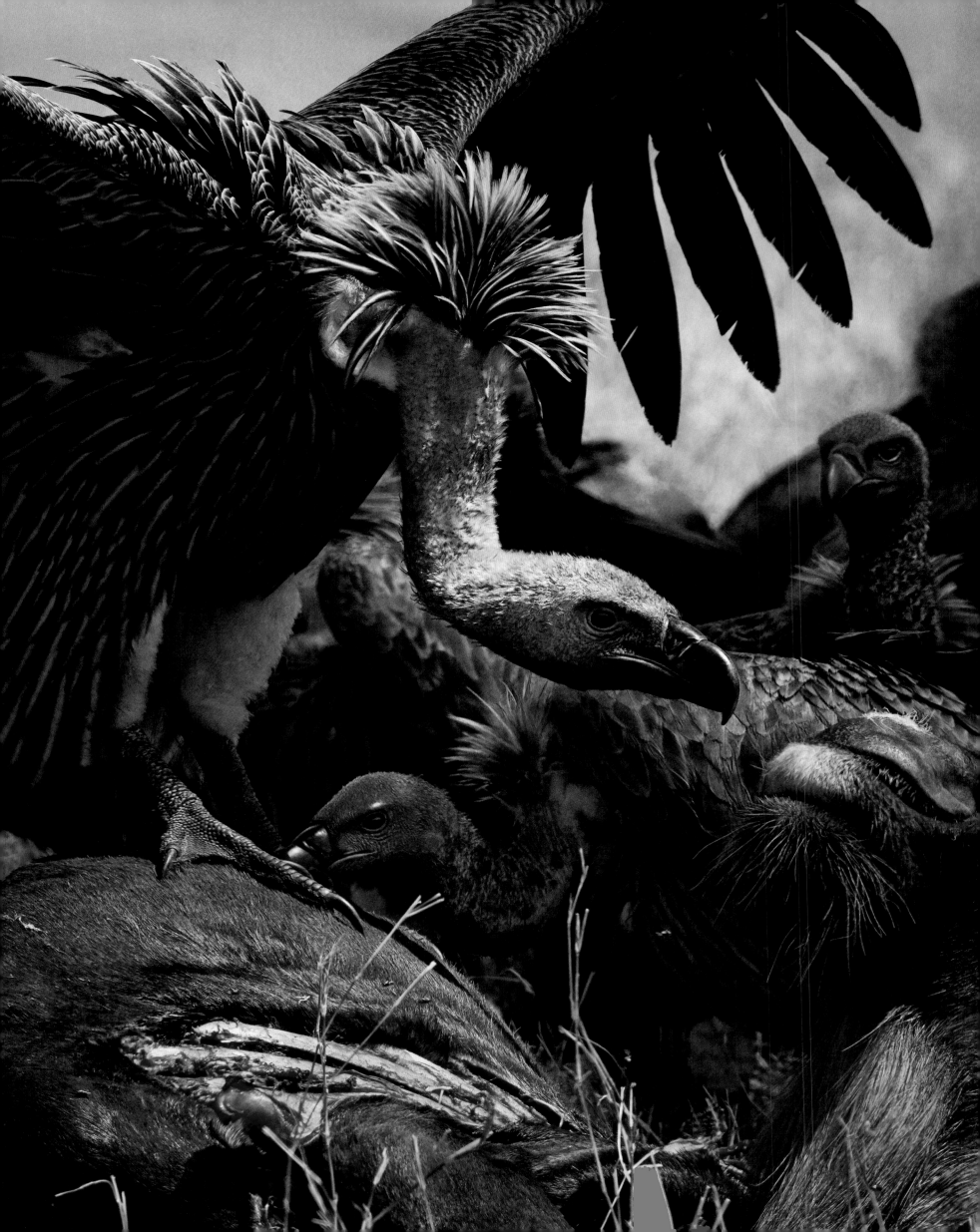

A safe route home

Native to Southeast Asia, India, and sub-Saharan Africa, elephants share space with some of the planet's fastest-growing, densest, and poorest human populations. They travel phenomenal distances to find food, water, and mates, but their ancient migratory routes are being fragmented by human developments. When elephants take to newly built roads or pathways, they can become startled by unexpected human contact, leading to panicked conflicts in which either elephants or people can be killed. When they wander into new farms, they trample crops, and are shot by the farmers who depended on the yield.

An effective solution is to preserve avenues of natural habitat running through human territories. These safe passages are known as migratory "corridors," and they are becoming increasingly common throughout Africa and Asia. When properly maintained, they allow us to live safely and closely with one of Earth's grandest mammals.

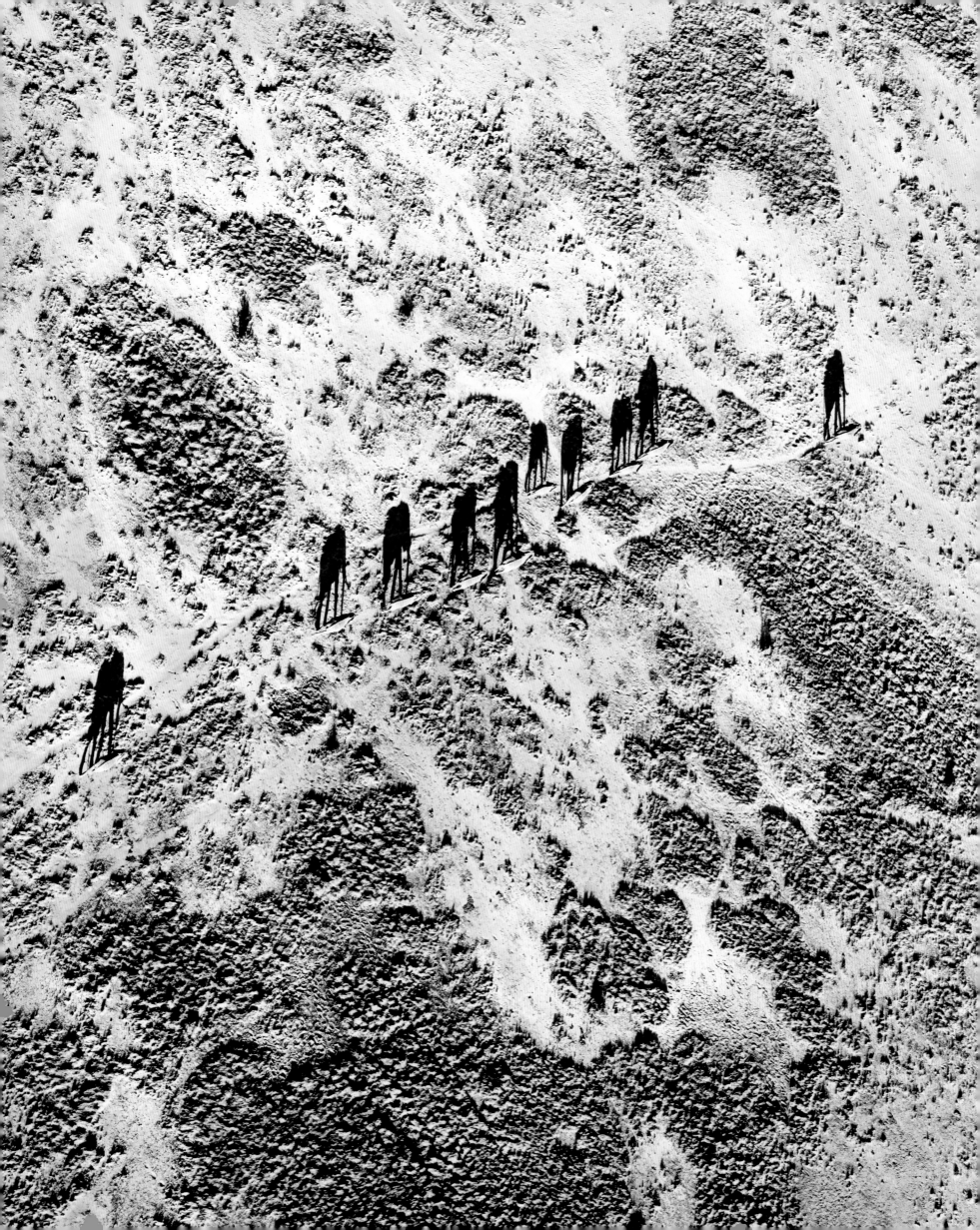

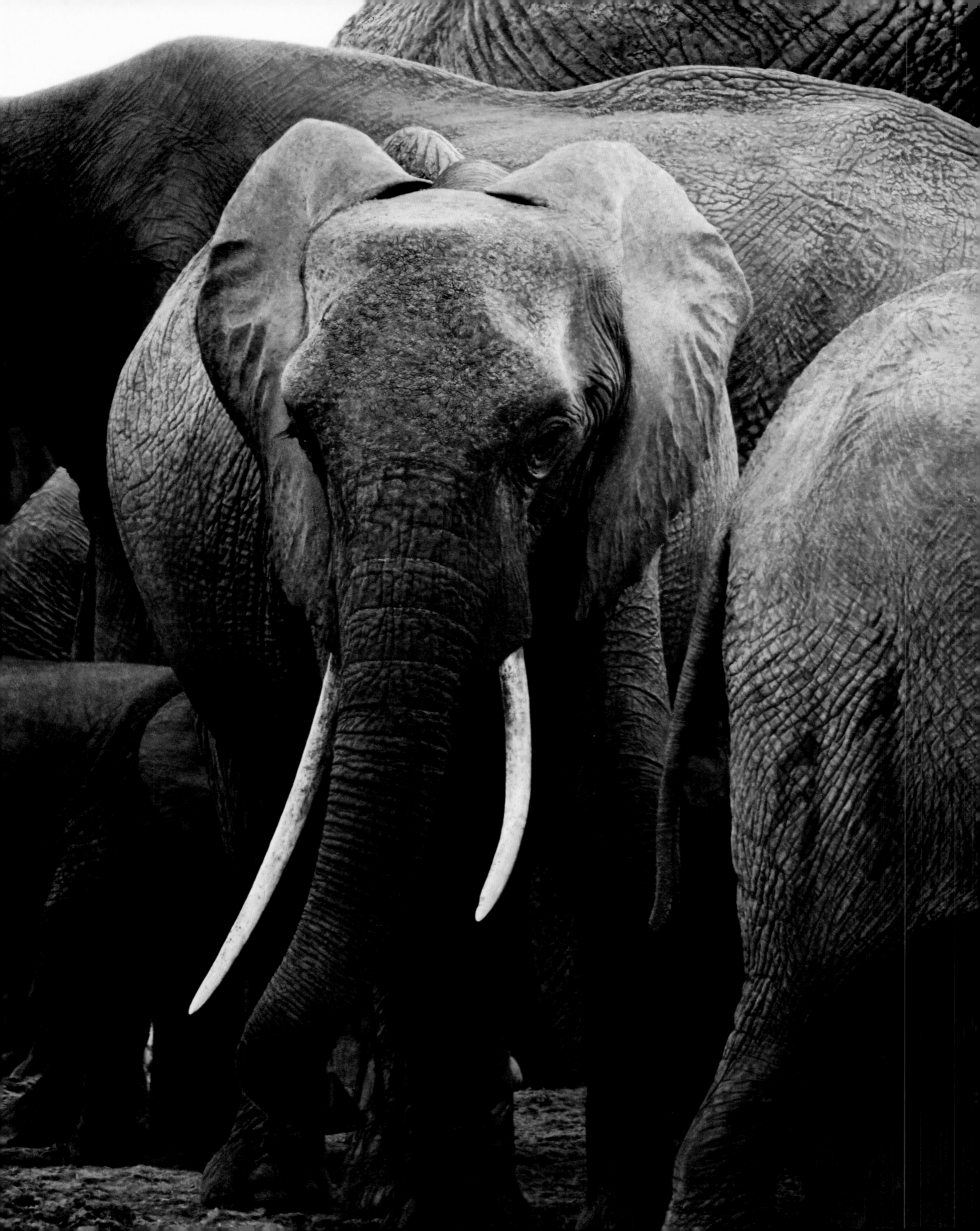

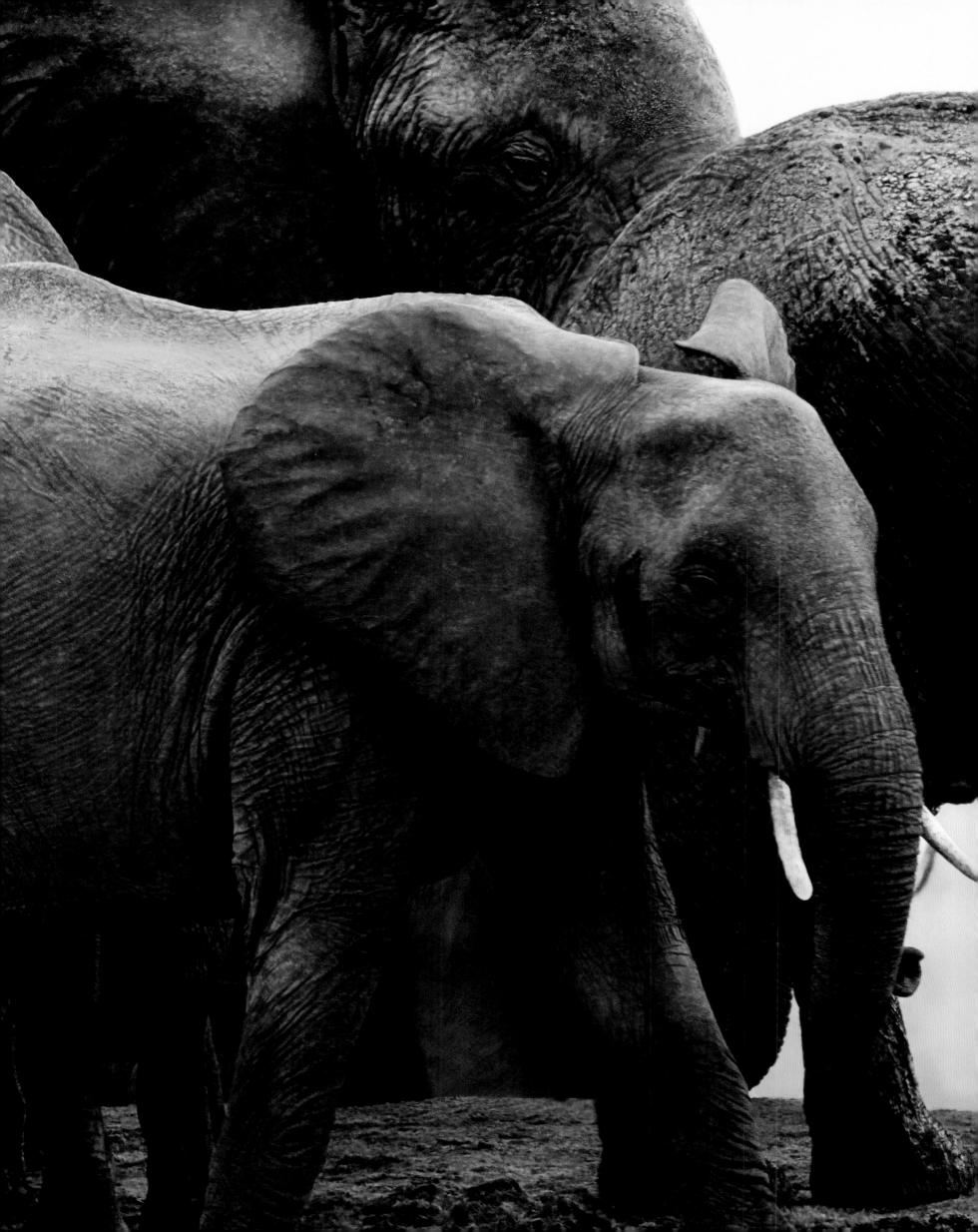

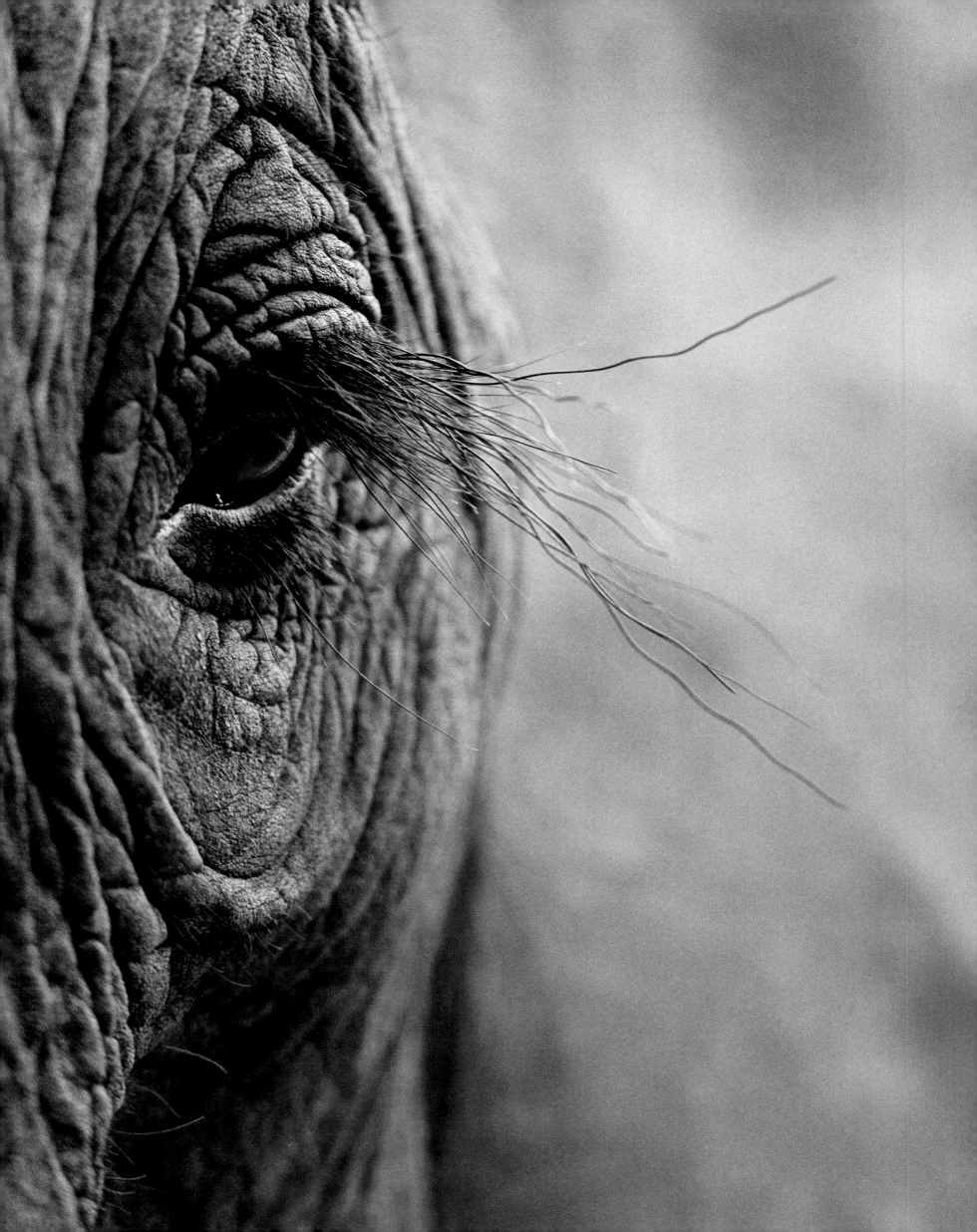

Never forget

Elephants demonstrate advanced spatial cognition, self-awareness, an excellent memory, and deep emotional relations, forming lifelong friendships and mourning their dead. They use language and, somewhat like whales, can communicate across several miles using infrasonic vibrations, sent through the ground and received through the feet and trunk.

During droughts, they dig for water and create oases that save other animals. They eat large fruits and excrete the seeds, dispersing trees and strengthening ecosystems. Yet elephants are still being killed at alarming rates, feeding a centuries-old trade in leather, bushmeat, and ivory—the unique "big tuskers" of Kenya now number just a few dozen.

Some consider Asian elephants more secure, as their females lack the tusks prized by poachers, but the male population is still plummeting, which reduces genetic variation and slows the rate of reproduction. The ivory trade has become so intense it has even forced an evolutionary effect: tusk-free males have begun to emerge.

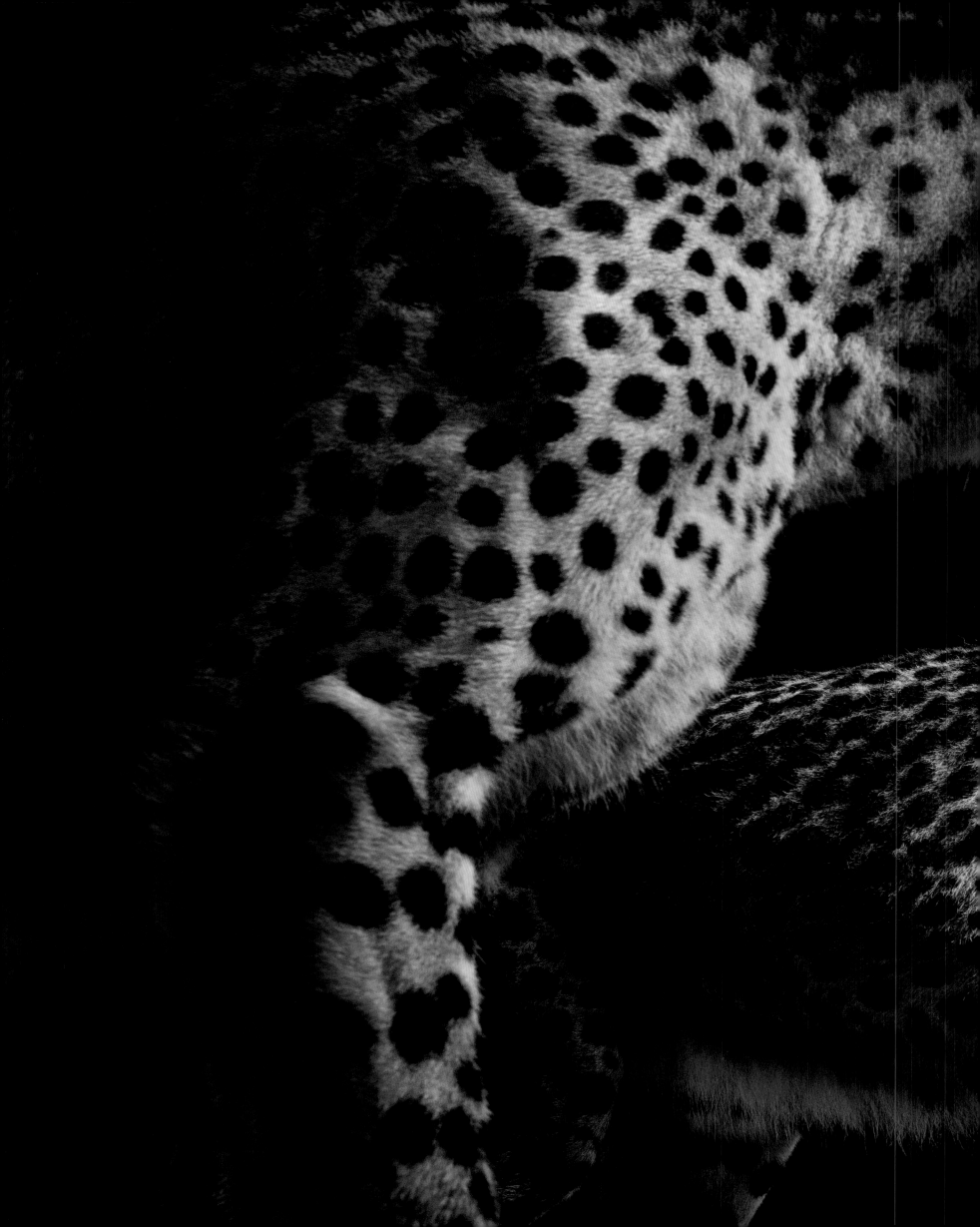

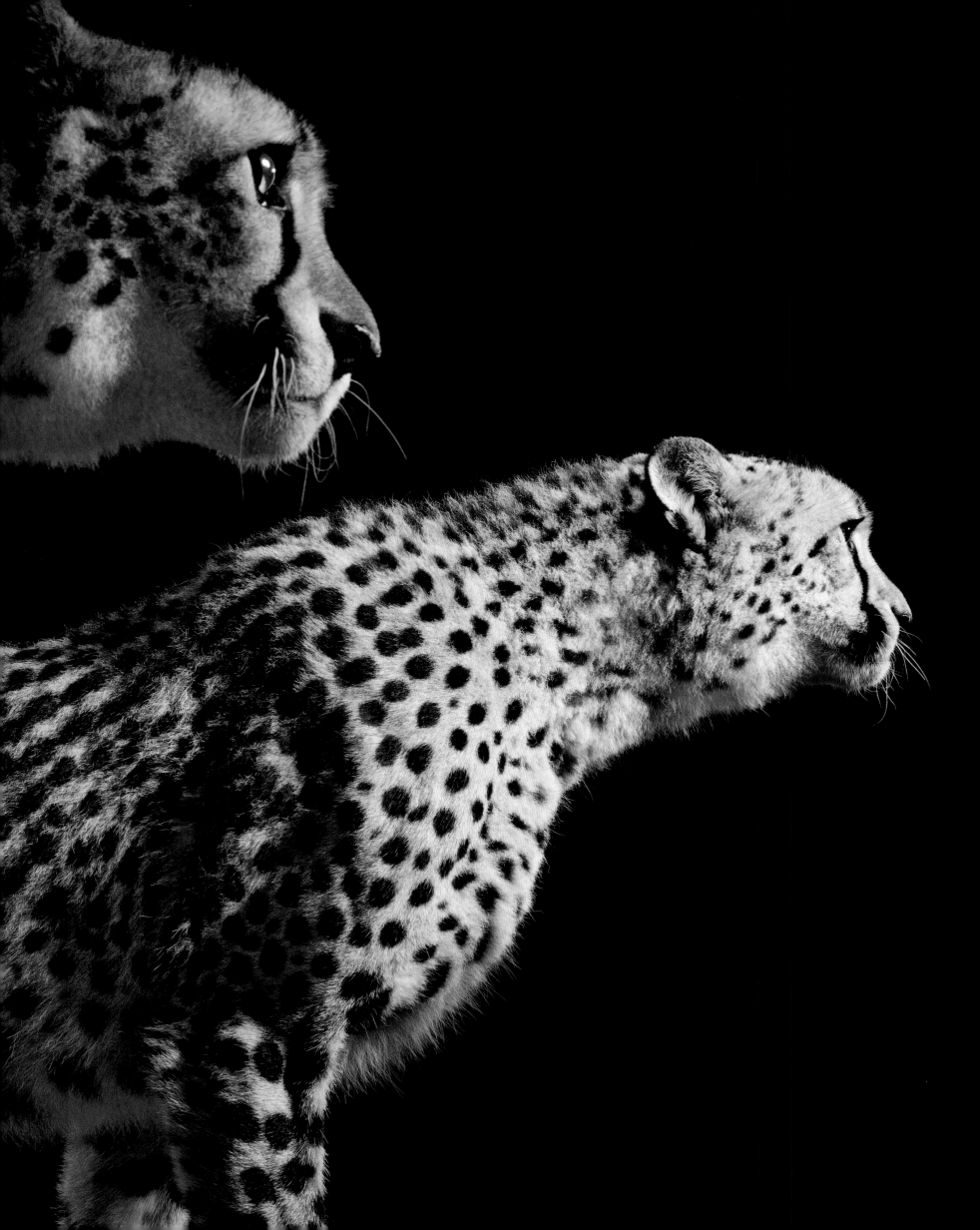

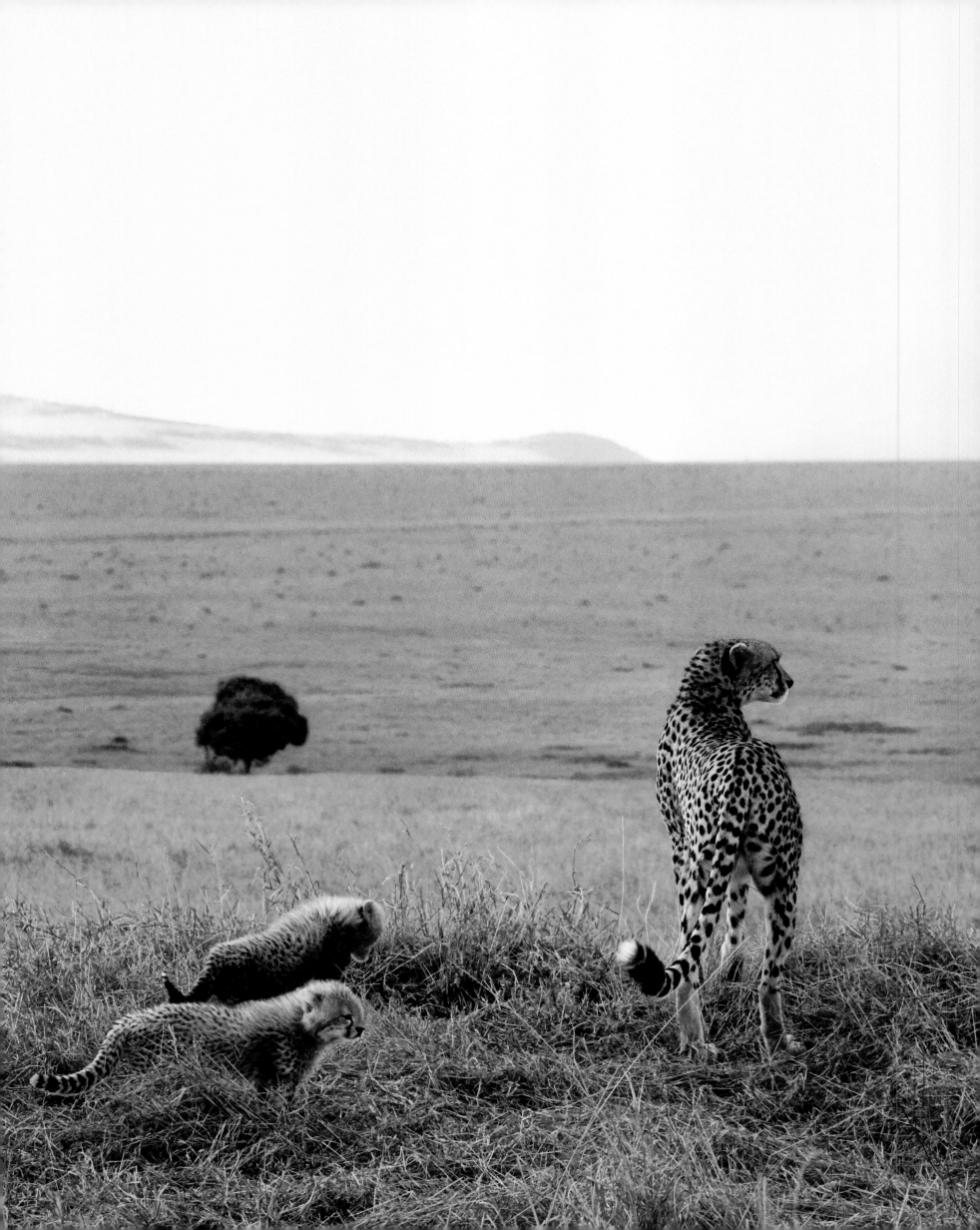

Nowhere to run

Cheetahs are one of Africa's most efficient predators. They prefer to keep away from humans, but as wilderness is converted into pasture, they are eating livestock and being shot by farmers. New roads present dangers they do not understand, and improve access for the poachers killing adults for furs and selling cubs as pets. Nature reserves are a complicated solution; a cheetah family needs an enormous range to survive, so small populations can become constricted inside protected areas. Furthermore, if they share their range with lions and hyenas, their kills can be stolen and their offspring preyed on. There is, however, an innovative resolution. At breeding age, cheetahs can be translocated, moved to another protected region, giving them the space they need while maintaining their genetic diversity.

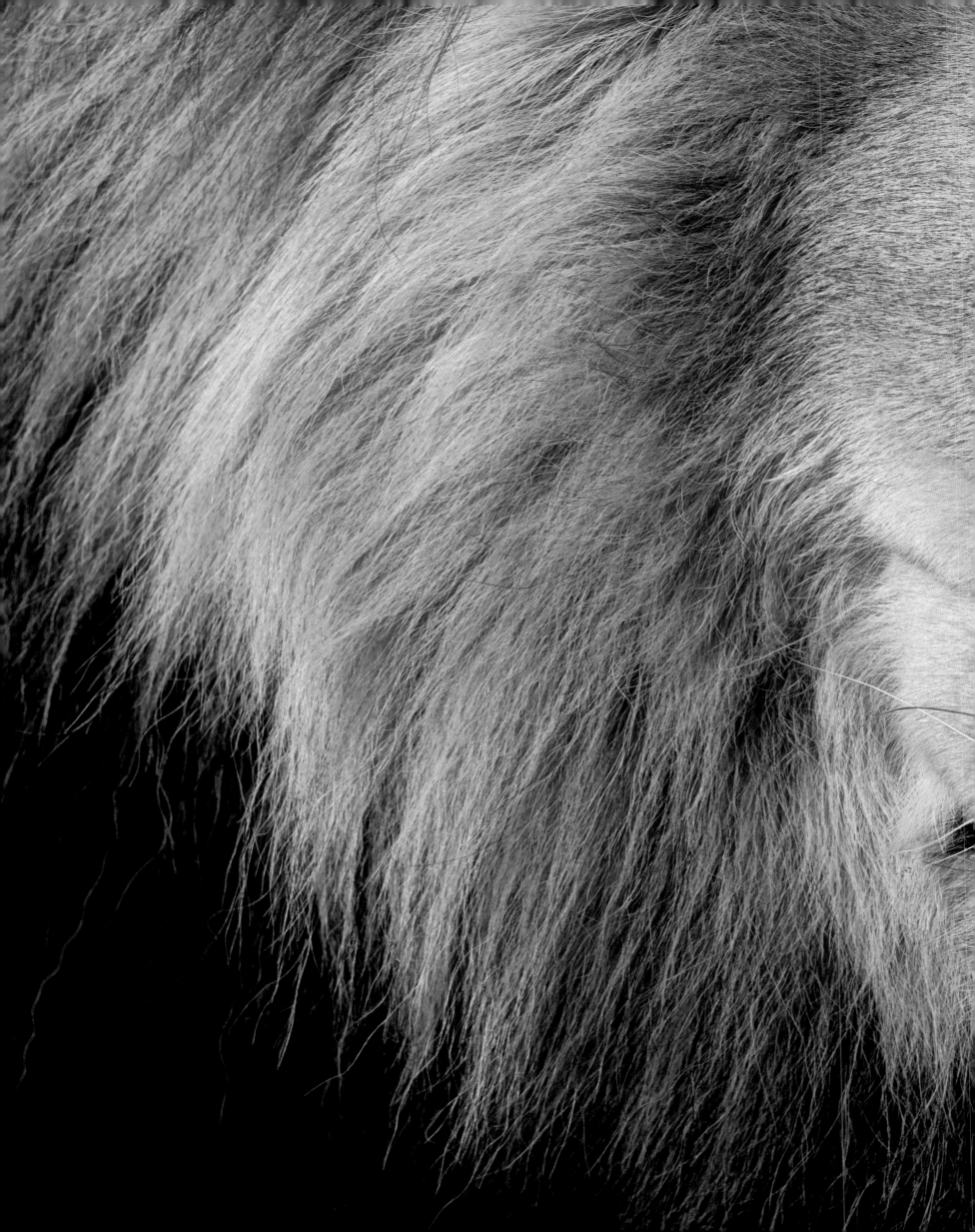

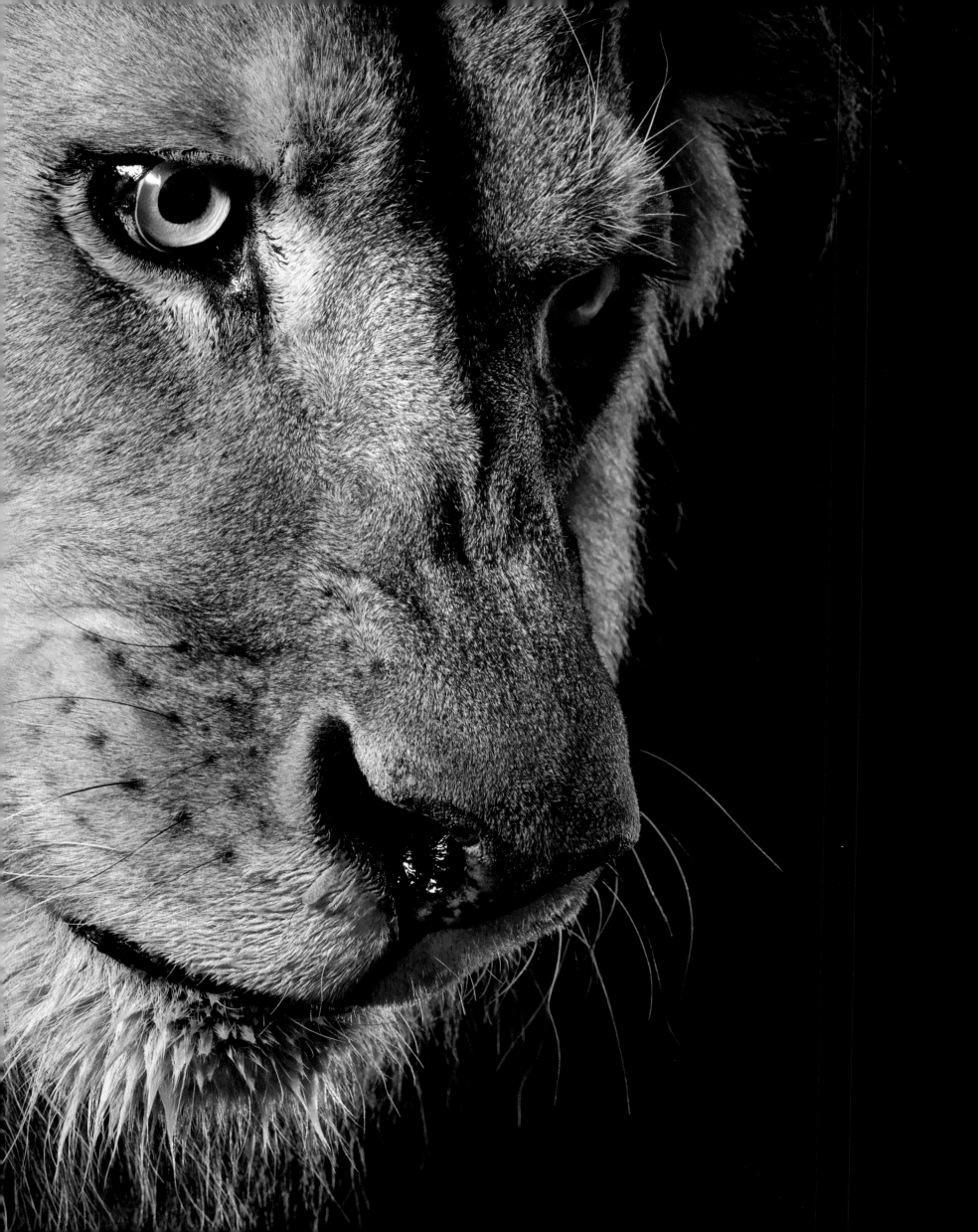

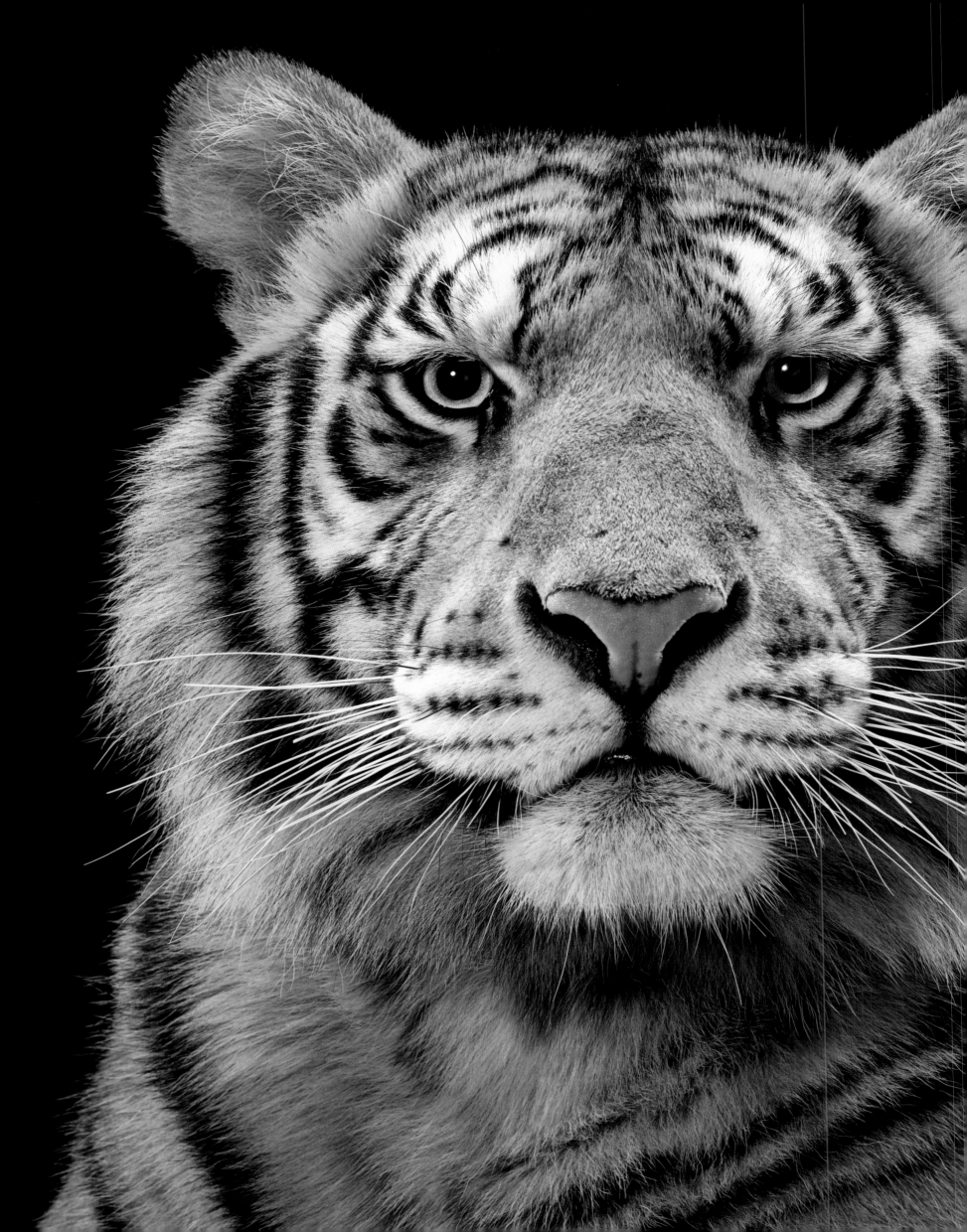

Clawing back

In the last hundred years, the world's tiger population has declined by 97 percent, and three of their nine subspecies have become extinct. In 2010, the remaining nations of the tiger's range made a groundbreaking pact to double the world's tiger population by 2022. They pledged to protect natural habitat and quell international trades, focusing on the demand for tiger-bone wine and various traditional medicines. Halfway through the initiative, in April 2016, a worldwide increase of tigers was announced for the first time in history, with India, Russia, Nepal, and Bhutan reporting significant improvements. Unfortunately, numbers are still in decline throughout Southeast Asia, save for one sanctuary in western Thailand. Cambodia has declared tigers nationally extinct, the South China tiger has almost died out, and the Sumatran tiger—Indonesia's last—is also critically endangered. Their future remains uncertain, but the desire to protect our most charismatic megafauna is clearly still burning bright.

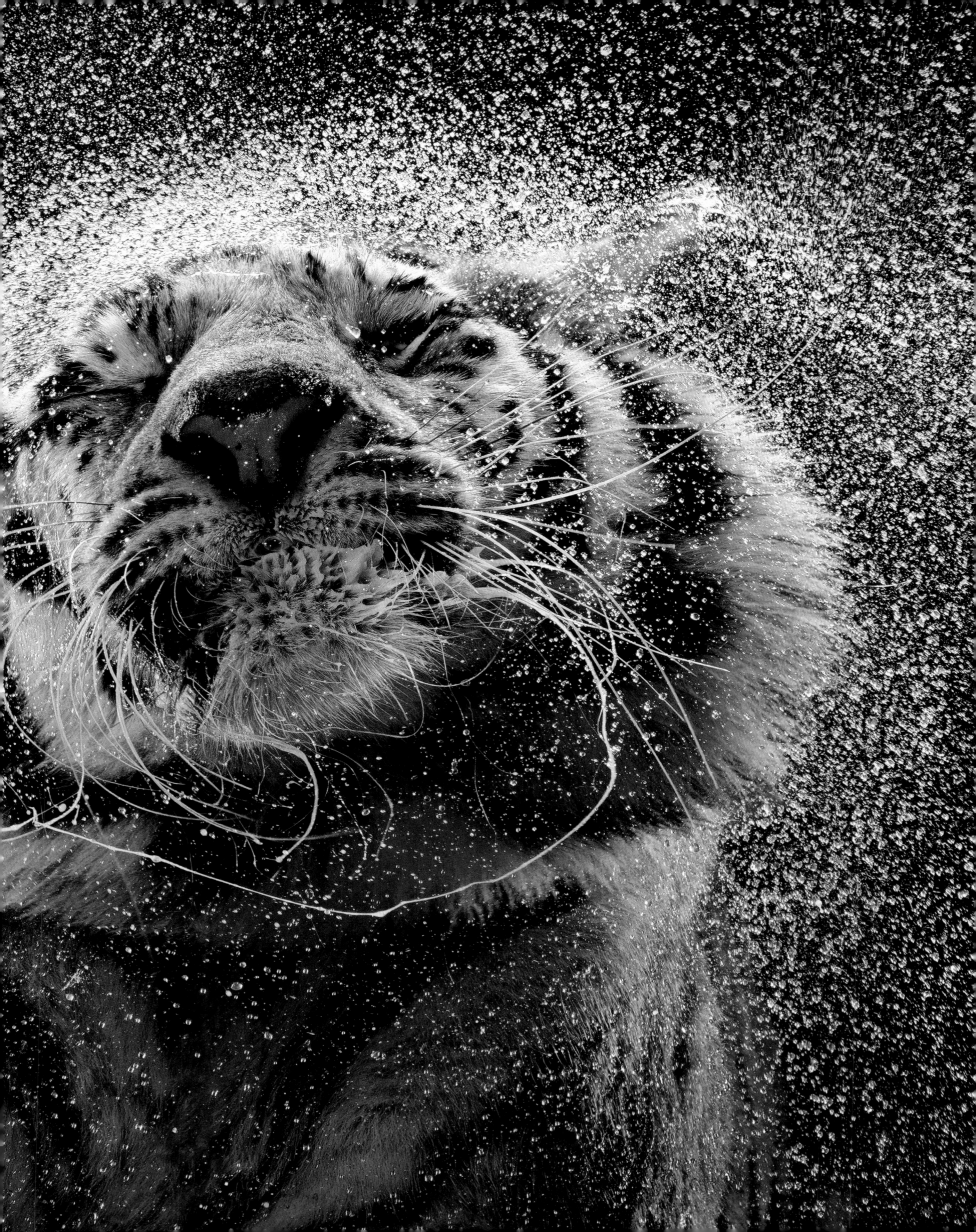

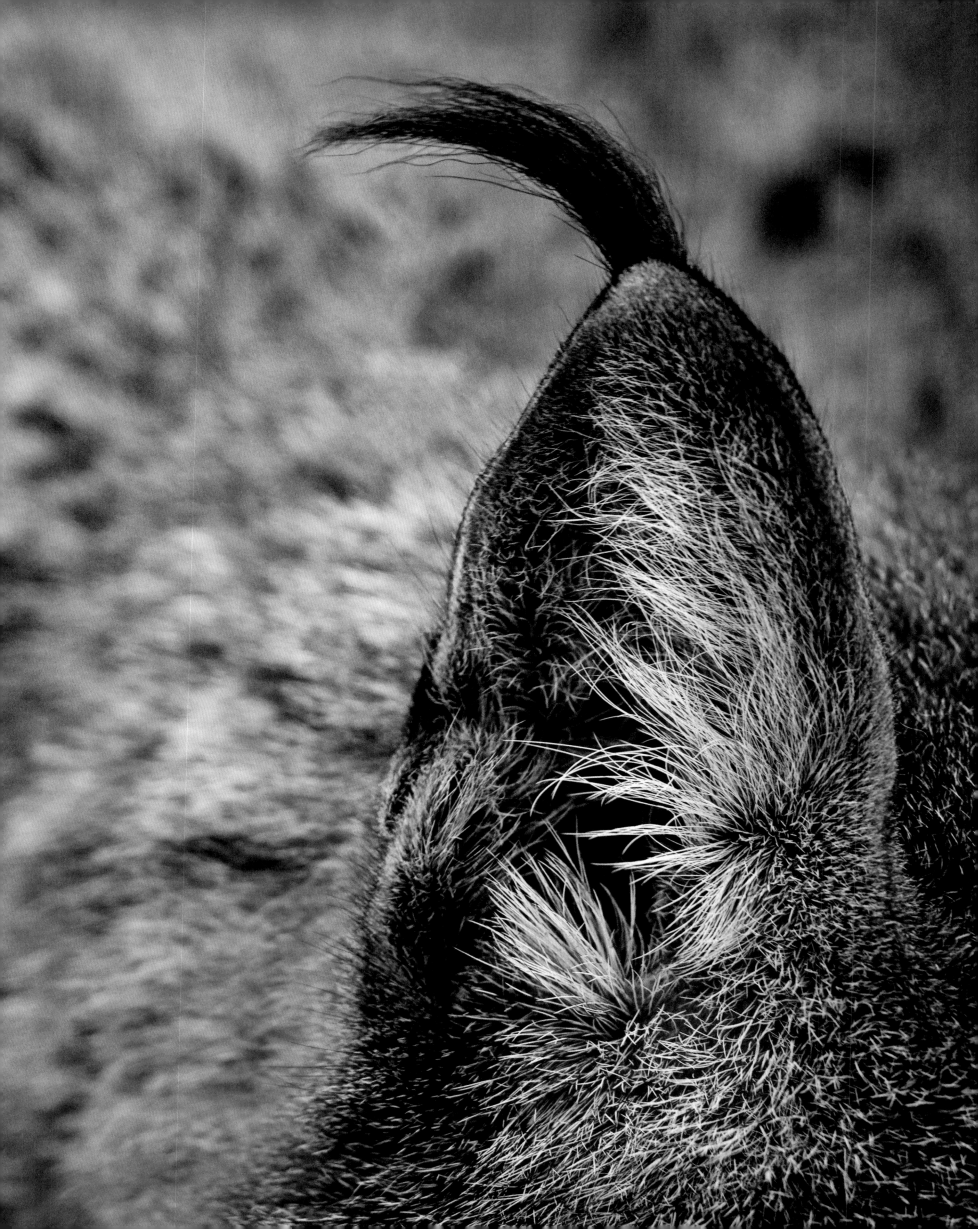

Chain effect

Wild rabbits were not the only victims of the myxomatosis virus, which swept through Europe in the 1950s, nor of the outbreaks of rabbit hemorrhagic disease that began in the 1980s. Iberian lynx, which prey almost exclusively on these animals, have been starved by the declines of their prey. Suffering also from the degradation of forests and the pressure of illegal hunting, Iberian lynx were almost extinct by 2003. They would have been the world's first feline species to disappear for ten thousand years, but Spanish and Portuguese authorities committed to a captive-breeding program. Funds were raised with an "environmental tax" on a public water company that built a dam on lands that were once lynx territories. The Iberian lynx population has now risen into the hundreds, but conservationists warn that ongoing reintroductions will be needed, and that climate change could soon jeopardize the quality of their habitat.

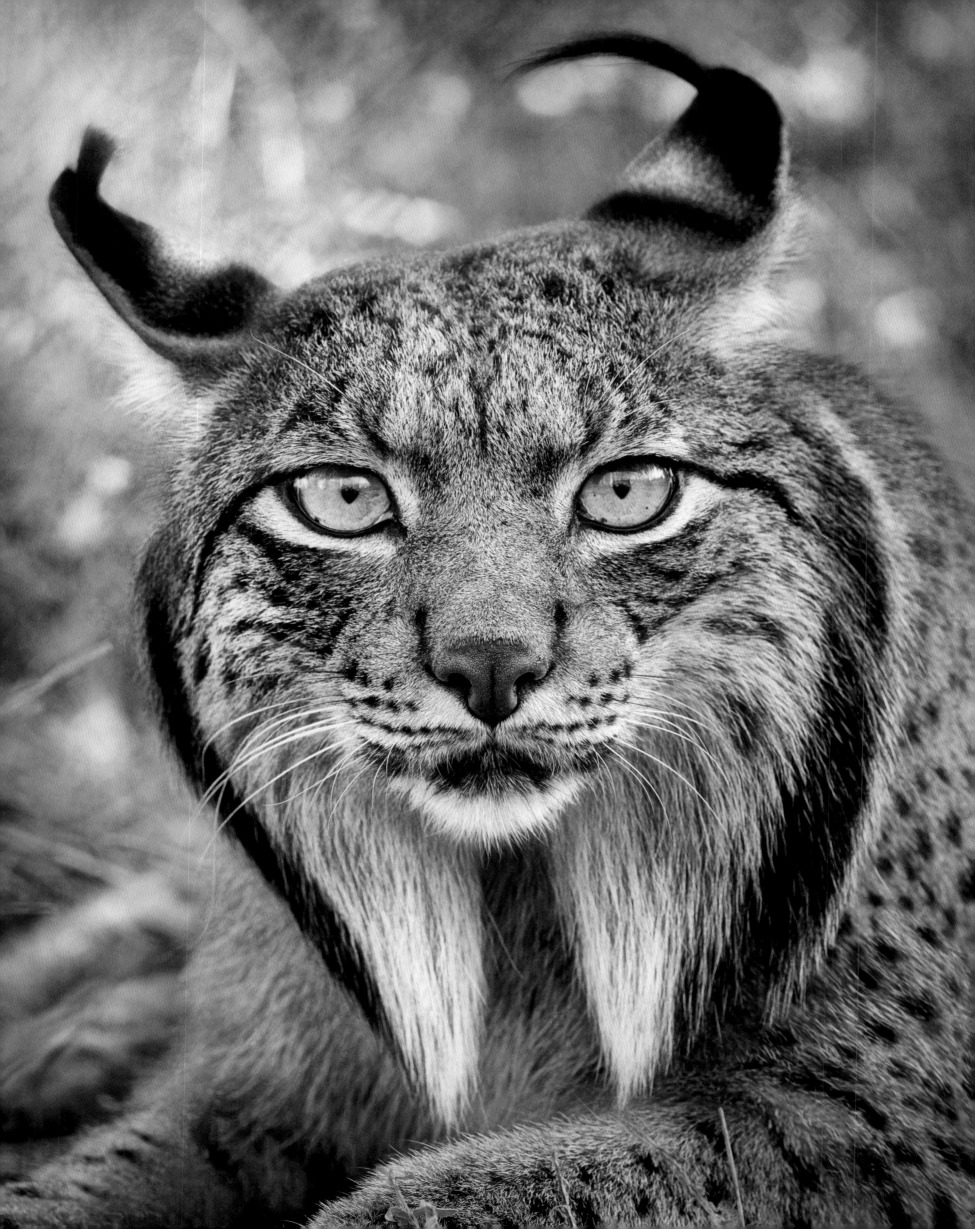

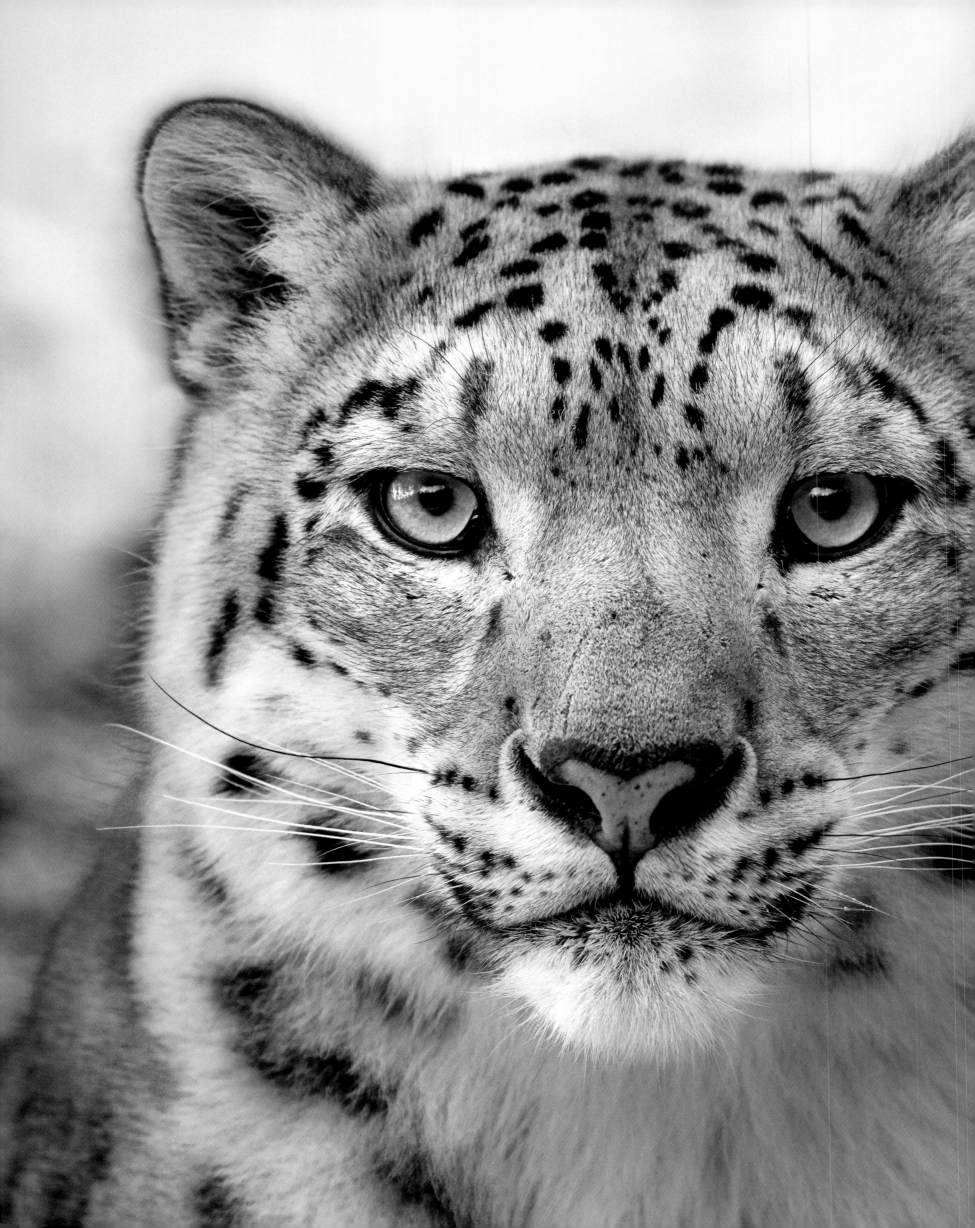

The ghost of the mountains

Snow leopards have long been known as one of the world's most elusive cats, hidden among the barren mountaintops of Central Asia. In 2016, research using GPS tracking technology showed that one snow leopard needs up to 80 square miles (207 sq. km) of territory to survive, which makes almost 40 percent of protected areas in their range too small to support even one breeding pair.

Our warming climate, which has hit the Himalayas around three times harder than elsewhere in the world, is pushing forests further up the slopes and constricting snow leopard habitats. Farmers are grazing livestock and planting crops at higher altitudes, increasing the possibilities of conflict between snow leopards and humans. The 2015 Paris Agreement was a step forward for the conservation of these legendary cats, but until their lands and way of life are protected, they will likely remain in decline.

A change in season

Saiga antelopes are survivors from the ice ages that have walked with woolly mammoths and saber-toothed cats. Their bizarre noses have evolved to warm up cold winter air, but also to filter out dust kicked up from the summer plains. They are able to anticipate the climate, growing out their coats and migrating south just before the snow arrives. In the early 1990s, there were over one million saiga antelopes across the Eurasian steppe, but only 2 percent of that population remains today. In May 2015, over two hundred thousand died in just a few weeks due to the outbreak of a catastrophic disease, and it is feared that such events may become more frequent under the ecological pressures being imposed by climate change. The males are poached for their twisted horns, which sell in East Asia as painkillers and anticonvulsants, so there may not be enough males left to pull this species out of endangerment.

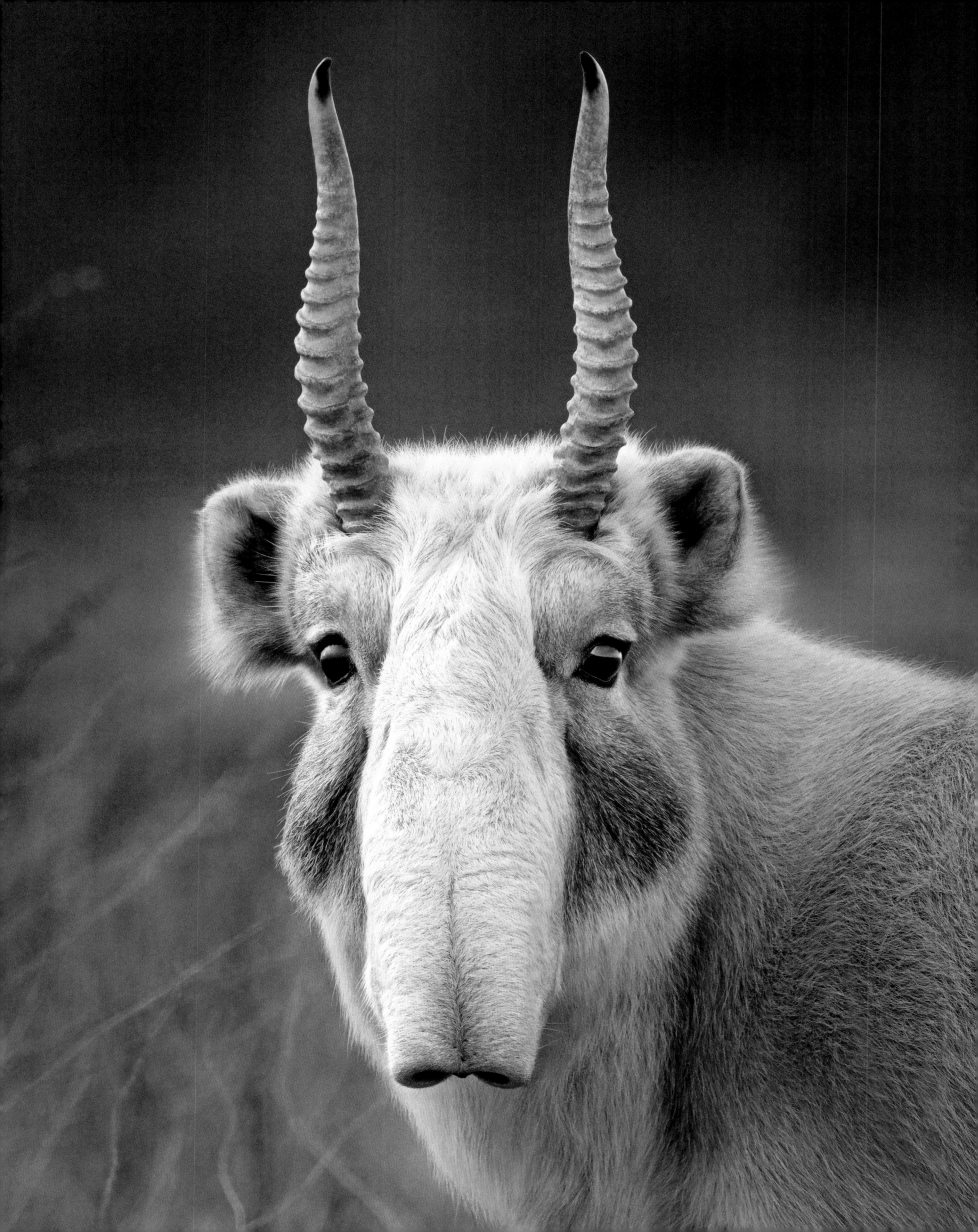

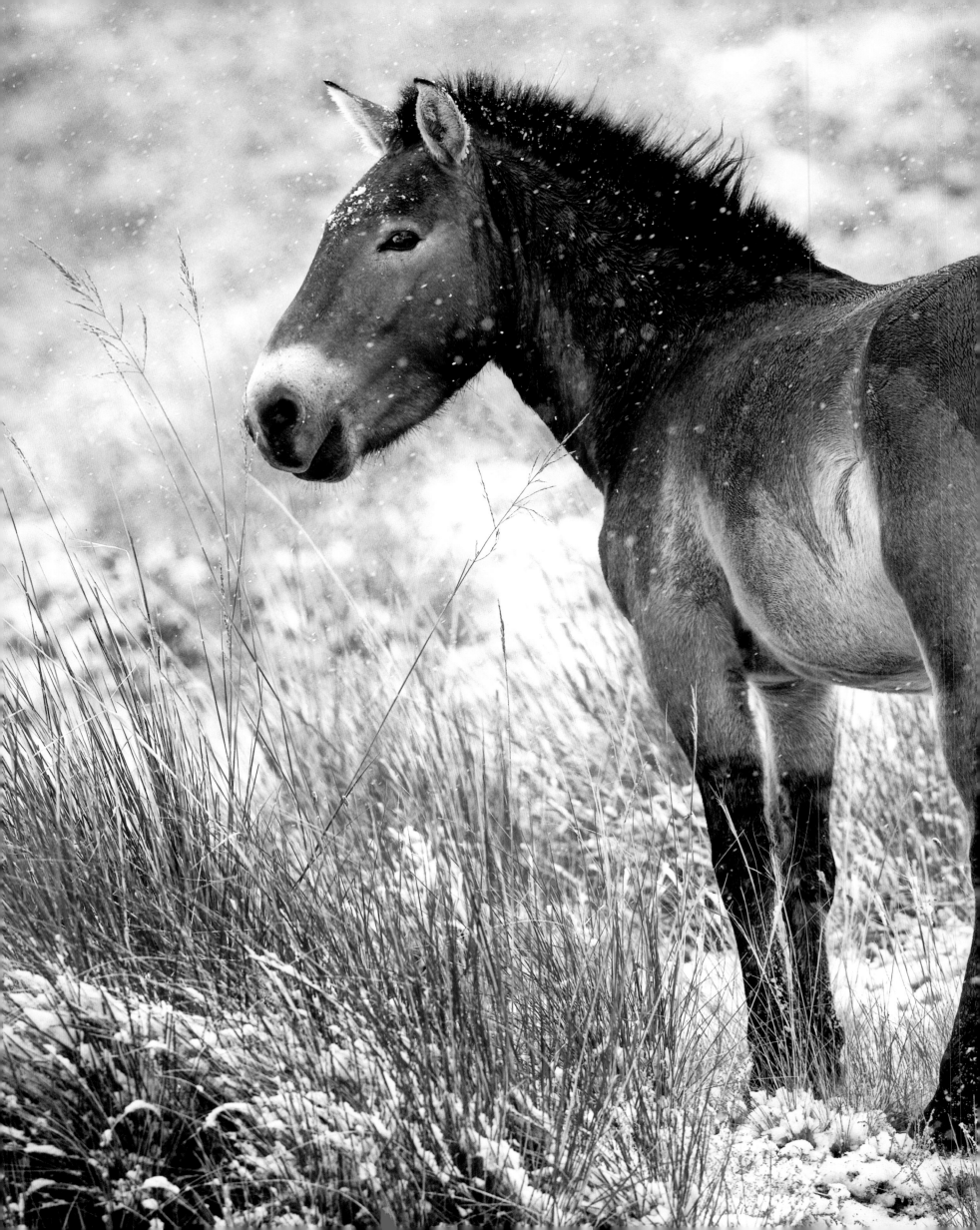

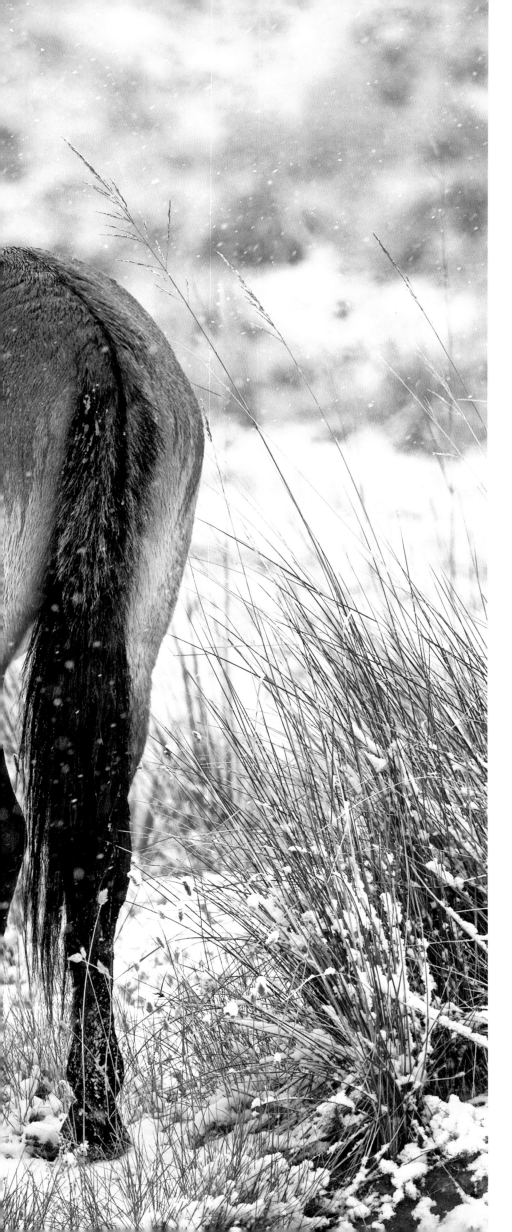

Wild at heart

This is the only species of wild horse alive today. In America and Australia, domestic horses have become feral and survived in the wild, but the Przewalski's horse—named after the Russian explorer, Nikolai Przewalski—has never been domesticated, and its ancestors can be traced throughout Central Asia and Europe. In 1966, it was declared Extinct in the Wild, following centuries of intensive hunting. It was only through a small captive group, descended from thirteen individuals captured in 1945, that their population has recently been revived. The only other modern species of wild horse, the tarpan, went extinct in 1909, before sophisticated breeding programs had been developed. Today, around four hundred Przewalski's horses survive in the wild, roaming the vast grasslands of Mongolia, the world's most sparsely populated country.

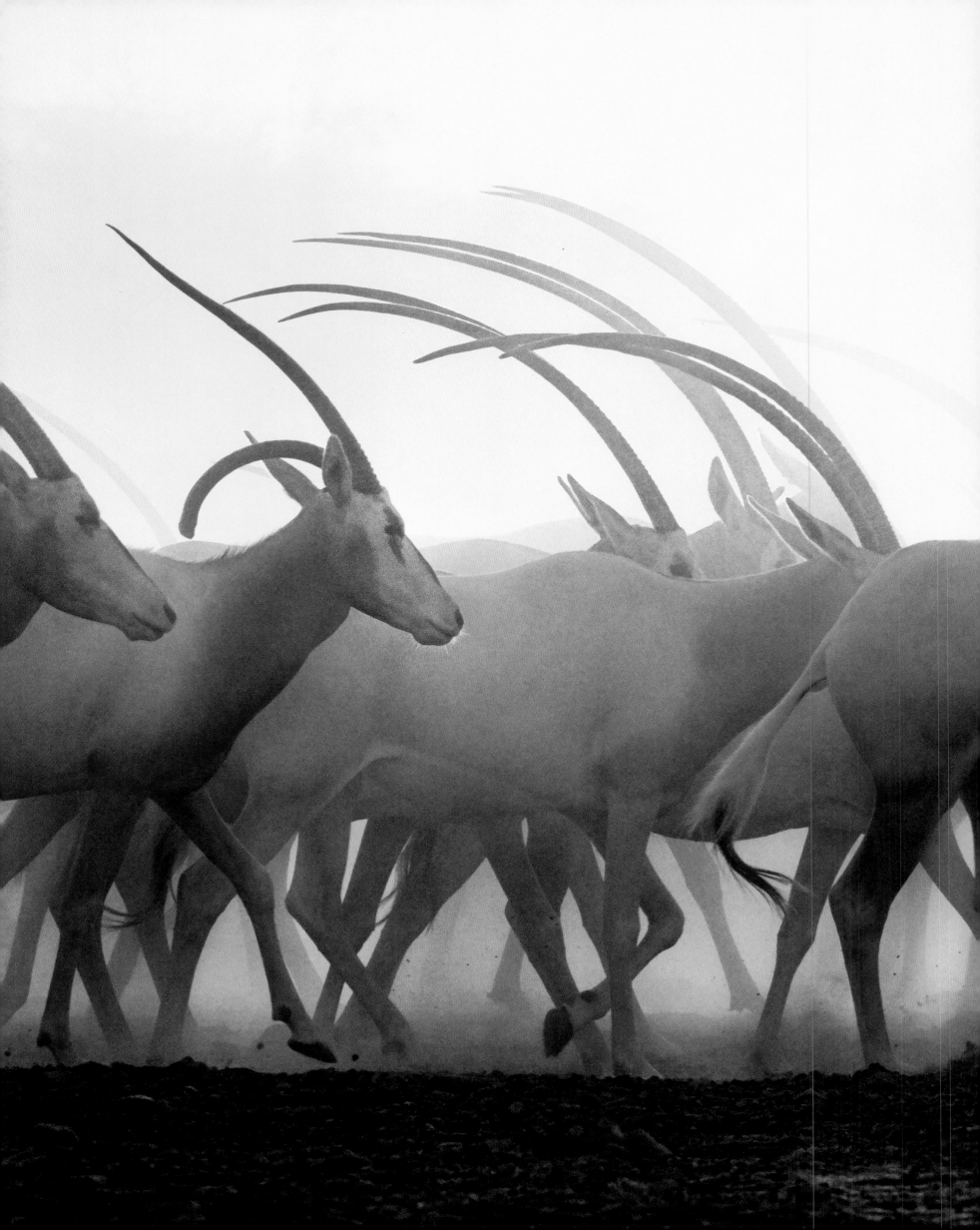

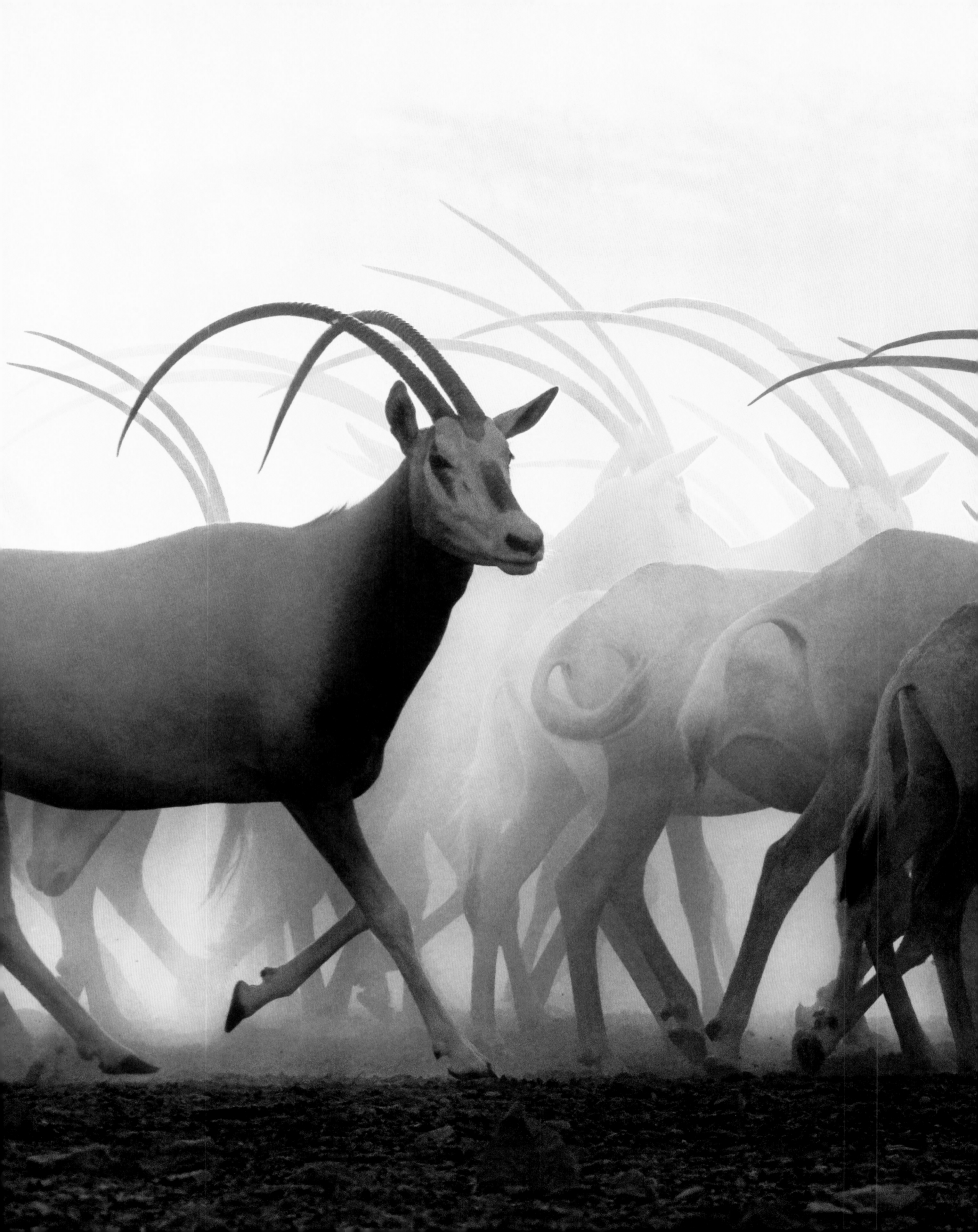

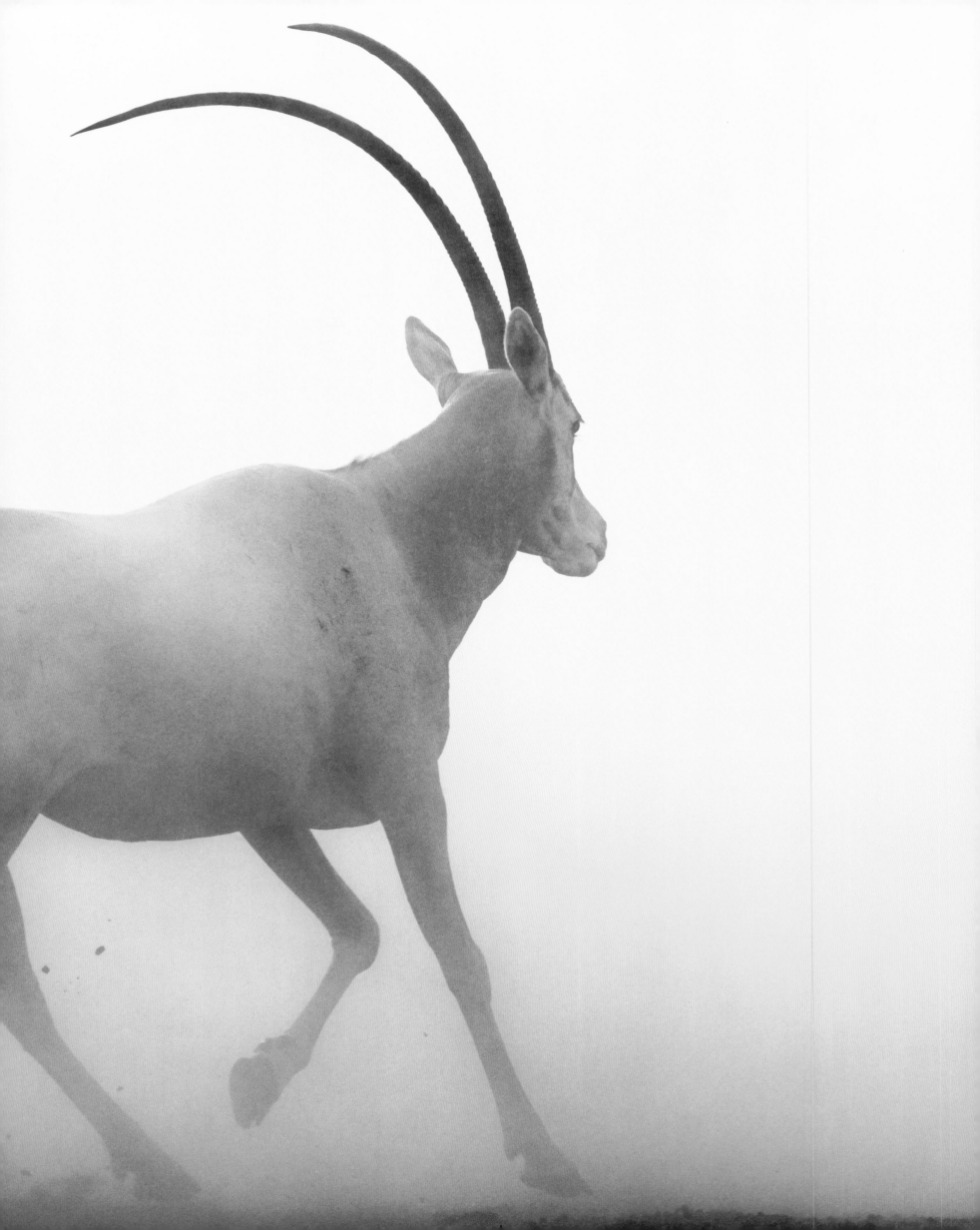

Away from home

Many historians believe that tales of
the unicorn originate with the scimitar-
horned oryx, but we are fortunate that this
magnificent creature remains more than a
myth. The scimitar-horned oryx, named after
the curved swords of the Middle East, is a
native of the Sahara Desert. Thousands of
years ago, it had a wide-ranging population
of one million, but today it is classed as
Extinct in the Wild. Poached relentlessly for
its trophy horns and exceptionally thick hide,
the last wild individuals died around 1990.
However, the late Sheikh Zayed bin Sultan
Al Nahyan—the United Arab Emirates' first
president—had taken a special liking to the
species, and was breeding a captive herd on
Sir Bani Yas Island near to Abu Dhabi. In
the summer of 2016, a small herd was fitted
with GPS collars and released into the deserts
of Chad. Fourteen more individuals were
released in January 2017, and with further
reintroductions scheduled, conservationists
are hopeful that this splendid oryx will be
rescued from extinction.

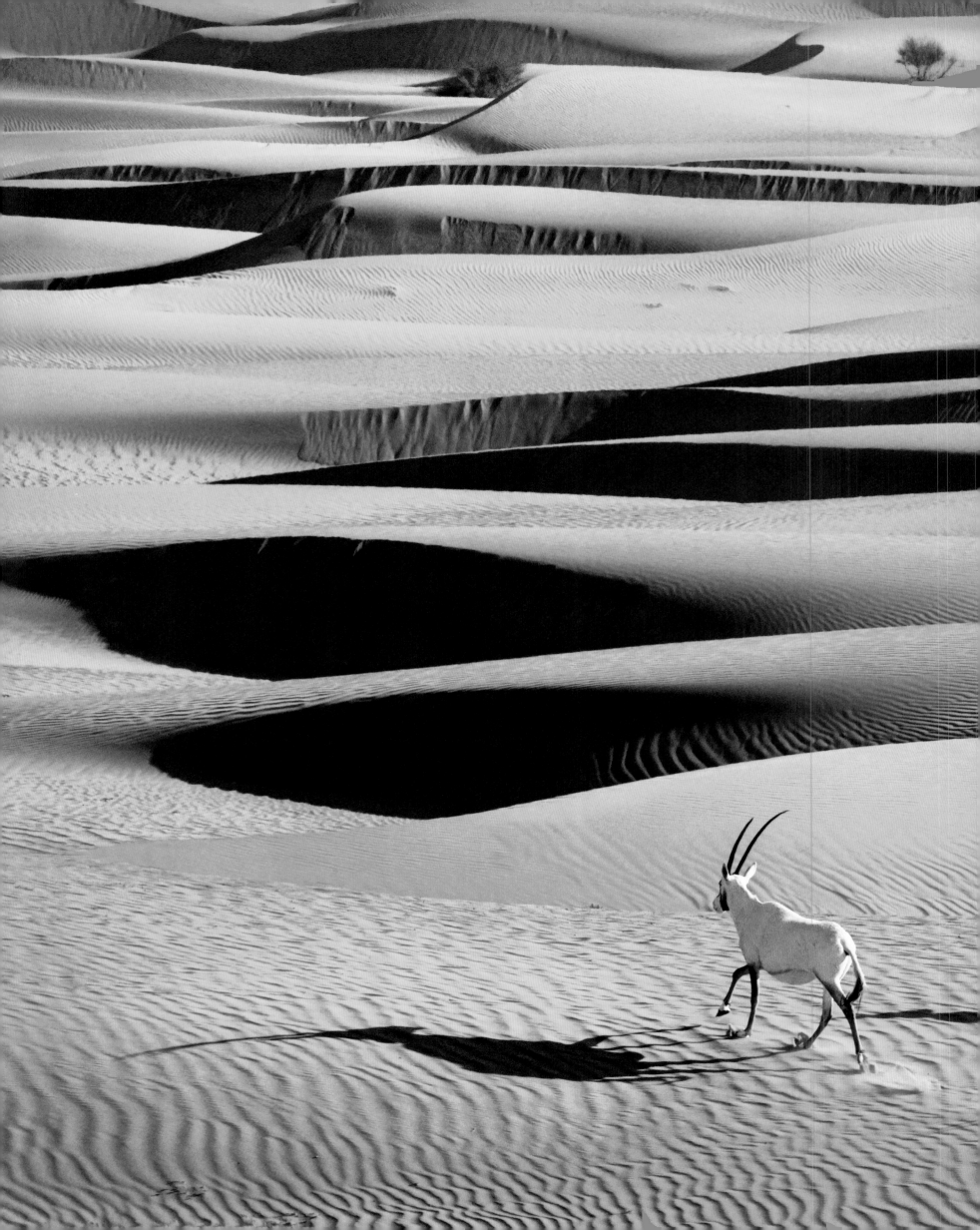

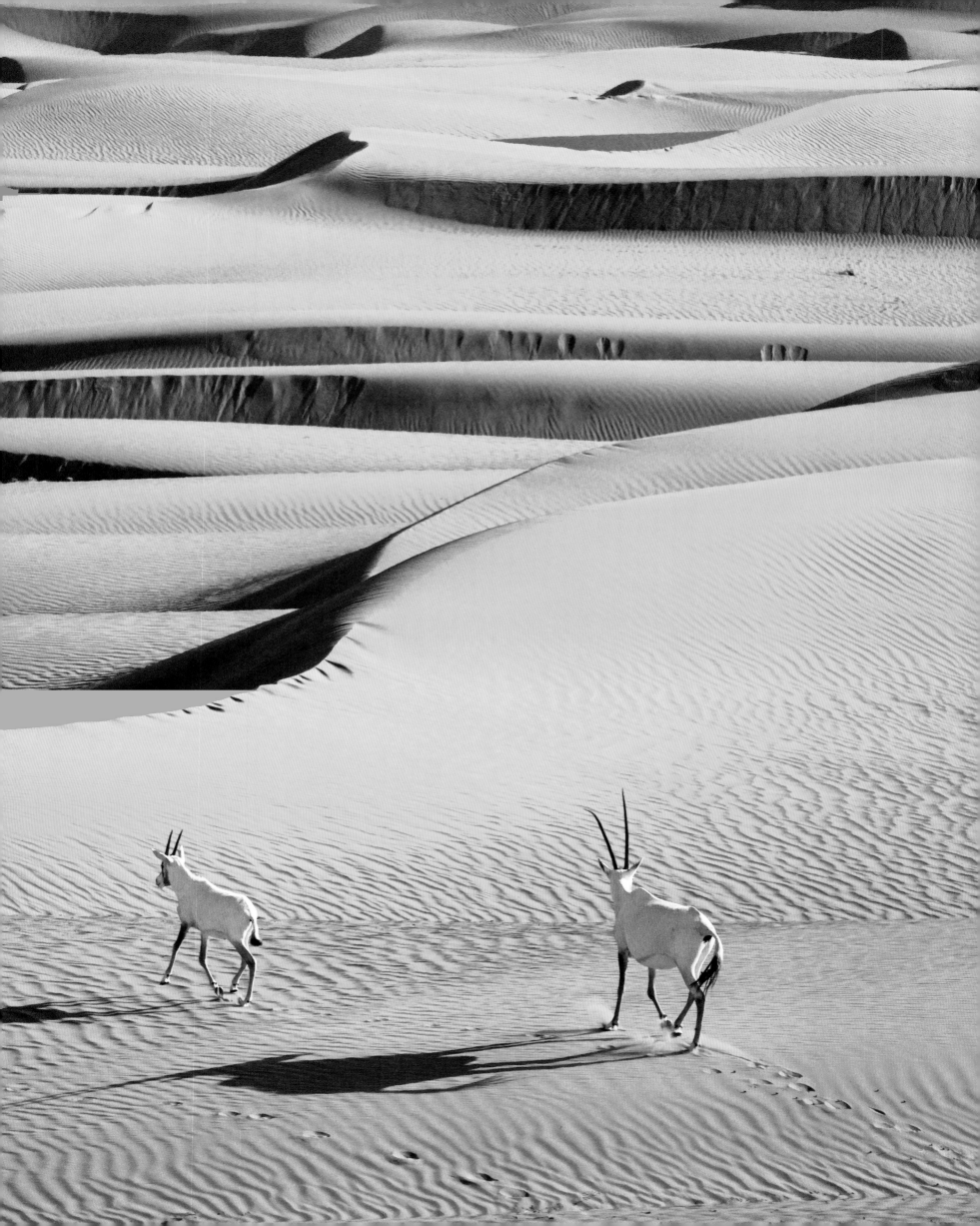

Gentle giants

The reticulated giraffe is one of the most endangered subspecies of giraffe, but also one of the most popular and well-recognized. Giraffes are a staple in the public image of African savannahs, found in children's alphabets, on television, and in our most popular zoos. They have been similarly secure in the eyes of conservational science, which focused on Africa's other giants—elephants, rhinos, apes, and lions—while giraffes were undergoing an unforeseen decline. Their habitats have been rapidly destroyed, and conflicts in East Africa have been disastrous, as giraffes are benign, curious animals that can be easily killed to feed a desperate family. In December 2016, they were upgraded from being of Least Concern to being Vulnerable, having lost 40 percent of their kind in thirty years and disappearing from seven countries entirely. Giraffes are safest in southern Africa, where their constant translocation between private reserves and national parks has overcome the dangers of fragmented natural habitats, while bolstering thriving eco-tourism industries.

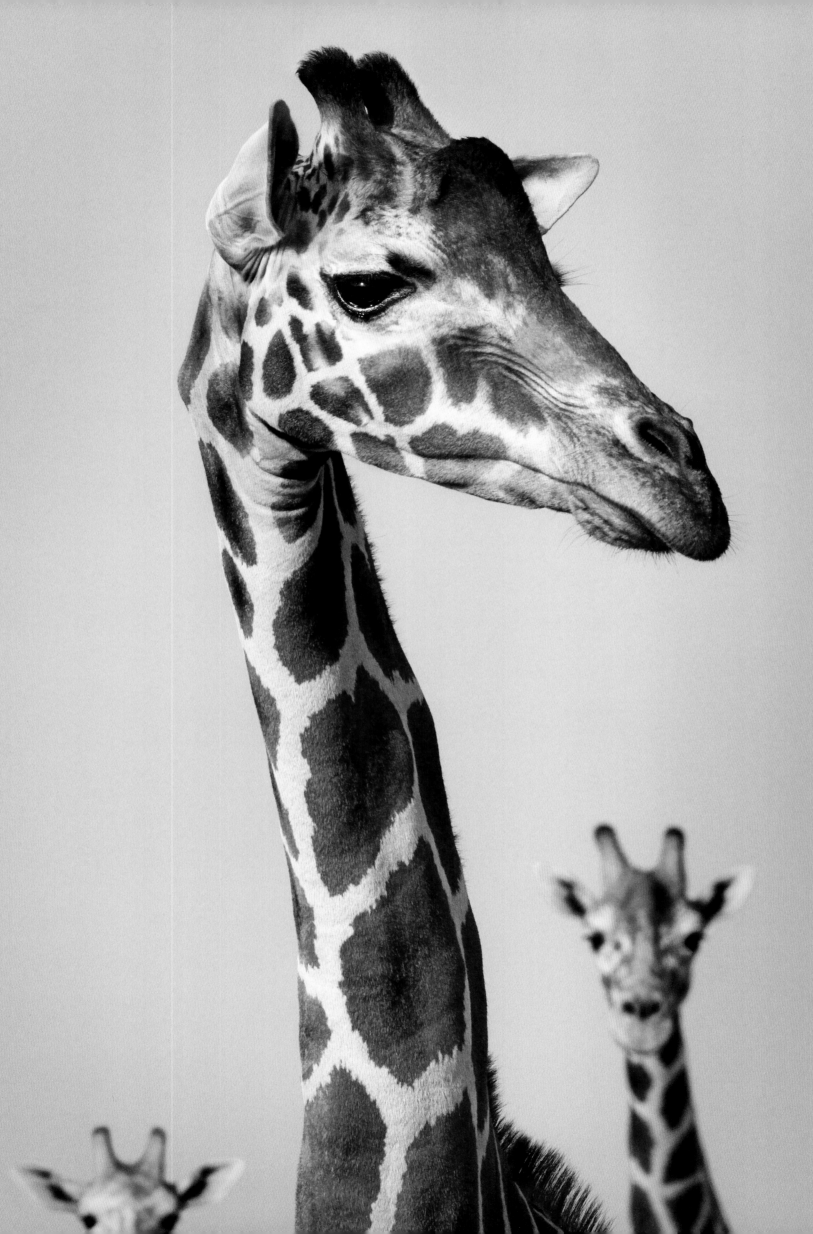

Nowhere to hide

Due to their black-and-white stripes, okapis are often thought to be closely related to zebras, but they are, in fact, the forest-dwelling cousins of giraffes. While the stripes of a herd of zebras may confuse their grassland predators, okapis become camouflaged in the slanting slits of light that filter through the Congolese canopy. With exceptional hearing and a skittish temperament, okapis are famously elusive. In their almost impenetrable forest habitat, they were not discovered by foreign scientists until the early twentieth century. Warfare, however, has exposed and endangered these intriguing animals, as Congolese rebel groups occupy the forest and deny entry to conservationists. Furthermore, these groups support their campaigns by hunting for bushmeat and mining for gold and diamonds, which releases lead, mercury, and arsenic into the environment. The Okapi Conservation Project publicly opposed this destruction, so in June 2012, a group of Mai-Mai rebels stormed their remote research center and killed seven people and every captive okapi.

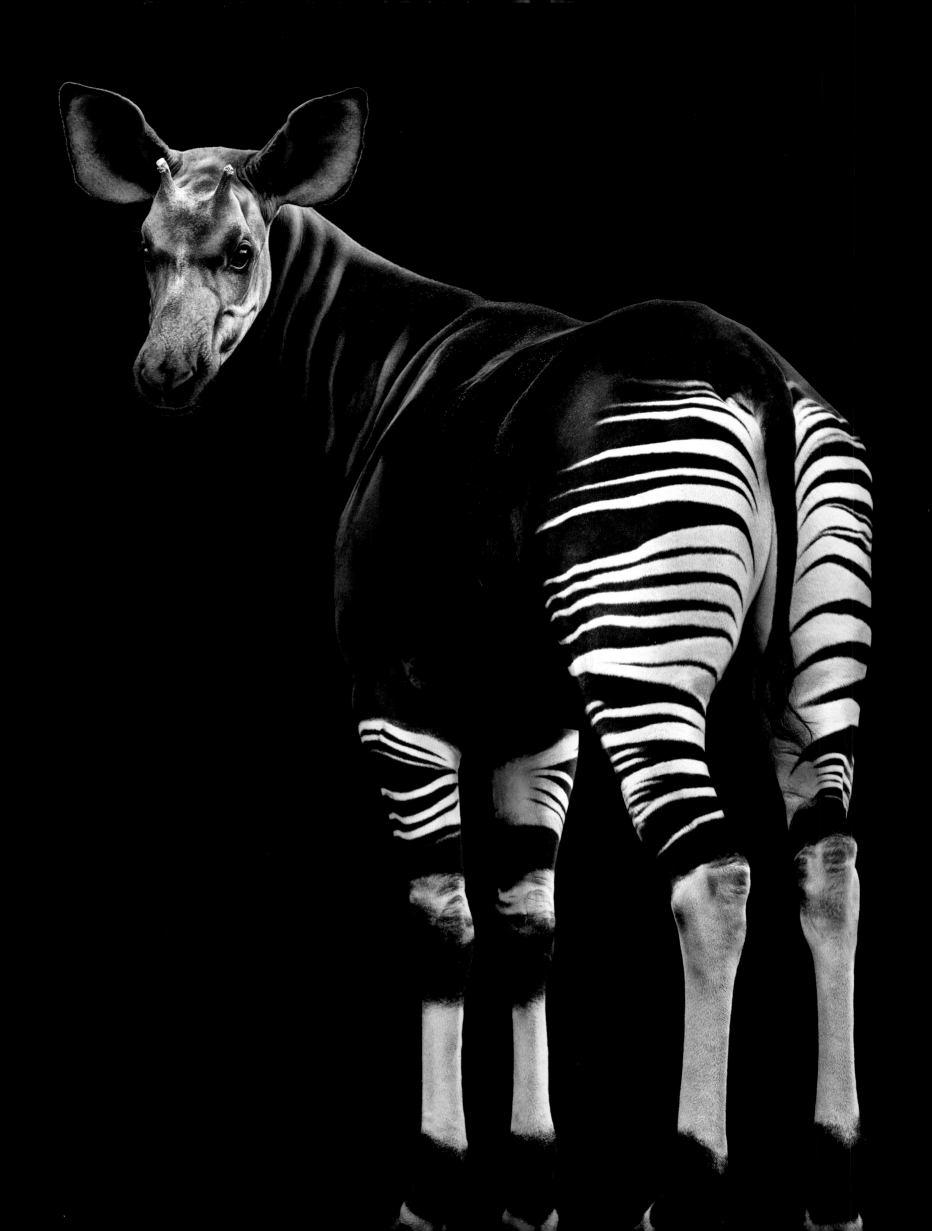

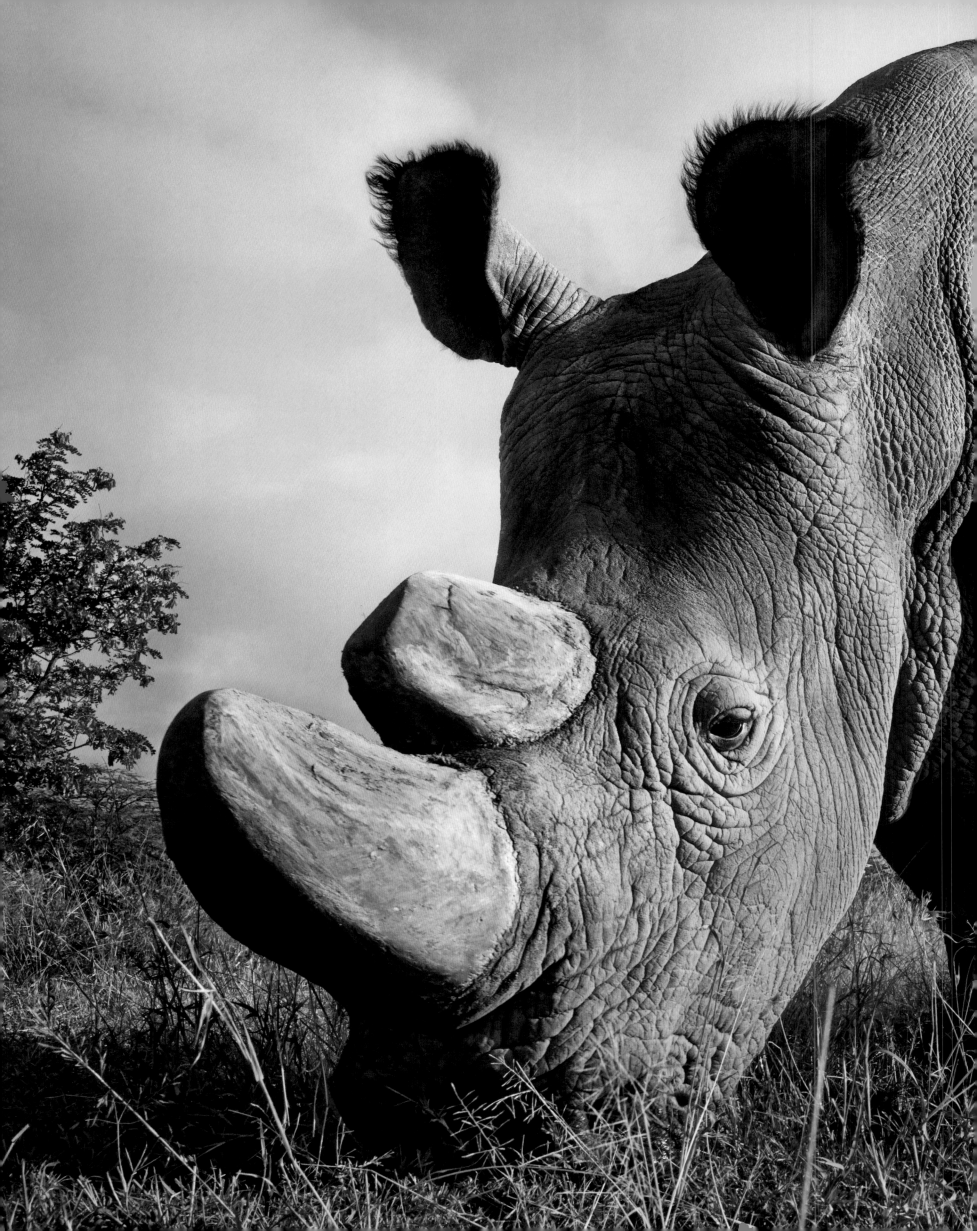

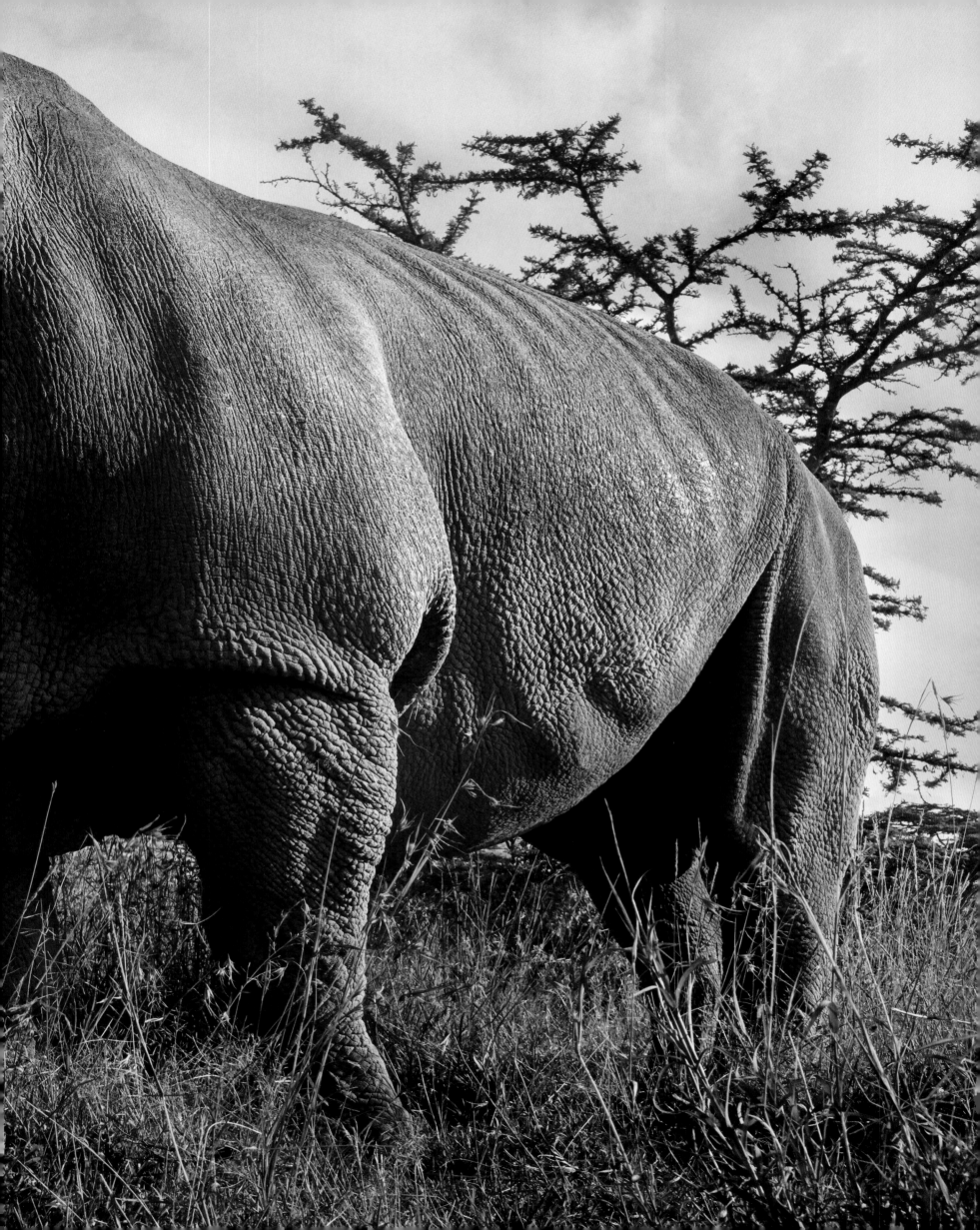

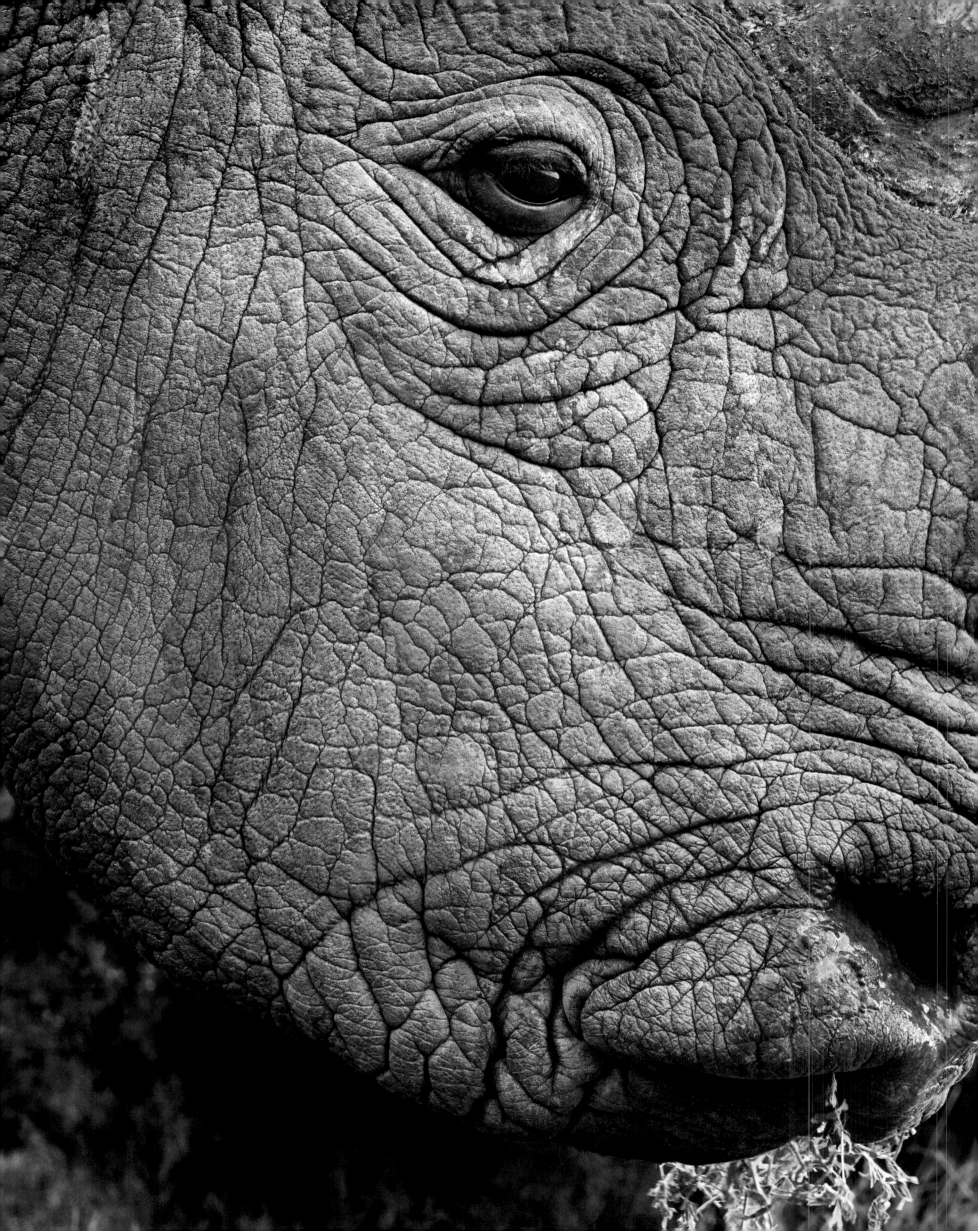

Last man standing

Sudan, aged forty-three (opposite), his daughter, Najin, and his granddaughter, Fatu, are a small family of northern white rhinoceroses. Together, they account for every northern white rhinoceros alive today. Their ancestors roamed through Central Africa in herds, holding a population of around two thousand until the year 1960. By 1990, numbers had fallen to just twenty-five. Now, there are three. If another is born, it will grow from an egg harvested from one of the females, fertilized by the frozen sperm of one of their deceased ancestors, and carried in the uterus of one of their South African cousins.

In their conservancy in Kenya, Sudan, Najin, and Fatu are systematically dehorned to reduce their value on the black market, and armed guards defend them from poachers. These protections are useful in the short term, but true conservation will rely on education. Despite superstitions fueling the trade, the keratin horns of northern white rhinoceroses do not treat cancer, hangovers, or erectile dysfunction.

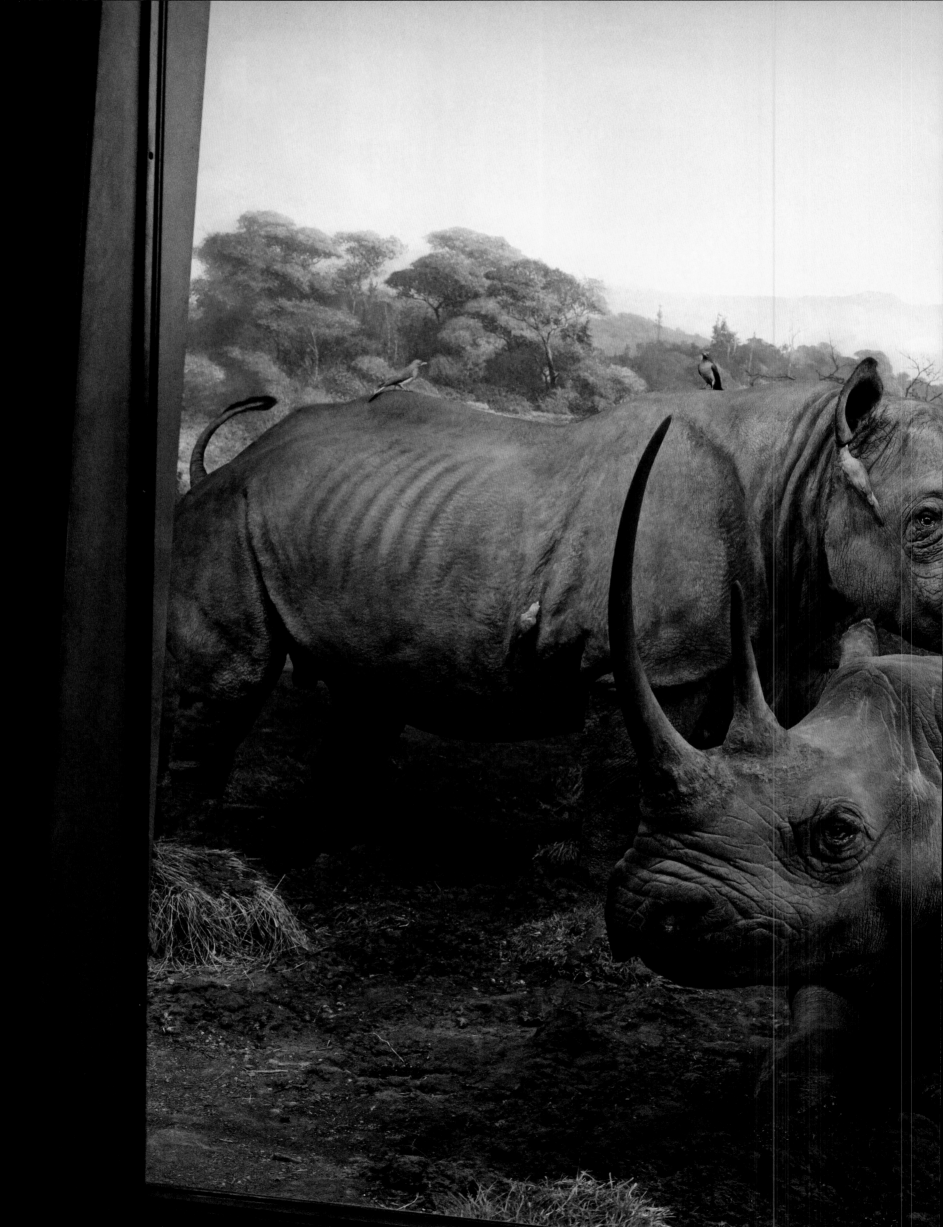

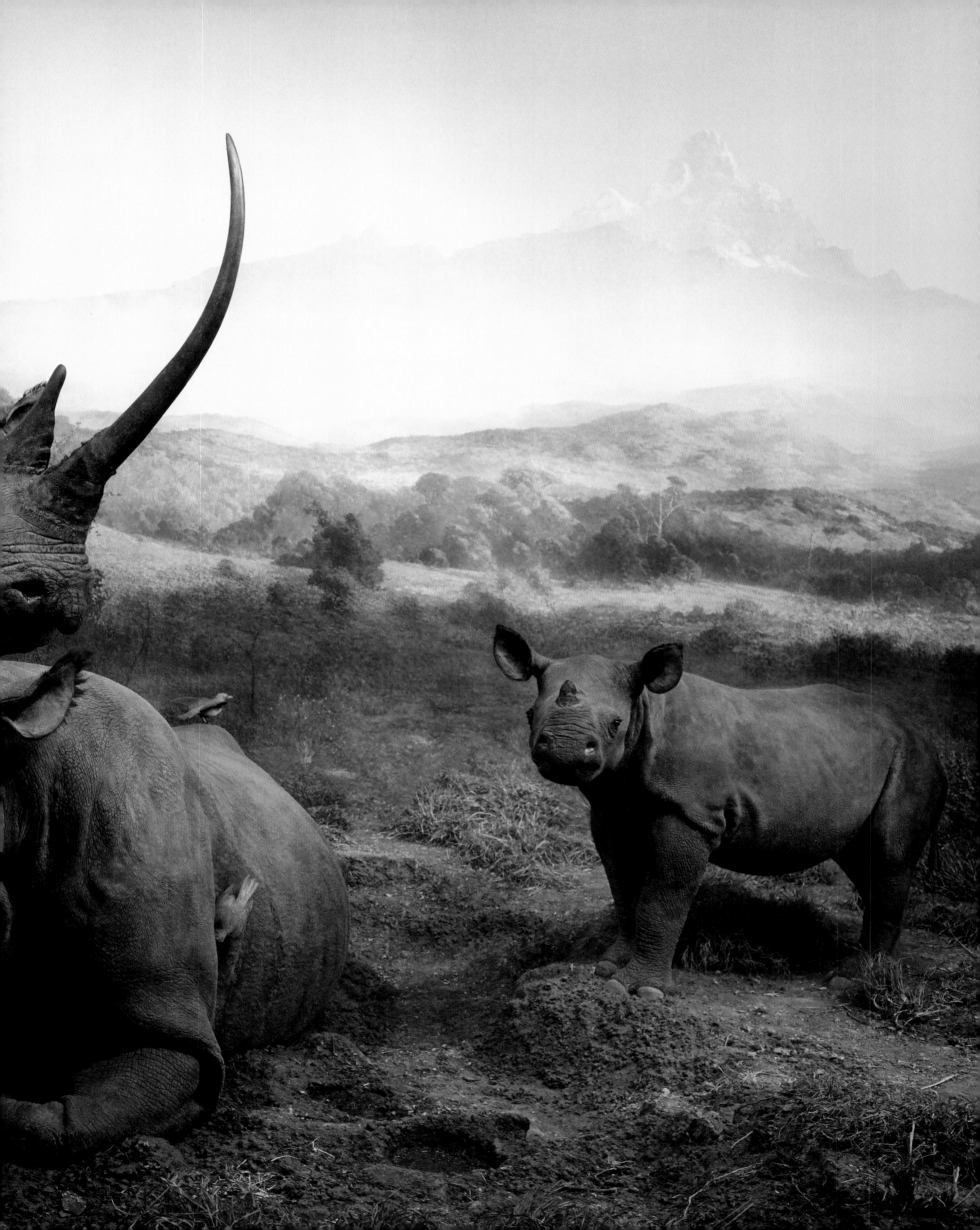

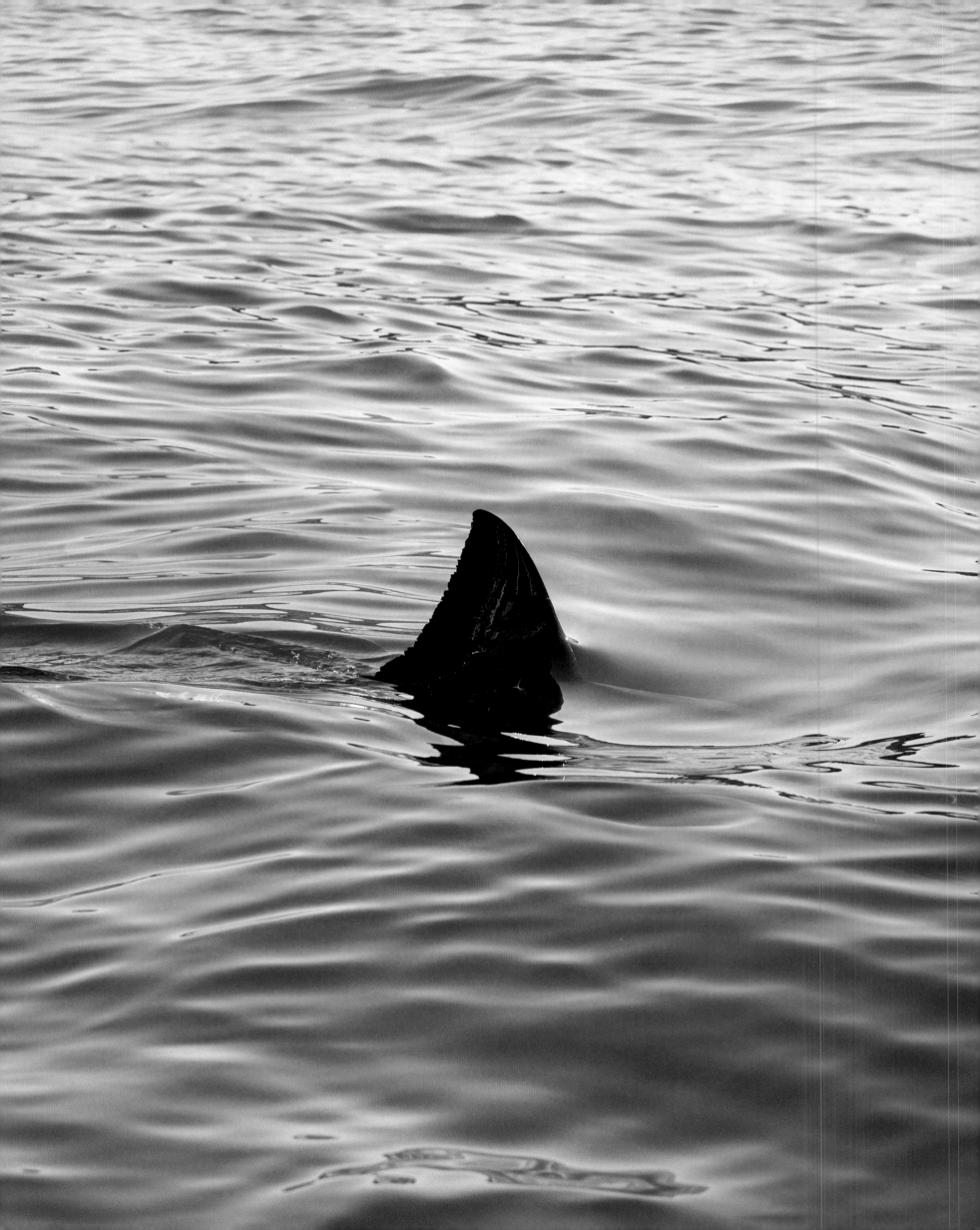

Beneath the surface

Every year, around one hundred million sharks are taken from the oceans to have their fins sliced off and shipped to East Asia, where they are dried, ground, and made into soup. The sharks themselves are dropped back into the ocean, powerless but alive, to sink to the seabed where they bleed to death. In 2013, the European Union finally banned this shockingly cruel practice in its member states, impeding some of the world's major exporters, but if consumer demand exists, a black market will always form.

Shark finning began to surge in the 1980s, when the Chinese economy boomed, because shark fin soup stands for good fortune and wealth. However, organizations such as WildAid have been publicizing its impact on the environment and, accordingly, its cultural significance has begun to fade, especially among China's youth. Although many shark species are threatened with extinction, our capacity for social and political change could see them recover.

Jaws

The public image of great white sharks, as monstrous man-eaters prowling our beaches, has weakened the social will for their conservation, and also made them something of a trophy species; their fins and teeth find buyers across the world, and their famous jaws often fetch over US$30,000. Their wild population—now of just a few thousand—is thinly spread throughout the world's oceans, and their coastal strongholds are diminishing.

The key to their survival will be the development of new, less destructive ways for locals to monetize their notoriety. Boat trips and cage-diving are becoming increasingly popular, and both of these industries are more lucrative and sustainable than the trade in body parts. Far from posing a threat to us, these apex predators maintain the marine ecosystem, which regulates our climate, removes carbon from the air, and provides us with food.

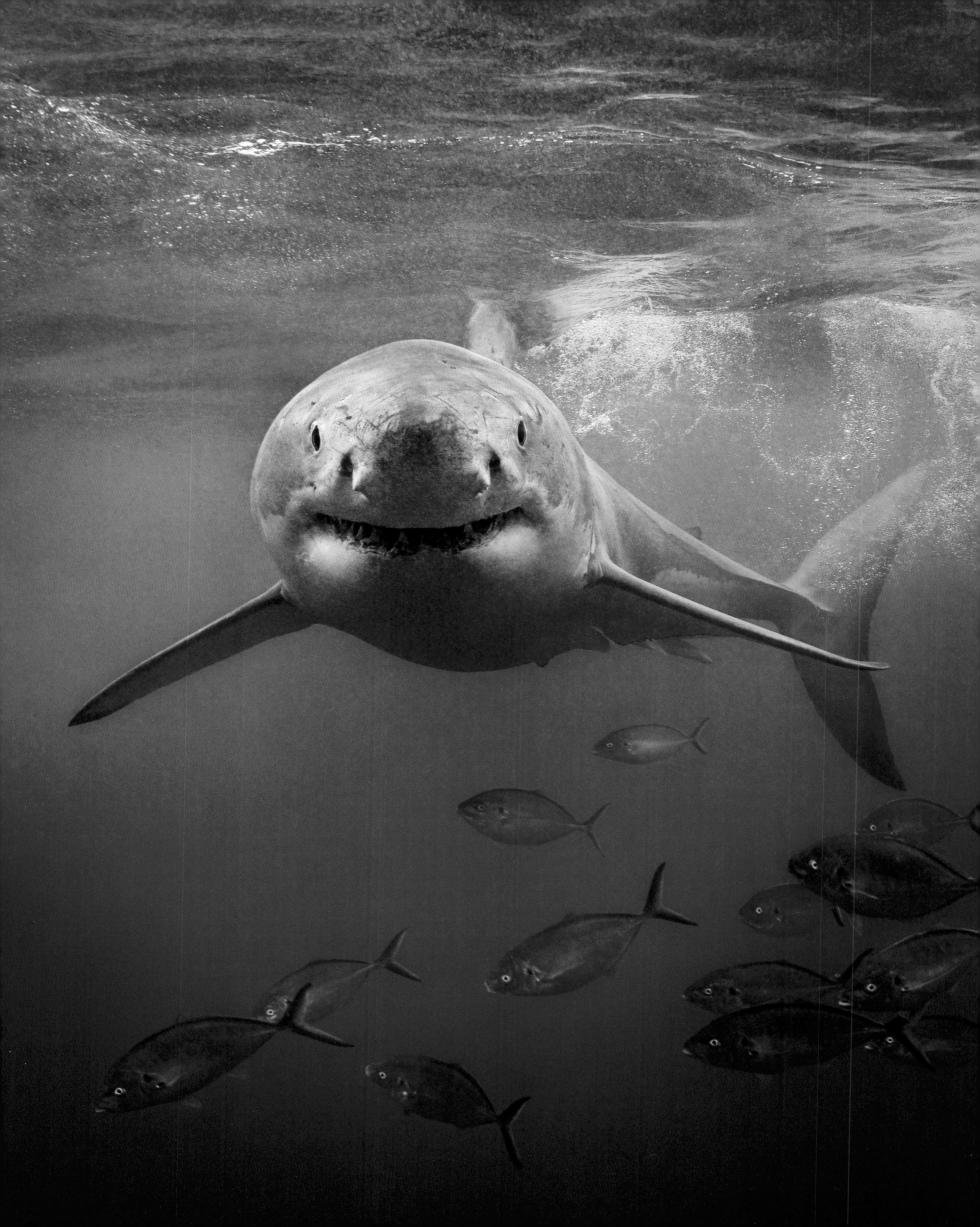

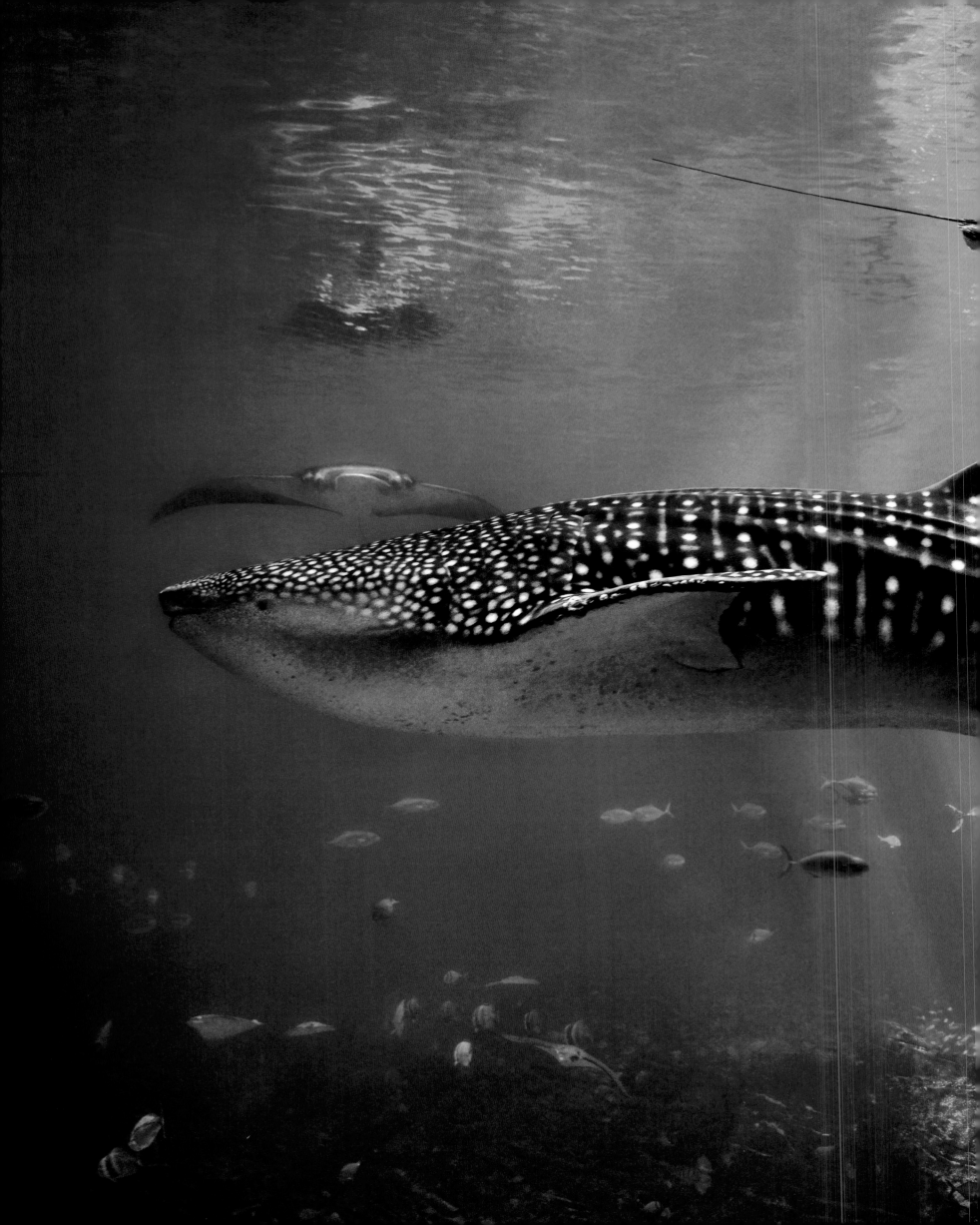

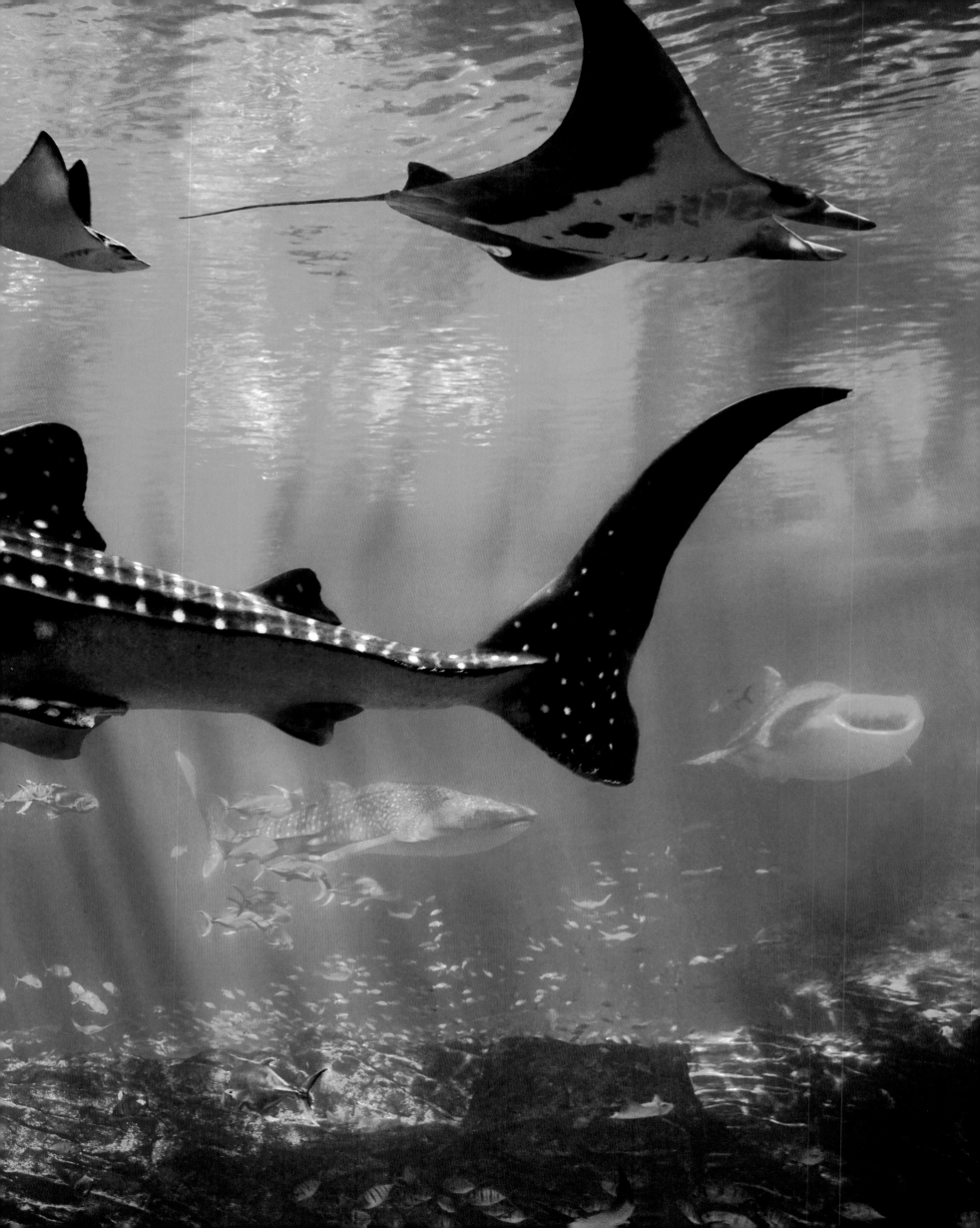

Group dynamics

As one of the world's most beguiling sea creatures, hammerheads have generally avoided the negative stereotypes suffered by most other sharks. These strange, iconic predators usually swim in large schools, and scalloped hammerheads (opposite) can be found in their hundreds, circling in temperate, coastal waters from Australia to China, from South America to West Africa, and into the Mediterranean Sea. With particularly valuable fins, these endangered fish are targeted by the brutal shark-finning industry, and their evolved grouping behaviors make them more vulnerable to reckless fishing practices. Although they live up to 1,600 feet (500 m) beneath the surface of the ocean, they can still become caught up in gillnets and longlines. Meanwhile, their young swim in shallower, even more exposed waters. The loss of infants can cripple hammerhead populations, which reproduce slowly, and leave them with very slim chances of bouncing back. Sharks now represent some of the ocean's most threatened fishes.

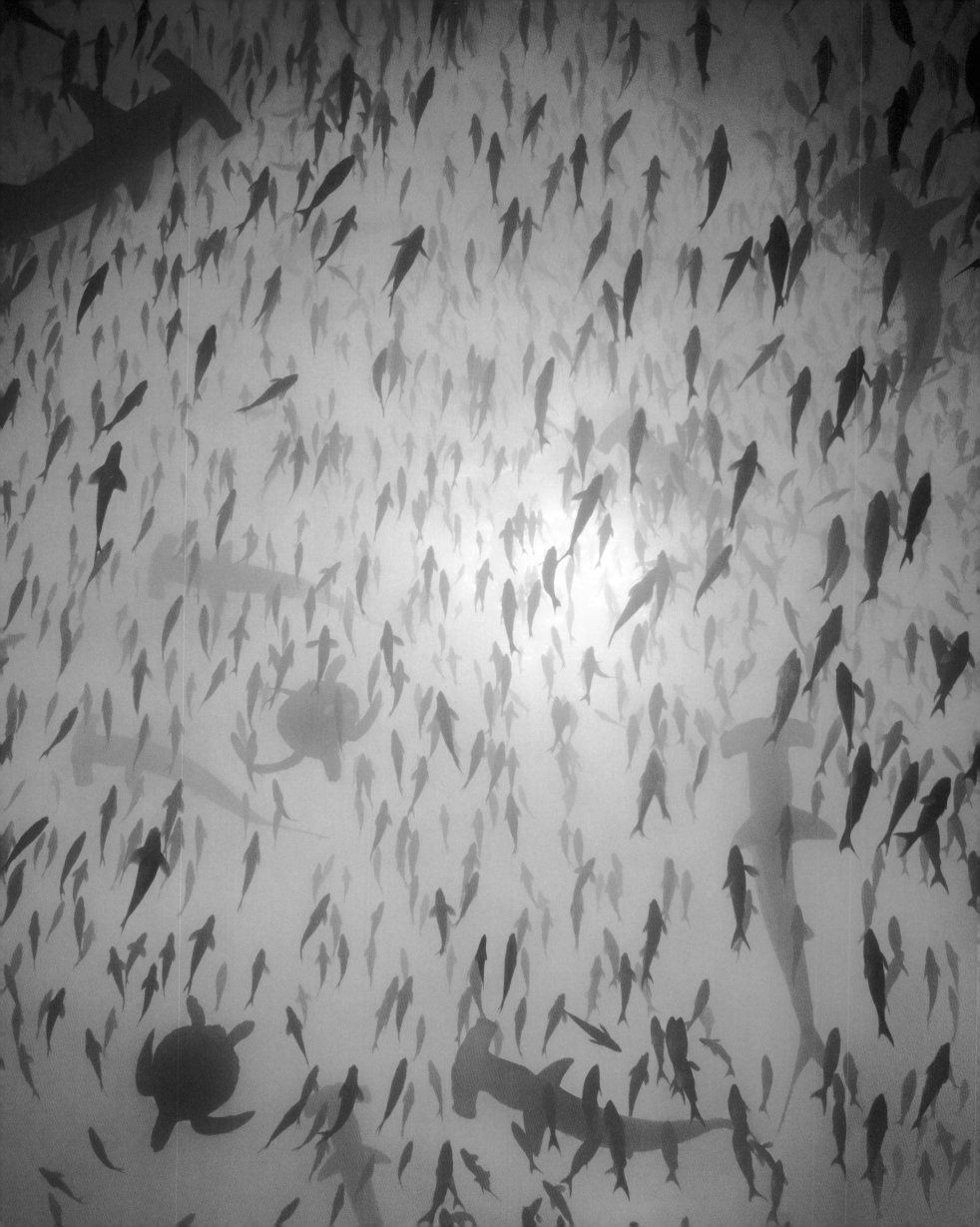

The mysterious deep

Melibe viridis has no common name, as it barely figures in the public eye. It is a species of nudibranch—a type of marine mollusk that often exhibits bizarre shapes and dazzling colors. Marine mollusks also include octopi, the most intelligent invertebrates, as well as sea slugs, cuttlefish, and the legendary giant squid. In fact, they represent almost a quarter of named marine taxa, with fifty-five thousand known species in the sea. And, yet, very few have been evaluated by the International Union for the Conservation of Nature. It has generally been assumed that marine mollusks would be protected from modern dangers by their widespread distribution and covert lifestyles, but research is emerging that details their worrying declines. Bottom trawling, pollution, and the degradation of coral reefs pose serious existential threats, and we may begin losing some of our most intriguing species, perhaps before many are even discovered.

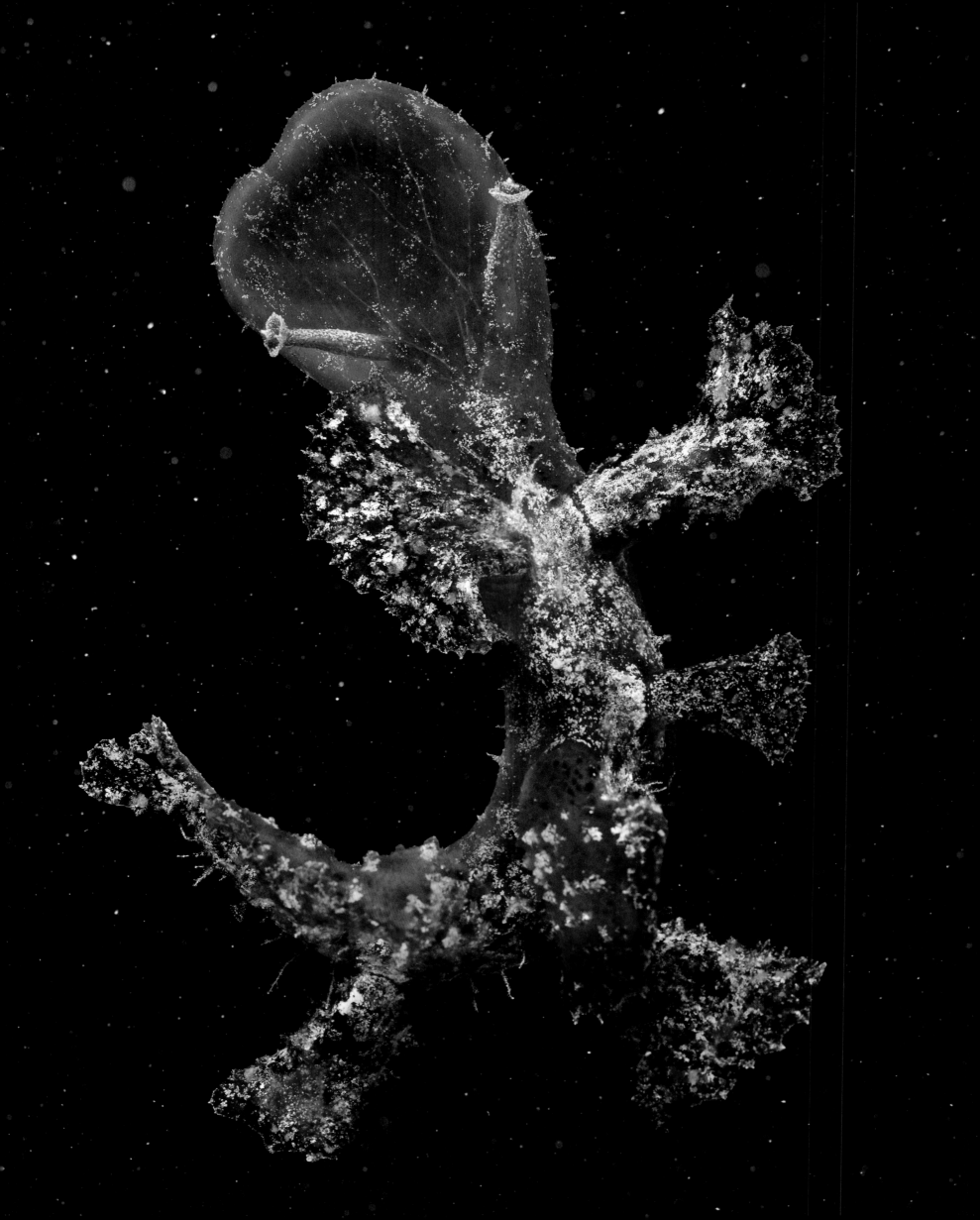

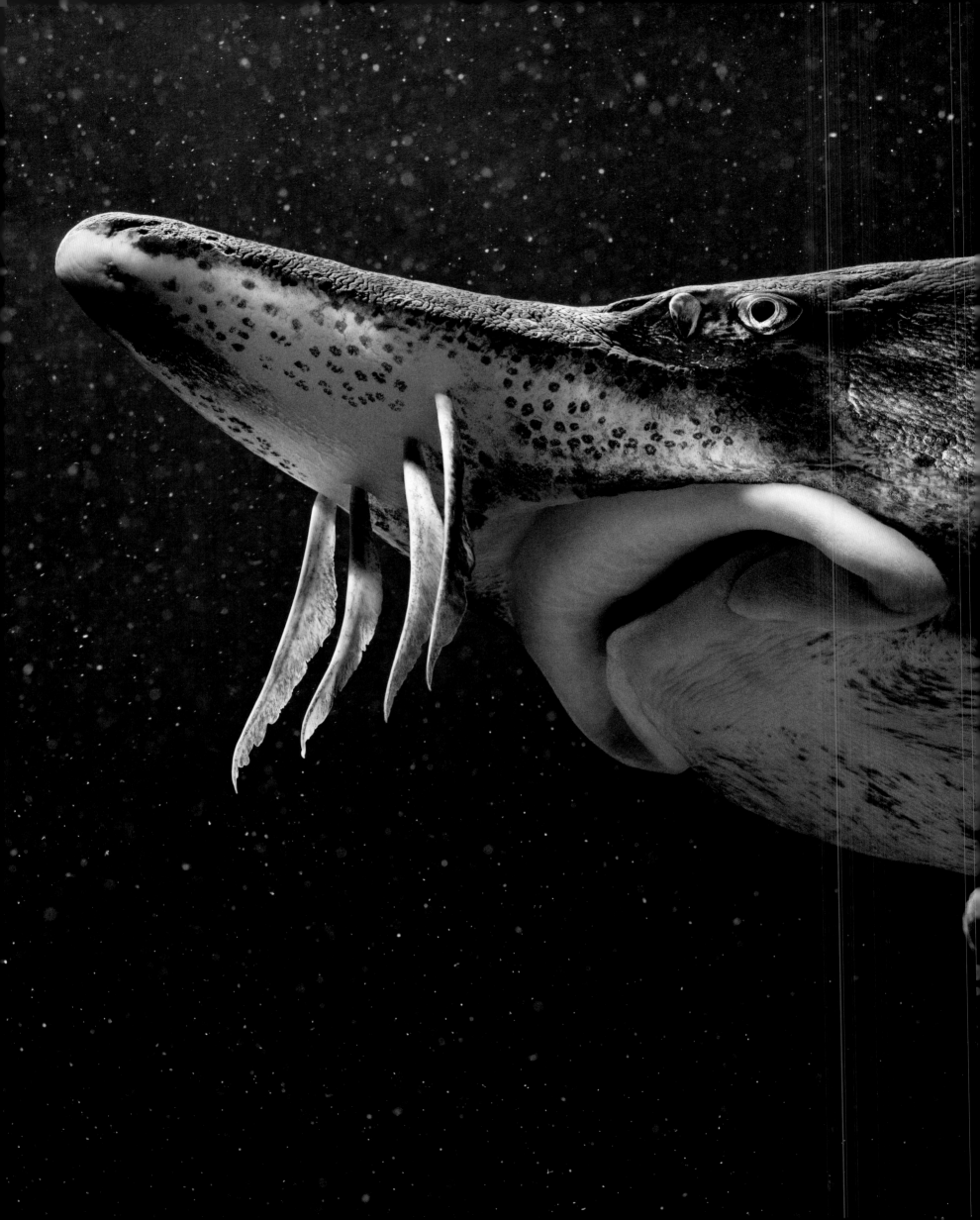

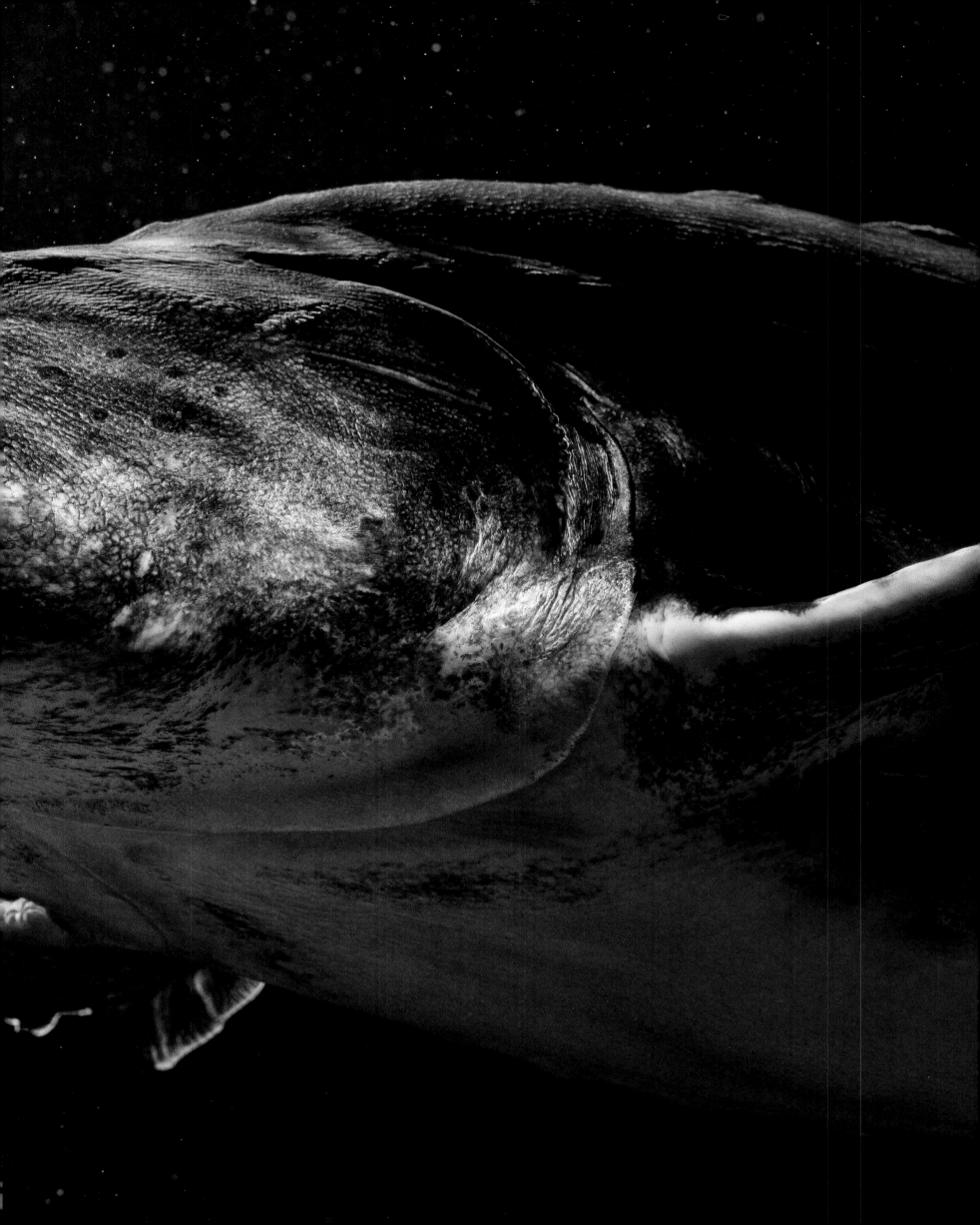

Dried out

The La Palma pupfish is one of several species of pupfish from Nuevo León, Mexico. They are so named for the playful way they flap their pectoral fins, like dogs wagging their tails, which is, in fact, a highly aggressive territorial display. For millennia, each species was contained in its own small desert spring, which became as warm as bathwater during the day and fell to almost freezing at night.

In the late 1980s, local farmers used groundwater abstraction to feed their crops and eliminated these fishes' tiny habitats. Some species were already in aquariums and survived, but others went extinct before they could even be named. La Palma pupfish are now being bred by the Zoological Society of London, but their habitat remains far too poor for reintroductions to be considered. Over 20 percent of species belonging to their genus *Cyprinodon* have been lost from the wild, and a further 10 percent have become completely extinct.

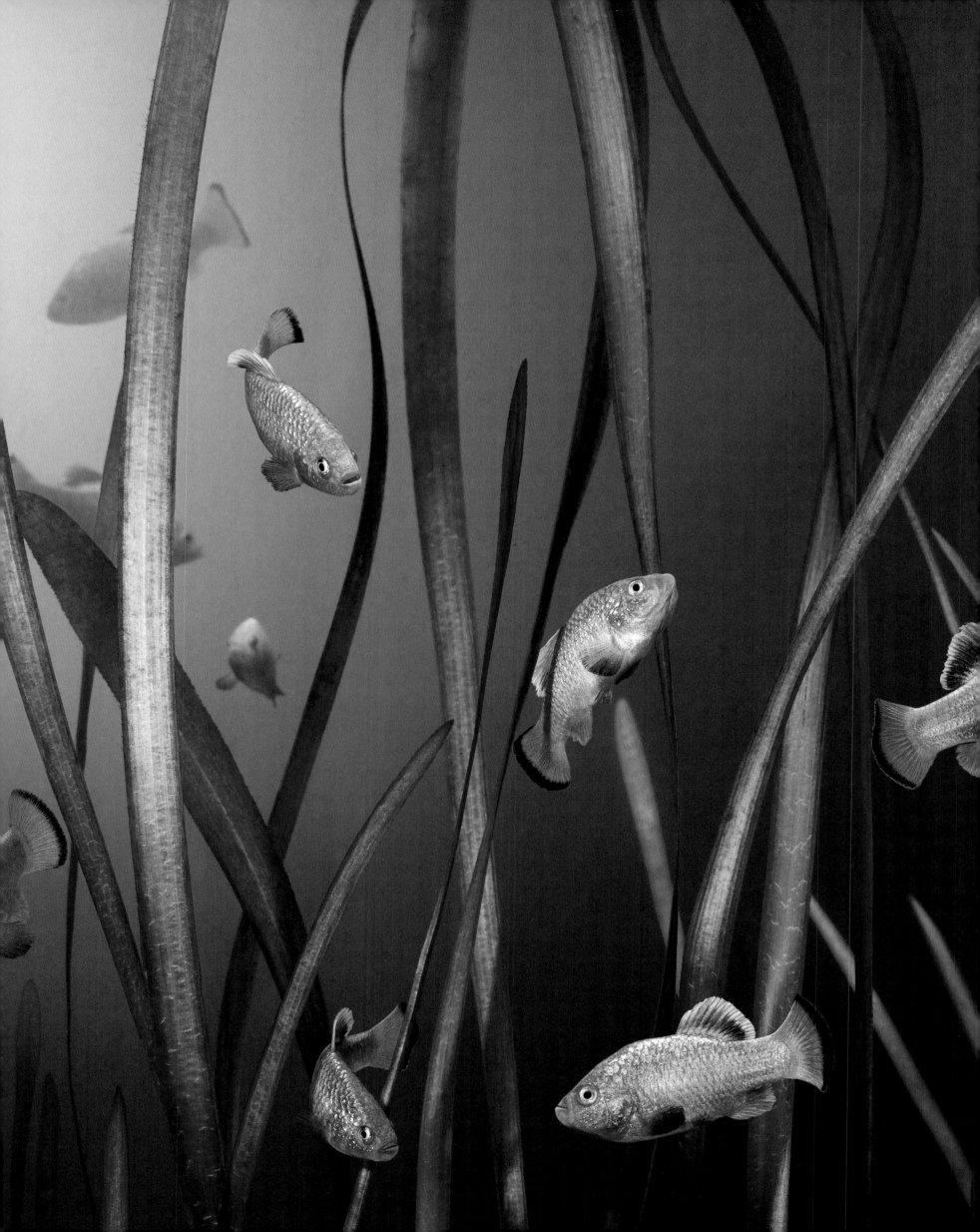

A second chance

In the 1970s, the islands of French Polynesia were suffering from an invasion of giant African land snails, which had probably come ashore from cargo ships. They were eating their way through crops and garden plants, so as pest control, the predatory rosy wolfsnail was introduced. But rather than hunting their intended targets, the rosy wolfsnails began eating endemic species of *Partula* snail. Many of these unique *Partula* species disappeared for good. Others went extinct in the wild, but not before scientists rescued individuals to be bred in captivity. Their descendants (opposite) have become strong enough to return to the wild, and in 2015 and 2016 ten *Partula* species were reintroduced. It was a monumental task, requiring diligent groundwork and the cooperation of governments, zoos, and scientists around the world. The rosy wolfsnail population has subsided over the years and become assimilated into the balance of the food web, so *Partula* snails will have the chance to thrive once again.

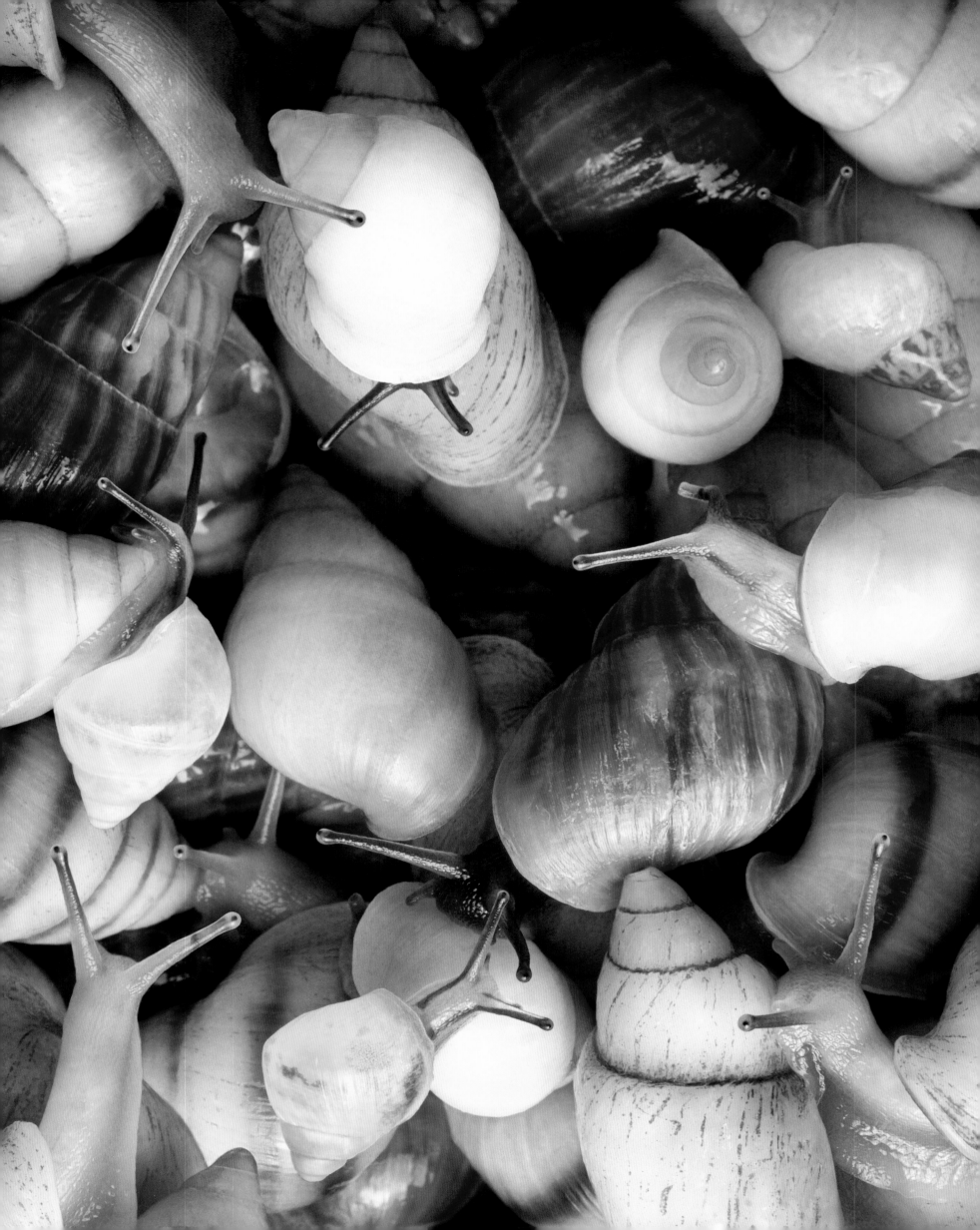

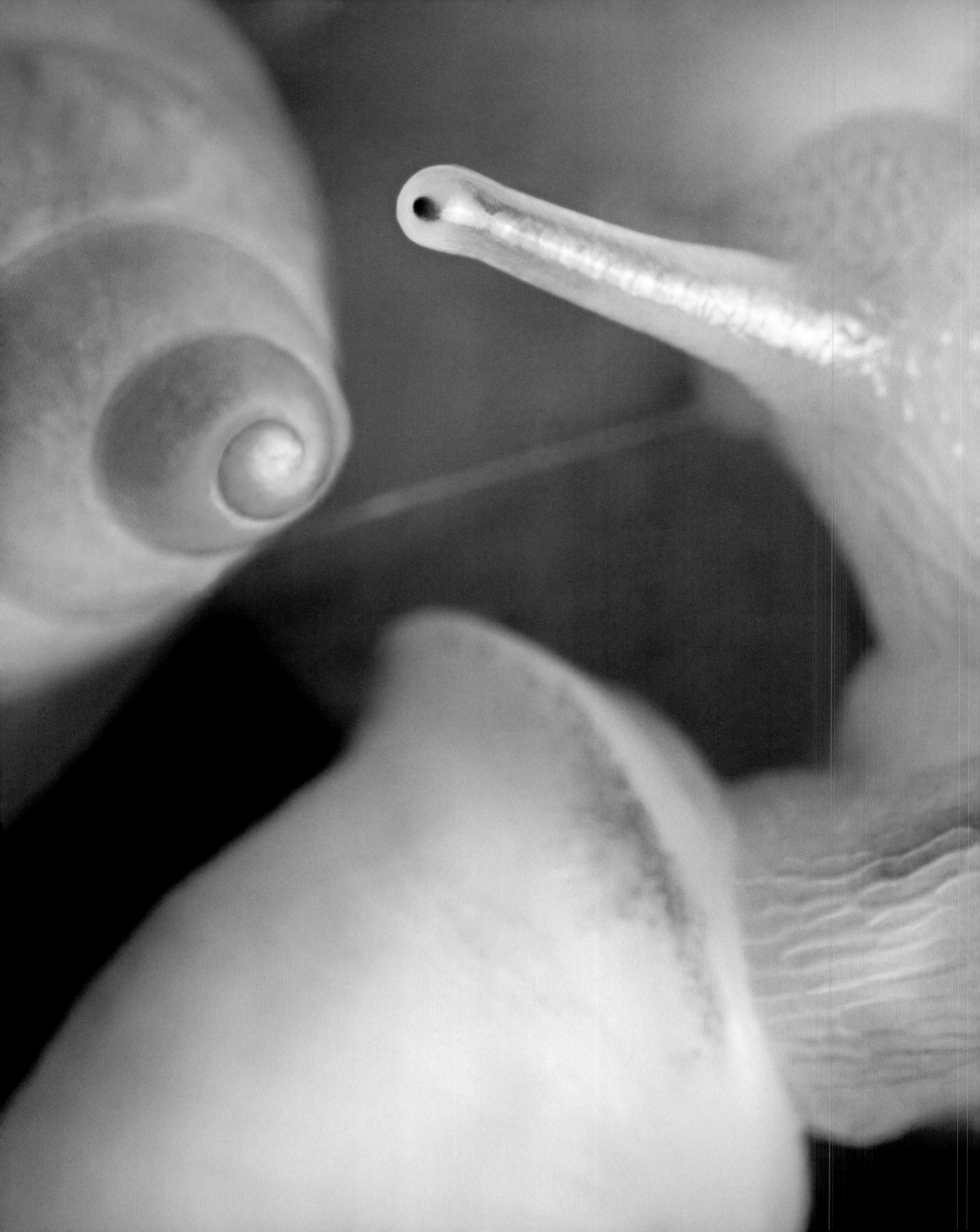

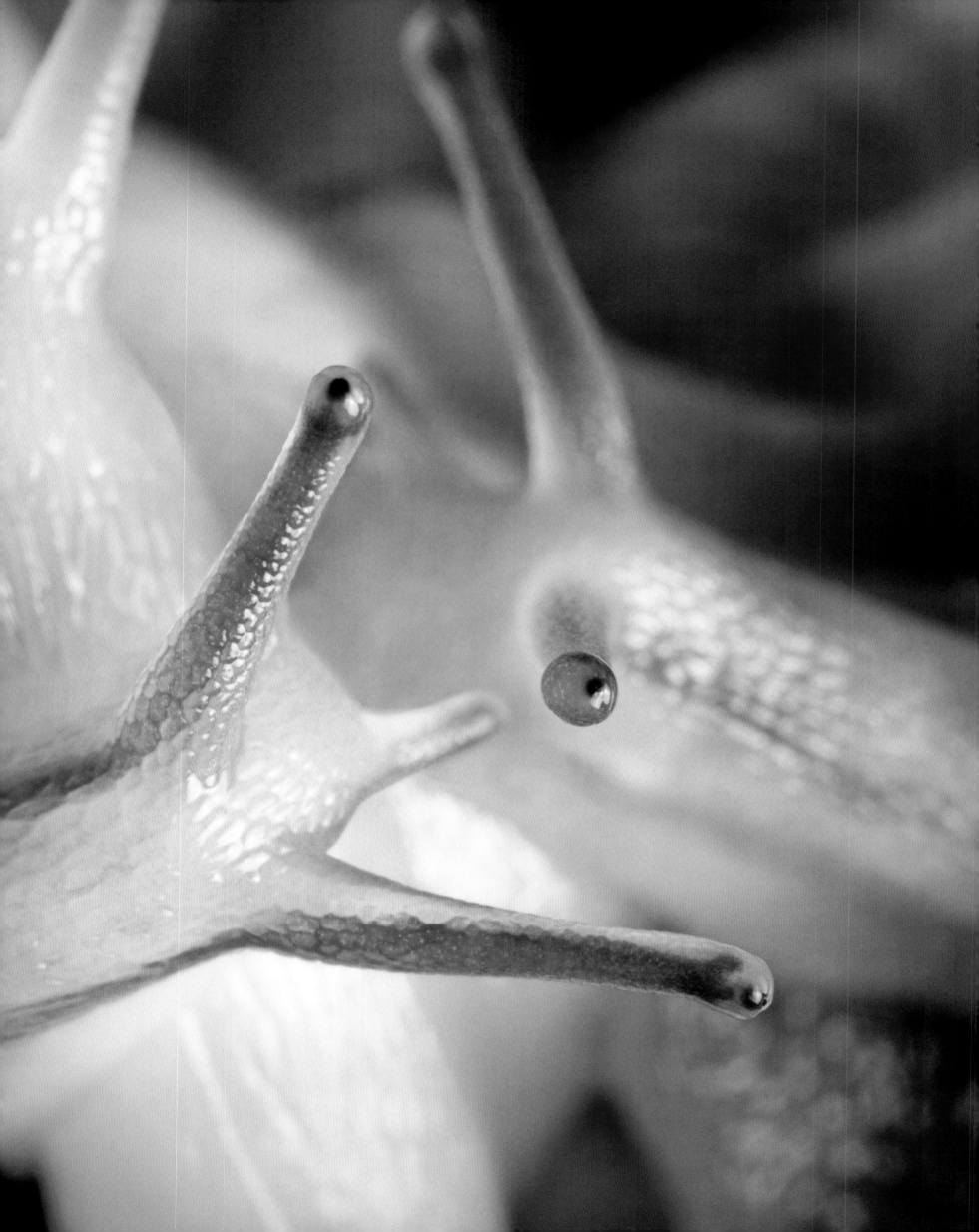

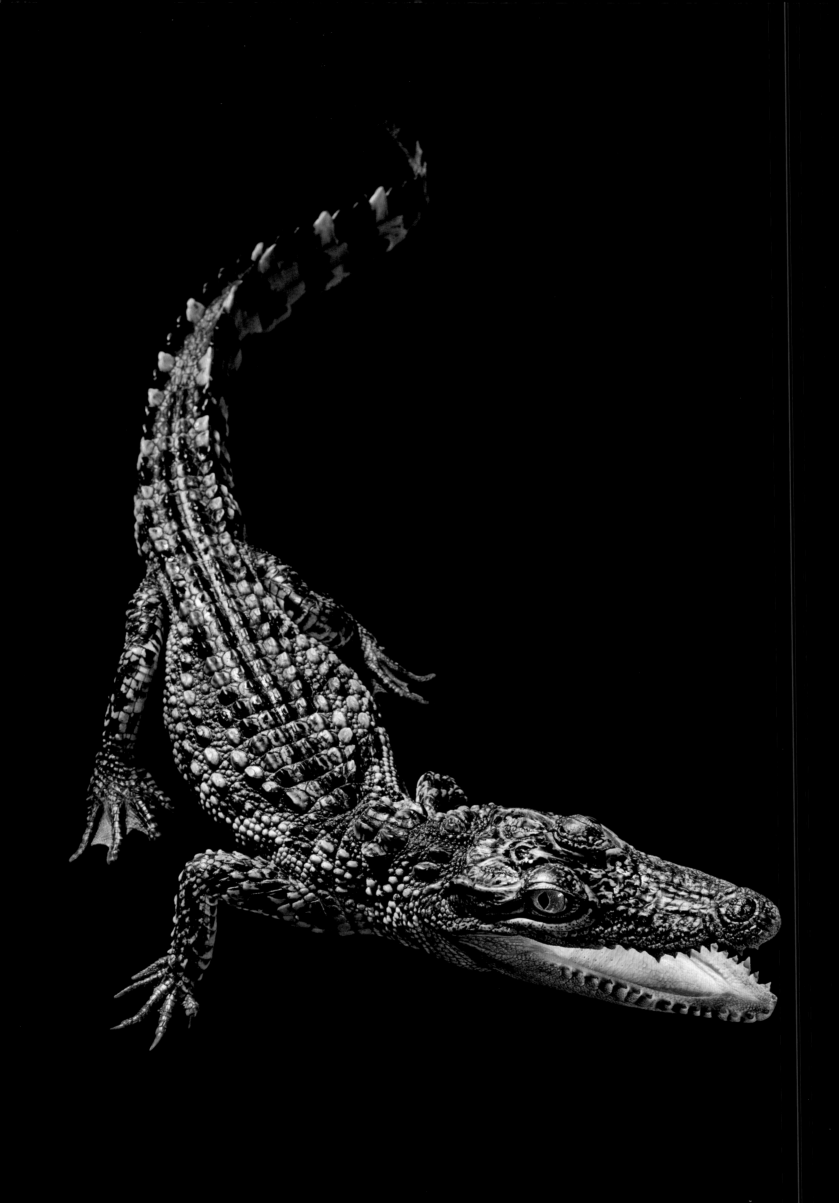

Under the skin

After a hundred years of being hunted for their leather, Siamese crocodiles number just a few hundred in Southeast Asia. Reproduction is slow, and to reach maturity is rare; climate change has pushed river levels higher, making traditional nesting spots unsafe. Suffering the impacts of flooding, deforestation, and poaching, fewer than 10 percent of eggs become adult crocodiles. Most crocodiles, including these 13-foot (3.9 m) giants, pose no threat to humans, and where they are traditionally respected by Indigenous communities, their populations remain most secure.

Although Siamese crocodiles are facing extinction in the wild, they are farmed throughout Asia in their hundreds of thousands to make boots, handbags, and wallets. These farms should be designed to aid conservation, but as stock is hybridized to make different kinds of leather, any reintroductions to the wild would jeopardize genetic purity. Crocodiles are usually at the top of the food chain, and so regulate everything beneath them. Their disappearance could prove catastrophic.

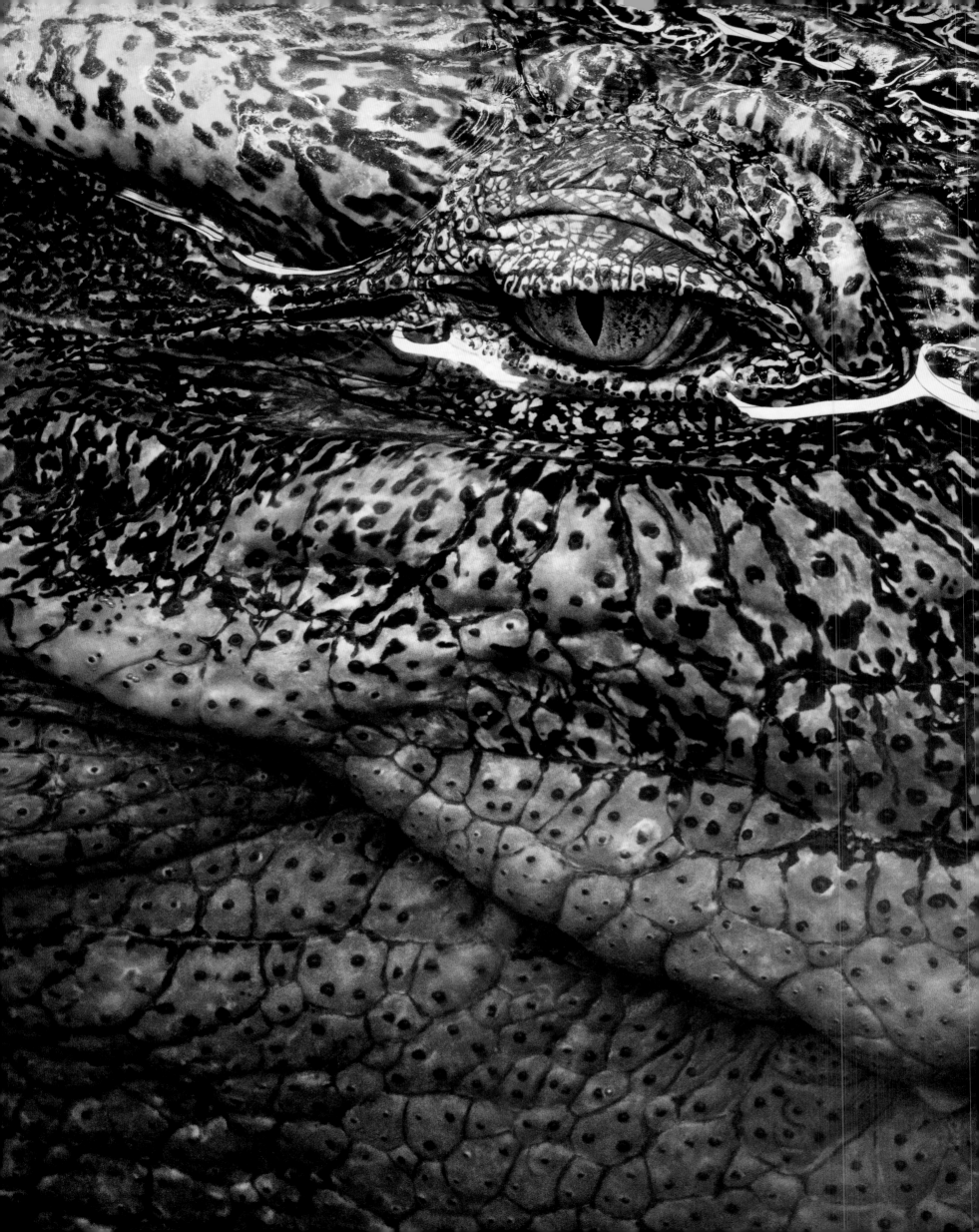

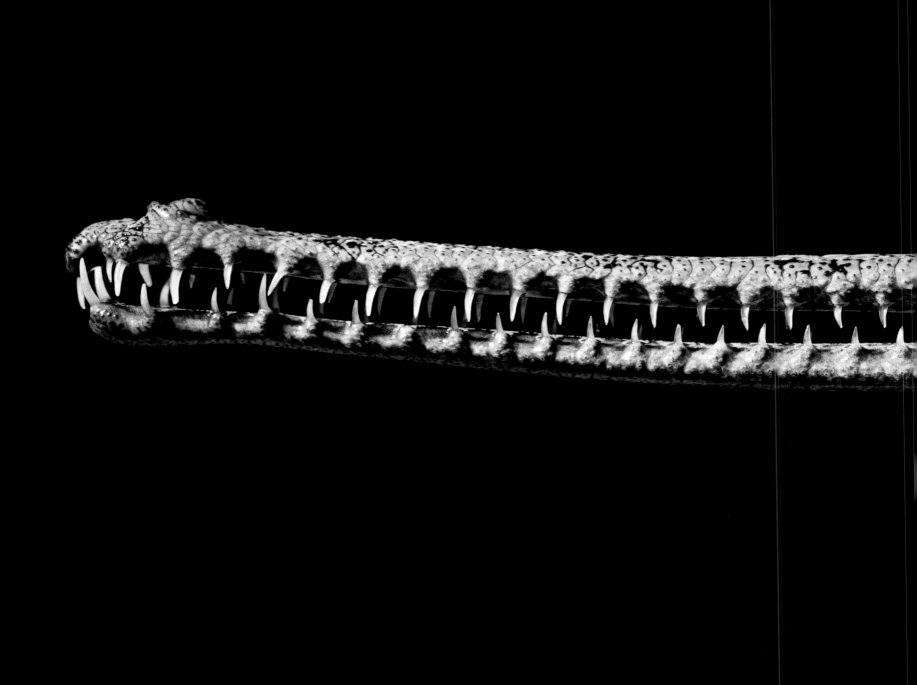

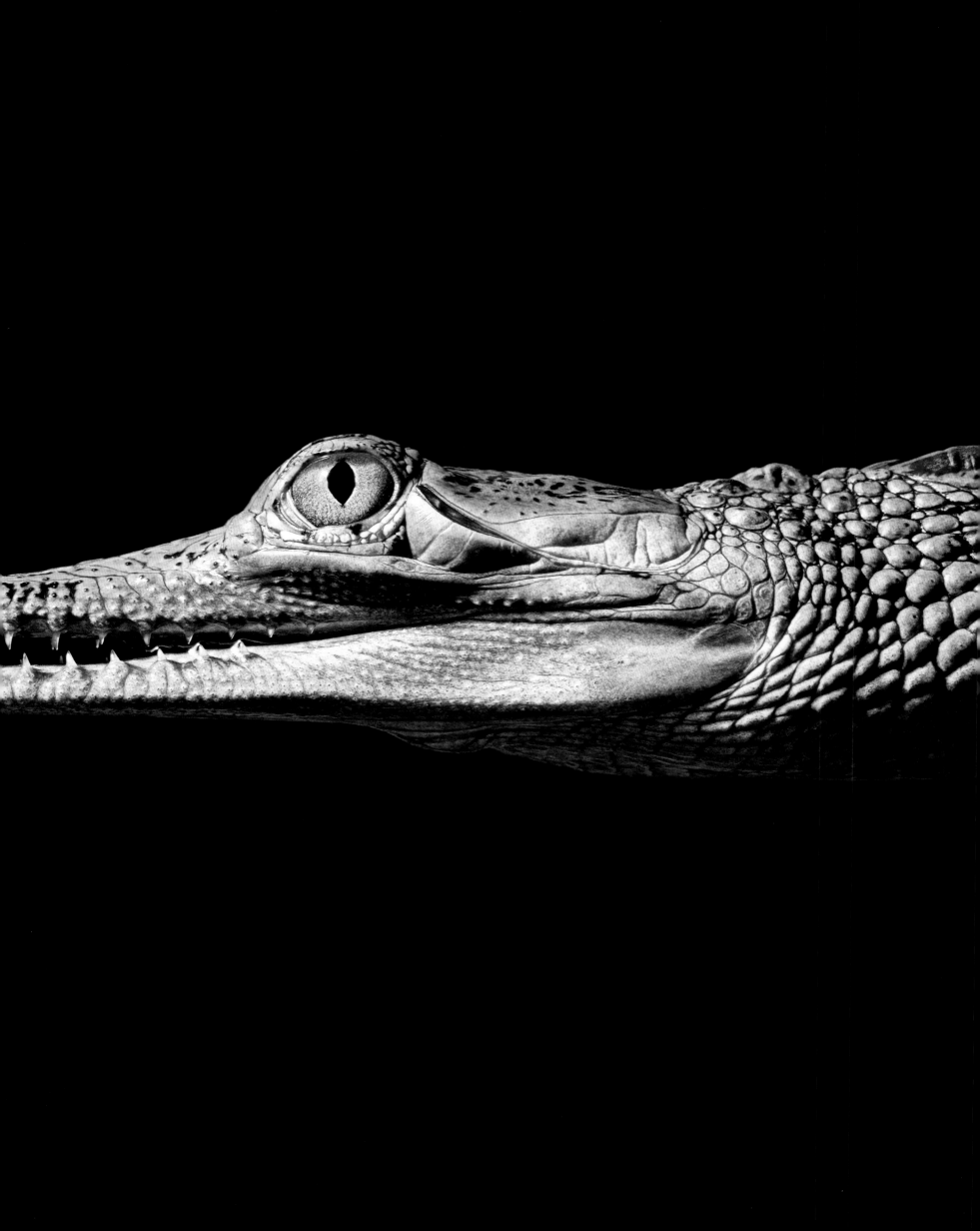

Survivors

The leather trade destroyed many crocodile, alligator, and caiman populations in the twentieth century, but smooth-fronted caimans have emerged relatively unscathed. As some of the smallest crocodilians in the world, they have evolved with the toughest, most osseous armor. So, while they are sometimes hunted for meat by local villagers, they are of little interest to the international leather trade, and today their population could be greater than one million. However, they are now threatened with habitat loss and the operations of illegal gold miners, who dump poisonous waste into rivers to keep their illicit activities under wraps. This prehistoric species bypassed mass hunting, but may find the twenty-first century a much harsher struggle.

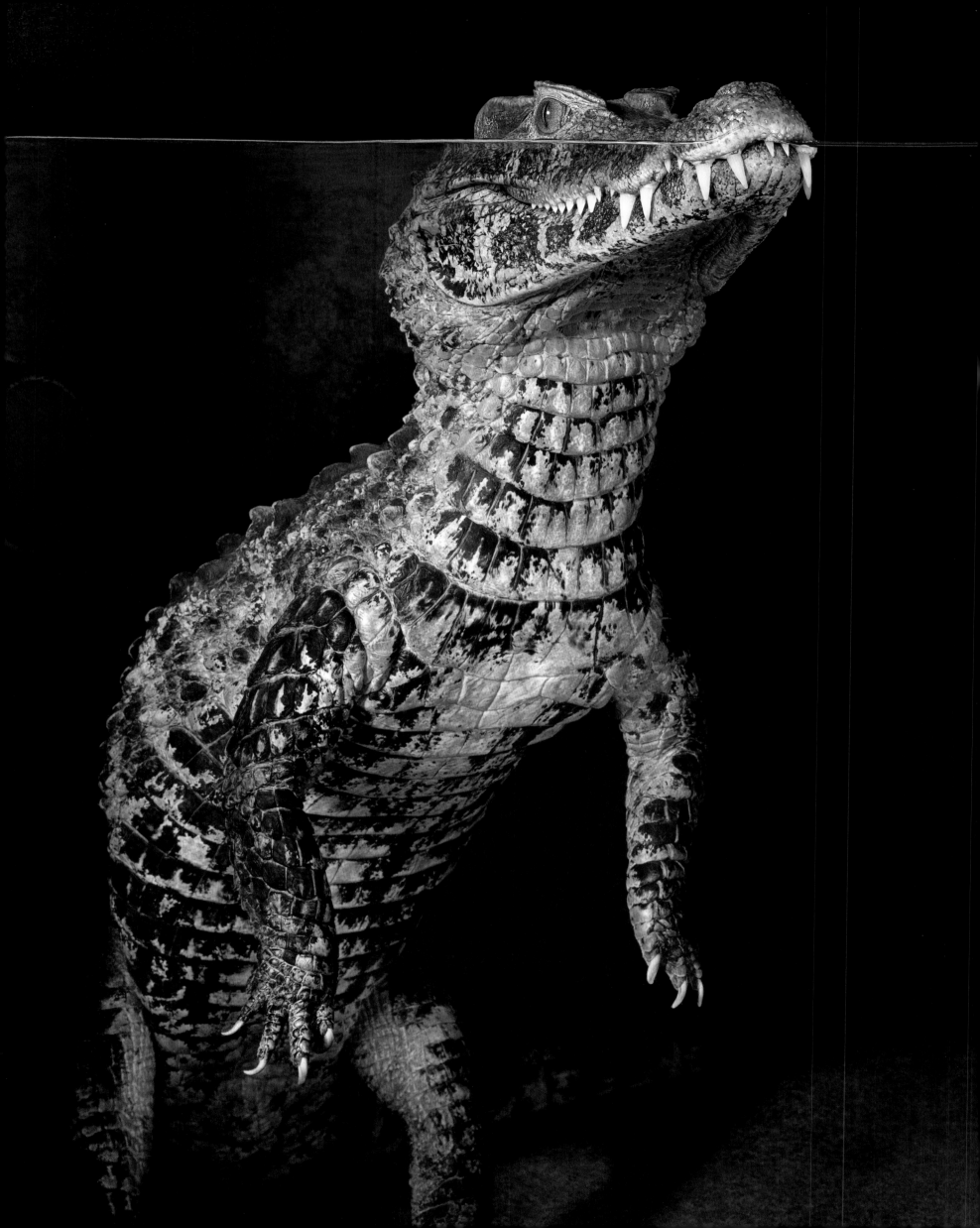

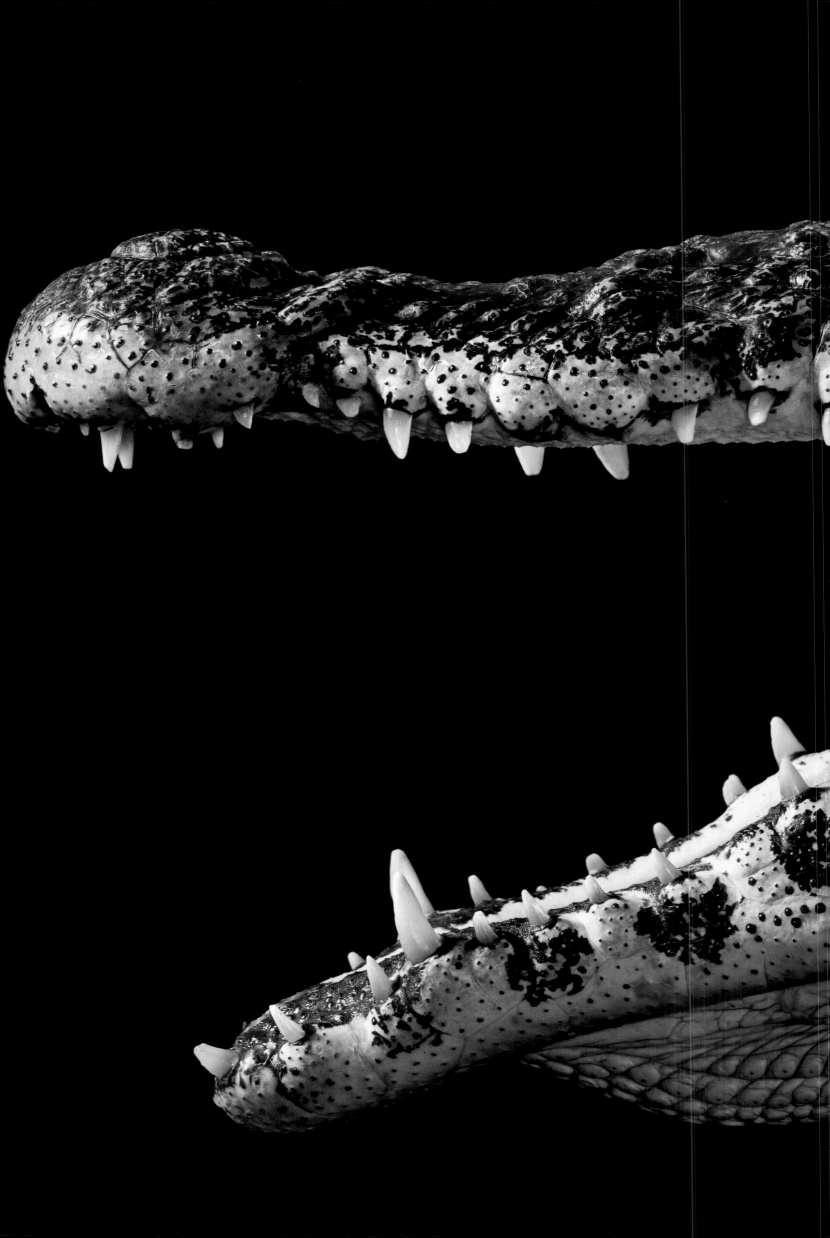

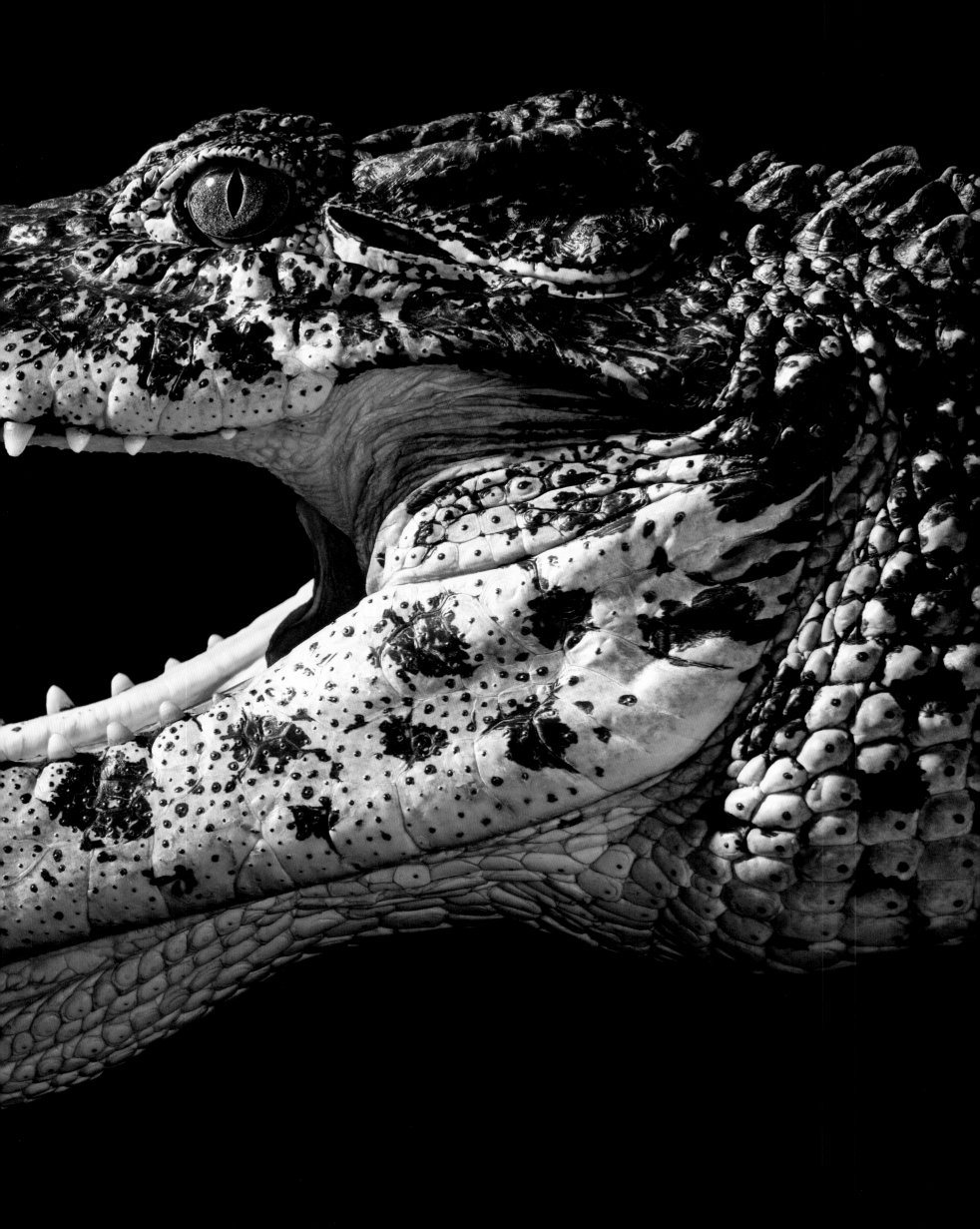

Melting pot

Marine iguanas forage for food underwater, diving up to 65 feet (20 m) deep for as long as thirty minutes looking for green algae. On land, they bask in the sun, reabsorbing heat through their black skin until they are ready to hunt again. When Charles Darwin first saw them, he was repulsed and called them "imps of darkness." But they eventually helped him to formulate his theory of evolution, as they demonstrated a unique adaptation fitted to their environment.

They are found in the Galapagos Islands, alongside coral reefs, giant tortoises, and penguins. This renowned biodiversity results from unique local microclimates, caused by the confluence of three different oceanic currents at this archipelago. At irregular intervals of two to seven years, warm waters from the western tropical Pacific displace the coolest current, leading to a devastating natural phenomenon known as El Niño. Rainfall increases, sea temperatures rise, and the marine iguanas' food source mostly disappears. The animals of the Galapagos have evolved to cope with El Niño, and it has become an integral part of the ecosystem, but climate change may increase its frequency and intensity, favoring invasive species while putting pressure on these unique marine lizards.

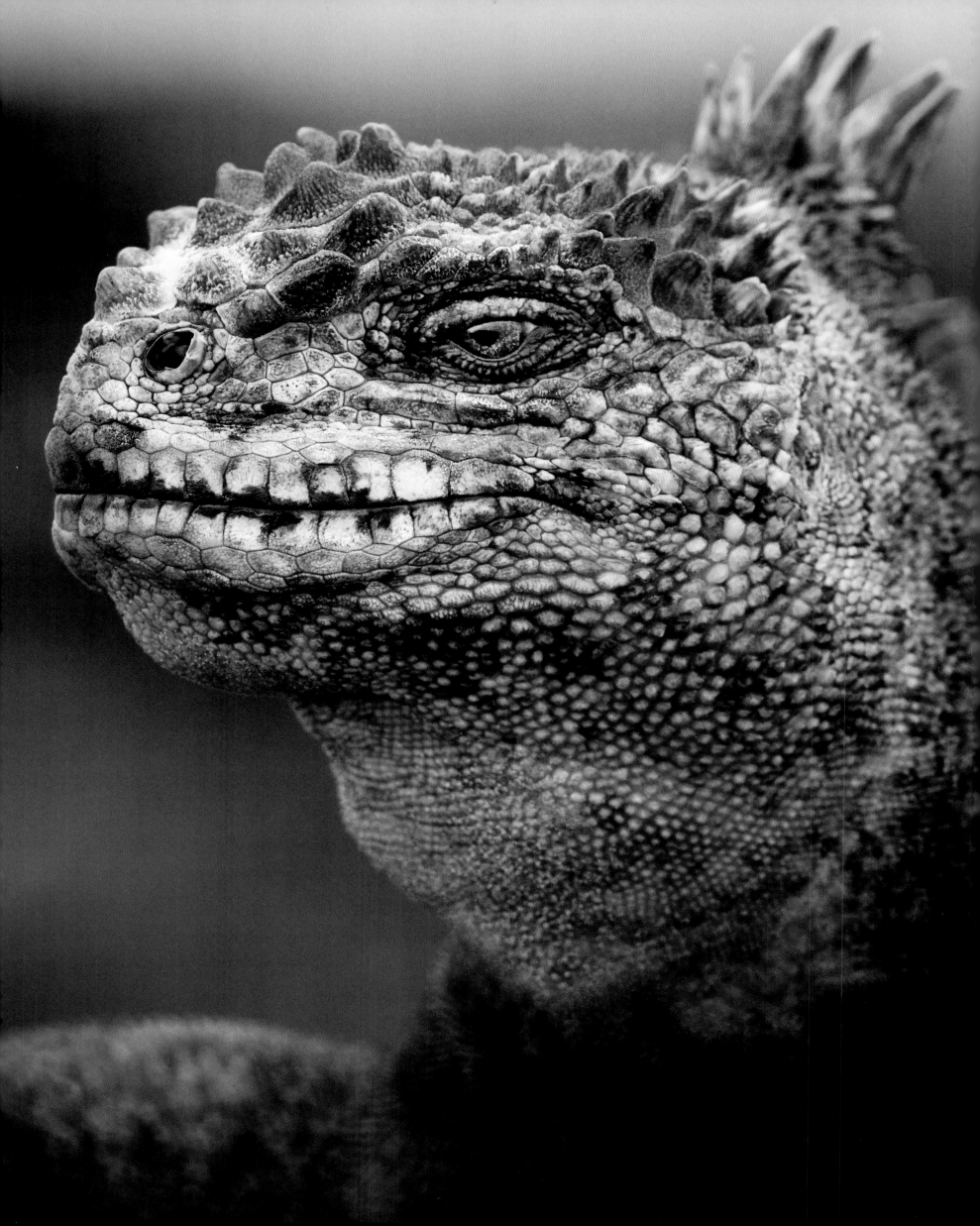

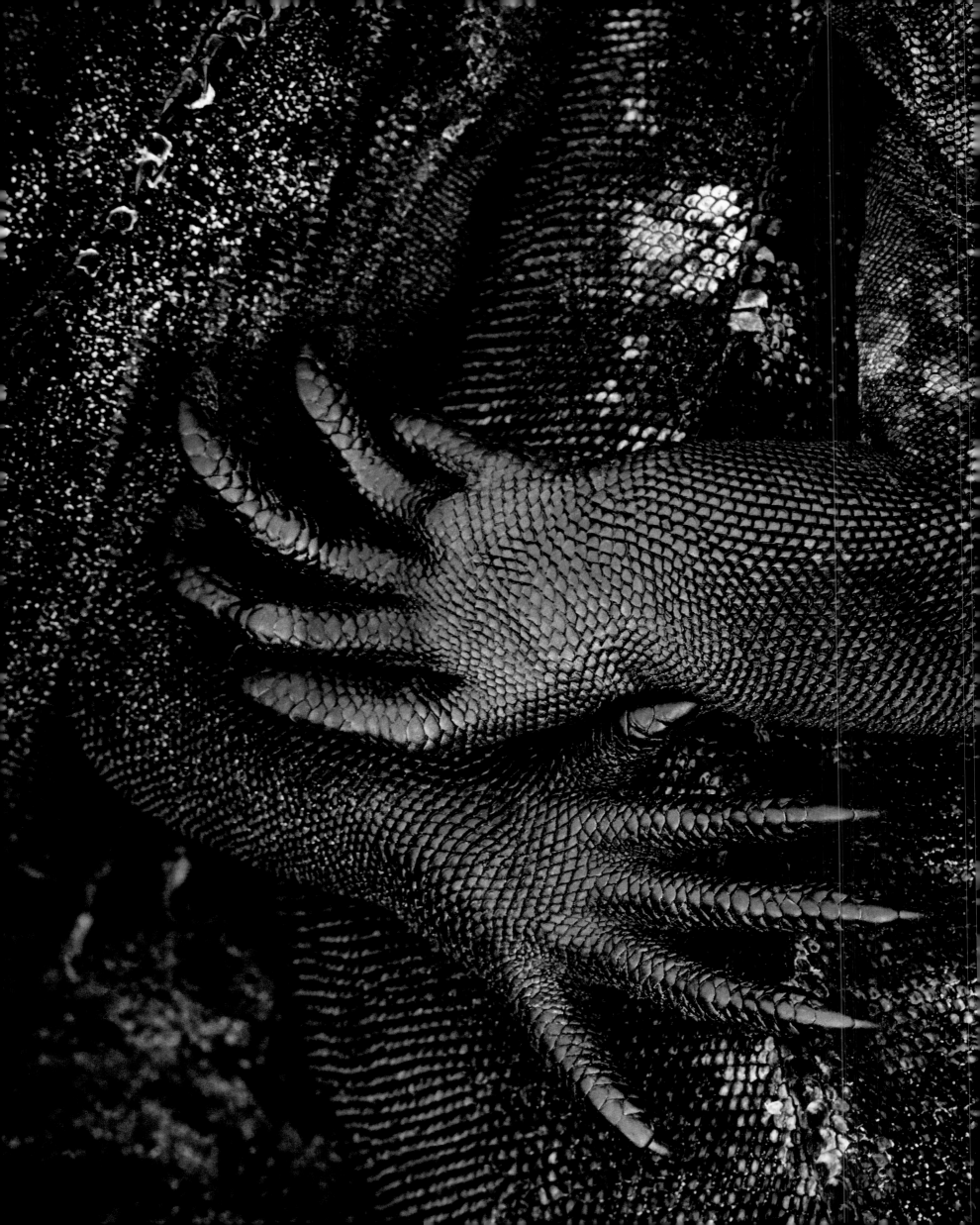

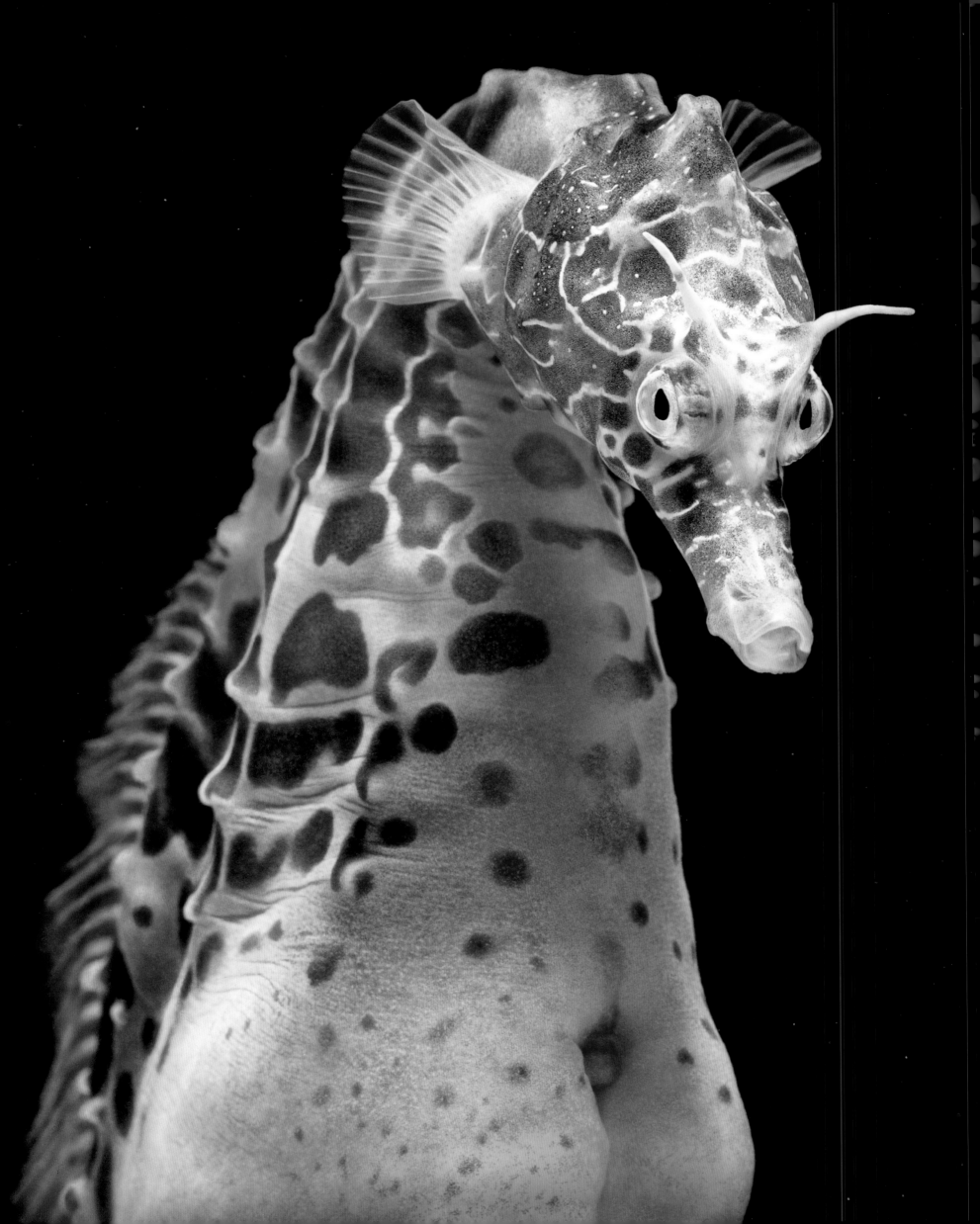

Epilogue
Professor Jonathan Baillie

You have now completed your initial participation in Tim Flach's experiment, and you have likely experienced a full range of emotions as you absorbed the images in *Endangered* and read the stories of each species and its habitat.

When analyzing your response, it is important to first acknowledge that, as a great ape, you have a biased view of the world. You tend to like things that are colorful, resembling ripe fruit; and you are fascinated by species that would make a rewarding meal or which have the ability to eat you. Anything that looks similar to you or a baby primate with big eyes or large head-to-body ratio also captures your attention. As a great ape, you also have a powerful intellect, giving you the ability to look beyond your primate-centric view of the world and place value on all species.

Which species in the book were you most drawn to? Did you feel an emotional connection with both the animals and the habitat? If the answer is yes, what was it that triggered that emotional response? Importantly, did reading this book result in you caring more about threatened species or make you want to take steps to protect them?

From the case studies in this book it is evident that being iconic or of interest to humans is not always an advantage. All our great ape relatives are either endangered or critically endangered. Many of the iconic animals represented in children's books are threatened—elephants, rhinos, giraffes, lions, and tigers. Clearly our cultural relationship with nature needs to shift if we are not even capable of protecting the species that society cares about most.

I spoke to Tim after he completed his final shoot in Japan of the red-crowned cranes engaging in their spectacular courtship dance. As you can see, he beautifully captures their poetic ritual, so commonly depicted in art across Asia. As we talked, Tim asked: how could a species so significant in the art of a culture be allowed to almost disappear? It is odd to think that we may value the art more than the subject itself. Ironically, the red-crowned crane is associated with immortality in Chinese mythology. This exemplifies how we need to connect with animals and their habitats on a much deeper level and truly commit to ensuring that they remain as a vibrant living part of both human culture and nature.

Tim illustrates the fact that an animal isolated from its environment is not a complete creature: that a gorilla is not a gorilla when isolated from the jungle, an olm is not an olm when removed from its freshwater cave. In this way, he encourages us to conceptualize the species as part of the landscape.

Humans are the only great apes that are not listed in this book, as we are currently far from threatened, but we, too, are losing our natural habitat. It is interesting to contemplate what a human is when isolated from its natural environment. Understanding the implications of this human isolation may likely explain many of the challenges faced by urban communities, such as high levels of violence, obesity, and depression.

This book is a first step in exploring how and why we connect emotionally to other forms of life through visual imagery. It is my hope—and Tim's—that this work stimulates much more experimentation and research into this field. Never before has it been so important to connect people with nature—our future depends on it.

Never before has it been so important to connect . . .

people with nature—our future depends on it.

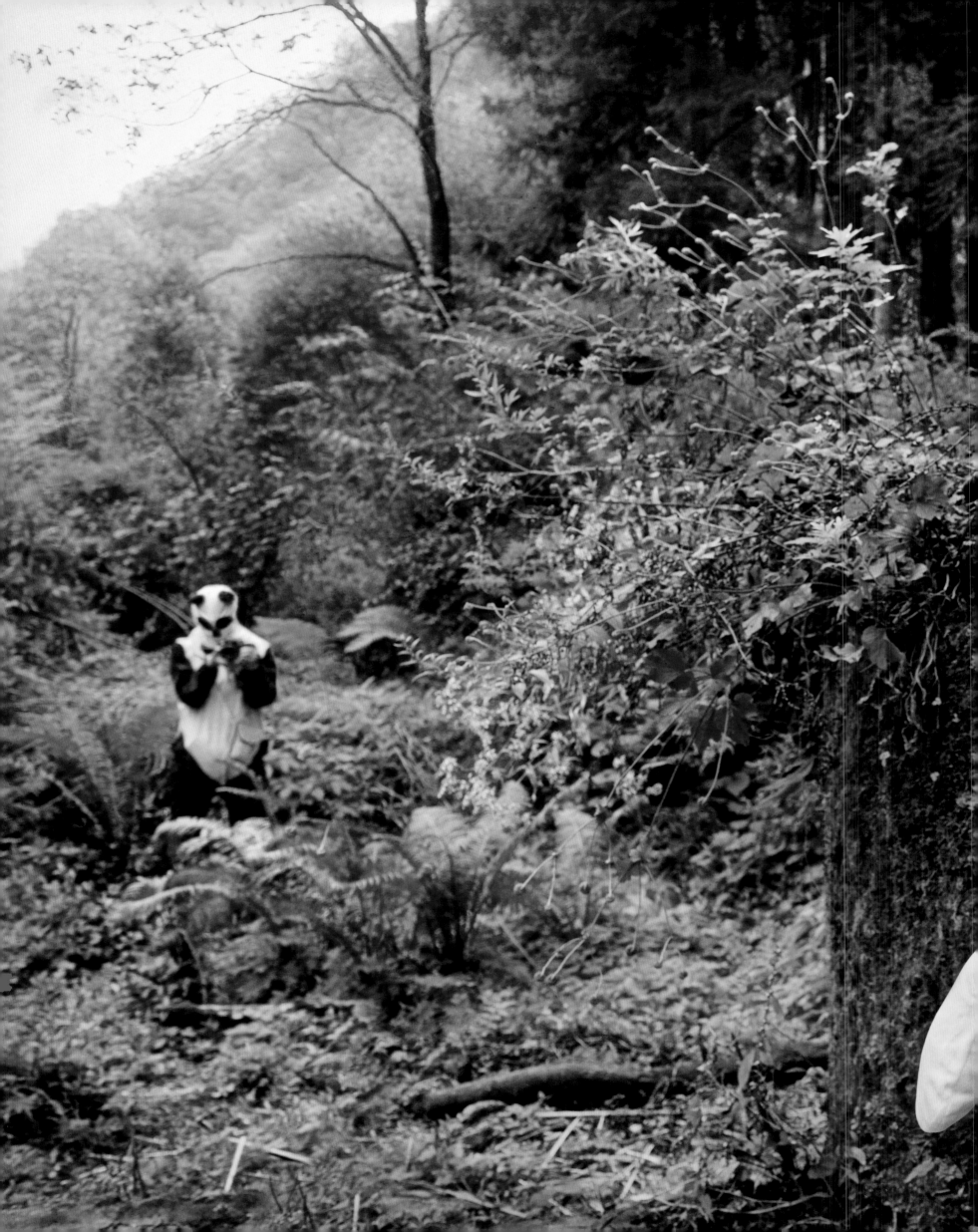

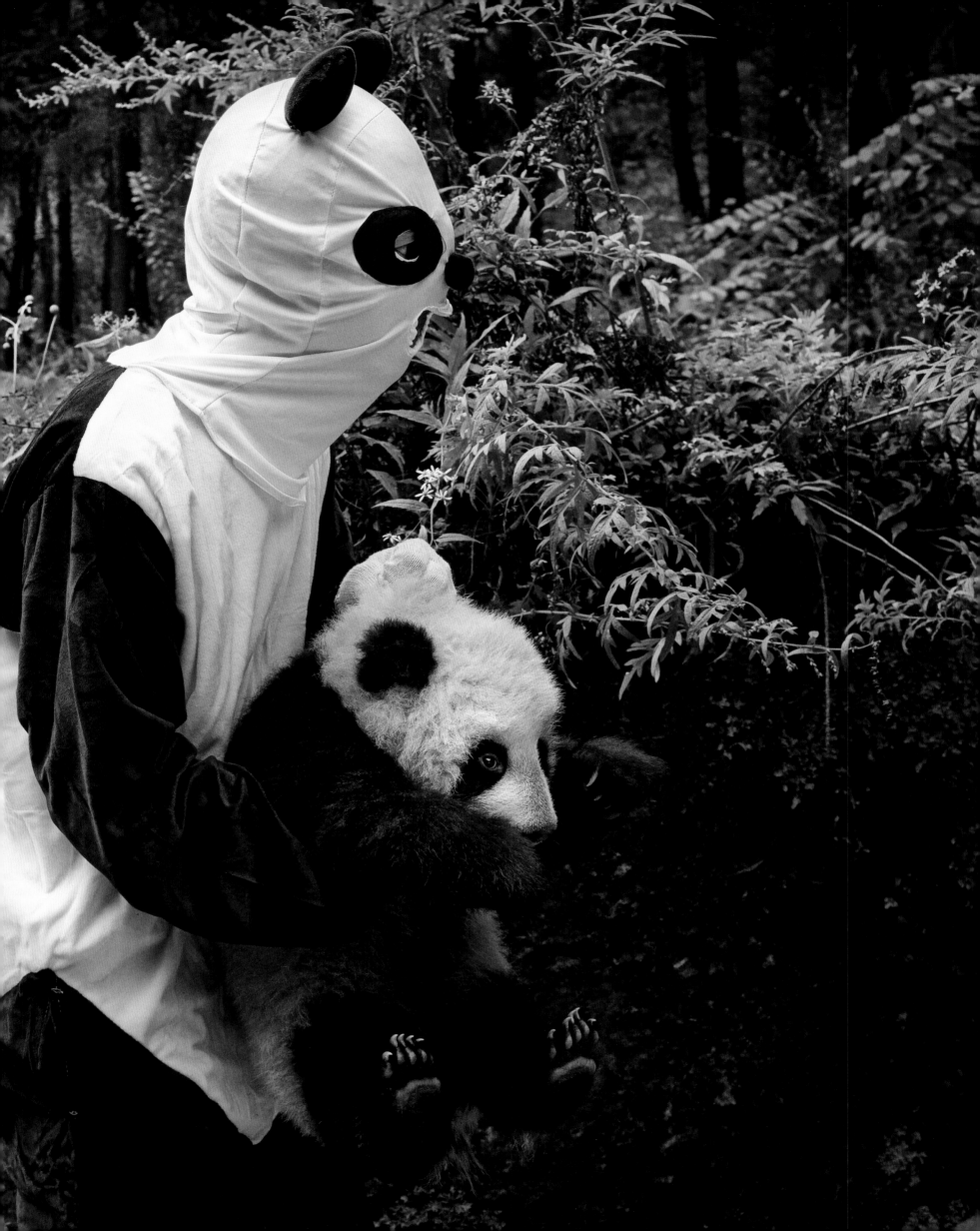

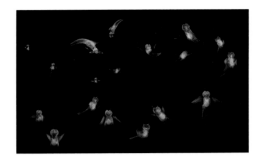

Sea angel front endpaper

. .

Scientific name: *Gymnosomata*
Range: Oceans worldwide
IUCN Red List status: Not Evaluated

. .

Meet the sea angel: a tiny, translucent link in a food chain whose collapse could have grave consequences. No more than 2 inches (5 cm) long, sea angels are mollusks, related to slugs and snails. Their wing-like fins (or fin-like wings) are parapodia: specialized extensions of the feet, which they flap in order to scull through the water. Sea angels prey on another group of marine mollusks, the sea butterflies, which also have fin-like extensions. In turn, sea angels are a vital food source for whales, seabirds, and many of our commercially valuable fish. But while a sea angel jettisons its shell soon after hatching from the egg, sea butterflies retain theirs, and herein lies the problem. The shell is very thin, easily dissolved by increasing ocean acidification. If, as seems likely, sea butterflies go extinct by around 2050, the sea angels will follow and, with them, probably, whole fisheries—hook, line, and sinker.

White-bellied pangolin p. 2

. .

Scientific name: *Phataginus tricuspis*
Range: Equatorial West, Central, and East Africa
IUCN Red List status: Vulnerable

. .

A young white-bellied pangolin. A female pangolin gives birth each year to a single baby. The newborn has soft scales for the first several days, but its eyes are open and it can instantly wrap around the base of the mother's tail, clinging firmly with its digits to travel in this "clip-on" style as she forages. If threatened, the mother quickly rolls herself around the baby, which slips around onto her belly as she curls. Poignantly, captive females have been known to curl protectively around dead young. Pangolins are solitary creatures that breed very slowly. There were disturbing reports in 2012 of pangolin farms, established in China to meet rising demand for body parts. But these are probably rumors; pangolins are very hard to breed in captivity, and so far all traded animals are likely coming from wild stocks, which replenish far too slowly to meet the illegal annual harvest.

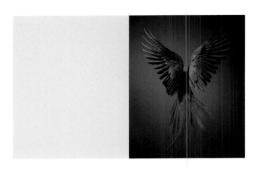

Hyacinth macaw p. 5

. .

Scientific name: *Anodorhynchus hyacinthinus*
Range: Bolivia, Brazil, Paraguay
IUCN Red List status: Vulnerable

. .

Neiva Guedes was a young biology graduate when she first visited the Pantanal in the late 1980s. This vast, biologically rich tropical South American wetland is the stronghold of the hyacinth macaw, which at up to 39 inches (1 m) long is the world's largest flying parrot. Across its range, the bird feeds almost exclusively on the fruits of just two palms, and favors nest holes in old manduvi trees (*Sterculia apetala*). The march of modern farming has damaged many nest sites, and the species was severely affected by the 1980s pet trade. In 1990, Neiva launched the Hyacinth Macaw Project, focusing on the Pantanal population. Her team installs nest boxes (and looks after natural holes, too), and helps instill pride of "ownership" among the local cattle ranchers. It's been a huge success: the Pantanal population of hyacinth macaws rose from around 1,500 in 1990 to over five thousand in 2017, and is a major draw for eco-tourists.

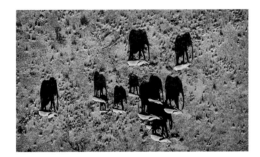

African elephant pp. 6–7

. .

Scientific name: *Loxodonta africana*
Range: Sub-Saharan Africa
IUCN Red List status: Vulnerable

. .

Elephants crossing conservation land in Tsavo, southern Kenya. Tsavo is an ancient Kamba word meaning "slaughter"—apt for its rust-red soils, and now for its terrible elephant losses. In the 1960s, the region was home to around thirty-five thousand elephants. Hard droughts in the 1970s killed some six thousand of them, but many more died at poachers' hands: by the late 1980s little more than six thousand survived. Continent-wide, the butcher's bill from the 1970s–80s poaching surge was obscene: a population of 1.3 million elephants cut down by more than half. The losses continue. Judging by the 2016 census, there are about 352,000 wild African elephants today, across eighteen countries: a fall of 30 percent in seven years. It comes down to two key threats: the ongoing trade in ivory, and the rising pressure of human population growth, which makes inroads into elephant country, leading inevitably to human–elephant flashpoints.

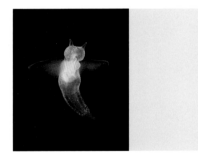

Sea angel p. 10

. .

Scientific name: *Gymnosomata*
Range: Oceans worldwide
IUCN Red List status: Not Evaluated

. .

Gareth Lawson, a biologist at the Woods Hole Oceanographic Institution, has been studying sea angels (pictured) and their related prey, sea butterflies. He talks about the "sea butterfly effect": the consequences of losing these tiny pteropod mollusks to oceanic acidification. Right now, the highly acidic waters lie below a level of around 9,000 feet (2,800 m) in the Atlantic, but in the Pacific that cut-off lies just 1,000 feet (300 m) or so deep. Year by year, worldwide, the acid cut-off depth becomes shallower, until by around 2050 we can expect the entire Pacific water column (and almost all of the Atlantic) to be hostile to shelled life. We tend to show concern at the loss of oysters and corals, but overlook the zooplankton. Yet they are vital food for cod larvae and for salmon, among other commercial fishes. To Lawson, the pteropods are the poster children for acidification, embodying the fragility of tremendously important life-forms.

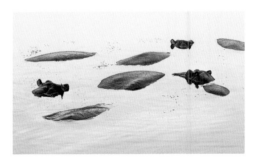

Common hippopotamus pp. 12–13

. .

Scientific name: *Hippopotamus amphibius*
Range: Sub-Saharan Africa
IUCN Red List status: Vulnerable

. .

The common hippo fully lives up to its species name, *amphibius*. To preserve its skin from the sun's drying effects, it wallows by day in lakes and rivers, often with its alert eyes and ears protruding, then hauls out at dusk to crop grass from nearby "lawns." But its dependence on fertile freshwater sites leads, unsurprisingly, to conflicts with people. That, plus widespread loss of habitat, has seen the overall population, spread patchily over a huge range, fall in recent years. Human-hippo conflicts can be reduced dramatically by helping communities to build enclosures or low fences—a strategy pursued by the Nairobi-based African Wildlife Foundation. And in the Maasai Mara National Reserve in southwestern Kenya, where this hippo was photographed, the Mara Conservancy works to improve park infrastructure, and build relationships with local people, so that communities support the aims of eco-tourism ventures, which in turn bring in funds for conservation work.

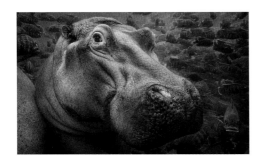

Common hippopotamus pp. 14–15

Scientific name: *Hippopotamus amphibius*
Range: Sub-Saharan Africa
IUCN Red List status: Vulnerable

Hippos are hunted for bushmeat, particularly in countries where finding protein is a struggle for communities. A 2003 survey in the Democratic Republic of the Congo estimated hippo numbers had fallen by 95 percent during eight years of civil war. It is not just meat, either; in the wake of the 1989 ban on trading elephant ivory, poachers have switched their attention to the hippo's magnificent canines, such that, today, African elephants outnumber hippos roughly four to one. Eradicating the ivory trade will be a tall challenge. Hippo teeth are still being smuggled out of several African countries (among them Tanzania, Uganda, South Africa, Zambia, Zimbabwe, Malawi, and Mozambique), mostly to Hong Kong, where ivory is carved into trinkets. The skin, too, is sought for leatherwork. Currently the hippo is listed on CITES Appendix II, restricting international trade; but until the law is enforced on the ground, hippo fortunes will continue to founder.

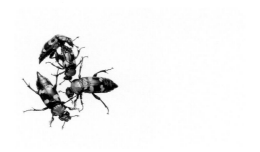

American burying beetle p. 16

Scientific name: *Nicrophorus americanus*
Range: United States
IUCN Red List status: Critically Endangered

Spearheading the recovery plan for American burying beetles (see also pages 174–75) is the aptly named Center for American Burying Beetle Conservation, based at Saint Louis Zoo in Missouri. It not only captive-breeds *Nicrophorus* by the thousand, it also has managed and monitored the program to rerelease the beetle into Missouri. And the state's program has been spectacularly successful. Since the initial release of 236 beetles into the Wah'Kon-Tah Prairie in 2012, center staff have set ground traps (sunken plastic pots) to check on beetle numbers. There were further annual releases, of a few hundred at a time, and each year the increase in survivors (and their offspring) has risen exponentially—from an initial handful, to 110 in 2015 and a triumphant 850 the following year. It's a resounding endorsement for collaborative projects: partner organizations have included the US Fish and Wildlife Service, the Missouri Department of Conservation, and the Nature Conservancy.

Polar bear tracks pp. 18–19

Location: Hudson Bay, Canada

These tracks on Hudson Bay are the pawprints of bears pacing as they wait for the winter freeze. Scientists recognize four major ice regions around the circumpolar Arctic. Bears living on the (1) seasonal ice, from south of Greenland down to Hudson Bay, are at grave risk because this ice fully melts away in summer. Those living on (2) polar basin divergent ice, north of boreal Eurasia, are in trouble because, come the summer ice melt, they have to make a choice between coming ashore (and risking human encounters) and swimming north over vast distances to hunt. To the north, east, and west of Greenland lies the (3) polar bear convergent ice; for now, this is a more stable region with productive, food-rich waters, but the ice is set to disappear by century's end. As climate change progresses, the species' final stronghold may be the (4) archipelago ice, above northwestern Canada.

Polar bear p. 21

Scientific name: *Ursus maritimus*
Range: Canada, Greenland, Norway, Russian Federation, United States
IUCN Red List status: Vulnerable

Polar bears are superbly adapted to their icy realm. Small, rounded ears and tail help minimize heat loss in temperatures that can plummet to minus 50 degrees Fahrenheit (−46 °C). A subcutaneous layer of fat up to around 4 inches (10 cm) thick sustains warmth in the water, and the double coat of underfur and guard-hairs is so efficient on dry land that bears are at greater risk of overheating—when running, particularly—than of freezing. So bears tend to avoid overexertion, and carefully husband their energy reserves. In the fiercest weather, they simply make a pit in the snow, like this individual, and hunker down, sometimes for days on end, as the snow drifts over them. In fall, pregnant females hide away in earnest to spend the winter sleeping in a den, emerging around March with their new cubs.

Polar bear pp. 22–23

Scientific name: *Ursus maritimus*
Range: Canada, Greenland, Norway, Russian Federation, United States
IUCN Red List status: Vulnerable

Hunting was formerly the polar bear's greatest threat, much less so since the signing of a 1973 accord between range nations that placed strict controls on capture and killing. The vanishing ice cover now poses the ultimate danger for all cold-adapted species in the Arctic food chain—from plankton, to fish, to seals, to the bear, the apex predator. As the water warms, its oxygen content falls, reducing productivity. Ringed and bearded seals, which make up the bear's main prey, need the ice cover for protection and for pupping. Polar bears can eat whale meat, but they need the seal flesh to maintain their bodyweight, and to keep up their omega-3 fatty acids (or otherwise risk high cholesterol—rather like us). With ever more open, ice-free seas, however, the bears are forced to swim ever greater distances to find an ever-diminishing supply of prey.

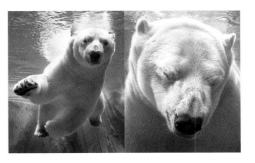

Polar bear pp. 24–25

Scientific name: *Ursus maritimus*
Range: Canada, Greenland, Norway, Russian Federation, United States
IUCN Red List status: Vulnerable

These vast paws—spreading up to a foot (30 cm) across, with non-slip soles—make excellent paddles, just as they enable the polar bear to tread lightly on thin ice. But champion swimmers or not, the bears are being ground down by the energy drain imposed by the marathon searches for food. A 2011 study by the US Geological Survey, looking at long-term ice loss trends, reported that one radio-collared female swam a record 426 miles (685 km) non-stop over the course of twelve days; on the way, she lost 22 percent of her bodyweight and her cub perished. In fact, of eleven collared bears that made long swims, five lost their cubs. Young bears, born in midwinter in the maternal den, simply don't have the fat reserves required for the sustained effort. Bears are additionally at risk of drowning because they cannot close off their nasal passages underwater.

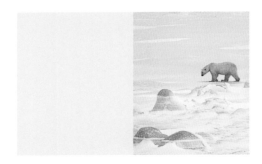

Polar bear p. 27

Scientific name: *Ursus maritimus*
Range: Canada, Greenland, Norway, Russian Federation, United States
IUCN Red List status: Vulnerable

Once the fall freeze sets in, bears spread out over the ice. Wanderlust poses no danger for the bear: solitary by nature, it uses a vast area, and a subadult will easily travel some 600 miles (1,000 km) from its mother to acquire "elbow room." This makes population surveys tricky. Some 60 percent of the world's polar bears live within Canadian territory; the rest occur from the United States and Greenland to Siberia. Scientists recognize nineteen subpopulations, and in a 2014 survey they found one of these to have increased, six stable, and three declined. The other nine are "data deficient"—bears in the wilder parts of the Eurasian Arctic are simply beyond reach. Recently, however, Polar Bears International has been exploring the use of drones and satellite imagery, which would enable risk-free and, importantly, non-invasive surveys to be made.

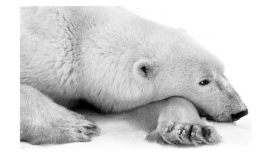

Polar bear pp. 28–29

Scientific name: *Ursus maritimus*
Range: Canada, Greenland, Norway, Russian Federation, United States
IUCN Red List status: Vulnerable

In the face of the dire threat—to the bear, to the Arctic, to us all—posed by climate change, it's easy to despair. But Polar Bears International (PBI), headquartered in Bozeman, Montana, operates under the creed that "knowledge is a catalyst for change, and inspiration is more powerful than fear." It backs this up by using media, science, and advocacy to full effect. Recent research areas include maternal den studies, population analysis, and a body condition project (which rates bears' fat reserves). PBI looks at the needs of Indigenous Peoples, and its Range States Conflict Working Group collaborates with local communities to manage human-bear encounters. These are on the rise as the dwindling ice increasingly forces bears ashore, and as our exploitation of Arctic resources—oil and gas extraction in Alaska, for instance—steps up.

Tundra landscape pp. 30–31

Location: Hudson Bay, Canada

Sunset's orange glow rakes the icy tundra terrain in Manitoba. In October and November, as the grip of winter ice creeps across Hudson Bay, the coastal town of Churchill draws tourists from around the world to watch polar bears as they head north for the seal-hunting season. The tundra of North America and Eurasia is the treeless zone, north of the great boreal forest belt. Given its prime location at the junction of three major biomes—forest, tundra, and marine—Churchill is also the spot where researchers from the Northern Studies Centre measure the effects of the Earth's warming on the local ecosystems. How are shorebirds faring? And the insect pollinators in the broad forest-tundra transition zone? And what about the worrying retreat of sea-ice? Answering such vital questions depends on cold, hard, brave funding into climate change—and that depends on political will.

Coral p. 33

Location: Wistari Reef, Queensland, Australia

This maze of submerged coral lies at the southern end of the Great Barrier Reef. Extending some 1,430 miles (2,300 km) parallel to the Australian coastline, this remarkable natural feature is the world's largest coral reef system. There are more than four hundred species of stony (hard) coral, 150 species of soft coral, vast seagrass meadows, plus more than 1,600 fish species, alongside whales, dolphins, crocodiles, and seabirds. Australia comprises one of six major coral zones worldwide, the others being the Caribbean, Middle East, Indian Ocean, Southeast Asia's "Coral Triangle," and the Pacific Ocean. Oceanographic surveys, using seabed sonar, have recently found new reefs—in Australia's Gulf of Carpentaria, for instance. In 2016, the vast Amazon Reef, extending for up to 600 miles (970 km) off the coast of Brazil, came to light; conservationists are racing to document it and, hopefully, stave off oil prospectors.

Coral pp. 34–35

Location: Wistari Reef, Queensland, Australia

Seen from the sky, coral mounts and sandbars, all fully submerged under pristine water, morph into abstraction. This is the southern, healthy (for now) end of the Great Barrier Reef. The reef's outstanding qualities saw it listed by UNESCO as a World Heritage Area in 1981. (The spectacular Ningaloo reef, off Western Australia, joined it in 2011.) Since then, however, damage to the coral has cast its status in doubt. There have been several mass bleachings of the reef since 1979, most notably in 1998, 2002, 2016, and 2017. Scientists had predicted consecutive-year bleachings to arrive by 2050 if global warming were left unchecked; and yet the latest events suggest they're already upon us. As well as climate change, threats to corals include pollution, sedimentation, and disturbance by fishing and tourism ventures. Given an opportunity, fast-growing corals can recover from damage within ten to fifteen years—longer for the slower-growing species—but we're not giving them that chance.

Chalice coral pp. 36–37

Scientific name: *Echinophyllia aspera*
Range: Indian and Pacific Oceans
IUCN Red List status: Least Concern

Seen now in close-up, these are the living polyps. A coral takes form when a single polyp attaches to a hard surface and multiplies by budding. The polyps secrete an armature of calcium carbonate, which builds into the skeleton of the colony as successive generations live and die over decades, centuries, millennia. Some species—soft corals—form no skeleton as such, but contain tiny, spiny pieces that enable them to build onto reefs. The bleaching that results from the loss of algae is not the only threat posed by climate change; there is also ocean acidification, which has been nicknamed global warming's "evil twin." As seawater absorbs atmospheric carbon dioxide, this produces carbonic acid, which dissolves the coral structures. Since the Industrial Revolution, ocean acidity has risen more than 30 percent, a figure expected to hit 150 percent by century's end.

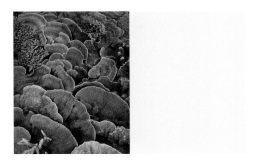

Coral p. 38

Location: Heron Island, Queensland, Australia

Montipora corals fan out almost like foliage, enabling the stingers of their tiny polyps to trap floating zooplankton, especially at night. By day, the symbiotic algae manufacture energy from photosynthesis. Social life in a coral broadly resembles a utopian commune with the added benefit of an "intranet." Barely larger than pinheads, the polyps share a nerve network, responding en masse to intruders by flinching back into the stony matrix of the plate, then cautiously emerging again to troll for prey. They also share food, and algae, by means of interconnecting canals. Protruding here and there among these plates are other corals, including *Pocillopora* (the fat green fingers at upper-right) and *Acropora* (branching corals at bottom-left and top).

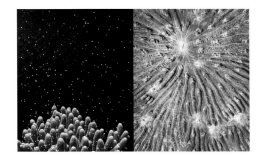

Coral pp. 40–41

Scientific names: *Acropora millepora* (left);
Lithophyllon undulatum (right)
Range: Atlantic, Indian, and Pacific Oceans (left);
Indian and Pacific Oceans (right)
IUCN Red List status: Near Threatened (both)

At nightfall, the dark waters are suddenly clouded with sex cells as all the local corals spawn at once (left). Triggered to occur a few nights following a full moon, this synchronized event ensures the mingling of eggs and sperm; it usually occurs on just two nights of the year. While polyps can multiply by budding, most corals also reproduce sexually like this to produce microscopic larvae named planulae, which float through the water column and colonize new habitats. This photograph was set up in London's Horniman Museum and Gardens aquarium where the curator, Jamie Craggs, triggers captive spawning events by recreating the environmental stimuli normally present in the wild. His goal is to enable captive coral breeding for climate change research, and to share his expertise for the purpose of reef restoration. *Lithophyllon* (right), restricted to shallow, clear waters in the Indo-Pacific, is at particular risk from pollution and sedimentation.

Frog eggs p. 43

Scientific name: *Agalychnis annae*
Range: Costa Rica
IUCN Red List status: Endangered

The yellow-eyed tree frog is one of several neotropical species that lay their eggs on vegetation over still water during the rainy season. With the male often still on her back in a mating amplexus, the female visits the water to fill her bladder, before climbing as much as 10 feet (3 m) to a leaf or branch to deposit a batch of eggs. Filling her bladder ensures the eggs are packed in a plump jelly coating, which keeps them moist. She then lays further batches, up to a total of around 160 eggs. Larger ponds can contain fish and other aquatic predators, from which the eggs will be safe for the week or so before they hatch. (The grubs of a carrion-eating fly may feed on the exposed eggs, but they are a relatively minor threat.) The tadpoles wriggle free of the jelly and drop into the water, or are flushed in by raindrops.

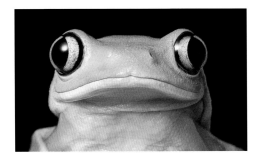

Yellow-eyed tree frog pp. 44–45

Scientific name: *Agalychnis annae*
Range: Costa Rica
IUCN Red List status: Endangered

In former years, during the May–November rainy season, Costa Rican coffee workers could expect to hear the soft *wo-o-rp* of a male yellow-eyed tree frog calling for his mate in the shaded plantations. No longer. This species, endemic to the cordilleras of northern-central Costa Rica, has all but vanished from the plantations, and also from the spectacularly species-rich cloud forests of Monteverde on the central divide. Today it survives only in the disturbed environs of the nation's capital, San José. Collection for the pet trade has dented numbers, as has the chytridiomycosis fungus, but a key threat has been fragmentation and loss of suitable habitat (including urban green spaces) due to development. Though the yellow-eyed tree frog can cope reasonably well in modified habitat, its population has fallen by around half since the 1990s.

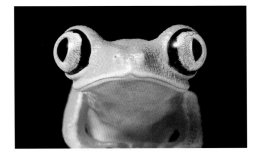

Lemur leaf frog pp. 46–47

Scientific name: *Agalychnis lemur*
Range: Costa Rica, Panama, Colombia
IUCN Red List status: Critically Endangered

Bulging eyes with vertical slit pupils mark the lemur leaf frog of Central America as a creature of the night. It lies low by day, practically invisible amid the foliage. As night falls, the bright green skin darkens to a reddish-brown, again for camouflage. As a group, neotropical amphibians exhibit extraordinarily diverse reproduction modes, from breeding in open ponds (much like common frogs) to laying eggs on land and carrying larvae to water; in some frogs, the tadpoles hide in the beds of swift streams. The lemur leaf frog sits somewhere in the middle of this range: the female lays her moist egg masses on vegetation overhanging a pond or puddle, and a week or so later the hatchlings drop into the water to develop as tadpoles. Numbers have crashed in recent years, due mainly to chytridiomycosis and deforestation, and the Costa Rican population has all but vanished, clinging on in just two or three upland locations.

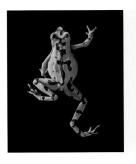

Harlequin toad p. 48

Scientific name: *Atelopus* spp.
Range: Costa Rica to Bolivia
IUCN Red List status: various, from Extinct/Data Deficient to Vulnerable

There's a bittersweet quality to amphibian research. Such is their extraordinary diversity in the American tropics that, while scientists continue to discover new species, others have undoubtedly vanished without ever coming to light. The harlequin toads of the genus *Atelopus* live on stream banks in Central and South American forests, where females release their eggs directly into the flowing water. Harlequin toads are among the most threatened amphibians on the planet, with two-thirds of nearly one hundred species categorized as Critically Endangered. As well as chytridiomycosis and habitat destruction, key factors in their decline include alteration of their habitat due to climate change and over-collection for the pet trade or medical research. They also suffer from competition with (and predation by) introduced species.

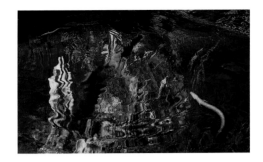

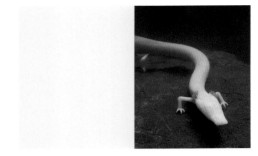

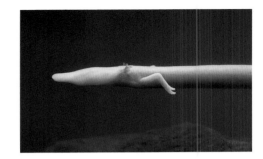

Olm pp. 50–51	**Olm** p. 53	**Olm** pp. 54–55

Scientific name: *Proteus anguinus*
Range: Central Europe, in the Dinaric Alps (Slovenia, Italy, Croatia, Bosnia, Herzegovina); introduced to French Pyrenees
IUCN Red List status: Vulnerable

Baredine Cave is one of a couple of thousand karst cave systems in the Istria region of Croatia, where the slow percolation of acidic water through the limestone bedrock carves spectacular subterranean chambers encrusted with stalactites. They are a tourist attraction, and so, too, are the resident olm, which swim in the underground lakes. Other cave-dwellers include crabs, snails, and various insects—all prey for the olm—and, above the water, bats. Prehistoric artifacts, such as pottery pieces, reveal a long period of human use, but it wasn't until 1973 that local cavers penetrated the lower depths and gained access to the lakes. The Baredine Cave was declared a national monument in 1986, and opened to tourists nine years later.

Scientific name: *Proteus anguinus*
Range: Central Europe, in the Dinaric Alps (Slovenia, Italy, Croatia, Bosnia, Herzegovina); introduced to French Pyrenees
IUCN Red List status: Vulnerable

Like the axolotl (pp. 56–57), the olm or cave salamander clings somewhat to infancy, retaining the feathery external gill tufts of its larval stage, despite the fact that adult olm develop lungs. Its head may seem featureless—but at the tip of the flattened snout are a pair of tiny nostrils, useful for sampling chemicals in the water that lead it to prey. The inner ears are highly sensitive, too, detecting vibrations in the water, and the olm possibly also navigates its dark world with the help of electroreceptors that pick up Earth's magnetic field. The olm grows to about the length of your forearm and is sexually active at seven years. Early reports of century-old olm are possibly exaggerated, but they can certainly reach seventy years.

Scientific name: *Proteus anguinus*
Range: Central Europe, in the Dinaric Alps (Slovenia, Italy, Croatia, Bosnia, Herzegovina); introduced to French Pyrenees
IUCN Red List status: Vulnerable

Clean, well-oxygenated water, in the range of 43–54 degrees Fahrenheit (6–12 °C), is all an olm needs. But up on the surface, the ancient woodlands are giving way to mechanized agriculture and industry, which releases a drip-feed of toxins—agro-chemicals, PCBs, mercury, and lead—down through the bedrock. Many of its caves are watered, too, by rivers that run above ground in their higher sections, and so are exposed to pollutants. The olm has also been collected as a pet, and for its curiosity and scientific value, at a pace that outstrips its slow breeding rate. In Slovenia, where the olm is regarded as a national treasure, most of its caves lie within protected areas, and it has legal protection also in Croatia, but its remote habitat makes in-situ study difficult. As late as 1986 a rare melanistic subspecies, with black or dark brown skin and more developed eyes, came to light in caves in Slovenia.

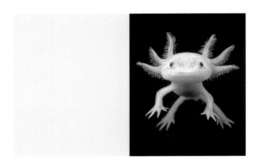

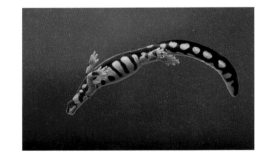

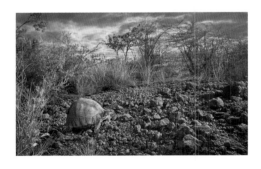

Axolotl p. 57	**Kaiser's newt** pp. 58–59	**Ploughshare tortoise** pp. 60–61

Scientific name: *Ambystoma mexicanum*
Range: Xochimilco (Mexico)
IUCN Red List status: Critically Endangered

The axolotl is a salamander, one of thirty-two species in the genus *Ambystoma* listed by the IUCN as threatened. Recent surveys found zero numbers of axolotl in their native Xochimilco wetlands, which cover less than 4 square miles (10 sq. km). Essentially, the animal is all but extinct in the wild. There are plenty of captive populations around the world, bred for pets or research, and the wetlands are undergoing restoration. But while the captives offer hope for reintroductions at some later point, they're not ideal: every generation that breeds in captivity is a further step removed from its wild state, and is that much less likely to adjust to life in the wild. Therefore, plans to reintroduce axolotl hinge on genetic "injections" from wild-caught individuals, should enough be found. One group working to save the axolotl is Umbral Axochiatl, which promotes "indigenous tourism" (tourism run by locals). Backed by university funding, the group maintains an on-site breeding laboratory in Xochimilco.

Scientific name: *Neurergus kaiseri*
Range: Iran
IUCN Red List status: Vulnerable

Kaiser's newt from Iran owns the dubious distinction of being the first animal species to be granted international protection due to e-commerce. In 2010, in the face of rampant collection for the pet trade, it was placed on Appendix I of CITES, which prohibits import or export without permit. Endemic to the arid Zagros Mountains in southwestern Iran, Kaiser's newt breeds in seasonal upland streams. Because courtship takes place on dry land, however, individuals rely on complex landscapes with connecting corridors, and these fragile biomes are easily fragmented or damaged by drought, human use (such as tourism or livestock grazing), and introduced non-native species. Unusually for an amphibian, in 2016 this species went from Critically Endangered to Vulnerable, after new research found its population to be around ten times greater than previously estimated. Today, with the CITES ban in effect, pet Kaiser's newts are bred in captivity.

Scientific name: *Astrochelys yniphora*
Range: Baly Bay (northwest Madagascar)
IUCN Red List status: Critically Endangered

A ploughshare tortoise lumbers into view, a dorsal radio transmitter beaming its location to guardians unseen. This species is named for its gular scute, a long projection on the front of the plastron (undershield); males use their scutes as jousting weapons during courtship rivalries, when they try to flip each other over. Known locally as the angonoka, this is the largest of Madagascar's five endemic tortoise species, which include a close relative, the radiated tortoise (*A. radiata*). Once there were two more species—giants, measuring over three feet (1 m) along the carapace—but they died out soon after humans settled the island about four millennia ago. Now the angonoka, too, is likely to disappear from the wild, possibly even by the time you read this. Too little is being done to keep smugglers and hunters away from the remaining animals in their small patch of dry scrub/forest at Baly Bay in northwest Madagascar.

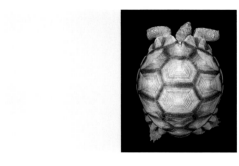

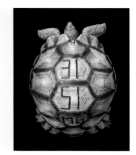

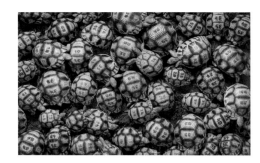

Ploughshare tortoise p. 63

Scientific name: *Astrochelys yniphora*
Range: Baly Bay (northwest Madagascar)
IUCN Red List status: Critically Endangered

The ploughshare tortoise is listed on CITES Appendix I, which bans live trade. But an adult ploughshare is worth tens of thousands of dollars on the black market, which plies routes from Madagascar to Nairobi or Réunion, and on to Bangkok, an entrepôt for the mainly Asian market. In recent years a huge upsurge in this ruthless trade has seen mass shipments of tortoises trussed up and stuffed into suitcases to go in airliner cargo holds, many of them dying en route from stress. In 2013, for instance, a stash of fifty-four ploughshares was intercepted at Bangkok airport and returned to Madagascar. The next year, 967 radiated tortoises and a sole ploughshare at the Comoros Islands . . . in 2015, 771 mostly radiated tortoises at Antananarivo, hidden among socks and babies' diapers . . . in 2016, 146 (again, mostly radiated) at Mumbai, wrapped in plastic bags . . .

Ploughshare tortoise p. 65

Scientific name: *Astrochelys yniphora*
Range: Baly Bay (northwest Madagascar)
IUCN Red List status: Critically Endangered

The Durrell Wildlife Conservation Trust is one of several organizations striving to save the angonoka. In 1986, with support from the World Wildlife Fund, it set up a captive-breeding station at Ampijoroa, Madagascar, using a founder population of twenty confiscated tortoises, and to date the DWCT has raised more than six hundred in captivity. When smugglers began brazenly stealing captives, the only solution was to deface the shells. Engraving is painless to the animal, as the shell is made from thick keratin; the ID code is cut into the top of the shell, to avoid interfering with growth at the margins. Richard Lewis of the Durrell team says they hate to do it, "but we believe this will be a genuine deterrent." And zoos around the world, from Singapore to the United States, are engraving their captive ploughshare tortoises, too. The codes resonate eerily with the arcane symbols that Neolithic Chinese used to carve into tortoiseshells during divination rituals; certainly, the ploughshare could use a little magic.

Ploughshare tortoise pp. 66–67

Scientific name: *Astrochelys yniphora*
Range: Baly Bay (northwest Madagascar)
IUCN Red List status: Critically Endangered

Critical predicaments demand urgent measures. In September 2016, a coalition of groups, including the Durrell Wildlife Conservation Trust, Wildlife Conservation Society, Turtle Conservancy, Turtle Survival Alliance and Global Wildlife Conservation, pitched a plea to the 17th CITES Conference of Parties (CoP17), which took place in Johannesburg. Their message was stark: this was "a wildlife emergency." If the government of Madagascar does not crack down on illegal trafficking of the ploughshare tortoise, they said, it "will likely go extinct in the wild within the next two years." This highlights a key issue in captive-breeding programs: they need to go hand in hand with protecting wild habitat. Why save a species in captivity if it has nowhere left to go? The Durrell team's Project Angonoka in particular has gone all out to win the hearts and minds of local people: in one of the poorest countries in the world, a commitment to saving the endemic wildlife is vital.

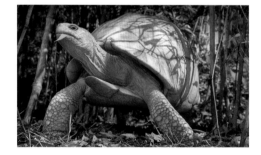

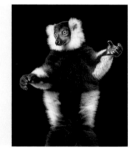

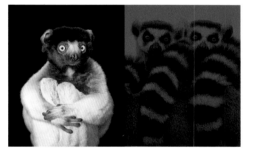

Ploughshare tortoise pp. 68–69

Scientific name: *Astrochelys yniphora*
Range: Baly Bay (northwest Madagascar)
IUCN Red List status: Critically Endangered

Turtles have roamed the earth for more than 200 million years, placidly surviving mass extinctions and climate change. But today, in the Anthropocene, there may be as few as one hundred adult ploughshare tortoises, split into several subpopulations, in their last wild stronghold at Baly Bay, and they face tough odds. Their total occupancy area is perhaps as low as 5 square miles (12 sq. km), and fires set by cattle farmers can be deadly for a slow-moving tortoise—although they are scarcer now that the park has created firebreaks in the tinder-dry scrub. Introduced African bush pigs take eggs and young. But most of all, rangers must be constantly vigilant against poachers, and this is where it falls to the government to take a stand. After all, conservationists are not police.

Black-and-white ruffed lemur p. 71

Scientific name: *Varecia variegata*
Range: Madagascar
IUCN Red List status: Critically Endangered

The fragility of nature is well exemplified by this beautiful two-tone lemur, endemic to the fast-disappearing rainforests of Madagascar. It's one of the few primates to build a special birthing nest in the trees, in which to raise its litter of two to six young. But with a highly selective diet of nectar and fruits, it is one of the first lemurs to vanish when loggers move into a forest. Its last strongholds are the scattered stands of forest in the east, where it is spread thinly through ten or so protected areas. Reintroductions have been patchily successful: of thirteen American-bred lemurs released into the Betampona Reserve from 1997 to 2001, five survived and integrated with the local wild population. The Durrell Wildlife Conservation Trust has bred the species since 1982, and the Aspinall Foundation is supporting initiatives to study the last wild populations and protect their habitat.

Crowned sifaka p. 72

Scientific name: *Propithecus coronatus*
Range: Madagascar
IUCN Red List status: Endangered

Sifaka have a delightful mode of travel—an exuberant sideways pogo, arms flung skyward for balance at each bound—though you might not think so from the shy body language of this crowned sifaka, Youssou, in captivity in the UK. One of the largest of the lemurs, the crowned sifaka needs tall trees in which to nest and feed, and is highly vulnerable to habitat change. Given the colossal scale of habitat loss in its native west-central Madagascar, it survives today only in tiny forest fragments, few of them within protected areas. Luckily, it can make do in a small home range covering as little as half a square mile (1 sq. km), so conservation efforts are focused on sustaining these "micro-populations" to preserve genetic diversity in captive-breeding programs. One such initiative, "Sifaka Conservation," is jointly run by Malagasy primatologists and the Cotswold Wildlife Park, Youssou's current home.

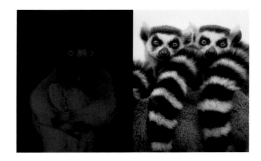

Ring-tailed lemur p. 73

Scientific name: *Lemur catta*
Range: Madagascar
IUCN Red List status: Endangered

The most common of all Madagascar's lemurs (which include the crowned sifaka), the ring-tailed lemur is arguably their most iconic and persuasive ambassador, with its robber mask and luxuriant, banded tail. The spectacle of them sunbathing and bickering in zoo enclosures has helped focus public attention on their plight. Intensively studied since the 1960s, the ring-tailed lemur has nonetheless declined rapidly, and almost from under our noses—a deception that owes much to its success in captivity: today, there are more individuals in European zoos than in the wild. In the wild, these lemurs live in small social groups at low densities within isolated forest fragments. One of the largest populations, around three hundred strong, is in Berenty Reserve, southeast Madagascar. Females are dominant over males and tend to take the lead in territorial "stink fights," in which the tail is used to waft scent toward opposing "gangs."

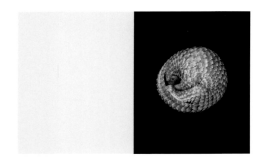

White-bellied pangolin p. 75

Scientific name: *Phataginus tricuspis*
Range: Equatorial West, Central, and East Africa
IUCN Red List status: Vulnerable

Looking like an animated globe artichoke, the pangolin's appearance testifies to truth being stranger than fiction. These are the only mammals with scales, which evolved as armor against big cats. Before rolling up, they may utter a snake-like hiss, and the tail is a defensive weapon, too: a hunter's report from 1960 told of an African giant pangolin dragging a freshly throttled leopard by its neck. The long, sharp claws come in handy for burrowing and climbing, and the prehensile tail gives traction for climbing trees. Pangolins use their claws to flip dung-pats, rip into rotting wood, and lay waste to anthills and termitaries in their search for prey. The muscular tongue, longer than the head and body combined, is a sticky, whip-thin organ ideal for licking up insects; given that an adult can eat seventy million insects per year, these animals play an important role in their ecosystem.

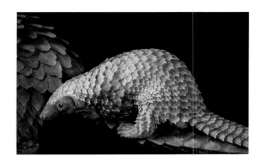

White-bellied pangolin pp. 76–77

Scientific name: *Phataginus tricuspis*
Range: Equatorial West, Central, and East Africa
IUCN Red List status: Vulnerable

There's a depressingly long list of pangolin end uses. In Buganda, for instance, a scale buried at a man's door will allegedly place him under his lover's command. Africans eat a lot of pangolin bushmeat, too, although by far the greatest demand is from China and Vietnam. In Asian communities worldwide, pulverized scales are sold to cure everything from asthma and nosebleed to cancer. The skin is turned into handbags, and the flesh is considered a delicacy. In one week in 2008, Vietnamese customs seized 25 tons (23 tonnes) of frozen meat, and in April 2013, the Philippine coast guard found 11 tons (10 tonnes) on a Chinese freighter. In May–June 2014, Hong Kong officials intercepted scales from some thirteen thousand pangolins. These and other hauls represent probably only a quarter of annual illegal traffic.

White-bellied pangolin p. 79

Scientific name: *Phataginus tricuspis*
Range: Equatorial West, Central, and East Africa
IUCN Red List status: Vulnerable

Laws are finally reflecting the urgency of the pangolin's situation. In 2000, CITES imposed zero export quotas on wild-caught Asian pangolins, and in 2014 its Pangolin Specialist Group unveiled an action plan, "Scaling up Pangolin Conservation." That year, too, the IUCN upgraded the pangolins' status: the Chinese and Sunda pangolins went to Critically Endangered, the Philippine and Indian pangolins to Endangered, and the four African species to Vulnerable. As Jonathan Baillie, cochair of the specialist group, put it, "All eight species are now listed as threatened with extinction largely because they are being illegally traded to China and Vietnam. In the twenty-first century, we really should not be eating species to extinction." In 2016, CITES shifted all species onto Appendix I, banning international trade. How this will affect illegal trafficking has yet to be seen; but with the specialist group focusing much of its funding on raising global awareness, there is hope.

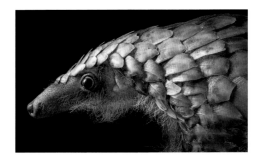

White-bellied pangolin pp. 80–81

Scientific name: *Phataginus tricuspis*
Range: Equatorial West, Central, and East Africa
IUCN Red List status: Vulnerable

With wild stocks of the Asian pangolins now largely exhausted, poachers are turning to the four African species. This animal is a white-bellied tree pangolin, photographed at the Florida headquarters of Pangolin Conservation, an NGO that is currently focusing on pangolins in Togo, West Africa. In August 2015, one of the Florida females successfully gave birth: a landmark event, given that the species has only once before bred in captivity. In Africa, meanwhile, the African Pangolin Working Group is studying all aspects of the four species—from their evolutionary history, past distribution, and present parasites, to the traditional uses of pangolin products. There is even a World Pangolin Day, every February. The more that is publicly known about these fascinating and deeply endearing animals, the more they have a fighting chance.

Western lowland gorilla pp. 82–83

Scientific name: *Gorilla gorilla gorilla*
Range: Angola, Cameroon, Central African Republic, Congo, Equatorial Guinea, Gabon
IUCN Red List status: Critically Endangered

Djala is one of more than thirty gorillas that the Aspinall Foundation has released into Gabon's Batéké Plateau National Park since the program began in 1998. Today, the 770-square mile (2,000-sq. km) park is home to four resident gorilla groups, which are founded on a mix of Gabonese orphans and UK-reared animals. The latter are first given a "soft release" in an enclosed area of the park, where they can acclimatize for a few years before being put into the wild. With the gorilla as its flagship or "umbrella" species, the Aspinall Foundation plays a vital role in protecting the overall ecosystem, and it plans to repopulate the park with other endangered wildlife. Meanwhile, research is a vital part of the foundation's contribution in Gabon. For instance, it facilitates visits from scientists to study the impact of parasites and disease vectors, such as malaria mosquitoes, on the ecosystem as a whole.

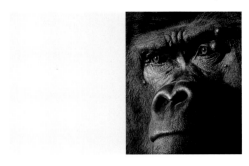

Western lowland gorilla p. 85

Scientific name: *Gorilla gorilla gorilla*
Range: Angola, Cameroon, Central African Republic,
Congo, Equatorial Guinea, Gabon
IUCN Red List status: Critically Endangered

There are still maybe a quarter-million western lowland
gorillas in the wild, but since this number is expected to
tumble by 80 percent over a three-generation span (from
2005 to 2071), the species qualifies as Critically Endangered.
As well as disease—including the Ebola virus, which can
wreak havoc on gorilla groups—two key threats are habitat
loss and illegal hunting for bushmeat. Djala, for instance,
was orphaned when poachers killed and presumably ate
his parents. Bushmeat is in high demand in local towns,
and the proliferation of logging roads grants poachers easy
access to gorilla country. At Batéké Plateau National Park,
which abuts the border with the Democratic Republic of the
Congo, there had been plans for a surrounding "greenbelt,"
but uncontrolled logging on the Congolese side put an end
to this. Within the park, an anti-poaching team, run by
the Gabon authorities but funded by Aspinall, maintains
constant vigilance.

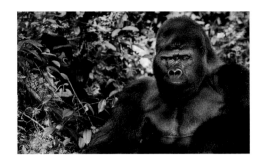

Western lowland gorilla pp. 86–87

Scientific name: *Gorilla gorilla gorilla*
Range: Angola, Cameroon, Central African Republic,
Congo, Equatorial Guinea, Gabon
IUCN Red List status: Critically Endangered

Currently, Djala lives with his son Djongo (seen here in
the background) and a daughter, Mwamba, though field
workers have temporarily transferred her to another group
to maintain genetic diversity. At eleven years old, Djongo
is fast approaching independence; and with a dad entering
middle age, he is expected to step up to the role of silverback
or alpha male, a role for which Djala has patiently been
preparing him. As adult male gorillas approach sexual
maturity, the silverback usually evicts them from the family
group, and these "blackbacks" then connect with females
from other groups. Encouragingly, Djala and company have
been seen fraternizing peaceably with one of the neighboring
groups at Batéké, which shows that these captive-reared
animals have acquired vital social skills—they have learned
how to mix.

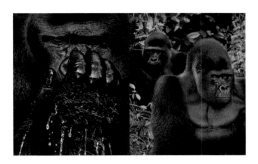

Western lowland gorilla pp. 88–89

Scientific name: *Gorilla gorilla gorilla*
Range: Angola, Cameroon, Central African Republic,
Congo, Equatorial Guinea, Gabon
IUCN Red List status: Critically Endangered

Biologist Alessandro Araldi, who works with the Aspinall
Foundation, spends much of his time in the field with the
Batéké gorillas. "I'm constantly surprised by the two-way
conversations that are possible," he says. "And although
we're taught not to 'read' animal behavior through human
eyes, we can see that many gorilla gestures are attached
to feelings. Each individual has such a strong personality."
Young gorillas are constantly learning life lessons—such as
which plants to eat or avoid—from siblings and from both
parents. (Males are just as doting as females; if a mother
dies, the silverback will care for it tenderly.) As to whether
the gorillas enjoy human company, males might strut about
to remind Alessandro of the pecking order, but it's mostly
just for show. And anyway, it's generally the females who
make the decisions . . .

Western lowland gorilla pp. 90–91

Scientific name: *Gorilla gorilla gorilla*
Range: Angola, Cameroon, Central African Republic,
Congo, Equatorial Guinea, Gabon
IUCN Red List status: Critically Endangered

Pick through a steaming pile of gorilla droppings and you're
likely to find a precious cargo. Studies show that lowland
gorillas play a vital role in the tropical forest ecosystem
by dispersing seeds from their heavily fruit-based diet,
especially in their open-canopy nesting areas where the
extra light helps seedlings flourish. What's more, some
fruits cannot germinate unless they have passed through
an animal's gut. Some 60 percent of local tree species are
seed-dispersed by animals; in Cameroon this figure reaches
a remarkable 82 percent. One endemic Gabonese plant—
Cola lizae, a mallow—is believed to depend entirely on the
gorilla for its survival, despite the fact that it's also in the
local chimpanzees' diet. What this shows is that gorillas are
vital to their ecosystem. How galling that it's only now, when
these apes are so scarce, that we are beginning to recognize
their ecological importance.

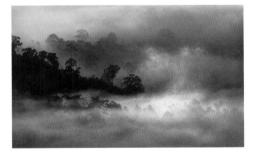

Danum Valley Conservation Area pp. 92–93

Location: Danum Valley, Sabah, Borneo

The dawn chorus of lar gibbons is one of Tim's lasting
memories from the time he spent photographing in the
Danum Valley Conservation Area in Sabah. This is a special
forest, having had almost no human presence in the past,
and now protected as a vast reserve, complete with a field
center that attracts scientists from around the world. It
was on Borneo in 1855 that the British naturalist Alfred
Russel Wallace wrote a paper on the mutability of species,
which would spur Charles Darwin to his own history-
making conclusions. Borneo is the epicenter of diversity
for dipterocarp ("two-winged seed") trees, with more than
150 species endemic to the island, including some true giants
that emerge from the canopy to heights of 260–295 feet
(80–90 m). These lowland rainforests are home to some
of Asia's rarest mammals, including the clouded leopard
and orangutan.

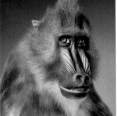

Mandrill p. 95

Scientific name: *Mandrillus sphinx*
Range: Cameroon, Congo, Equatorial Guinea, Gabon
IUCN Red List status: Vulnerable

To look at the gaudy adult male, you wouldn't think that
mandrills are elusive. But huge troops of these big monkeys
can simply melt away into the equatorial African forests.
Mandrills have been studied most at Lopé Reserve in Gabon,
where the New York City–based Wildlife Conservation
Society has been leading conservation efforts. Researchers
fit animals with temporary radio collars to be tracked as
they move through the rainforest, fastidiously picking over
stones and leaves in search of anything to eat. The WCS
also trains local villagers to serve as eco-guides, supporting
eco-tourism that brings in much-needed foreign dollars;
and it assists the government's anti-poaching squads, too.
Gabon is rich in minerals, and the railways now penetrate
the ancient forests, carting away timber, minerals, and
bushmeat; so the more the mandrills are under the locals'
watchful eyes, it is hoped, the less they will fall to poachers.

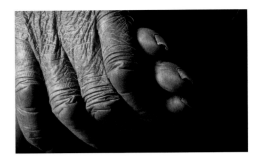

Chimpanzee pp. 96–97

Scientific name: *Pan troglodytes*
Range: Forested West, Central, and East Africa
IUCN Red List status: Endangered

Sharing 98 percent of our genes, chimpanzees are intelligent, inquisitive, capable of grief, love, and empathy; they use gestures familiar to us, such as kissing and holding hands. Nobody knows this as well as Dr. Jane Goodall, the British primatologist who went to Gombe in Tanzania in 1960 and immersed herself in their world. She brought them to the world's attention, including the startling discovery of how they use tools. Goodall went on to formulate a radical new approach to conservation. Chimpanzees challenge our humanocentric superiority complex: we are not so unique after all, we need the forests as much as the other animals do, and we owe them their survival. The Jane Goodall Institute, founded in 1977, puts this into practice by taking orphaned apes into care, and helping local communities find their feet—by nurturing livelihoods such as beekeeping and micro-forestry, and mentoring schoolgirls in education.

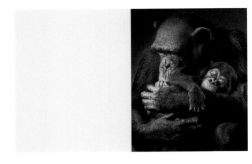

Chimpanzee p. 99

Scientific name: *Pan troglodytes*
Range: Forested West, Central, and East Africa
IUCN Red List status: Endangered

Ruma and Vali are a mother and son living in a private safari park in Myrtle Beach, South Carolina. Their true haunts are the last big tracts of moist forest in western-central Africa, home to perhaps three hundred thousand chimpanzees. They are like us in many ways: a diet that includes meat, greenery, honey, eggs; a near-monthly estrus cycle, with singletons or twins born; close families raising kids into their teens. A century ago there were a million, but today, chimpanzees suffer attrition as their forests are cut from beneath them; many are picked off for bushmeat on the fringes of logging camps, their orphaned infants taken as pets, rendered incapable of returning to the wild. Forest loss is intensifying under palm-oil production and mining (to supply the automobile and cellphone industries, for instance). National and international laws govern all chimps, right across their range, but are poorly enforced. Chimpanzees need protection—better, stricter, faster.

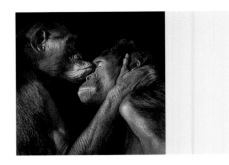

Bonobo pp. 100–101

Scientific name: *Pan paniscus*
Range: Congo
IUCN Red List status: Endangered

Kissing in bonobos is often an adjunct to sex, for which they have acquired a somewhat exaggerated reputation. What's interesting about bonobos is how they seem to use sex as a social gambit, a way of defusing tensions, especially during feeding sessions, but also when forming personal bonds and establishing group hierarchies within their female-dominated society. But lots of sex doesn't mean more reproduction; bonobos are still slow breeders, like chimpanzees, and suffer similar threats. The bonobo has been a victim of both war and of peace. Conflict in the Democratic Republic of the Congo during 1990–2000 increased the rate of deforestation in its moist lowland forests—but the return to an unstable peace has brought renewed exploitation for agriculture, plus increased capture for the voracious bushmeat trade.

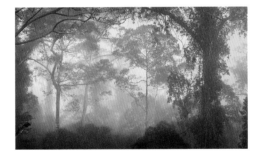

Danum Valley Conservation Area pp. 102–3

Location: Danum Valley, Sabah, Borneo

As forests go, the airy, vaulted dipterocarp canopy at Danum Valley is relatively open, and this may explain why Borneo has more gliding animals than anywhere else on the planet. Some sixty species of gliding snake live in Southeast Asia, more than half of them in Borneo, spreading their ribs flat as they ripple through the air. Frogs, too, with oversized toes webbed like mainsails; draco lizards that unfurl wing-like webs when they spread their limbs; and geckos with loose, air-cushioning skin. Then there are the "flying" squirrels— elusive mammals that coast from one feeding spot to the next—and the flying lemurs or colugos, which are not lemurs at all but unique, almost bat-like creatures of the night. These are all animals that have coevolved with the forest, their body specially adapted for floating safely down from high trees.

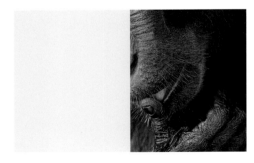

Celebes crested macaque p. 105

Scientific name: *Macaca nigra*
Range: Sulawesi
IUCN Red List status: Critically Endangered

It was a winsome, gurning selfie, taken in 2011 by a male Celebes crested macaque named Naruto, that led to a thorny copyright lawsuit and went viral, alerting the world to the plight of this threatened Indonesian monkey. The species, known locally as *yaki*, has been quietly dwindling away on Sulawesi, where its remaining stronghold is the Tangkoko Nature Reserve at the northern tip. A separate population was introduced 150 years ago to the small offshore island of Bacan, where—incongruously—its high numbers (some one hundred thousand) are straining natural resources. Meanwhile, back on the main island, the macaques are losing to loggers and poachers (their meat is served as a delicacy at special occasions). They're taken as pets, too, only to be kept on a chain because of their wild nature. Poaching and trapping is illegal; but infringers usually escape with just a fine, so there is little incentive to toe the line.

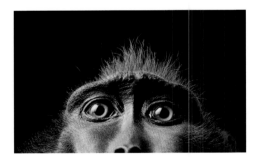

Celebes crested macaque pp. 106–7

Scientific name: *Macaca nigra*
Range: Sulawesi
IUCN Red List status: Critically Endangered

The yaki's plight is the focus of a global rescue effort. Partners include the Tasikoki Wildlife Rescue Center on North Sulawesi, which is rearing orphaned and injured macaques for rerelease. In the nearby town of Manado is Selamatkan Yaki—"Save the Yaki"—a grass-roots campaign covering conservation, education, and research. They work closely with local schools (the children are zealous informers on illegal pet keepers). Partners of Selamatkan Yaki include the Whitley Wildlife Conservation Trust in Devon, UK, and the nearby Paignton Zoo, which maintains the European captive-breeding program for the species. But it all depends on the Indonesian government stepping up. Sulawesi is an epicenter of astonishing biodiversity—98 percent of its terrestrial mammals and 25 percent of its birds are endemic—and if the yaki is upheld as a flagship for the remaining forests, then the cumulative benefits will be huge.

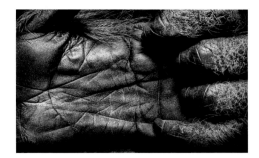

Orangutan pp. 108–9

Scientific name: *Pongo abelii* (Sumatran),
P. pygmaeus (Bornean)
Range: Borneo and Sumatra
IUCN Red List status: Critically Endangered

Rajang the orangutan, who has spent more than three decades at Colchester Zoo, is ineligible for re-release because he is "impure"—a hybrid between the Bornean and Sumatran orangutans, which in the wild are discrete island species. With immensely powerful arms that span up to 7 feet (2.1 m), orangutans are great apes built for a life spent largely aloft. Much like gorillas, they sleep in the canopy, fashioning a new nest each night by weaving branches into a sturdy cradle. The forest supplies their food, too—from more than three hundred species of fruit to insects and flowers. Both the Bornean and Sumatran species are expected to vanish from the wild within ten to twenty years under the combined onslaught of deforestation, fire, poaching, and persecution. Then there's climate change, too: scientists estimate that some 19,000–32,000 square miles (49,000–82,000 sq. km) of orangutan habitat will be non-viable by 2080. But will the apes even be around then?

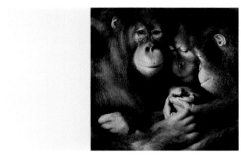

Bornean orangutan pp. 110–11

Scientific name: *Pongo pygmaeus*
Range: Borneo
IUCN Red List status: Critically Endangered

In 2008–09, a research team interviewed nearly five thousand villagers in Kalimantan (Indonesian Borneo), nearly 3 percent of whom admitted to having killed at least one orangutan, and some several. Extrapolating data across the orangutan's range, the team calculated a total of up to 66,500 killings. Of the killings reported in the survey, 27 percent were conflict-based: motivated by fear, self-defense, or protection of crops. The rest were non-conflict, for food (56 percent) for instance. Killing at this rate is far, far beyond any capacity to replace losses; the orangutan is, after all, the world's slowest-breeding mammal. A glimmer of hope comes from initiatives like the US$28.5 million fund agreed in 2011 between Indonesia and the United States, which will boost forest conservation in Kalimantan through the Heart of Borneo Initiative, in which the World Wildlife Fund plays a key role. But this must go hand in hand with a clampdown on poaching if orangutans are to have a future.

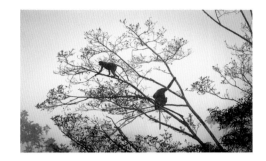

Proboscis monkey pp. 112–13

Scientific name: *Nasalis larvatus*
Range: Borneo
IUCN Red List status: Endangered

To borrow an old cliché, size matters for the male proboscis monkey: the bigger his long, pendulous snout, the louder his call, and the higher his chances of mating. The sexes differ markedly in size, too, with the males twice the weight of females. These pot-bellied monkeys live in wet lowland forest, freshwater swamps, and mangroves on Borneo, where their partly webbed feet help them ford rivers. They feed mainly on leaves and unripe fruit (a diet, incidentally, that is hard to match in captivity). In 2001, a team of Japanese researchers observed male proboscis monkeys bringing up food for a second chew—a trait known in ruminants (and koalas and kangaroos), but never before in primates. Unfortunately for proboscis monkeys, their gut secretions create bezoar stones, which poachers collect for traditional Chinese medicines. They're also hunted for food. But by far the gravest threat is the loss of their watery habitat.

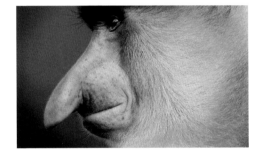

Proboscis monkey pp. 114–15

Scientific name: *Nasalis larvatus*
Range: Borneo
IUCN Red List status: Endangered

Proboscis monkeys like to wander over a wide home range, but their home is becoming increasingly fragmented. They fare very poorly in captivity, hence preserving them means saving the forests. But in Sabah, where they (and the local elephants) are acknowledged as a flagship species and tourist drawcard, only 15 percent of the monkeys live within protected areas. Unprotected forests are being converted into shrimp farms and palm-oil plantations. The situation in neighboring Kalimantan is equally grave. All told, one-third of Borneo's rainforests have gone since 1973, most of it around the coastal fringes favored by proboscis monkeys, and the notion of a "protected area" offers little defense against commercial exploiters. In 2011, Norway offered Indonesia a billion dollars as incentive for protecting its forests; but it's too little, too late. At the current rate, Borneo will have lost all of its unprotected lowland rainforests by 2020.

Lichen p. 117

Lichens are unsung wonders. They're found planet-wide, and widely ignored, yet these incredibly tough organisms contribute so much: recycling nutrients, making soil, fixing nitrogen, supplying food (to insects, monkeys, mollusks, musk oxen, reindeer, for instance), and more besides. It turns out we don't know them very well, either. In 1868, Swiss botanist Simon Schwendener reported that a lichen is a symbiotic organism, a fungus living with an alga or a cyanobacterium. The fungus provides shelter and moisture, while its partner produces nutrients via photosynthesis. But in 2016, scientists in Montana discovered a third party, in the form of a basidiomycete yeast: a single-celled fungus that forms a thin layer on the "skin" of a lichen and probably wards off infections. This remarkable find turns lichen science on its head: textbooks will be rewritten. It may also explain why researchers have so far failed to "captive-breed" lichens in the lab.

Strangler fig pp. 118–19

Scientific name: the species pictured is unidentified; it is thought to be a member of the genus *Ficus*

Strangler figs (*Ficus*) are a double-edged forest element. They throttle the host tree on which they scramble toward the light—and yet the fruits they supply through the year nourish countless forest-dwellers, including pigs, bats, birds, and primates. (In the dipterocarp forests of Borneo, photographed here, orangutans feed on strangler figs.) A strangler fig begins life as a seed deposited—by wind, or a bird—somewhere up on the host tree. From here it sends thin roots down to the soil, while stems also snake up into the canopy. The host tree, held in a death-grip, eventually rots away, leaving the empty lattice of the strangler (viewed here from within). Each *Ficus* species has its own wasp pollinator, too, in one of the world's most extraordinary examples of coevolution: adult wasps carry pollen into the fig fruit (via a tiny entrance-hole), where they breed and, in the process, inadvertently fertilize the fruit's ovaries.

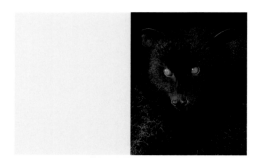

Livingstone's fruit bat p. 121

Scientific name: *Pteropus livingstonii*
Range: Comoros Islands
IUCN Red List status: Critically Endangered

For endemic species on oceanic islands, geographic isolation initially confers security. You're safe on your fortress. But when "home" shrinks beyond a tipping point, there's nowhere left to run . . . or even fly. Livingstone's fruit bat, or flying fox, is a giant among bats, with a wingspan over 4 feet (1.2 m). It forages and roosts on the forested hillslopes on Anjouan and Mohéli, two of the Comoros Islands, which lie off East Africa. There, villagers are cutting down the trees for firewood, or clearing undergrowth to plant crops, and in just two decades they've stripped 75 percent of the cover. Local groups are working to spread awareness of the bats' vital ecological role and to promote sustainable land use. Meanwhile, a captive-breeding plan, founded by the Durrell Wildlife Conservation Trust in 1992, is under way in Europe. If these off-site and on-site projects bear fruit, there's hope for the island bat.

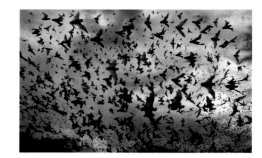

Mexican free-tailed bat pp. 122–23

Scientific name: *Tadarida brasiliensis*
Range: North, Central, and South America, and Caribbean islands
IUCN Red List status: Least Concern

Small enough to fit in your palm, the little Mexican or Brazilian free-tailed bat is so named because the last part of its tail is "free" of webbing. It roosts in buildings, mines, and caves, sometimes in unthinkable numbers; the Bracken cave in Texas is home to twenty to forty million. They swarm out at dusk, blotting out the moonlight en route to feeding. Before dawn, they swarm back, mass above the cave mouth, then drop like stones to swoop into safety before predators—owls, possums, skunks—can grab them. Free-tailed bats consume tons of insects—including blowflies, leafhoppers, and weevils—each year, but are widely seen as pests, partly because they carry rabies. Now they face an insidious fungal menace, first recorded in North America in 2006, which they cannot help but spread. For this species there's still safety in numbers . . . but for how long?

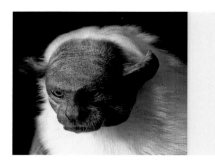

Pied tamarin pp. 124–25

Scientific name: *Saguinus bicolor*
Range: Amazonas (Brazil)
IUCN Red List status: Endangered

At the heart of the vast Amazon lies the city of Manaus—home to more than two million people and growing fast. The scraps of suburban forest vanishing under its sprawl, together with a patch of forest to the north, are the last strongholds of the pied tamarin, arguably the most threatened of all the Amazonian primates, now exposed to the squalid fate of becoming roadkill. A rescue operation mounted by Proyecto de Sauim de Coleira, in partnership with the Durrell Wildlife Conservation Trust, is racing to rescue pied tamarins from the Manaus hinterland for translocation to safer habitat. But to safeguard the species' future in the wild, conservationists at Durrell and elsewhere must also establish a captive-bred population. Although the species is acutely sensitive and reluctant to breed in captivity, numbers are at last growing. This individual enjoyed clambering over Tim and his photographic equipment.

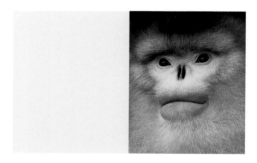

Yunnan snub-nosed monkey p. 127

Scientific name: *Rhinopithecus bieti*
Range: Yunnan (China), Tibet (southwest China)
IUCN Red List status: Endangered

The combination of *retroussé* nose and puffy lips might suggest extreme cosmetic surgery in another primate, but in the snub-nosed monkeys it confers an otherworldly beauty. The first photographs of this species were taken by Xi Zhinong when, in 1993, he was sent to document wildlife for the Chinese government. Captivated by the monkeys, he spent the next decade filming them. Later, he founded a wildlife film company—Wild China Film—and returned to the mountains to make the documentary *Mystery Monkeys of Shangri-La* (2015). A Yunnan native with a childhood love of nature, Xi has done more than any other human to publicize and protect the species, and not merely through his lens work. In 2005 when the government consigned a forest reserve for logging, threatening the loss of two hundred monkeys, he wrote in protest. Not only was the reserve spared, but it was also extended by 350 square miles (900 sq. km).

Yunnan snub-nosed monkey pp. 128–29

Scientific name: *Rhinopithecus bieti*
Range: Yunnan (China), Tibet (southwest China)
IUCN Red List status: Endangered

Diet, as much as anything, dictates the pace of life for the Yunnan snub-nosed monkeys. In their remote mountain fastnesses they feed mainly on *Usnea* lichens—but while lichens are abundant and easily digested, they grow slowly and contain little food value. So the monkey troops must wander widely to find new lichen sources while depleted areas recover. With lichen so plentiful, there is low competition for food, which explains the existence of troops numbering several hundred; within these are smaller family units made up of a male with multiple females and the young of two or more generations. Older family members lend a hand caring for the young, especially in the case of twins, given that the troop must keep on the move in the ceaseless quest for food in the thin, cold mountain air.

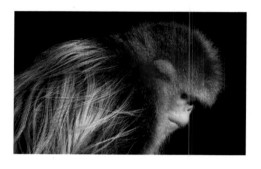

Golden snub-nosed monkey pp. 130–31

Scientific name: *Rhinopithecus roxellana*
Range: Gansu, Hubei, Shaanxi, Sichuan provinces (China)
IUCN Red List status: Endangered

In the mountain forests of west-central China, where snow may lie for six months each year, troops of golden snub-nosed monkeys get by on eating mostly pine needles and lichen. Perhaps their frost-hardiness inspired the old belief that the plush coat warded off rheumatism if worn by humans. Today, the species, which the government regards as a national treasure, has full legal protection. There are three geographically separate subspecies, and researchers have been modeling their past, present, and future. Which of the three was the ancestral stock before they dispersed? How has environmental change affected them in the past couple of million years, and what does this century hold in store? One report suggests the species' range will reduce by almost 30 percent by 2020, 70 percent by 2050, and over 80 percent by 2080 . . . and that's without factoring in any other pressures.

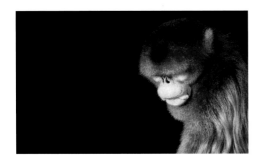

Golden snub-nosed monkey pp. 132–33

Scientific name: *Rhinopithecus roxellana*
Range: Gansu, Hubei, Shaanxi, Sichuan provinces (China)
IUCN Red List status: Endangered

Recent genetic studies suggest the spread of humanity began putting pressure on this golden monkey a good five centuries ago. Compare that with the blink-and-you-miss-it history of the Myanmar snub-nosed monkey (*R. strykeri*), totally unknown to science until early 2010 . . . and already on the Critically Endangered list. Ironically, it was hunters that proffered the first dead specimen of the new discovery, from a remote area of cool-temperate rainforest in Myanmar. Then in 2012 came the first live shots of the species, which has black fur, a white face, and a tendency to sneeze in the rain. Locals call it *mey nwoah*—"monkey with an upturned face." A small group was later discovered in China, too, on the Myanmar border, prompting calls for the two countries to work closely on protecting the shared species, whose total population, probably numbering fewer than three hundred, is threatened by hunting, logging, and dam projects.

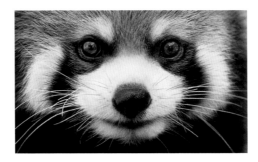

Red panda pp. 134–35

Scientific name: *Ailurus fulgens*
Range: Bhutan, China, India, Myanmar, Nepal
IUCN Red List status: Endangered

Habitat loss presents the greatest peril to the red panda, which is picky to a fault over its living conditions: it likes just the right aspect and gradient of slope, with the right density of mixed-forest canopy; the right rainfall, plus proximity to water sources; and plentiful tree stumps and logs for shelter. It also has a low, almost sloth-grade metabolism, and so tends not to forage far unless pressed. All of these factors mean that any disturbance can be hugely destructive—and logging, slash-and-burn subsistence farming, share-cropping, and road-building are all having an effect, removing prime habitat, and also loosening soil, increasing the risk of slips. Farmers collect bamboo, particularly the species known as malingo, the panda's main food source. With the humans come their dogs, vectors of canine distemper, which is lethal to the red panda.

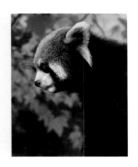

Red panda p. 137

Scientific name: *Ailurus fulgens*
Range: Bhutan, China, India, Myanmar, Nepal
IUCN Red List status: Endangered

The red panda is just as appealing as the black-and-white variety, with its button eyes, snub nose, and the rufous fur that has earned it the name of firefox. In earlier decades, the international pet trade fueled uncontrolled hunting. This is less of an issue today, with the species listed on CITES Appendix I (banning unlicensed export), and protected by national laws across its range. It is managed in more than eighty zoos worldwide, many of which supply captive-bred animals for the international studbook. Nonetheless, widespread human poverty in its range states is motive enough for opportunistic collection, and there's been a worrying rise in its popularity as a pet, particularly in Thailand and China. Occasionally a bycatch in deer-hunters' traps, the red panda is hunted directly for its flesh and skin; in parts of China the coat is occasionally made into good-luck charms for newlyweds, and its body parts feature in traditional medicines.

Red panda pp. 138–39

Scientific name: *Ailurus fulgens*
Range: Bhutan, China, India, Myanmar, Nepal
IUCN Red List status: Endangered

The little panda functions as a metric for the health of the environment on which local people's livelihood depends. It's the old story: save the red panda, and you save everything else. In Nepal, for example, the *panchayats*—local village councils—collaborate via a network of Community Forest User Groups to monitor red pandas. The San Francisco-based Red Panda Network, founded by Peace Corps veteran Brian Williams, appoints local villagers as forest guardians to liaise with the forest user groups, working out how best to align the needs of the panda with the needs of people. The Network is also fund-raising to create the Panchthar-Ilam-Taplejung Red Panda Protected Forest, to serve as a corridor between protected areas in India and Nepal. This would create a haven for a wealth of native species including the clouded leopard and Himalayan black bear.

Giant panda pp. 140–41

Scientific name: *Ailuropoda melanoleuca*
Range: Gansu, Shaanxi, and Sichuan provinces (China)
IUCN Red List status: Vulnerable

The giant panda's dependence on bamboo shackles it to a life of foraging up to fourteen hours per day. The bamboo forms undergrowth in high-altitude cloud forest; after flowering, it dies off, then takes ten to fifteen years to recover. Since the panda does not lay down fat reserves, nor hibernates, it must go in search of more bamboo, though it will eat fish or flowers when available. But today, as human encroachment parcels up the forests, pandas increasingly are cut off from food and from potential mates. Habitat loss was the main reason for the wild population falling to just over 1,200 during the 1980s. Between 2004 and 2014, panda-occupied habitat grew by nearly 12 percent, and this has underpinned the recovery to over 1,860 animals. But with the growing threat to bamboo presented by climate change, this ever-hungry animal is not out of the woods yet.

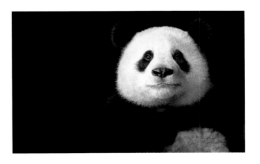

Giant panda pp. 142–43

Scientific name: *Ailuropoda melanoleuca*
Range: Gansu, Shaanxi, and Sichuan provinces (China)
IUCN Red List status: Vulnerable

Conditions in the cloud forests are cool and wet, but the panda's fur—coarse, dense, and rather oily to the touch—shucks off water easily and keeps the animal warm. This, coupled with the animal's famous lethargy, helps it conserve the meager energy yield of its diet. (You will seldom see a panda run; interestingly, its bones are twice the weight of other bears'.) The iconic piebald coat pattern is more or less uniform from one individual to the next, and keepers rely on fine details, such as small markings on the muzzle, to tell captive animals apart. And unlike other bears, which communicate through a range of facial expressions, the panda has a somewhat fixed gaze. So it tends to "talk" by posturing and head movements, or via a sophisticated repertoire of vocalizations, which include moans, bleats, honks, yips, barks, and roars.

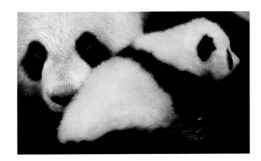

Giant panda pp. 144–45

Scientific name: *Ailuropoda melanoleuca*
Range: Gansu, Shaanxi, and Sichuan provinces (China)
IUCN Red List status: Vulnerable

The panda's shift from Endangered to Vulnerable has some experts worried—and not merely about the prospect of waning public compassion. Zhang Hemin, head of the China Conservation and Research Center for Giant Pandas (CCRCG), is concerned for the genetic viability of the wild population, given that it comprises thirty-three isolated groups—"some," he adds, "with fewer than ten individuals, severely limiting the gene pool. Of the eighteen subpopulations consisting of fewer than ten pandas, all face a high risk of collapse." Meanwhile, the deadly toll from the May 2008 earthquake included five staff members at the Wolong Panda Center in Wolong Nature Reserve, Sichuan, where the CCRCG was headquartered. Two captive pandas also died at the center, and there was severe damage to the reserve's bamboo stands. Natural disasters have, of course, always taken their toll on panda numbers—but today, at such a critical pass, every loss has consequences.

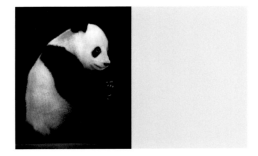

Giant panda p. 146

Scientific name: *Ailuropoda melanoleuca*
Range: Gansu, Shaanxi, and Sichuan provinces (China)
IUCN Red List status: Vulnerable

The Chinese call the giant panda *da xiong mao*—"big bear cat"—a hedging term that neatly frames a question that has, until recently, sparked scientific debate: exactly what is a panda? It was formerly classified with the raccoons, but is now placed, albeit fairly distantly, with the bears. This gives it carnivore ancestry, and herein lies a paradox, given that 99 percent of its wild diet is bamboo. The panda even uses an opposable "pseudo-thumb"—a sixth digit on its forepaws, unique among bears—for gripping plant stems. In 2015, Chinese researchers studied the panda's gut flora and, in place of herbivore-friendly bacteria, found a carnivore-friendly set. Essentially, the panda has a meat-eater's gut that is desperately inefficient at lifting nutrients from bamboo, a plant source it adopted perhaps only two million years ago.

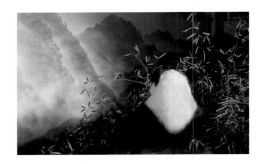

Giant panda pp. 148–49

Scientific name: *Ailuropoda melanoleuca*
Range: Gansu, Shaanxi, and Sichuan provinces (China)
IUCN Red List status: Vulnerable

This image shows a giant panda in its enclosure at Smithsonian's National Zoo, Washington. Critics may question the financial burden of preserving an animal that, as the song goes, "just wasn't made for these times," but China is fully committed to saving the panda. Its experts have pioneered techniques of raising twin cubs where in the wild one would be left to die, thus helping to sustain genetic diversity. New reserves are being established; farmers are paid to turn cropland over to forest or commercial tree plantations, and Wolong Nature Reserve has been replanted after the devastating 2008 earthquake. Currently, nearly 70 percent of the wild population lives within the reserve system, which protects some 5,400 square miles (14,000 sq. km) of panda habitat. Vital support, too, comes from overseas organizations such as Pandas International, based in the United States. It is almost exactly a century since a Westerner first saw a living panda (in 1916), and from then on the species' fortunes sank to a critical low; but they are, at last, on the up.

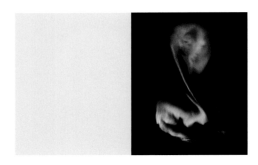

Northern lights p. 151

Location: Wapusk National Park, Canada

As solar radiation enters Earth's magnetic field and collides with the upper atmosphere, it gives off a wondrous flickering. Normally the polar lights appear just inside the Arctic and Antarctic Circles. The sun's radiation output varies, on a roughly eleven-year cycle: during a solar maximum, sunspots proliferate, and the light shows on Earth are not only more frequent but also appear at lower latitudes. The last solar maximums were around 2001 and 2013, and the next is predicted for 2022–24. But they've not always been regular. From about 1645 to 1715, there were markedly few sunspots; this period, known as the Maunder Minimum, corresponds to the peak of the "Little Ice Age," a cold stretch that spanned roughly the years 1300–1850. There's no reasonable evidence that fluctuations in solar activity might be responsible for global warming, but they do show that Earth is subject to natural variations, sometimes over long cycles.

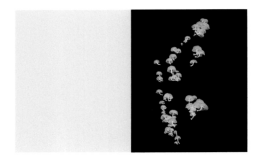

Forest light mushroom p. 153

Scientific name: *Mycena silvaelucens*
Range: Borneo
IUCN Red List status: Not Evaluated

Glowing fungi are rare: out of the 135,000 named species on Earth, only one hundred are bioluminescent. It's fairly unusual, too, for a photographer to shoot a still-unnamed species: biologists Dr. Dennis E. Desjardin of San Francisco State University and Dr. Brian A. Perry of California State University East Bay named *Mycena silvaelucens* two years after Tim took this shot in Borneo. Like other bioluminescent fungi, the forest light mushroom emits a constant light, though, understandably, it is visible to us only after sunset. At night, when humidity is relatively high, the fungus releases its spores, some of which settle on the nocturnal insects and other arthropods that have clustered around its glow; they later carry the spores away to colonize new terrain in the forest.

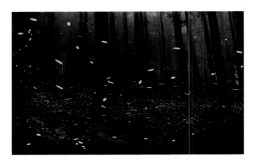

Fireflies pp. 154–55

Scientific name: Family Lampyridae
Range: Circumglobal, tropical/temperate latitudes
IUCN Red List status: Not Evaluated

Fireflies—which are not flies, but beetles—create light through the controlled oxidation of an enzyme in the abdomen, and they can flash the light on and off. They use the light to attract a mate (using a species-specific pattern), and also to warn would-be predators that the glowing chemicals, unsurprisingly, taste bad. The female *Photuris* firefly has a third use: she mimics the flash pattern of another genus, luring a male close, whereupon she devours him. These fireflies were photographed at Matsuyama, on the island of Shikoku. In Japan there is a long tradition of watching the displays of *genji-botaru* and *heike-botaru* (two common species) on cool summer evenings; in legend, the dancing lights represented the souls of slain warriors. The increased use of pesticides in recent years is killing off the *kawanina* (river snails) on which the insects feed, leading, sadly, to fewer dancing lights on summer evenings.

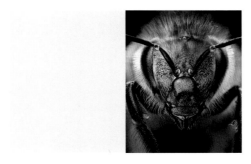

European honey bee p. 157

Scientific name: *Apis mellifera*
Range: Worldwide
IUCN Red List status: Not Evaluated

In this close-up of a live bee, one of the three ocelli (simple eyes) can be seen atop the head, and on each foreleg is a strigil, a notch used in grooming the antennae. Fortunately, no mites are in evidence. When the Asian *Varroa destructor* mite reached the United States in 1987 and New Zealand in 2000, it was widely seen as the death knell for apiculture and for crop pollination. Bombarding varroa with miticides is costly, and furthermore the mites are developing chemical resistance. More promisingly, though, some bees have shown resistance to varroa, and others practice a behavior called varroa sensitive hygiene, in which they locate and uncap larval cells infested with the mite, which stops the mite breeding. Apiarists have begun to breed the hygiene trait into bee populations, in hopes that, if we can't eradicate the mite, we can at least help the bees suppress it the way they know best.

Paper wasp pp. 158–59

Scientific name: the species pictured is unidentified; it is thought to be a member of the subfamily Polistinae

A wasp nest in the Danum Valley, Sabah, Borneo—naturally blotched for camouflage against the mottled bark. Paper wasps, totaling about 1,100 species worldwide, are social insects that build their nests from chewed-up wood pulp and saliva. Though maligned, wasps play an important ecological role, and have much to offer us, too. Their building "paper" is so lightweight and waterproof that, in 2014, a university research team reverse-engineered wasp proteins into a construction material for making unmanned aerial vehicles for NASA. Several wasp species, particularly the parasitoids that lay eggs in other invertebrate hosts, are used in the bio-control of agricultural pests. Also, a 2015 research study found that peptides in the venom of a South American wasp, *Polybia paulista*, may have an application in anti-cancer drugs. While these uses all signify a form of exploitation, they also point the way to a mutualism that is, at least, less one-sided than the norm.

Monarch butterfly p. 160

Scientific name: *Danaus plexippus*
Range: Americas (southern Canada to northern Brazil), Australia, Indonesia, Malaysia, Morocco, New Zealand, Spain, Timor-Leste, and several Pacific and Atlantic islands
IUCN Red List status: Not Evaluated

Other butterflies make epic migrations; the painted lady, for instance, flies a 9,000-mile (14,500 km) circuit between tropical Africa and the Arctic. But the monarch's feat is unmatched for sheer spectacle. In fall, western monarchs fly south to California and Baja California, while eastern monarchs head from Canada to cluster into the oyamel pine forests of Michoacán, central Mexico. It wasn't until 1975 that researchers located these southern forests, which cover a relatively tiny area. Indeed, the entire migration had been a mystery until zoologist Fred Urquhart stepped in. As a young man in Canada, Urquhart had wondered where the butterflies overwintered; and from 1938 he began tagging them with tiny paper ID labels. As people heard of his scheme, thousands offered to help. Over the decades, volunteers sent him tagged insects from all over—until finally, with the help of naturalists Kenneth Brugger and Catalina Trail, he traced the monarchs to Michoacán.

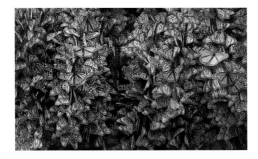

Monarch butterfly pp. 162–63

Scientific name: *Danaus plexippus*
Range: Americas (southern Canada to northern Brazil), Australia, Indonesia, Malaysia, Morocco, New Zealand, Spain, Timor-Leste, and several Pacific and Atlantic islands
IUCN Red List status: Not Evaluated

In 1976, with the Mexican summer quarters now known, the World Congress of Entomology set the monarchs' plight as its top priority. These New World wanderers have spread far—they've colonized Spain, Australia, and New Zealand—and, as yet, the species is not endangered. Nonetheless, in 1983, the IUCN took the unprecedented step of creating a new category in the Invertebrate Red Data Book, in order to list the monarch migration as a Threatened Phenomenon. This is because the numbers of American migrants are falling sharply. Every year, volunteers conduct a Thanksgiving count run by the Xerces Society for Invertebrate Conservation, and the figures for 1997–2016 show a 74 percent decline in California's overwintering monarchs, with a slump of 80–90 percent in Michoacán over the same period. This trend paints a dire picture requiring a coordinated solution.

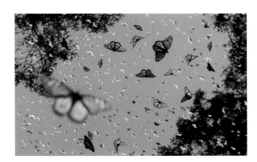

Monarch butterfly pp. 164–65

Scientific name: *Danaus plexippus*
Range: Americas (southern Canada to northern Brazil), Australia, Indonesia, Malaysia, Morocco, New Zealand, Spain, Timor-Leste, and several Pacific and Atlantic islands
IUCN Red List status: Not Evaluated

At the winter quarters in Michoacán, local peasant farmers used to exploit the forests for resources, such as firewood or farmland. Then, in 1986, the government created a Monarch Butterfly Biosphere Reserve, cutting the *ejidos*—farmer communes—out of their land blocks, and offering scant compensation in return. And so the exploitation continued, illegally. The solution was the Monarch Butterfly Sanctuary Foundation. Established in 1997, the foundation promised to work with the *ejidos* in managing the forest blocks, and to offer them fair compensation, making it a win–win option. The World Wildlife Fund, too, works with the farmers, promoting tree-planting schemes that offer them a sustainable source of income. Protection of the Mexican forests is also part of the wider North American Monarch Conservation Plan, set up in 2008 by the Commission for Environmental Cooperation, to coordinate the efforts of Canada, the United States, and Mexico to conserve these unique migrants.

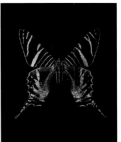

Sloane's urania p. 167

Scientific name: *Urania sloanus*
Range: formerly Jamaica
IUCN Red List status: Extinct

You might take it for a butterfly, but *Urania sloanus*, named for the famous Irish-born collector Sir Hans Sloane, was a day-flying moth. Sloane, who described eight hundred plants during a long stay in the Caribbean, illustrated the moth for the *Natural History of Jamaica* (1725), more than half a century before its formal scientific description, and only 170 years before its extinction. How many species are we unwittingly blotting out before we even know of their existence? The UN Environment Program (UNEP) recently calculated that up to two hundred plant or animal species are dying out daily. If there are ten million species on Earth (and there could be as many as ten times that number), and 50–90 percent of those are in tropical forests, and we are each year felling tropical forest equal to the area of Sri Lanka, then the UNEP math easily stacks up.

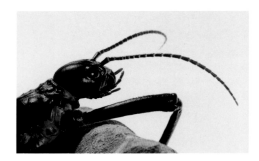

Lord Howe Island stick insect pp. 168–69

Scientific name: *Dryococelus australis*
Range: Lord Howe Island (Australia)
IUCN Red List status: Critically Endangered

Though it is in safe hands now, the Lord Howe Island stick insect came within a whisker of oblivion. For a start, the tiny colony on Balls Pyramid was surviving in a shrubby patch of its food plant—a species of tea tree—covering just 1,940 square feet (180 sq. m) of the cliff-face. (The former main island population used to hide inside hollow trees, but there are no trees on Balls Pyramid.) Even today, the shrub remains under threat from morning glory, an invasive introduced vine. Next, Eve, one of the breeding females transferred to Melbourne Zoo, became very sick; luckily she pulled through and laid a clutch of eggs the next day, launching the captive population. Zoos Victoria, which leads the global breeding program, now maintains three separate populations, in part to spread the risk. After all, one major incident—such as disease—could wipe out a colony in an instant.

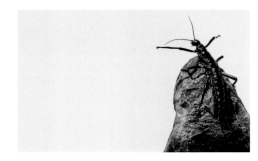

Lord Howe Island stick insect p. 171

Scientific name: *Dryococelus australis*
Range: Lord Howe Island (Australia)
IUCN Red List status: Critically Endangered

The rescue of the Lord Howe Island stick insect shows the work that zoos can do in saving the less charismatic species, such as insects, which are just as deserving as gorillas and snow leopards when it comes to survival. A few of the stick insects have been released in a rat-free zone on the island, but full-blown reintroduction must wait until the rats have gone. And therein lies a problem. A plan drafted in 2009 to air-drop poisoned rat bait met stiff resistance from islanders for fear it would harm them and their environment. Sure enough, some islanders were also against reintroducing the "tree lobster," as the stick insect is known, because they see it as an ugly nuisance. Nevertheless, the fate of several other endemic Lord Howe species—birds, as well as invertebrates—hangs on removing the rats, so the long-term solution is to go predator-free.

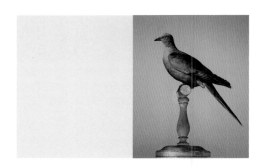

Passenger pigeon p. 173

Scientific name: *Ectopistes migratorius*
Range: formerly North America
IUCN Red List status: Extinct

Extinction, they say, means forever. Or does it? One day, the passenger pigeon will fly again, according to Revive & Restore (R&R), an organization that aims to "enhance biodiversity through the genetic rescue of endangered and extinct species." For instance, R&R is working with a team at Harvard University that claims to be close to engineering a mammoth embryo, using CRISPR gene-editing technology. As for the erstwhile bird, the plan is to splice its DNA with that of a modern band-tailed pigeon, which would then lay passenger pigeon eggs. R&R's aim is that the born-again passenger pigeon will help restore the ecological balance of native American forests. This does throw up a few challenging questions. Should we meddle with the course of natural history (even if we extinguished the species in the first place)? And if we created another billion passenger pigeons, what would be the impact on today's world?

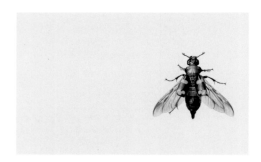

American burying beetle p. 175

Scientific name: *Nicrophorus americanus*
Range: United States
IUCN Red List status: Critically Endangered

By 1989, the American burying beetle was down to one known colony on Rhode Island. Fortunately, beetles readily breed in captivity, and reintroductions soon began: Massachusetts (1990), Nantucket (1994), Ohio (1998), and Missouri (2012). The rewilding technique involves putting carrion in a hole in the soil, priming it with a pair of beetles, then covering it over. When the eggs hatch, both parents feed the larvae by vomiting food into their mouths. The larvae go through the pupa stage before emerging as adults. Using their antennae, adults can sniff out a corpse from a mile or two away and fly over to claim it as their own meal-cum-nursery. First, though, they secrete a natural embalming fluid over it, to slow decomposition; then they bite off the plumage or fur, and even remove the bones, before burying it a foot or so deep. And on it goes—hopefully for many years yet.

Green-winged macaw pp. 176–77

Scientific name: *Ara chloropterus*
Range: Argentina, Bolivia, Brazil, Colombia, Ecuador,
French Guiana, Guyana, Panama, tropical South America
IUCN Red List status: Least Concern

Distributions and classifications can be deceptive. Although the green-winged macaw is labeled Least Concern across its range, its local status in Argentina is far more precarious. Until recently, in fact, it hadn't been seen there in two centuries, a victim of habitat loss and over-collection. In 2015, the first of what will turn out to be several reintroductions of the species took place at Los Esteros del Iberá, a large wetlands reserve in the country's northeastern province of Corrientes. Candidates are selected from captive-bred zoo populations, and first spend time in a "boot camp" aviary, learning to adjust to a new lifestyle, before release. Project staff then radio-track the birds and see how they get along. Iberá is a spectacular example of how a biologically rich area can serve as an "ark" for rare species: other current and planned residents include the giant anteater, jaguar, marsh deer, and maned wolf.

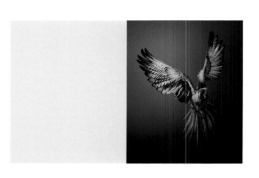

Military macaw p. 179

Scientific name: *Ara militaris*
Range: Mexico to Argentina
IUCN Red List status: Vulnerable

The military macaw faces a battle for survival. A 2007 Defenders of Wildlife report estimated that each year, up to 78,500 birds were being caught in Mexico alone for the pet trade, and that three-quarters of them were dying in transit. Poachers generally use mist nets, to avoid damaging the "goods," but some will recklessly fell trees to get at nesting squabs—a double whammy, given that tree holes are in such short supply that mature pairs have to wait their turn, sometimes for years, for occupancy. In 2008, Mexico passed an export ban on its twenty-two parrot species, and in 2015, the United States added the military and great green macaws to its Endangered Species Act. But the illegal trade continues, with much of it (in Mexico, at least) destined for the local market, not export. The fight is still on.

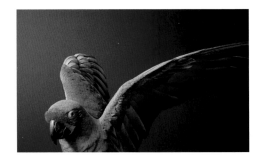

Military macaw pp. 180–81

Scientific name: *Ara militaris*
Range: Mexico to Argentina
IUCN Red List status: Vulnerable

Today, fewer than ten thousand military macaws are spread over more than 4 million square miles (10 million sq. km) of increasingly patchy habitat. Vast swathes of the Amazon are being cleared for soy plantations, and in Mexico nearly a quarter of the species' original habitat has been cleared, mainly for logging and agriculture. And while the bird can use mixed forest/plantation habitats, its fondness for crops, such as corn and olives, will win it no friends among farmers. Loss of nesting sites is a major problem. Logging of the tropical coastal forests of Puerto Vallarta in Mexico, for instance, is clearing the old, decaying trees the bird favors for nest sites. Macaws will also use nest holes in cliff faces, but these, too, are threatened, for instance by mining and dams. Perhaps only 5 percent of prime macaw habitat in Mexico lies within nationally protected areas, and this isn't enough to ensure the future of local populations.

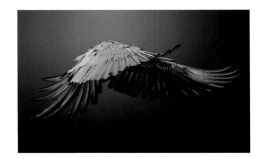

Military macaw pp. 182–83

Scientific name: *Ara militaris*
Range: Mexico to Argentina
IUCN Red List status: Vulnerable

Among the military macaw's staunchest allies are Defenders of Wildlife (DoW) and the World Parrot Trust. In 2007, DoW published a damning report on the illegal parrot trade in Mexico, prompting both Mexico and the United States to pass protective laws. At Jalisco, a stronghold for the species on the Pacific coast of Mexico, DoW is monitoring nest sites and running an outreach program with locals, which has helped boost the local birds' breeding success and deter poachers. Meanwhile, the World Parrot Trust has been studying the species at Jalisco since 2002. Currently it is working with locals to establish a protected corridor of semi-deciduous forest, containing the macaw's favored local delicacy, the young fruits of the sandbox tree (*Hura polyandra*). Their goal, if realized, will secure a small, but vital fragment of the bird's range.

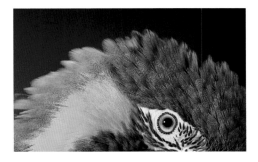

Blue-throated macaw pp. 184–85

Scientific name: *Ara glaucogularis*
Range: Bolivia
IUCN Red List status: Critically Endangered

Ransacked for the pet trade, the wild population of this macaw, fewer than 250 mature birds, is barely genetically viable. But with live export now largely eradicated, numbers are beginning to stabilize. Like other macaws, the blue-throated macaw nests in holes in old trees, many of which have been cleared; but most landowners are now supportive of initiatives to install nest boxes and plant food trees. The biggest flocks today are found in the 42-square-mile (108 sq. km) Barba Azul Nature Reserve, in Bolivia's Beni region, home to more than 140 bird species. The fortunes of its nest box program evoke that old proverb about leading a horse to water: of twenty-two boxes erected in the north of the reserve in 2014, seven were used by ducks, one by a barn owl . . . and none by macaws. But success with nest boxes elsewhere suggests that, with these slow-breeding birds, patience is a virtue that will pay off.

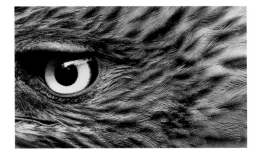

South Philippine hawk-eagle pp. 186–87

Scientific name: *Nisaetus pinskeri*
Range: Philippine islands of Basilan, Biliran, Bohol, Leyte, Mindanao, Negros, Samar, and Siquijor
IUCN Red List status: Endangered

No sooner had scientists recognized the South Philippine hawk-eagle as a full species than it received an Endangered rating. Until genetic analysis proved its unique status in 2014, it had been lumped in with the North Philippine hawk-eagle (*N. philippensis*), which is facing equally serious threats. Hawk-eagles are medium-sized raptors endemic to several Philippine islands, where the rapid pace of lowland deforestation—for agriculture, mainly, and logging—is whipping the habitat away from under their talons. Overall, the huge group of seven thousand islands has lost over half of its old-growth forest; the island of Bohol has just 6 percent of original cover remaining. Shot or trapped specimens are occasionally found, but the birds' habits remain largely a mystery. Today, there are probably fewer than one thousand South Philippine hawk-eagles in the wild, split into two main subpopulations.

South Philippine hawk-eagle p. 189

Scientific name: *Nisaetus pinskeri*
Range: Philippine islands of Basilan, Biliran, Bohol, Leyte, Mindanao, Negros, Samar, and Siquijor
IUCN Red List status: Endangered

The South Philippine hawk-eagle is one of ten species in the genus *Nisaetus*, all native to tropical Asia. The status of each relates directly to the quality and area of habitat remaining. For instance, the changeable hawk-eagle, found through India and Sri Lanka across to Indonesia and the Philippines, is designated Least Concern, as are the Sulawesi and mountain hawk-eagles. But the Javan hawk-eagle is probably down to six hundred pairs in its homeland, where the fast-growing human population is putting pressure on forest resources, and it is also traded in bird markets. Rarest of all is the Flores hawk-eagle, numbering fewer than one hundred pairs spread over a handful of Indonesian islands; like the South Philippine hawk-eagle it was only recently elevated to full species—an honor that, in these beleaguered birds, seems something of a poisoned chalice.

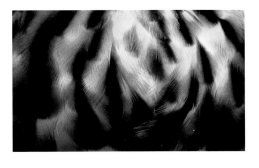

South Philippine hawk-eagle pp. 190–91

Scientific name: *Nisaetus pinskeri*
Range: Philippine islands of Basilan, Biliran, Bohol, Leyte, Mindanao, Negros, Samar, and Siquijor
IUCN Red List status: Endangered

The Philippine Eagle Foundation in Davao was founded to rescue its namesake, a much bigger raptor (pp. 192–97); but the hawk-eagles also come under its aegis. The foundation launched a captive-breeding program for the South and North Philippine hawk-eagles, using adults rescued from hunters, or nestlings that have been handed in. But with so little knowledge of the birds' wild nesting habits, it has been a slow process. In 2012, they finally hatched their first chick in an incubator, and hand-fed it on ground quail meat. At full size it will measure up to 27 inches (69 cm) long, with this beautifully barred plumage and distinctive head crest. What happens next will depend on properly enforced habitat protection from the Philippines government, and on global action—given that climate change will hit these islands hard.

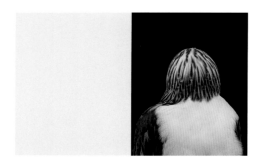

Philippine eagle p. 193

Scientific name: *Pithecophaga jefferyi*
Range: Philippine islands of Leyte, Luzon, Mindanao, and Samar
IUCN Red List status: Critically Endangered

How did the Philippine eagle evolve to be so huge? The answer lies in the absence of any large mammalian carnivores in its native forests. With scant competition for prey, the eagle grew into its apex-predator niche . . . all the way to a 7-foot (2.1 m) wingspan. Now, however, its size is a curse: with the forest vanishing, the eagle is, as Filipino biologist Hector Miranda puts it, "at an evolutionary dead end." Island gigantism has a parallel in the Australian little eagle, a falcon-sized raptor. Long ago, it colonized New Zealand, and there it found a land that lacked mammals, but which offered a rich prey base in the form of moa: giant, flightless birds. Rapidly it evolved into the largest eagle the world has ever known: Haast's eagle, weighing up to 33 pounds (15 kg) or more. When moa were hunted to extinction around AD 1400, Haast's eagle, deprived of prey, went the same way.

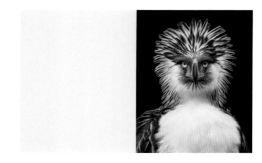

Philippine eagle p. 195

Scientific name: *Pithecophaga jefferyi*
Range: Philippine islands of Leyte, Luzon, Mindanao, and Samar
IUCN Red List status: Critically Endangered

An eagle tends to erect its crest, as shown in this image, when on alert. The fight to rescue the eagle began in earnest in 1965, when pioneering Filipino conservationists Dioscoro Rabor and Jesus Alvarez alerted the World Wildlife Fund to the bird's plight; celebrity aviator Charles Lindbergh also lent vocal support. A US Peace Corps volunteer named Robert Kennedy dedicated himself to studying the eagle in the wild, and founded the nonprofit Films and Research for an Endangered Environment (FREE) to help publicize it. Kennedy's 1977 population estimate of two to four hundred was a wake-up call, leading to the species' name change (from "monkey-eating eagle," which was misleading anyway) in 1978. Then in 1995 President Ramos, elevating the eagle to national bird status, called it "the best biological indicator of the quality of our forest ecosystems" and "the flagship species in the conservation of Philippine wildlife." This highlights a key point: save the eagle, and you save the forests and their incredibly diverse wildlife.

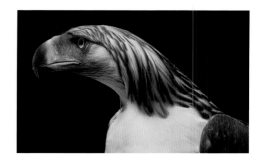

Philippine eagle pp. 196–97

Scientific name: *Pithecophaga jefferyi*
Range: Philippine islands of Leyte, Luzon, Mindanao, and Samar
IUCN Red List status: Critically Endangered

Philippine eagles breed slowly, and fewer than 10 percent of juveniles make it to adulthood, so a captive-breeding program, run by the Philippine Eagle Foundation on Mindanao, gives a vital boost to numbers. In 1992, Pag-asa ("Hope") became the first eagle to hatch in captivity. Because he has imprinted on his keepers, he cannot be returned to the wild, but he contributes by breeding. At age twenty-one years he sired his first daughter, Mabuhay, who was denied direct contact with keepers in order to preserve her "wildness." By 2017, the Eagle Foundation had hatched twenty-eight eagles, but not all reintroductions have been successful. For instance, Kagsabua ("Unity") was released in 2008, but shot dead a month later by a hunter. Old prejudices, which had seen the bird maligned as a chicken-thief, clearly die hard. Accordingly, the foundation works with schoolteachers on Mindanao to promote positive attitudes, so that the next generation of volunteers will treasure this flagship bird.

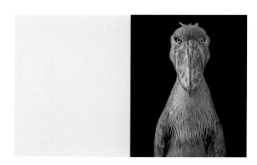

Shoebill p. 199

Scientific name: *Balaeniceps rex*
Range: East Africa, from South Sudan to Zambia
IUCN Red List status: Vulnerable

Standing 4 feet (1.2 m) tall, the shoebill feeds in swampy shallows, ambushing fish and frogs with a quick stab and snap. The bird resembles one of Dr. Seuss's more sinister creations, but its unique characteristics—somewhere between a stork and a pelican—could in the end be its salvation. Its population is scattered across seven African countries, which united in 2013 to draw up a Single Species Action Plan. High on the list of threats are habitat disturbance: fires, set to renew grasslands, are a particular hazard to nestlings. And while legal trade is now very limited, uncontrolled illegal collection, mainly for private sale in the Middle East, can easily wipe out local collections. (Shoebills fare poorly in captivity, too.) The Action Plan recognized the importance of protecting the species by encouraging grass-roots support; in Bangweulu, Zambia, for instance, home to an important shoebill population, guardians drawn from local communities help protect nest sites.

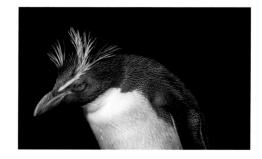

Northern rockhopper penguin pp. 200–201

Scientific name: *Eudyptes moseleyi*
Range: Atlantic Ocean (Gough Island and Tristan da Cunha), Indian Ocean (Amsterdam and St. Paul Islands)
IUCN Red List status: Endangered

In just three generations—thirty-seven years—the northern rockhopper population has dived by more than half, and no one quite knows why. Perhaps it's simply a confluence of several factors. But the 2011 oil spill from the MV *Oliva*, which grounded on Nightingale Island in the Tristan da Cunha group, reveals the long reach of humanity into Earth's remotest areas, and the threat posed by catastrophic events. For their part, the Tristan Islanders leapt to the rescue. Over a three-month span, they collected 3,718 oiled *pinnamins* (as the birds are known locally) and housed them in the main store. They gave veterinary glucose feeds, dug fish from freezers to feed the exhausted birds, showered and soaped them, and put them in the swimming pool when clean. Ultimately, though, just 12 percent of the hospitalized birds survived to return to sea.

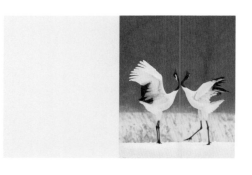

Red-crowned crane p. 203

Scientific name: *Grus japonensis*
Range: China, Japan, Korea (North and South), Mongolia, the Russian Federation
IUCN Red List status: Endangered

Red-crowned cranes dance in snow in Kushiro-shitsugen National Park, a wetland system in the east of Hokkaido, Japan. For all the world they resemble the birds frozen in elegant poses on Maruyama Okyo's painted screens, or Utagawa Hiroshige's woodcuts. The crane, which typically pairs for life, is beloved throughout its range as a symbol of luck, fidelity, and longevity; in Japan it is reputed to live for a thousand years (although the real figure is closer to forty); it was said, too, that if you folded a thousand origami cranes you could petition the bird for happiness and long life. Perhaps also the crane stands for unity, given that seven of the world's fifteen crane species nest in the Korean demilitarized zone, a thread of terrain just 2½ miles (4 km) wide but nearly 160 miles (250 km) long; this fragile sanctuary and its cargo will call for an elegant diplomatic dance.

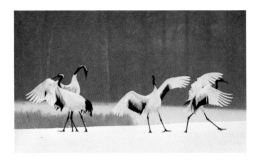

Red-crowned crane pp. 204–5

Scientific name: *Grus japonensis*
Range: China, Japan, Korea (North and South), Mongolia,
Russian Federation
IUCN Red List status: Endangered

Mainland red-crowned cranes are migrants, stopping off
at wetlands along flyways that traverse China, Siberia,
Mongolia, and Korea. There is a well-known tendency to
view wetlands as marginal habitats, ripe for exploitation;
even when protected, they remain vulnerable. The fertile
Yellow River delta, one of the crane's key wintering grounds
in China, was gazetted as a nature reserve in 1992, but
oil extraction in the delta has recently increased, stealing
land from the core reserve area. Land conversion wounds
reserves, too, and healing efforts are not always a success.
At Zhalong in Heilongjiang Province, home to a large flock
of captive cranes, droughts in the early 2000s led to serious
reed fires. Authorities desperately pumped water into the
reserve, but this in turn flooded nests.

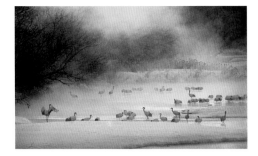

Red-crowned crane pp. 206–7

Scientific name: *Grus japonensis*
Range: China, Japan, Korea (North and South), Mongolia,
Russian Federation
IUCN Red List status: Endangered

While they are free to leave, cranes are becoming overcrowded
here in their sole Japanese stronghold at Otowa Bridge,
Kushiro, particularly at feeding areas. Yet the species
overall remains critically rare, with around 2,750 in the wild;
although it has long been bred in captivity, reintroduction
efforts have so far had little success. Worryingly, the
captive-bred population in China seems to be rising at the
expense of wild cohorts, as eggs, juveniles, and adults are
taken from the wild to supplement numbers in zoos and
nature reserves. A 2008 red-crowned crane workshop in
Japan concluded that, throughout the crane's range, habitat
protection remains the priority. This requires national efforts
to safeguard reserves and international cooperation. Migrant
birds, after all, are no respecters of national borders.

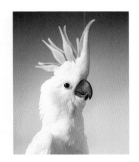

Yellow-crested cockatoo p. 209

Scientific name: *Cacatua sulphurea*
Range: Indonesia, Timor-Leste
IUCN Red List status: Critically Endangered

Wholesale deforestation across Indonesia has hit the
yellow-crested cockatoo's habitat, and the bird has in the
past been persecuted as a crop pest; but the pet trade is
overwhelmingly to blame for its steep decline. Between
1980 and 1992, Indonesia exported one hundred thousand
of the birds; yet it wasn't until 2005 that the species was
added to CITES Appendix I, banning export. Today the
total population, far-flung over several islands including
Sumba, East Nusa Tenggara, and Pasoso, could be anything
from in the range 2,500–10,000, and much of the ongoing
illegal trapping is for the domestic market. But recovery
plans, bringing together groups including the World Parrot
Trust, Indonesian Parrot Project, and Konservasi Kakatua
Indonesia, are paying off in some areas, thanks to support
in local communities. For instance, villagers are elected to
act as forest wardens to monitor forests and deter poachers,
and farmers plant sacrificial crops (such as sunflowers) to
distract cockatoos from more valuable crops.

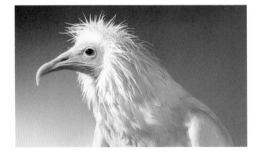

Egyptian vulture pp. 210–11

Scientific name: *Neophron percnopterus*
Range: Western Europe and Africa to India and Nepal
IUCN Red List status: Endangered

One of the smaller vultures, the Egyptian vulture has a
slender bill, ideal for grabbing scraps of carrion after larger
birds have fed on a carcass. That said, it will eat almost
anything, from droppings to beetles, and often haunts village
dumps and nomad camps. The species is spread thinly over
Europe, Africa, and the Indian subcontinent. While some
populations are resident, others breed in the north from
Spain east to Nepal, before migrating south for the winter,
and they face several threats on their seasonal flyways.
Carrion baited with poison is laid out by poachers and
livestock farmers; wind farms and poorly insulated power
lines present collision hazards; and the birds are hunted for
bushmeat, eggs, chicks, and body parts. Across the past fifty
to sixty years the European population has fallen by as much
as 80 percent, with an even steeper decline in India.

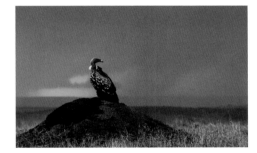

White-backed African vulture pp. 212–13

Scientific name: *Gyps africanus*
Range: Sub-Saharan Africa
IUCN Red List status: Critically Endangered

Under a lowering sky, an African white-backed vulture gazes
out over the Maasai Mara. This is Africa's most widespread
vulture species, and yet its numbers have been tumbling
rapidly everywhere (with the exception, for now at least,
of South Africa). Vultures have evolved stomach acid that
is strong enough to neutralize deadly pathogens, such as
anthrax and brucellosis, but their metabolisms are no match
for synthetic toxins. Farmers put out carcasses laced with
strychnine or the pesticide carburofan to kill marauding
carnivores, such as lions and hyenas, and the vultures ingest
the toxin when they feed. More insidious are some of the
new veterinary painkillers. The drug diclofenac, for instance,
is harmless to livestock but causes lethal kidney failure in
vultures; used across Africa, Asia, and Europe, it was largely
to blame for a 99 percent decline in India's vultures until
banned there in 2006. Lead ammunition from poached
carcasses is another source of poisoning.

White-backed African vulture p. 215

Scientific name: *Gyps africanus*
Range: Sub-Saharan Africa
IUCN Red List status: Critically Endangered

Soaring on updraughts, vultures roam far—hundreds of
miles, often—in search of food. Their habit of circling high
over a kill unwittingly leads them into lethal conflict: the
kettle of birds, visible from afar, alerts wardens to the likely
presence of poachers on the ground below. It's one reason
why poachers have been retaliating with poison. And the
mass killing of adult birds means that their nestlings, too,
die—from starvation. Vultures lack the obvious charm
of, say, big cats and elephants, and it's only recently that
conservationists became aware of their desperate plight.
In 2015, BirdLife International and the IUCN upgraded the
status of six African species: four (the hooded, Rüppell's,
white-backed, and white-headed vultures) to Critically
Endangered, and two (the Cape and lappet-faced vultures)
to Endangered. The decline of vultures means that
other scavengers—rats, feral dogs—are burgeoning, one
consequence of which is a rise in diseases such as rabies.

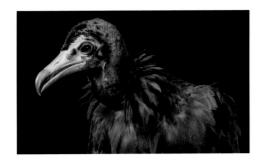

Hooded vulture pp. 216–17

Scientific name: *Necrosyrtes monachus*
Range: Sub-Saharan Africa
IUCN Red List status: Critically Endangered

Like the Egyptian vulture, the hooded vulture is another relatively small species that waits its turn at kills; the characteristic bare head and neck are a practical adaptation to the gory business of feeding. It, too, has recently suffered a massive population decline over three generations, and from a similar suite of threats, though they vary from one area to another. While poisoned livestock is an issue in East Africa, for instance, in West and Central Africa there is still a brisk trade in vulture parts for traditional medicine. The birds' fat, brains, heads, and plumage are used to treat diarrhea or rheumatism, or to increase intelligence in children or success in gambling. In parts of Senegal, while there are cultural protections around the hooded vulture because of its totemic value, a growing paucity of its preferred nesting trees is driving its numbers down.

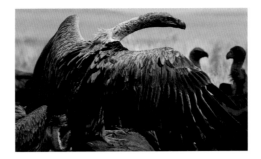

White-backed African vulture pp. 218–19

Scientific name: *Gyps africanus*
Range: Sub-Saharan Africa
IUCN Red List status: Critically Endangered

Vultures are astonishingly efficient janitors. Given that a flock can strip a cow carcass to its bones within the hour, the time-honored practice in villages was to put dead livestock out for these feathered undertakers. (For millennia, too, Tibetans and Indian Parsis practiced a similar ritual in their hilltop "sky burials"—although, today, there are too few vultures to pick clean the corpses.) In Europe, meanwhile, tighter abattoir legislation has taken away another traditional food source for vultures, and there are now moves to relax it again for the birds' sake. One concept that is proving successful in parts of India, Nepal, Cambodia, Spain, and southern Africa is the "vulture restaurant"—a dumping ground for approved carcasses of cattle and pigs, where vultures cluster in their dozens to feed. This brings tourism revenue for the local people and assures vultures of a safe food source.

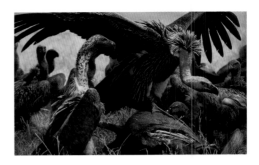

White-backed African vulture pp. 220–21

Scientific name: *Gyps africanus*
Range: Sub-Saharan Africa
IUCN Red List status: Critically Endangered

Gore-encrusted carrion-birds that gobble putrid flesh need seriously good publicists; consider, too, that the word "vulture"—like "shark," "pig," "snake in the grass," and the like—has acquired a pejorative meaning. Luckily, a realization that it makes economic as well as environmental sense to restore their useful role in the ecosystem has earned widespread acknowledgment. Most governments are now supporting their native vultures—although both Spain (home to 95 percent of Europe's vultures) and Italy still permit the sale of veterinary diclofenac, despite widespread campaigns to have it banned. Meanwhile, among several NGOs involved in helping vultures are the Vulture Conservation Foundation, focusing on European species; Saving Asia's Vultures from Extinction (SAVE); and VulPro in southern Africa (which works with several African species, including the white-backed vulture, pictured). All are committed to advocacy, education, research, and captive breeding to give these maligned, yet magnificent birds a second chance.

African elephant p. 223

Scientific name: *Loxodonta africana*
Range: Sub-Saharan Africa
IUCN Red List status: Vulnerable

"Together with rain, sun, fire and man the elephant has been one of the forces that have shaped the ecology of Africa," wrote naturalist Jonathan Kingdon. African elephants mangle and ring-bark tree trunks, and often push them over to bring food within reach. They kick up grasses, and disperse seeds in dung. And seasonally they wander, sometimes hundreds of miles, to find sustenance; per day, an adult eats about 660 pounds (300 kg) and may drink over 50 gallons (200 liters) of water. Nearly three-quarters of their huge sub-Saharan range today lies in unprotected areas, where human interests stand in their way. (Tsavo, for instance, is bisected by the new Mombasa–Nairobi railway.) Not surprisingly elephants, denied access to ancient feeding grounds, damage crops—and are shot for it. With Africa's 1.2 billion humans on target to surpass four billion by the end of this century, the stage is set for a very tough showdown.

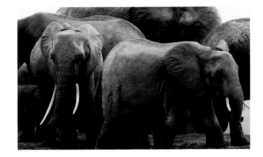

African elephant pp. 224–25

Scientific name: *Loxodonta africana*
Range: Sub-Saharan Africa
IUCN Red List status: Vulnerable

Among the elephants of Tsavo are nine or so of Africa's last few "big tuskers": a genetic strain with tusks so long they practically drag on the dusty red ground. They are not photographed here—and indeed their whereabouts are deliberately not disclosed, for obvious reasons. Protecting the big tuskers is one of the key aims of the Tsavo Trust, a field-based NGO established in 2012 to support the Kenya Wildlife Service. As well as monitoring, researching, and guarding the herds, the trust works closely with local communities to foster mutually beneficial outcomes for people and wildlife. The Tsavo Conservation Area is twice the size of Wales; keeping tabs on the elephants, which often wander into neighboring Tanzania, would be impossible without their Super Cub aircraft. The Trust's CEO, Richard Moller, flew Tim over Tsavo to take the aerial photographs in this book.

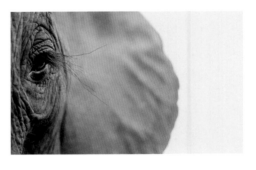

African elephant pp. 226–27

Scientific name: *Loxodonta africana*
Range: Sub-Saharan Africa
IUCN Red List status: Vulnerable

It was mainly Japanese demand for ivory that fueled the calamitous fifteen years of poaching that led to the ivory ban of 1990. For a while, the ban largely worked. But in 1997 Botswana, Namibia, and Zimbabwe sought, and won, a local downgrading to Appendix II for their large herds; that year, they legally sold 54 tons (49 tonnes) of ivory to Japan. Further legal sales followed of higher quantities in 2002 and 2008—in hopes that it would swamp the markets and inhibit poaching. All it did was reignite demand, fanned by the soaring economies of China and Thailand, and the trade actually tripled over the five years to 2012. But public education efforts are at last taking effect, and in 2016 China banned its legal trade. It's hoped that this will not drive the traffic underground, but reinforce the message that ivory is best left on elephants, hippos, and narwhals.

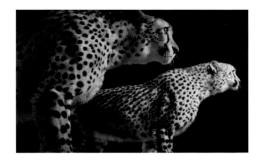

Cheetah pp. 228–29

Scientific name: *Acinonyx jubatus*
Range: Africa (20 countries), Iran
IUCN Red List status: Vulnerable

From its blistering pace to its wanderlust, the cheetah is uniquely specialized for a slim ecological niche: running down prey in a typically huge home range. (Ranging widely, generally by day, may be a spatial-temporal adaptation to staying out of the way of less wide-roaming, more dangerous nocturnal predators, such as lions and hyenas, which prey on cheetah cubs.) But modern Africa's fast-changing landscape negates all these refinements, and today the cheetah's unique niche is all but extinct. Another problem is an alarmingly limited gene pool, thought to have been caused by a mammalian extinction event ten to twelve thousand years ago. All of today's cheetahs are, essentially, as closely related as a pair of twins—they will forever be so, even if the population bounces back—and this leaves them with perilously low resistance to disease outbreaks. Managing genes is therefore a major arm of cheetah conservation.

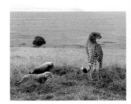

Cheetah p. 230

Scientific name: *Acinonyx jubatus*
Range: Africa (20 countries), Iran
IUCN Red List status: Vulnerable

Human-cheetah conflict is a grave threat. Cheetahs do take livestock—although, being mostly diurnal, they are often blamed unfairly for other predators' kills. But while translocating the cats out of problem areas *can* work, it is costly and only partly effective. In a recent study in Botswana, only 18 percent of translocated cheetahs survived their first year in new digs. One organization seeking novel solutions is the Cheetahs Conservation Fund (CCF), based in Namibia (where in the 1980s farmers killed nearly ten thousand cheetahs, effectively halving the national population). For instance, the CCF breeds specialist guard dogs and offers them to farmers to protect herds—bark, in this instance, being better than bite. Another is the Mara Cheetah Project, launched by the Kenya Wildlife Trust, which uses a research-driven approach: monitor the local population, do ecological research, promote community-based conservation . . . and basically find ways for humans and cheetahs to coexist.

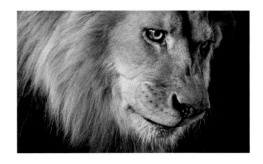

Lion pp. 232–33

Scientific name: *Panthera leo*
Range: Sub-Saharan Africa, India (Gir Forest)
IUCN Red List status: Vulnerable

Felix the lion is a supporting actor in movies including *Evan Almighty* and *We Bought a Zoo*; at Hollywood Animals in Santa Clarita, California, his stable-mates include bears, tigers, and leopards. As far as captive big-cat entertainment goes, it's a far cry from (and a lot more civilized than) ancient Rome, when criminals, Christians, and gladiators battled lions—and bears, tigers, and leopards—in bloodbaths that saw uncountable wild animals slaughtered. The Romans imported lions in the thousands, decimating wild stocks. Today, a shortage of natural prey and habitat, along with conflicts with livestock farmers, is wiping out lions even more rapidly. Since the early 1990s, the population has tumbled by nearly 45 percent overall, although that figure varies depending on location. In South Africa, where funding for protection is adequate, populations are stable, but lions are now extinct in several of the poorer range states, including Burundi, Congo, Gabon, Gambia, Sierra Leone, and Western Sahara.

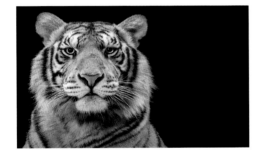

Bengal tiger pp. 234–35

Scientific name: *Panthera tigris*
Range: Bangladesh, Bhutan, China, India, Indonesia, Malaysia, Myanmar, Nepal, Russian Federation, Thailand; possibly also Laos, North Korea, Vietnam
IUCN Red List status: Endangered

Bengal tigers, like Kanja here, number as many as 2,500 today, which is roughly two-thirds of the world's tiger total. Their survival owes much to Project Tiger, founded by Indira Gandhi in 1973, shortly after the hunting ban. Today there are fifty tiger reserves in India, totaling over 19,000 square miles (50,000 sq. km). But the Bengal tigers are still in trouble. They're apex predators requiring a big range and prey base, so they can kill a large mammal (such as a wild pig or deer) at least every week. Unprotected land has dwindled fast in the wake of rapid economic development; surveys in 1997 and 2006 showed a 41 percent decline in available habitat. Also, creating tiger reserves often involves evicting whole villages—a policy that, says Survival International, overrides the rights of tribal people. Better, surely, to involve tribes in managing their local patch of tiger forest—which, after all, they have been doing for generations.

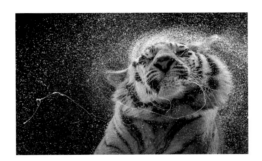

Bengal tiger pp. 236–37

Scientific name: *Panthera tigris*
Range: Bangladesh, Bhutan, China, India, Indonesia, Malaysia, Myanmar, Nepal, Russian Federation, Thailand; possibly also Laos, North Korea, Vietnam
IUCN Red List status: Endangered

Tiger juju is old and ingrained. In his cultural history *Tracking the Weretiger*, Patrick Newman cites examples from earlier times across the species' range when locals ate tiger liver for courage, wove whiskers into rings to ward off evil, and even placed their babies over a freshly killed tiger to "absorb its sinewy vitality." Tiger clavicles were taken as lucky charms, tiger fat smeared onto sickly cattle. Today, body parts are still in demand, mostly from wealthy devotees. With the South China subspecies all but gone by 1985, poachers turned on the Bengal tiger—as evidenced by a steep rise in hauls: in August 1993, for instance, Delhi police intercepted 880 pounds (400 kg) of tiger bones. That same year, China ostensibly banned the use of tiger bone; while this has dampened trade, a black market persists, and there are currently tigers being farmed in parts of Asia for their products.

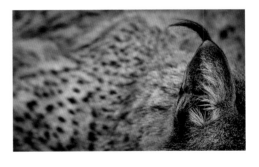

Iberian lynx pp. 238–39

Scientific name: *Lynx pardinus*
Range: Portugal, Spain
IUCN Red List status: Endangered

Formerly classed as Critically Endangered, the world's most threatened cat is inching back from the brink of extinction. In decades past, hunting (by protective farmers) and trapping (for its coat) hastened the Iberian lynx's steep decline, alongside the catastrophic crash in its rabbit prey. Today, loss of habitat to industrialized agriculture is largely to blame, along with dam projects and new roads (cars are lethal to lynx). By 2002 there were fewer than one hundred lynx left, clinging on in the eastern Sierra Morena (south-central Spain) and Coto Doñana National Park (on the southwestern coast). That year, Spanish authorities, with funding from the EU, launched LIFE+Iberlince, a major initiative to stabilize existing populations and found new ones. Over 140 captive-bred lynx have since been released into three new sites in Spain and Portugal, and the latest population count (2016) is over four hundred.

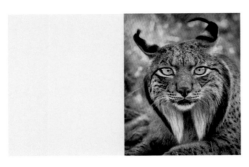

Iberian lynx p. 241

Scientific name: *Lynx pardinus*
Range: Portugal, Spain
IUCN Red List status: Endangered

Bob-tailed, spotted, bearded, and tufted, the Iberian lynx is certainly one of the more attractive excuses for opening a bottle of wine . . . but only if the stopper is made of cork. The groves of cork oaks (*Quercus suber*) of Spain and Portugal have long been a haunt of the cat and its rabbit prey, and they're also a haven for birds (including the Iberian imperial eagle, another predator of the rabbit). But with the recent switch to plastic wine stoppers, growers are neglecting the cork oak for higher-yield crops, and in the process a vital habitat is disappearing. The oak groves sequestered carbon and nurtured honey bees, farmers grazed their goats in the clearings, and cork was a lucrative export. Lynx, too small to take larger prey, helped keep the rabbit populations under control. For many, finding new uses and markets for cork would be a win–win scenario.

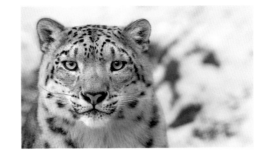

Snow leopard pp. 242–43

Scientific name: *Panthera uncia*
Range: Afghanistan, Bhutan, China, India, Kazakhstan, Kyrgyzstan, Mongolia, Nepal, Pakistan, Russian Federation, Tajikistan, Uzbekistan
IUCN Red List status: Endangered

Up on the roof of the world, the cold, arid plateaux and ranges of Central Asia are home to hardy mountaineers like blue sheep and Siberian ibex, the main prey of the snow leopard. But the herds of domestic sheep and goats that now encroach on this high terrain make easier pickings for snow leopards, which have been known to enter corrals and kill dozens of livestock animals in a night. A 2016 report from wildlife trade monitoring network TRAFFIC found that, on average, four snow leopards have been killed every week since 2008. Of those, more than half are revenge killings by herders, angry at losing their already-meager income. Another 20-odd percent succumb to poachers (some for their illegally traded fur, others for body parts used in traditional Asian medicines), and a further 20 percent are caught in traps set for other animals. Around four to seven thousand snow leopards survive today.

Snow leopard pp. 244–45

Scientific name: *Panthera uncia*
Range: Afghanistan, Bhutan, China, India, Kazakhstan, Kyrgyzstan, Mongolia, Nepal, Pakistan, Russian Federation, Tajikistan, Uzbekistan
IUCN Red List status: Endangered

With so many conflict killings taking place, TRAFFIC is focusing on herders, and urging governments to offer them worthwhile insurance and compensation for lost livestock. NGOs, too, such as the Snow Leopard Trust (SLT) and Snow Leopard Conservation Foundation (SLCF), are working with herders to improve corral fencing, as well as providing school camps and nature clubs to engage local communities on all levels. As well, there are at last moves to protect the environment. An example is the Tost mountain range in the South Gobi area of Mongolia, where since 2008 the SLCF and Mongolian Academy of Sciences have been conducting groundbreaking research, such as radio-tracking snow leopards and monitoring nursing mothers in their dens. In 2016, the Mongolian government accepted proposals to turn Tost into a nature reserve—where hunting, mining, and construction are banned—specifically to protect the snow leopard.

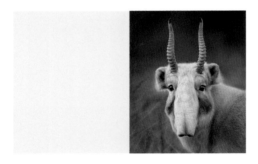

Saiga p. 247

Scientific name: *Saiga tatarica*
Range: Kazakhstan, Mongolia, Russian Federation, Turkmenistan, Uzbekistan
IUCN Red List status: Critically Endangered

Hunted for its meat and horns since prehistory, the saiga has proved incredibly resilient, thanks to its breeding prowess in the wild. Numbers tumbled to under a thousand in the early twentieth century, but total protection in Europe (1919) and Soviet Central Asia (1923) brought them back to around two million by mid-century. After illegal hunting led to further population plunges, a coalition of governments and NGOs leapt to the saiga's rescue—and numbers were at last back into six figures when the disease of 2015 struck. The bacterium *Pasteurella multocida*, which caused the die-off, is not normally lethal, and scientists have yet to explain why it turned so deadly. One theory is that climate change had weakened the saigas' immune systems. After a fresh infection struck again in December 2016, killing thousands more saiga, conservationists remain on high alert, yet hopeful that this endearingly bizarre mammal will manage another comeback.

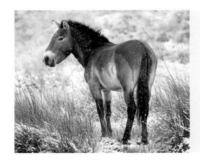

Przewalski's horse pp. 248–49

Scientific name: *Equus ferus przewalskii*
Range: China, Mongolia
IUCN Red List status: Endangered

A short, stiff mane, guard hairs on the upper tail, and a dark dorsal stripe are three features distinguishing the Przewalski's subspecies from the domestic horse. Przewalski's is not an ancestor of its domestic cousin, either: the two lines diverged somewhere between 38,000 and 117,000 years ago. Although they have a different chromosome count, they can interbreed and produce viable offspring; today's entire population of Przewalski's horses is descended from a dozen wild-caught animals, plus up to four domestic horses. As a consequence of this bottleneck, nearly two-thirds of the subspecies' original gene quota has been lost over the years. Thanks to strict adherence to the international studbook, Przewalski's horse remains genetically viable—but its future, like its recent past, remains very much a numbers game.

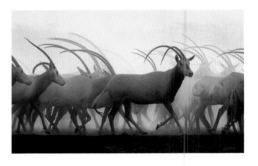

Scimitar-horned oryx pp. 250–51

Scientific name: *Oryx dammah*
Range: Chad (wild)
IUCN Red List status: Extinct in the Wild since 2000
(most recent IUCN assessment in 2008)

The return of scimitar-horned oryx to the wild has been one of the most successful reintroductions anywhere, ever. Classed as Extinct in the Wild since 2000, the oryx is once again roaming the Ouadi Rimé-Ouadi Achim Game Reserve in central Chad, which was its last stronghold until hunting wiped out the final herds there in the 1990s. The four-decades-long project has involved a cast of thousands, including the Zoological Society of London, the government of Chad, the Environment Agency Abu Dhabi, the Sahara Conservation Fund, and more than two hundred captive-breeding centers. In March 2016, twenty-one oryx were flown from a "world herd" in Abu Dhabi to the Ouadi reserve, where they were released in August. A second cohort, of fourteen animals, was released in January 2017. Ultimately the aim is to create a self-sustaining herd of five hundred animals on the reserve, which covers an area roughly the size of Scotland.

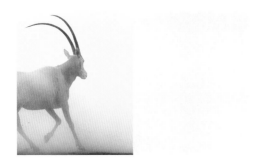

Scimitar-horned oryx p. 252

Scientific name: *Oryx dammah*
Range: Chad (wild)
IUCN Red List status: Extinct in the Wild since 2000
(most recent IUCN assessment in 2008)

These animals are from the herd at Sir Bani Yas Island, west of Abu Dhabi. They are among some three thousand captive oryx held in collections across the UAE, where the world herd has been collated from collections worldwide to preserve genetic diversity. (Sir Bani Yas recently donated seventy animals to the world herd.) There is a surprising number of oryx in captivity—eleven thousand in Texas alone—but most are likely to have descended from just forty to fifty "founder" animals taken from Chad in the 1960s. Although long-term captive breeding runs the risk of institutionalizing animals, the reintroductions have to date been successful. One reason for this, ironically, is that the oryx's natural predators—the lion and cheetah—are locally extinct in the Ouadi reserve. Added to that is the goodwill of local Chadians, who have welcomed the oryx's return. In time, the reserve may be a stronghold for other flagship species, such as the dama gazelle, addax, and ostrich.

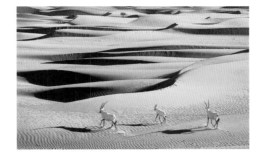

Arabian oryx pp. 254–55

Scientific name: *Oryx leucoryx*
Range: Israel, Oman, Saudi Arabia
IUCN Red List status: Vulnerable

Few comebacks in nature match that of the Arabian oryx. This antelope was wiped out from the wild, but reintroduced a decade later, and would become the first ever species to jump from Extinct in the Wild down to Vulnerable in the Red List. A rugged relative of the scimitar-horned oryx and gemsbok, the Arabian oryx once roamed Egypt, Israel, the Middle East, and right across the Arabian Peninsula, but was hunted down for its meat, hide, and spectacular horns. The last wild animal was shot in 1972. Luckily by then, Fauna & Flora International had already initiated Operation Oryx, a captive-breeding program launched in 1962. From 1982 on, zoo-reared animals from the United States, Europe, and elsewhere were released into protected habitat in former range states. The species now numbers around a thousand animals in the wild and six to seven thousand in captivity globally.

Reticulated giraffe pp. 256–57

Scientific name: *Giraffa camelopardalis reticulata*
Range: Kenya, Ethiopia, Somalia
IUCN Red List status: Vulnerable

Every giraffe coat is unique, spanning a range from melanistic to pale and all manner of markings in between. There's variation, too, from one subspecies to the next, reaching its extreme expression in the reticulated giraffe (*G. c. reticulata*) of East Africa, which has a thin but crisp white tracery delineating each brown patch. While giraffes today live in open woodland, ancestral forms perhaps lived in denser cover where the dappled coat provided camouflage, particularly to the vulnerable calves (which in some areas suffer up to 75 percent mortality in their first year). But there's another, less obvious function of the markings. Beneath each brown patch lies a complex network of blood vessels and glands, comprising a "thermal window" that allows the animal to radiate heat and cool off without losing too much moisture through sweating. It is one of many remarkable giraffe adaptations to life in a hot, arid environment.

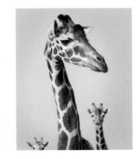

Reticulated giraffe p. 259

Scientific name: *Giraffa camelopardalis reticulata*
Range: Ethiopia, Kenya, Somalia
IUCN Red List status: Vulnerable

The giraffe population is made up of many small, isolated groups across Africa, classed in nine subspecies. While some subspecies are stable or increasing, the reticulated giraffe has suffered a fivefold drop, from perhaps 47,000 in the 1990s to some 8,600 today. Responding to news of the giraffe's decline, in September 2016 the IUCN called on all range states and partners to develop an Africa-wide conservation strategy and action plan for the giraffe and its relative the okapi. This is a Somali or reticulated giraffe, quartered on Sir Bani Yas Island, a sanctuary in the Persian Gulf, near Abu Dhabi. Sir Bani Yas runs a breeding program dedicated to sustaining numbers. Meanwhile, Kenya, home to three subspecies, is assembling an action plan: tackle illegal hunters (some of whom are after the giraffe's bones and brains, as a supposed cure for HIV); raise awareness in local communities; and protect suitable habitat.

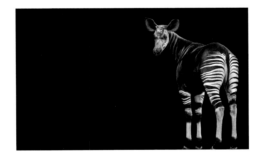

Okapi pp. 260–61

Scientific name: *Okapia johnstoni*
Range: Democratic Republic of the Congo
IUCN Red List status: Endangered

It can take courage to stick your neck out for nature. Following the atrocious 2012 attack on the research center at the Okapi Wildlife Reserve, its founder-director, John Lukas, marshaled his forces; the center is back up and running, with armed rangers patrolling the reserve, rooting out elephant poachers' traps, which are the main cause of local okapi deaths. The situation is complex, though: many locals support the rebels' cause, complaining that too much forest has been locked up in the reserve, denying them a livelihood. As one pygmy spokesman put it, "We feel like the big, non-governmental organizations and the rangers have privileged the animals over the people." Nonetheless, the reserve, founded in 1992, remains the okapi's sole stronghold, as well as harboring leopards, forest buffalo, and thirteen primate species, including chimpanzees.

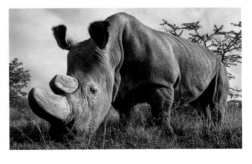

Northern white rhinoceros pp. 262–63

Scientific name: *Ceratotherium simum cottoni*
Range: formerly Central African Republic, Congo,
South Sudan, Uganda
IUCN Red List status: Critically Endangered

Yesteryear's vision of conservation—of vast, untouchable reserves—depended on a world very different from our own. A century ago, the world's human population was around four times smaller, and its animal population far more robust. Conservation meant insulating this self-sufficient nature from the human world; but today we have weakened many animal populations to the point that they depend on our help. Of the northern white rhino, for example, there are just two females, both incapable of carrying a child, and one male with a low sperm count. Left to be "wild and free," they would be extinct within a generation.

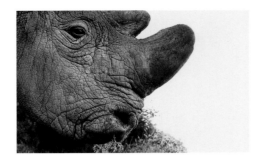

Northern white rhinoceros
pp. 264–65

Scientific name: *Ceratotherium simum cottoni*
Range: formerly Central African Republic, Congo, South Sudan, Uganda
IUCN Red List status: Critically Endangered

With black-market rhino horn more highly valued than gold, an alarming rise in poaching in southern Africa is being blamed in part on the increasing involvement of organized crime. And the networks extend to Europe: in March 2017, poachers broke into the Thoiry Zoo in France and shot dead Vince the southern white rhino, hacking off his horn. In response, the Czech zoo of Dvur Kralove (former home of the last living northern white rhinos) dehorned its eighteen rhinos, for fear of a similar attack. Later in March, the South African government reaffirmed its long-held plans to legalize domestic trade in rhino horn. Its strategy was to flood the market and depress the black-market value; but conservationists claim that any relaxation will simply stoke demand, which already is high. Given that one thousand of South Africa's rhinos were killed for their horns in 2016 alone, it seems they have a point.

Greater one-horned rhinoceros
pp. 266–67

Scientific name: *Rhinoceros unicornis*
Range: India, Nepal
IUCN Red List status: Vulnerable

The gnarly hide of this Indian rhino's rump distantly recalls the famous woodcut by Albrecht Dürer, commemorating the gift of said animal to King Manuel I of Portugal in May 1515. The first live rhino seen in Europe for 1,200 years, it created a huge stir. Dürer himself never saw it, but, on hearsay, confidently declared that it "has the color of a speckled tortoise" and "a strong sharp horn on its nose which it sharpens on stones." A century of strict protection in India and Nepal has seen the great one-horned rhino recover from an all-time low in the early twentieth century, when there were fewer than two hundred animals. Risks remain: for instance, poaching is on the rise in Kaziranga National Park, home to 70 percent of the population, and any outbreak of disease there would be disastrous. Yet numbers still rise overall, and hope for this species is growing.

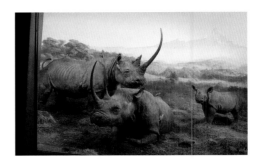

Black rhino
pp. 268–69

Scientific name: *Diceros bicornis*
Range: East and Southern Africa (Angola, Kenya, Mozambique, Namibia, South Africa, Tanzania, Zimbabwe)
IUCN Red List status: Critically Endangered

This magnificent diorama sits in the Akeley Hall of African Mammals at the American Museum of Natural History in New York. Carl Akeley (1864–1926), the American taxidermist and namesake of the hall, was in fact a biologist and conservationist. He helped establish Africa's first protected national park, now Virunga National Park in the Democratic Republic of the Congo, and his taxidermy continues to serve educational purposes. These three black rhinos belonged to a distinctive gene pool that Akeley could not protect, and that sadly disappeared from Kenya's plains as British colonialists developed a taste for recreational hunting. Today, some maintain that big-game hunting is helpful for conservation, as an economic incentive for breeding endangered mammals. This misjudgment shows an unawareness that all economies depend on healthy ecosystems, and, moreover, an underestimation of the power of our compassion for animals.

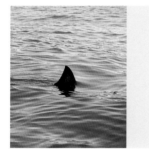

Great white shark
p. 270

Scientific name: *Carcharodon carcharias*
Range: Circumglobal, mainly in temperate coastal waters
IUCN Red List status: Vulnerable

The fin of a great white shark breaks the surface. Sharks and rays are an elusive lot. Of the thousand-plus species on the IUCN's Red List, close to half are "Data Deficient." But from extrapolating what *is* known, it is likely one in four species is threatened with extinction. Bycatch, especially in coastal waters, is a problem, but the main threat is overfishing for their meat, fins, jaws (for trophies), gills, liver oil, and skin. Rays are vulnerable because they are heavily fished and lightly protected; "hot spots" for at-risk species include the Indo-Pacific (especially the Gulf of Thailand), and the Red and Mediterranean Seas. Losing sharks and rays can have indirect effects in the food chain. Overfishing of the Caribbean reef shark, for instance, allowed its main prey, the grouper, to proliferate, leading to a dearth of grouper prey, including the parrotfish, a vital coral cleaner. The result: degraded coral reefs.

Great white shark
p. 273

Scientific name: *Carcharodon carcharias*
Range: Circumglobal, mainly in temperate coastal waters
IUCN Red List status: Vulnerable

In 2014, following a spate of human deaths, the state of Western Australia instigated a January-to-April cull of great white, tiger, and bull sharks. Drum lines—traps with baited hooks—were deployed along the coast, snaring 172 sharks. The cull sparked mass protests across Australia, with surveys showing that most ocean users opposed the cull on ethical grounds. In September, on the advice of its Environmental Protection Agency, the state abandoned plans to reinstate the summer cull. The decision, hailed by experts as "historic," "remarkable," and "a victory for science," manifests a sea change in our attitude to sharks. As Andrew Fox, a great white specialist, puts it: "In human–shark interactions, it's not a case of which species is more important, but whether we will make lifestyle choices to avoid conflict with a creature that does a great job of fixing up the mess we are making of the ocean environment."

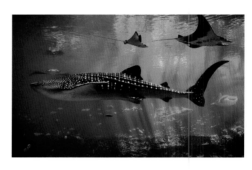

Whale shark
pp. 274–75

Scientific name: *Rhincodon typus*
Range: Circumglobal, in tropical and warm-temperate waters
IUCN Red List status: Endangered

The world's largest living fish, the whale shark is an oceanic wanderer capable of travelling 12–18 miles (20–30 km) a day and diving to nearly 6,500 feet (2,000 m) in search of its prey, mainly plankton and small fish. Subverting our usual blinkered view of sharks as deadly predators, this gentle filter-feeder has become an eco-tourism drawcard at hot spots including Quintana Roo (Mexico), the Maldives, and Ningaloo Reef (Western Australia), where it tends to school in large numbers. Yet the global population—split roughly one-quarter Atlantic, three-quarters Indo-Pacific—has crashed by some 50 percent over the past seventy-five years. Though the species is widely protected by national and international laws, whale sharks are still fished illegally to supply demand, mainly in Asia, for meat, oil, and fins. Bycatch is another problem, as is ship strike, particularly where pressure from tourist boats is beginning to present a nuisance factor.

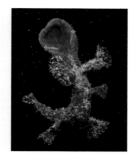

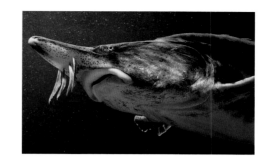

Scalloped hammerhead p. 277

Scientific name: *Sphyrna lewini*
Range: Circumglobal, in tropical and warm-temperate
coastal waters
IUCN Red List status: Endangered

In 2014, the scalloped hammerhead became the first shark
species to gain protection under the US Endangered Species
Act, in response to a petition from WildEarth Guardians
and Friends of Animals. Yet it's still heavily poached off
the Atlantic and Pacific American seaboards, particularly
in the shallow coastal waters where the pups tend to
congregate. Divers once marveled at the sight of hundreds
of hammerheads milling off the Galapagos or the Cocos
Islands, but no longer. Young sharks are often caught as
bycatch, and the number of scalloped hammerheads directly
targeted each year for their fins may be up in seven figures—a
tally that their low breeding rate cannot possibly support.
Paddling placidly among these scalloped hammerheads
pictured off the Galapagos Islands are endangered green
turtles; these rare chelonians are prone to getting tangled in
nets set by the illegal fishers.

Nudibranch p. 279

Scientific name: Nudibranchia (gastropod clade)
Range: Seas worldwide
IUCN Red List status: Not Evaluated

The name nudibranch, "naked gills," explains how these
marine mollusks extract oxygen from the water. Some of
their respiratory "frills," known as cerata, contain stinging
cells, which the nudibranch has salvaged from prey (such as
anemones) for its own defense. Rare mollusks get far less
press than they deserve. Of the hundreds of documented
animal species that have gone extinct since AD 1500, over
two-thirds are mollusks; they include more than sixty
partulid species (see pp. 284–87), whose passing has barely
registered in public consciousness, and yet they all play their
role recycling nutrients in ecosystems. Most of the extinct
and threatened mollusks are non-marine: North America, for
instance, formerly had one thousand-odd freshwater snail
and mussel species, but a tenth of these are now presumed
extinct, and one-third more are gravely threatened, owing to
human impacts on waterways. Until we tighten protection of
their habitats, our mollusks will remain hostage to fortune.

Beluga sturgeon pp. 280–81

Scientific name: *Huso huso*
Range: Black and Caspian Seas and associated rivers
IUCN Red List status: Critically Endangered

In winters long past, sturgeon measuring 16 feet (5 m) or
more, some reliably over a century old, would glide deep in
Eurasian seas to suck up their fish prey. In spring, sturgeon
migrate up rivers to traditional spawning grounds; the
hatched young then thread their way back to the sea and
stay there until mature, entailing a wait of a decade or two.
But the giant sturgeon are gone, and it's easy to see what
went wrong for a slow-growing, river-dependent fish whose
eggs sell for up to US$9,000 per pound (US$20,000/kg).
Dam projects—on the Volga, Don, Terek, Sulak, and other
rivers—have impounded the sturgeon's spawning grounds,
and fishing continues illegally for the caviar, meat, skin, and
other body parts. With its wild population dwindling despite
bolstering from protective legislation and captive-breeding
programs, the sturgeon is sinking into extinction.

La Palma pupfish p. 283

Scientific name: *Cyprinodon longidorsalis*
Range: formerly Mexico
IUCN Red List status: Extinct in the Wild

The passing of two species, unnamed, barely noticed, is
a scenario that plays out all too often. As a group, the
New World pupfishes (genus *Cyprinodon*) are small, no
longer than 4 inches (10 cm), many of them restricted to
marginal environments—often just one spring in remote
desert terrain; so they figure little on most people's radar.
In evolutionary terms, they're as fascinating as Darwin's
finches, some having radiated rapidly into diverse ecological
niches: tolerating high salinity, for instance, or preying on
hard-shelled crustaceans and mollusks. Several pupfishes
live in or near Death Valley, California; they would have
colonized their habitats in wetter times, later becoming
isolated from one another by a drying climate. Among
them is the perilously rare Devil's Hole pupfish, under an
inch (2.5 cm) long, confined to a geothermal pool in the
eponymous cavern, numbering two hundred individuals or
fewer . . . but on the map at least.

***Partula* snail** p. 285

Scientific name: *Partula* spp.
Range: Tahiti and other islands in the tropical Pacific
IUCN Red List status: various, from Extinct to Least Concern

Among the natural wonders collected on Captain James
Cook's 1769 voyage to the Pacific was a small land snail, later
named *Partula faba*—"bean snail." This was the first of its
genus known to Western science, though local Polynesians
had long used the shells in their necklaces. Partulids would
be closely studied over the years to come, featuring in
theories of speciation. On February 21, 2016, the last-known
living specimen of *P. faba* died in Edinburgh Zoo. It was by no
means the first partulid extinction; in all, over fifty species
of *Partula* in French Polynesia had succumbed in the wild
to the Central American rosy wolf snail, the bio-control
"cannibal" unleashed on French Polynesia in the 1970s. Later
in 2016, however, zoo and French Polynesian conservationists
released captive-bred cohorts of ten *Partula* species and one
subspecies into Tahiti, Moorea, and Raiatea, marking the
third release operation since 1994. Pictured are some of the
released snails, species *P. hebe*, *P. dentifera*, and *P. tohiveana*.

***Partula* snail** pp. 286–87

Scientific name: *Partula* spp.
Range: Tahiti and other islands in the tropical Pacific
IUCN Red List status: various, from Extinct to Least Concern

Introductions to oceanic islands are fraught, given the
risk of introducing alien pathogens or species capable of
wrecking fragile local ecosystems. So the Partulid Global
Species Management Program was a mammoth operation,
involving over thirty years' planning by the international
zoo community, the French Polynesian government, and
specialist support from IUCN groups. There was quarantine,
naturally, for the new arrivals. Each snail was then given
an identifying dab of enamel paint before being placed out
in enclosures or directly among shrubs and trees. Field
biologist Dr. Trevor Coote reported later that the snails
settled in well, and "reverted to ancestral behavior." If they
survive long term—there still remains a threat from another
introduced predator, the New Guinea flatworm—they'll strike
a triumphant blow for the little guys: the invertebrates and
others that lack the obvious charm of tigers or pandas, but
which often play a vital role in their native ecosystem.

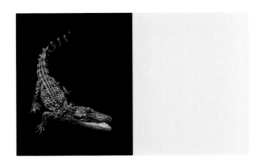

Siamese crocodile p. 288

Scientific name: *Crocodylus siamensis*
Range: Cambodia, Indonesia, Laos, Thailand
IUCN Red List status: Critically Endangered

In December 2016, People for the Ethical Treatment of Animals (PETA) filed a lawsuit against Vietnam, citing violation of animal welfare laws. At the same time, it published an exposé of the methods used in some of the country's 2,500 or so crocodile farms; Vietnam currently exports around thirty thousand skins annually to the makers of famous-name luxury goods, and produces about the same number for its domestic market. (Roughly speaking, four skins make a large handbag.) On some farms, crocodiles are confined for over a year in shallow pools of fetid water until ready for skinning. Workers may sometimes give crocodiles an electric shock to subdue them before carrying them to the abattoir. There, a worker cuts deeply across the animal's head, then thrusts a steel rod into its spinal column to cause paralysis. The living animal is then flayed; but it can still take up to five hours to die.

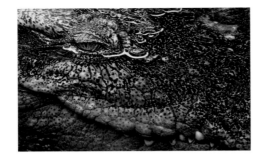

Siamese crocodile pp. 290–91

Scientific name: *Crocodylus siamensis*
Range: Cambodia, Indonesia, Laos, Thailand
IUCN Red List status: Critically Endangered

Life is upside down for the Siamese crocodile. As many as one million are kept in squalid conditions on farms across Southeast Asia, where once the species had a vast range, but in the wild today it is barely hanging on in a handful of scattered river systems. It is not all bad news, though. There is a Siamese Crocodile Task Force, which liaises with conservation groups in all the range states. Reintroductions are in preparation or under way in Cambodia, Laos, Vietnam (for instance, in Cat Tien National Park), and Thailand, using DNA-verified purebred crocs from farms. The success of these projects hinges on educating local people to the mutual benefits of restoring and protecting wetland habitats, offering the possibility of eco-tourism revenue. At the same time, the IUCN's Crocodile Specialist Group has been brought in to advise on the farmed trade—a case, perhaps, of, "Let it at least be humane."

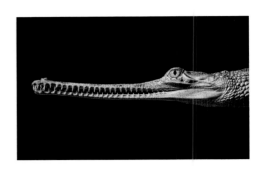

Indian gharial pp. 292–93

Scientific name: *Gavialis gangeticus*
Range: India, Nepal; possibly also Bangladesh, Bhutan, Pakistan
IUCN Red List status: Critically Endangered

This is Makara. Hatched in Florida in June 2016, he was the first Indian gharial ever to be captive-bred outside of his native range. At six months old, he's about as long as your arm, but he could grow to 20 feet (6 m). In times past, this big crocodilian with its trademark slender snout could be found from the Indus River in Pakistan east to the Irrawaddy in Myanmar, and throughout the great rivers of India. Long hunted for its skin, meat, eggs, and body parts (for traditional medicines), and persecuted by fisher folk, the species has lately faced a slew of new threats, including irrigation and engineering projects, plus the sheer pressure of encroaching people and livestock. By the 1940s there were perhaps five to ten thousand gharials, but today, despite valiant conservation efforts since the mid-1970s, they number just a couple of hundred, most of them in two big sanctuaries in northern India.

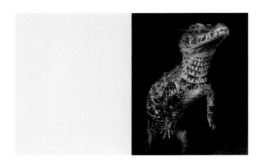

Smooth-fronted caiman p. 295

Scientific name: *Paleosuchus trigonatus*
Range: Bolivia, Brazil, Colombia, Ecuador, French Guiana, Guyana, Peru, Suriname, Venezuela
IUCN Red List status: Least Concern

Trigger, the resident smooth-fronted caiman at Crocodiles of the World in Oxfordshire, UK, features in countless visitors' selfies—which is hardly surprising, given his photogenic resting pose. Smooth-fronted caimans live in South and Central America, where a close relative, the dwarf caiman (*P. palpebrosus*), shares a broadly similar range. Caimans spend the day lying low in riverbank hollows, emerging at night to feed and mate. The female builds her nest near a termite mound or old timber, where the warmth from decomposing vegetation speeds the incubation of her eggs. For Colin Stevenson, educator at Crocodiles of the World, Trigger's popularity serves as "a gentle boost for crocodilian conservation." Thanks to the bony plates on its belly and back areas, the smooth-fronted caiman is largely spared by skin hunters, but it is under pressure from habitat degradation (through mining, for instance, and logging), and subsistence hunting for its meat.

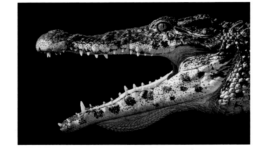

Cuban crocodile pp. 296–97

Scientific name: *Crocodylus rhombifer*
Range: Cuba
IUCN Red List status: Critically Endangered

Once widespread on Cuba and beyond, this species has the smallest range of any living crocodilian. One population lives in the Zapata swamp on Cuba's main island, and another on the offshore Isla de la Juventud. In the last century, much of the Zapata lagoon was reclaimed for agriculture, leaving the crocodiles confined to a small western area. With so little room, the species is highly vulnerable to pollution, water table instability, invasion by alien species, and other environmental changes. Also, it is breeding freely with the American crocodile (*C. acutus*), which shares part of its range, producing *mixturados*—hybrids—that are genetically impure. A breeding program has been running for decades, and, fortunately, the Cuban crocodile adjusts well to captivity. It is, however, an unusually athletic animal with a high-stepping gait, capable of explosive leaps from the water; its temperament, described as "pugnacious," has keepers on their toes.

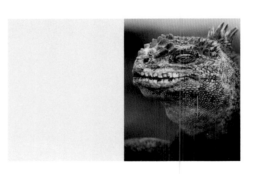

Marine iguana p. 299

Scientific name: *Amblyrhynchus cristatus*
Range: Galapagos Islands
IUCN Red List status: Vulnerable

Charles Darwin rather harshly described the marine iguanas as "disgusting . . . imps of darkness"—but he also found them fascinating. It is now believed they split from the Galapagos land iguanas up to 10.5 million years ago—which makes them even older than the extant islands (a paradox explained by ongoing volcanism). The world's only marine lizards, they rest and feed in the surf zone; but they nest a few hundred yards inland. Hatchlings need no parental care, as evidenced by gripping BBC footage of young iguanas scrabbling desperately across the rocks to escape predatory racer snakes. They are, however, vulnerable to introduced rats and feral cats and dogs. Tourism, too, requires management. In 2012, for instance, the Charles Darwin Foundation worked with the local municipality to extend the Galapagos National Park around fragile nesting areas on a tourist beach.

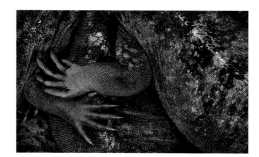

Marine iguana pp. 300–301

Scientific name: *Amblyrhynchus cristatus*
Range: Galapagos Islands
IUCN Red List status: Vulnerable

The ocean's edge is a zone of extremes, where only the larger individuals can retain enough solar-powered warmth to dive deep to the bigger growths of algae. To cope with the salt in their food, iguanas sneeze it out in crystalline chunks. And then there's El Niño, which starves around half of the iguana population every few years. The survivors go lean, but they also—incredibly—shrink in length by up to 20 percent, as a consequence of digesting nutrients from their own bones; when times of plenty return, they simply put the length back on. The iguanas take El Niño in their stride, but cope less well with added factors. Though over 60 percent of the iguanas on Santa Fe Island died after a diesel spill in 2001, their numbers recovered; how they will deal with climate change is open to question.

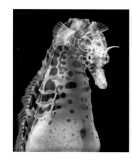

Big-belly seahorse p. 302

Scientific name: *Hippocampus abdominalis*
Range: Australia, New Zealand
IUCN Red List status: Data Deficient

Each year, claims the Seahorse Trust, the pet trade takes a million or so seahorses from the wild, only to survive a few weeks in captivity. It's the same count for the curio trade, in which the fish are left to dry—and die—in the hot sun, then sold as souvenirs. These figures pale next to the 150 million taken annually for traditional Asian medicines, and it wasn't long before breeders saw a lucrative opening for seahorse "farms." When a New Zealand farm had to close in 2006 after a main stakeholder pulled out, its animals faced euthanasia; but luckily the National Marine Aquarium in Plymouth, England, acquired some of the stock, including this big-belly seahorse (pictured). All seahorse species are listed on Appendix II of CITES, which allows regulated international trade. This, say some experts, is just not enough to prevent their extinction.

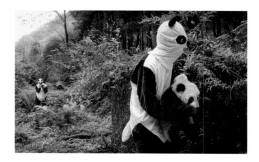

Giant panda pp. 306–7

Scientific name: *Ailuropoda melanoleuca*
Range: Gansu, Shaanxi, and Sichuan provinces (China)
IUCN Red List status: Vulnerable

You'd be forgiven for thinking these field workers were trying to pass themselves off as giant pandas—but no. The true purpose of the suit is to ensure that captive-reared cubs destined for introduction into the wild have absolutely no direct human contact, to prevent them "imprinting" on staff at the Wolong Nature Reserve in Sichuan. This cub is in the first phase of the rewilding process: acclimatizing with its mother in a pre-release "boot camp," it undergoes periodic weigh-ins and health checks. Staff adopted the dress-up policy after an attempted reintroduction in 2006, which resulted in tragedy when wild pandas attacked and killed a captive-reared youngster. After release, the cub will be monitored carefully on hidden cameras. For his part, Tim also put on a suit in order to take this photograph.

Southern white rhinoceros back endpaper

Scientific name: *Ceratotherium simum simum*
Range: Southern Africa
IUCN status: Vulnerable

Monty the southern white rhino, at the Cotswold Wildlife Park in England, thrilled staff recently by siring a couple of calves. The southern white rhino has been much luckier than the northern white rhino, though it nearly died out in the early twentieth century, when it numbered just twenty animals. A huge conservation effort has restored the population to over twenty thousand in the wild and some 750 in captivity. In fact, the population has bounced back to the point where the cost of protecting the rhinos has risen steeply. The rhinos are an easy target for poachers, being fairly placid, trusting herd animals; it is hard not to think of American zoologist Ernest Walker's dedication in his landmark publication *Mammals of the World*: "To the mammals, great and small, who contribute so much to the welfare and happiness of man, another mammal, but receive so little in return, except blame, abuse, and extermination."

References and further reading

The IUCN Red List

The *IUCN Red List of Threatened Species* is produced by the International Union for Conservation of Nature (IUCN), and is widely recognized as the most comprehensive inventory of the global conservation status of plant and animal species. The Red List serves to highlight those species that are threatened with extinction, and therefore promote their conservation. The categories of the Red List are defined briefly as follows (for more information go to www.iucnredlist.org):

Extinct (EX): a taxonomic group is Extinct when there is no reasonable doubt that the last individual has died.

Extinct in the Wild (EW): known only to survive in cultivation, in captivity or as a naturalized population well outside its past range.

Critically Endangered (CR): considered to be facing an extremely high risk of extinction in the wild.

Endangered (EN): considered to be facing a very high risk of extinction in the wild.

Vulnerable (VU): considered to be facing a high risk of extinction in the wild.

Near Threatened (NT): does not qualify for Critically Endangered, Endangered, or Vulnerable now, but is close to qualifying for a threatened category in the near future.

Least Concern (LC): has been evaluated against the criteria and does not currently qualify for Critically Endangered, Endangered, Vulnerable, or Near Threatened.

Data Deficient (DD): there is inadequate information to make an assessment.

Not Evaluated (NE): has not yet been evaluated against the IUCN Red List criteria.

The categorizations for specific species given in this book were sourced from version 2016-3 of the *IUCN Red List of Threatened Species*.

Other key websites

Arkive: www.arkive.org
EDGE of Existence: www.edgeofexistence.org/species
Protected Planet: www.protectedplanet.net

Select references

Arabian oryx
Hunter, M., et al. "Case Study: The Arabian Oryx." In *Fundamentals of Conservation Biology*, p. 324. Chichester, UK: John Wiley and Sons Ltd, 2006.

Axolotl
Lewis, T. "Missing Parts? Salamander Regeneration Secret Revealed." May 20, 2013: www.livescience.com/34513-how-salamanders-regenerate-lost-limbs.html

Blue-throated macaw
Asociación Armonia. "Barba Azul Nature Reserve Program: Protecting the Beni Savanna of Bolivia." January 27, 2017: armoniabolivia.org/protecting-the-beni-savanna-of-bolivia

Cheetah
Boast, L. K., et al. "Translocation of Problem Predators: Is It an Effective Way to Mitigate Conflict Between Farmers and Cheetahs (*Acinonyx jubatus*) in Botswana?" *Oryx* 50, no. 3 (July 2016): 537–44.

Weise, F. J., et al. "Cheetahs (*Acinonyx jubatus*) Running the Gauntlet: An Evaluation of Translocations into Free-Range Environments in Namibia." October 22, 2015: doi: 10.7717/peerj.1346

European honey bee
Tirado, R., et al. "Bees in Decline: A Review of Factors That Put Pollinators and Agriculture in Europe at Risk." Greenpeace Research Laboratories Technical Report (Review). Exeter: University of Exeter, 2013.

Giant panda
Binbin, V. L., et al. "China's Endemic Vertebrates Sheltering Under the Protective Umbrella of the Giant Panda." *Conservation Biology* 30, no. 2 (2015): 329–39.

Platt, J. R. "Giant Panda Conservation Also Helps Other Unique Species in China." September 16, 2015: blogs.scientificamerican.com/extinction-countdown/giant-panda-conservation

Great white shark
Sandin, S. A., et al. "Baselines and Degradation of Coral Reefs in the Northern Line Islands." *PLOS One* 3, no. 2 (2008): 1–11.

Whitcraft, S., et al. "Evidence of Declines in Shark Fin Demand, China." San Francisco, CA: WildAid, 2014.

Green-winged macaw
Argentinas, A. "The Return of a Giant: Green-Winged Macaw Back in Argentina." November 2, 2015: www.birdlife.org/americas/news/return-giant-green-winged-macaw-back-argentina

Cantú-Guzmán, J. C., et al. "The Illegal Parrot Trade in Mexico: A Comprehensive Assessment." Bosques de las Lomas, Mexico: Defenders of Wildlife, 2007.

Military macaw
Renton, K. "In Search of Military Macaws in Mexico." *PsittaScene* 16, no. 4 (2004): 12–14.

Monarch butterfly
Center for Biological Diversity. "Saving the Monarch Butterfly." August 2016: www.biologicaldiversity.org/species/invertebrates/monarch_butterfly/

Nudibranch
Endangered Species International, Inc. "Amazing Nudibranchs." September 2016: www.endangeredspeciesinternational.org/news_sept16.html

***Partula* snail**
Coote, T., et al. "Experimental Release of Endemic *Partula* Species, Extinct in the Wild, Into a Protected Area of Natural Habitat on Moorea." *Pacific Science* 58, no. 3 (2004), 429–34.

Passenger pigeon
American Museum of Natural History. "Passenger Pigeons: Gone Today but Once Abundant." February 18, 2014: www.amnh.org/explore/news-blogs/from-the-collections-posts/passenger-pigeons-gone-today-but-once-abundant

Philippine eagle
Donald, P., et al. *Facing Extinction: The World's Rarest Birds and the Race to Save Them.* 2nd ed. London: Bloomsbury Publishing PLC, 2013.

Walters, M. *Endangered Birds: A Survey of Planet Earth's Changing Ecosystems.* Sydney, Australia: New Holland Publishers, 2011.

Przewalski's horse
Sokolov, V. E., et al. "Introduction of Przewalski Horses into the Wild." In "The Przewalski Horse and Restoration to its Natural Habitat in Mongolia." FAO Animal Production and Health Paper 61. Rome, Italy: Food and Agriculture Organization of the United Nations, 1985.

Saiga
Coghlan, A. "Mystery Disease Claims Half World Population of Saiga Antelopes." Updated June 9, 2015: www.newscientist.com/article/dn27598-mystery-disease-claims-half-world-population-of-saiga-antelopes

Scimitar-horned oryx
The Zoological Society of London. "How to Bring a Species Back from Extinction." February 24, 2017: www.zsl.org/blogs/conservation/how-to-bring-a-species-back-from-extinction

The Zoological Society of London. "Scimitar-horned Oryx Returns to Sahara." February 14, 2017: www.zsl.org/conservation/news/scimitar-horned-oryx-returns-to-sahara

Seahorse
International Union for Conservation of Nature. "IUCN Behind Major Advance for Seahorse Conservation." September 28, 2016: www.iucn.org/news/iucn-behind-major-advance-seahorse-conservation

Siamese crocodile
McKerrow, L. "Lessons Learned from 15 Years of Siamese Crocodile Research and Conservation in Cambodia." February 4, 2016: www.fauna-flora.org/news/lessons-learned-from-15-years-of-siamese-crocodile-research-and-conservation-in-cambodia

Snow leopard
Coghlan, A. "Hundreds of Endangered Wild Snow Leopards are Killed Each Year." October 21, 2016: www.newscientist.com/article/2109894-hundreds-of-endangered-wild-snow-leopards-are-killed-each-year

South Philippine hawk eagle
Platt, J. R. "Threatened Philippine Hawk-Eagle Bred in Captivity for First Time." April 18, 2012: blogs.scientificamerican.com/extinction-countdown/threatened-philippine-hawk-eagle-bred-in-captivity-for-first-time

Tiger
Platt, J. R. "Wild Tiger Populations are Increasing for the First Time in a Century." April 10, 2016: blogs.scientificamerican.com/extinction-countdown/tiger-populations-increasing

Tilson, R., et al. (eds.). *Tigers of the World: The Science, Politics and Conservation of Panthera tigris.* 2nd ed. Norwich, USA: William Andrew Publishing, 2010.

Vulture
Karnik, M. "India Has a Grand Plan to Bring Back its Vultures." June 8, 2016: qz.com/700998/india-has-a-grand-plan-to-bring-back-its-vultures

Press Information Bureau, Government of India. "Asia's First 'Gyps Vulture Reintroduction Programme' Launched." June 3, 2016: pib.nic.in/newsite/PrintRelease.aspx?relid=145965

Recommended reading

The following texts might be of interest to readers wanting to further explore the importance for humans of interaction with the natural world.

Balmford, A., et al. "Trends in the State of Nature and their Implications for Human Well-Being." *Ecology Letters* 8 (2005): 1218–34.

Berman, M. G., et al. "The Cognitive Benefits of Interacting with Nature." *Psychological Science* 19, no. 12 (2008): 1207–11.

Daw, T., et al. "Applying the Ecosystem Services Concept to Poverty Alleviation: The Need to Disaggregate Human Well-being." *Environmental Conservation* 38, no. 4 (2011): 370–79.

Forest Research. "Benefits of Green Infrastructure." Report prepared for Forest Research, Farnham, UK, 2010.

Gladwell, V. F., et al. "The Great Outdoors: How a Green Exercise Environment Can Benefit All." *Extreme Physiology & Medicine* 2, no. 3 (2013): 1–7.

Hartig, T., et al. "Health Benefits of Nature Experience: Psychological, Social and Cultural Processes." In *Forest, Trees and Human Health* by K. Nilsson, et al., 128–67. Dordrecht, Netherlands: Springer Science Business and Media, 2010.

Kalof, L., et al. "The Meaning of Animal Portraiture in a Museum Setting: Implications for Conservation." *Organization & Environment* 24, no. 2 (2011): 150–74.

Maller, C., Townsend, M., Pryor, A., et al. "Healthy Nature Healthy People: 'Contact with Nature' as an Upstream Health Promotion Intervention for Populations." *Health Promotion International* 21, no. 1 (2005): 45–54.

Maller, C., Townsend, M., St Leger, L., et al. "Healthy Parks, Healthy People: The Health Benefits of Contact with Nature in a Park Context." *The George Wright Forum* 26, no. 2 (2009): 51–83.

Milner-Gulland, E. J., et al. "Accounting for The Impact of Conservation on Human Well-being." *Conservation Biology* 28, no. 5 (2014): 1160–66.

National Trust. "Natural Childhood." Report prepared by S. Moss. Swindon, UK: National Trust, 2014.

The Natural Learning Initiative. "Benefits of Connecting Children with Nature: Why Naturalize Outdoor Learning Environments." Report prepared for The Natural Learning Initiative. Raleigh, NC: North Carolina State University, 2012.

Sandifer, P. A., et al. "Exploring Connections Among Nature, Biodiversity, Ecosystem Services, and Human Health and Well-being: Opportunities to Enhance Health and Biodiversity Conservation." *Ecosystem Services* 12 (2015): 1–15.

Townsend, M., et al. "Healthy Parks Healthy People: The State of the Evidence 2015." Report prepared for Parks Victoria. Melbourne, Australia: State Government of Victoria, 2015.

Acknowledgments

A project of this scale requires the talent and experience of many skilled and remarkable people. Although I cannot name them all here, I am eternally grateful to the many individuals and organizations listed who contributed to this project.

My special thanks go to Alessandro Araldi at The Aspinall Foundation, someone who had to put up with me for more than a week as I went up and down a river, pursuing gorillas in the Gabon; Andrew Terry at Durrell Wildlife Conservation Trust, who was involved in this project from the very beginning; Igor Bochkarev, my man in Moscow, who arranged a number of projects and also accompanied me as I photographed saiga in extreme environments; Paul Pearce-Kelly at the Zoological Society of London, for so freely offering his time and advice; Clare Carolan for her indispensable guidance and support throughout this project; Eric Himmel at Abrams; and at the originating publisher Blackwell & Ruth, Geoff Blackwell, Ruth Hobday, Leanne McGregor, Dayna Stanley, and designer Cameron Gibb.

Over the last couple of years, I have had the good fortune to benefit from working with many exceptional conservationists, people who offered their time in the field and others who were generous with their research and comments. In particular I would like to mention: Baredine Cave; Matthieu Bonnet and Amos Courage (The Aspinall Foundation); Suzanne Braden (Pandas International); Mark Bushell (Bristol Zoo Gardens); Canon Europe Ltd; Dr. Vanessa Champion; Shen Cheng; Jamie Craggs (The Horniman Museum and Gardens); Jamie Craig (Cotswold Wildlife Park and Gardens); Rodrigo Cunha Serra (Centro Nacional de Reprodução de Lince Ibérico); Dr. Dennis E. Desjardin (San Francisco State University); Hiroko Enseki; Prof. Matthew Fisher (Imperial College School of Public Health); Shaun Foggett (Crocodiles of the World); Errol Fuller (extinction specialist); GBU AO Management of the State Wildlife Sanctuary "Stepnoi," founded by the Nature Management and Environmental Protection Office of the Astrakhan region; Andrew R. Gray (The Vivarium, Manchester Museum); Mr. Zhang Hemin (Wolong National Natural Reserve Administration and China Giant Panda Protection and Research Center); Tony Hutchings; Jayson Ibanez (Philippine Eagle Foundation); Paul Ives; Dusan Jelic Ph.D. (Croatian Institute for Biodiversity and Croatian Herpetological Society Hyla); Paul Lister (The European Nature Trust); Abid Mehmood and Bilal Kabeer (Sir Bani Yas Island); Bob Merz (Saint Louis Zoo); Justin Miller (Pangolin Conservation); Prof. E. J. Milner-Gulland (University of Oxford); Richard Moller (The Tsavo Trust); Kei Nomiyama (The Center for Marine Environmental Studies [CMES], Ehime University); Masato Ono and Naoyuki Ogino; Dr. Brian A. Perry (California State University East Bay); Hannah Reeves (bee specialist); Gregory Simpkins (Dubai Desert Conservation Reserve); Tom Svensson; Dr. Samuel Turvey; Barrett Watson; Edward Whitley OBE (Whitley Fund for Nature); Dominic Wormell and Richard E. Lewis (Durrell Wildlife Conservation Trust); Xi Zhinong (Wild China Film); and Brian Zimmerman (Aquarium, Zoological Society of London). I have included below an alphabetical listing of the many institutions who assisted me on this project, along with their locations and websites.

Thanks also to my extraordinary photography team—to my producers, Joanna Niklas and Anna Roberts; to my researchers, Amy Fitzmaurice and Nafeesa Esmail; to my assistants, Radi Konstantinov and Henry Jackson; and, of course, to my dedicated studio team, Amelia Katz, Bryony Daniels, and most especially Sophie Leuschke, who spent many long hours helping me make this project happen.

Special thanks is due to my remarkable writer, Sam Wells, for bringing to life in words each of my images and for telling so clearly the story of *Endangered*. Many thanks also to Matt Turner for producing such a brilliant set of thumbnail captions, and to Prof. Jonathan Baillie for his thoughtful commentary.

Institutions

American Museum of Natural History—New York, USA
www.amnh.org

The Aspinall Foundation—England
www.aspinallfoundation.org

Bristol Zoo Gardens—Bristol, England
www.bristolzoo.org.uk

Center of Oceanography and Marine Biology Moskvarium—Moscow, Russian Federation
www.moskvarium.ru

Centro Nacional de Reprodução de Lince Ibérico (Iberian Lynx National Breeding Centre)—Bartolomeu de Messines, Portugal
www.lynxexsitu.es

Chengdu Research Base of Giant Panda Breeding—Sichuan, PRC
www.panda.org.cn

China Conservation and Research Center for the Giant Pandas (CCRCGP)—Sichuan, PRC
en.chinapanda.org.cn

Colchester Zoo—Colchester, England
www.colchester-zoo.com

Cotswold Wildlife Park and Gardens—Burford, England
www.cotswoldwildlifepark.co.uk

Croatian Institute for Biodiversity—Zagreb, Croatia
www.hibr.hr

Crocodiles of the World—Brize Norton, England
www.crocodilesoftheworld.co.uk

Dubai Desert Conservation Reserve—Dubai, UAE
www.ddcr.org/en

Durrell Wildlife Conservation Trust—Jersey, Channel Islands
www.durrell.org/wildlife

Eckert James River Bat Cave Preserve (The Nature Conservancy)—Mason, Texas, USA
www.nature.org/ourinitiatives/regions/northamerica/unitedstates/texas/placesweprotect/eckert-james-river-bat-cave-preserve.xml

Georgia Aquarium—Atlanta, Georgia, USA
www.georgiaaquarium.org

Heron Island Research Station, The University of Queensland—Heron Island, Queensland, Australia
www.uq.edu.au/heron-island-research-station

Horniman Museum and Gardens—London, England
www.horniman.ac.uk

Hustai National Park—Ulaanbaatar, Mongolia
www.hustai.mn

The International Centre for Birds of Prey—Newent, England
www.icbp.org

Manu National Park—Peru
www.visitmanu.com/en

Monarch Butterfly Biosphere Reserve—Mexico
mariposamonarca.semarnat.gob.mx

The National Marine Aquarium—Plymouth, England
www.national-aquarium.co.uk

The Natural History Museum—London, England
www.nhm.ac.uk

Nordens Ark—Hunnebostrand, Sweden
en.nordensark.se

Ol Pejeta Conservancy—Nanyuki, Kenya
www.olpejetaconservancy.org

Osaka Aquarium, Kaiyukan—Osaka City, Japan
www.kaiyukan.com/language/eng

Pandas International—Littleton, Colorado, USA
www.pandasinternational.org

Pangolin Conservation—USA
www.pangolinconservation.org

Philippine Eagle Center—Davao City, Philippines
www.philippineeagle.org/center

Philippine Eagle Foundation—Davao City, Philippines
www.philippineeaglefoundation.org

Polar Bears International—Bozeman, Montana, USA
www.polarbearsinternational.org

St. Augustine Alligator Farm Zoological Park—St. Augustine, Florida, USA
www.alligatorfarm.com

Saint Louis Zoo—St. Louis, Missouri, USA
www.stlzoo.org

Sir Bani Yas—Desert Islands, Abu Dhabi, UAE

Smithsonian's National Zoo and Conservation Biology Institute—Washington, D.C., USA
www.nationalzoo.si.edu

Tampa's Lowry Park Zoo—Tampa, Florida, USA
www.lowryparkzoo.org

The Tsavo Trust working in partnership with KWS (Kenya Wildlife Service)—Tsavo National Park, Kenya
www.tsavotrust.org

Twycross Zoo, The World Primate Centre—Atherstone, England
www.twycrosszoo.org

The Vivarium, Manchester Museum, The University of Manchester—Manchester, England
www.museum.manchester.ac.uk/collection/vivarium

White Oak Conservation—Yulee, Florida, USA
www.whiteoakwildlife.org

The Whitley Fund for Nature (WFN)—London, England
www.whitleyaward.org

Wild China Film—Beijing, PRC
www.wildchina.cn

Zagreb Zoo—Zagreb, Croatia
www.zoo.hr

Zoological Society of London (ZSL)—London, England
www.zsl.org

ZSL London Zoo Aquarium—London, England
www.zsl.org/zsl-london-zoo/exhibits/aquarium

ZSL Whipsnade Zoo—Dunstable, England
www.zsl.org/zsl-whipsnade-zoo

ISBN: 978-1-4197-2651-4

Library of Congress Control Number: 2016960608

Produced and originated by Blackwell and Ruth Limited
Suite 405 IronBank, 150 Karangahape Road
Auckland 1010, New Zealand
www.blackwellandruth.com

Publisher: Geoff Blackwell
Editor in chief: Ruth Hobday
Designer: Cameron Gibb
Production manager: Dayna Stanley
Editorial manager: Leanne McGregor
Body text: Sam Wells
Thumbnail text: Matt Turner
Editor: Brian O'Flaherty
Technical editor: Dr. Samuel Turvey
Additional editorial: Lisette du Plessis

Images copyright © 2017 Tim Flach
Text pages 8–11, 20–298 and 308–33 copyright © 2017 Tim Flach
Text pages 17 and 303–5 copyright © 2017 Jonathan Baillie
Design and concept copyright © 2017 Blackwell and Ruth Limited

Printed and bound in China
10 9 8 7 6 5 4 3 2 1

Abrams books are available at special discounts when purchased
in quantity for premiums and promotions as well as fundraising
or educational use. Special editions can also be created to
specification. For details, contact specialsales@abramsbooks.com
or the address below.

ABRAMS The Art of Books
115 West 18th Street, New York, NY 10011
abramsbooks.com

This book is made with FSC®-certified paper products and is
printed with soy vegetable inks. The Forest Stewardship Council®
(FSC®) is a global, not-for-profit organization dedicated to the
promotion of responsible forest management worldwide to meet
the social, ecological, and economic rights and needs of the present
generation without compromising those of future generations.

MIX
Paper from
responsible sources
FSC® C016973

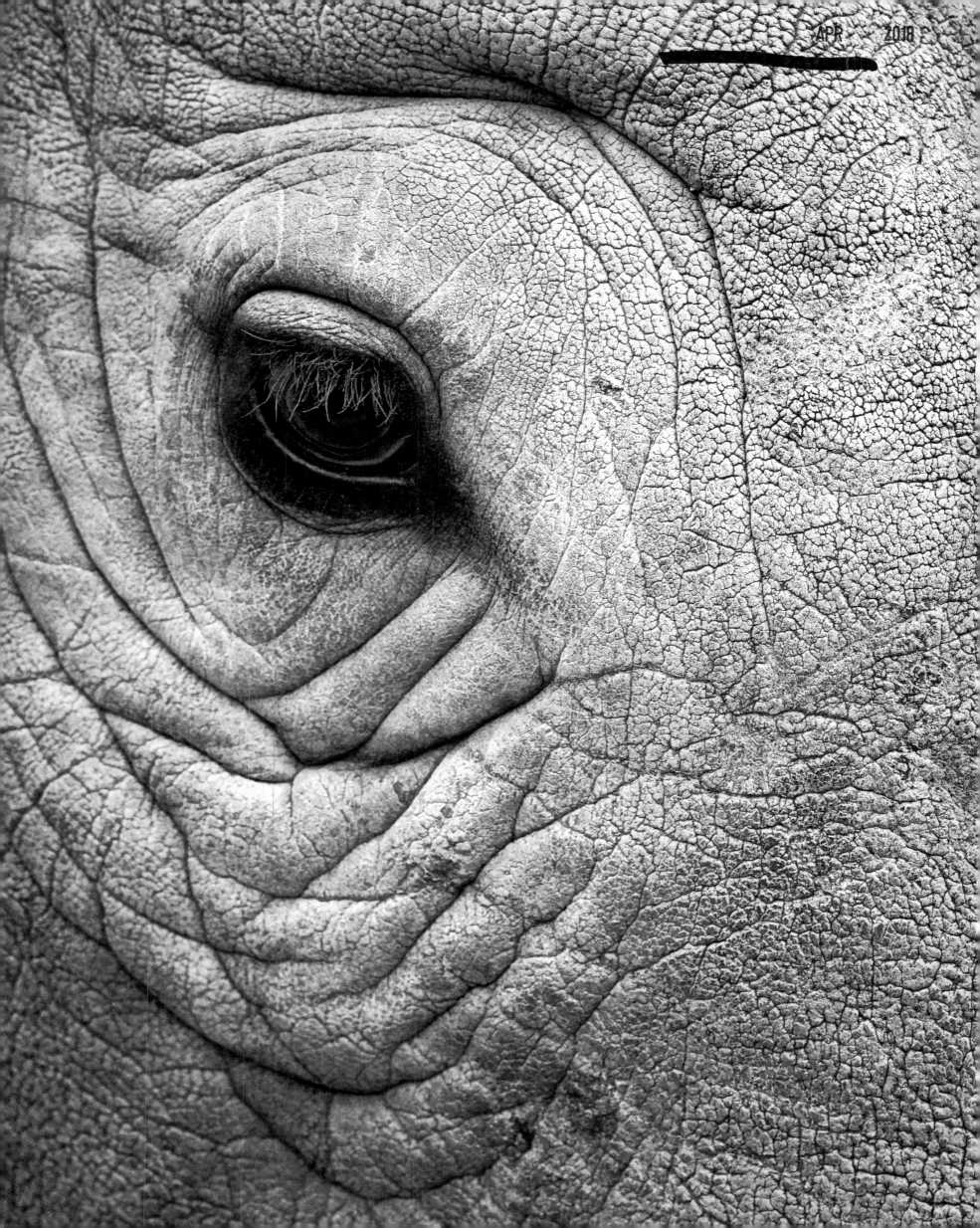